ANDREA
MANTEGNA

Royal Academy of Arts, London
17 January – 5 April 1992

The Metropolitan Museum of Art, New York
9 May – 12 July 1992

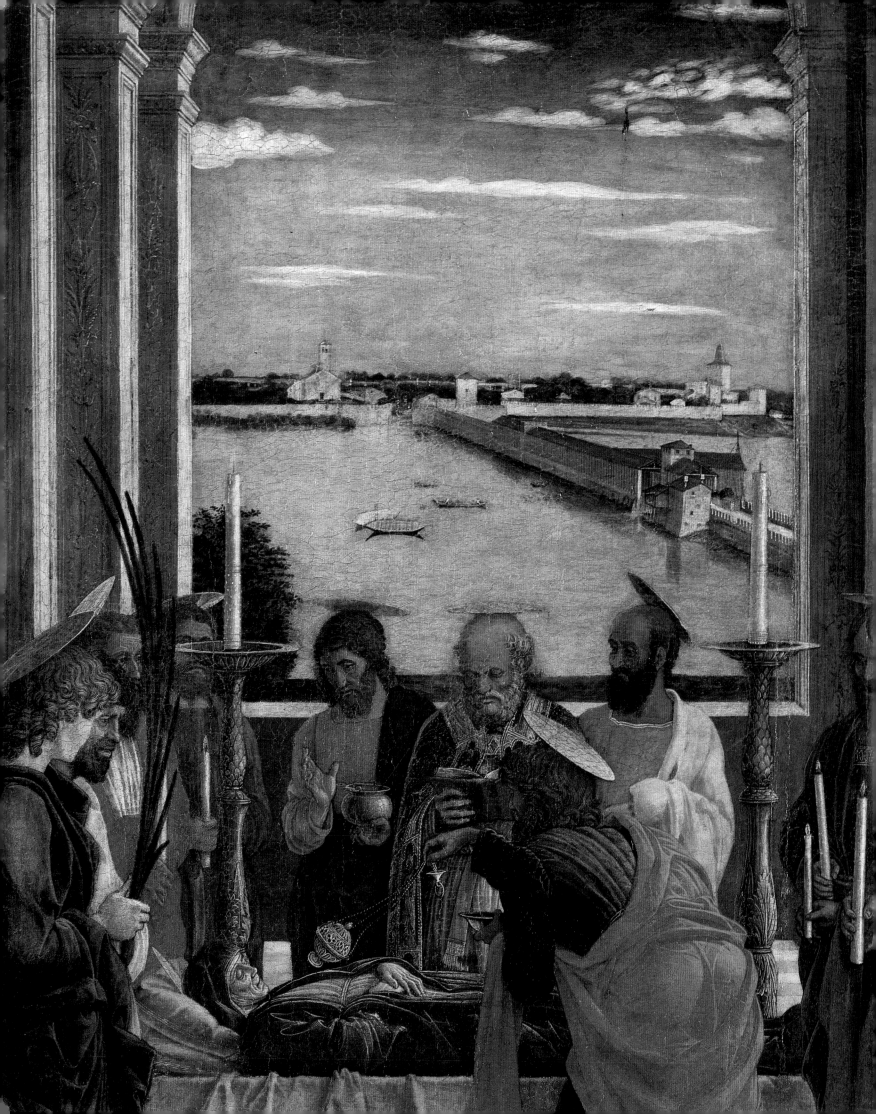

ANDREA MANTEGNA

Edited by Jane Martineau

Suzanne Boorsch, Keith Christiansen, David Ekserdjian,
Charles Hope, David Landau and others

ROYAL ACADEMY OF ARTS, LONDON
THE METROPOLITAN MUSEUM OF ART, NEW YORK

OLIVETTI | ELECTA

1992

This catalogue was first published
on the occasion of the exhibition *Andrea Mantegna*

Royal Academy of Arts, London
17 January – 5 April 1992

The Metropolitan Museum of Art, New York
9 May – 12 July 1992

Presented by Olivetti

The exhibition was organised by the Royal Academy of Arts and The Metropolitan Museum of Art

This catalogue is dedicated to the memory of Lawrence Gowing and Philip Pouncey

The Royal Academy of Arts is grateful to Her Majesty's Government for its help in agreeing
to indemnify the exhibition under the National Heritage Act 1980 and to the Museums and
Galleries Commission for their help in arranging this indemnity.

The exhibition in New York was supported in part by the National Endowment for the Arts
and by an indemnity from the Federal Council on the Arts and Humanities. Additional support
for the exhibition in New York was provided by the Italian Cultural Institute.

Alitalia was the official carrier for the exhibition

Catalogue published in association with: Electa, Milano – Elemond Editori Associati
Catalogue design and graphics coordination: Crispin Rose-Innes Limited, London

Typeset by: Accent on Type, London
Typeset in Monotype Bembo
Film composition by: Apex Computersetting, London
Colour and black and white separations by: Bassoli Olivieri Prestampa, Milan

Printed in Italy by: Fantonigrafica – Elemond Editori Associati
Distributed for The Metropolitan Museum in North America by
Harry N. Abrams, Inc., New York

ISBN (RA) 0 900946 39 3 (clothbound)
ISBN (RA) 0 900946 40 7 (paperbound)
ISBN (MMA) 0 87099 642 8 (clothbound)
ISBN (MMA) 0 87099 640 1 (paperbound)
ISBN (HNA) 0 8109 6415 5

Frontispiece:
Andrea Mantegna, *Death of the Virgin,* cat. 17, detail
Museo del Prado, Madrid

CONTENTS

PATRONS

Her Majesty The Queen
Il Presidente della Repubblica Italiana, S.E. Francesco Cossiga

COMMITTEE OF HONOUR

On. Giulio Andreotti
Presidente del Consiglio dei Ministri

The Right Hon. John Major
Prime Minister and First Lord of the Treasury

Sen. Giovanni Spadolini
Presidente del Senato

On. Gianni De Michelis
Ministro degli Esteri

The Right Hon. Douglas Hurd
Secretary of State for Foreign and Commonwealth Affairs

The Right Hon. Timothy Renton
Minister for the Arts

Alessandro Vattani
Direttore Generale per le Relazioni Culturali

Nicholas Elam
Head of Cultural Relations, Foreign and Commonwealth Office

Ambasciatore Giacomo Attolico
Ambasciatore Italiano a Londra

Ambasciatore Boris Biancheri
Ambasciatore Italiano a Washington

Sir Stephen Egerton, KCMG
Her Majesty's Ambassador in Rome

Prof. Francesco Sisinni
Direttore Generale per i Beni Culturali e Ambientali

Lord Palumbo of Walbrook
Chairman of the Arts Council of Great Britain

Sir Roger de Grey KCVO
President, Royal Academy of Arts

Philippe de Montebello
Director, The Metropolitan Museum of Art

Francesco Negri Arnoldi
Presidente del Comitato di Settore per i Beni Artistici e Storici

Bruno Visentini
Presidente Onorario Olivetti e Presidente Fondazione Giorgio Cini

Carlo De Benedetti
Presidente Ing. C. Olivetti & C. SpA

Paolo Tosi
Managing Director, Olivetti Systems & Networks Limited

ADVISORY COMMITTEE

Francis Haskell (chairman)
Giulio Carlo Argan
Henning Bock
Sydney J. Freedberg
Konrad Oberhuber
Antonio Paolucci
Anna Maria Petrioli Tofani
Pierre Rosenberg
Rodolfo Signorini

STEERING COMMITTEE

David Landau (chairman)
Suzanne Boorsch
Keith Christiansen
David Ekserdjian
Jane Martineau
The late Philip Pouncey
Norman Rosenthal
Renzo Zorzi

EXECUTIVE COMMITTEE

Piers Rodgers (chairman)
Secretary, Royal Academy of Arts

Mahrukh Tarapor
Assitant Director, The Metropolitan Museum of Art

Allen Jones RA
Chairman, Exhibitions Committee of the Royal Academy of Arts

Norman Rosenthal
Exhibitions Secretary, Royal Academy of Arts

Colta Ives
Curator in Charge, Dept of Prints and Photographs, The Metropolitan Museum of Art

David Barker
Director, Finance and Administration, Royal Academy of Arts

MaryAnne Stevens
Librarian and Head of Education, Royal Academy of Arts

Emily K. Rafferty
Vice President for Development and Membership, The Metropolitan Museum of Art

Griselda Bear
Director, Royal Academy Trust

Basil Cousins
Marketing Communications Manager, Olivetti Systems & Networks Limited

Mauro Broggi
Anna Galeazzi
Direzione Attività Culturali, Ing. C. Olivetti & C. SpA

Annette Bradshaw (secretary to the Committee)
Deputy Exhibitions Secretary, Royal Academy of Arts

Linda M. Sylling
Assistant Manager for Operations, The Metropolitan Museum of Art

EXHIBITION COORDINATORS

Suzanne Boorsch
Annette Bradshaw
Keith Christiansen
Jane Martineau

PHOTOGRAPHIC COORDINATOR

Miranda Bennion

EDITORIAL NOTE

The following works have been especially restored for the exhibition:
5, 11, 12, 27, 38, 42, 44, 54, 55, 102

Dimensions of paintings are given in centimetres to the nearest 0.5 cm;
dimensions of drawings and engravings are given in millimetres;
height precedes width.

Dimensions of prints are those of the platemark or sheet. If the dimensions of
the platemark are taken from an impression not in the exhibition, the location
of that print is given in parentheses. If the dimensions of the platemark are not
known, those of the sheet are given in parentheses. For further explanation see
Appendices I and II.

References in the text and at the foot of the entries refer to the general
bibliography.

Catalogue entries are signed with the initials of the following contributors:

S. B. Suzanne Boorsch
K. C. Keith Christiansen
A. C. de la M. Albinia de la Mare
D. E. David Ekserdjian
C. H. Charles Hope
D. L David Landau
A. F. R. Anthony Radcliffe

*The Steering Committee would like to extend their thanks to the following
individuals who contributed in many different ways to the organisation of the
exhibition and to the preparation of the catalogue.*

Janet Abramowicz, David Acton, Marianne Aebersold, Giovanni Agosti,
Maryan Ainsworth, Jonathan Alexander, Filippa Aliberti Gaudioso,
Victoria Atkinson, Jake Auerbach, Charles Avery, Graeme Barraclough,
Andrea Bayer, Sandrina Bandera Bistoletti, David P. Becker, Carlo Bella,
Maria Grazia Benini, Jadranka Bentini, Alessandro Bettagno, Veronika Birke,
David Bomford, Evelina Borea, Gabriella Borsano, Graham Bosch van
Rosenthal, John Brealey, Rose-Helen Breinin, Mauro Broggi,
Clifford M. Brown, David A. Brown, Emanuelle Brugerolles, John Buchanan,
David Bull, Richard Campbell, Caterina Caneva, Carmen Cappel, Rita Cassano,
Mimi Cazort, Alessandro Cecchi, Luisa Cervati, Tanya Chambers,
Hugo Chapman, Marco Chiarini, Marco Ciatti, Aldo Cicinelli,
Marjorie B. Cohn, Joseph Cowell, Paolo Crisostomi, Laura D'Agostino,
Louise d'Argentcourt, Sophie de Bussierre, Ellen D'Oench, Alessandro Dalai,
Arnold Davies, Peter Day, Anna Della Valle, Alfio Del Serra, Andrea Di
Lorenzo, Barbara Dossi, Peter Dreyer, Alexander Duckers, Jill Dunkerton,
Charles Eiben, Caroline Elam, Andrea Emiliani, Siri Engberg, Cecilia M.
Esposito, Marzia Faietti, Lola Faillant-Dumas, Rupert Featherstone, Sylvia
Ferino-Pagden, Monsignore Ciro Ferrari, Richard S. Field, Jan Piet Filedt Kok,
Nancy Finlay, Jay M. Fisher, Sarah Fisher, Betty Fiske, Roberto Fontanari,
Lucia Fornari Schianchi, Marcello Francome, Nadia Fusetti, Felipe Garin,
J.-C. Garreta, Carmen Garrido, Jane Glaubinger, George Goldner,
Margaret Morgan Grasselli, Antony Griffiths, Giovanna Giusti,
Werner Gundersheimer, Paul Gumn, Richard Harprath, Gisela Helmkampf,
Eve Hickey, Reinhold Hohl, Julian Honer, Eric Horovitz, Isabel Horowitz,
Frederick Ilchman, Robert Jameson, George Keyes, Benjamin Kohl,
Eva Korazija, Fritz Koreny, Sabine Kretzschmar, Gisele Lambert, Brigitte Laube,
Sarah Lawrence, Catherine Le Grand, Adrian Le Harivel, Manfred Leithe-Jasper,
David Llewellyn, Benjamin Kohl, Evelyn Lincoln, Christopher Lloyd,
Katharine A. Lochnan, Anna Maria Lorenzoni, Katherine Crawford Luber,
Ger Luijten, Suzanne McCullagh, Christopher McGlinchey, Elizabeth McGrath,
George McKenna, Kristin Makholm, Annette Manick, Nina Maruca,
Patrick Matthiesen, A.T.M. Meij, Christopher Mendez, Eleanore Merrill,
Jennifer Montagu, Diane Mooradian, Alessandra Mottola Molfino,
Daniele Mosca, Herb Moskowitz, Giovanna Nepi Scirè, Denise Pagano,
Bruno Passamani, Amanda Paulley, Nicholas Penny, Gerhart Pieh,
Pietro Petraroia, Viola Pemberton Piggot, Sir John Pope-Hennessy,
Myril Pouncey, Maxime Préaud, Patrick Ramade, Sue Welsh Reed,
Catherine Rickman, William Robinson, Andrew Robison, Liliana Ronca,
Barbara T. Ross, Francesco Rossi, Ruth Rubinstein, Francis Russell,
Maurizio Saraceni, Pietro Scarpa, Eckhard Schaar, Erich Schleier, Keith Shaw,
Wendy Stedman Sheard, Janice Shell, Alan Shestack, Innis H. Shoemaker,
Helen Smith, Kristin L. Spangenberg, Nicola Spinosa, Paolo Spezzani,
Alan Stahl, Leo Steinberg, Nicholas Stogdon, Harriet K. Stratis, Carl Strehlke,
Margret Stuffman, Mark Stuffmann, Gail Swerling, Marilyn Symmes,
Martha Tedeschi, Dominique Thiebaut, Mark Trowbridge, Filippo Trevisani,
David Tunick, Nicholas Turner, Jesus Urrea, Mariella Utili, Françoise Viatte,
Eli Valeton, Carlos van Hasselt, Hubert von Sonnenberg, Roberta Waddell,
Matthew Wallis, Angelo Walther, Uwe Westfehling, Catherine Whistler,
Lucy Whitaker, Daniel Wildenstein, Robert Williams, Paul Williamson,
John Wilson, Timothy Wilson, Louisa Wood, Amy N. Worthen,
Irena Zdanowicz and Hans-Joachim Ziemke.

PREFACE

Olivetti is delighted to be associated with two distinguished institutions, the Royal Academy of Arts of London and The Metropolitan Museum of Art in New York, in the preparation and organisation of this exceptional exhibition. Andrea Mantegna was one of Italy's greatest artistic geniuses, whose prodigious technical skill, innovative use of techniques and, above all, breadth of imagination and vision, make him one of the outstanding figures of the Italian Renaissance.

From the very beginning, we were aware that a Mantegna exhibition was an event of the utmost scholarly importance. As such it might be thought possible to justify the transfer of priceless and often fragile works of art to permit direct comparisons without which it is impossible to assess the essential qualities of an artist, to trace his development in different media through his career, and to understand the full significance of his art in his own time and for us today.

Olivetti's support for the arts takes one of two forms. First, the company promotes and finances the restoration of great fresco cycles, such as the Brancacci Chapel in the church of the Carmine, Florence, Masolino's frescoes in San Clemente, Rome, and, most recently, Masaccio's *Trinity* in Santa Maria Novella, also in Florence, on which work has just begun. Second, Olivetti has been active in organising outstanding exhibitions with leading museums and institutions throughout the world. These activities have become a company tradition, the trademark of Olivetti in its role as one of the great European companies.

Inevitably with an exhibition of this scope many people have made outstanding contributions to its planning and realisation, and to all of them we extend our warmest thanks. In particular, I would like to pay tribute to the two institutions that have made the exhibition possible: the Royal Academy and The Metropolitan Museum; this is not the first occasion on which Olivetti has worked with them on artistic initiatives; Olivetti's exhibitions of the Houses of San Marco and the Cimabue Crucifix both came to the Academy. It is a great honour to be associated with them in an event that, we trust, will advance scholarship and widen the knowledge of the Italian Renaissance among the ever increasing number of people on both sides of the Atlantic with an enthusiasm for the visual arts. Finally, I should like to express our gratitude to Her Majesty Queen Elizabeth II, who has graciously consented to the exceptional loan of the *Triumphs of Caesar* to the Royal Academy, and has agreed, with His Excellency the President of the Italian Republic, Francesco Cossiga, to bestow her patronage on this exhibition.

Carlo De Benedetti
Chairman of Olivetti

FOREWORD

Mantegna is, it could be argued, the most perfect of the great artists of 15th-century Italy. His conscious efforts to recapture the essence of the ancient world make him quintessentially *the* artist of the early Renaissance, yet he has never been the most loved. His formidable intellect and arrogance made him unapproachable, and these traits, transferred to his art, have distanced him from the sympathy of many 19th- and 20th-century critics as well. In the 16th century Vasari observed that Mantegna so worshipped the Roman remains that were every- where visible that his style was 'rendered somewhat sharp, more closely resembling stone than living flesh'. His works confront the viewer not with the abstract aloofness of a Piero della Francesca, but with an expressive intensity that is the more discomforting for its uncom- promising, lapidary precision. Not surprisingly, critics and commentators have all too fre- quently failed to appreciate the tragic and, ultimately, human dimension of Mantegna's work.

This exhibition, projected and guided throughout its various phases by David Landau, sets out to explore the creative mind of this remarkable genius. To do this it has espoused a somewhat unconventional approach. It seemed to the organisers that a purely monographic exhibition was neither feasible nor desirable. Key works such as the St Luke Altarpiece in the Brera, Milan, the San Zeno Altarpiece in Verona and the *Madonna della Vittoria* in the Louvre are, by the conservation standards of today, untransportable, and Mantegna's frescoes must be seen *in situ*. More importantly, the organisers wished to show in roughly equal measure the drawings that are the basis of Mantegna's creativity, the engravings by which his ideas were so widely disseminated over the centuries, and the paintings on which his fame was based. Responsibility for the selection of the works in these various media was distribu- ted among the organising committee. Throughout, support was unswervingly given by Lawrence Gowing.

Philip Pouncey's fecund ideas about Mantegna as draughtsman have never been followed up by a comprehensive study, and he was most anxious to use this as the occasion to do so. Alas, he died before the exhibition took final shape, but until the end he communicated his ideas in conversations with the committee and with the author of the drawings entries, David Ekserdjian. It is to Philip Pouncey and to Lawrence Gowing that the catalogue is dedicated.

Ten years ago David Landau organised an exhibition on Mantegna's engravings in Oxford, and to him and to Suzanne Boorsch fell the enormous task of making sense of the engravings associated with Mantegna's name and with his 'School'. The results of their careful investigations mark a new chapter in our understanding of 15th-century printmaking. It may seem strange that there has never before been an attempt to bring together the finest, extremely rare, richly printed impressions of these engravings, but such is the case. The prints displayed here will come as a revelation to those who are familiar only with the worn impressions usually exhibited. Keith Christiansen oversaw the selection and cataloguing of the paintings, with Charles Hope writing on the *Triumphs of Caesar*, while to Jane Martineau fell the unenviable task – admirably prosecuted – of coordinating the exhibition and bringing the catalogue together. The concept of the exhibition owes much to Norman Rosenthal.

The divisions of the catalogue and the exhibition reflect various areas of Mantegna's creativity: his formation in that cradle of archaeological humanism, Padua; the character and development of his drawing style – long a subject of dispute; his involvement with printmaking; his activity as a portrait painter; and his fascination with certain themes. These issues also informed the selection of the objects in the exhibition, which seeks to open avenues of investigation and to question received opinions rather than to present a view of the artist sanctioned by tradition.

Although this has been a joint project and every effort has been made to maintain its fundamental unity, the rarity and fragility of the material has meant that the two showings differ in significant respects. By the exceptional generosity of H. M. The Queen, the *Triumphs of Caesar*, which Mantegna himself regarded as his crowning achievement, will be transported from Hampton Court to the Royal Academy, but it was out of the question that these large works should make a trip across the Atlantic. Fragility has also meant that Mantegna's finest grisaille painting, *The Introduction of the Cult of Cybele in Rome*, could not make the trip to New York. And, of course, the justifiable concerns of drawing collections in exposing works on paper to light has meant that some works will be seen in only one of the two venues. Working within these practical realities, the organisers have attempted to maintain the integrity of individual sections, so that the range of Mantegna's activity as a portraitist will be seen intact in New York, while his fascination with the theme of the Descent into Limbo will be shown in London.

That this exhibition has been realised is due to the exceptional cooperation and generosity of some key institutions, among which we would like to single out the British Museum, which possesses the richest holdings of Mantegna's drawings, and the Albertina in Vienna, which has lent thirteen engravings as well as four drawings. The paintings on panel posed particular problems, and to the various lenders we owe a heartfelt thanks. That visitors will be able to see *The Man of Sorrows with Two Angels* from the Statens Museum for Kunst in Copenhagen – perhaps Mantegna's least familiar masterpiece – is something the organisers scarcely dared to hope for. The quite exceptional loans from Italy were procured through the cooperation of various superinter:dencies and with the support of Francesco Sisinni. To all lenders a special thanks is due.

Our final debt of thanks is to Olivetti, and to their chairman Carlo De Benedetti. Olivetti has a long history of cooperation with the Royal Academy and the Metropolitan Museum. They organised such memorable exhibitions as the *Horses of San Marco* and the *Crucifix of Cimabue*. We are most grateful to them not only for their generous financial support but also for the energetic involvement in every stage of the organisation of this exhibition and for their help in overcoming sometimes formidable hurdles.

Sir Roger de Grey, KCVO
President, Royal Academy of Arts

Philippe de Montebello
Director, The Metropolitan Museum of Art

I

MANTEGNA

LAWRENCE GOWING

Mantegna gives us as many reasons to dislike him as any great artist. He is dry; he is violent; he has a reputation for pedantry. In his pictures we sometimes catch a bitter reflection of the temperament which made him as difficult a neighbour as any recorded painter before Caravaggio. Looking back, it is a considerable surprise to read how truly disagreeable Bernard Berenson, the writer of *The North Italian Painters of the Renaissance*, found him. Among modern painters perhaps only Wyndham Lewis has really loved him. Yet no one forgets him. He has deposited something angular and painful under the skin of European art, a recurrent reminder of how much of it is by his standards merely amiable or optimistic. He is, no doubt, a prime exponent of something essential in the tradition – one of the great archetypes. But an exponent and an archetype of what?

The essential element that resists description in Mantegna had no parallel even among the artists closest to him. Classical antiquity, the common ancestor that united what was typical of the Quattrocento, had a special and different significance in his hands. In Padua the recovery of the past rested with scholars, rather than sculptors or architects. But the antiquarianism that was in the air only half explains the lack of anything heroic or idyllic in Mantegna's evocation of the ancient world. There was nothing in it, for example, of the lyricism of Pollaiuolo; for Mantegna the terrific masonry of antiquity and the stony imagery that decorated it were sufficient in themselves. The other common concern of his time, perspective, had in his extreme form as strange a meaning. In the towering townscapes through which St James was led to martyrdom (fig. 1), perspective had the character not of a new logic so much as of a new and violently compelling paradox: the spectator was drawn involuntarily into the fatal system of the picture.

Though the invention was not often so violent, the painting of Mantegna's maturity had always this frozen, rock-like force. A similar impersonal power inhabited the human frame. The figures in the Ovetari frescoes suggest that it was a chief function of the perspective to impart a terrific upward thrust to a thigh, lifting the hip and tilting the body, bending the spine in a passionate, rigid curve. The physical pattern is one that reappears continually in Mantegna's work. In the cumulative anatomy of European art, where Masaccio

fig. 1 Andrea Mantegna, *St James Led to Execution*, fresco, *c.* 1450-54, formerly Cappella Ovetari, Chiesa degli Eremitani, Padua

left his mark upon the human shoulder, the thigh and hip are Mantegna's peculiar preserve. Such figures stand apart from the other creations of the Quattrocento. Even Castagno, whose fibrous toughness provided one of Mantegna's starting-points, was by comparison humane.

The Christ of the *Agony in the Garden* (National Gallery, London), possibly painted a little later than the fresco, was called by Berenson a 'rock-born giant': the description is perhaps the only part of his account that was exactly right. Behind Mantegna's attitude to antiquity, even perhaps underlying the peculiar value which dryness itself and archaism had for him, there was a deep absorption in stone. Stone is everywhere in his pictures. It is cast up, stratified, fractured and fragmented – finally falling to kill – of its own inward force. Mantegna's mountains are not those of the actual world: he seems rather to have invented, on the basis of the archaic Gothic formula, symbolic renderings of the character of rock. Still less is Mantegna's stone the serene material out of which the Renaissance was built in Tuscany and Umbria.

His attitude to antiquity is the mark of the difference. Elsewhere the relics of Roman art revealed to architects and sculptors a live potentiality inherent in stone: they showed a natural way for the stone to flower. Mantegna, by contrast, came to love the very ruination of ancient art: he dwelt on its death and dismemberment. Looking upon the ruins, he let them lie. The severed antique foot lying beside the bound ankles of the martyr was a reminder of the ruthlessness inherent alike in man and in carving (fig. 2).

There was no pity in Mantegna. The most merciless martyrdom in his pictures holds no promise of reward. The permeation of life with death was in itself his profoundest subject: he returned to it continually in every variation of his habitual themes, in the stories of Judith, St Sebastian and Orpheus alike. And it left him undisturbed: it was an appropriate, invariable condition with which he was entirely content. The discovery of death in life uncovers Mantegna's deepest passion. It is the expression of the same stony hostility that we recognise in his own face.

Such reflections tell us something of the grave import and the personal meaning which we feel in the fixity of Mantegna's style itself. It is there, at the centre of his art, in the very character of the figuration, whose force is so close to self-annihilation that we feel a quality of the sublime. It has the consistency of a deadly passion, a passion which the sensuous surface of the arts rarely admits, but one that is deep within us nonetheless. This is the context that gives to Mantegna's moments of tenderness their special and unique significance. In his little Madonna pictures, Mother and Child are drawn together more profoundly than in any others. The mother enfolds the child, as

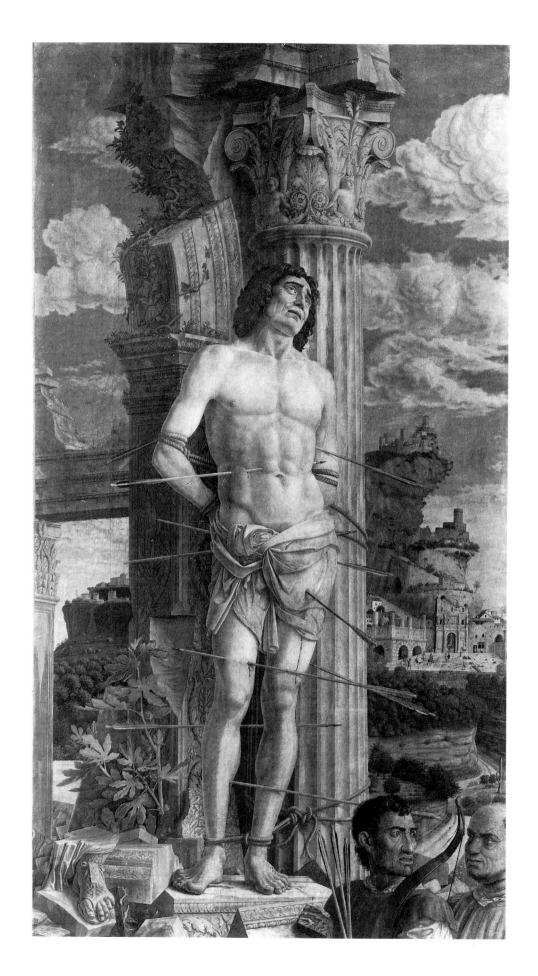

fig. 2 Andrea Mantegna, *St Sebastian*,
canvas, 257 x 142 cm, probably 1480s,
Musée du Louvre, Paris

if to contain him; a single contour encloses the two in a monolithic block (cat. 41 and fig. 72). It is a truer view of natural tenderness, truer in its implicit recognition of the natural forces that beset it – than any but the very greatest of the humane painters have shown. The intimate truth of it is perhaps the explanation of the unexpected link between Mantegna and Rembrandt.

Mantegna painted a *Virgin of the Stonecutters* (fig. 3) – rock-born again – which was the product of a veritable eruption in the stone; it already belonged to the Medici in Vasari's day. In one of Mantegna's engravings, which he developed from it (cat. 48), the form became as massive and self-contained as sculpture. After a hundred and sixty years the print reached Rembrandt. In his hands it inspired a solid truthfulness inseparable from his own.

Study reconciles itself rather slowly, as if reluctantly, to the character of Mantegna's art. Yet even the more extreme interpretations shed light on qualities that are in turn tragic and ironic.

Mantegna was exceptional not only in his creative longevity but in the comprehensiveness with which he grasped the opportunities it offered. His order of imagining was exclusively his own. The continuously innovative range of his invention was unparalleled since the previous generation had established the terms of reference that lasted almost as long as the century. Mantegna was extraordinary in that his drastic renewal of style in the likeness of antiquity opened to his precocity a vein of invention that was of its nature metaphoric. The example of Donatello, direct and indirect, required that painting should be as solid as sculpture. Imagery was to be as if carved in antiquity, immovable as marble or bronze.

The fantasy of painting-as-sculpture had itself an irresistible metaphoric force. Eventually, in separate half-decorative imaginings, narrative was conceived as if carved in bas-relief. It was chiselled and polished like marble, as sumptuously veined as if by nature or natural fancy. Everything was envisaged with prodigal allusiveness, unimaginably rich in antique reference.

The materiality of the idea of painting-as-sculpture was itself compelling. Form is outlined inescapably by contour that is in every sense drawn, as tight as a wire. In painting, the metaphor grows increasingly rich, no less rigorous, but allusive enough for the humanistic eye. The colour of the close-fitting fabrics that clothe the figures in the later pictures is customarily *cangiante*, shot with mutations that illuminate the forms. Drapery gathers in folds that ebb and flow round the swelling shapes, in patterns that catch the light like moiré. The expression is, again in both senses, figurative. It makes visible the tensions with which a body moulds its garment.

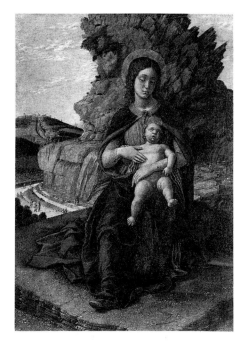

fig. 3 Andrea Mantegna, *Virgin of the Stonecutters (Madonna delle Cave)*, tempera on panel, 32 x 29.6 cm, *c.* 1490 Galleria degli Uffizi, Florence

The metaphor was not limited to painting. Forms as hard and definite as if they were made in metal were appropriately drawn *with* metal. The contour was ploughed into copper with a burin. The sharpness and the spring of metal attached to the line that was printed from it. Mantegna's fantasy was immediately autonomous and soon ubiquitous. Again under the stimulus of Florentine example, engraving became the forceful and influential art we know.

Perhaps we understand the basic metaphor of figure art better with Mantegna than with any other painter. The dismemberment of antiquity leaves its lesson in a mysterious sense intact. Excavated in isolation a great toe must evidently have come from a noble foot and the chain of inference leads irresistibly to the grandeur of a whole physique, the lost unity from which they came. This is just the conceptual logic illustrated and exemplified in Mantegna's three St Sebastians (figs. 2, 5, and Ca' d'Oro, Venice). More than any other painter he was led continually to demonstrate the wholeness and coherence of a figure image, which is the paradigm of unity in a work of art. In the art of Mantegna as nowhere else we are reminded of what we still seek when we draw from the antique.

Ferocious or not, Mantegna possessed a social awareness unequalled among Renaissance painters. The Ovetari frescoes in their splendidly imagined place chronicled a fearfully specific time. The agonised bystander prevented from watching St James's way to martyrdom is pushed back by the militia with a bruising force that still affords the clearest vision in the whole of art of life under a police regime. A dozen years later the humanity that was the perceptive counterpart of Mantegna's ruthlessness allowed him to see the converse, the family life of the Gonzaga court, as clearly.

The unfolding of Mantegna's art to the conclusion, sardonic or tragic, which combined so oddly with his ultimate lyric grace, is perhaps a little clearer for the knowledge that accrues in an exhibition like this. Yet it is still by no means clear, and the mystery is Mantegna's own. The vein of metaphor in which we recognise the vision and meaning that are so personal hardly developed in the usual respects. The achievement was to remain stable, though never inert. Instead of growing, successive works seem to have been separately ejected by the force of his will.

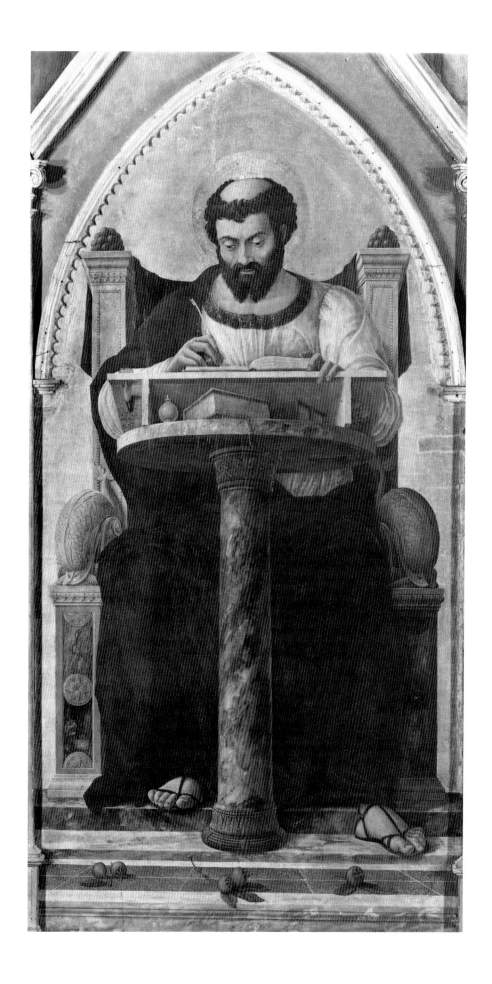

MANTEGNA AND THE MEN OF LETTERS

DAVID CHAMBERS, JANE MARTINEAU AND RODOLFO SIGNORINI

It was Mantegna's great fortune to have grown up in Padua. The son of a country carpenter, he can scarcely have had much formal education, but on coming to Padua as a boy, that peculiar city must have excited his imagination. It also fostered certain traits that stayed with him for the rest of his life: principally, a fascination for the ancient Roman world and with natural phenomena, and a passion for depicting stone in all its forms – rocks, ruined masonry and polished veneers. It is likely that he also acquired there a taste for the company of scholars: mathematicians, natural philosophers (scientists), very probably, but above all of antiquarians and 'humanists' dedicated to classical literature, whether or not he was aware that this was precisely what the Florentine polymath Leon Battista Alberti had recommended in his treatise on painting.[1]

The social, as well as professional, ambition which characterised Mantegna may have been helped by his being exceptionally articulate and possessed of great wit. About this we can only guess, but it seems more than likely that he could, when he wanted, display 'good manners and amiability', those precepts which Alberti counselled as useful for an artist, even if there is evidence that he could also be violently abusive and litigious. The literary élite – astonished, doubtless, by the sheer technical brilliance of the young painter's work as they were delighted by its content – responded with elegant verses complimenting the prodigy, whom they predictably labelled the new Apelles. Whether they exerted a direct influence on his work is debatable, but this mutual attraction between artist and intellectuals will provide the main theme of this essay.

The seat of a famous university, Padua also had a Roman past as Patavium, a seniority that in some ways afforded its scholars and citizens a consolation for their annexation by Venice in 1405. Paduans had for long made much of their civic antiquity; a monumental tomb erected in 1283 supposedly contained the bones of their legendary founder, the Trojan Antenor.[2] It was in Padua, too, that the ceremony of crowning a poet with bay as poet laureate was revived for Albertino Mussato in 1315, and in about 1320 a newly found inscription was taken to refer to the historian Livy, a native of Patavium.[3] The presence of Petrarch (d. 1374) in the city in his last years had further stimulated antiquarian studies there; his friend Giovanni Dondi dell'Orologio wrote a description of

the ancient buildings he had seen and measured in Rome,[4] and Petrarch's own *Lives of Famous Men* was the basis for a scheme of decoration in the palace of the Carrara family, the former rulers of Padua. A more recent event had been the discovery in 1413 of the supposed bones of Livy at the monastery of Santa Giustina; plans to build a mausoleum were not carried out, but in 1426 an inscription and bust were erected at the Palazzo della Ragione.[5] Mantegna's cast of mind could hardly have been so decisively formed in any other city. Nor should we underestimate the effect upon the young painter of the religious ambience of Padua, its many sacred buildings, shrines and images and ubiquitous clergy; he may well as a boy have been among the huge crowds who attended the sermons of the famous Franciscan revivalist Bernardino of Siena in 1443.[6]

Initially Mantegna must have derived many ideas from his Paduan master, Francesco Squarcione, though eventually he went to the law courts to free himself from this overbearing adoptive father. Squarcione, according to his autobiography, now lost, but available to the 16th-century historian of Padua Bernardino Scardeone,[7] had visited Greece and made drawings of 'many things of note that seemed likely to promote skill in art'. From 1431 he had started to take pupils; he boasted that over 137 passed through his hands; it sounds almost like an artisan equivalent of the Paduan boarding school of Gasparino Barzizza (d. 1431) which was attended by young men of promise, many sons of Venetian nobles and, perhaps, Alberti.[8] At first Squarcione described his studio as a workshop (*bottega*); by 1455 he had upgraded it: an inventory of that date refers to a large *studium* containing his collection of reliefs and drawings and a smaller one called the 'house of reliefs'. In making his students copy the 'very many sculptures [*signa*] and paintings … ',[9] Squarcione would have had the blessing of Alberti who, while insisting that an artist should learn from copying nature, added that if he has to copy a work of art, 'I prefer you to take as your model a mediocre sculpture rather than an excellent painting',[10] since from sculpture one learns to draw light and shade. According to Vasari, Squarcione later commented of Mantegna's St Christopher scenes in the Ovetari chapel that 'they were not good works, because in making them he had studied antique sculpture from which it is impossible to learn to paint perfectly because stones always retain their hard quality' (*i sassi hanno sempre la durezza con esso loro*);[11] yet it was from his master that Mantegna learnt to study stone. At the same time, he was obviously fascinated by the endless activity of builders and masons in the city, and it is more than likely that he made independent excursions to the nearby Euganean Hills to gaze at rock formations; Paduan acquaintances had probably drawn his attention to Pliny's *Natural History*, with

its discussion of geology and an encyclopaedic range of other subjects, including the miraculous skill of ancient Greek artists. Perhaps Mantegna himself had an idea of emulating the ancient masters; it may not have been merely the literary conceit of his humanist admirers.

Paduan society was almost bound to take up a young artist with such tastes, skills and ambition; rich Venetian patricians who governed both church and state, members of the local nobility and higher citizenry, many of them eminent in the study or practice of law or medicine, numerous notaries, scribes and students, all had strong interests in the study of antiquity, and particularly of Patavian antiquity. Paradoxically, some of the leading figures in Padua at the time Mantegna first arrived there were beginning to disappear as he started to make his name. The humanist Sicco Polenton, for many years Chancellor of the city, who had taken charge of the presumed bones of Livy and the erection of two inscriptions and commemorative sculptures, died in 1448, the same year as Pietro Donato, who had been Bishop since 1428; a builder on a grand scale, Donato had spent prodigiously on his book collection.[12] A friend of both of them, the distinguished physician Michele Savonarola, had moved in 1440 to the court of Ferrara, where he wrote his descriptive laudation of Padua, praising among the city's other assets 'our school of pictorial art' (*studium pictorie*), stressing its connection with the study of literature and the liberal arts, and particularly with perspective (optics) as a branch of philosophy.[13] Savonarola may have noted, or even promoted, the visit to Ferrara of 'Andrea of Padua' – Mantegna – in 1449 to paint a portrait of Lionello d'Este. He did not lose touch with Padua and his family there; and from 1458 he or his sons sublet to Mantegna part of a house in the parish of Santa Lucia.[14]

Mantegna's life-long passion for script was formed in Padua. Bishop Donato was a friend of Ciriaco d'Ancona, a merchant who from 1418 had travelled in Greece and its islands and even to Egypt transcribing inscriptions; Ciriaco visited Padua in 1443 and reinforced the local craze for epigraphy: he made a copy of his own collection of inscriptions for Donato that in the 1450s was transcribed by Felice Feliciano of Verona, later to be one of Mantegna's closest friends. A more learned epigrapher, Giovanni Marcanova (*c.* 1418-67), who was also a doctor of medicine and had taught at Padua university until 1452, knew and probably advised Mantegna at an early date; it was he who composed the inscription for the base of Donatello's bronze equestrian statue of Gattamelata outside the Santo, a public work of art that was intended to rival the bronze equestrian monuments of ancient Rome and glorify a local military hero.

In 1450 the new bishop, Fantin Dandolo, a former pupil of Barzizza, who in 1447 had been welcomed to Padua with a Latin oration by Marcanova,[15] ordered a manuscript to be made of the ecclesiastical history of Eusebius. The scribe was his secretary, Biagio Saraceni of Vicenza, one of the first to experiment with epigraphic lettering in coloured inks and classical letter shapes; the single miniature painting in the volume seems to be the work of Mantegna, then aged about twenty (cat. 7).[16]

Mantegna's understanding of the art of the scribe is illustrated in the Altarpiece of St Luke painted in 1453-4.[17] The wells of black and red ink (for the text and decoration) and the splashes of ink left by the saint's quill pen on the underside of his desk where he wiped it clean speak of Mantegna's familiarity with the technique (fig 4). He learnt a singularly delicate and elegant humanist script, utterly different from Squarcione's late Gothic hand (fig 8),[18] and possibly, like Leonardo da Vinci (some twenty years his junior), acquired some Latin. He evidently took pleasure in writing the cryptic inscription under Marcello's miniature portrait (*c.* 1453; cat. 10) and, probably in the late 1450s, his fascination for lettering led him to sign his name in Greek on the *St Sebastian* (fig. 5). Presumably one of his scholarly admirers traced the characters for him to copy, since it is virtually certain that he knew no Greek. Although it is unlikely that Mantegna was responsible for the initial capitals in a copy of Strabo's *Geography*, as was once suggested,[19] it is clear that the ease of association in Padua between scribes and painters led to many striking experiments in the production of manuscripts, both in the initials and the ornament. The Paduan style of decoration, with tripods, candelabra, triumphal arches, dolphins and marine gods, was born of this association.[20]

One of the most elegant and productive scribes of the Renaissance, Bartolomeo Sanvito, was born in Padua in 1435; he was thus a near contemporary of Mantegna, though he came from a superior social background. In the 1450s he was already copying manuscripts for the erudite young Venetian patrician Bernardo Bembo.[21] He and Mantegna can only be linked by inference during their early years, though they were indirectly associated; on 17 October 1466 Sanvito acted as a witness for Squarcione in a contract for the decoration of the Chapel of Corpus Christi in the Santo,[22] and later he worked for Cardinal Francesco Gonzaga.

In his early twenties Mantegna was already beginning to attract the praise of writers. Although literary eulogies were also written in honour of Jacopo Bellini (Mantegna's father-in-law after 1453) and Pisanello, the most celebrated northern Italian artist of the previous generation, no other painter of his day received so many poetic tributes over so long a period as did Mantegna. This is

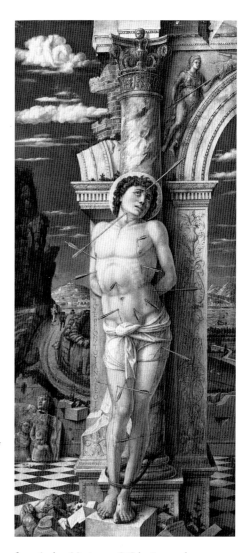

fig. 5 Andrea Mantegna, *St Sebastian*, poplar, 68 x 30 cm, probably 1459, Kunsthistorisches Museum, Vienna

remarkable even if in part it can be explained as the convention in those places in which he worked: Padua, with a long tradition of eulogising its men of distinction, and Mantua, the seat of the Gonzaga court, which played host to a succession of professional scholars and amateur poets.

Of those who praised Mantegna in verse during his lifetime, only one of his later admirers, Jacopo Sannazaro, was a poet of the first rank. Reading the laudations, there is a certain uniformity of expression, which was inevitable, given that eulogies of works of art were a standard humanist literary exercise. Yet, Mantegna was praised for many of the qualities for which he is still famed today: verisimilitude, particularly in his portraits, for making painted figures seem alive, usually in mythological scenes, for the sculptural quality of his figures, his brilliant technical skills and for equalling, if not excelling, ancient artists. To praise Mantegna's sense of drama, religious pathos or his use of perspective, would have been beyond the constraints of the literary form; while the qualities of his art which later appealed so much to Goethe or Proust, for example, may have been equally esteemed by contemporary men of letters, they could not be recorded within the conventions of their verse.

The first recorded poem written in Mantegna's praise probably dates from *c.* 1448, when he was about eighteen. Ulisse degli Aleotti (1412–68) was a Venetian civil servant and amateur poet, a somewhat pedestrian imitator of Petrarch whose verse is all in Italian (he had also written in praise of a portrait by Jacopo Bellini). In 1448 he acted as arbiter in a dispute between Mantegna and Squarcione. His sonnet describes a portrait, now lost, painted in Venice by Mantegna of a young nun, and he praises it for its sculptural qualities, 'truly life-like and real'.[23]

Not all Mantegna's admirers were intellectuals. In 1448, when he was only seventeen, he was commissioned by a rich baker, Bartolomeo di Gregorio, to paint an altarpiece, since destroyed, for Santa Sofia, Padua. It seems that he solemnly signed the painting, recording his age,[24] and it was this work which first made his name. Soon the clerical and intellectual élite were also demanding his services. The same year he was chosen to be one of the artists to paint the memorial chapel to Antonio Ovetari in the church of the Eremitani (Hermit Friars), a decorative scheme that, from the outset, was intended to represent the best of contemporary art in northern Italy. The project was controlled by the Capodilista, an old patrician family which, by the 15th century, was also distinguished in the Paduan faculty of law. Giovan Francesco Capodilista (d. 1450) was a friend of Bishop Donato; his son Francesco, a lawyer and lecturer at the university, seems to have supervised the decoration of the memorial chapel to Ovetari, who was probably his uncle by marriage

(the imperious Madonna Imperatrice, widow of Antonio Ovetari, may have been Giovan Francesco Capodilista's sister).

From the early 1450s, therefore, Mantegna was patronised by a close circle of friends, several of whom had been to school or university together; at times he seems almost to have been handed round from one to another. Years later, one of his friends, Girolamo Campagnola (*c.* 1433/5–1522), a Paduan lawyer and amateur painter, wrote a letter intended to perpetuate Mantegna's fame, and – though the original is lost – it seems to have been exploited by Scardeone and Vasari. According to Campagnola, some of the members of this Paduan circle were portrayed in the scenes of the *Martyrdom of St Christopher* (fig. 6).[25] They included the Hungarian humanist and poet Janus Pannonius (1434–72), later Bishop of Pècs; Jacopo Antonio Marcello (1398–after 1461), a soldier whose military exploits were lauded in Janus's long poem *Panegyris*; Janus was shown with his Florentine friend Nofri Strozzi, son of the exiled Palla Strozzi, banker, humanist and student of Greek. Also portrayed was another banker, Antonio Borromeo (whose daughter was married to a Capodilista),[26] Bonifacio Figimelica, a lawyer acting for the Ovetari family, and the Latin poet and physician Girolamo della Valle who had dedicated a poem, *De Passione Christi*, to Bishop Pietro Donato. Finally, two artists were included: Niccolò del Papa, a goldsmith who had made the metal Holy Name of Jesus set into Mantegna's lunette over the entrance to the basilica of Sant'Antonio, and Squarcione himself, who is portrayed as a stout, helmeted executioner, an ironic comment on the role his master had played during Mantegna's adolescence.[27]

Some of his patrons Mantegna painted twice: Marcello appears in severe miniature profile in the Life and Passion of St Maurice (cat. 10). The lost double portrait of Pannonius with his greatest friend, the humanist and philosopher Galeotto Marzio da Narni (*c.* 1428–*c.* 1497), must have been painted by 1458, when Pannonius returned to Hungary. In his eulogy of Mantegna, Pannonius rhapsodised on the perfect technique of these portraits, so close to the originals that they could have been reflections in a mirror, save that they lacked voices. Mantegna had been created by Mercury, he was of divine ancestry, nourished on the milk of Minerva, he surpassed the ancients in genius and art; the foremost glory of painting, he was destined to receive the heavens themselves as his reward. As Livy was the greatest of historians, so Mantegna was the greatest of painters: this was to prove an apt comparison, given that later he displayed a genius for recreating spectacular Roman triumphs equal to that of Livy.[28]

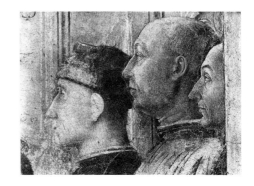

fig. 6 Andrea Mantegna, *The Martyrdom of St Christopher*, detail, heads of bystanders, fresco, *c.* 1454–7, formerly Cappella Ovetari, Chiesa degli Eremitani, Padua

fig. 7 Jacopo Bellini, Three Roman tombstones and a round sepulchre with two sculptures of maenads on top; a sestertius of Domitian with *Germana Capta* on the reverse; pen and ink on parchment, 28.3 x 42.2 cm, *c.* 1440-60, Musée du Louvre, Paris (RF. 1512)

It is evident from Mantegna's frescoes in the Ovetari chapel that he shared the archaeological enthusiasms of his patrons and fellow artists. *The Trial of St James* (fig. 58) is densely packed with ancient Roman visual and epigraphic quotations mixed with medieval buildings with little regard for how an ancient city might have appeared. The borrowing of inscriptions was also practised by his father-in-law, Jacopo Bellini, who used the same inscriptions, taken from a votive stone formerly on Monte Buso at Este, in a study of Roman tombs and altars (fig. 7; Louvre, Paris). In this case Jacopo was more accurate in his transcription than Mantegna; whether either had seen the original is open to question: it was Giovanni Marcanova who gave the location of the stone in his collection of Roman epigraphs.[29] Yet, despite the haphazard inclusion of anachronistic details, Mantegna created scenes of dramatic intensity that astounded Goethe when he saw them in 1786, and Proust in 1900,[30] reactions which illustrate the continuing fascination Mantegna's work has exerted over literary minds.[31] Comparing Mantegna's *Martyrdom of St Christopher* (figs. 64, 65), in which drama, architecture and the new science of perspective are all supremely controlled, with Ansuino da Forlì's scene of *St Christopher Preaching* (fig. 60), once immediately above it, it is evident that both artists were endeavouring to achieve the same end, but the point is made that classical quotations, whether visual or verbal, are not in themselves enough to create a Renaissance work of art.

By January 1457 Mantegna had agreed to enter the service of Ludovico Gonzaga, Marchese of Mantua (d. 1478),[32] though he delayed his move for almost three years while he finished works for his Paduan circle, among them, the widow of the *condottiere* Gattamelata, Giacoma Leonessa, a friend of Jacopo Marcello, who commissioned a series of scenes commemorating her husband and son to decorate her palace in the Santa Lucia quarter.[33]

One of the last works Mantegna painted in Padua, and one of the most important works of his career, was for the high altar of San Zeno in Verona, commissioned by its abbot, the Protonotary Gregorio Correr (1409-64),[34] a scholarly Venetian patrician formerly associated with Pietro Donato (and tipped in vain as his successor as Bishop of Padua). Correr had imposed on the monks of San Zeno the reformed discipline of Santa Giustina in Padua for which his uncle Antonio was responsible. He had been less austere in his youth when, as a precocious pupil in the school of Vittorino da Feltre in Mantua, he written a tragedy, *Progne*, inspired by Seneca and Ovid, and had fallen in love with Ludovico Gonzaga's sister, the prodigiously clever Cecilia (who later took the veil). In later life he addressed verses, now lost, to the sculptor and architect Antonio Rizzo, a native of Verona.[35]

The *St Sebastian* in Vienna (fig. 5), one of Mantegna's most humanistically inspired works, probably dates from this period, and may well be the small work he had to finish in eight or ten days for Marcello.[36] Mantegna was perhaps emulating the ancient Zeuxis who, according to Pliny painted a boy carrying grapes, in the fragment of relief on the left.[37] A cloud in the sky takes the form of a horse and rider; it would seem that Mantegna was illustrating the classical conceit, revived by Alberti, that nature on occasion makes chance works of art, forming images in her own creations. As a further nuance he gives the horse and rider the appearance of a relief of Theodoric at the Hunt, a Romanesque relief in San Zeno, Verona.[38] Such 'natural' images recur in the print of the *Descent into Limbo* (cat. 67), in canvas III of the *Triumphs of Caesar* (cat. 110) and in *Pallas Expelling the Vices* (cat. 136).

Ludovico Gonzaga, one of the best educated but least solvent of Renaissance rulers, may have first heard of Mantegna from Lionello d'Este or Jacopo Marcello, or from his school companion Gregorio Correr. The Gonzaga court was modest by comparison with that of the Sforzas at Pavia and Milan or that of the Este at Ferrara, but there Mantegna was elevated in professional and social status to a level that he could never have attained elsewhere. Although he sometimes went without a salary when the Gonzaga jewels were in pawn;[39] he demanded, even before he arrived at court, a coat of arms and a motto, later received an Imperial title, and was held in near reverence by three generations of the ruling family. The coincidence that his surname resembled the name of the city may have appealed both to him and his patrons in their mutual pursuit of fame.

Mantua was very different from Padua. Although Virgil had been born there, it had not been a Roman settlement of anything like the stature of Patavium. Moreover, it had no university: all intellectual life centred on the court. In the second half of 1459, just before Mantegna arrived, a congress called by Pius II to inaugurate a crusade against the Turks was held there when the city had been full to bursting with the prelates and intellectuals of the papal court. Alberti arrived in the train of the humanist Pope, who deplored the damp and the sound of frogs croaking by the lake;[40] some of Mantegna's previous acquaintances were also there: Jacopo Antonio Marcello[41] and Ulisse Aleotti. Alberti was among those who stayed on for some months after the congress ended, but the departure of the papal court meant that the prospect of congenial company for Mantegna was more limited. However, notable figures were often passing through, or present for short periods, and there was a coterie of educated courtiers and professional experts, including scholars hired to educate the Gonzaga children.

In their support of humanist education and moral values, the Gonzagas had an honourable record. From 1423 to 1446 Vittorino da Feltre had taught in his school two generations of distinguished pupils, among them, the lord of Urbino and military captain Federico da Montefeltro, the humanist and musician Carlo Brognoli, the mathematician and astrologer Bartolomeo Manfredi, the humanists Iacopo da San Cassiano, Sassolo da Prato, Francesco Castiglione, Giampietro da Lucca, Gregorio Guarino and Giovanni Andrea de' Bussi. But for Mantegna the most significant pupil to emerge from the school was Ludovico Gonzaga, a model patron, whose profound respect for humanist values led him to collect books, employ scribes and scholars, including Platina and Gregorio Tifernate,[42] summon from Florence the architect Antonio Manetti and the sculptor and engineer Luca Fancelli (both of whom had known Brunelleschi), and, from Padua, Mantegna himself.

It was probably either in Padua in 1459 or at the end of the Congress of Mantua in January 1460 that Mantegna painted the steely portrait of Cardinal Ludovico Trevisan (*c.* 1401-65), Patriarch of Aquileia (cat. 100), whom Squarcione claimed to have known.[43] Trevisan had first studied medicine at Padua; later he visited Greece while serving as Papal legate in the war against the Turks in 1456-8. He was an avid collector of antique medals and gems;[44] and his friend Ciriaco sent him copies of inscriptions. Although usually resident in Rome, he had visited Padua in the summer of 1459. In 1451 he had bought from the Capodilista family the ancient Arena, a ruined compound in which lay the palace which the Cardinal restored, but also the Scrovegni Chapel, where Mantegna must have often gazed at the frescoes by Giotto.[45]

In Mantua, the same intellectual influences continued to have a close hold upon Mantegna's mind. An acquaintance from Padua, Felice Feliciano (1433-80), scribe, antiquary and doggerel poet, became one of Mantegna's closest friends, and addressed him as '*amicus incomparabilis*'. Feliciano's bizarre and volatile character may have been sympathetic to the painter. From 1465 he was working in Bologna as scribe to Giovanni Marcanova, but he was said to have wandered in the mountains around Modena vainly searching for antimony, the philosophers' stone, and his own brother described him as: 'unstable, a vagabond here today and there tomorrow, fantastic, prodigal, an imitator of difficult things; an alchemist, a time-waster and a spendthrift in every vain and foolish enterprise'.[46] His hero was Ciriaco d'Ancona, from whom he derived his eccentric minuscule and his use of coloured inks and tinted paper. Feliciano wrote the first treatise on the design and proportion of capital letters based on his measurements of antique inscriptions;[47] he also collaborated with the printer Severino da Ferrara in 1475, and in 1476 set up

his own press with Innocente Zileto in Poiano, near Verona,[48] activities which may well have intrigued Mantegna. Feliciano was also close to Giovanni Bellini and, although frightened by the painter's dogs, to Marco Zoppo, another of Squarcione's former adopted sons and a good friend of Mantegna's, according to Vasari.[49]

Early in the 1460s, Feliciano dedicated a sonnet to the painter, and pleaded for his help in obtaining a place in the service of the Marchese's second son, Cardinal Francesco Gonzaga.[50] In January 1463 he dedicated to Mantegna two collections of antique inscriptions remarking (in Latin) that the painter was 'ever most prompt and partial to the investigation of antiquities of this sort' and wishing him (in Greek) good luck. He adds, rather patronisingly for a man whose 'grammar and syntax, in Italian, are often faulty; and his Latin is deplorable'[51]: 'there is no desire in me that is dearer or more ancient than that you should become as learned as possible, and be a man of consummate knowledge in all worthy subjects which I have little fear shall come to pass if you will only strive to unite to the goods of the body and of fortune those of the mind … '.[52]

The most memorable event in their friendship was an excursion on 23 and 24 September 1464 (a Sunday and Monday), in the company of the painter Samuele da Tradate, who had decorated apartments in the Gonzaga villa at Cavriana to Mantegna's designs, and one Giovanni 'Antenoreo'. This nickname implies a Paduan on account of the legendary founder Antenor; probably it was used for the hydraulic engineer and building surveyor Giovanni da Padova, who had come to Mantua in 1455, and with whom Mantegna can be linked on a number of other occasions.[53] (He has also been identified as Marcanova, but Marcanova was never referred to as 'da Padova', and seems too elevated a figure both in rank and age – about 46 at this date – to have joined in such a boisterous outing.) The four friends made an archaeological boating trip around the southern end of Lake Garda, collecting inscriptions and acting out an elaborate antiquarian charade. It was recorded by Feliciano in a manuscript mostly given over to a eulogy of Ciriaco d'Ancona, transcribed at the request of Samuele da Tradate. Samuele was named the commander, *imperator*, of the group, while the *viri primarii*, Mantegna and Giovanni 'Antenoreo', were *consules*. Samuele was garlanded with myrtle, periwinkle, ivy and other plants; he sang, accompanying himself on a lute, and the boat was extravagantly decorated with carpets and branches of bay.[54] Even taking into account Feliciano's literary pretentions in writing this description, it illustrates the friends' romantically antiquarian and even whimsical turn of mind. They ended by giving up prayers and thanks to the Virgin and her son for having granted

them 'the wisdom and the will to seek out such delightful places and such venerable ancient monuments'.

Emulating his patrons and friends, Mantegna also became an ardent collector of antiquities. Feliciano made him a copy of Marcanova's collection of inscriptions, but Mantegna also acquired pieces of antique sculpture, and gained some reputation as an expert. It is well known that Cardinal Francesco Gonzaga, when planning to take a cure at the baths of Porretta, near Bologna, asked in July 1472 that Mantegna should be sent there to amuse him (implying that Mantegna was a witty and convivial companion) and to examine and discuss the Cardinal's cameos, bronze statuettes and other antiquities.[55] The doctors advised the Cardinal against taking the waters,[56] so it is unlikely that this meeting took place, but the idea indicates the esteem in which the artist was held.

Another distinguished collector who sought Mantegna's company was Lorenzo de' Medici. On 23 February 1483 during a brief visit to Mantua, he attended mass at San Francesco, and then, together with Francesco Gonzaga, the future Marchese, visited Mantegna in his house. There the artist showed Lorenzo some of his own paintings, and also heads sculpted in relief ('*teste di rilievo*') and many other antique things.[57]

Potentially the most significant of all Mantegna's new contacts in Mantua was his direct acquaintance with Alberti, yet nothing is positively known about their relationship. After his sojourn there in 1459-60, Alberti returned for some time in 1463 and again 1470 to advise on building projects and enjoy the hospitality of the Marchese. It is arguable that a hypothetical conversation with Alberti could have played some part in the conception of the Camera Picta. There are certain resemblances between its decoration and a description in the dialogue *The Hall* (*Peri tou oikou*) by the ancient Greek satirist Lucian, and Alberti was the principal contemporary disciple of Lucian.[58] Nevertheless, only inferences remain. In other projects of Marchese Ludovico, such as his new palace at Gonzaga, in which Mantegna was involved in 1470 and about which Alberti expressed opinions,[59] the meeting of their minds remains an enigma.

Meanwhile, Mantegna also met court poets, such as Filippo Nuvoloni (1441-78), a young man from a noble family with a taste for dancing and gambling, who gave to the artist his 'book of rhymes' ('*libro pien di rime e frotule*') and dedicated to the painter two sonnets which were copied down by Feliciano.[60] Nuvoloni declared Mantegna was greater than the 'Roman' Parrhasius (who was, incidentally and probably fortuitously, praised by Pliny for his subtlety of outline), greater even than Apelles, and a learned man too.

A tragic episode in Mantegna's life at Mantua illustrates the respect in which he was held by scholars. When his son Girolamo died on 22 August 1484, the learned canon Matteo Bosso of Verona (*c.* 1427-1502), who may have known Mantegna years earlier in Padua (he went to study there in 1451) and who gave Giovanni Marcanova antique silver coins,[61] expressed his concern in a letter in Latin to another friend.[62] Bosso declared that the artist who emulated and equalled, if not excelled, Zeuxis and Apelles, had been grief-stricken at the boy's death (he had already lost a son in 1480) since he had given signs of inheriting his father's genius. According to Vasari, Mantegna sent Bosso a painting of the Virgin and Child with singing angels,[63] and may also have painted Bosso's portrait.[64]

Probably in about 1484 Mantegna started work on the *Triumphs of Caesar*, although they are first mentioned only in August 1486. Whether he received scholarly advice is unknown (see cats. 108-15), but the first literary response to the earliest canvases was made (in hexameters) by the Carmelite friar and neo-Latin poet Battista Spagnoli in about 1490.[65] The painter, he wrote, outshines the stars with his lustre; Mantegna is to painting as Virgil and Homer were to Roman and Greek literature; his figures are so realistic that they seem alive; Zeuxis and Parrhasius, Myron and Lysippus, Phidias and Polycleitus, yield to such superior skill. The artist is the ornament of Italy, 'the glory of our century'.

Mantegna also appears in the rhyming chronicle of Giovanni Santi (d. 1494) of the *Life of Federico of Urbino*.[66] 'No man who ever took, or who will take up his brush to follow the style of antiquity, will be so truly its successor as he is, nor with greater beauty'; Mantegna's supreme talent 'made the Duke of Urbino stop in his tracks, stupefied, when he saw his paintings and his singular art'. This, if it is true, could have happened during the course of a very brief visit to Mantua by the Duke in early May of 1482.[67] An epigram by Vosonius, datable between 1484 and 1498, belongs to the same genre: Mantegna has inherited the glory of Apelles.[68]

Not all the literary tributes to Mantegna are so generic. Some, like that of Ulisse degli Aleotti already mentioned, tell us about lost works: the distychs[69] of Falco Mantovano (Falco Sinibaldi or Domizio Falcone; d. 1505) describe a painting by Mantegna of the race between Atalanta and Hippomenes, an Ovidian subject (*Metamorphoses*, X, 560-680), also mentioned by Petrarch in his *Trionfo d'Amore*.[70] Mantegna, he wrote, depicted their very breath: neither of them is moving, yet they run on and on, and their laboured gasps seem audible.

It was in Jacopo Sannazaro's poetical work *Arcadia*, however, that Mantegna first gained a place in a serious work of literature, although Ariosto's

Orlando Furioso, with its tribute to him (Canto XXXIII.2), was published only ten years after his death. Sannazaro described a shepherds' wrestling contest in an idyllic, primeval setting; the prize for the victor was a magnificent vessel made of maple wood upon which '*Padoano Mantegna*' had painted many things, including a nymph with goats' legs suckling a baby satyr, two children wearing horrible masks frightening another couple of boys; the scene was garlanded with a vine tendril, while the handle of the vase was fashioned as a snake showing its fangs and entwined around the vine. Very probably this description was based on a composition by Mantegna himself (cat. 149).[71]

In some poems Mantegna is described striving to equal the work of the ancients. In two anonymous sonnets[72] he is urged to overcome his unwillingness to draw a very beautiful woman. He claimed that it would be a useless labour, 'like trying to kindle a star from a burnt coal, or to pound water in a mortar'. Although Apelles would have succeeded,[73] Mantegna could not, since the woman's beauty increases every time he sees it afresh, she has too much light in her eyes, too much sun in her face, an eternal, infinite beauty, so that any finished portrait of her would seem scarcely to have been started. Yet, on another occasion, Mantegna painted so realistically that he could fool the Holy Ghost: Panfilo Sassi (1455–1527), in a distych published in 1499, described a painting by Mantegna of the Virgin apparently so lifelike that 'if the Holy Spirit descended the Virgin would give birth again to Christ: it was a miracle of the new Apelles, a divine work by Pygmalion'.[74]

Battista Fiera (*c.* 1465–1538), a Mantuan by birth, physician and poet at the Gonzaga court, knew Mantegna certainly from the late 1480s until the painter's death.[75] In some hexameters addressed to a certain Marius, he described a cycle of paintings decorating a suite of three rooms; in the first Mantegna had depicted Venus with the Naiads dancing round a fountain, in the second, Ulysses and Nausicaa and a Bacchic revel, while the third was apparently decorated with allegories, its vault supported by columns of Parian marble. It has been suggested they may have decorated three rooms in the Gonzaga palace at Revere.[76]

In 1488, in his late fifties, Mantegna went to Rome, probably for the only time in his life. Several of his letters from the city survive, including a vivid description of the dissolute brother of the Ottoman Sultan, a fellow lodger in the Vatican Palace,[77] but tantalisingly they contain nothing about his response to the city, its monuments and ruins. He had been invited by Pope Innocent VIII to decorate the chapel and sacristy of the recently built Villa Belvedere inthe Vatican,[78] and Marchese Francesco Gonzaga may have allowed him to go hoping that he would help advance the case for his brother Sigismondo

Gonzaga to be appointed a cardinal: this was believed (in vain) to be imminent in 1489.[79]

It is not known who had recommended Mantegna to the Pope, but probably Giovan Pietro Arrivabene, one of his domestic secretaries, was in some way involved.[80] This erudite Mantuan, a scholar in Latin and Greek and former poet, had been Cardinal Francesco Gonzaga's secretary until the latter's death in 1483; like many others formerly in Francesco's household (which had included a significant group of Paduan artists, Bartolomeo Sanvito among them), he continued his career in Rome. Arrivabene had probably known Mantegna since 1460; he had been in Mantua with the Cardinal in 1464, 1472-3 and for most of 1480; he was resident in the Vatican Palace during Mantegna's stay there, and it was he who penned and signed the papal brief of 1 January 1490 to Marchese Francesco Gonzaga explaining that Mantegna was too ill to travel to attend the Marchese's wedding to Isabella d'Este.[81]

Mantegna's relations with the Pope were uneasy, and his new employer paid him no more promptly than the Gonzagas had done. Paolo Cortesi (1465-1510), who held a lucrative office in the papal chancery, and was a leading Ciceronian Latinist,[82] provides the earliest account of a somewhat acerbic encounter between Mantegna and Innocent VIII in the new chapel. Mantegna, a man of wit ('*ingeniosus*'), had painted roundels containing personifications of the Seven Virtues; there was an eighth roundel in which he had only sketched the figure of an elderly woman. The Pope asked what she was meant to signify. Mantegna, who had not received his pay, replied 'Ingratitude'.[83]

Another of the Virtues was, of course, Justice; Battista Fiera, who was also in Rome, later wrote a dialogue[84] in the style of Lucian on the subject of how she should be painted. This may have had some factual basis: although Fiera flatters Mantegna by making him speak in Latin, many of the remarks placed in his mouth ring true. His interlocutor is Momus, Lucian's archetypal derisive nit-picker. Mantegna at first insists that he is just a painter, but since he likes to take meticulous care with every detail (Fiera appreciated this aspect of his friend's technique) he decided that he should consult the philosophers about the appearance of Justice. He adds that he cannot take the ancient gods seriously since such fatuous things are told of them; perhaps a reflection of his a taste for mythological jokes. The subsequent suggestions of the 'philosophers' constitute a mock-serious debate on humanists inventing imagery.

Panfilo Sassi of Modena, who had already praised Mantegna in verse, proposed a one-eyed Justice seated on the throne holding the scales; another wit suggested that she should be covered with eyes, like Argus. Yet another envisages her as one-handed (so that with her other hand she cannot cheat the

balance), but Fiera himself makes one of the silliest suggestions, that Justice should be covered with ears lest she become deaf. Momus then asks Mantegna if he has consulted the Carmelite at the church of San Crisogono in Trastevere, meaning Battista Spagnoli. Mantegna replies that he had often visited him but, being a mere painter, he may not have understood him very well. Spagnoli had advised him that Justice cannot be painted at all, since Justice is the divine will. Finally Momus asks if Justice had made any decree that no man could doubt; Mantegna replies 'Death ... the supreme necessity for everyone ... so sacred and stern is Justice'. He defends those who plan their own tombs before their death (as both Fiera and he himself were to do; Justice is painted among other virtues in his funerary chapel in Sant'Andrea, Mantua), explaining that their motive is merely to save posterity trouble. Resolving to die fearlessly and with fortitude, Mantegna utters a laconic Latin tag of the kind he included in paintings, '*hic labor, hic lachrymae*' ('in this is my task, my sorrow').[85] Mantegna thus emerges as the only true philosopher among the pedants.

Mantegna can hardly have spent all his time in Rome cooped up in the narrow chapel (it was about ten foot square); presumably he explored the ancient city, perhaps with one of the guidebooks based on the *Mirabilia Romae Urbis*,[86] which was intended to lead the Christian pilgrim to shrines and explain legends, but which incidentally mentioned ancient buildings. He may also have already known the works of the great historian and pioneer archaeologist Flavio Biondo (1392-1463), who in his *Roma Instaurata* (1444-6?) attempted to reconstruct the ancient city, and expressed a horror of the destruction of the grand ruins that Mantegna might well have echoed.[87] Mantegna seems to have made drawings of specific statues and reliefs (see cat. 145), but on the occasions that he incorporated them into a design they were transformed into his own creations.

'Here in Rome', Mantegna wrote, 'there are many worthy men of good judgement', adding that he was treated with favour 'by all the Palace'.[88] To whom was he alluding? Perhaps to the Cardinal Chamberlain, Raffaelle Riario, who was about to rebuild the palace where Cardinal Gonzaga had lived, and would have been excited to have Mantegna at hand.[89] Also resident in the Vatican was the Mantuan Ludovico Agnelli, a clerk of the Apostolic Chamber and, like Arrivabene, formerly a member of Cardinal Gonzaga's household. Both were book collectors and patrons of the scribe Bartolomeo Sanvito.[90] Somewhat surprisingly the Mantuan ambassador, Giovan Lucido Cattanei, never mentions Mantegna in his dispatches;[91] but Mantegna also moved beyond the expatriate community. It is tempting to suppose that it was there that he might have met Sannazaro, on a visit from Naples; maybe the ageing humanist

teacher Pomponio Leto (d. 1498) made his acquaintance; members of the rising generation of Roman antiquarians certainly did so, including Rafaelle Maffei, who wrote of him with reverence.[92]

On his return to Mantua in 1490 Mantegna met for the first time the sixteen year-old bride of Francesco Gonzaga, Isabella d'Este, who was soon to become the dominant personality of the court. Possibly he had some premonition of her character, for he had written to her former tutor, Battista Guarini, son of the Greek scholar Guarino of Verona, asking for a commendation, and Guarini had complied.[93]

Isabella was an exacting patron who set quite new demands upon Mantegna. She was determined to keep abreast of fashion in collecting and patronage, and was also eager to impress scholars with her zeal and erudition. Her idea to raise a statue to Virgil in 1499 was broadcast as far as Naples, where the humanist Giovanni Pontano praised her initiative. Fiera acted as her costume adviser on Roman dress and on the poet's appearance; Mantegna was chosen as the designer, although a suitable sculptor (the statue was to be made of marble) was never found. A drawing from Mantegna's school of such a monument (Louvre, Paris) probably records this project, although it was never realised.[94] Fiera wrote some distychs which seem to refer to the statue, though he fails to mention Mantegna, instead eulogising Mantua and its ruler.[95]

Although Isabella's personal taste was for amusing literary works such as Ovid's *Metamorphoses*, she also hankered after subjects drawn directly from Greek literary sources. Novel allegories *all'antica* had to be devised for her private apartments, and she pestered the experts to devise mythological and allegorical fantasies, in particular the erudite Paride da Ceresara (1466-1532). He was a friend of Fiera and Battista Spagnoli and a correspondent of Matteo Bosso, so it seems fair to surmise that he had many conversations with Mantegna, particularly since he was also a oriental linguist, knowing Greek, Syriac, Hebrew and 'Chaldean', enabling him to gratify the painter's fascination for exotic scripts and alphabets. In a letter of 10 November 1504, Isabella commiserates with Paride ('you who have to devise new schemes every day') because he has to put up with the bizarre ways of painters that include a disregard of detailed instructions.[96] Although the letter's immediate concern is a painting commissioned from another artist, it may allude to Mantegna's attitude towards Paride or other learned advisers. Isabella implies that Mantegna acknowledged they were 'useful' – to borrow Alberti's word – worth consulting and hearing, but not necessarily to be obeyed very closely. Mantegna was working on the *Story of Comus* (fig. 108; Louvre, Paris) a few months before he died. In spite of his recent illness, he declared to Isabella,

'that modicum of wit (*quel pocho de ingegno*) which God had given him was still undiminished'.

Fiera's obsequious use of simile landed him in embarrassment once: when describing the *Parnassus* (fig. 106; Louvre, Paris) he identified Venus and Mars as Isabella and her husband. Intending to compliment Isabella by comparison with Venus in the painting he failed to think through the implications – that she, by being with Mars, was in an adulterous relationship, in full view of her furious husband, Vulcan – even if she was equal to Venus in beauty.[97]

In the last two decades of his life Mantegna increasingly illustrated texts – such as that of Lucian's *Calumny* or *The Fall and Rescue of Ignorant Humanity*[98] – or worked to the instructions of learned scholars, possibly Pietro Bembo in the case of the *Introduction of the Cult of Cybele* (cat 135).[99] Unlike Perugino, who was stultified by Isabella d'Este's instructions when he painted the *Battle of Love and Chastity* (Louvre, Paris), or Giovanni Bellini, who evaded her entreaties to work to a given scheme, Mantegna responded to learned ideas and subjects, but transformed them through the power of his imagination. The dramatic tension between violence and fear in the *Battle of the Sea Gods* or in his lost composition of the *Death of Orpheus*, known only through Dürer's drawing (Kunsthalle, Hamburg) and print;[100] the wistful delicacy of the *Mars, Diana and Iris?* (cat. 146); the stoic heroism of *Sophonisba* (National Gallery, London) and *Dido* (cat. 133) were not matched by any artist of the 15th century. Only Botticelli came near Mantegna in his personal interpretations of literature and fable.

The subjects from classical literature and mythology that Mantegna illustrated were not uncommon among the humanistically inclined artists of his generation: Botticelli was the most famous, but not the only other painter to recreate Lucian's description of *The Calumny of Apelles* (c. 1495; Uffizi, Florence);[101] Antonio Pollaiuolo's engraving of the *Battle of the Nude Men* is comparable in subject-matter, but not in drama and characterisation, to Mantegna's *Battle of the Sea Gods*;[102] Pollaiuolo also illustrated the various Labours of Hercules in paint and bronze. Virtuous women formed the theme of many decorative schemes by painters, but no other artist approached the subtlety of Mantegna's *Tuccia* and *Sophonisba* (both National Gallery, London) in their delicacy of characterisation and sumptuous use of simulated bronze and marble.

Paradoxically, it was only at the end of his life that Mantegna's paintings seem to illustrate specifically some of the subjects Alberti promoted in *De Pictura*, written over seventy years earlier. By that time they were out of date by the standards of Leonardo, Michelangelo and Raphael. The *Pallas Expelling the Vices* (cat. 129) is peopled with allegorical personifications, each betraying its

character through gesture and facial expression, reinforced by inscriptions which, according to Alberti, would place the painter on a par with the writer.[103] And a drawing, which may be the last by his hand to survive, of the *Calumny of Apelles* illustrates the best known example of a 'historia', for Alberti, the highest form of painting (cat. 154).[104]

Mantegna's passion for lettering never waned. The elegant sibyl (cat. 91) instructs the prophet from what looks something like a Hebrew Purim scroll.[105] Greek and pseudo-Greek characters are mixed on the scrolls in the *Pallas Expelling the Vices from the Garden of Virtue*, and a cursive invented script (closer to Hebrew than Arabic) was used on the head-dress of the mocking Jew in the *Ecce Homo* (cat. 61; fig. 38), while St Joseph's headband is inscribed with Hebrew in *The Families of Christ and St John the Baptist* (cat. 64). Whereas Giovanni Bellini may have added Greek inscriptions to paintings of the Madonna at the request of Greek Orthodox clients,[106] Mantegna seems to have done so as much for his own delight as for that of his patrons.

Nor did Mantegna's love of antique objects diminish. Isabella d'Este asked for his expert advice on several occasions,[107] appreciating that artists were deemed, rightly, best to be able to distinguish the real from the false at a time that fakes were proliferating.[108] On 28 March 1505 she returned to Giovanni Gonzaga in Rome an ivory head which Mantegna and Giancristoforo Romano had judged to be 'neither antique nor good'. But he was forced to part with the most cherished pieces in his collection: two marble busts of Roman matrons. In 1498 Mantegna tried in vain to keep one of these ('*quella testa de marmoro antiqua*') which he had bought while in Rome. Unfortunately, it was said to resemble Isabella of Aragon, the widowed Duchess of Milan, and she was set on adding it to her collection of portraits. Mantegna offered to have it cast in bronze (indicative of his familiarity with bronze-casters) so that its slight imperfections could be eliminated, but after a personal visit from Isabella d'Este (aged 24) he was forced to part with the original.[109] He called his other bust 'my dear antique Faustina of marble' and managed to keep it in his possession until the very last months of his life when, having got into debt over repayments for his house, he offered it to Isabella d'Este at a price of 100 ducats (fig. 8). Isabella intended to buy it for considerably less than the asking price and, with the sculptor Antico acting as an independent assessor, tried to beat Mantegna down. He finally parted with it in August 1506 in such distress that Isabella's agent thought he would die of grief.[110]

In the last years of his life Mantegna may have felt greater sympathy for Ludovico Gonzaga (1460-1511) than for most of the younger generation of the Gonzaga family. Ludovico, youngest brother of Cardinal Francesco and his

fig. 8 Letter of Andrea Mantegna written to Isabella d'Este, 13 July 1506, Archivio di Stato, Mantua; Archivio Gonzaga (busta Autografi 7, *fol. 146r*)

successor as Bishop of Mantua, had been painted as a boy in the Camera Picta, and was a collector of books, bronzes (he was the patron of Antico) and antique objects.[111] He lived in retreat on his country estates near Mantua, on bad terms with his relatives, but he had been indirectly in touch with Mantegna in Rome in 1488 when he was hoping in vain to become the next Gonzaga cardinal.[112] One of Mantegna's last recorded wishes was that Ludovico should possess his painting of *St Sebastian* (Ca' d'Oro, Venice), with the bleak message of its gutting candle enjoining faith in the face of persecution.[113]

As an old man, Mantegna remained a paragon for the literary élite. In the last year of the painter's life Pietro Bembo had praised his exceptional 'courtesy and civility',[114] and these qualities must have appealed to Baldasar Castiglione, a well-born Mantuan who was in Francesco Gonzaga's service from 1500 to 1504 and was *persona grata* with Bishop Ludovico. Castiglione named Mantegna as one of the five greatest contemporary painters (the others were all far younger) in his *Book of the Courtier* (I:37), which he began to write in 1508.

On 13 September 1506 Mantegna died. In his funerary chapel the two lines inscribed on a plaque beneath the bronze bust of the painter, have been tentatively attributed to Battista Spagnoli:[115] but they could just as well be the work of Fiera, who witnessed the artist's last will and testament.[116] On the epitaph the artist's name is again equated with that of Apelles. Another friend, the musical instrument maker Lorenzo da Pavia, repeated this well worn conceit in a letter to Isabella, adding that he believed that God would make use of Mantegna to make '*qualche bela opera*' in heaven, and that he doubted ever to see a finer draughtsman and more ingenious mind on earth again.[117]

NOTES

1. ' … It will be of advantage if they [the artists] take pleasure in poets and orators, for these have many ornaments in common with the painter. Literary men, who are full of information about many subjects, will be of great assistance in preparing the composition of a 'historia', and the great virtue of this consists primarily in invention.', Alberti, ed. 1972, p. 95. The Italian text was written by 1436; the Latin original had been dedicated to Gianfrancesco Gonzaga in 1435.
2. Gasparotto, 1979, pp. 3-12.
3. Mommsen, 1952, p. 95-116.
4. Weiss, 1969 ed. 1988, p. 50.
5. See particularly Ullmann, 1973, pp. 53-77.
6. Squarcione claimed that he met San Bernardino when he visited Padua; Scardeone, 1560, p.371; Kristeller, 1902, p. 502.
7. Scardeone, 1560.
8. Martellotti, 1965, VII, pp. 34-9.
9. Scardeone, 1560, p. 371.
10. Alberti, ed. 1972, p. 101.
11. Vasari, ed. 1878-85, III, p. 389.
12. 358 titles are listed in the inventory made on his death; see Sambin, 1959, pp. 53-98.
13. Savonarola, ed. 1902, p. 55.
14. Also living in that quarter of the city were the Capodilista family and Gattamelata's widow, Giacoma Lionessa; see Lightbown, 1986, pp. 32, 458.
15. Sighinolfi, 1921, p. 187.
16. Gios, 1984, p. 162, n. 3.
17. The painting intrigued Stendhal when he saw it in the Brera just after it had been moved there in 1811. *Journal: Oeuvres intimes*, ed. H. Martineau, Paris, 1955, p. 1211: '*A[ngela] a passé une heure et demie avec moi … .She seemed to have pleasure … I went out at 2½. J'allai à Brera … . Je trouvai de l'intérêt à une peinture de Giotto et à un tableau d'André Mantègne, … '.

18. See the contract of 17 October 1466 for the decoration of the Chapel of Corpus Christi in the Santo, which includes Squarcione's autograph; London, 1990, pp. 22-5, lot 14.
19. Meiss, 1976, pp. 165-7.
20. Alexander and de la Mare, 1969; Alexander, 1988, pp. 145-52.
21. Giannetto, 1985, pp. 102-3.
22. See n. 18, above.
23. Venturi, 1885 dated the poem to 1452-3, suggesting that the allusion to 'salt waves' could imply it was painted in Venice: Shaw with Boccia Shaw, 1989, p. 55, n. 84, proposes that the poem dates from 1448, when Mantegna first visited Venice. See also Segarizzi, 1906, pp. 41-66; Savonarola, ed. 1902, pp. 41-66; Kristeller, 1902, p. 488, doc. 1; Lightbown, 1986, pp. 457-8, cat. 65.
24. Scardeone, 1560, p. 372; Shaw with Boccia Shaw, 1989, suggested that the signature could not date from the 1440s since it was written in Latin, but Scardeone, who recorded it, wrote only in Latin, and it would be an anachronism to expect him to break into Italian for the sake of accuracy.
25. For Campagnola see Safarik, 1974, XVII, pp. 317-18.
26. Lightbown, 1986, p. 32.
27. For these identifications see Lightbown, 1986, pp. 398-400.
28. Kristeller,1902, pp. 489-90, doc. 4; Lightbown, 1986, pp. 459-60.
29. See Moschetti, 1929-30, pp. 227-39; Blum, 1936; Meiss, 1976, pp. 162-3; Eisler, 1989, pp. 183-211. It has been suggested that Marcanova acted as Mantegna's antiquarian mentor when he was painting the Ovetari frescoes but, as Lightbown, 1986, p. 41, observes, there is no evidence for this.

30. G. Painter, *Marcel Proust*, rev. Harmondsworth, 1983, p. 256. He wrote to Montesquieu that the fresco of the *Martyrdom of St Christopher* was 'one of the paintings I love best in the world'. Later he transformed Mantegna's languid soldiers into the 'tall, magnificent, idle footmen' in the hall of the Marquise de Saint-Euverte in *Un amour de Swann*: '*un grand gaillard en livrée rêvait, immobile, sculptural, inutile, comme ce guerrier purement décoratif qu'on voit dans les tableaux les plus tumultueux de Mantegna, songer, appuyé sur son bouclier, tandis qu'on se précipite et qu'on s'égorge à côté de lui … il semblait aussi résolu a se désintéresser de cette scène, qu'il suivait vaguement de ses yeux glauques et cruels, que si c'eut été le massacre des Innocents ou le martyre de saint Jacques. Il semblait précisément appartenir à cette race disparue – ou qui peut-être n'exista jamais que dans le retable de San Zeno et les fresques des Eremitani … . Et les mèches de ses cheveux roux crespelés par la nature, mais collés par la brillantine, étient largement traitées comme elles sont dans la sculpture grecque qu'étudiait sans cesse le peintre de Mantoue*'.

31. *Italienische Reise*, 27 September 1786: 'In the Church of the Eremitani I saw some astonishing paintings by Mantegna … . What a sharp, assured actuality they have! It was from this actuality, which does not merely appeal to the imagination, but is solid, lucid, scrupulously exact and has something austere, even laborious about it, that the later painters drew their strength', trans. W. H. Auden and E. Mayer, London, 1962; repr. London 1970 p. 72.

32. Puppi, 1972, p. 67, doc. I.

33. Probably after the death of her son, Gianantonio, in 1457; his tomb in the Gattamelata chapel in the Santo was inscribed with verses by Galeotto Marzio who had been painted by Mantegna; the altarpiece was by Jacopo Bellini and his sons Gentile and Giovanni. See Lightbown, 1986, pp. 458-9; Eisler, 1989, p. 60.

34. Puppi, 1972, pp. 35-49.

35. Degli Agostini, 1752, I, pp. 1-44.

36. Kristeller, 1902, p. 519, docs. 17, 18; Puppi, 1972, p. 72, docs XII, XIII.

37. Signorini, 1985, pp. 104-7, who suggested it was painted in Mantua.

38. Puppi, 1972, p. 89, fig. 7; Janson, 1961, pp. 65-6; Lightbown, 1986, p. 80, who cites Lucretius, *De rerum natura*, IV, 132ff; Wollheim, 1987, pp. 54-6.

39. Kristeller, 1902, p. 535, doc. 71.

40. Lamoureux, 1979, doc. L and p. 131.

41. Puppi, 1972, p. 26; p. 33 n.

42. Luzio and Renier, 1890, pp. 119-217; Signorini, 1985, pp. 23-7.

43. Scardeone, 1560, p. 371.

44. Vespasiano da Bisticci, ed. 1951, p. 438.

45. Paschini, 1939, pp. 162-3, 193.

46. Wardrop, 1963; Pratilli, 1939-40, pp. 33-105; Mitchell, 1961, pp. 197-223.

47. Feliciano, ed. 1960; Meiss, 1976, p. 177.

48. Mitchell, 1961.

49. Vasari, ed. 1878-85, III, p. 405. See also Armstrong, 1976, pp. 3-5. Later Zoppo collaborated with Sanvito in illuminating a copy of Cicero's letters, Paris, B.N. Lat. 11309; see Alexander, 1969, pp. 541-5.

50. Kristeller, 1902, p. 489, doc. 3. The undated sonnet must have been written after 18 December 1461, when Francesco was nominated cardinal, or 24 March 1462, when he formally received his red hat in Rome.

51. Wardrop, 1963, p. 17.

52. Kristeller, 1902, pp. 523-4; Lightbown, 1986, p. 95.

53. First suggested by Fiocco, 1936, pp. 179-83. For Giovanni da Padova see Rodella, 1988. Another Giovanni da Padova was a scribe employed by Marcanova with Feliciano from 1461; see Sighinolfi, 1921, p. 187.

54. This was apparently one of the earliest of such reenactments of an antique ceremony: in 1468 Marsilio Ficino staged a latter-day symposium to celebrate Plato's supposed birthday on 7 November; see Panofsky, 1960, ed. 1972, p. 173, n. 2.

55. Kristeller, 1902, p. 527, doc. 45.

56. e.g. letter of G. P. Arrivabene from Bologna, 3 August 1472 (ASMn AG b. 1141 c. 243).

57. Kristeller, 1902, p. 541, doc. 86. Lightbown, 1986, p. 122, and Rosenthal, 1962, pp. 327-48, discuss where the collection may have been kept.

58. Robinson, 1979, p. 86.; Signorini, 1985, p. 18.

59. Braghirolli, 1869, p.13.

60. Signorini, 1980, pp. 165-72.

61. Weiss, 1969, ed. 1988 p. 170.

62. Signorini, 1986¹, pp. 233-5.

63. Vasari, ed. 1878-85, III, p. 394.

64. Kristeller, 1901, p. 177.

65. Kristeller, 1902, pp. 491-3, doc. 10. On Spagnoli see Faccioli, 1962, II, pp. 151-87.

66. Kristeller, 1902, pp. 493-5, doc. 12.

67. Tommasoli, 1978, pp. 346-7, 350, n. 146; see Santi, ed. 1985, pp. XVII, XX on Santi and the work's composition.

68. Buzzoni (Stephanus Vosonius), *c*. 1498, *fol. 12v*. See Guerrini, 1937, p. 247; Treccani degli Alfieri, II, 1963, p. 750, n. 1.

69. Vatican Library, MS Vat. Lat. 2836 *fol. 7r* and *fol. 11r*. See Battisti, 1965, pp. 54-5.

70. Lightbown, 1986, p. 465

71. *Arcadia*, from section IX, composed after 1491; see Kurz, 1959, II, pp. 277-83.

72. Published here for the first time: see p. 30. Dr Andrea Comboni of Brescia generously drew the attention of Rodolfo Signorini to this manuscript, on which see Mandalari, 1893; Calmeta, 1959, p. XIV, n. 2.

73. This too is a *topos*; compare the sonnet of Niccolò da Correggio addressed to Leonardo da Vinci: Niccolò da Correggio, ed. 1969, p. 201, no. 189.

74. Sassi, *Epigrammata, De Bello Tarrensi, De laudibus Veronae, Elegiae*, ed. Angelo de' Brittannici, Brescia, 1499, *fol.* a viii*v*.

75. D'Arco, 1857, II, p. 50.

76. Fiera, 1515, *fols* B*v*-B2*r*; Battisti, pp. 25-28. On Fiera see Faccioli, 1962, pp. 366-73; London, 1981, p. 154.

77. Mantegna to Marchese Francesco II Gonzaga, 15 June 1489, Kristeller, 1902, pp. 546-7, doc. 104.

78. The frescoes were destroyed in 1780. Two 18th-century descriptions of them, by Agostino Taja and Giovanni Pietro Chattard, are reprinted by Kristeller, 1902, pp. 510-13, docs. 43, 44; see also Lightbown, 1986, pp. 155-8, cat. no. 29, pp. 433-5.

79. Letter of G. B. Cattanei to Marchese Francesco II Gonzaga, 20 February 1489 (ASMn AG b. 848 *fol.* 17). Elam, in London, 1981, p. 22, suggests that Mantegna's mission was to aid Sigismondo's promotion, which finally occurred in 1505.

80. On Arrivabene see Chambers, 1984, pp. 397-438. More about Arrivabene and Cardinal Gonzaga will appear in Chambers, 1992.

81. The original is in ASMn AG b. 834; Kristeller, 1902, p. 548, doc. 107.

82. See Pintor, 1907, esp. pp. 28-37.

83. *De Cardinalatu*, 1510, lib. II, De Sermone, *fol.* LXXXVIIv.

84. Finally printed in 1515. Fiera, ed. 1957; its significance is stressed by Gombrich, 1972, pp. 175-6, and Lightbown, 1986, p. 157.

85. Possibly an echo of *Aeneid*, VI 129: '*hoc opus, hic labor est*'.

86. *c.* 1150, but used until the 16th century; Weiss, 1969, ed. 1988, p. 7

87. Weiss, 1969, ed. 1988, p. 68.

88. Letter of 15 June 1489, see n. 77, above.

89. It has been claimed that later he took into his household the Paduan prodigy Giulio Campagnola, son of Girolamo, who was praised for the ability, among his many other skills, to imitate Mantegna's art. See Safarik, 1974, XVII, pp. 317-18; on Riario's palace, see Valtieri, 1982, pp. 3-24.

90. De la Mare, 1984, pp. 245-89.

91. On Cattanei see Zapperi, 1979, XXII, pp. 406-8; his funeral orations for Barbara of Brandenburg, Cardinal Francesco and Federico Gonzaga were published at Parma, 1493.

92. R. Maffeius Volaterranus, *Commentarii rerum urbanarum*, Rome 1506, lib. XXXI, *fol.* 300r.

93. Kristeller, 1902, p. 549, doc. 110.

94. Baschet, 1866, pp. 488-9; London, 1981, pp. 152-3.

95. Fiera, n. 76, above, *fol.* P2r.

96. Canuti, 1931, II, p. 223.

97. Fiera, as above n. 76, *fol.* N2r; Lightbown, 1986, pp. 200-01. The theme was developed further by Jones, 1981, pp. 193-8.

98. Massing, in London, 1981, pp. 171-2, nos. 125-6; *idem*, 1990², *passim*.

99. Lightbown, 1986, pp. 214-18.

100. Tietze-Conrat, 1955, p. 247. Poliziano's *Orfeo* was performed at Mantua in 1491.

101. Massing, 1990², *passim*.

102. Apparently Squarcione owned a drawing by Pollaiuolo of a similar subject.

103. Alberti, ed. 1972, p. 97.

104. For the discrepancies between Alberti's and Mantegna's versions, see Popham and Pouncey, II, pp. 97-9; Alberti, ed. 1972, p. 81.

105. Landsberger, 1952-3, I, pp. 2-4.

106. Suggested by Robertson, 1968, p. 79. The paintings are the *Pietà* at the Accademia Carrara, Bergamo, the *Virgin and Child* of the 1470s in the Brera, Milan, and the *Crespi Madonna* in the Fogg Museum of Art, Cambridge, MA.

107. Brown, 1969, pp. 140-64.

108. Kurz, 1948.

109. There is no inventory of Mantegna's collection. After his death Francesco Gonzaga ordered that no 'paintings, antique objects or other of his rare things' should be removed from his house until he returned to Mantua, but since no antiques are mentioned in Mantegna's will of 1504, Brown, 1969, suggests the collection had already been dispersed.

110. It may be the bust of Faustina the Elder in the Palazzo Ducale, Mantua, although Martindale, 1979, p. 140, and Brown, in Mantua, 1989, p. 314, questioned the identity of the bust, which is not recorded before the 17th century; however Antico's description of it, as worn in many places, corresponds with the portrait, which has been repaired on the nose and been broken in several places. See Rossi, 1888, pp. 187-8; Lyttelton, in London, 1981, p. 170, no. 122.

111. See Lightbown, 1986, p. 151.

112. Ludovico Gonzaga to Bernardino Castigato, Sabbioneta 25 September 1488: '*L'Agnello ... haverà facto rechiedere a la Sanctità del Nostro Signore e simelmente el Mantegna per messer Hieronymo cameriero ...* ', ASP, Arch. Gonzaga di Guastalla, b.41/3 reg. 3.

113. Letter of Mantegna's son Ludovico, 2 October 1506; Kristeller, 1902, pp. 583-4, doc. 190; Lightbown, 1986, p. 445, cat. 42.

114. Lightbown, 1986, p. 128.

115. Matteucci, 1902, p. 136.

116. Kristeller, 1902, p. 570, doc. 163.

117. Lorenzo da Pavia to Isabella d'Este, 26 October 1506; Kristeller, 1902, doc. 193. The humanist Giovanni Bonavoglia also commemorated him as '*Apelles alter*'; 'Gonzagium Monumentum', Biblioteca Comunale, Mantua, MS 120 [A. IV. 26], *fol.* 84v.

Non t'affannar, non pensar più Mantegno

per far madonna naturale in carthe,

ché mille anni potresti affaticarte

e sempre più te mancharia lo ingegno.

Se chiude gli ochi, tu fara' il dissegno

del corpo, te 'l concedo, in qualche parte,

ma farla con tal modo e con tal arte

è come a fare el cel senza alchun segno.

Poi gli ochi, è bella ogni excellentia in quella:

vòl, senza quelli che retrar la vole,

da un carbon spento ritrare una stella.

Se fulgura col guardo come sòle,

tanto la pinggerai come l'è bella

quanto tu pinggi come è bello el sole.

Non pingger più. Tu t'affatichi invano,

Mantegno, e batti l'aqua col martello,

ché questa opra non è dal tuo penello

né bastaria d'Apel l'arte e la mano.

La prima volta che 'l so volto humano

vedi, per excellentia te par bello,

la seconda non è come era quello,

ma più del primo assai degno e soprano.

La terza vedi quante fiamme e rai

el lume à che i mortali al celo invita,

onde tal opra mai non finirai,

ché una belleza eterna et infinita,

che bella a un modo non se trova mai,

comenciata non è quando è finita.

CHECKLIST OF LITERARY REFERENCES MADE TO MANTEGNA DURING HIS LIFETIME
IN APPROXIMATE CHRONOLOGICAL ORDER

1. *c.*1448? U. Aleotti, *Ulixes pro Andrea Ma[n]tegna pictore, dicto Squarzono pro quadam moniali,* Modena, Biblioteca Estense, MS α. 7. 24, *fol.* 162r (Ital. 262 III. D. 22, *fol.* 55r).

2. Before 1458. J. Pannonius, *Laus Andreae Mantegnae pictoris Patavini. Elegia XVI, J. Pannonii Quinqueecclesiensis Episcopi Opera,* Basel, n.d., pp. 232ff.

3. 1464. F. Feliciano *Memoratu digna. A.D. IX KL. Oct. MCCCCLXIIII. Una cum Andrea Mantegna …: Iubilatio. A. d. VIII KI. Oct. MCCCCLXIIII. Sub imperio faceti viri Samuellis de Tridate …,* Treviso, Biblioteca Capitolare, MS 138, *fols.* 201v, 205v

4. After 18 December 1461 and before 27 June 1465. F. Feliciano, *Felice [Feliciano] ad Andria [Mantegna] antedicto, compatre del Reverendissimo cardinale mantuano, pregandolo si voglia adoperar per lui di aconzarlo col dito monsignore secondo il parlamento haùto insieme,* Modena, Biblioteca Estense, MS α N.7.28 *fol.* 7r (Ital. 1155, *fol.* 7r).

5. Before June 1465. F. Nuvoloni, *Per Philippum Nuvolonum virum clarum ad Andream Mantegnam pictorem Convere' che 'l figliol di Citarea; El dito Philippo havendoli presentato un libro pien di rime e frotule in dono o sopra tutti gli altri incliti e insegni,* MS as in no. 4, above, *fols.* 5v (7s) and 6r (7d).

6. 1484. M. Bosso, … *Mantineam nostrum audio filii mortem dolentius ac gravius ferre …, Opera varia,* Bologna, 1627, p. 270 (letter to Alvise Antilla).

7. *c.* 1484-7. G. Santi, *La Vita e le gesta di Federico di Montefeltro, Duca d'Urbino,* Lib. XXII, cap. XCI, lines 217-79, 421-6, ed. L. Michelini Tocci, Vatican City, 1985, II, pp. 667-76.

8. 1490? B. Spagnoli, Opera, Paris, 1513, II, *fols.* CLXVIv-CLXVIIr. *In Andream Mantiniam Pictorem, Sicut Agaenorei surgunt ubi cornua tauri, Opera,* Paris, 1513, III, *fols.* CLXVIv - CLXVIIv.

9. After 1491. J. Sannazaro, *Arcadia,* XI, pp. 101-2, in A. Mauro, *Opere Volgari,* Bari, 1961.

10. *c.* 1484-98. S. Buzzoni (Stephanus Vosonius), *Ad Andream Mantengam equitem et pictorum decus Carmina,* Brescia, n.d., *fol* 12v.

11. 1499. P. Sassi, *Epigrammata, De bello Tarrensi, De laudibus Veronae, Elegiae,* Brescia, 1499. *Admiratur ingenium Andreae Mantegnae pictoris eximii Arte novus mira vivam me pinxit Apelles.*

12. Before 1505. F. Mantovano, *Falco Mantuanus: Virgineum succincta latus. nudata lacertos,* Città del Vaticano, Biblioteca Apostolica Vaticana, MS Vat. Lat. 2836, *fol.* 7r (and *fol.* 11r).

13. Before 1506. Anonymous, MS 174, *fol.* 196, *fol.* 197r, Rome, Biblioteca Alessandrina, see opposite.

14. Before 1515. B. Fiera, *Coena, Hymni divini, Silvae, Melanysius, Elegiae, Epigrammata, De iusticia pingenda,* Mantua, 1515. *Hic picturato vernantia prata decore; De iusticia pingenda Baptistae Fiaerae Mantuani dialogus; De Virgilio per statuam restituto; formosam Venerem noster tibi pinxit Apelles; Si quae Mantyniae quae Costae munera donas; Mantynia vivente tuo, tua dona fuere.*

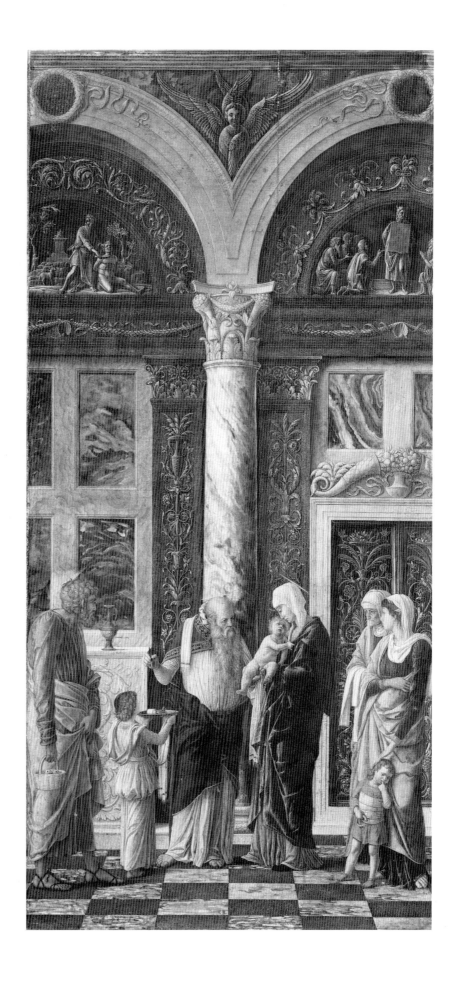

THE ART OF ANDREA MANTEGNA

KEITH CHRISTIANSEN

When, at the close of the 15th century, the chief painter at the court of Urbino, Giovanni Santi, compiled a list of the greatest artists of his age, beginning with Jan van Eyck and Rogier van der Weyden in Flanders and Gentile da Fabriano in Italy and ending with Pietro Perugino and Leonardo da Vinci, one person seemed to him to stand apart as a paradigm of all that an artist could aspire to. That artist was Andrea Mantegna whom, he declared, Nature had 'endowed with such outstanding and worthy gifts that I think it would be impossible to grant more, because he unites all the parts of painting'.[1] Mantegna's name must have been familiar to Giovanni: Federico da Montefeltro was closely allied with the Gonzagas, having betrothed his son Guidobaldo to Elisabetta Gonzaga. Perhaps he accompanied Duke Federico on a brief visit to Mantua in 1482. In 1493 he certainly visited the city to paint a portrait of Isabella d'Este – ironically enough, commissioned to replace one by Mantegna she had rejected. We do not know if Giovanni met Mantegna on that occasion; the artist, then in his sixties, was still a formidable and autocratic personality. Nor do we know what the painter from Urbino made of the peculiarities of taste and vanity that would lead Isabella to prefer his modest talent to that of her own court artist. The only record we have is of his astonishment and admiration at what he saw. Giovanni's comments take on a special significance, coming as they do from a painter rather than a literary admirer of Mantegna.

Urbino was, of course, a leading centre of art and culture, where Giovanni had ready access to works by Piero della Francesca, the Fleming Joos van Ghent, the Spaniard Pedro Berruguete and Perugino, the most popular painter of the late 15th century, whose works were the basis of Giovanni's own painting and to whom he apprenticed his son, Raphael. Nonetheless, he cannot have been fully prepared for what met his eyes. Foremost among Mantegna's works were the private chapel he had decorated shortly after moving from Padua to Mantua in 1460 (see cat. 17), the frescoes in the Camera Picta and the *Triumphs of Caesar* (cats. 108-15). Everything he had seen before paled when compared to these works. Giovanni was not alone in this view: more praise was lavished on Mantegna than on any other early Renaissance artist (see pp. 8-30). What impressed Mantegna's contemporaries was not simply his excellence

fig. 9 Andrea Mantegna, *Circumcision*, tempera on panel, 86 x 43 cm, right-hand panel of the 'Uffizi Triptych', early 1460s, Galleria degli Uffizi, Florence

as a designer and draughtsman ('*disegno*'), his remarkable inventive capacity ('*invenzione*'), his audacious foreshortenings and tricks of perspective, and those sculptural effects ('*rilievo*') that figure so large in the Renaissance conception of painting, but his '*ingegno*': the quality and character of mind that informed his works.

Mantegna's genius was recognised early on, and there are few works in which he did not find some way of making it apparent. In his early cycle of frescoes for the Ovetari Chapel in Padua, undertaken in partnership with the gifted and ill-fated painter, Niccolò Pizzolo, it was displayed in the dramatic action and scenographic conception of the scenes, some of which are shown *di sotto in sù* with figures projecting beyond the picture plane, and in the use of *all'antica* settings and props. Just how far Mantegna departed from conventional practice is revealed by the claims of his patron Madonna Imperatrice Ovetari that in the fresco of the *Assumption of the Virgin* he had defrauded her by showing eight instead of twelve apostles and employing azurite instead of the more expensive ultramarine blue. Squabbles of this sort were common enough in the 14th and 15th centuries, when the cost of a work of art was carefully calculated by the physical labour and materials it involved, but in the case of Mantegna's frescoes the very terms of the claim were absurd. From the testimony given by the painter Pietro da Milano, it is clear that in his mind Madonna Imperatrice had paid for Mantegna's genius, not his craft – great though that was (typically, Mantegna had not been guilty of substituting azurite in the Virgin's drapery).

The measure of artistic genius had been established by the great humanist writer, theorist and architect Leon Battista Alberti in his treatise on painting, the *De Pictura*, written in 1435. Alberti proposed two gauges by which an artist could judge his work: the mirror of Nature, with those laws of perspective that he believed governed our perception of it; and the example of antiquity – not simply its visible remains, but the testimony of ancient writers as well. The art he envisaged was informed alike by observation, experience, theory and learning, refracted through the example of antiquity. Although numerous artists were influenced by one or other aspect of Alberti's vision, Mantegna was alone in espousing the whole of it – including the close association with literary men Alberti thought essential. He became the exemplar of the Renaissance painter.

At turns, Mantegna appears in the guise of the born naturalist, recording the factual data of the flora and fauna of northern Italy with merciless precision; the detached observer, able to recreate the variety of a given moment without sacrificing the event which gives it significance; the dry humourist, whose visual puns crackle with irony; the poet of intimacy; the master conjurer, who

effortlessly transforms an ordinary room into a Roman pavilion and opens up vistas onto mythic landscapes (fig. 16); and the antiquarian, who proudly displays his knowledge of ancient cultures in the objects and inscriptions with which he ornamented his compositions like learned footnotes.

Perhaps the most tangible example of the degree to which Mantegna identified with the classical world is the well-known excursion he made with his colleagues at the Gonzaga court, the painter Samuele da Tradate and the Gonzaga architect–engineer Giovanni da Padova, and with that eccentric antiquarian and friend of artists, Felice Feliciano, to the Lago di Garda in September 1464. Mantegna was then in his thirties, but he evidently felt no inhibitions about dressing up and assuming the role of a Roman consul to Samuele's *imperator* (see pp. 17-18).[2]

To trace Mantegna's career is to participate in the transformation of the youth who painted the frescoes in the Ovetari Chapel in Padua, with their romantic evocation of Roman monuments and buildings; to the dedicated student of ancient literature and archaeology who conceived the Imperial Roman temple in the *Circumcision* (fig. 9, Uffizi, Florence), embellished with coloured marbles and gilt bronze ornament, and adorned the vault of the Camera Picta with feigned marble busts of the Caesars set against a pseudo-mosaic background (fig. 10); to the reincarnation of those ancient masters whose works, long since lost, had been held up to him as paradigms. Throughout, his development was attended by an ever-widening circle of humanist friends and antiquaries who fired his imagination with their studies and collections. The key person was Alberti himself, who Mantegna may conceivably have met in Padua or Ferrara, and with whom he must have become well acquainted after his move to Mantua, where Alberti stayed on a number of occasions between 1459 and his death in 1472, supervising architectural projects for Ludovico Gonzaga.[3] The Latin edition of Alberti's treatise on painting had been dedicated to Ludovico's father, and it had doubtless helped to form Ludovico's taste for what was then referred to as the 'Ancient' style (as opposed to the 'modern style' – what we call Gothic – still current throughout Italy). Ludovico owned a copy of Vitruvius' treatise on architecture, which he lent to Alberti in 1460, and he, like Mantegna, must also have been a student of Alberti's *De Re Aedificatoria*. However, of even greater importance for Mantegna than Alberti's writings was his personality: here was a humanist who also practised painting (or so Alberti claimed), and who had risen to be the foremost architect in Italy; someone who viewed artists as colleagues rather than intellectual inferiors.

Alberti had been the first architect to translate Roman forms to serve in contemporary building practice, and it is probably not fortuitous that the changing attitude towards antiquity evident in his architecture paralleled that of Mantegna: his move from 'an emotional to an archaeological outlook', to one in which classical authority was subordinated to more purely structural considerations and, finally, the use of 'classical architecture as a storehouse which supplied him with the motives for a free and subjective planning ... '.[4] This is, roughly, the route Mantegna travelled from the frescoes in the Ovetari Chapel to those of the Camera Picta (perhaps planned in concert with Alberti during the latter's visit to Mantua in 1463) and then on to the *Triumphs of Caesar*, in which the effect is of actuality rather than archaeological reconstruction. In the pictures for the Studiolo of Isabella d'Este (cat. 136) and the late allegorical drawings (cats. 147, 154), Mantegna went yet further, creating a personal 'neo-Attic' style. In a similar fashion, his religious paintings shed the touching poignancy characteristic of his Paduan years (cat. 12) and take on a haunting seriousness: the Christ Child becomes, in effect, the infant Zeus–Redeemer to whom Mantegna had paid homage on his expedition to Lake Garda, and Joseph acquires the serious mein of a patriarch (cats. 52, 64).

Although there is a temptation to equate Mantegna's erudition with academicism and to lament the manner in which his 'too great devotion to the Antique ... hampered [him] in all his movements, checking in every direction his free development, and curbing the natural course of his genius',[5] nothing could be further from the truth. Ancient art, as culled from literary sources as well as from the study of its monuments, was an animating force in Mantegna's art. It sometimes provided incidental details, such as the winged boots of Mercury in the *Parnassus* (fig. 107, Louvre, Paris), which in fact derive from a drawing after an archaistic relief by Ciriaco d'Ancona[6] – transformed by Mantegna's *fantasia* into splendid, high-fashion objects – or, in a more serious vein, it spurred him to produce such works as the engraved *Entombment* (cat. 38), in which he attempted to emulate an ancient depiction of the dead Meleager, praised by Alberti 'because those who are bearing the burden appear to be distressed and to strain with every limb, while in the dead man there is no member that does not seem completely lifeless ... This is the most difficult thing of all to do, for to represent the limbs of a body entirely at rest is as much the sign of an excellent artist as to render them all alive and in action'.[7]

To a degree paralleled only in Donatello, whose work undertaken during his stay in Padua from 1443 to 1453 provided a crucial reference point, Mantegna openly sparred with the legends of antiquity. He did so with an elevated sense of humour and irony that is an added testament to the quality of

fig. 10 Andrea Mantegna, *The Emperor Tiberius*, fresco, 1465-74, from the vault of the Camera Picta, Palazzo Ducale, Mantua

fig. 11 Peter Paul Rubens, Study after a figure in Mantegna's *Bacchanal with a Wine Vat* (cat. 74), pen and ink on blue prepared paper, 256 x 142 mm, Kupferstichkabinett, Berlin (Kd 2 1551)

his mind and the nature of his achievement.[8] On one level, the engravings of the *Battle of the Sea Gods* (cat. 79) are exercises in antique imagery, evoking nereid sarcophagi, with their shallow, congested spaces and fantastic creatures. But by their deliberately mocking accent – a triton wielding a bull's skull as a defensive shield, two figures doing battle with strings of fish, and the hag with her sagging breasts – their classical source is transformed into a scathing condemnation of human foibles, in this case of Envy. In a similar fashion, the phallic spigot emitting wine and the soundly sleeping infants in the *Bacchanal with a Wine Vat* (cat. 74) are pungent comments on a typically ancient theme, which Mantegna treated with a mastery that surpasses any putative model. Alberti recommended Lucian's account of the Calumny of Apelles as a noteworthy '*invenzione*', but in Mantegna's hands the subject became a vehicle for a personal comment on the world he lived in (see cat. 154). Rubens's drawing after one of the figures in the *Bacchanal with a Wine Vat* (fig. 11) – perhaps not coincidentally a figure Mantegna had based on a Roman sarcophagus – reminds us of the degree to which the artistic path Mantegna blazed between the study of Nature, on the one hand, and the example of antiquity, on the other, prefigures the classical–academic tradition of 17th- and 18th-century Europe, from Annibale Carracci, Domenichino, Rubens and Poussin down to Mengs and David.

No less indicative of his subtle sense of humour is the inclusion, in his fresco of the *Trial of St James* (fig. 12), of a page who comically wears his master's over-size helmet and holds a shield decorated with a head that casts a furtive glance towards a Roman centurion (actually, a self-portrait of Mantegna) while the page looks in the opposite direction. The cloud formations that in the *St Sebastian* (fig. 5) and the *Pallas Expelling the Vices* (cat. 136), assume the momentary shape of a figure or face, can be appreciated as arcane iconography, pure fancy, or as emblems of the transforming power of Mantegna's art. But they are also erudite references to ancient writers who commented on chance images made by Nature.[9] Were not Mantegna's evocations of marble relief sculpture in the grisaille paintings and his unprecedented exploitation of the medium of printmaking to translate the character of his drawings also testimonies to his '*ingegno*'?

Perhaps inevitably, critics of the last century and a half – those responsible for creating our pantheon of Renaissance idols – have not been kind to Mantegna or sympathetic to his achievement. Predictably, Ruskin sounded an early note of dissent. Without questioning Mantegna's gifts or his genius, Ruskin nonetheless found fault with those features in his work that bound him so closely to Alberti and the Renaissance: his obsession with antiquity, his

mastery of complicated perspective and his understanding of anatomy.[10] The theme of the artist gone astray was taken up by Berenson[11] and developed with polemical force by Roberto Longhi, whose ideas have had such an enormous impact on Italian criticism in this century. In a brilliantly destructive 'open letter' published in 1926, a year before the appearance of his ground-breaking monograph on Piero della Francesca, Longhi referred to Mantegna's 'archeological mysticism' and his 'desperate and subtle dogmatism' based on classical antiquity.[12]

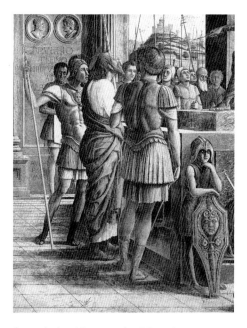

fig. 12 Andrea Mantegna, detail from the *Trial of St James*, fresco, formerly Cappella Ovetari, Chiesa degli Eremitani, Padua

However, for Mantegna, classical art represented far more than an aesthetic norm or dogma – the '*beau idéal*' of academic teaching. It embodied a view of the world to which he subscribed wholeheartedly. Perhaps for this reason he remained impervious to those innovations of style that were to make his own art appear old-fashioned to a younger generation. With what mixed emotions he must have observed the rising star of Leonardo da Vinci at the Sforza court in neighbouring Milan and the transformation in the work of his brother-in-law Giovanni Bellini in Venice. Upon his return to Mantua from Rome in 1490, he was confronted with the young and fashion-conscious Isabella d'Este, who knew only too well that the Mantuan state did not define the artistic horizons of Italy. She laboured long and hard, and mostly unsuccessfully, to obtain works by Leonardo da Vinci, Giovanni Bellini, Pietro Perugino, Lorenzo Costa and Francesco Francia. Isabella's interest in the works of the three last artists has often elicited expressions of bewilderment. Yet, Vasari singled out Perugino and Francia as having led the way to the High Renaissance by their 'sweetness of fused colour' – traits apparently repugnant to Mantegna (see cat. 136).[13] Perspicacious in matters of style, Isabella was less sympathetic to the purposefully stern element in Mantegna's art: that clarity of detail and contour that Ruskin equated with Mantegna's 'ethical state of body and mind'.[14] Is it any wonder that, finding himself bypassed by the momentum of artistic innovation in the 1490s, he consoled himself with the bitter motto '*virtuti semper adversatur ignorantia*': 'Ignorance is always opposed to Virtue'?

A true estimate of Mantegna's art can only be made by someone willing to approach it as embodying a system of values rather than an aesthetic posture, and it is for this reason that the most eloquent appraisal of Mantegna is due to Goethe, for whom antiquity was still a living, vital force rather than a cultural deadweight. To Goethe, the *Triumphs*, which he knew from the late 16th-century woodcuts of Andrea Andreani, were more like a sequential *tableau vivant* than an archaeological reconstruction (this is the way they also must have impressed Mantegna's contemporaries). Each figure seemed to him to possess an individual personality drawn from life, and he saw the idea of Mantegna's art

as a deviation or betrayal of artistic principles as the shibboleth it is, disposing of the accusation that Mantegna disregarded Nature in favour of ancient art by unmasking it at its source: in the story told by Vasari of Squarcione, Mantegna's teacher, criticising his work in the Ovetari Chapel for its lapidary character.

'When master and pupil became enemies, Squarcione forgot his leadership and his aspirations, his teaching and instruction; and he now contradicted himself by blaming what the youth had achieved and was achieving on his advice and at his behest; and he joined that public which tries to bring an artist down to their level so that they may judge him. They demand naturalness and verisimilitude so that they may have some point of reference, not a high, spiritual one, but a commonplace external one which always wants to contrast and compare the original with the copy. Mantegna was now worthless; he could produce – so the story went – nothing lifelike; his most magnificent works were criticized as wooden or like stone, rigid and stiff. The noble artist, still at the height of his powers, grew angry, for he knew full well that nature was only the more natural, and his artist's vision only the more understanding from the standpoint of the Antique. He felt adequate to it, and risked swimming in its swell. From that moment onwards he decked out his paintings with the portraits of many of his fellow-townsmen; he immortalized a friend as an elder and his mistress as a delightful young girl, and thus gave the most enjoyable memorial to noble and worthy people; nor did he disdain to represent the extraordinary, the notorious, the strangely-formed, even, as the final contrast, the malformed.

We sense these two elements in his works not separately, but inextricably intertwined. The high and ideal is manifest in the general layout, in the value and dignity of the whole; here is revealed the meaning and intention, the basis and the grasp of the subject. On the other hand, nature also forces her way in with a primitive violence, and as the mountain torrent finds its way between the rocks and crashes down with the same force with which it reached these falls, so it is here. The study of the Antique provides the form, but nature the skill, and, in the end, the life.'[15]

It is from the works of the complex artist Goethe admired – despite all his flaws of personality and character – that numerous painters have drawn inspiration over the centuries. Quite apart from the understandably deep influence Mantegna's paintings and engravings had on artists in the Veneto, and especially in nearby Verona,[16] there is the widespread diffusion of his ideas, first in Italy, and then beyond the Alps. By the end of the 15th century, the

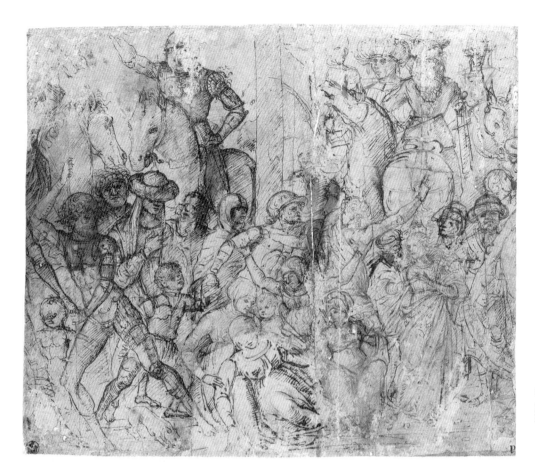

fig. 13 Ercole de'Roberti, *Study for the Crucifixion*, pen and ink, 370 x 306 mm, Kupferstichkabinett, Berlin (Kd 2 615)

illusionistic architectural framework of the Camera Picta had become part of the common currency of Renaissance painting: Pintoricchio employed it in his frescoes at Spello and Rome, as did Raphael in his decorations in the Vatican *Stanze*. No less influential was the audacious oculus Mantegna painted on the vault in the Camera Picta, with winged infants poking their heads through the balustrade and a potted tub balanced precariously on a slender branch – a model for Garofalo's ceiling in the Palazzo Costabili in Ferrara, for Sodoma's ceiling in the Stanze and for Giulio Romano's later work in Palazzo Te in Mantua. Correggio's ceiling in the Camera di San Paolo and Parmigianino's at Fontanellato, near Parma, derive from the decorations of Mantegna's funerary chapel in Sant'Andrea (see cat. 64). But Mantegna's influence went well beyond these feats of illusionism. From a study of Mantegna's prints and paintings the Ferrarese Ercole de' Roberti transformed his quirky, regional style into one of great expressive range and resonance (fig. 13).[17] Dürer sought to learn the secrets of classical diction by painstakingly copying two of Mantegna's prints in pen and ink. During his years of service to Vincenzo I

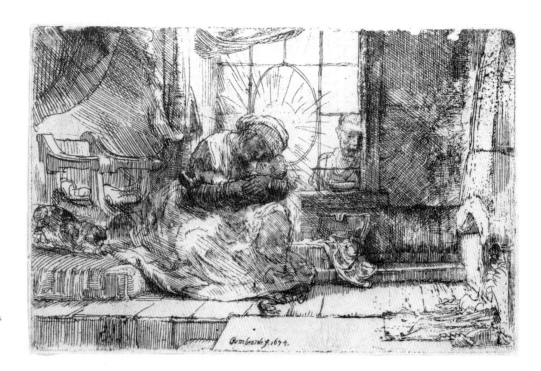

fig. 14 Rembrandt van Rijn, *Virgin and Child*, etching, 94 x 143 mm, 1674, The Metropolitan Museum of Art, New York, Gift of Henry Walters

fig. 15 Edgar Degas, Copy of the *Crucifixion* by Andrea Mantegna, canvas, 69 x 92.5 cm, Musée des Beaux-Arts, Tours

Gonzaga in Mantua, Rubens studied the *Triumphs* at first hand and must also have collected Mantegna's prints. Among Rembrandt's most prized possessions listed in the inventory drawn up in 1656 was 'the precious book of Andrea Mantegna', which must have included an impression of the *Virgin and Child* (cat. 48), on which Rembrandt based his own etching of the *Virgin and Child with a Cat* (fig. 14). In the 19th century, when Mantegna's works were no longer appreciated for their references to the antique but, rather, for their pre-Raphaelite purity of line, Burne-Jones set himself before the drawing of the *Calumny of Apelles* in the British Museum (also copied by Rembrandt), and Gustave Moreau and Degas set up their easels before his pictures in the Louvre (fig. 15). It is doubtful if any other 15th-century painter has spoken, in differing guises, to so many diverse artists with such divergent interests.

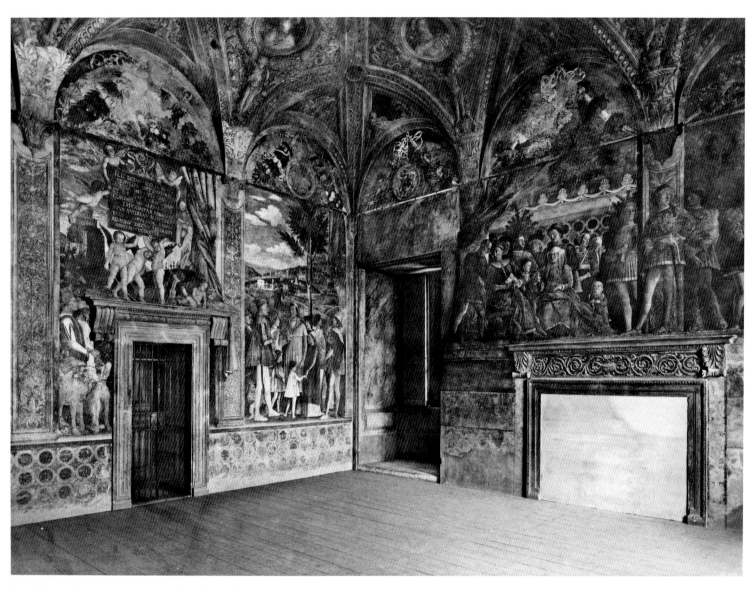

fig. 16 Andrea Mantegna, general view of the Camera Picta,
1465-74, Palazzo Ducale, Mantua

NOTES

1. The portion of Giovanni Santi's rhymed chronicle relating to Mantegna is reprinted in Kristeller, 1902, pp. 493-5, no. 12. Whether Giovanni's comments were written immediately after his visit to Mantua in 1493 or a decade earlier, when the rest of the chronicle was composed, cannot be said with certainty.

2. Felice Feliciano's description of the excursion is reprinted in Kristeller, 1902, pp. 523-4, doc. 34.

3. Alberti is documented in Mantua in 1459-60, 1463 and 1470, during which time he was chiefly, but not exclusively, concerned with the building of San Sebastiano and Sant'Andrea. Ludovico Gonzaga owned a copy of Vitruvius that Mantegna surely consulted.

4. See Wittkower, 1949, p. 49.

5. Berenson, 1907, pp. 48-9.

6. See Lehmann, 1973, pp. 125-30.

7. De Pictura, II, 37, ed. 1972, p. 75. See also the comments of Baxandall, 1971, pp. 133-4, regarding the possible relation of Mantegna's print to Alberti's ideas about pictorial composition.

8. On this aspect of Mantegna's character, see the comments of Barolsky, 1978, pp. 24-31.

9. See Janson, 1961, ed. 1973.

10. Ruskin, ed. 1903-12, XXI, p. 293; XXIV, p. 156, XXII, pp. 482-3; 122.

11. Berenson, 1907, pp. 42-50.

12. Longhi, 1926, ed. 1967, p. 93.

13. Vasari, ed. 1879, IV, p. 11.

14. Ruskin, ed. 1903-12, XX, p. 79.

15. Goethe, 1823, trans. 1980, pp. 151-2.

16. Not only did Mantegna's San Zeno Altarpiece serve as a model for painters from Verona to Venice, but the high altarpiece from Santa Maria in Organo had a deep impact, perhaps most notable in Girolamo dai Libri's altarpiece for San Leonardo nel Monte (Metropolitan Museum of Art), in which the angels and lateral saints of the Santa Maria in Organo Altarpiece are combined with a Virgin and Child adapted from the *Madonna della Vittoria*, but shown against a landscape background copied from two of Dürer's prints. Mantegna's engraving of the *Virgin and Child* (cat. 48) was the point of reference for Domenico Morone's half-length *Virgin and Child* (Museo del Castelvecchio, Verona) of *c.* 1500-05. More important for the bearing they have on the date of Mantegna's engravings are two miniatures by Girolamo's father, Francesco dai Libri, that have been convincingly dated to *c.* 1480: see Castiglioni, in Verona, 1986, pp. 83-5. In one, of the *Lamentation* (Museum of Art, Cleveland), the group of Holy Women and the pose of the figure of the dead Christ derive from the vertical *Entombment* of Mantegna (cat. 29), as does the soldier in the background, while the mourning figure of St John derives from the horizontal *Entombment* (cat. 38). The manner in which elements from the two prints are combined precludes the possibility that Francesco studied drawings rather than the prints. A companion miniature of the *Entombment* (Courtauld Institute, London) bases the pose of Christ on the drunken

faun in the *Bacchanal with a Wine Vat* (cat. 74), as noted by Levenson, Oberhuber and Sheehan, in Washington, 1973, p. 185; a related drawing in the British Museum is almost certainly after the miniature: see Popham and Pouncey, 1950, p. 19. In a third miniature, the *Adoration of the Magi* (Musée Marmottan, Paris), the pose of one of the kings is taken over from Mantegna's African king in his painting of the same subject (fig. 80; Uffizi, Florence), demonstrating how thoroughly Francesco studied Mantegna's works in various media. The vertical *Entombment* had almost as widespread influence as the horizontal composition, being used both by a Veronese artist close to Caroto (Portland Art Museum, Portland, Oregon; Kress 1117) and by Carpaccio, in his *Entombment* (Gemäldegalerie, Berlin). Carpaccio combined the Holy Women from the horizontal print with the St John of the vertical one: see Oberhuber and Sheehan, in Washington, 1973, p. 206. When these derivations are taken into consideration together with the many others (including the case of the provincial Matteo Cesa, cited in cat. 45), it must be concluded that Mantegna's prints were in fairly wide circulation in the last two decades of the 15th century. See also n. 17, below.

17. The commission in which these studies come together is that for the decoration of the Garganelli Chapel in San Petronio, Bologna, carried out between *c.* 1478 and 1486 (destroyed, but known through a painted copy). In fig. 13, which is a preparatory drawing for the *Crucifixion*, the group of Holy Women at the foot of the Cross as well as the Magdalene with outflung arms derive from Mantegna's engraving of the *Entombment* (cat. 38). The group was modified in the finished work, where one of the executioners pounding a stake to wedge the cross repeats the pose of the *Faun Attacking a Snake* (cat. 82), a print that bears a dedicatory inscription to Ercole d'Este. Ercole probably studied the prints rather than a derivative drawing, especially in view of the pervasive influence of the *Entombment* on artists as diverse as Vincenzo Foppa, Sodoma, and even Raphael. Ercole also knew the vertical print of the *Entombment* (cat. 38), on which he based the Holy Women and the lamenting figure seen from the back in the background of his *Pietà* (Walker Art Gallery, Liverpool). The *Pietà* is part of a predella, and in its companion, *Agony in the Garden* (Gemäldegalerie, Dresden) he is obviously indebted to Mantegna's picture in the National Gallery, London, which seems to have been painted for the Este in Ferrara (see cat. 8). In 1490 Ercole accompanied Isabella d'Este to Mantua, where he evidently had time – despite his seasickness – to study the *Death of the Virgin* (cat. 17), which became the point of departure for his *Last Supper* (National Gallery, London). It is curious that the evident role of Mantegna's work in his development has received little comment. These derivations are yet further evidence that Mantegna's prints – including the non-autograph *Faun* – were already in circulation by *c.* 1480.

43

MANTEGNA AS PRINTMAKER

DAVID LANDAU

Mantegna was the first artist of genius to devote his attention to engraving, a medium born in what is now southern Germany at more or less the same time as Mantegna himself, that is around 1430. Woodcuts had been in existence for much longer, and it is likely that by the second half of the 15th century most important shrines in Europe were producing devotional images in this form for sale to pilgrims. The function of engravings produced before the 1460s, that is before Mantegna become interested in the medium, is more difficult to assess, but it appears that they were produced for a number of purposes. Some were made for playing cards or other games and entertainments, some for decorative or practical purposes, such as embellishments for the lids of boxes or as calendars, some served as patterns for artisans, but the vast majority of engravings were small images of religious subjects made, like woodcuts, for devotional use. Engravings were often pasted down to the pages of prayer books, which would suggest a certain degree of literacy among those who acquired them. In a number of recorded instances visitors to shrines were offered three types of print: at the cheaper end of the market a plain woodcut, at a slightly higher price a hand-coloured woodcut, and at the highest price an engraved image.

Mantegna may have become interested in the medium of engraving during his visit to Florence in 1466, but it is equally possible that he had seen prints in Padua, Mantua or, most likely, Venice, where they may have been introduced by the flourishing German community living there. Prints were being made elsewhere in Italy by this time, probably in Ferrara; certainly in Florence. They fell mainly into three categories: devotional images, mostly of little formal quality; ornamental prints for the use of craftsmen; and tiny, precious *niello* prints produced by the workshop of Maso Finiguerra. These showed a predominantly white image set against a black background, in imitation of the metal plaques produced in the same workshop, in which the image appeared in silver on a matt black background. This unconventional method of representing the natural world in terms of white on black was not lost on Mantegna (see cats. 59, 60). The earliest prints attributed to him, however, are in fact closer in spirit to the best northern prints, which he could have seen in Venice, than to contemporary Florentine examples: drypoints by the anonymous artists the

fig. 17 Attributed to Andrea Mantegna, *Deposition* (cat. 32), detail

44

Master of the Playing Cards and the Master ES reveal that they were deeply interested in producing richness of tone.

In his first edition of the *Vite,* Vasari described Mantegna as the inventor of printmaking, an accolade that he removed in the second edition to bestow it on the Florentine Maso Finiguerra. Mantegna never called himself an engraver – nor, on the other hand, did he ever call himself a draughtsman or a designer – and there is no certitude that he actually incised the plates with his own hands rather than using the services of a professional engraver. There are, however, a number of compelling reasons that suggest that this was indeed the case. First, few can dispute that these engravings are the most beautiful prints of the Italian Renaissance: had a professional engraver produced them, is it likely that his name would have disappeared completely both from the rich Mantuan archives and the history of printmaking? Second, there is a clear technical progression within the *œuvre,* from clumsy beginnings to absolute assurance: this is evident both in the handling of the tools and in the complexity of the techniques used. A professional engraver would have demonstrated his skills from the very first print, and would not have needed to find his way around the technical difficulties by experimenting with plates, inks, papers and printing methods, a feature that is so obvious in early impressions of Mantegna's prints, many of which are complete technical failures. Third, many of Mantegna's early prints are unfinished, something that is difficult to explain if a professional craftsman were put in charge of making them. Fourth, in a document of 1475, discussed below, Mantegna is indeed said to have been looking for a professional engraver to help him, but stylistic and other evidence suggests that by that date he had made most of his prints, and had presumably grown tired of the difficulties of printmaking. The document confirms that prints had been produced in Mantua before that date, yet no mention is made of any other printmaker whose task the writer, himself a professional engraver, was meant to take over. Fifth, a letter written by Gerolamo Casio six weeks after Mantegna's death mentions that he had engraved a plate of '*il Christo*': is it credible that a Mantuan contemporary, an admirer of the artist, a man close enough to the Gonzaga court to give advice on artistic matters to Isabella d'Este, would get his facts wrong?

Mantegna did not make many prints, and those he did make were probably all produced in a comparatively short space of time, from the mid-1460s to the early 1470s. The size and complexity of what seems to be Mantegna's first print, the *Entombment with Four Birds* (cat. 29), dating from *c.* 1465, is evidence that he was interested in prints chiefly as a new vehicle of artistic impression rather than for any decorative or reproductive purposes. The large scale of his

fig. 19 Here attributed to Andrea Mantegna, *Entombment*, bronze relief,
parcel gilt, the figures artificially patinated brown,
24.4 x 44.9 cm, *c.* 1470–80, Kunsthistorisches Museum, Vienna

fig. 20 Donatello, *Lamentation*, bronze relief,
33.5 x 41.5 cm, *c.* 1458–9, Victoria and Albert Museum, London

me to compassion that he should be so badly treated and I told him that I would remake the said engraved plates for him and I worked for him for about four months. When that devil Andrea Mantegna learnt that I was remaking the said plates he sent to threaten me by means of a Florentine, swearing he would pay me for it. And in addition to this, Zoan Andrea and I were assaulted one evening by the nephew of Carlo de Moltone and over ten armed men so as to kill us, and I can give proof of this. And again Andrea Mantegna to prevent the said work from continuing has found certain knaves who to serve him have accused me of sodomy to the *Maleficio*. ... Being a stranger perforce I had to flee and at present I am in Verona so as to finish the said plates'.[4]

The letter has been interpreted in several ways. Lightbown came to the conclusion that Simone was making copies of engravings by Zoan Andrea, but this is unlikely since there is no evidence that Zoan Andrea ever engraved[5] and second, it seems unlikely that Mantegna would have become '*idemoniato*' with rage had the prints being copied not been his own. Simone wrote in the letter that he had agreed to engrave copies of the plates that had been stolen from Zoan Andrea out of pity for his friend, implying that Zoan possessed some plates. In the circumstances, these could only have been Mantegna's plates: after all, would Mantegna have threatened Simone and Zoan so violently had he only wanted to prevent other prints being made in Mantua? As Zoan was no engraver – otherwise he would not have asked Simone to do the work – in what way was he involved in Mantegna's prints? Was he keeping the plates on behalf of Mantegna? Zoan had been summarily dismissed by the Marchese in 1471, who immediately informed Mantegna of his action,[6] and there was obviously great acrimony between the two painters: it is thus extremely unlikely that Zoan was holding the plates on behalf of Mantegna. How, then, had he got hold of them? Conceivably Zoan had stolen them from Mantegna, and that may have been the reason for his dismissal a few years earlier. It seems possible that Zoan Andrea hatched a plot to copy Mantegna's prints with the help of Simone in revenge for his dismissal in 1471, when he may have been forced to return the plates to Mantegna. Since the document refers to *stampe* (plates or prints) in the plural, it follows that there were at least two plates, which could mean as many as four prints, since all the prints Mantegna had engraved by that date had used both sides of each plate, and Simone might have done the same. That more than one print was involved is also confirmed by the fact that Simone stated in the letter that he had been working on the plates for four months when the attack occurred, and that he was still working on them in Verona, whence he was writing (for an alternative

interpretation of the letter see p. 58). We do not know what Simone's copies looked like. Suzanne Boorsch and I have given what we believe are convincing attributions for most known contemporary copies of Mantegna's prints, which leaves none to be attributed to Simone. However, it still happens that unknown 15th-century prints turn up (see cat. 80), and one by Simone may surface in the future.

Whether the unfortunate episode with Simone convinced Mantegna that prints were too much trouble, or whether – as is more likely – he tired of them, cannot be established, but it appears that for a number of years he did not make prints at all. He seems to have returned to practising the medium himself sometime in the 1480s, when he produced the magnificent *Virgin and Child* (cat. 48), his greatest achievement in printmaking, in which his aspiration to surpass the chiaroscuro effects of Donatello's *rilievo schiacciato* technique were finally fulfilled. In this technical *tour de force*, the combination of the use of burin and drypoint was handled with such absolute mastery that it resulted in the greatest range of tone ever attained by Mantegna or any artist before him. This print created a sort of yardstick as to what his monochrome works in all media should look like thereafter: Mantegna here added to the richness of chiaroscuro a fully mastered subtlety of tonality, so that the Dublin *Judith and Holofernes* (cat. 129), for instance, would have been inconceivable before this print, as would most of the coloured drawings of the 1490s, and the late paintings in grisaille.

As is to be expected, the prints based on Mantegna's designs produced at the end of the master's life are also formally dependent on the print of the *Virgin and Child*. Probably in the 1490s, when he was in his sixties, Mantegna revived his interest in printmaking, but did not, this time, take up the burin himself: rather, he employed the services of a collaborator. Although in this catalogue the prints in question are divided between two hands, Giovanni Antonio da Brescia and the person we have baptised the 'Premier Engraver', I believe that the latter was probably one and the same as Giovanni Antonio. He had probably joined the master's workshop in the 1490s and had started by making copies of Mantegna's prints of twenty years before. In time, he acquired sufficient skill to engrave plates after finished designs by Mantegna, but under the strict and attentive supervision of the master. There is great variety of quality among the prints attributed to the Premier Engraver, from the rather clumsy *Silenus with a Group of Children* (cat. 84) to the immensely proficient *Hercules and Antaeus* (cat. 93): they reveal the development of a craftsman who used his tools with increasing mastery in his efforts to imitate the 'greyness' of Mantegna's *Virgin and Child* (cat. 48). The Premier Engraver

did not, however, use both a burin and a drypoint: his burin was thin, and this allowed him to produce tone without over-emphasising the richness of the chiaroscuro. All the prints by this engraver are 'greyer' than Mantegna's own prints, and thus very similar to his paintings of the time. This is the case even when the figures are set against a very dark background, a solution that Mantegna was experimenting with in his grisailles at the time. The use of the burin alone was also undoubtedly dictated by Mantegna's wish to pull more impressions from the plates than he was able to do from those he had engraved himself: the experimental nature of his printmaking and the fact that he made so much use of the drypoint suggest that Mantegna was not initially interested in producing prints as multiple images, but was excited by the formal solutions afforded by the medium.

When Mantegna started employing a professional engraver in the 1490s it must have been because by then prints had become a common sight in Italy, were normally treated as a means for replicating images, and thus offered him the chance to earn money and at the same time spread the knowledge of his *invenzioni*. When Giovanni Antonio left the workshop, or Mantua, he found himself with the skills of an accomplished printmaker, but with nothing to show for it, since all the plates remained the property of Mantegna. He had no master to work for, no guidance and no designs. He probably went to Milan, to work for Leonardo, whom he could have met in 1499 (see cat. 2), in the hope of starting with him a collaborative relationship of the kind he had had with Mantegna. Probably before going there Giovanni had copied Mantegna's entire print *œuvre*, including the early works engraved by the master and the later ones that he himself had engraved but whose plates were left in Mantua. This scenario would, in my view, make sense of the striking technical similarity between, say, the two versions of the *Dancing Muses* (cats. 138, 139), here attributed to the Premier Engraver and Giovanni Antonio da Brescia respectively; it would also make sense of the extraordinary jump in quality between the earliest prints we attribute here to Giovanni Antonio – crude copies of Mantegna's own prints (cat. 77) – and his later work, such as the *Virtus Combusta* (cat. 148), a technically masterful work. Suzanne Boorsch has arrived at strikingly different conclusions (see pp. 63-4), but we agree that Zoan Andrea was not an engraver in Mantegna's workshop: the initials ZA found on some of the prints are, in fact, those of Giovanni Antonio da Brescia spelt Zohanne Antonio (see pp. 57-60).

The survival of only a handful of early impressions of prints by Mantegna suggests that this obsessively punctilious artist must have felt that, even if they were far from perfect, they were worth preserving as the best he could make at

the time. The hypothesis that the prints that have survived have done so by chance, and that all the good impressions have been lost, seems extremely improbable: Mantegna died, immensely famous, at a time when print collecting was becoming fashionable, particularly in northern Italy, and it is inconceivable that his best impressions would not have been sought after at that time. The rarity of prints by Mantegna during his lifetime is also suggested by two other facts. First, many of the images are unfinished, and it seems to me totally removed from the mentality of the artist that he would have wished them to circulate in such a state. Second, there are a number of contemporary drawings that copy some of the prints very carefully, often line by line. Admittedly, faithfully copying works by an established master was part of the learning process in most artists' workshops; but in this case, many of the drawings are of very high quality, obviously by accomplished artists, so much so that they have often been taken to be Mantegna's preparatory drawings for the prints. Two drawings by Albrecht Dürer (Albertina, Vienna), dated 1494, faithfully copy two of Mantegna's prints (the right half of the *Battle of the Sea Gods* and the *Bacchanal with Silenus*), and were made during Dürer's first trip to Italy. They suggest that Mantegna's engravings were not readily available, for why should the German artist have not simply bought an impression of each subject, instead of spending a considerable amount of time painstakingly copying them? Certainly copying Mantegna's prints was the highest form of compliment the young artist could pay to the old master, the greatest printmaker of the 16th century acknowledging his debt to the greatest printmaker of the previous century.

NOTES

1. Quoted in Brown, 1974.
2. Cennini, ed. 1960, chapters XXIII to XXVI.
3. Leithe-Jasper, in Washington, Los Angeles and Chicago, 1986, pp. 61-4
4. Lightbown, 1986, pp. 234-6.
5. Lightbown, 1986, p. 236, convincingly proposed that Zoan Andrea can be identified with the Zohanne Andrea, son of the late Maestro Billano de' Bugatti,

described as 'our beloved citizen and painter' by Ludovico Gonzaga on 29 March 1469. See Luzio, 1913, p. 22, n.3. He further proposed that Zoan could have been related to Zanetto Bugatto, court painter to the Sforza family in Milan, who was at Gonzaga in August 1471 and was proposing to visit Mantua to see Mantegna's works; Kristeller, 1902, doc. 44.
6. Lightbown, 1986, p. 236; Luzio, 1913, p. 22, n.3.

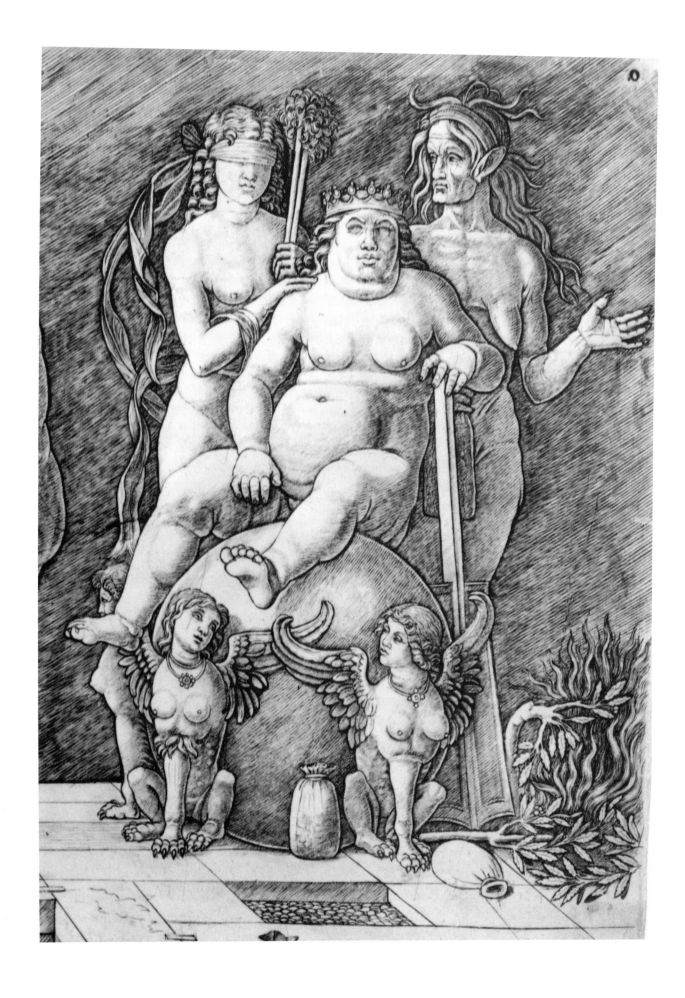

MANTEGNA AND HIS PRINTMAKERS

SUZANNE BOORSCH

All the engravings in this exhibition are based on designs by Andrea Mantegna. In preparing the exhibition, one aim was to elucidate as far as possible the circumstances under which Mantegna's designs were transformed into prints, and the identity of the printmakers who did this work. The first systematic catalogue of prints listed by printmaker was compiled by Bartsch; in his volume on early Italian engravers (1811) he gave 23 prints to Mantegna.[1] In 1864 Passavant added one,[2] and in 1886 Portheim reduced the number to fourteen, although his article has been little noticed.[3] Kristeller (1901, 1902) drastically reduced this list, attributing only seven prints to Mantegna.[4] Since then these seven engravings have been generally accepted as autograph works by Mantegna, and the other associated works, with the exception of a handful – most of which are monogrammed – have been classed as 'School of Mantegna'.

This phrase conjures up a vision of a number of disciples engraving plates under the supervision of a master teacher. Even if such a vision can be dismissed as too literal, the underlying assumption is that several engravers worked in Mantua producing engravings after Mantegna's designs, and that this activity was to a greater or lesser degree presided over by Mantegna.

Two recent publications reflect this view. In the catalogue of early Italian engravings exhibited in Washington in 1973, Levenson, Oberhuber and Sheehan stated: 'To explain the variety in the style and character of these prints one must consider several factors: they are the work of different hands ... executed over a period of about forty years ... the engravers' technique, as well as Mantegna's own, underwent considerable development; and, finally, they follow designs supplied by the master that date from different stages of his career, which are not always identical with the date of production of the engravings'.[5] The same authors also wrote, 'the drawings which Mantegna provided for the printmakers as models had some influence on the ... engraving style of the school'.[6]

Mark Zucker, in his *Commentary* on the *Illustrated Bartsch,* confronted the issue of the 'School' directly. After noting that 'the phenomenon of a "School" is unprecedented in early Italian engraving', he continued: 'Apparently, there were a group of craftsmen, most of whom will always remain anonymous, whose chief occupation was to reproduce Mantegna's inventions as faithfully as

fig. 21 Giovanni Antonio da Brescia, *Allegory of the Fall and Rescue of Ignorant Humanity (Virtus Combusta, Virtus Deserta)*, detail, (cat. 148)

possible and to counterfeit his technique insofar as they were capable of doing so. There can hardly be much doubt that some, at least, of these artisans were carefully trained by the master, with whom they would have been associated in a business-like arrangement.'[7] After careful study of the group of prints reproducing Mantegna's designs, however, the evidence that emerges suggests that the truth, in fact, was far simpler.

To a considerable extent, we think we have been successful in assigning what at first seemed a bewildering array of 'School' prints to just a few hands. We have proposed that two artists previously only peripherally connected with Mantegna's prints may have made some of them: Giulio Campagnola (see cats. 83, 118, 123), and the so-called Master of 1515 (see cats. 31, 78, 80, 88, 92). We have been able to attribute a much larger group – sixteen unmonogrammed prints – to Giovanni Antonio da Brescia, one of the engravers traditionally associated with the 'School'. As far as Giovanni Antonio is concerned, however, our major discovery is more surprising, and it is this new information that has helped to simplify the grouping of the rest of the prints. This discovery, in turn, has raised other important questions, including, ultimately, the question of whether Andrea Mantegna actually engraved plates himself. But first, Giovanni Antonio.

In 1819, Jean Duchesne, of the Bibliothèque Nationale, Paris, wrote about Giovanni Antonio da Brescia: 'The works of this master are rare; it is nonetheless very probable that we should also attribute to him those marked A.Z. [*sic*; corrected to Z.A. in subsequent editions] and that Zoan Andrea of Venice is none other than Giovanni Antonio of Brescia'.[8] In later editions of the same work, up until 1855, he reiterated this belief, promising to 'clarify this fact' elsewhere.[9]

Duchesne never wrote his fuller discussion. In 1860, J.D. Passavant wrote ' … but we cannot agree with Duchesne, who thinks that Zoan Andrea and Giovanni Antonio da Brescia are one and the same person, and who, in the collection in Paris, has as a result united the *œuvres* of these two artists.'[10] Presumably Achille Deveria, head of the Cabinet des Estampes from 1855 to 1857, or his successor Henri Delaborde, from 1858 to 1899, separated the prints again.[11] By 1875 Delaborde could write, 'The prints of Antonio da Brescia are fairly generally confused with those of his contemporary Zoan Andrea, although the inequality of talent between the two artists is perceptible … '.[12]

From then on Duchesne's opinion seems to have been forgotten, or thought unworthy of mention. A.M. Hind, the colossus of print cataloguers of the 20th century, does not refer to it in his 1910 catalogue of the early Italian engravings in the British Museum, nor in his monumental *Early Italian*

Engraving of 1938-48. Thus, it is not surprising that the thesis that Giovanni Antonio da Brescia and Zoan Andrea are one and the same person disappeared from view.

We are reviving the idea, more than 170 years after its first publication, because, even before we became aware of Duchesne's view, we had reached the same conclusion. We believe that our evidence is decisive, and proves that Duchesne was right: the engraver who monogrammed twenty plates with the initials 'ZA' was the same person who later monogrammed his plates 'IO. AN. BX.' – standing for 'Ioannis Antonius Brixianus', the Latinate form of 'Giovanni Antonio da Brescia'. The letters 'ZA' do not stand for 'Zoan Andrea' but for 'Zoan (Zoanni, Zovanni) Antonio' (the pronunciation of the soft 'G' as 'Z' being the norm in Venice and elsewhere in northern Italy).

It was Pietro Zani who made the first error. In 1802 he asserted that the monogram 'ZA' stood for 'Zoan Andrea', identifying the engraver who used this monogram with a Venetian woodcutter who used the initials 'i.a.', although he gave no evidence to support the theory.[13] In 1811[14] Bartsch accepted Zani's identification, and Passavant concurred, stating his disagreement with Duchesne, and giving 'Zoan Andrea Vavassori' and Giovanni Antonio da Brescia each his own section.[15] Then, in 1876, a letter of 1475 from Simone di Ardizone of Reggio Emilia to Ludovico Gonzaga was first published (see also pp. 48-51).[16] Simone, who described himself as a 'painter and engraver', wrote that when he had first come to Mantua, Mantegna had made him 'offers'. Most scholars have assumed that Mantegna wanted to hire him to engrave Mantegna's own designs, and this seems probable. Simone, instead, chose to help an old friend, a painter named Zoan Andrea, to remake some plates (or prints) that had been stolen, together with drawings and medals, and he wrote that he worked with him for four months. According to Simone, when Mantegna learnt of this activity, he hired some ruffians who assaulted Simone and Zoan Andrea and left them for dead in the street.

Because Mantegna was so furious – Simone called him *'idemoniato'*, 'possessed' – it has been conjectured that the prints must have had something to do with him. But no known print of a Mantegna design can be attributed to Simone, so Mantegna's fury would seem not to have had to do with the prints themselves, but with the fact that Simone, without his knowledge, had been working for Zoan Andrea. Simone complained of Mantegna's 'pride and dominion over Mantua', although as court artist to the Gonzaga Mantegna was supposed to be in charge of all artistic matters in Mantuan territory. It was surely the effrontery of Simone defying Mantegna's 'dominion' and deciding to work for the hated Zoan Andrea that had put him in such a rage.[17]

Because Zoan Andrea apparently owned engraved plates, it has been assumed that he was an engraver. The letter, however, clearly described him only as a painter, and Simone used the first person singular, not the first person plural, when he wrote of remaking the engravings. Nonetheless, it was probably inevitable that scholars would assume that this Zoan Andrea could be none other than the engraver who used the monogram 'ZA', who had already been given this name by Zani.

This double error – that 'ZA' stood for Zoan Andrea, and that the painter Zoan Andrea of Mantua was this engraver – has persisted, despite the efforts of some scholars to dispel it. Donati (1959) argued that the engraver who used the monogram 'ZA' could not be the Zoan Andrea who was in Mantua in the 1470s; additionally, he proposed, on stylistic grounds, that the person in question did not begin engraving until the second decade of the 16th century.[18] Mezzetti (Mantua, 1961), followed Donati and affirmed that the Zoan Andrea in Mantua 'was solely a painter'.[19] But the compilers of the Washington catalogue of 1973 rejected Donati's argument,[20] as, more recently, did Zucker.[21] Lightbown, to his credit, wrote that the identification of the painter with the engraver 'must be strongly open to doubt'.[22]

Duchesne, presumably, arrived at his opinion on stylistic grounds, and it was the stylistic similarities between the prints monogrammed 'ZA' and those monogrammed 'IO. AN. BX.', together with the list of unsigned prints we attributed to Giovanni Antonio (a list that kept growing longer), that became increasingly evident during our researches. We were prompted to investigate if there was any reason why 'ZA' could not simply have been an alternative monogram used by Giovanni Antonio.

First we examined the twenty plates monogrammed 'ZA'. One reproduces a composition by Mantegna (cat. 144), five are copies of prints by Dürer and most of the rest are ornament panels (including the only monogrammed print with a date: 1505). Next, we studied the watermarks we had gathered and those Hind recorded for prints attributed to Zoan Andrea. There were an Orb and Cross, a High Crown, an Ox Head with Serpent and Cross and a Cardinal's Hat; all of these had been found on prints by Giovanni Antonio da Brescia (see Appendix II). Finally, we re-examined an impression of Giovanni Antonio's *Venus* (Hind, V, 41.14), a print monogrammed *IO. AN. BX.*, about which Hind had noted, 'There are traces of earlier work on the plate imperfectly erased, e.g. sandalled feet like the S. Joseph in No. 4, to the r. of the signature'. Reusing copper plates was probably more common in early Italian engraving than is realised: copper was expensive; for the same reason, it was normal for an engraver to use both sides of the same plate (see Appendix I).[23]

fig. 22 Giovanni Antonio da Brescia, *Judith with the Head of Holofernes*, engraving, detail, H.ZA.5, *c.* 1506-7, Graphische Sammlung Albertina, Vienna (cat. 144)

fig. 23 Giovanni Antonio da Brescia, *Venus, After the Antique*, engraving, 309 x 224 mm, detail showing Judith's feet partially erased, H. 41.14, British Museum, London

It had proved impossible to identify the partially erased feet in Giovanni Antonio's *Venus* (fig. 23) in any of his signed or attributed prints, but among the works of 'Zoan Andrea' they were easily found: they were those of Judith (fig. 22), in the only print after Mantegna monogrammed 'ZA' (cat. 144).

It seems surprising that Hind did not come to this conclusion himself: time and again he wrote statements such as, 'From the style of the engraving there is little to choose between an attribution to G.A. da Brescia or to Zoan Andrea' (*Portrait of Pope Leo X*, Hind, V, 41.15); or 'Not signed, but very probably by Zoan Andrea, in his Mantegnesque technique. Kristeller's attribution to G.A. da Brescia is less likely ...' (*Head of a Woman*, Hind, V, 66.14). But as long as 'ZA' was firmly established in his mind as Zoan Andrea, he could not entertain the idea that the initials could stand for Zoan Antonio. Even Kristeller, while he never doubted that two personalities existed, wrote in his article on Giovanni Antonio in Thieme–Becker (1921): 'Also [Giovanni Antonio's] relationship to Zoan Andrea ... needs to be clarified'.[24]

Most of Giovanni Antonio's surviving engravings made after Mantegna's designs were copied from other prints rather than from drawings (see chart, p. 65). Bartsch and Hind had to a great extent realised this, without making it explicit, and Sheehan, in the Washington catalogue, stated clearly, 'Most of his Mantegnesque engravings appear to copy other prints by the master and the school ... '.[25] Of the nineteen exhibited engravings monogrammed by or here attributed to Giovanni Antonio, only six do not copy a known print (and for at least two of these, cats. 117 and 97, an earlier print probably once existed).[26]

Giovanni Antonio da Brescia was a prolific engraver who made at least 130 other prints besides the Mantegnesque ones.[27] Yet, his life is undocumented; the only evidence comes from the prints themselves. Some prints are dated or datable from historical circumstances: the earliest date, 1505, is found on the print of an *Ornament Panel* (Hind, V, 69.26) monogrammed 'ZA', whereas the *Portrait of the Emperor Charles V* (under Leonardo da Vinci, Hind, V, 92.16) can have been made no earlier than 1519, when Charles was elected Holy Roman Emperor. Giovanni Antonio appears to have abandoned the 'ZA' monogram between 1505 and 1507, the date on his copy of Dürer's *Satyr Family* (Hind, V, 49.40), which is monogrammed *IO. AN. BX..* Presumably between these two dates he engraved the *Ornament Panels, Upright, in the Form of Pilasters* (Hind, V, 69.25A, B), which he monogrammed *IA* in the first state but *ZA* in the second (the other pilaster on this same plate is a copy of the one that appears at the side of *The Corselet Bearers*, cat. 121; see also cat. 120). For this reason the three Mantegnesque prints signed in the Latinate form – the three Hercules subjects (cats. 87, 94, 97) – are here dated '1507 or later'.

After 1507 the following engravings are dated, or can be dated within limits: *The Flagellation* (Hind, V, 40.13), signed *IO. ANTON. BRIXIANU*, dated 1509; the *Prognosticatio 1510* (anonymous, Hind, V, 296.15), presumably made in or just before that year,[28] which appears incompletely erased under the signed *Virgin and Child* (Hind, V, 38.6); the *Portrait of Leo X* (as Giovanni Antonio, Hind, V, 41.15), between 1513 and 1521; the *Portrait of Francis I*, 1515 or later;[29] the signed copy of Marcantonio Raimondi's *Illustrations to the Aeneid* (Hind, V, 48.33-6), dated 1516;[30] and the *Portrait of the Emperor Charles V* (see above).

For the unsigned prints the dating is more difficult. As a working hypothesis it is assumed that these all predate Mantegna's death in 1506, after which Giovanni Antonio presumably felt he could sign Mantegna's images with impunity, as he did the *Judith* (monogrammed 'ZA', cat. 144), and the three Hercules subjects. Thus, the unsigned images are here dated in or before 1506. There is no hard evidence for the earliest date for these prints, but if Giovanni Antonio's copy of the *Four Dancing Muses* (cat. 139) – which cannot be earlier than 1496, the date the *Parnassus* was painted – was earlier engraved on the same plate as the *Virtus Deserta* (cat. 148), making the former a comparatively early work, then the last years of the Quattrocento would probably have been the first years of his activity.

If Giovanni Antonio's work based on Mantegna's designs consists primarily of copies of other prints, the traditional assumption that he worked in Mantua in close association with Mantegna comes into question. It seems unlikely that Giovanni Antonio would have made his copies of Mantegna's images in Mantua, especially if, as seems probable, the plates of the earlier prints that he copied remained there at least until Mantegna's death (see Appendices I, II); to copy prints that could be pulled from extant plates would have been redundant. It is possible that Giovanni Antonio could have made a few early copies of these extraordinary images and then gone to Mantua, around the turn of the 16th century. It is clearly visible that his somewhat crude reversed copy of the *Bacchanal with a Wine Vat* (cat. 77) was engraved, earlier, on the same plate as the very accomplished *Virtus Combusta* (cat. 148); the above scenario might account for this. But is is equally possible that he did not go to Mantua at all; the question cannot be resolved with the information at hand.

Once it was established that there was no engraver named Zoan Andrea, and that the prints listed under this name were the work of Giovanni Antonio da Brescia, the prints reproducing Mantegna's designs, the so-called 'School' prints, began to fall into distinct groups. As mentioned above, a few of the prints are here ascribed to two other printmakers. Two prints that are engraved on reverse sides of the same plate, and possibly a third image (cats. 118, 123, 83)

are tentatively attributed to the fifteen-year-old Giulio Campagnola, who probably spent at least part of the year 1497 or 1498 in Mantua. Campagnola (*c*.1482 – *c*.1515-18), born in Padua, was the son of Mantegna's friend the lawyer Girolamo Campagnola, who in 1497 was eager to procure for his son a position at the court of Marchese Francesco Gonzaga; it is usually assumed he succeeded. Pomponius Gauricus wrote that Giulio 'imitated' Mantegna's *Triumphs* (see cat. 118) and *Pallas Expelling the Vices* (see cat. 136);[31] the figure in his signed print *St John the Baptist* (Hind, V, 201.12) derives from a lost Mantegna drawing. Later Giulio worked for the Este family in Ferrara and Venice; he was last mentioned in the will of the great printer Aldus Manutius in January 1515. Seven signed engravings by him survive, and Hind assigned 22 prints to him in all.[32] His later style was distinctly Giorgionesque, often showing contemplative figures in landscape settings. Thus, Campagnola could be described as an engraver of the Mantegna 'School' only briefly, at the very start of his career.

Five other prints would seem almost certainly to have been made by the so-called Master of 1515 (cats. 31, 78, 80, 88, 92). This engraver, who made about 40 prints, is as yet unidentified; the name comes from the date on an engraving of *Cleopatra* (Hind, V, 283.1).[33] Various attempts have been made to identify this unusual printmaker, who some have thought originated in northern Europe (see cat. 31). His Mantegnesque images are mostly third-hand versions of the compositions – that is, they are copies of the prints by Giovanni Antonio, which are already copies themselves. They were certainly made after Mantegna's death, probably by a young engraver learning by copying earlier prints; as such they cannot really be called engravings of the Mantegna 'School'.

When the prints by Giovanni Antonio were set aside, together with the few given to the two engravers just mentioned, a new group emerged. It was fairly large, relatively coherent, and higher in quality than those by Giovanni Antonio. In fact, when the prints by Giovanni Antonio were put into one list, many of the others could immediately be perceived to be the engravings from which he worked (see chart, p. 65). Nine of these prints were the better version of pairs of engravings of the same composition: the *Entombment with Four Birds* (cat. 29), the *Descent into Limbo* (cat. 67), the *Flagellation with a Pavement* (cat. 36), the *Silenus and Children* (cat. 84), two of the scenes from the *Triumphs of Caesar*: *The Corselet Bearers* and *The Senators* (cats. 120, 126), the *Four Dancing Muses* (cat. 138) and two of the *Hercules and Antaeus* compositions (cats. 86, 93). Of the latter two compositions, the weaker prints bear the monogram of Giovanni Antonio, and it seems evident that of the other seven pairs, the more timid, mechanical version is also by him.

The new group comprised the nine better versions together with a few prints for which no copy by Giovanni Antonio is known. It was these prints that were in search of an author. In recent years some have been given to Zoan Andrea.[34] If Zoan Andrea cannot have made them, since he was not an engraver, who did?

Bartsch, as mentioned above, had catalogued 23 prints as the work of Mantegna. Three of these – all portraits – are certainly by Giovanni Antonio (see cat. 2 for one of these, which seems to be a portrait not by, but of, Mantegna); and two are here attributed to Campagnola (cats. 118, 123). Of the remaining eighteen prints, only seven were accepted by Kristeller as Mantegna's. Thus, from Bartsch's list, the group requiring an attribution – assuming one followed Kristeller's view – consisted of the remaining eleven prints of his catalogue (with the difference that we believe the vertical *Entombment* with four birds to be the original, and the one with three birds to be Giovanni Antonio's copy), plus one that Bartsch ascribed to Zoan Andrea (cat. 138), two that he listed as anonymous copies of prints by Giovanni Antonio (cats. 86, 141) but one of which, on the contrary, is certainly the original that Giovanni Antonio copied, and two more that were unknown to him (cats. 57, 84). These appear in the left-hand column of the chart, from the *Flagellation with a Pavement* down.

This then, is the group of 'School' prints that was re-examined, with the hope that certain questions could be answered. First, did they all seem to be by the same engraver, or should they be further subdivided? Next, was Kristeller correct in severing seven prints from Bartsch's much longer list, or would the evidence indicate yet a different division?

David Landau and I answered these questions in divergent ways. We are both convinced that Kristeller's grouping was too restricted: David Landau added four prints from the newly constituted 'School' group to the seven selected by Kristeller. He thus would attribute eleven prints to Mantegna (the first eleven in the left-hand column in the chart); the rest he would leave as 'School' prints, the work of one engraver, all post-dating the mid–1480s, when, in his opinion, Mantegna made his last print (cat. 48).

Study of this group of prints has convinced me that to add only four to Kristeller's list does not go far enough. I see a continuity of style among all these prints, and I would add to Kristeller's list of seven not just four but the entire group of 'School' prints discussed above. In other words, I would essentially restore as the work of a single engraver Bartsch's catalogue of 23 prints (with the five deletions, five additions, and one switch detailed above); the group I see as the work of a single hand corresponds to the entire list in the

left-hand column in the chart. But, having done this, I would make a more fundamental break with received opinion, or rather, a break of a different kind. Once this list numbered, in my view, not just seven, or even eleven, but more than twenty prints, I began to question the traditional assumption that the time-consuming work of engraving the plates had been done by Mantegna.

In 1938 Hind wrote, 'with few exceptions, of which Antonio Pollaiuolo and Andrea Mantegna are the most notable, the early Italian engravers are artists of secondary importance, craftsmen who never had the same status which was held by the painters, sculptors and architects, in the society of the time'.[35] Zucker also noted that 'Except for Pollaiuolo, whose single plate is clearly a special case, Mantegna is the only Italian master of the first rank ever to have practised engraving'.[36] I see no reason to maintain that Mantegna was such an exception in this regard, and I have concluded that it is extremely unlikely that these engravings were made by him. In my opinion all the engravings in the left-hand column in the chart were made by one engraver, who would have been a professional specifically hired for this purpose by Mantegna, no earlier than the 1480s and very possibly beginning as late as 1490 after Mantegna's return from Rome, and who would have worked from drawings made at various moments in the artist's career.[37]

In this catalogue, we have left the name of Mantegna attached to Kristeller's seven engravings and have designated the four that David Landau would add to this list as 'Attributed to Mantegna'. For the others, we have used the Pirandellian name of 'Premier Engraver'. Whether in fact Mantegna and one other engraver made these prints, or whether the 'Premier Engraver' made all of them, the assumption that Mantegna worked with a 'School' of printmakers clearly must be revised. What cannot be doubted is that these prints, translating as they do Mantegna's incisive drawing style into the intractable medium of the copper plate, are the climax of 15th-century Italian printmaking and fully merit the admiration they have elicited over the centuries.

ATTRIBUTIONS OF BARTSCH, KRISTELLER AND HIND
Listed in order of Hind's catalogue (prints attributed to Campagnola and
the Master of 1515 are not included)

Cat.	Title	Bartsch	Kr	Hind	Copy by GAB	Bartsch	Hind
48	*Virgin and Child*	AM 8	AM	AM 1	none		
38	*Entombment*	AM 3	AM	AM 2	cat. 40	ZA 3	S 2a
75	*Bacchanal with Silenus*	AM 20	AM	AM 3	cat. 76	AM 20 copy	S 3a
74	*Bacchanal with Wine Vat*	AM 19	AM	AM 4	cat. 77	unknown	S 4b
80	*Sea Gods*, left	AM 18	AM	AM 5	none		
79	*Sea Gods*, right	AM 17	AM	AM 6	none		
45	*Risen Christ*	AM 6	AM	AM 7	cat. 47	GAB 3	S 7a
36	*Flagellation with Pavement*	AM 1		S 8	*Flagellation with a Landscape* (cat. 37)	AM 1 copy	S 8a
67	*Descent into Limbo*	AM 5		S 9	68	unknown	S 9a
32	*Deposition*	AM 4		S 10	none		
29	*Entombment with Four Birds*	AM 2 copy		S 11b	*Entombment with Three Birds* (cat. 30)	AM 2	S 11
21	*Virgin and Child in Grotto*	AM 9		S 13	none		
120	*Corselet Bearers*	AM 14		S 15b	cat. 121	GAB 9	S 15a
126	*Senators*	AM 11		S 16	cat. 127	GAB 7	S 16a
93	*Hercules and Antaeus*	AM 16		S 17	cat. 94	<u>GAB</u> 14	<u>GAB</u> 1
138	*Four Dancing Muses*	ZA 18		S 21	cat. 139	GAB 20	S 21a
59	*St Sebastian*	AM 10		S 23	none		
84	*Silenus with Children*	unknown		S 24a	cat. 85	GAB 17	S 24
58	*Man of Sorrows*	AM 7		S 26	none		
	Faun and Snake	AM 15		S 27	none		
86	*Hercules and Antaeus*	GAB 13 copy 2		GAB 3a	cat. 87	<u>GAB</u> 13	<u>GAB</u> 3
57	*Two Peasants*	unknown		GAB 12	none		
141	*Judith and Holofernes*	ZA 1 copy		ZA 5a	none		

AM Andrea Manregna
GAB Giovanni Antonio da Brescia
<u>GAB</u> monogrammed by Giovanni Antonio da Brescia
Kr Kristeller
S School of Mantegna
ZA Zoan Andrea

NOTES

1. The 21 volumes of Bartsch's catalogue were originally published between 1803 and 1821. The early Italian engravers are in Vol. XIII; Mantegna's prints are catalogued on pp. 222-43.

2. Passavant, 1864, V, p. 78, no. 24, *Two Peasants* (our cat. 50).

3. Portheim, 1886, pp. 220-23.

4. Kristeller, 1901, p. 386.

5. Washington, 1973, p. 197.

6. *Ibid*, 1973, p. 198.

7. Zucker, 1984, p. 77.

8. Duchesne, 1819, p. 49.

9. Duchesne, 2nd ed., 1823, pp. 10-11; 3rd ed., 1837, p. 18; and, in effect, a 4th ed., published posthumously with the title *Description des estampes exposées…*, 1855, pp. 19-20.

10. Passavant, 1860, I, p. 243.

11. See Delaborde, 1875, p. 187, for a list of the conservators from 1720 to 1858.

12. Delaborde, 1875, p. 202.

13. Zani, 1802, p. 110, n. 20.

14. Bartsch, 1811, p. 293.

15. Passavant, 1864, V, pp. 79-88; 103-12. On p. 80 he cites Duchesne, *Notice des estampes exposées…*, p. 61, with no year; it has not been possible to locate an edition where Duchesne's opinion is given on this page.

16. Brun, 1876, pp. 54-6. In Kristeller, 1902, p. 530, doc. 55, and Hind, 1948, V, pp. 5-6, n. 2.

17. If Simone spent four months remaking engravings for his friend Zoan Andrea, and they were not Mantegna's prints, what were they? The only series of prints of the appropriate date and locality that exists in two versions, one a copy of the other, are the so-called '*Tarocchi*', a set of fifty prints with the proportions of playing cards (although considerably larger, about 180 x 100 mm), which were once called the '*Tarocchi* of Mantegna' (Hind, 1938, I, pp. 221-40; Levenson in Washington, 1973, pp. 81-157). The earlier set is called the 'E series', the copies the 'S series', because in the originals the letter 'A' to 'E' identify five groups within the series, while in the copies, although the other letters remain the same, the 'E' has unaccountably been changed to an 'S'. The existence of this series in originals and copies has puzzled print cataloguers; perhaps the explanation, and attribution of the 's series', has been in this letter of 1475 all along. The suggestion that the 's series' Tarocchi might be the copies Simone Ardizone made for Zoan Andrea is at this point highly conjectural, but it will be further investigated by the present writer in the near future.

18. Donati, 1959.

19. Mantua, 1961, p. 210.

20. Washington, 1973, p. 266.

21. Zucker, 1984, pp. 255, 257, n. 5.

22. Lightbown, 1986, p. 236.

23. A plate engraved on both sides, by Cristofano Robetta, is preserved in the British Museum (Hind, 1938, I, p. 198); another, by an anonymous engraver, is in Washington (Washington, 1973, p. 526).

24. Kristeller, 1921, p. 104.

25. Washington, 1973, p. 235.

26. Of these nineteen prints, fifteen are unsigned. Bartsch attributed ten of these (plus two incorrectly) either to Giovanni Antonio or Zoan Andrea: to Giovanni Antonio he gave Hind's Mantegna School 7a, 11b (incorrectly; it should be 11), 14a, 15a, 16a, 20 (incorrectly), 21a and 24 and Hind's Giovanni Antonio da Brescia 4 (our cats. 29, 47, 83, 85, 117, 121, 127, 139); he gave to Zoan Andrea Hind's 2a and 22 and Hind's no. 3 of Zoan Andrea (cats. 40, 148, 153); of the others, he left two anonymous (cats. 29, 86) and two were unknown to him (cats. 57, 84). Hind concurred with Bartsch's attributions for his no. 22 as Zoan Andrea (cat. 148) and the two prints he listed under the two engravers' names (cats. 40, 153) but merely mentioned Bartsch's attribution for the others. Washington, 1973 (pp. 198, n. 5, and 235, n. 2) listed Hind's 8a, 9a, 11, 14a, 15a, 16a, 21a, and 24a (incorrectly; it should be 24), and Hind's Giovanni Antonio 4 as by Giovanni Antonio (cats. 30, 37, 52, 68, 85, 117, 121, 127, 139) and Hind's Zoan Andrea no. 3 (cat. 153) as by the latter.

27. Only a few of the 65 engravings Hind gave to Giovanni Antonio and of the 37 he gave to Zoan Andrea should be deleted; to these lists should be added perhaps eighteen of those he catalogued under Leonardo, many of which in fact he suggested were by Zoan Andrea – again, for several of these, as for example *Three Heads of Horses* (Hind, 1948, V, 87.6), he wrote, 'Engraved in the manner of Zoan Andrea or G.A. da Brescia'. Further, a handful of prints Hind put under other engravers should be added: for example, Nicoletto da Modena 5 (already rejected by Zucker, 1984, pp. 249-50, and given by Byam Shaw in 1950, p. 60, n. 10, to Giovanni Antonio); Mocetto 2 (also doubted by Zucker, 1984, p. 45); and Montagna 16 (which, according to Hind, Kristeller attributed to Giovanni Antonio); and some he left anonymous.

28. The imagery of this print is analysed in Zucker, 1989.

29. Published in Donati, 1959, pp. 31, 34, fig. 12.

30. See Landau, 1979, pp. 4-5, where the top section of this print, previously unknown, was first published.

31. Gauricus, 1504, ed. 1969, p. 101.

32. Hind, 1948, V, pp. 189-205; see also Washington, 1973, pp. 390-413.

33. See Hind, 1948, V, pp. 279-90; Washington, 1973, pp. 456-65.

34. Of the prints on this list, Sheehan in Washington, 1973, attributed the *Flagellation with a Pavement*, the *Descent into Limbo*, the *Deposition*, the *Entombment with Four Birds*, the *Four Dancing Muses* and the *St Sebastian* to Zoan Andrea (p. 265, n. 4); Zucker was more tentative but found these attributions possible (1984, pp. 101, 104-5, 112, 131).

35. Hind, 1938, I, p. 15.

36. Zucker, 1984, p. 76.

37. One scholar has previously stated this opinion. Erica Tietze-Conrat first wrote in 1943 that 'not Mantegna himself but a professional engraver in his shop made these engravings under the master's supervision' (p. 378), and she reiterated this belief in 1955 (pp. 241-2). Lightbown did not overtly question the generally accepted attribution of the engravings but nonetheless pointed out that Tietze-Conrat's 'case … has not been answered' (1986, p. 488).

SOME OBSERVATIONS
ON MANTEGNA'S PAINTING
TECHNIQUE

KEITH CHRISTIANSEN

One of the most singular factors of Mantegna's devotional paintings – and, indeed, of so much of his work after his move to Mantua – is his apparent preference for canvas over panel supports. This was not always the case: in 1468 he painted what must have been a small panel of the Descent into Limbo for Ludovico Gonzaga,[1] and the three scenes of the Uffizi triptych (figs. 9, 76, 80), the *St George* (cat. 42) and the *Virgin of the Stonecutters* (fig. 3) are on panel supports as well. Nor was the support necessarily a matter of his own choosing. In 1477 Mantegna wrote to Ludovico asking whether the portraits he was requested to make were to be drawn on paper or painted on panel or canvas; he awaited the Marchese's instructions.[2] However, the quantity of works he carried out on canvas as opposed to panel – from small pictures to altarpieces and large decorative series – suggests that this was Mantegna's preferred support. Paintings on canvas were more common in northern Italy than in Florence: in Padua, where Mantegna was trained, there still exist a number of works on canvas dating from the 14th and early 15th centuries.[3] Interestingly enough, two of these, in the Santo, are paintings of the Madonna and Child that Mantegna surely knew.[4] In his *Libro dell'arte* (chap. CLXII), Cennino Cennini describes working on canvas as 'sweeter to work on than panel … and just as though you were working in fresco, that is, on the wall'. Mantegna excelled in the medium of fresco, and he may have adopted the technique of canvas painting for portable works because it most closely resembled fresco. In 1491 the Marchese was informed that Mantegna's son had begun painting a set of triumphs for the Gonzaga palace at Marmirolo using canvas, 'as had Master Andrea Mantegna, and they say in so doing they shall be finished sooner, be more beautiful and more durable, and so say all experts in this practice'.[5] Mantua's climate is notoriously damp in the winter and frescoes suffered as a result: the Camera Picta was already in need of repair by 1506, despite or because of Mantegna's use of a mixed technique on one of the walls. To a degree, Mantegna's *Triumphs* (cats. 108-15) can be viewed as works that combined the monumentality of mural paintings with the portability of tapestries. Indeed, according to Vasari, one of the advantages of canvas was that it enabled pictures to be rolled up and carried from one place to another. He continued: 'Because painting on canvas has seemed easy and convenient it has

fig. 24 Andrea Mantegna, *Death of the Virgin* (cat. 17), detail of St Peter, showing the underdrawing with infra-red reflectography

been adopted not only for small pictures that can be carried about, but also for altarpieces and other important compositions, such as are seen in the halls of the palace of San Marco [the Doge's Palace] at Venice, and elsewhere'.[6] In 1477 Mantegna wrote to Ludovico Gonzaga that 'If your Lordship wishes to send the [portraits] far they can be done on fine canvas and wrapped around a dowel'.[7] This may have been how the Duchess of Ferrara expected her painting of the Virgin and Child to be transported by Francesco Gonzaga. For the same reasons, it seems probable that the '*Nostra Dona*' sent by Francesco Gonzaga in April 1505 to Cardinal Marco Cornaro in Venice was on canvas.[8] These were certainly among the considerations that Isabella d'Este had in mind when commissioning paintings for her Studiolo. In 1500 she wrote to Giovanna Feltria della Rovere asking for help in securing Perugino's services. Should he accept, she would send the canvas cut to the required measurements.[9] The intention was not only to match the support chosen by Mantegna for his two allegories (cat. 136), but to facilitate the transport of the finished picture. To a degree, then, canvas was an inevitable choice for devotional pictures commissioned outside Mantua or sent as diplomatic gifts. Once they arrived at their destination, they could either be mounted on a panel, as the *Dead Christ* (fig. 74) once was and the *Ecce Homo* (cat. 61) still is,[10] or on a strainer, as is the case with the *Presentation in the Temple* (fig. 39; Gemäldegalerie, Berlin).[11]

When Vasari wrote, he assumed that the medium employed for a painting on canvas would be oil, but it is clear both from technical analysis and from documentary evidence that Mantegna used either distemper (that is, paint made with a simple animal glue or casein binder) on a sized canvas with little or no gesso preparation, or tempera (pigments tempered in egg yolk medium).[12] Those works done in distemper had the unvarnished, matt appearance of a fresco rather than the transparency of an oil painting, while for those carried out in tempera, Mantegna achieved a surface akin to that of a panel painting by laying a proper gesso ground and applying a coat of varnish to the finished work.[13] *The Madonna della Vittoria* (Louvre, Paris), the altarpiece in the National Gallery, London, and the two paintings for Isabella d'Este's Studiolo are in tempera on canvas, while the *St Sebastian* (fig. 2) and the Santa Maria in Organo Altarpiece seem to be in distemper. Unfortunately, these distinctions were lost on later owners and restorers, who tended to make the same assumption as Vasari. As a result, most of Mantegna's distemper paintings have been damaged and their colours darkened through the indiscriminate application of successive coats of varnish. Only occasionally, as in the miraculously preserved *Ecce Homo* (cat. 61), is it possible to appreciate the

care and precision (the '*diligentia*') Mantegna brought to this kind of work and the sculptural effects he was able to obtain.

The potential misunderstandings posed by Mantegna's technique are revealed by the incredulity of the Bolognese painter Lorenzo Costa, who had been commissioned to provide a companion piece to Mantegna's pictures for Isabella d'Este, upon being informed that the allegories were in distemper and were shiny. He asked Antonio Galeazzo Bentivoglio, who was acting on behalf of Isabella, for a clarification: 'It is necessary for [Costa] that Your Excellency advise me whether the work of Mantegna is shiny ('*è lustro*') or, in truth, if it is varnished or not...'.[14] Isabella mistakenly responded that the pictures were painted in distemper, '*a guazo*', 'and then varnished after being finished'.[15] Costa was familiar with oil painting, but he had also carried out a number of '*guazzi*', including the large canvases in the Bentivoglio Chapel in San Giacomo Maggiore, Bologna, and he obviously thought varnish inappropriate or detrimental to them: he opted to paint his canvas in oil.[16] An examination by the conservation laboratories of the Louvre proves that Mantegna's Studiolo allegories are, in fact, painted on a gesso preparation in egg tempera, possibly with a slight addition of oil.[17] By contrast, a companion allegory of the *Battle of Love and Chastity* (Louvre, Paris) by Perugino (who relied for his

fig. 25 Andrea Mantegna, Santa Giustina from the Saint Luke Altarpiece, detail showing the underdrawing visible with infra-red light, Pinacoteca di Brera, Milan

technical information of Mantegna's paintings on a misleading report of the Mantuan painter Leonardo Leonbruno) is painted in tempera on a canvas without preparation, in conformity with a practice frequently used for processional banners. More accustomed to painting in oil, and less curious than Costa, he probably did not understand the particular qualities Mantegna was striving to achieve. When, after interminable delays, his picture was delivered, Isabella found it 'well composed and coloured, but had it been finished with greater care ('*diligentia*'), having to be placed next to those of Mantegna, which are unsurpassably clear, it would have been to your greater honour and our greater satisfaction'.[18] It is this precision of handling and clarity of colour, with their resultant sculptural effects, that give Mantegna's pictures their unique character and made him loath to relinquish the technique of tempera and distemper painting for the more fused and pictorial effects of oil.

'*Diligentia*' was not reserved for the surface effects of Mantegna's paintings. Examination of his pictures by means of infra-red reflectography demonstrates that the act of painting was preceded by no less meticulous drawings, frequently culminating in an elaborate cartoon that could be transferred by pouncing or by use of a stylus and carbon paper onto the prepared panel or canvas.[19] This may have been Mantegna's practice as early as the 1450s, for the underdrawing of the drapery of the figure of Santa Giustina in Mantegna's St Luke Altarpiece (Brera, Milan), dating from 1453–5, could hardly have been done without the aid of some sort of preliminary drawing or cartoon: the lines pick out the contours of the folds in a way antithetical to a freehand study (fig. 25). It is possible that a preliminary drawing was done on the panel freehand in charcoal and then brushed away, as recommended by Cennino Cennini in his *Libro dell'arte* (chap. CXXII), and that what we now see are only the reinforcing lines in ink; but the use of a cartoon cannot be ruled out.[20] Also visible are the diagonal strokes Mantegna preferred for indicating shaded areas, both in his drawings and prints. What Mantegna's truly freehand underdrawing looked like at this time can be adduced from the approximately contemporary devotional panel of the *Virgin and Child with Seraphim and Cherubim* (cat. 12), in which the heads of the cherubs have been sketched in with consummate concision (fig. 26), with the nose and eyes of the figures reduced to a few quick notations to establish the placing of the heads in space (Mantegna introduced significant modifications in the actual painting).

In the miraculously detailed predella scene of the *Crucifixion* from the San Zeno Altarpiece, completed before Mantegna's move to Mantua in 1460, the underdrawing was also done freehand, with numerous changes introduced in the process of painting. Of great importance is the resemblance the

fig. 26 Andrea Mantegna, *Virgin and Child with Seraphim and Cherubim* (cat. 12), detail showing the underdrawing of cherubs' heads visible with infra-red reflectography.

fig. 27 Andrea Mantegna, *Crucifixion*, detail showing the underdrawing of the bad thief visible with infra-red reflectography, Musée du Louvre, Paris

underdrawing shows to Mantegna's graphic work, where we find the same tendency to schematise the head and body into geometric areas: the rendition of the head of the kneeling soldier (fig. 28) might be compared to that of the holy women in a drawing of the *Entombment* (fig. 29) or that of three apostles, while the delineation of the torso of the bad thief (cat. 27) is not unlike that of the study of *Christ at the Column* (cat. 35).

Cartoons and freehand drawing are combined in the three panels forming the so-called Uffizi Triptych (the *Ascension*, the *Adoration of the Magi* and the *Circumcision* that have been framed together in the Uffizi since 1827; see figs. 9, 76, 80).[21] These panels are modest in size (the largest measures 77 x 75 cm), and it is all the more surprising that their designs should have been so carefully and fully developed in cartoons.[22] Yet, such is demonstrably the case. In the *Ascension*, for example, the drapery of the Virgin was delineated with a dry, unmodulated line that is the direct result of transfer techniques. According to traditional practice, the cartoon would have been pricked and its design transferred by means of charcoal dust forced through the pin-holes; the resulting pattern of dots could then be carefully retraced with brush or pen and ink to recreate the details of the cartoon. As in the underdrawings for the

fig. 28 Andrea Mantegna, *Crucifixion*, detail showing the underdrawing of the kneeling soldier visible with infra-red reflectography, Musée du Louvre, Paris

fig. 29 Andrea Mantegna, *Entombment*, detail (cat. 27)

fig. 30 Andrea Mantegna, *Ascension*, detail of the Virgin's robe visible with infra-red reflectography, Galleria degli Uffizi, Florence

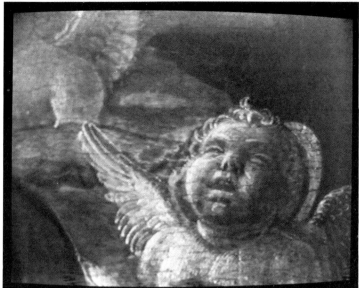

predella of the San Zeno Altarpiece, fine, diagonal lines indicate the areas to be shaded, but the emphasis was on the configuration of the folds rather than tonal relationships. In the course of execution, most of the dots of charcoal dust from the transfer (*spolveri*) would have been either wiped away or covered when the artist or his assistant went over them in ink, but pounce marks are still visible in the drapery of one of the apostles in the *Ascension* (fig. 30).

In the *Adoration of the Magi*, an elaborate cartoon was again used for the principal figures, but for some reason Mantegna preferred to draw some – not all – of the cherubs freehand. Whereas he followed the design based on the cartoon closely in the painting, he significantly modified the position of those cherubs for which no cartoon had been prepared (figs. 31, 32). Features in the background landscape were indicated in the most cursory way – a few circular notational strokes for the trees, a line for the contour of the distant hill (fig. 33). In painting, Mantegna held the area for the trees in reserve, positioning them only at the very end. It is this undogmatic approach, which combines careful planning and freedom of invention, that stands behind these small masterpieces.

Curiously, in the *Death of the Virgin* (cat. 17), usually thought to have formed part of the same series as the Uffizi panels, there is no evidence of the use of a cartoon.[23] Rather, the figures seem to have been drawn in freehand, probably on the basis of a preliminary sketch that was brushed away (fig. 24). The matter is quite different in the *Circumcision* (fig. 9), in which Mantegna created a highly decorated interior that required careful planning, doubtless including a perspective study: pounce marks from the use of a cartoon are visible even in the acanthus leaf decoration of the splendid Roman capital

fig. 31 Andrea Mantegna, *Adoration of the Magi*, detail showing the underdrawing of a cherub's head visible with infra-red reflectography, Galleria degli Uffizi, Florence

fig. 32 Andrea Mantegna, *Adoration of the Magi*, detail of a cherub's head, Galleria degli Uffizi, Florence

fig. 33 Andrea Mantegna, *Adoration of the Magi*, detail of the landscape visible with infra-red reflectography, Galleria degli Uffizi, Florence

fig. 34 Andrea Mantegna, *Circumcision*, detail of a capital showing pounce marks visible with infra-red reflectography, Galleria degli Uffizi, Florence

(fig. 34). The evidence of the use of elaborately executed cartoons goes a long way to explain the length of time Mantegna frequently took to complete a picture. It also points to one of the fundamental duties of a young workshop assistant, spending hours at a time pricking the cartoon and then carefully transferring the design to the gessoed surface of the panel.

Even more importantly, these cartoons, now lost, for the panels of the Uffizi triptych help explain the existence of those otherwise curious but attractive drawings done on paper prepared with a coloured ground in which figures, or groups of figures, have been isolated from Mantegna's compositions (see cats. 18, 19, 20). Most of these drawings were probably done in his workshop from the cartoons, possibly with the aid of pouncing: they are student's exercises that should not be confused with preliminary drawings by Mantegna, and their peculiar beauty is that of works with no function beyond the attainment of technical proficiency (the *Muse*, now in Munich, was demonstrably created with the use of a cartoon: see cat. 137).[24] This is not to say that all such drawings were done after Mantegna's cartoons rather than the finished painting. A comparison of the drawing of the *Virgin and Child* (cat. 19) with the underdrawing for the identical figure group in the

Adoration of the Magi establishes that it was based on the painting, not the pre-paratory cartoon. The same is true of the engraving by a follower of Mantegna that repeats the central figure group of this composition, in which the unmodelled lines of the magus, St Joseph and the rocky plateau on which the Virgin sits, bear a spurious resemblance to Mantegna's underdrawings (see cats. 21, 22).

Mantegna seems to have made equally careful cartoons for his engravings. At least, this is suggested by two highly finished drawings that seem to have been used as cartoons for prints (cats. 44, 147). The related engraving of one of these is usually ascribed to Mantegna, while the other is given to a follower, but whether or not Mantegna used the burin himself is perhaps less important than the way the inked grooves of the copper plate faithfully transcribe the graphic style of the drawings. Nothing could be further from Baccio Baldini's craftsmanlike reduction of Botticelli's compositional drawings for Dante's *Divine Comedy* into charming but characterless engraved illustrations. It is tempting to explain the unfinished character of some of the engravings associated with Mantegna, such as the *Flagellation* (cat. 36), which lacks a fully worked-up background, in the light of the evidence gleaned from the underdrawing of the *Adoration of the Magi:* that Mantegna sometimes restricted his preparatory cartoons to the figures. So closely related is Mantegna's drawing style to the engravings that one might well wonder if the great drawing in the British Museum for the *Calumny of Apelles* (cat. 154) was not intended for an engraving. (It was so employed by Girolamo Mocetto, who, however, made no attempt to replicate its penwork and who inappropriately added a cityscape background that destroys its frieze-like conception.) Mantegna's drawings and cartoons evidently continued to be exploited after his death, and this obviously increased the rate of attrition.

Looking at the underdrawings, one might conclude that the actual painting was a purely mechanical act, as easily carried out by a talented assistant as by the master. But, anyone who has examined Mantegna's paintings with the aid of a lens or a microscope can attest to the almost terrifying precision of his brushwork. (The frequently cited letter in which it is reported that Mantegna felt unsuited to small-scale work is belied by the evidence of the pictures and cannot be used to dismiss the idea that he painted miniatures: clearly, the artist did not want to be bothered with that particular commission.[25]) For Mantegna, as for every great artist, the creative act cannot be reduced to a series of fixed steps. It was a fluid process, subject to variation, interpolation and flashes of inspiration. When, in 1506, the aged artist wrote to Isabella, informing her of the progress he was making on a canvas for her Studiolo, he stated that 'I have

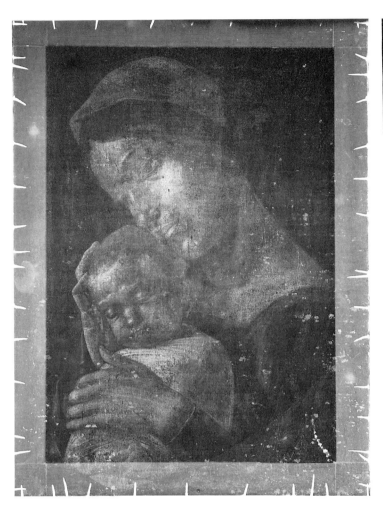

fig. 35 Andrea Mantegna, *Virgin and Child*, (cat. 41),
x-radiograph, Gemäldegalerie, Berlin

fig. 36 Andrea Mantegna, *Virgin and Child*,
x-radiograph, Museo Poldi Pezzoli, Milan

almost finished designing the story of Comus for your excellency, which progresses when my fancy ('*fantasia*') aids me'.[26] He seems already to have been drawing onto the canvas, introducing details and variations as work progressed. It is in the head of one of the flying cupids in an earlier canvas for the Studiolo – the *Pallas Expelling the Vices from the Garden of Virtue* (cat. 136) – that the type of detailed drawing he was working on can be deduced. In this case the head of the cupid, fully delineated, is both larger and positioned differently from the way it was finally painted (it is slightly lower and to the right: fig. 37). Whether the underdrawing was done freehand, on the basis of some summary indications, or from a cartoon is difficult to say, but clearly, the design of the painting continued to evolve as Mantegna painted. (Numerous *pentimenti* in the picture confirm that Mantegna refused to be bound to any scheme if moved by his '*fantasia*'.)

A comparison of x-rays of the *Virgin and Child* (cat. 41), painted in the 1450s, and that in the Poldi Pezzoli, Milan (figs. 35, 36), dating from some three decades later, underscores the fact that Mantegna's working procedure cannot be codified. We might expect the complex, affective composition of the later picture to have been carefully worked out in a cartoon that was followed closely during painting – as in the figural components of the Uffizi Triptych. Yet, such was not the case for, whereas the eloquent but relatively simple composition in Berlin shows no significant changes in design, in the Poldi Pezzoli *Virgin and Child* the left foot of Christ and the left hand of the Virgin were altered in the process of painting, and throughout the brushwork has an exploratory character absent in the earlier work.

fig. 37 Andrea Mantegna, *Pallas Expelling the Vices from the Garden of Virtue*, detail of the underdrawing of a cupid seen with infra-red reflectography, Musée du Louvre, Paris

The resulting impression is of an artist consumed with the idea of attaining perfection but disdainful of any single means of achieving it; someone who loathed short cuts and results that were easily obtained. Late in life Mantegna became obsessed with the idea that he had been insufficiently appreciated and, in Rome, had not received the monetary reward due for the work he produced. He was scarcely the first artist to experience these feelings, but few expressed them with such forthrightness. If his neighbours are to be believed, he was an irascible man, almost impossible to get on with. Even Ludovico Gonzaga had to put up with a rude, complaining letter accusing the Marchese of not living up to the promises made to the artist when he moved to Mantua in 1460.[27] This is ironic, for no 15th-century artist enjoyed a more sympathetic, admiring series of patrons, all of whom valued his work enough not to make impossible demands. But, for someone so acutely aware of his worth and consumed with pride (Mantegna would doubtless have preferred the word *virtù*), it was inevitable that the constricting position of a court painter should have rankled.

NOTES

1. Kristeller, 1902, p.525, doc. 39.

2. Kristeller, 1902, p.534, doc. 69.

3. The use of canvas by Venetians was widespread. Among the most notable examples of the middle years of the 15th century are the *Death of the Virgin* (Museo di Castelvecchio, Verona) by Giambono, the large triptych by Antonio Vivarini and Giovanni d'Alemagna for the Scuola della Carità (Accademia, Venice) of 1446, Jacopo Bellini's *Crucifixion* (Museo di Castelvecchio, Verona) and the narrative cycle of scenes from the life of the Virgin frequently associated with his work for the Scuola di San Giovanni Evangelista (see Eisler, 1989, pp. 521-3; the pictures he states are in the Prado are, instead, with Stanley Moss, Riverdale, and are almost certainly painted in distemper, not oil). Work commissioned by the Scuola di San Marco in 1466 from Jacopo Bellini and Squarcione was, again, on canvas (see Eisler, 1989, pp. 524, 532). Canvas was commonly used for the production of organ shutters, such as those by Gentile Bellini for San Marco (Museo Diocesano a Sant'Apollonia, Venice), and for processional banners, such as that by Gentile Bellini showing Lorenzo Giustiniani (Accademia, Venice). For the two Paduan pictures, see Padua, 1974, cats. 71-2, and Lucco, 1990, pp. 80-82.

4. On these, see Padua, 1974, cats. 2, 51. The second image is by Giusto de'Menabuoi. See also *idem*, cats. 71 and 72, for two large-scale works on canvas painted for confraternities in Padua.

5. Kristeller, 1902, p.550, doc. 111.

6. *Vasari on Technique*, translated by L. Maclehose, New York, 1907, p. 237.

7. Kristeller, 1902, p.534, doc. 69.

8. See Brown, 1974, pp. 101-2. Neither the author nor the type of support is mentioned.

9. Canuti, 1931, doc. 305.

10. For the *Dead Christ*, see p. 86, below.

11. The *Presentation* has been remounted, following relining, on its original strainer, in turn reinforced by planks of wood. See Wolters, 1960, p. 161, who illustrates the strainer and the means of attachment. A Venetian frame in the Lehman collection of the Metropolitan Museum dating from *c.* 1500 has remnants of a painted canvas between the backing and the front moulding, suggesting that in the late 15th/early 16th century the frame was sometimes applied directly to these strainers: see Newbery, Bisacca and Kanter, 1990, no. 63.

12. Simonetti, 1990, gives a useful survey of the techniques of Venetian painting, although she misinterprets the documents relating to Mantegna's pictures for Isabella d'Este.

13. The purchase of varnish for the Duchess of Ferrara's picture is alluded to in the documents cited above (but that picture was not certainly on canvas). Varnish was purchased for the first of the Studiolo allegories in 1497: see Brown, 1969, p. 542.

14. Kristeller, 1902, p.574, doc. 167.

15. Luzio, 1909, pp. 864-5. These letters are referred to by Brown, 1969, p. 542.

16. See the findings of Delbourgo, Rioux and Martin, 1975, pp. 26-7. Interestingly, Costa's second picture for Isabella, carried out in Mantua after Mantegna's death, is in tempera: having seen Mantegna's pictures, he was able to understand the technique employed. The interpretation of the documents by Simonetti, 1990, pp. 263-4, is incorrect.

17. Technical report of 4 July 1975, for which I am most grateful to the conservation department of the Louvre. See also Delbourgo, Rioux and Martin, 1975, pp. 21-8. Lightbown, 1986, p. 228, has misinterpreted the published analysis of the *Parnassus* to read that Mantegna built up 'layers of paint and glazing'. The oil paint above the layer of varnish on the *Parnassus* is from an extensive repainting of the picture, possibly carried out shortly after 1522, when the painting was moved to the new Studiolo in the Corte Vecchia.

18. Canuti, 1931, doc. 376.

19. On all of the pictures that I have examined the infra-red videocon was able to penetrate only certain areas, due to the pigments Mantegna employed. Works on canvas present special problems, since a proper gesso ground, such as is necessary for optimal results with a videocon, was not used.

20. Some of the underdrawings for the St Luke Altarpiece are published by Bandera Bistoletti (1989, pp. 70-87), whom I should like to thank for discussing them with me. I am, however, unable to see the evidence for her statement that the heads of the Virgin and St John were first conceived in profile and only subsequently given their present, three-quarters view. What is remarkable is the degree to which the underdrawing is followed in the painting.

21. See Lightbown, 1986, p. 412, for a discussion of the history of these panels and their association with the altarpiece Mantegna is presumed to have painted for the chapel in the Castello di San Giorgio in Mantua.

22. I carried out an examination on the Uffizi pictures in the summer of 1989 through the offices of E.Di.Tech., and would like to thank Maurizio Saracini for his assistance, and Alessandro Cecchi of the Uffizi for arranging the examination.

23. I would like to thank the staff of the Prado, particularly Carmen Garrido, for making photographs of their investigation available to me.

24. When Mantegna's *Descent into Limbo* in the Johnson Collection (cat. 70), was exhibited at the Metropolitan Museum together with the related drawing in Berlin (cat. 71), I made a detailed comparison. The figure of Christ in the drawing is precisely the same size as that in the painting, which it follows exactly. Unfortunately, I was unable to examine the painting for an under-drawing, but the drawing is clearly after the painting or its cartoon and not by Mantegna.

25. See Kristeller, 1902, p.538, doc. 79.

26. Kristeller, 1902, p.577, doc. 174.

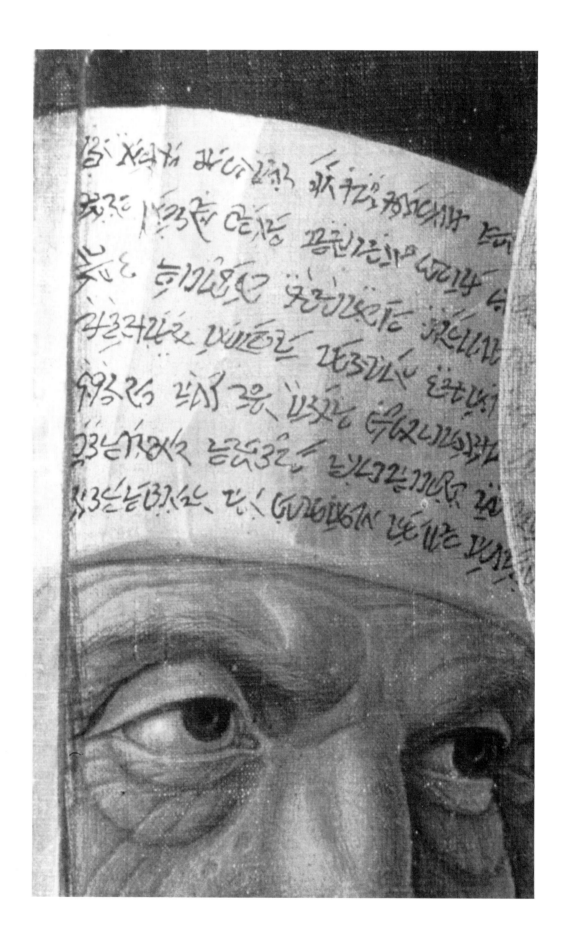

MANTEGNA'S PAINTINGS IN DISTEMPER

ANDREA ROTHE

Distemper is the name given to a technique that uses animal glue instead of egg as a medium. Invariably, the support is a finely woven canvas that has been sized and sometimes thinly gessoed. Left unvarnished, the colours have an opaque brilliance and precision akin to pastels, enabling the paintings to be viewed in any light without the reflections of a varnished picture. The technique was popular in the Netherlands and Germany. Indeed, the painter's guild in Bruges in the 15th century was divided into *schilders*, or those who painted on panels, and *cleederscrivers*, those who worked on fabric supports.[1] Dürer painted more than sixteen distempers,[2] which he refers to as *tüchlein*, or linen paintings.[3] In Italy the technique was especially associated with processional banners and organ shutters; Mantegna was alone in making it his preferred non-mural medium.

Unfortunately, the technique is as fragile as it is beautiful. Of the thousands of works in this medium that were painted in the Netherlands, fewer than 100 have survived, and in Italy the losses are only slightly less drastic. Moreover, those that do survive are, for the most part, in far worse condition than pictures painted in tempera or oil. There are a number of reasons for this. Although the canvas was sized, it remained porous, and there was no thick, protective layer of gesso between it and the layer of paint. The glue, linseed oil and Venetian turpentine mixtures traditionally used to apply a relining canvas could have disastrous effects as they penetrated the paint layer. The absence of a coat of varnish leaves the surface unprotected from accumulations of soot and dust. At the same time, the all too frequent applications of varnish by later owners not only destroys the inherent character of the distemper but darkens the tonality and muddies the overall effect. Even when subsequent layers of varnish are removed, it is impossible to return the colours to their original relationships or to restore fully the matt appearance that must always have been a key feature of distemper. In Mantegna's work, a comparison of the cloaks of the Virgin in the unvarnished *Virgin and Child* (fig. 69; Accademia Carrara, Bergamo) with the *Adoration of the Magi* (cat. 56), whose subsequently applied varnish has been removed, and with the varnished *Virgin and Child* in Berlin (cat. 41), amply demonstrates the effects of misguided, if well-intentioned, varnishing and relining.

fig. 38 Andrea Mantegna, *Ecce Homo* (cat. 61), detail

Although the aesthetic qualities of distemper paintings are apparent, little is known about their chemical properties, and it may be that the technique varies considerably. Moreover, the vulnerability of the medium and the compromising effects of the later applications of varnish and repaints makes it particularly hard to interpret analysed data. The information derived from documents and treatises, such as Cennino Cennini's, is paltry at best. Gum arabic (a water-soluble natural resin), which was commonly employed as a medium in illuminated manu-scripts, has similar optical properties to those found in Mantegna's paintings and was probably employed by him for his applications of shell gold (gold that is ground to a powder).[4] In paint samples, the presence of polysaccharides may indicate the use of gum arabic as a binder for the gold powder and other pigments. Mantegna seems sometimes to have employed casein (an adhesive made from skimmed milk) for paintings such as the large *St Sebastian* (fig. 2; Louvre, Paris). The medium of the early *St Mark* (cat. 5) may also be casein.

In the correspondence relating to the paintings for Isabella d'Este's Studiolo, it emerges that Mantegna varnished some of his paintings on canvas, though these were painted with an egg rather than a glue medium.[5] Lorenzo Costa expressed disbelief that a distemper would be varnished to obtain a shiny surface. On the other hand, the *Judith* in Dublin (cat 129), which has the matt appearance associated with an unvarnished painting, is lightly coated with an unidentified substance – possibly a layer of egg white or, conceivably, a thin matt varnish of which only the residue remains. The presence of wax in many of the samples analysed could be an indication of such a protective varnish coating applied by the artist.

There follows a list of paintings by or attributed to Mantegna painted in a medium that has either been analysed as distemper or that shows some of the characteristics of distemper. In a few cases, a glue medium has been identified with reasonable certainty. With others, the medium may be casein or a mixture of egg and animal glue. With many of the paintings, the technique could only be deduced visually. Only five of the paintings seem never to have received a conventional coat of varnish and, in consequence, retain their original matt surface and brilliant crispness of detail. These are the *Ecce Homo* (cat 61), the Bergamo *Virgin and Child*, the *Lamentation over the Dead Christ* (fig. 74, Brera, Milan), the *Judith* in Dublin (cat. 129) and the *Judgement of Solomon* (cat. 130). The others have all suffered the indignity of being varnished at some point in the past, stained by the oil of subsequent retouchings and by the lining adhesives.

fig. 39 Andrea Mantegna, *Presentation in the Temple*, distemper on fine canvas mounted on a wooden frame, 68.9 x 86.3 cm, *c.* 1455, Gemäldegalerie, Berlin

fig. 40 Andrea Mantegna, *Presentation in the Temple*, x-radiograph

The following points should be borne in mind in determining a distemper medium:

i. The support should be a fine plain weave linen.[6]
ii. There should be only a layer of animal glue or, at the most, a very thin layer of gesso (calcium sulphate) rubbed into the canvas.
iii. The paint layer remains sensitive to water.
iv. There should be no pronounced craquelure, unless from the layers of applied varnish and oil.
v. The paintings may show a greying of the surface due to either natural ageing or absorption of dust or soot. (The exceptions are those pictures that have been protected by glass.)
vi. If unvarnished, the paint layer has an opaque brilliance. Otherwise, the colours have darkened as a result of the absorption of varnishes and oils.
vii. Chemical analysis should indicate the presence of proteins. Detailed amino-acid analysis should show the presence of hydroxiproline. The analysis for cholesterol should be negative. The medium should have very low or practically no concentrations of phosphorus.

The purpose of the following list of paintings is not merely to record the proportions Mantegna used in the various media he concocted, or to determine if they were all painted in pure distemper, but also to show that optically most of them now are not what they were meant to be. Mantegna had to ensure that these small devotional paintings could be visible even in the worst possible lighting conditions, such as the Palazzo Ducale in Mantua, and one of the inherent benefits of distemper is its similarity to fresco painting, which is renowned for its luminosity.

Paintings are listed in alphabetical order of location.

1. *Virgin and Child*
Accademia Carrara, Bergamo fig. 69

The canvas is a fine linen weave with a very thin gesso ground.[7] The binding medium was identified as animal glue. The painting has never been varnished and is kept under glass. It has never been lined and the condition is good. There are some damaged areas with small paint losses on the forehead of the Christ Child and a larger one in the veil over the Virgin's head. Judging by the accumulation of original paint at the edges, the canvas was folded over and nailed to a strainer (a stretcher without keys), or a panel (see notes on the *Ecce Homo* in Paris). The exceptional brilliance of the blue in the Virgin's robe was found to be a mixture of natural ultramarine and azurite. The moiré effect on the blue robe and the pink camise of the Virgin, as well as the haloes, are painted with shell gold.

2. *The Presentation in the Temple*
Staatliche Museen Preussischer Kulturbesitz, Berlin (fig. 39)

The canvas is a fine, tightly woven linen. The gesso layer is very thin. The binding medium was identified as animal glue and traces of wax were found. The painting is in good condition, but heavily varnished and, consequently, much darkened. The background seems to be repainted and the haloes are not original. Until the early 1960s the painting was attached to the original fir strainer with theoriginal nails. As with many of the northern Italian paintings of

fig. 41 Andrea Mantegna, *Presentation in the Temple*, panel support seen from the front

fig. 42 Andrea Mantegna, *Presentation in the Temple*, detail of the bottom edge of the canvas

fig. 43 Diagram of the frame, canvas and strainer of the *Presentation in the Temple*

this period, the canvas was stretched and nailed to the front of the strainer rather than folded over the edges. The stretchmarks, or scalloping, in the canvas, which are quite obvious, correspond to the large nail holes.[8] The canvas was removed from the original support and the edges were reinforced because the rust from the nails had eaten away the linen fibres. The painting was remounted on the original strainer, which has a centre support and two panels inserted from the back into the open spaces (fig. 41). The two panels are flush with the front of the strainer and thus form a rigid support for the painting. This could account for its description as a '*quadro in tavola*' by Marcantonio Michiel in the early 16th century.[9]

Judging by the many splinters and additional nail holes that can be found all around the image, a frame was nailed and glued on top of the canvas (fig. 42). At the corners of the strainer one can also see the diagonal incision marks made while the frame was cut to fit the strainer before the canvas was applied. Given the size of the strainer and the fact that these engaged frames are usually flush with the edge,[10] the frame could not have been more than 4.5 centimetres wide (fig. 43). Of particular importance is the fact that, upon close inspection, the paint layer of the fictive marble moulding around the image can be seen to continue up onto the splinters. This would indicate that at least part, if not all of the frame was similar to the fictive moulding.

The x-radiograph shows various *pentimenti* (fig. 40). The face of the Virgin was originally higher up and further to the left, with a halo painted in perspective. The head of the priest was uncovered and his ear was showing. His robe had a high collar.[11]

3. *Virgin and Child*
Staatliche Museen Preussischer Kulturbesitz, Berlin (cat. 41)

The canvas is a very fine linen weave with a very thin red-brown preparation, or *imprimitura*. The binding medium was identified as animal glue. Traces of wax were also found. The picture is generally in good condition but varnished, which has caused the colours to darken considerably. Mantegna did not use any shell gold in this painting.

4. *A Sibyl and a Prophet?*
The Cincinnati Art Museum (cat. 128)

The canvas is a fine linen weave with a very thin layer of gesso and toned with a red earth *imprimitura* similar to the two paintings from Montreal. The binding medium was identified as animal glue. Originally the painting was larger but has been cut down on all four sides and nailed to a stretcher. In more recent times the painting had to be lined, covering up an old inscription on the back. During this lining procedure the edges that had been folded over were flattened out and the painting attached to a larger stretcher. These formerly folded over edges were not varnished, as was the rest of the painting, and the original pinkish *imprimitura* can be seen. The painting is in very good condition. Extensive highlighting and modelling is painted in shell gold.

5. *Christ the Redeemer*
Congregazione di Carità, Correggio (cat. 55)

The canvas is a very fine linen weave with no visible gesso ground. The picture has been relined, heavily retouched and varnished, causing the colours to darken. The paint layer is thin and shows some abrasion. The letters and the halo are painted in shell gold.

6. *Holy Family with the Infant St John the Baptist*
Gemäldegalerie, Dresden (fig. 73)

The canvas is a medium thick twill weave with a gesso ground. The paint layer, which is thicker than in the other paintings in distemper, is well preserved but darkened by a thick yellow varnish. The craquelure is quite prominent with a slightly shrivelled paint film. No sample could be taken, but the technique, which could be either egg tempera or casein, resembles the three paintings in Mantegna's funerary chapel in Sant'Andrea in Mantua (see below), and the paintings of *St Sebastian* in the Louvre and Ca' d'Oro in Venice. Egg tempera was confirmed analytically on Mantegna's two paintings made for the Studiolo of Isabella d'Este (fig. 107, cat. 136, Louvre, Paris).

7. *Judith with the Head of Holofernes*
National Gallery of Ireland, Dublin (cat. 129)

The binding medium was identified as animal glue. A very thin gesso preparation can be seen on the very fine linen weave canvas. The general appearance is that of an unvarnished painting, although closer examination has revealed a very thin coating, perhaps original. Except for a horizontal crease in the middle, the painting is in excellent condition. A black border is painted around the image.[12]

8. *Holy Family with St Elizabeth and the Infant St John the Baptist*
The Kimbell Art Museum, Fort Worth (cat. 51)

The canvas is a fine linen weave with a thin layer of gesso. The painting has been folded three times and the paint film has been abraded, exposing some of the preparatory paint layer. A layer of varnish has been applied to the surface.[13]

9. *St Mark*
Städelsches Kunstinstitut, Frankfurt (cat. 5)

The canvas is not as fine a linen weave as the other distemper paintings. The paint is applied more thickly and is not soluble in water. A protein was identified that is not egg yolk. These findings, and the fact that significant amounts of phosphorus were analysed, indicate that the medium is probably casein. Traces of gesso were found, and some preparatory *imprimitura* can be seen under the paint film. The fruit garland above the Saint's head has coloured glazes that were analysed as a natural resin.[14] Traces of wax were also found. After the recent cleaning it became evident that the heavy layer of varnish had not stained the paint layer as much as other distemper paintings. The surface has suffered damage from abrasion and paint particle loss, but on the whole, the condition after restoration is much better than previously perceived. The cleaning has also revealed a number of *pentimenti*.[15]

10-18. *The Triumphs of Caesar*
Her Majesty The Queen (cats. 108-15, fig. 100)

The binding medium seems to be animal glue.[16] The cycle consists of nine large paintings on medium twill canvas. A fine layer of gesso is underneath the paint layer. Many of the highlights are painted in shell gold. Although the consensus was that they are painted in egg tempera,[17] the paintings have all the characteristics of distemper. According to Mario Equicola in his *Chronica di Mantova*, Francesco Gonzaga commissioned from Lorenzo Costa a now lost painting, *a guazzo* (distemper), to be hung together with Mantegna's *Triumphs*, which was to match their technique.[18]

Any analysis is complicated by the fact that the paintings were heavily repainted and damaged in previous restorations. John Brealey restored eight of the paintings from 1962 to 1974.[19] Various residues of oil paint from previous restorations and paraffin wax from a disastrous relining were removed as much as possible.[20] This was particularly difficult given the absorbent nature of the medium. To make the pictures legible, it was necessary to varnish them.[21]

19. *Samson and Delilah*
National Gallery, London (fig. 104)

The canvas is a fine linen weave. There is no gesso ground, only a thick layer of glue. The original canvas is mounted on a board.[22] The painting, which is now under glass, is well preserved, although very fragile. It has the greyish overall tone that one often finds on distemper paintings. A black border is painted around the image. The surface has been coated with a thin layer of synthetic resin.

20. *The Introduction of the Cult of Cybele in Rome*
National Gallery, London (cat 135)

The binding medium was identified as animal glue.[23] Close observation of the cross-sections revealed a fine layer of gesso that was rubbed into the fine weave canvas.[24] The painting, which had been varnished previously, was cleaned in 1977-8. A layer of grime found between the varnish and paint layer indicates that the surface was originally left unvarnished. The surface is currently coated with a synthetic varnish.

21. *Holy Family with the Infant St John the Baptist*
National Gallery, London

Only a layer of glue was found between the fine weave canvas and the paint layer. The painting, which is very damaged, had been varnished and retouched by Helmut Ruhemann in the late 1950s. In his treatment report, he states that the paint layer was sensitive to water.[25]

22. *Adoration of the Magi*
J. Paul Getty Museum, Malibu (cat. 56)

The support is a fine linen with a fine layer of gesso. The binding medium was identified as animal glue, and the colours are sensitive to water. On the right a thick vertical strip of white preparation can be seen beneath the paint layer; remnants of canvas fibres are embedded in it. This would indicate that originally Mantegna added a strip of canvas and extended the composition to the right.

The stretcher is 19th century, and probably dates from the time when the painting was removed from its original support to be relined and its tears mended.

Remnants of slivers of wood found glued to the back of the right-hand edge of the canvas suggest that the painting could have been mounted on a strainer. Since practically no scalloping is visible, there is also the possibility that the *Adoration* was glued by its edges to a panel. This might account for the sharp horizontal tear, made, presumably, when the panel buckled or broke, subsequently creasing and damaging the canvas.

The execution adheres to Mantegna's original composition, with some *pentimenti* in the faces of the Virgin and the Christ Child, visible in the x-radiograph (fig. 44). The intricate details and extensive gold highlighting are applied over preparatory colours in a manner similar to those visible on the borders of the *Ecce Homo* (fig. 38). The figures themselves are placed against a uniform black background.

Over the centuries, a grey layer of grime has collected on the thin and very porous paint surface. Attempts had been made to revive the surface through varnishing, which caused further darkening. The varnish, as well as the grime, had to be removed. To do this without causing the surface to blanch, a solvent gel[26] was used which removed most of the varnish and some of the grime. After retouching the losses with a matt, non-aqueous medium, the painting was left unvarnished.

23. *The Families of Christ and St John the Baptist*
Sant'Andrea, Mantua (cat. 64)

An off-white gesso ground is visible on a medium-thick, twill weave canvas. The paint film is much thicker than the other paintings in distemper, and slightly shrivelled. Although no samples could be taken, the characteristics point to a casein medium. The painting is heavily varnished. No shell gold was used in the highlights and haloes.

fig. 44 Andrea Mantegna, *Adoration of the Magi*, x-radiograph, The J. Paul Getty Museum, Malibu (cat. 56)

24. *Baptism of Christ*
Sant'Andrea, Mantua

As in the previous painting, an off-white gesso ground is visible on a medium-thick, twill weave canvas. The paint film is also thicker and slightly shrivelled. Again, no samples could be taken, but the characteristics point to a casein medium. The painting is heavily varnished. There is no use of shell gold in the highlights and haloes. A *Visitation*, hanging in the same chapel, although inferior to the other two paintings, has the same canvas and seems to be painted in the same technique.[27]

25. *Virgin and Child in Glory with Saints (The Trivulzio Madonna)*
Castello Sforzesco, Milan

The canvas is a very fine linen weave with a fine gesso ground. The gesso has differently toned areas of *imprimitura*. Although earlier analysis misinterpreted the medium as egg tempera,[28] the binding medium was identified as being animal glue. The painting was recently restored and lightly varnished.[29] Given its very good state of preservation, one is inclined to believe that some form of protective layer, such as egg white, was applied early on in its history.[30] Mantegna made extensive use of shell gold to highlight the vestments of the saints, the wings of the angels and the haloes.[31]

26. *The Lamentation over the Dead Christ*
Pinacoteca di Brera, Milan (fig. 74)

The canvas is a fine linen weave. Although no samples could be taken, the technique is probably distemper. No gesso preparation could be found. Although this painting appears to be unvarnished, there is a very slight surface gloss that might indicate remnants of a coating material or fixative. Even though the painting is documented as being under glass since the beginning of the 19th century,[32] it has a characteristic grey layer, and the colours have darkened. The paint film is very fragile and there is extensive loss of minute paint particles. The presence of vertical painted strips on either side of the composition is puzzling, yet in keeping with the painted porphyry frame around the *St Sebastian* in the Louvre and the *Presentation* in Berlin. On the right is a thin black strip on the inside and a dark grey one on the outside, while on the left only a white strip can be discerned. The halo is painted in shell gold.

Although now lined and mounted on a stretcher, early Aldobrandini inventories describe the canvas as being on a panel.[33] A careful examination of the edges shows pronounced stretch marks and tack holes with remnants of rust, which exclude the possibility of it being glued to the support by its edges like the Paris *Ecce Homo*. Most likely the painting was mounted on a strainer, like the *Presentation* in Berlin, with flat wooden inserts in the back which gave the appearance of a panel.[34]

27. *Virgin and Child*
Museo Poldi Pezzoli, Milan (fig. 72)[35]

The canvas is a fine weave. No gesso ground is visible. The binding medium was identified as animal glue. Traces of wax were also found. The picture has been heavily varnished, causing a general darkening in tonality. The original blue cloak of the Virgin, which has darkened, was repainted in the restoration of the last century. The canvas has been dated to be from 1495, +/− 35 years.[36]

28-29. *Dido* and *Judith*
Museum of Fine Arts, Montreal (cats. 133, 134)

The fine canvases have a very thin gesso ground and a red *imprimitura* on top. The binding medium was identified as animal glue. Their condition is very good. The predominant pigment is shell gold. In the recent restorations, which have brought back much of the original splendour, no varnish was applied.[37]

30. *Mucius Scaevola*
Staatliche Graphische Sammlung, Munich

The canvas has a fine weave primed with a very thin ground and an off-white *imprimitura* that could contain lead white, since it is very prominent in the x-radiograph. The binding medium was identified as animal glue. The painting is covered with a very thin wax coating.[38] The paint film is water soluble, as demonstrated by an old smudge on the breast-plate of Mucius Scaevola.

31. *St Euphemia*
Museo e Gallerie Nazionali di Capodimonte, Naples (cat. 13)

The canvas is a very fine linen weave. No gesso preparation is visible. The binding medium has been identified as animal glue. The paint layer, worn and damaged by a fire in the 18th century, was heavily restored in 1960 and revarnished. Many areas, such as the dark blue garment of the Saint, are illegible. Viewed with infra-red, the garment is revealed to be decorated with a very ornate design.[39]

32. *Holy Family with St Mary Magdalene*
The Metropolitan Museum, New York, The Altman Collection (cat. 55)

The canvas is a very fine weave without a gesso preparation. The binding medium is animal glue. The painting, badly damaged, was recently restored and a light varnish applied, following the removal of extensive overpaints and layers of varnish.[40]

33. *Ecce Homo*
Institut de France, Musée Jacquemart-André, Paris (cat. 61)

The canvas is a very fine linen weave. There are no signs of a gesso ground under the paint layer. The painting, unvarnished and kept under glass, is in practically pristine condition, with only one rubbed and retouched area in the proximity of the hand of Christ. Very little dirt has accumulated on the surface. The canvas is of a fine weave and is glued by the edges to a thin panel (fig. 38), a support for *tüchlein* often used in northern Europe.[41] Since the edges of the canvas are well preserved and have never been tampered with, it would indicate that the panel is the original one; the fact that the shrinking of the panel has caused the canvas to bulge would also point to its being the original. Carbon-14 dating tests show it to be circa 1391, +/− 30 years.[42]

Interestingly, Mantegna must have finished the painting after it was placed in a frame. This is evidenced by an approximate 5 mm band around the edge that lacks all the fine detailing of the rest of the painting and exposes the preparatory paint layer. Some of the highlights and the halo in the top paint layer are painted in shell gold.

34. *Virgin and Child and Three Saints*
Institut de France, Musée Jacquemart-André, Paris

The painting is on a very fine linen weave with no visible gesso preparation. The paint layer is very thin and darkened by an old yellow varnish. The haloes and garments have highlighting in shell gold.

35. *St Sebastian*
Musée du Louvre, Paris (fig. 2)[43]

The canvas is a twill weave linen with a thick gesso layer, as well as a thicker paint layer. Technically it is similar to the *St Sebastian* in the Ca' d'Oro, the *Holy Family* in Dresden and the paintings in Mantegna's funerary chapel in Mantua. An analysis done in 1985 shows traces of phosphorus; an earlier analysis in 1983, identified the medium as egg tempera. The colours are dulled by a coating, probably egg white, that has turned grey and opaque. Of interest is the painted porphyry frame around the image which in analysis was found to be technically similar to the rest of the painting.[44]

36. *The Judgement of Solomon*
Musée du Louvre, Paris (cat. 130)[45]

The canvas is a very fine linen weave. Some gesso might have been rubbed into the canvas. There is some surface gloss, probably due to the starch adhesive used to attach the back of the canvas to a piece of paper; otherwise the surface is unvarnished. Except for some losses, the painting is in a remarkable state of preservation. The technique seems similar to the other grisailles; however, the very fine craters caused by burst air bubbles that are visible in many areas are unusual. Normally, these would be a clear indication of egg tempera. In this case it might be due either to vigorous mixing by the artist which trapped the air bubbles into the gouache-like colours or to the hydrogen sulphide released during decomposition of the animal glue medium.

37. *St Sebastian*
Galleria Franchetti, Ca' d'Oro, Venice

The canvas is a twill weave with perhaps a thin gesso ground. No samples could be taken. The paint layer is much thicker than the other distemper paintings. It was recently lined, and about 3 cm of the original image was folded over the tacking edge on the bottom. The top and the lateral sides are not visible, but presumably have also been reduced to fit the frame. The overall condition is good. A distinguishing feature is the slightly shrivelled surface that this painting has in common with the *St Sebastian* in the Louvre, and the paintings in Dresden and Mantua. Of particular interest is the painted marble frame around the image.

38. *Christ and Simon Carrying the Cross*
Museo di Castelvecchio, Verona

The fine canvas has a red *imprimitura*. No gesso was visible. The wax lining and heavy varnishing from previous restorations have darkened and abraded the paint layer. However, the painting has all the characteristics of distemper. The halo is painted with shell gold, and some *pentimenti* are visible when viewed with infra-red.

39. *The Infant Redeemer*
National Gallery of Art, Washington, DC (cat. 15)

The painting, which is painted on very fine linen, does not have a preparatory gesso ground.[46] The x-radiograph also shows that the painting may have been rolled up. Analysis found convincing indications that the medium was egg tempera.[47] The fact that there is no preparatory ground, and that considerable amounts of animal glue were found in the analysis, might suggest that a mixture of egg and glue may have been employed.

40. *The Sacrifice of Isaac*
Kunsthistorisches Museum, Vienna (cat. 132)[48]

The canvas is a fine linen weave with no apparent gesso ground, although in some areas a thin *imprimitura* is visible. The paint layer seems to be sensitive to water. The painting has been lined, retouched and varnished. Remnants of a black border are visible on all sides except the left.

41. *David with the Head of Goliath*
Kunsthistorisches Museum, Vienna (cat. 131)[49]

Technically, the painting is similar to its pair (no. 40). Again, the canvas is a fine linen weave with no apparent gesso ground. The paint layer, which is somewhat thicker than *The Sacrifice of Isaac*, also seems to be sensitive to water. The painting, which has been cropped on all four sides, has been lined, restored and varnished.

NOTES

I am particularly indebted to Dusan Stulik, Michelle Derrick, Michael Schilling and Eric Doehne of the Getty Conservation Institute for their inventive media analyses of innumerable paint samples. I would also like to thank Keith Christiansen for his innumerable suggestions and revisions, and Diane Mooradian for her patience in typing and editing.

1. See Wolfthal, 1989, p. 6.
2. See Bosshard, 1982, p. 41.
3. See A. Dürer, *Diary of his Journey to the Netherlands*, Greenwich, 1970.
4. See Cennini, ed. 1960, p. 102.
5. See nn. 37, 38, below.
6. Paintings in this technique are generally on very fine canvas with 23 or more threads per centimetre in either direction of weft or warp.
7. See report of the Opificio delle Pietre Dure, Florence, compiled by Paola Bracco, Ottavio Ciappi, Alfredo Aldovrandi and Marco Ciatti.
8. See Wolters, 1960, p. 161.
9. See Lightbown, 1986, p. 405.
10. See Newbery, Bisacca and Kanter, 1990, fig. 63, diagram erroneously under no. 64.
11. Erich Schleier, Curator, and Gerhard Pieh, Conservator, Staatliche Museen, were extremely helpful in providing me with photographs, slides, samples and an abundance of information.
12. Information kindly provided by Andrew O'Connor, Conservator of the National Gallery of Ireland.
13. The painting was recently restored by John Brealey.
14. Information kindly furnished by Peter Waldeis, Conservator of the Städelsches Kunstinstitut, and GCI analytical laboratories.
15. The painting was recently restored by Peter Waldeis, Conservator of the Städelsches Kunstinstitut.
16. I am indebted to John Brealey for the paint samples.
17. See Martindale, 1979, p. 127.
18. See Lightbown, 1986, p. 430.
19. *The Captives* was too damaged to warrant a restoration.
20. See Martindale, 1979, p. 126-8.
21. Information and annotations on cross-sections written by Joyce Plesters were kindly provided by Ashok Roy, Principal Scientific Officer of the National Gallery, London.
22. Information kindly provided by Jill Dunkerton, National Gallery, London.
23. See J. Mills and R. White, *Technical Bulletin*, National Gallery, London, I, September 1977, p. 58.
24. Information kindly provided me by David Bomford, National Gallery, London.
25. *Idem.*
26. Richard Wolbers, University of Delaware Art Conservation Program; notes from Workshop on New Methods in the Cleaning of Paintings, Getty Conservation Institute, 1990.
27. I am indebted to Giovanni Agosti from the Soprintendenza for his assistance.
28. See scientific report by EDITECH, Florence, in the Castello Sforzesco files.
29. The painting was restored by Pinin Brambilla Barcilon in 1987, to whom I am indebted for all her help and information regarding the painting.
30. Although the painting was reportedly cleaned with a dilute solution of sodium hydroxide by Mauro Pellicioli in Milan around 1940, it did not corrode the paint film, indicating the existence of some protective layer.
31. I am indebted to Mercedes Garberi, Director of the Musei Civici di Milano for her assistance.
32. *Lettere di Giuseppe Bossi ad Antonio Canova*, Padua, 1839.

33. *Inventario dei quadri di Olimpia Aldobrandini-Pamphili* [before 1665], ed. C. D'Onofrio, 1964, p. 207, no. 260: '*Un quadro con Nostro Signore morto in scorcio in una tavola con due donne, che piangono, alto p. tre incirca con cornice dorata di* Andrea Mantegna *in tela sopra tavola segnato n. 260*'.
34. I am indebted to Sig. Pini, Photographer of the Soprintendenza, for all his help and photographs.
35. I am indebted to Alessandra Mottola Molfino, Director of the Poldi Pezzoli, for her help and assistance.
36. The Getty Conservation Institute carried out carbon-14 dating on some fibre samples.
37. The restoration was carried out by Hubert von Sonnenburg, Chief Conservator of Paintings at the Metropolitan Museum of Art, New York.
38. I am indebted to Hubert von Sonnenburg, former Director of the Bavarian State Galleries, for his assistance and observations.
39. I am indebted to Rossana Muzii, Director of the Collection of Prints and Drawings of the Soprintendenza in Naples, for her kind help and assistance.
40. The restoration was carried out by John Brealey.
41. In northern paintings there are the following examples of *tüchlein* paintings glued or nailed to a panel:

- Netherlandish (Bruges Master?), *Crucifixion*, Memlingmuseum, Bruges. The canvas is stretched and glued to a panel but shows no nail holes (see Wolfthal, 1989, pp. 74-5).
- Albrecht Dürer, *The Dresden Altar*, Gemäldegalerie, Dresden (See Gross-Anders, 'Dürers Dresdner Altar und seine Rettung', *Maltechnick,* LXVII, 1961, pp. 68-81). The three sections of the altarpiece were stretched on three panels that were removed in 1840.
- Pieter Brueghel, *The Adoration of the Magi*, Musée des Beaux-Arts, Brussels. The painting was on a very rough wooden support which was removed and replaced by a lining canvas (see Philippot, Goetghebeur and Guislan-Wittermann, 'L'Adoration des Mages de Brueghel au Musée des Beaux-Arts de Bruxelles. Traitement d'un "Tüchlein"', *Bulletin de l'Institut Royal du Patrimoine Artistique, Brussels*, 1969). Recently, it was proven that the panel, which no longer exists, was the original one (it was used to restore the panel of *St John* in the *The Adoration of the Lamb* altarpiece by Van Eyck). See H. Veroughstraet, M. and R. Van Schoute, *Cadres et supports dans la peinture flamande aux 15ᵉ et 16ᵉ siècles*, Heure-le-Romain, 1989.
- Flemish, 16th century, *Calvary* Memlingmuseum, Bruges (see R.H. Marijnessen, *Paintings Genuine, Fraud, Fake: Modern Methods of Examining Paintings*, Brussels, 1985, pp. 332-5. The canvas in this painting is glued to a panel.
42. The Getty Conservation Institute did carbon-14 dating of the splinters.
43. I am indebted to Jean Habert, Dominique Thiébaut and Mme Faillant-Dumas for their invaluable help.
44. Analyses done by Jean-Paul Rioux and Elisabeth Martin in the Laboratoire de Recherche des Musées de France.
45. I am indebted to Françoise Viatte for allowing me to view the painting.
46. Condition report by Paula DeCristofaro, National Gallery, Washington, DC.
47. Analysis carried out by Susanna Halpine of the National Gallery, Washington, DC.
48. I am indebted to Karl Schütz, Director, Wolfgang Prohaska, Curator, and Robert Wald, Conservator, at the Kunsthistorisches Museum in Vienna.
49. See n. 48, above.

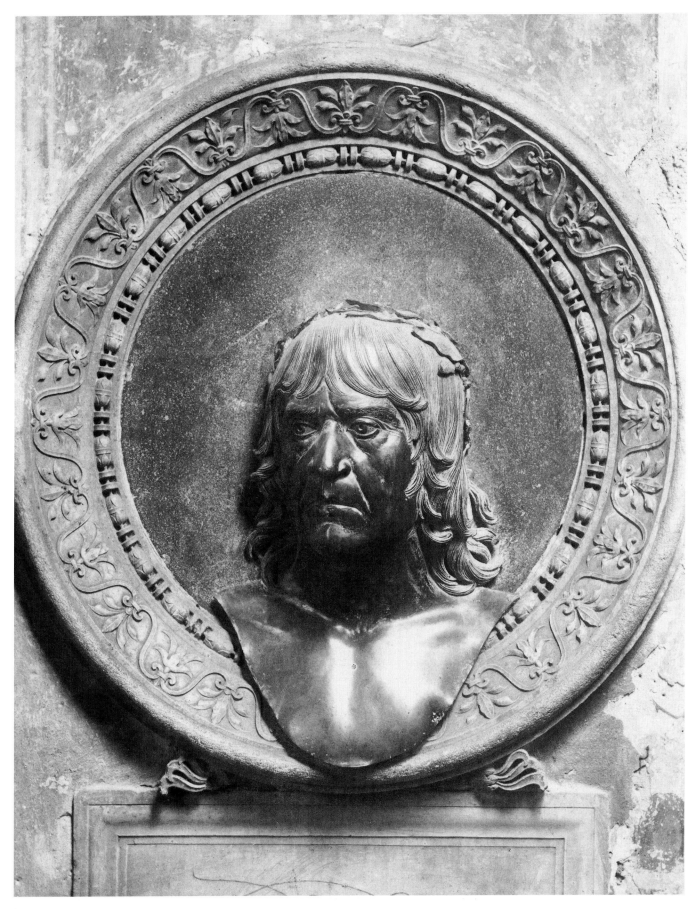

fig. 45 Bronze Bust of Andrea Mantegna, Sant'Andrea, Mantua

I

Portrait of Andrea Mantegna

Modern coloured plaster cast of the original bronze
bust by Andrea Mantegna of himself set on a disk of
porphyry within a frame of Istrian stone in his
memorial chapel in the Basilica of Sant' Andrea,
Mantua
Height of bust 47 cm; diameter of roundel 70 cm

Trustees of the Victoria and Albert Museum
(inv. 1893-498)

PROVENANCE
1893 purchased from E. Pierotti

REFERENCES
Scardeone, 1560, p. 372; Amadei, 1955, II, p. 440;
D'Arco, 1827, pp. 7-8; *idem* 1857, I, pp. 73-4; Fabriczy,
1888, pp. 428-9; Rossi, 1888, pp. 453-4; Bode, 1889,
pp. 211-16; Bertolotti, 1890, p. 61; Rossi, 1892, p. 483;
Kristeller, 1902, pp. 364-5, no. 149; Venturi, 1914,
VIII, 3, p. 252; Fiocco, 1937, pp. 102-3; *idem, 1940*,
pp. 224-8; Tietze-Conrat, 1955, pp. 19, 248;
Paccagnini, 1961, p. 74; Marani and Perina, 1961, II,
p. 74; Prinz, 1962, pp. 52-4; Middeldorf, 1978, p. 314;
Camesasca, 1964, pp. 49-50; Signorini, 1976,
pp. 205-12; Radcliffe, in London, 1981, pp. 121-2,
no. 30; Lightbown, 1986, pp. 131-2, 455-6, no. 62;
Signorini, 1986², pp. 23-42; Jones, 1987, p. 73

The original bronze bust (fig. 45) is set on
the left flank of the entrance to the first
chapel in the left-hand aisle of Sant' Andrea
(chapel of San Giovanni Battista). Below it is
a panel carved with the inscription '*ESSE
PAREM / HVNC NORIS / SI NON PREPO / NIS
APELLI / AENEA MA(N)TINIAE / QUI
SIMVLACRA / VIDES*' ('you who see the
bronze images of Andrea Mantegna know
him to be equal if not superior, to Apelles'),
and above it a painted inscription, now
largely effaced, which, as established by
Signorini, originally read '*M.D.XVI /MENS(IS).
OCTOBRIS / DIE. XXI*' (21 October 1516).
The bust is in the form of a classical Roman
imago clipeata and is laureate.

In his will of 1 March 1504 Mantegna set
aside a sum of 200 ducats for his mausoleum,
and in August of the same year the Canons
of Sant' Andrea granted him the chapel of
San Giovanni Battista which was at that time
undecorated. Announcing his father's death
to Marchese Francesco Gonzaga on
2 October 1506, Ludovico Mantegna stated
that his father had left 200 ducats for the
memorial chapel, which was to be finished in
a year. Work on the decoration of the chapel
must have begun soon after Mantegna's
death, but, as two inscriptions in the chapel
show, it was not finished until the autumn of
1516. No contemporary documents relating
to the modelling, casting or installation of the
bust have been discovered.

Scardeone, writing in 1560, stated that
Mantegna had cast the bronze bust himself
(' ... *sepultus est humi in phano divi Andreae, ubi
aeneum capitis eius simulacrum visitur, quod suis
sibi conflaverat manibus* ... ': ' ... he is buried in
the church of Sant' Andrea, where the bronze
portrait of his head can be seen, which he cast
for himself with his own hands ... ').
Nevertheless, in the 18th century and for
most of the 19th, as recorded by d'Arco, it
was traditionally ascribed to the Mantuan
medallist Sperandio. Fabriczy, who believed
the bust to be posthumous, removed it from
Sperandio, who died *c.* 1500, and proposed an
attribution to the Mantuan medallist Melioli
(d. 1514). Rossi, however, tentatively
suggested the name of the goldsmith Gian
Marco Cavalli (*c.* 1454 – *c.* 1508), a friend and
associate of Mantegna, and this ascription was
long generally accepted. Bode made use of it
to ascribe to Cavalli the bronze clipeate bust
of Giovanni Battista Spagnoli, now in Berlin,
which is clearly by a different hand, and must
date from long after Cavalli's death. Tietze-
Conrat argued that Scardeone's statement
referred only to the process of casting, and
that the bust was cast by Mantegna from a
life-mask of himself. However, as noted by
Paccagnini, the bust does not have the
character of a life-mask, and Scardeone's
statement should be taken as referring to the
whole creative process. This view was
supported by Camesasca and by Middeldorf,
who argued that the bust is not the work of a
professional sculptor. There seems to be no
good reason for doubting Scardeone's
statement, which must record an early local
tradition, and the bust is likely to be in both
modelling and casting the work of Mantegna,
who is several times stated in early sources to
have practised as a modeller, and who appears
to have been competent at casting bronze.
Several contemporaries of Mantegna allude to
these activities: in his rhyming chronicle,
Giovanni Santi said that Mantegna worked
'in relief in pleasing and graceful fashion so as

to show sculpture how much heaven and the
sweet graces have bestowed upon him', and
Battista Spagnuoli, in a poem of *c.* 1486-97,
claimed that Mantegna had surpassed the
greatest ancient Greek sculptors, as well as
their painters (Kristeller, 1902, pp. 491-2;
Lightbown, 1986, pp. 131, 161, nn. 68-70).

Amadei, writing in the mid-18th century,
described the bust as having the pupils of the
eyes inlaid with two diamonds. The pupils are
unusually deeply bored, and the statement
should not necessarily be discounted. If
Amadei was mistaken, and they were not set
with diamonds, it remains possible that they
were inlaid with some other bright material,
such as paste or glass.

The bust was removed by the French early
in 1797 and installed in the Louvre in April of
that year. It was recovered from there in
October 1815, and reinstalled in the chapel in
March 1816. It is clear from the records that
only the bust was removed and not the
roundel, and it is therefore likely that it
occupies its original position. A drawing of
the monument by Bettinelli of 1794 showing
the bust with draped shoulders and contained
within the frame of the roundel is inaccurate
in many respects: it seems to have been drawn
from memory, and is not evidential for an
original setting of the bust, which must have
been designed to be set as it is today.

It is generally agreed that the bust must
have been modelled and cast in about
1480-90, when Mantegna was in his fifties,
and it was probably cast in the ordnance
foundry in Mantua. The roundel, which must
be to Mantegna's own design, would have
been carved by a professional stonemason. In
view of the painted inscription above it, the
installation of the monument is likely to have
been completed on 21 October 1516.

A.F.R.

2a, b

GIOVANNI ANTONIO DA BRESCIA
Portrait of Andrea Mantegna (?)
(Old Man in a Cap)

Engraving
(**a**) 104 x 67 mm
(**b**) 142 (including margin below) x 119 mm
(sheets; plate 135 x 120, Vienna)
H.LdV.2
(B) Inscribed (in pen): *IL MANTEGNA*

The Trustees of the British Museum, London
(1845-8-25-617; 1921-11-15-13)

REFERENCES
Bartsch, 1811, XIII, 242.23 (Mantegna); Hind, 1948, V,
86.2 (under Leonardo da Vinci)

2a

Leonardo da Vinci was in Mantua at the end
of 1499 and early in 1500 – the exact length
of time is not known – where he made a
drawn portrait of Isabella d'Este (see
Martineau, in London, 1983, pp. 159-60).
There is no record of a meeting between the
47-year-old Leonardo and Mantegna, then
about 70, but it is inconceivable that these
two great artists would not have met even if
Leonardo's stay in Mantua was as short as a
few weeks. This engraving would seem to be
an indirect record of such a meeting. Since
the 18th century at least, the portrait has been
recognised as a design by Leonardo, but the
sitter, apparently, has never been identified.
One of the two impressions exhibited here,
and also one in Paris (Bibliothèque
Nationale), bear a hand-written inscription
'*IL MANTEGNA*'; perhaps because of this
Bartsch attributed the engraving to
Mantegna, and Hind simply remarked that
the inscription 'shows that Bartsch's
attribution was probably derived from an
earlier suggestion'. It seems to have occurred
to no one that Mantegna could be the person
depicted as the 'old man in a cap', as Bartsch
and Hind called it.

By comparing the features in this engraving
with those of the portrait bust (fig. 45) and
the self-portrait inserted in one of the foliate
pilasters of the Camera Picta (fig. 95), it
would seem very probable that the engraving
records a lost portrait drawing of Mantegna
by Leonardo. The large hooded eyes set
under a strong brow, the long straight nose,
pendulous lower lip and square chin visible in
the earlier portraits can all still be seen here,
although the face is obviously worn by age
and illness. If it is Mantegna, it is the last
portrait we have of him. Leonardo's
depiction is sympathetic but unsentimental –
and thereby all the more touching. The
insolence and bravado of the earlier years are
gone, and what we see is the frailty of human
flesh. To paraphrase Willibald Pirckheimer's
epitaph for Albrecht Dürer: 'Here can be
seen what was mortal of Andrea Mantegna'.
Most of the engravings after Leonardo's
designs are by Giovanni Antonio da Brescia.
Hind recognised that many, including this
one, were by one hand, which he called

'possibly' Zoan Andrea, doubtless choosing
that name rather than that of Giovanni
Antonio since some of the images
monogrammed 'ZA' were connected with
Milan; writing specifically of this print, he
called the engraver 'very probably' Zoan
Andrea.

Giovanni Antonio made perhaps fifteen
engravings after Leonardo's designs. None of
these has a signature, which have helped in
dating the engravings, although there seems a
good possibility, to judge by the plate size,
that the *Four Studies for an Equestrian Statue*
(Hind V, 87.7) was engraved on the reverse of
the same plate as *Hercules and the Bull of
Marathon* (H. V, 41.16), which bears Giovanni
Antonio's Latinate signature and thus
probably dates from 1506 or later. Further,
the *Four Studies* was engraved on a plate
already used for one of Giovanni Antonio's
lascivious subjects, *Two Women* (H. V, 67.17;
incidentally, according to Hind, the *Four
Studies* is offset on the *verso* of an impression
of Giovanni Antonio's copy of the *Risen
Christ*, in the Gabinetto Nazionale, Rome).
What seems most likely is that Giovanni
Antonio made these engravings when
Leonardo was in Milan between 1506 and
1512, or even in Rome between 1512 and
1515, after which time Leonardo left for
France.

Nine impressions of the print are known.
The image was engraved on the back of the
same plate as the *Virgin and Child,* also after
Leonardo (H. V, 86.1).

S.B. and D.L.

2b (actual size)

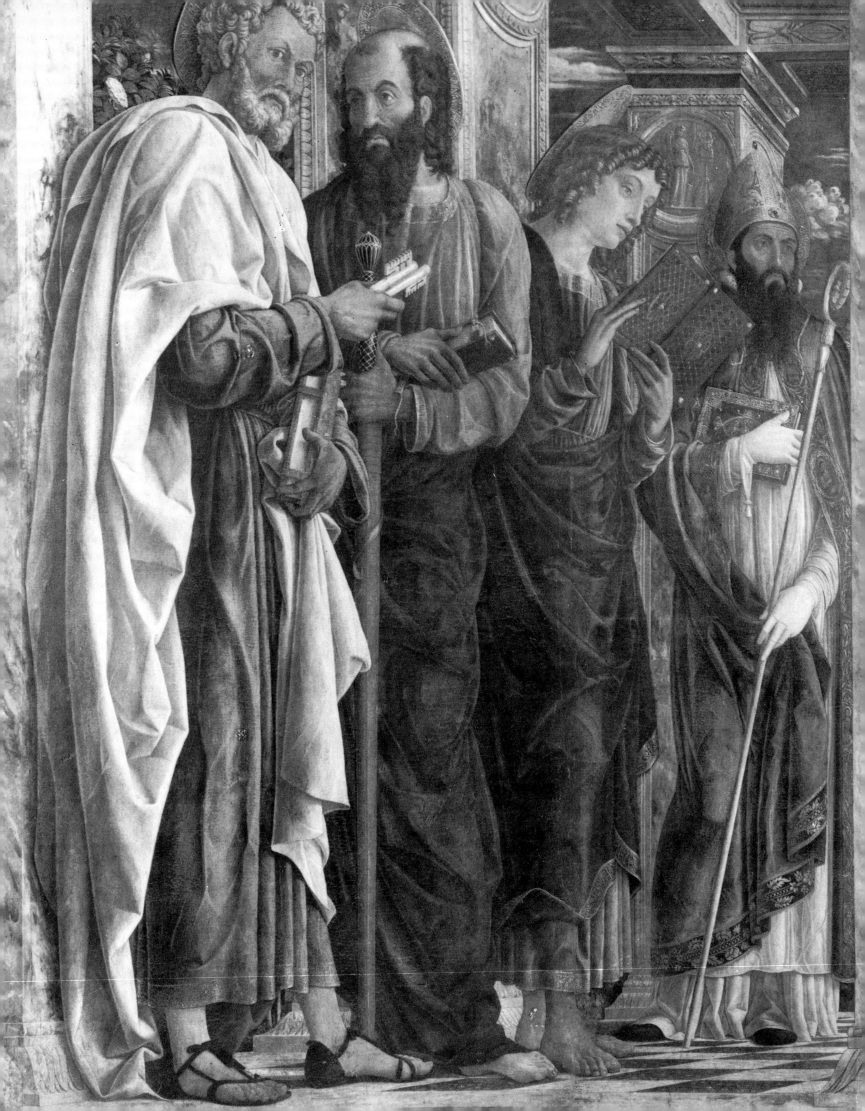

I EARLY WORKS: PADUA

From 1440 to 1460, when he moved to Mantua to become court artist to the Gonzaga family, the centre of Mantegna's activity was Padua, from 1405 part of the Venetian state on the *terraferma* and seat of one of the most renowned universities in Europe. It was in this city of jurists and scholars that Mantegna was apprenticed and his vision of art was formed. 'No man', wrote Giovanni Santi, the father of Raphael, in his rhymed chronicle, 'has ever taken up the brush or other tool who was more truly the brilliant successor of Antiquity.'[1]

So closely did Mantegna ally his art with the intellectual aspirations of the humanist movement and the specifically antiquarian interests of the circle of friends he forged in Padua, that there is a temptation to treat its character as if predetermined by his training in the birthplace of Livy and his subsequent career in Virgil's native city.[2] Yet, so radical was his break with Paduan painting of the preceding generation that his work has been seen as a direct offshoot of Florentine art.[3] Precisely because our view of Mantegna's origins bear directly on the works that may be ascribed to his early career, a somewhat detailed discussion of the evidence is unavoidable.

Mantegna must have moved to Padua from the village of Isola di Cartura in the Paduan countryside around 1441-2, when he began a six-year apprenticeship with Francesco Squarcione (1394/7-1468). These were exciting years for a young, ambitious artist. Leon Battista Alberti's treatise on painting, the *De Pictura*, written in 1435, was circulating in humanist circles, establishing an intellectual basis for the displacement of a still-dominant taste for what has come to be known as the International Gothic style. In Padua, the major exponent of this current was Stefano 'da Verona', active in the city from 1396 to 1421.[4] Alberti had been educated in Padua, and copies of his treatise must have been available there. In the mid-1430s Filippo Lippi worked in the city, leaving behind several important works, none of which survive,[5] and Andrea del Castagno must have passed through Padua *en route* for Venice, where in 1442 he frescoed the apse of the church of San Tarasio and left designs for part of the mosaic decoration of a chapel in San Marco.[6] Paolo Uccello decorated a room in the Vitaliani palace, perhaps in 1445, with a cycle of giant figures painted in monochrome that Mantegna purportedly admired.[7] But the crucial artist was Donatello, who lived in the city for ten years, from 1443 to 1453, during which time he undertook three major commissions for bronze sculpture: the great equestrian monument of the *condottiere* Erasmo da Narni, better known as Gattamelata, and the high altarpiece and a crucifix for the basilica of Sant'Antonio (the Santo).[8] He must, in addition, have created a variety of less conspicuous but equally influential works for private patrons, including terracotta reliefs and bronze plaquettes of the Virgin and Child.[9] He employed as an assistant a young painter of consequence with whom Mantegna was to be associated, Niccolò Pizzolo (1421-53). Of equal importance was the close and continual contact Paduan artists had with the two most forward-looking workshops in Venice, those of Jacopo Bellini and, more particularly, of Giovanni d'Alemagna and Antonio Vivarini.

Throughout the 1440s, the leading workshop in Padua was that of Francesco Squarcione, Mantegna's

fig. 46 Andrea Mantegna, *SS. Peter, Paul, John The Evangelist and Zeno*, left wing of the San Zeno Altarpiece, panel, 213 x 134 cm, 1456-9, San Zeno, Verona, detail

teacher and adoptive father.[10] Squarcione's role in the creation of an indigenous, northern Italian Renaissance style has long been a matter of debate, exacerbated, on the one hand, by his self-proclaimed status as the head of the Paduan school of painting – 'the most singular and outstanding teacher of all painters of his time', wrote Scardeone in 1560 (see p. 9)[11] – and, on the other, by the survival of only two tentatively painted pictures, both post-dating Mantegna's apprenticeship. By his own account, Squarcione had travelled extensively, not only in Italy but in Greece, gathering material for the creation of a sort of painting academy in which his pupils – an incredible one hundred and thirty-seven by Squarcione's count – copied from his accumulated drawings and casts, and purportedly received a theoretical grounding in perspective and foreshortening. It has been proposed that the model for this novel institution was Gasparino Barzizza's humanist school in Padua.[12] If this could be proved, then a strong case could be made for Squarcione's importance in forming Mantegna's conception of painting as a liberal discipline rather than a mechanical art. However, the evidence is ambiguous.

The son of a notary who had served the former lords of Padua, Squarcione was trained as a tailor, the trade of the uncle with whom he lived. He seems to have decided upon a career as a painter only at an advanced age: the first recorded commission dates from 1426.[13] Moreover, despite the theoretical pretensions he espoused, documents tell a tale of a series of menial tasks: decorating a tabernacle door (1433), an organ case (1441) and the floor before an altar (1449).[14] The evidence of his ability to teach pupils the principles of Renaissance art is no less compromised. In 1465 he lured a prospective apprentice with the promise of teaching him 'the true rule of perspective and everything necessary to the art of painting', declaring '... I made a man of Andrea Mantegna, who stayed with me, and I will do the same to you'. A few months later the disillusioned pupil sued for breach of contract, maintaining that 'the said master

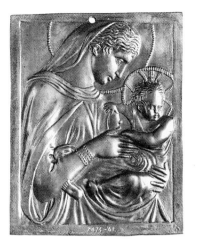
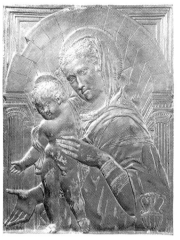

fig. 47 Follower of Donatello, *Virgin and Child*, bronze plaquette, 11.6 x 9.4 cm, Victoria and Albert Museum, London

fig. 48 Follower of Donatello, *Virgin and Child within an Arch*, bronze plaquette, 20.3 x 15.2 cm, National Gallery of Art, Washington, DC

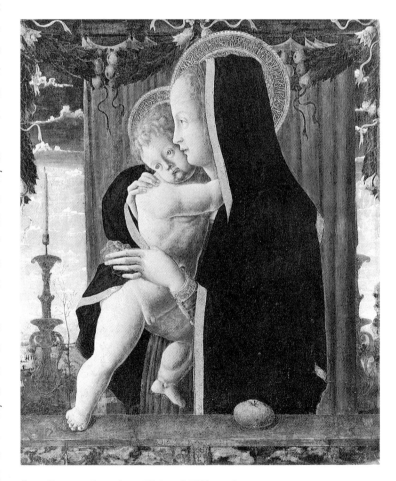

fig. 49 Francesco Squarcione, *Virgin and Child*, panel, 82 x 70 cm, Gemäldegalerie, Berlin

Francesco [Squarcione] has not and cannot give anything but promises, but the facts he cannot give because he does not possess them'.[15] Were this the sole suit against Squarcione by a pupil it might be dismissed, but such is not the case, and one must conclude that Squarcione's ambitions far outstripped his abilities. Scardeone, in his otherwise laudatory biography, says as much, recording what appears to have been a widespread opinion that Squarcione 'was certainly a man of greatest judgement in art, but … not much practised'.[16] The first part of this report seems corroborated by Squarcione's repeated employment as an arbiter, while the second is borne out by the artist's two certain works.

The earliest of these is a polyptych (Museo Civico, Padua) painted between 1449 and 1452 for the De Lazara Chapel in the church of the Carmine.[17] It is a curious work, combining a noteworthy interest in some of the most progressive ideas of the day with a weak technique and a markedly superficial grasp of the problems tackled. The conceit of the lateral figures, posed like statues on small, misshapen marble pedestals before low, semicircular walls, derives from an idea explored by Giovanni d'Alemagna and Antonio Vivarini as early as 1441, and employed by them in a polyptych painted in 1447 for the church of San Francesco in Padua (National Gallery, Prague). The centre panel shows St Jerome, his bent arm propped on a rustic table foreshortened in the exaggerated fashion found throughout Jacopo Bellini's drawing albums in the British Museum and the Louvre. In the second picture, a signed *Virgin and Child* (fig. 49; Gemäldegalerie, Berlin), a spirited child collides against the impassive form of his mother, who is viewed in strict profile.[18] Painted for the same patron as the altarpiece, but about five years later, its composition is an amalgam of motifs culled from contemporary sculptural reliefs from the circle of Donatello. The perfunctory execution of both works (the De Lazara altarpiece is badly damaged) explains why Squarcione repeatedly relied on assistants to execute his commissions.

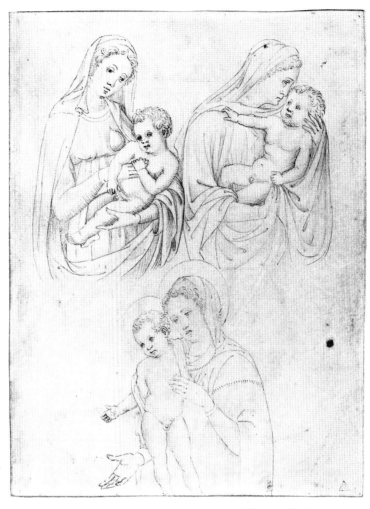

fig. 50 Circle of Pisanello, *Three studies of the Virgin and Child*, pen and ink, 275 x 195 mm, *c*. 1440, Musée Condé, Chantilly (Ecole Florentine et Romain I, no. 4)

What initially attracted the many assistants to Squarcione's shop seems to have been the opportunity to study his extensive collection of drawings. When, for example, the nineteen year-old Dario da Treviso entered into a two-year contract in 1440 – a year before Mantegna – he agreed to work in return for an allowance, instruction and the use of Squarcione's drawings. Copying from drawings, or '*exempla*', to use the term employed in a similar contract of 1431 with a certain Michele di Bartolomeo, was hardly new. It is described as part of the normal training of apprentices by Cennino Cennini,[19] who spent a good part of his career in Padua, and it was, interestingly enough, approved of by

Gasparino Barzizza, who advised a fellow teacher of Latin to do 'what good painters practise towards their pupils; for when the apprentices are to be instructed by their master before having acquired a thorough grasp of the theory of painting, the painters follow the practice of giving them a number of fine drawings and pictures as models (*exemplaria*) of the art'.[20] The key, as both Cennino and Barzizza recognised, was to choose the right models. The repeated references in contracts to Squarcione's drawings suggest that those he had assembled offered a variety of material that could not readily be found elsewhere.

Of what did this collection consist? If Squarcione is taken at his word, he had studies after both ancient and modern works of art gathered during his travels in Italy and Greece.[21] These drawings must have been carried out in the precise hand characteristic of late Gothic graphic practice then still current. As it turns out, a group of drawings of exactly this sort – a *taccuino di viaggio* – exists.[22] Compiled in the workshop of Squarcione's great contemporary Pisanello, the group presents a curious anthology of heterogeneous interests: copies after ancient sarcophagi, paintings by Lombard and Florentine masters and contemporary Tuscan sculpture, including three Donatellesque compositions of the Virgin and Child based on plaquettes (figs. 47, 48).[23] Squarcione was evidently familiar with, and possibly actually owned, a cast of one of these plaquettes (fig. 47), from which his painting of the Virgin and Child in Berlin depends for the curiously posed left hand of the Virgin. This is held parallel to the picture plane with the fingers bent in a way that makes little visual sense in the painting, but in the plaquette helps to establish the depth of the relief.[24]

This *taccuino* establishes a context for evaluating the novelty of Squarcione's purported interests and method of teaching. Yet, important though such drawings may have been to Squarcione's pupils – Dario da Treviso, Marco Zoppo, Giorgio Schiavone and Mantegna – the timid, late Gothic style in which they were doubtless

carried out made them useful only as compositional models.[25] Of greater importance were Squarcione's collection of casts and sculptural reliefs, which he kept in two studios (see p. 9).[26] Once again, there are parallels for this sort of artist's collection in the Veneto, for among the materials Gentile Bellini inherited from his father's workshop in 1471 were 'works of gesso, marble, and reliefs'.[27] When, in 1455, Marco Zoppo dissolved his association with Squarcione, he received as compensation for his work 'pictures, casts, medals, and other studio props' worth a total of 20 ducats.[28] His own later drawings of the Virgin and Child reveal just how important Donatellesque reliefs (including plaquettes) remained as creative stimuli – and so also do the devotional paintings of other pupils of Squarcione (fig. 51).[29] That Mantegna's conception of the theme of the Virgin and Child should be so closely bound up with Donatello's is, therefore, hardly surprising. Vasari reports that Squarcione, recognising his own limitations (and, we may add, the limited usefulness of his drawings as models), set his prodigiously gifted pupil to work drawing from casts, by which we ought probably to understand casts after contemporary relief sculpture rather than the antique statues Vasari conjured up.

One of the difficulties in evaluating Squarcione's impact on northern Italian painting is that the components of his workshop and the nature of his teaching must have been continually updated to meet rapidly changing tastes. When he took on his first documented pupil in 1431, he could have had no operative knowledge of perspective and no drawings after Renaissance works of art, of which there were at that date but a handful in Florence and Rome. Not until 1467 do we hear of Squarcione promising to teach the rules of perspective to an assistant, and only towards 1440 is there evidence for painters having collections of drawings and casts after ancient works of art as part of their workshop property. The drawings in the *taccuino di viaggio* from Pisanello's circle, referred to above, reflect

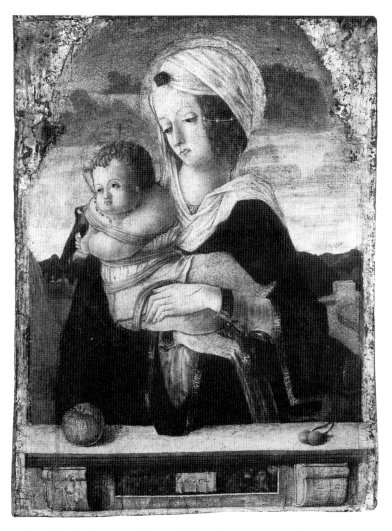

fig. 51 Giorgio Schiavone, *Virgin and Child*, panel 52 x 44 cm, *c.* 1460, Museo Correr, Venice

the humanist culture of Ferrara, inspired by Alberti's precepts, as do the drawings in the albums of Jacopo Bellini, and it is unlikely that Squarcione conceived of such a collection of drawings without a similar stimulus. But as time went on his collection expanded. Vasari specifically mentions that Squarcione purchased pictures on canvas (!) imported from Tuscany and Rome. It may be that Squarcione profited from Filippo Lippi's sojourn in Padua in the mid-1430s to secure examples of his work – or at least of his draughtsmanship.[30] Similarly, Donatello's ten-year sojourn provided Squarcione ample opportunity to supply his studio with casts after reliefs of

the Virgin and Child. It is hardly coincidental that the first document mentioning such casts being made in Squarcione's studio is the contract of 1455 with Marco Zoppo, who was required to furnish gesso for modelling figures.[31] This is likely to refer to reliefs manufactured in the studio and then polychromed for sale.[32] In 1466 Squarcione owned a drawing by Niccolò Pizzolo, probably purchased from Pizzolo's estate following the artist's murder in 1453; it was used as the basis of a now-lost altarpiece painted by Pietro Calzetta. Eight years later, in 1474, Squarcione's heirs were still trying to recover a 'cartoon of certain nudes by Pollaiuolo' stolen by Schiavone when he left Squarcione's workshop and returned to his native Dalmatia in 1461.[33] It is difficult to believe that Pollaiuolo would have readily parted with a highly finished cartoon, and the work may have been an impression of his engraving of the *Battle of Nude Men*.[34]

If this reconstruction of Squarcione's '*curriculum*' is accepted, then the role he played as Mantegna's teacher is fairly clear. He introduced his brilliant young pupil to a wide spectrum of ideas and pictorial sources, albeit imperfectly and without true understanding. It may have been in Squarcione's shop that Mantegna first set eyes on an Italian manuscript of Alberti's treatise with its humanistic vision of the artist, and that, through Squarcione's collection of medals, plaquettes and sculptural reliefs, he caught a glimpse of the expressive potential of Renaissance art. Yet, the very presence of these items must have diminished Squarcione's own capacity in the eyes of Mantegna, particularly as this perspicacious pupil compared his master's work with what had been produced by the visiting Florentines and Venetians, foremost among whom were Antonio Vivarini and Giovanni d'Alemagna.[35] The matter would have become particularly acute after 1447, when the first bronze reliefs for Donatello's altar in the Santo were cast.

By this time Mantegna had assumed an increasingly dominant role in Squarcione's shop, particularly after the departure of his fellow assistant, Dario da Treviso, in

1446. It was Squarcione's practice to adopt his most gifted pupils, partly to avoid responsibility of reimbursing them for their work. Mantegna later claimed that the value of the pictures he had carried out as an apprentice – 'from which maestro Francesco [Squarcione] accrued no small advantage and profit'³⁶ – surpassed the very considerable sum of 400 ducats. Interestingly, Mantegna's bitter break with his adoptive father occurred not in Padua but in Venice, where Squarcione was living temporarily in 1447. One of the arbiters of the dissolution, formalised on 26 January 1448, was the notary and amateur poet Ulisse degli Aleotti. An admirer of Jacopo Bellini, Aleotti soon became one of Mantegna as well, and it may have been through him that the two artists met.³⁷ Jacopo possessed a far broader culture than Squarcione and his works were prized not only in Venice and Padua, but in Ferrara, Verona and Brescia. A glimpse at Jacopo's two albums of drawings, with their imaginative recreations of ancient monuments, their innovative treatment of religious and mythological subjects in terms of everyday life and their interest in perspective, would have convinced Mantegna that here was an artist who combined practice with understanding. His marriage to Jacopo's daughter Nicolosia five years later formalised his association with the Bellini family and, if Vasari is to be believed, further alienated his teacher. The importance of Jacopo Bellini's work for Mantegna, especially his use of colour, praised by the medical doctor and scientist Giovanni da Fontana in his treatise on colour and aerial perspective, has long been recognised, but it is perhaps well to emphasise that Jacopo's discursive approach to narrative painting made a strong and lasting impression on his future son-in-law.

Even before his formal separation from Squarcione, Mantegna had begun to undertake independent commissions. An altarpiece for the church of Santa Sofia in Padua was begun in 1447 and completed the following year, when, according to the inscription it bore, Mantegna was only seventeen years old.³⁸ Describing the altarpiece, which has long since disappeared, Vasari wrote that it 'appeared the work of an old, practised artist rather than a youth'. In attributing works to this early phase of Mantegna's career, it is important to bear in mind that Vasari's comment refers to the level of accomplishment, not to any stylistic relation to the artist's mature pictures.

The turning-point in Mantegna's career occurred in 1448. In May of that year he and three other painters were contracted to decorate the funerary chapel of Antonio degli Ovetari in the church of the Eremitani with a cycle of frescoes that changed the course of northern Italian Renaissance painting.³⁹ Mantegna took on the task in partnership with a slightly older artist of remarkable genius and difficult temperament, Niccolò Pizzolo, and in collaboration with Giovanni d'Alemagna and Antonio Vivarini. According to Vasari, the initial commission went to Squarcione, who of necessity put forward his two former pupils; but in fact the four artists were selected as the most outstanding painters available, Giovanni d'Alemagna and Antonio Vivarini having worked alongside Andrea del Castagno in Venice and having produced the most forward-looking altarpiece for a Paduan church in 1447, and Pizzolo having been employed by Donatello on the altar for the Santo. By 1448 Pizzolo was rightly regarded as the most progressive local artist:⁴⁰ in November 1448 a certain Luca di Puglia offered himself as an apprentice to Pizzolo 'in order to learn to paint in the modern style' ('*ut disceret pingere in recente*').⁴¹ The collaborative partnership between Pizzolo and Mantegna was short-lived but decisive.

The frescoes of the Ovetari Chapel were all but destroyed by an Allied bomb in 1944 – only two scenes and some fragments (cat 6) remain – and it is only with difficulty that their full novelty can be appreciated. The chapel itself was undistinguished, consisting of a vaulted rectangular space separated from a pentagonal tribune by an arch. Pizzolo and Mantegna were responsible for decorating the tribune, the tribune arch and one wall of the Chapel, as well as for making a terracotta altarpiece

(this latter task fell to Pizzolo). The first decision must have been to adopt the system of illusionistic architecture that was used to confer on the Chapel a more modern appearance as well as to integrate the various figural components. The ribs of the vault were transformed into swags flanked by feigned stone mouldings from which further swags were shown as though suspended in space, in front of figures of saints and God the Father. Flanking a circular window below the vault were painted stone oculi, projected *di sotto in sù* – again with swags suspended from iron rings – through which the four Doctors of the Church were portrayed at work in their studies (fig. 55). A feigned cornice separated this portion of the tribune from the lower walls, pierced by four tall windows surrounded by painted Renaissance mouldings. An identical moulding at the centre of the tribune framed the *Assumption of the Virgin*, with the apostles shown spilling into the space of the tribune itself. The same system of feigned stone mouldings, decorated with clusters of fruit and sculpted busts, was carried over into the Chapel as a framework for the scenes of the lives of SS. James and Christopher, and here again swags of fruit as well as frolicking putti and shields bearing armorial devices were used to increase the illusionistic effect.

Pizzolo's work in the tribune of the Ovetari Chapel post-dates his association with Donatello and demonstrated not only his incomparable mastery of perspective, but an approach to figural painting based on the innovative use of sculptural models. In the figure of God the Father (fig. 52; destroyed), for example, the cavity between the legs was articulated by a heavy fold of cloth and the sleeve of the left arm was bunched up above the elbow in a fashion that presupposes study from an actual draped model or mannequin. The impression of three-dimensionality was comparable to that of the Virgin in his terracotta altarpiece, to which the same creative process was applied. That Pizzolo's work before 1446, when he is first mentioned as an assistant to Donatello, was conceived along more conventional lines,

fig. 52 Niccolò Pizzolo, *God the Father*, fresco, 1448-53. formerly in the apse of the Cappella Ovetari, Chiesa degli Eremitani, Padua

is suggested by the only extant picture that may plausibly be ascribed to him: the centre panel of a polyptych, the background of which has been regilt, showing a bishop-saint seated on an elaborate, Renaissance throne (fig. 53; Musée Jacquemart-André, Paris).[42] The rich, surcharged decoration of the throne depends from Donatello, but the frontal pose of the figure, whose right hand reads as a flat shape rather than a three-dimensional form, indicates that this impressive work, painted with a precise brushwork equalled only in the work of Mantegna, predates his adoption of Donatello's creative working procedure.

fig. 53 Here attributed to Niccolò Pizzolo, *Enthroned Bishop-Saint*, panel,
73.1 x 52.1 cm, 1445-50, Musée Jacquemart-André, Paris (no. 1022)

The degree to which Mantegna absorbed the lessons
Pizzolo had to offer can be gauged from the fact that
the work the younger artist painted in the Ovetari
Chapel in 1448 and 1449 was long ascribed to his older

partner; only when the document establishing the
responsibilities of each artist was published in 1928
did Mantegna's role become clear.[43] What he appro-
priated was not so much the external idiosyncracies of
Pizzolo's style, as the technique of employing draped
mannequins or sculpted ·models to obtain a three-
dimensional effect. This is readily apparent in photo-
graphs of Mantegna's *St Peter* (fig. 54), where the drapery
clings to the underlying body like wet cloth dipped in
gesso, and the *Seraph* (cat. 6), in which the feigned
moulding was used to enhance the three-dimensionality
of the figure. The same technique underlies what may
be Mantegna's earliest extant picture, *St Jerome in the
Wilderness* (cat. 3).

The discipline of studying from sculptural models
inevitably influenced Mantegna's creation of a drawing
style that aimed at describing the underlying structure of
a form and its position in space with quick, probing, but
frequently sketchy penstrokes overlaid with a network of
parallel lines to suggest tonal effects (see cats. 11, 28). This
revolutionary style – so different from the conservative,
more purely tonal concerns of Jacopo Bellini and the
delicately descriptive penwork of Pisanello – was adopted
by Mantegna's slightly younger contemporaries, Marco
Zoppo and Giovanni Bellini, but without the same
grounding in the use of modelled figures and without the
same volumetric results. It became the foundation of a
distinctly northern Italian graphology, and was translated
by Mantegna into an engraving style no less revolu-
tionary. How much this style owed to Donatello or
Pizzolo is conjectural, since there are no certain drawings
by either master.[44]

No less important for Mantegna was Pizzolo's mastery
of perspective and his employment of it for both expres-
sive and illusionistic effects. Pizzolo's most revolutionary
contribution to the decoration of the Ovetari Chapel was
the four Doctors of the Church shown behind desks, at
work in their studies. A close analogy for the enframing
circular mouldings, embellished with marble insets or

fig. 54 Andrea Mantegna, *St Peter*, fresco, 1448-50, formerly in the apse of
the Cappella Ovetari, Chiesa degli Eremitani, Padua

carved decoration, occurs in the background architecture
of Donatello's bronze relief of the *Miracle of the Miser's
Heart* for the Santo altar. Interestingly, in a circular relief
of the *Virgin and Child* for the Chapel of St Calixtus
in Siena Cathedral, dating from 1457-8, Donatello
employed a similar frame, with the inner surface enriched
with real, rather than feigned, squares of marble, but in
which the figures overlap the frame so that they seem
catapulted into the viewer's space. In Pizzolo's frescoes,
the frame describes a fictive window through which the
Church Doctors are viewed. Mantegna's early painting
of the evangelist St Mark, positioned behind an arched
window casement (cat. 5), combines the attitude of

Pizzolo's St Gregory (fig. 55) with Donatello's use of the
architectural frame as an illusionistic foil for the figure,
and in much of his subsequent work – the 1452 frescoed
lunette for the façade of the Santo, the *St Euphemia*
(cat. 13), the San Zeno Altarpiece (fig. 66), the *St George*
(cat. 42) and the *St Sebastian* (Ca' d'Oro, Venice) – the
affective power of the image is bound up with the use of
an illusionistic frame. The *tour de force* of illusionism in
the Camera Picta in Mantua was but a further
development of this experiment in the Ovetari Chapel.

Fruitful though Mantegna's partnership with Pizzolo
was, his conception of art differed in essential ways and
the two were temperamentally incompatible, neither
being able to abide the competition of the other. In an
arbitration of 1449 that put to an end what must have

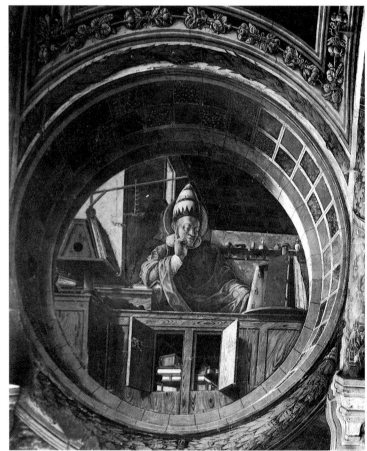

fig. 55 Niccolò Pizzolo, *St Gregory in his Study*, fresco, 1448-53,
formerly Cappella Ovetari, Chiesa degli Eremitani, Padua

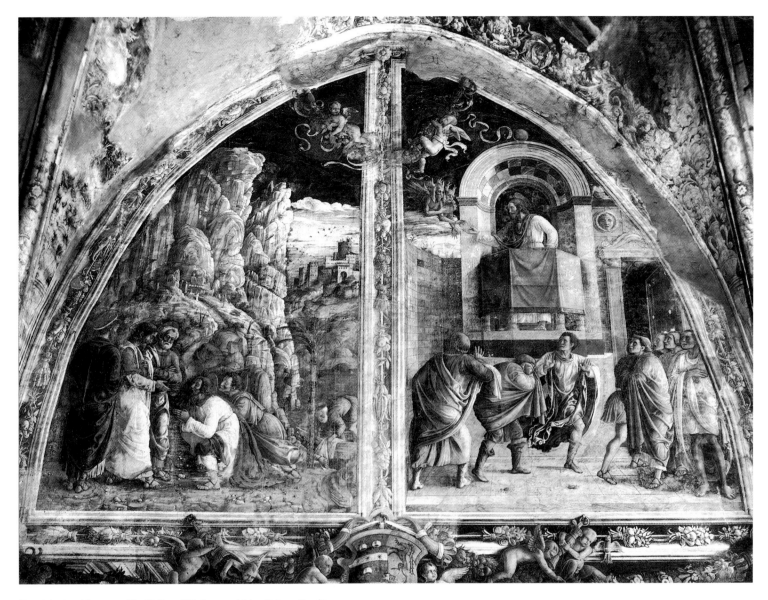

fig. 56 Andrea Mantegna, *The Calling of SS. James and John; St James Preaching*, frescoes, 1449-50, formerly Cappella Ovetari, Chiesa degli Eremitani, Padua

been continual haggling between the two artists, it was not only necessary to divide their pay and assign them separate tasks, but an agreement had to be reached that would allow them to carry out their work without interference from each other. 'Master Andrea [Mantegna] shall not obstruct [master Niccolò] … [and] … said master Niccolò shall not in any way hinder [master Andrea's part] …And so that master Andrea has light, master Niccolò is obliged to open and remove the screen installed by him dividing the tribune from the chapel either entirely or in part as is necessary to admit said light for working.'[45] It even proved necessary to divide the pigments and the wood for the scaffolding. It is difficult to know which of the two was more to blame for this state of affairs. Pizzolo was notoriously headstrong and a habitual troublemaker: the envy and animosity he inspired led to his murder in 1453. But Mantegna was no less adept at playing the part of the bully. Later, in

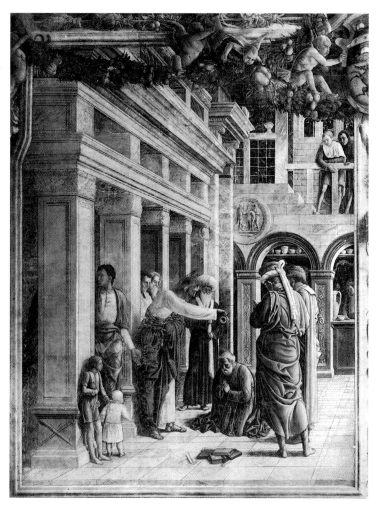

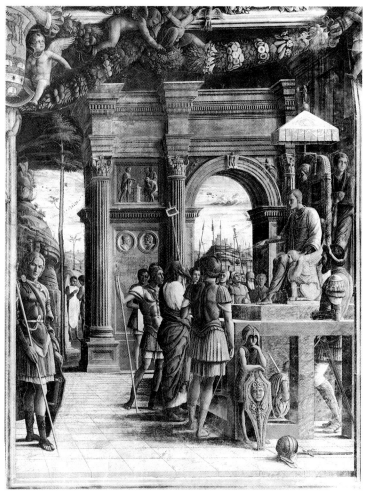

fig. 57 Andrea Mantegna, *St James Baptising Hermogenes*, fresco, c. 1450–54, formerly Cappella Ovetari, Chiesa degli Eremitani, Padua

fig. 58 Andrea Mantegna, *The Trial of St James*, fresco, c. 1450–54, formerly Cappella Ovetari, Chiesa degli Eremitani, Padua

Mantua, he abided no competition, however feeble, going so far as to hire thugs to beat artists into submission. Mantegna's last experiment in Pizzolo's Florentine-inspired realism was the two frescoes of *The Calling of SS. James and John* and *St James Preaching* (fig. 56) in the uppermost range of the main chapel, undertaken after the settlement of 1449.[46] In the tier below, with the scenes of *St James Baptising Hermogenes* and the *Trial of St James* (figs. 57, 58), Mantegna emerged from this Tuscan chrysalis the master of his own, unmistakable style. The figures, shorn of the assertively realist intent of Pizzolo's work, aspire to the elevated realm of classical sculpture, reanimated by what Longhi

termed '*il misticismo-archeologico del Mantegna*'[47] to inhabit a fluid but commensurable space articulated by monumental architecture inspired by that of ancient Rome. How did this remarkable transformation take place? The traditional answer, given official sanction by Vasari, looked to Mantegna's training in Squarcione's shop and his copying from casts of ancient sculpture, but this accords neither with the chronological evidence nor with what we can deduce of Squarcione's teaching.[48] Rather, Mantegna owed his romantic vision of antiquity to a wide circle of humanists (see pp. 8–27, above).

Squarcione's studio attracted a good deal of attention in Padua: according to Scardeone, San Bernardino visited

it in 1443, and in 1452 Emperor Frederick III summoned Squarcione for an audience. It is possible that Mantegna's acquaintance with some of those humanists with whom he was later associated dates back to his apprenticeship, although if this is so it had strangely little impact on either his or his teacher's work. The social gulf between painters and poets was considerable in the first half of the 15th century. Only a few artists – Donatello, Ghiberti and Brunelleschi foremost among them – managed to bridge it. It was this gap that Alberti's *De Pictura* aimed to eliminate by establishing a theoretical basis to replace the practical expertise fostered by the guild system, laying down a set of moral and aesthetic values (as well as subject-matter) derived from ancient writers, and establishing a scientific basis for painting through the use of linear perspective.

It may have been at the court of Lionello d'Este in Ferrara that Mantegna first glimpsed the potential of art as an extension of humanist discourse. On 23 May 1449, a panel was prepared in Ferrara on which Mantegna was to depict Lionello d'Este and the Marchese's factotum, Folco da Villafora.[49] He must have travelled to Ferrara for the purpose, establishing a relationship with Lionello and with his brother and successor, Borso. Lionello had already sponsored a number of innovative projects. The antique-inspired, bronze portrait medal had been revived by Pisanello; in 1441, in emulation of competitions between ancient Greek artists, Pisanello and Jacopo Bellini were commissioned to paint Lionello's portrait; another competition followed in 1443 to erect a bronze equestrian statue in honour of Niccolò III d'Este, for which Alberti acted as judge; and at the end of the decade work had begun on the decoration of a study in the pleasure villa of Belfiore with a cycle of pictures showing the nine Muses according to a programme drawn up by Lionello's own tutor, the great humanist and scholar Guarino of Verona (1374-1460). Lionello's taste was wide-ranging. In addition to his patronage of Jacopo Bellini, Pisanello, Piero della Francesca, the

mysterious Angelo Maccagnino (the highly praised painter of the Muses for the study of Belfiore) and the Florentine sculptors Antonio di Cristoforo and Niccolò Baroncelli, he owned a triptych of the *Deposition* by Rogier van der Weyden and regularly commissioned Flemish pictures in Bruges through an Italian agent. The common denominator of the works he collected was their susceptibility to a type of criticism based on the ancient literary form of ekphrastic poetry, with its emphasis on variety, copious detail and a superficial naturalism.[50] In the *De politia litteraria* (1462) written by

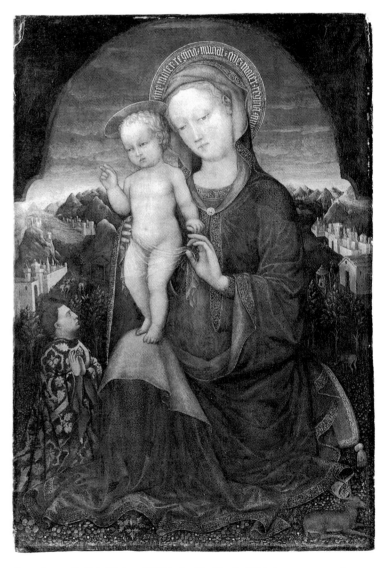

fig. 59 Jacopo Bellini, *Virgin and Child adored by Lionello d'Este*, tempera on panel, 60.2 x 40.1 cm, 1440-45, Musée du Louvre, Paris

fig. 66 Andrea Mantegna, The San Zeno Altarpiece, panel, 1456-9, San Zeno, Verona

humanist andantiquarian interests and who had gathered around him some of the most outstanding scholars and architects in Italy, one of whom, the Florentine Luca Fancelli, was employed as an emissary in arranging the terms of Mantegna's move from Padua to Mantua in 1460. It was,therefore, in Mantua that Mantegna's vision was given full scope through a series of unparalleled commissions that were to leave their mark not only on Italian but on European art.

K.C.

NOTES

1. See Kristeller, 1902, p. 494.
2. See, for example, Berenson, 1907, p. 24: 'Reared among the fragments of ancient art, in a shop haunted by Professors … a lad of genius could not help growing up an inspired devotee of Antiquity'.
3. Kristeller, 1901, and Fiocco, 1927, ed. 1959, are the major proponents of the importance of Florentine art over local traditions for his development. For a contrasting view, see Longhi, 1926, ed. 1967, pp. 77-98.
4. For an up to date biography of Stefano di Giovanni di Francia (misleadingly known as Stefano da Verona), with references to the documents that have transformed our knowledge of the artist's activity, see the anonymous entry in Zeri, ed., 1987, II, p. 758.
5. The duration of Lippi's sojourn in Padua, where he is recorded in 1434, is uncertain. The most recent article dealing with his activity in Padua is Rowlands, 1989, who, however, was more concerned with the impact of Paduan and Venetian painting on Lippi than with Lippi's influence on local artists. The classic statement on Lippi's role in the development of a Renaissance style in Padua is Fiocco, 1927, ed. 1959, pp. 49-57. One of the very few works attributable to Lippi with a claim to dating from his years in Padua is a small image of the Virgin and Child in a niche formerly in the Loeser collection, Florence, reproduced in Marchini, 1975.
6. Castagno's influence on Paduan painting seems to me greatly exaggerated. See Christiansen, 1987², pp. 143-5, where I also touch on the controversial attribution to Castagno of the mosaic in the Mascoli Chapel showing the *Death of the Virgin*, unconvincingly ascribed by Fiocco, 1927, ed. 1959, pp. 100-13, to Mantegna.
7. Uccello's fresco cycle was described by Michiel and Vasari. Vasari based his information on a letter written by the well-informed local source Girolamo Campagnola. Vasari states that Uccello accompanied Donatello to Padua, where Donatello is recorded in January 1444. Uccello is most likely to have left Florence after payment for his cartoons for the windows in the cathedral on 28 January 1445.
8. For the relative documents, see Janson, 1957, pp. 147-89.
9. See Pope-Hennessy, 1976, repr. 1980.
10. The key documents on Squarcione's life are in Lazzarini and Moschetti, 1908, pp. 123-70; see also Sambin, 1979, pp. 443-65. For a recent attempt to reconstruct Squarcione's career, see Boskovits, 1977. I remain unconvinced by Boskovits's attributions to the artist. The key work, an altarpiece from the church of Santa Maria in Castello, Arzignano, near Vicenza, has been the focus of much debate, having been ascribed to Squarcione's circle, to a pupil or pupils of Squarcione (including Pizzolo and Mantegna), and to Squarcione himself: see the summary in Padua, 1976, p. 20. It does not seem to be by the same hand as the documented De Lazara Altarpiece in the Museo Civico, Padua. The reported date of 1445 is not legible. Muraro, 1959, published the remains of a fresco cycle attributed to Squarcione in the 16th century which he dated late in the artist's career. They are almost impossible to evaluate. Lightbown, 1986, pp. 15-25, gives a well-balanced appraisal of Squarcione's career, with references to previous bibliography. See also Lipton, 1974; De Nicolò Salmazo, 1990, pp. 513-21. Kristeller, 1909, and Testi, 1910, had an interesting exchange of views on his importance.
11. Kristeller, 1902, p. 502.
12. See Muraro, 1966, pp. 392-93; *idem, 1974*. Interesting though Muraro's views are, they seem to me highly speculative and do not make sufficient allowance either for the unlikelihood of such an academy at this date in an artistically backward area like Padua or for the braggart character of Squarcione.
13. See Sambin, 1979, pp. 450-51.
14. See Lazzarini and Moschetti, 1908, docs. XVIII, XXVII, XXXV.
15. Rigoni, 1970, p. 16, doc. 5.
16. Kristeller, 1902, p. 502.
17. The relevant documents are in Lazzarini and Moschetti, 1908, pp. 147-8.
18. The picture was acquired from the De Lazzara family in Padua in 1882. It was first cited by Moschini, 1817, p. 182, and is signed *OPVS SQVARCIONI/PICT/ ORIS*. Two related compositions are known: one in the Musée des Arts Decoratifs, Paris, and the other in a private collection (published by Boskovits, 1977, p. 66, n. 53). The repetition of the pose of the child demonstrates the importance of prototypes in Squarcione's workshop. That the child in Domenico Veneziano's *Virgin and Child* in Bucharest, of *c.* 1440, is strikingly similar to these suggests a common source in Donatello.
19. *The Craftsman's Handbook*, chap. XXVII.
20. Quoted by Baxandall, 1965, p. 183.
21. The trip is presumed to have been made around 1427, but there is no way of confirming this. What motivated Squarcione to make drawings after ancient monuments of dubious usefulness to his activity as a painter has never been satisfactorily explained. Kristeller, 1901, pp. 28-9, rightly points out that Squarcione's pictures show no evidence of a special interest in ancient art. Was he inspired by the example of that inveterate traveller and cataloguer of ancient monuments and inscriptions, Ciriaco d'Ancona, and were his drawings intended for some humanist circle with which he was in touch? Lipton, 1974, notes that Ciriaco went to Athens in 1437 and that this is a more probable date for Squarcione's trip.
22. See Degenhart and Schmitt, 1960, and *idem*, 1968, pp. 13-17, 25-42; Fossi-Todorow, 1962; *idem*, in Florence, 1966, pp. 47-8, 124-44; Christiansen, 1982, pp. 145-8; Cavallaro, in Rome, 1988, pp. 89-100.
23. For the plaquette, see Pope-Hennessy, 1965, no. 60, pp. 21-2.
24. The same hand occurs, in reverse, in a contemporary painting of the *Virgin and Child with Angels* (Louvre, Paris) by one of Squarcione's most gifted pupils, Marco Zoppo. Kokole, 1990, pp. 50-54, noted that the plaquette further served as a model for Schiavone's *Virgin and Child* (National Gallery, London; no. 904), which is about contemporary with Marco Zoppo's picture. Schiavone combined features of this plaquette with the architectural setting of a Donatellesque terracotta relief (my thanks to Alison Luchs for calling Kokole's article to my attention). Armstrong, 1976, p. 21-2, noted the possible importance of this relief for Zoppo's painting. See also n. 28, below.
25. It is difficult to imagine the drawings as a primary source for Mantegna, as supposed by Tamassia, 1956¹, pp. 159-65; *idem*, 1956², pp. 215, 219-20.

26. Lazzarini and Moschetti, 1908, doc. XXXVIII, p. 151.
27. Ricci, 1908, doc. XXV, p. 59.
28. For the document, see Lazzarini and Moschetti, 1908, doc. XL, p. 155. The mention of casts ('*improntis*') suggests that Squarcione had larger-scale reliefs. One such relief served as the basis for a *Virgin and Child* sometimes ascribed to Squarcione (Museo Civico, Padua; no. 399: see Banzato and Pellegrini, 1989, p. 107). Another, possibly by Niccolò Pizzolo, was the model for the many images by Squarcione's pupils of the Virgin and Child beneath an arch or in an architectural niche: see Kokole, 1990, pp. 52-5. Boskovits, 1977, pp. 52-3, noted the relevance of reliefs from the circle of Donatello for these sorts of paintings; he ascribed the Museo Civico picture to Squarcione. Kokole ascribed the relief of the Virgin and Child beneath an arch (fig. 48) to Donatello's assistant Giovanni da Pisa, but he also discussed the possibility of an attribution to Pizzolo, which seems to me the more probable solution. The arch in this relief is patterned on those in Donatello's *Miracle of the Ass* for the Santo altarpiece, in which the motif of the putto in front of the corbel is similarly used. A *Virgin and Child* by Jacopo Bellini (Los Angeles County Museum of Art) is taken from a cast of another Donatellesque relief: see Christiansen, 1987[1], and Joannides, 1987, pp. 4-5; a stucco squeeze of the relief is in the Victoria and Albert Museum (fig. 47); see Pope-Hennessy and Lightbown, 1964, I, no. 76, pp. 96-7.
29. The plaquette reproduced in fig. 47 is known in a number of casts, one of the best of which is in the Victoria and Albert Museum, London. The invention can be dated to the mid-1430s, since at about that date a stucco squeeze was employed as part of a painted tabernacle by the Florentine Paolo Schiavo: see Pope-Hennessy and Lightbown, 1964, I, no. 68, pp. 83-4. For Schiavone's picture, see Mariacher, 1957, p. 74. Schiavone's painting takes over from the plaquette the full-cheeked child, the plump arm crossing the torso, and the position of the legs.
30. Two pictures produced in Squarcione's shop in the late 1430s seem to depend on a compositional model by Lippi: see Zeri, 1976, I, pp. 204-5. Boskovits, 1977, p. 62, n. 39, tentatively suggested an attribution to Pizzolo.
31. Lazzarini and Moschetti, 1908, doc. XXXVIII, p. 149.
32. Lazzarini and Moschetti, 1908, pp. 52-3, first suggested this interpretation, adding the possibility that Zoppo also made casts after ancient statues and reliefs. It can hardly be coincidental that pigmented stuccoes of two of the plaquettes referred to above exist: see Pope-Hennessy and Lightbown, 1964, I, nos. 68, 72, pp. 83-4, 90-91; De Nicolò Salmazo, 1990, pp. 538-9, n. 168, and n. 29, above.
33. Lazzarini and Moschetti, 1908, doc. LXI, pp. 169-70.
34. This is no more than a conjecture, but Pollaiuolo's print seems to have served as the point of departure for a drawing, now in the Woodner Collection, that formed part of a sketchbook by a pupil of Squarcione: see Munich, 1986, p. 242; Madrid, 1986-7, pp. 19-20, and Popham, in London, 1958, p. 141. Schmitt, 1974, pp. 205-13, has ascribed these drawings to Squarcione himself, but her arguments do not stand up to close scrutiny: see Boskovits, 1977, p. 61, n. 27. The artist in question must be a contemporary of Marco Zoppo, possibly active in

Squarcione's shop about the same time. It might be pointed out that the study of a head from this sketchbook is probably after a classical bust rather than related in some way to the giant heads in the Ovetari Chapel. In the Woodner sketch of nude men fighting, the figure with both hands raised derives, in reverse, from a similar figure in the background of Pollaiuolo's print, and the victim lying on the ground also seems inspired, albeit more loosely, from another figure. This would place the *Battle of Nudes* considerably earlier than is frequently allowed, but the current tendency to retard the date of Italian prints has no documentary basis. A related print of *Hercules and the Giants* is conceivably a crude, north Italian engraving after a lost cartoon by Pollaiuolo and was already available to northern Italian artists by *c.* 1470: see Armstrong, 1968, and 1981, pp. 23-24.
35. Longhi, 1926, ed. 1967, correctly emphasised the leading role played by Antonio Vivarini and Giovanni d'Alemagna in Padua, where they were inscribed in the painters' guild between 20 October 1447 and 4 November 1448. Their careers and interests run parallel to those of Jacopo Bellini. The series of panels illustrating the life of St Apollonia (National Gallery, Washington; Accademia Carrara, Bergamo; Museo Civico, Bassano), reveals a precocious interest both in the uses of perspective and in ancient monuments, and is the basis for what Longhi has suggestively termed the '*rinascimento umbratile*'. Their contribution to the Ovetari Chapel frescoes reveals a remarkable awareness of progressive trends.
36. Rigoni, 1970, doc. 1, pp. 11-12.
37. See Venturi, 1885; *idem*, 1896, p. 46. For Aleotti, see Rizzi, 1960, and Lightbown, 1986, pp. 28, 457-8.
38. Mantegna must have been a prodigiously gifted youth, but the information on the inscription is so unusual and self-laudatory that it is worth considering whether it may be a piece of biographical embellishment added at a later date. Shaw with Boccia-Shaw, 1989, pp. 49-52, argue that the Latin inscription recorded by Scardeone is in a form Mantegna only employed after *c.* 1470. However, as Jane Martineau has kindly pointed out to me, Scardeone's biography is in Latin, and what he gives is the contents of the inscription, with proper punctuation, rather than an archeological transcription, which would be anachronistic at this date. See also De Nicolò Salmazo, 1990, p. 534, n. 71.
39. The contract is published in Lazzarini and Moschetti, 1908, doc. XCVI, pp. 191-4.
40. For Pizzolo see especially Rigoni, 1970, pp. 25-46, who published most of the known documents concerning his career, and Mariani Canova, in Padua, 1974, pp. 75-80. Pizzolo's role in Paduan painting has, it seems to me, been greatly undervalued: marginalised by speculation about Squarcione, on the one hand, and overshadowed by the genius of Mantegna, on the other. Even Longhi, 1926, ed. 1967, pp. 88-9, succumbed to the fallacy that Pizzolo 'was nothing other than an executant of designs by Donatello, Mantegna, and perhaps, when a youth, of Filippo Lippi'. The documents and contemporary reputation Pizzolo enjoyed flatly contradict this interpretation, as does a dispassionate analysis of the works.

Filippo Lippi may have been a major influence, though Pizzolo is hardly likely to have assisted him in the destroyed frescoes in the chapel of the Palazzo del Podestà, recorded by Michiel in the early 16th century. At the time, Pizzolo was barely a teenager. Castagno's purported influence on him is much exaggerated. Indeed, if Castagno's God the Father in the vault of the apse of San Tarasio, Venice, is compared with Pizzolo's in the Ovetari Chapel, it will be seen that Castagno's figure can have served as little more than an iconographic reference point. The drapery is flat and schematic and the features caricatural. By 1448 Pizzolo had passed well beyond this superficial imitation of Donatello's sculpture. Equally wide of the mark are the comments of Romanini, 1966, who has characterised Pizzolo's art as '*nella sostanza gotica di una visione basata su di un ritmico, ondulante ricamo lineare in superficie*'.

41. See Rigoni, 1970, doc. V, p. 39. The affair is of considerable interest for understanding Pizzolo's later conflicts with Mantegna. Not knowing Luca's abilities and having nothing suitable for him in hand, Pizzolo arranged for work with a specialist in painting coffers. However, when the occasion arose, he thought nothing of hiring Luca away, in blatant disregard for these arrangements, declaring that the artist in question was able to teach the apprentice nothing but was suited only for '*laboreria grossa*'.

42. The picture was acquired from Bardini in 1887 as a work of the school of Ferrara. It was first ascribed to Pizzolo by Ballarin, in Padua, 1974, p. 78. The attribution is, strangely, not accepted by Boskovits, 1977, p. 63, n. 39.

43. See Rigoni, 1970, doc. VI, pp. 17-20. According to the settlement, Mantegna was responsible for painting the standing figures of SS. Peter, Paul and Christopher: see also cat. 6.

44. The only drawing that has serious claim to being by Donatello is a study for the *Massacre of the Innocents* and a triumphant *David* at Rennes, for which see Detroit, 1985, pp. 141-2. Pizzolo's drawing style can only be deduced in a generic way from the two copies of his compositional sketch for an altarpiece carried out in 1466 by Pietro Calzetta, for which see Hahnloser, 1962, pp. 377-93; London, 1990, no. 14.

45. Rigoni, 1970, doc. VI, pp. 19-20.

46. The fresco of *St James Preaching* seems to have been carried out by Mantegna assisted by Ansuino da Forlì. Rigoni, 1970, p. 34, first suggested a collaboration between Mantegna and Ansuino on the basis of a joint payment to the two artists on 30 October 1451. There is no way of demonstrating which fresco this payment was for, but it is certainly true that in the *St James Preaching* the group of figures at the right bears little resemblance to Mantegna's work and are strikingly similar to those in Ansuino's signed fresco. Ansuino was a bit older than Mantegna and had, according to Michiel, worked with Pizzolo in the chapel of the Palazzo del Podestà, where Filippo Lippi had also painted. There has been speculation to the effect that Mantegna may have had a part in designing Ansuino's signed fresco of *St Christopher Preaching*. The receding arcade does, indeed, mirror that in Mantegna's scene of *St James Baptising Hermogenes* on the opposite wall, but the mind at work is less archaeological, and the simple tunnel perspective of the buildings has more do to with the sort of backgrounds found in the work of Filippo

Lippi than of Mantegna. Moreover, the group of soldiers crowded into a shallow space in the foreground echo Donatello's bronze relief of *The Miracle of the Miser's Heart* in a way for which there is no parallel in Mantegna's work. If there was another, guiding, hand in the frescoes on this side of the chapel, it was that of Pizzolo, whose preference for steeply foreshortened views emphasised by geometrically patterned ceilings is evident from the roundels of the Church Fathers. This applies also to the scene of *St Christopher and the King of Canaan*, which Longhi, 1926, ed. 1967, p. 90, plausibly attributed to Girolamo di Giovanni da Camerino. Girolamo was inscribed in the painters' guild in Padua in 1450, but his name does not occur among the documents for the chapel, which are, however, incomplete. Evidently following the death of Giovanni d'Alemagna in 1450, an effort was made to speed along production of the frescoes by enlisting any available talent. Only after Pizzolo's death in 1453 did Mantegna assume total responsibility for the chapel.

47. Longhi, 1926, ed. 1967, p. 93. The change in direction remarked upon here is not intended to negate Mantegna's continued interest in Donatello's sculpture, most thoroughly analysed by Dunkelman, 1980. However, I would make a distinction between the use of compositional motifs and devices and the actual style of Mantegna's work.

48. Zeri, 1983, pp. 566-8, has brilliantly characterised the gulf that separated the two and has pointed out that none of Squarcione's other pupils achieved a truly Renaissance style. See also the comments of Knabenshue, 1959, pp. 71-3. Knabenshue discusses a number of possible ancient sources for Mantegna's scene of the *Trial of St James*, most of which I find unconvincing.

49. Kristeller, 1902, p. 514, doc. 4.

50. The standard studies on this subject are Baxandall, 1963; *idem*, 1964; *idem*, 1965; *idem*, 1971.

51. Quoted by Baxandall, 1963, p. 320.

52. The identity of the kneeling donor in Jacopo Bellini's painting in the Louvre has been the object of considerable controversy. For the most recent opinions, see Christiansen, 1987[1], p. 177 n. 25. Eisler, 1989, p. 518, gives a summary of earlier bibliography. His own views on the picture are somewhat confusing and contradictory, for he appears both to accept and question the attribution to Bellini and to question and accept the identity of the sitter as Lionello. He dates the work to *c.* 1430, which seems to me a decade too early.

53. For a discussion of the Este patronage of these two pictures, see cat. 8.

54. The bibliography on Jacopo Bellini's albums is considerable: see Eisler, 1989, especially pp. 78-97 for a review of the history of the albums and various opinions about their function. Elsewhere I have stated my reasons for believing them directly inspired by contact with Alberti and the Este court in Ferrara: see Christiansen, 1987[1], pp. 170-72. The date of the two albums is crucial to any evaluation of Jacopo's place in the development of Renaissance art in the Veneto. Degenhart and Schmidt, 1984, have argued that the Louvre album is earlier than the British Museum one and that it was begun as early as 1430. Like virtually all other scholars, including Eisler, I believe the evidence of style indicates that the British

Museum album is the earlier of the two but that their production may have overlapped. The Louvre album is on parchment. Conceived as a de luxe edition – it, not the British Museum album, was considered a fitting gift by Gentile Bellini to Sultan Mehmed II – its drawings are more highly finished and more formal in character. The albums may date anywhere between *c.* 1440 and *c.* 1460. If the subject of the tomb monument on a sheet from the Louvre album is, in fact, Bertoldo d'Este, who was killed in the Battle of Morea in 1463, then this would provide a surprisingly late *terminus*, especially since the sheet was the second folio page: see Eisler, 1989, pp. 31, 252; also Ricci, 1908, p. 39, for alternative identifications with members of the Este family. I am reluctant to accept the notion that any of the drawings had a practical function or that they represent projects for specific commissions. Rather, they reflect the cultural *milieu* of Venice and, especially, of Ferrara, and propose ideal, Albertian, schemes.

55. Eagles appear on two drawings of equestrian monuments (Brit. Mus. MS. *fols. 27v, 79v*), suggesting some connection with the bronze statue of Niccolò III d'Este commissioned in 1443; on a festive cart (Brit. Mus. MS. *fol.* 95); on the caparison of a horse whose mount bears a generic resemblance to Borso d'Este (Brit. Mus. MS. *fol.* 54); and on a tomb monument (Louvre, R.F. 428): see Ricci, 1908, p. 73, and Eisler, 1989, pp. 31, 221, 252-3.

56. On these scenes, see n. 46, above.

57. Kristeller, 1902, p. 488.

58. For Feliciano's activity as a scribe and illustrator, see in addition to Meiss, 1957, pp. 68-77, Mitchell, 1961. Ciriaco's drawings are treated in an illuminating article by Ashmole, 1959.

59. For Felice's drawing, see Mitchell, 1961, pl. XXIXa. When Felice drew up his will in 1466, he singled out his 'drawings and pictures on paper by many

excellent masters of drawing' as well as silver medals and ancient coins: see Mardersteig, 1939, pp. 106-8. Fiorio, 1981, pp. 65-71, discusses the collaboration of Marco Zoppo on one of Felice's manuscripts.

60. The manuscripts in question are a *Passion of St Maurice* (cat. 10), and Strabo's *Geographia* (Bibliothèque Rochegude, Albi; MS 4). Both were published by Meiss, 1957, with attributions to Mantegna and the workshop of Mantegna, respectively. Since that time the attribution of these two key manuscripts has been much debated (see cat. 10). They are, quite surprisingly, all but passed over by Goffen, 1989, p. 297, n. 7 – whose erratic, unconvincing reconstruction of the career of the young Bellini might have benefited from taking the style of this dated manuscript into account – while Lightbown, 1986, pp. 494-5, who gives a good review of the earlier literature, rejects Meiss's arguments out of hand, rather naively accepting at face value Mantegna's much later statement that he was unused to painting small figures (an obvious excuse to get out of a task he did not want to perform). Eisler, 1989, pp. 534-5, accepts some participation by Giovanni Bellini in the Paris miniatures. After examining both manuscripts, I am confident that the principal illuminations in the *Passion of St Maurice* are, indeed, by Mantegna (the depiction of St Maurice is remarkably similar in handling to the soldier behind the Marys in the *Crucifixion* in the Louvre, which I was able to examine unframed), and that those in the Strabo are by Giovanni Bellini and constitute a firm basis for the reconstruction of his poorly documented early career. See also Joost-Gaugier, 1979.

61. See Rigoni, 1970, docs. VIII, IX, pp. 22-3.

62. Kristeller, 1902, p. 489.

63. The letters relating to the arrangements between Ludovico and Mantegna are transcribed in Kristeller, 1902, pp. 516-20, docs. 9-11, 13-20.

3

ANDREA MANTEGNA
St Jerome in the Wilderness

Tempera on wood, 48 x 36 cm

c. 1448-9

Museo de Arte, São Paulo

PROVENANCE

Until 1936, private collection; sold Christie's, London, 20 November 1936, lot 97; bought by Betts; by 1938-53, Prince Paul of Yugoslavia; Museo de Arte, São Paulo

REFERENCES

Fiocco, 1937, pp. 76-7; Borenius, 1938, pp. 105-6; Fiocco, 1954, p. 224, n. 4; Tietze-Conrat, 1955, p. 197; Longhi, 1956, ed. 1968, p. 180; *idem*, 1962, ed. 1978, p. 151; Cipriani, 1962, p. 57; Camesasca, 1964, pp. 14-15, 35, 106; Ruhmer, 1966, p. 71; Garavaglia, 1967, no. 6; Berenson, 1968, p. 241; Armstrong, 1976, pp. 367-8; Lightbown, 1986, p. 475; Camesasca, in Milan, 1987, pp. 40-44; Shaw with Boccia - Shaw, 1989, p. 56, n. 85; De Nicolò Salmazo, 1990, p. 497

This subject enjoyed widespread popularity in northern Italy during the 15th century, particularly among humanists. For example, Guarino da Verona owned one such picture by Pisanello, and in his dialogue, the *De politia litteraria* (1462), Angelo Decembrio described the usefulness of 'some pleasant picture of St Jerome at his writing in the wilderness by which we direct the mind to the library's privacy and quiet and the application necessary to study and literary composition' (see Baxandall, 1965, p. 196). The popularity of the theme may, as Baxandall has suggested, be traced back to the 14th-century Bolognese canon Giovanni d'Andrea, who promoted the works of Jerome (see Sabbadini, 1914, pp. 159-62). The list of artists who painted independent pictures of the subject in the mid-15th century and who were associated in some way with Mantegna includes Pisanello's pupil, Bono da Ferrara (National Gallery, London), Marco Zoppo, a fellow pupil with Mantegna of Squarcione (Thyssen-Bornemisza Coll., Lugano), Jacopo Bellini (Museo di Castelvecchio, Verona), and Jacopo's son Giovanni (Barber Institute of Fine Arts, Birmingham). St Jerome in the

Wilderness was also the subject of the centre panel of Squarcione's altarpiece painted in 1449-52 for the jurisconsult Leone de Lazara. The theme had been developed most fully in the two albums of Jacopo Bellini in the British Museum and the Louvre, in which the various motifs of the São Paulo picture appear. Mantegna's picture may well have been painted for a Paduan humanist or someone with humanist interests, such as Ulisse degli Aleotti (see p. 12, above). Camesasca suggested the Hungarian humanist, Janus Pannonius (see p. 13) as the possible patron, but this may be excluded since Pannonius is known to have been in Padua only from 1454.

In the São Paulo picture, the surface of which has, unfortunately, suffered badly from abrasion, St Jerome is shown outside his cave/study absorbed in the devotion of the rosary; he supports a book on his left leg, as though symbolically balancing scholarly pursuit with religious fervour. On a stony ledge behind him are placed his books, pen and ink-well, while within the cave a lit oil lamp is suspended in front of a crucifix. A strongly foreshortened wooden plank, from which hang two wooden mallets, is ingeniously attached to the projecting rocks. In front of the Saint, depicted with an attention to light reminiscent of Flemish painting, are a pair of clogs and a cardinal's hat – Jerome's traditional attribute, although he never held that position. Perhaps only in Giovanni Bellini's later depiction of St Francis in his retreat on La Verna (Frick Coll., New York), does Nature conspire in a like degree to accommodate the needs of an ascetic, providing the saint with both shelter and a seat and arm-rest.

This remarkable picture, unrecorded before 1936, was first ascribed to the young Mantegna by Borenius. Since then the attribution has been disputed between Mantegna (Longhi, Shaw) and Zoppo (Fiocco, 1937; Armstrong). Most recently, Lightbown has argued that 'neither in sentiment, nor in colour, nor in its rather nervous line is [the *St Jerome*] close to Mantegna's early works', and has concluded that it is 'certainly the work of an artist with a Paduan-Venetian formation'. This analysis scarcely does justice to the exceptionally high quality of the picture – which is obviously by

an artist of the first rank – nor does it make allowance for its poor condition.

The ascription to Zoppo is based more on a matter of elimination than on resemblance to his work, for it would be impossible to find in the paintings certainly by Zoppo such a command of figure construction and coherent articulation of space. His fantastical rock formations, while dependent on those of Mantegna, lack the structural logic found here. And the manner in which the highlights are described with beautifully fluid brush-strokes is almost a trademark of Mantegna's. Zoppo certainly knew this work, for in his painting of the subject in the Thyssen-Bornemisza Collection he created a large rocky mass that opens to reveal a landscape vista that must derive from the São Paulo picture (the most convincing date for Zoppo's painting is *c.* 1465-70: see Ruhmer, p. 71, and Armstrong, pp. 367-8).

The closest parallel for the rock formation in this picture (conspicuously modified by the artist in the upper left) is with the fresco of the *Calling of SS. James and John* in the Ovetari Chapel, painted by Mantegna after September 1449 (fig. 56). The figure of St Jerome is much more elongated than those in Mantegna's earliest frescoes in the Ovetari Chapel, and the network of drapery folds is less elaborate and crisp, but Camesasca (1987) was surely correct in maintaining that the picture is an early work by Mantegna. It must, indeed, be his earliest surviving work, possibly painted while he was still in Squarcione's shop (that is, before 1448), but at a time when the young artist was already looking to Niccolò Pizzolo as a guide to the new style introduced into Padua by Donatello that the humanist writer Bartolomeo Fazio pointedly praised in his *De viris illustribus*. By 1448 Pizzolo was the most advanced painter in Padua, and the possibility of associating himself with this representative of the nascent Renaissance style must have been an added inducement to Mantegna to take on the collaborative commission for the Ovetari Chapel. Like Pizzolo in his sculpted figure of the Virgin in the terracotta altarpiece for the Ovetari Chapel, Mantegna posed St Jerome diagonally to the picture plane, with his shoulders drawn back, his head turned at the opposite angle and the cavity between his legs emphasised. In other words, he conceived the

3

figure in three-dimensional terms (the contrast with Zoppo's insubstantial, papery figures is notable). Indeed, were it not for the landscape of this picture, an attribution to Pizzolo might be entertained.

The landscape, punctuated by rock formations and measured by the curves of a meandering river, has analogies with those in Jacopo Bellini's albums and may be an index of Mantegna's awareness of Jacopo's work. Mantegna was in Venice with Squarcione in 1447, and would hardly have missed the opportunity to become acquainted with the leading Venetian painter.

The matter of the possible influence of Flemish painting, first advanced by Camesasca, is difficult to resolve. Mantegna certainly saw Flemish paintings at an early date: if not in Padua, then in Ferrara, where there were outstanding works by Rogier van der Weyden (see cat. 8). But whether any of the features of this picture, such as the light that plays on the clogs (which appear in Jacopo Bellini's drawing on *fol.* 19*v* of the Louvre album), may be the result of the influence of these works is questionable.

K.C.

4

ATTRIBUTED TO
ANDREA MANTEGNA
St Jerome

Black chalk or lead point, some red chalk (?) spots and two stains at bottom
172 × 135 mm

c. 1448-9

Staatliche Museen Preussischer Kulturbesitz, Kupferstichkabinett, Berlin (5114)

PROVENANCE
Von Beckerath collection

REFERENCES
Kristeller, 1901, p. 460; Parker, 1927, p. 26, no. 17; Fiocco, 1937, pp. 76-7, 182; Gronau, 1949, p. 244; Tietze-Conrat, 1955, p. 203

St Jerome is shown seated on a rocky escarpment, reading a book. He is accompanied by a lion, his traditional attribute, which befriended him after he extracted a thorn from its paw. The shading behind the lion and a faint diagonal line above suggest a mountainous landscape beyond. Both the facial type and intent expression of the Saint and the corrugated folds of his draperies are close to Mantegna's style.

Kristeller first mentioned the drawing, describing it as 'excellent and quite Mantegnesque', but so reworked that it did not seem autograph; Parker attributed it to 'an artist resembling in style the engravers of the Mantegna school' and wrongly stated that it was executed in pen. Fiocco attributed the drawing to Giovanni Bellini and tentatively connected it with the painting of the same subject (cat. 3), which he gave to Zoppo. Tietze-Conrat thought the drawing was connected with a composition of Mantegna's of around 1475 but rejected the painting. Here the painting is given to Mantegna and dated to the late 1440s. Indeed, the composition recorded in the drawing appears to be a first idea, in reverse, for the panel. It is open to question whether this sheet is an autograph study or a copy after a lost drawing. Almost all Mantegna's extant early drawings are executed boldly in pen and ink, and the delicate black chalk of this sheet creates a very different impression. It might, therefore, be suggested that this is an early copyist's translation of a lost pen drawing into black chalk, but it should be borne in mind that Jacopo Bellini, Mantegna's father-in-law from 1453-4, and undoubtedly known to him earlier, made extensive use of feathery leadpoint and metalpoint to comparable effect, especially in his album in the British Museum. The quality of the drawing is high (the main weakness being the rather lifeless right hand) and an attribution to Mantegna himself, while by no means guaranteed, should not be excluded.

D.E.

4 (actual size)

5

ANDREA MANTEGNA
St Mark

Casein(?) and gold on canvas, 82 x 63.7 cm
Inscribed: *INCLITA MAGNANIMI VEN.../EVANGELISTA PAX TIBI M[ARCV]S/ANDREAE MANTEGNAE PICTORIS/LABOR.*

c. 1448-9

Städelsches Kunstinstitut, Frankfurt

PROVENANCE
Duque d'Uceda, Madrid(?); Marqués de Salamanca; sold Pillet, Paris, 3-6 June 1867

REFERENCES
Morelli, 1891, p. 231; Weizsäcker, 1900, pp. 40-41; Kristeller, 1901, p. 457; Knapp, 1910, p. 180; Venturi, 1913, pp. 162-4; Fiocco, 1927, ed. 1959, p. 76; Berenson, 1932, p. 327; Fiocco, 1937, pp. 28-9, 199; Suida, 1946, pp. 57-8; Tietze-Conrat, 1955, p. 183; Boeck, 1957, p. 198; Moretti, 1958, pp. 60-63; Longhi, 1962, ed. 1978, p. 151; Cipriani, 1962, pp. 80-81; Puppi, 1966, Garavaglia, 1967, no. 12; Berenson, 1968, p. 239; Lightbown, 1986, p. 475; De Nicolò Salmazo, 1987, p. 170; Shaw with Boccia-Shaw, 1989, pp. 49, 56, n. 85; De Nicolò Salmazo, 1990, p. 497

This remarkable but worn image of the Evangelist Mark, gazing pensively from behind an arched marble opening to one side of which his gospel is propped ostentatiously, is one of Mantegna's key works. It is his earliest surviving signed picture, the first in which he employed his much-favoured illusionistic device of an architectural moulding to mediate between the pictorial space and that of the viewer, and his earliest surviving work on canvas, a support he, more than any other 15th-century artist, was to exploit to marvellous effect. Longhi described the picture as a 'stupendous work of the very young Mantegna at the outset of his work in the Eremitani'. Yet, Mantegna's authorship has been doubted by a number of scholars, beginning with Morelli (1891), who first questioned the authenticity of the inscription (see also Weizsäcker, Knapp, Tietze-Conrat, Moretti, Lightbown). These judgements are due as much to an inadequate appraisal of the condition of the picture as to an over restrictive view of Mantegna's early career.

Much of the damage the picture has sustained is due to the vulnerability of the medium (see p. 84). The Saint's beard and hair, as well as the reflection of his head onto the under surface of the halo, are worn down to the canvas, and the colours have darkened somewhat from the old varnish (removed during a restoration undertaken for this exhibition). Nonetheless, in the illuminated part of the halo, the highlights on the pearl-embroidered collar, the metal studs on the cover of the book and the citrus fruit set on the ledge, one gains some idea of the delicacy and quality of execution. The inscription is particularly damaged. However, microscopic examination reveals it to be authentic, and the cleaning has now made the letters far more legible. Lightbown has questioned the use of the Italian spelling of Mantegna in the genitive case, but the same form is employed on the *St Euphemia* (cat 13), which is dated 1454, and it would appear that in his early work Mantegna experimented with a variety of semi-Latinate constructions of his name. In the lunette painted in 1452 over the central doorway of the Santo in Padua his Christian name is declined, but not his surname. This is also true of the rediscovered signature on the St Luke polyptych (fig. 4; Brera, Milan; see Bandera Bistoletti, 1989, p. 89), commissioned in August 1453 but only completed by November 1454 (the gilding was carried out the following year), and in the somewhat later *Agony in the Garden* (National Gallery, London). A correct Latin form of Mantegna's name occurs only after his move to Mantua in 1460 (see Shaw with Boccia-Shaw, 1989, pp. 49-50).

The *St Mark* is earlier than any of these works; both in conception and in its somewhat schematic figure type it is closely related to the destroyed work of Mantegna and Pizzolo in the tribune of the Ovetari Chapel in Padua, carried out between 16 May 1448 and 27 September 1449. This close relationship was implicitly recognised by Fiocco, who in 1927 (ed. 1959) ascribed the picture to Pizzolo, but in 1937, following Rigoni's publication of the arbitration of 1449 in which the two artists' contributions to the Ovetari Chapel are specified, recognised it as an early work by Mantegna.

Analogies for the pose of the Evangelist, who rests his head on his projecting arm, and

the use of a strongly foreshortened book protruding beyond the ledge into the viewer's space, are found in Pizzolo's destroyed roundels of SS. Gregory and Augustine, in which an architectural frame was used to enhance the spatial illusionism of both of the Church Fathers, and in the frieze of cherubim and seraphim on the tribune arch (see cat. 6).

Despite the connection with Pizzolo's work, it is important to underline the fact that Mantegna had moved beyond the example of his older companion to that of Donatello: not simply the bronze reliefs of angels and Evangelists for Donatello's high altar of the Santo, in which the figures and their attributes protrude beyond their rectangular mouldings, but the Madonna reliefs that seem to have been carried out under Donatello's direction during his ten-year Paduan sojourn (see also cat. 12 and p. 97). Most pertinent is a plaquette showing the Virgin in front of an arch and behind a ledge on which the Christ Child stands beside a vase (Pope-Hennessy and Lightbown, 1964, no. 72; Pope-Hennessy, 1965, no. 62; Luchs, in Detroit, 1985, pp. 139-40). There is, also, the possibility that Filippo Lippi painted a similar composition when he visited Padua in 1434-5 (see p. 98), and it may be that the illusionistic *cartello* fixed to the parapet derives from that work, since the earliest appearance of such a device in Italian art occurs in Lippi's *Tarquinia Madonna* of 1437 (Palazzo Barberini, Rome). Castagno also signed his frescoes in San Zaccaria, Venice, on a fictive *cartello*.

There were, of course, local precedents in the border decoration of fresco cycles for showing the Evangelists at work behind their desks, but nothing is comparable to this. The *St Mark* brings together a number of features that were to become hallmarks of Paduan painting: the window-arch in front of which is suspended a swag of fruit (here curiously shaped leaves, a variety of citrus fruit and sprays of myrtle and juniper with, at the centre, a gem mounted with three pearls), and a *cartello* below. As one might expect from a work of this date, the architecture is only generically classical, and the figure style still somewhat primitive. Nonetheless, the power of invention is remarkable, and the description of such details as the book clasps, with their dangling cords, and the carefully

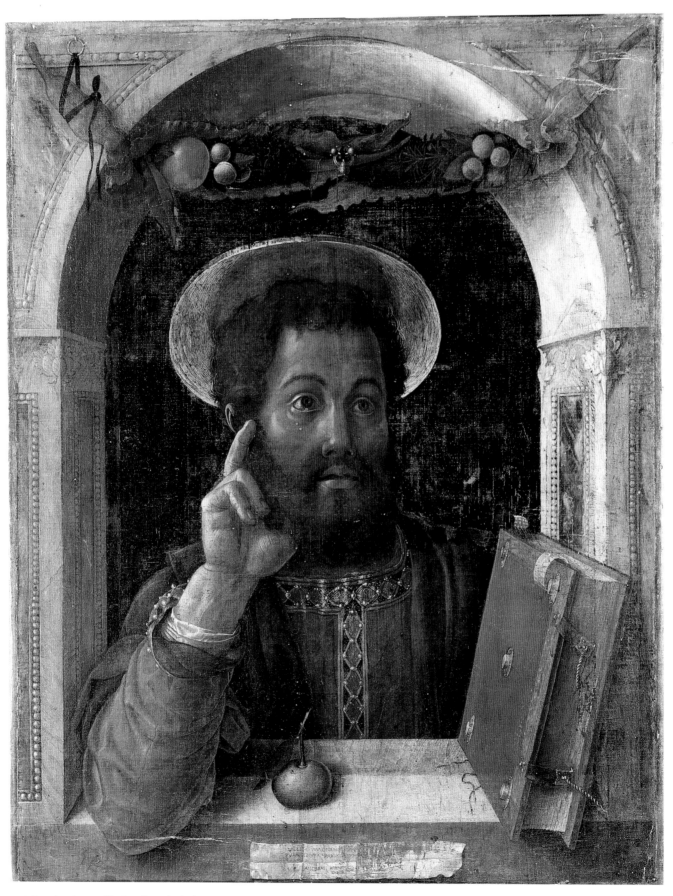

5 (after cleaning and before in-painting)

laced ribbons from which the swag is hung, no less than the attention to effects of light, announce the concerns of Mantegna's mature work.

Mantegna seems to have changed the angle from which the arch is viewed: judging from the *pentimento* to the right and along the bottom of the arch, the opening was originally larger, with an axis to the right of centre. As finally projected, the viewing point is from the left.

Nothing is known of the picture's provenance, of its patron, or even the city in which it was painted. Fiocco (1937) suggested Venice, whose patron is St Mark: Mantegna was in Venice with Squarcione in 1447.

Jacopo Bellini painted a half-length image of St Mark, on canvas, depicted against a blue background, before 13 April 1466 to be used as an altar-curtain in the Scuola di San Marco (see Testi, 1915, II, p. 144, n. 2, 255, and Eisler, 1989, pp. 26, 524, 530, who, however, incorrectly gives the date as 1421).

K.C.

6

ANDREA MANTEGNA
Seraph

Detached fresco, 46 x 55 cm

1449-50

Cappella Ovetari, Chiesa degli Eremitani, Padua

PROVENANCE
Cappella Ovetari, Chiesa degli Eremitani, Padua

REFERENCES
Rigoni, 1927-8, ed. 1970, p. 19; Kristeller, 1901, p. 67; Fiocco, 1927, ed. 1959, p. 77; *idem*, 1937, p. 24; Paccagnini, in Mantua, 1961, p. 11; Furlan and Mariani Canova, in Padua, 1974, p. 79; Padua, 1976, p. 19; Lightbown, 1986, pp. 387-96; De Nicolò Salmazo, 1987, p. 743; Shaw with Boccia-Shaw, 1991, pp. 21-8

This fragmentary red seraph holding a flaming torch (emblematic of Divine Love) and enclosed within an oval moulding, is one of the few surviving elements from the decoration undertaken in 1448 by the young Mantegna together with a group of outstanding Paduan and Venetian artists for the funerary chapel of Antonio degli Ovetari in the Eremitani church in Padua. The chapel contained the most important Renaissance fresco cycle in Padua. The tribune was painted by Mantegna and Niccolò Pizzolo with figures of God the Father and four saints in the vault, the four Doctors of the Church in roundels below, and on the east wall the *Assumption of the Virgin* by Mantegna. The vault of the chapel was frescoed by Giovanni d'Alemagna and Antonio Vivarini with the four Evangelists,

while the walls were decorated with cycles of the lives of SS. James and Christopher by Mantegna, Ansuino da Forlì, Bono da Ferrara and, possibly, Girolamo di Giovanni da Camerino. The chapel was destroyed by an Allied bomb in 1944; all that survives of this extensive cycle are the fragmentary figures of two seraphs and the large scenes of the *Martyrdom of St Christopher* (figs. 64, 65) and the *Assumption of the Virgin* (for a review of the history of the chapel see Lightbown, pp. 387-96). The seraphs decorated the underside of the arch separating the main chapel from the tribune.

In the initial contract of 16 May 1448 Mantegna and Pizzolo agreed to carry out jointly one half of the chapel decoration together with a terracotta altarpiece, the division of labour being left unspecified (Lazzarini and Moschetti, 1908, pp. 191-4). This arrangement resulted in intense disagreements between the two artists, and in a subsequent arbitration of 27 September 1449, the responsibilities of each were specified and the payment divided equally (Rigoni, 1927-8, ed. 1970, pp. 17-20). Among Pizzolo's tasks was that of painting the right half of the entrance arch, while Mantegna was assigned the left half: throughout the documents the directions were given from the point of view of a spectator facing the altar. This was a relatively minor portion of the commission, and the decorative components were decided at the outset. They consisted of classically inspired ox-heads (*bucrania*) linked by garlands of fruit and leaves on the face of the arch, large portrait heads at the base and, on the intrados, eight cherubs holding lilies and

tambourines and six seraphs holding torches. The two surviving seraphs are shown in mirrored poses that were obviously generated from a single cartoon reversed for the purpose. This was a common practice, but it underscores the essential coherence of the decorative scheme. Given Pizzolo's seniority (he was perhaps as much as ten years older than Mantegna) and the precedence he is given in the documents, he is likely to have been responsible for the cartoon. However, in the actual execution of the frescoes it is highly improbable that these two irascible, litigious artists did not observe the specified divisions. Indeed, it has never been doubted that the two large heads painted at the base of the arch were done by different hands: one a self-portrait by Mantegna and the other a self-portrait by Pizzolo (Fiocco, 1927, ed. 1959, p. 77 suggested that Pizzolo's head was painted by Ansuino da Forlì, despite the fact that, according to a document of 6 February 1454, only decorative details had been left unfinished by Pizzolo: see Rigoni, ed. 1970, pp. 20-21, doc. VII).

The seraph exhibited here has been reported as coming from the right-hand portion of the entrance arch and, in consequence, it has been assigned to Pizzolo (see Paccagnini, in Mantua, 1961; Mariani Canova, in Padua, 1974; Furlan, in Padua 1974). Nonetheless, as recently demonstrated, the fragment is from the summit of the left-hand arch: it is visible in photographs of the vault of the chapel, and the direction of the light alone would establish that it could not come from the right-hand portion, since the frescoes were shown as though illuminated from the apsidal windows (Shaw

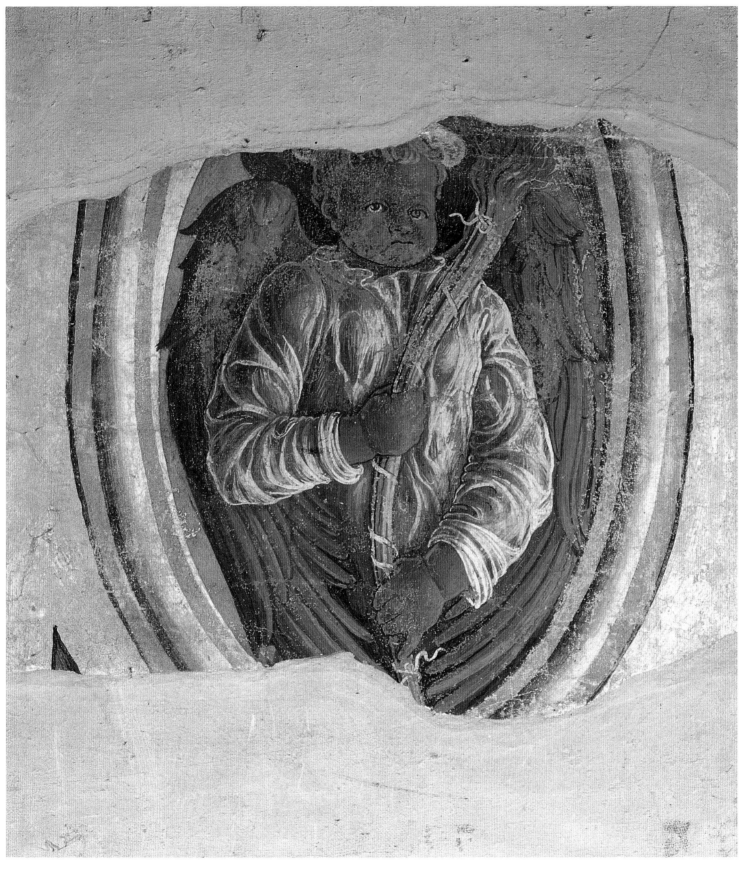

with Boccia-Shaw, 1991). It must, therefore, be counted the earliest surviving documented work by Mantegna, painted shortly after the arbitration of September 1449 or early in 1450.

The first observation to be made is the novel conception of the under-arch decoration as a whole and its independence from the example of Andrea del Castagno's frescoes in the chapel of San Tarasio in San Zaccaria, Venice, with which the decoration of the Ovetari Chapel is frequently compared. In Castagno's decoration, actively posed putti viewed against a porphyry-coloured background hold wreaths containing half-length figures of saints and prophets – a revival of the classical *imago clipeata* (see Horster, 1953, pp. 106-9; Hartt, 1959, pp. 179-80). The decorative components on the arch and in the tribune of the Ovetari Chapel are architectural in conception and more illusionistic in their intent. There are local, 14th-century analogies for the use of fictive mouldings surrounding half-length figures of saints, most conspicuously in the under-arch of a chapel decorated by Guariento in the Eremitani itself (see Shaw with Boccia-Shaw). However, the elaborate and dynamic illusionism employed by Mantegna, not only in the mouldings surrounding the cherubim and seraphim, but the swags on the face of the arch and the vaulting of the tribune, has its source in Donatello's altar for the Santo in Padua, on which Pizzolo was employed in 1447.

The second point is the strong debt the seraph shows to Pizzolo's figure style and the evidence the fragment provides for Pizzolo's importance to Mantegna at this date; an importance that far outweighs his training under Squarcione. The drapery style of the seraph, as of the three destroyed figures Mantegna painted in the vault of the tribune, reflects Donatello's favoured method of dipping cloth in size and arranging it on a mannequin to study various effects. It was a procedure that Pizzolo employed in the creation of the terracotta altarpiece for the Ovetari Chapel and one Lomazzo (1584; ed. 1844, II, p. 443) asserts was used by Mantegna. Kristeller, although under the mistaken impression that all the figures in the tribune were by Pizzolo, commented on the resemblance to Donatello's manner.

The third point is that despite this dependence by Mantegna on a procedure Pizzolo had learnt from Donatello, and even on Pizzolo's figure types, the modelling is achieved through individual, fluid brushstrokes that both describe the form and create a flickering quality of light. This draughtsman-like approach contrasts to the brushwork in Pizzolo's seraph (so far as its damaged state allows any generalisations) and to his preference, in the tribune figures, for broad patches of colour that create a powerfully sculptural, though far less descriptive, effect. This technical distinction is crucial in evaluating the *St Jerome in the Wilderness* (cat. 3), and the *Saint Mark* (cat. 5).

K.C.

fig. 67 Chronicle of Eusebius, MS. 315, Merton College, Oxford

7

ATTRIBUTED TO
ANDREA MANTEGNA
The Chronicle of Eusebius

Eusebii Pamphyli temporum liber, seu chronicon ad Adamo ad annum Christi 326

Illuminated miniature on vellum, cut on all edges, 163 *fols*; folio: 273 x 183 mm

Dated 1450

Biblioteca Nazionale Marciana, Venice, Cod. Lat. ix. 1 (3496) *fol.* 133*v*

PROVENANCE
Fantino Dandolo(?); by 1784, Convent of SS. Giovanni e Paolo, Venice

REFERENCES
Meiss, 1960, pp. 107, 111; Wardrop, 1960, p. 7 and pl. 3 (*fol.* 58); Alexander and de la Mare, 1969, p.XXVIII, n. 4; Marcon, 1987, pp. 254-6; *idem* in Zorzi, 1988, p. 152 and Tav.LXXXV-VI (*fols.* 17, 133*v*)

This miniature of the Christ Child lying swaddled in the manger is the only figurative illumination in a manuscript of Eusebius' Chronicle, which was executed in Padua in 1450, as an inscription on *fol.* 13*v* states. The manuscript is copied in a distinctive formal humanist hand. The scribe is identifiable as Biagio Saraceni of Vicenza, who was chancellor to Fantino Dandolo, Bishop of Padua from 1450 to 1459, and the likelihood is that the manuscript was made for the Bishop (for Saraceni, see Gios, 1984, p. 162, n. 4).

The striking layout of the text, with its use of different styles of script, several colours, text patterns and decorative coloured roundels and semicircles to assist the articulation of the different strands of the Chronicle, is modelled on a Carolingian copy of the text (fig. 67; Merton College, Oxford, MS.315; see Oxford, 1988, no. 61) which was probably copied at Reichenau. This manuscript was apparently acquired and

FILIVS DEI IN BETHLEEM IVDAEAE NASCITVR.

ROMANO RVM

IVDAEO RVM

LTVLLIANVS
EOLIBROQVE
NTRAIVDAE
SCRIPSIT.AF
AMAT XPM
LAN.AVGV
INATVM
T.XV.TIBE
II ESSE
ASSVM

xli — Herodes ad ea quae supra crudeliter gesserat. etiam hoc — XXXI
addidit. uirum sororis suae salome interficit. et cu eam
alij tradidisset uxorem etiam hunc necat. scribas quoq;
& interpretes diuine legis simili scelere occidit

xlii

IESVS XPZ — COLLIGVNTVR OMNES — ABHABRAHAM VSQVE AD NATIVITATEM XPI — AN.II.XV.

xliii — Quirinus ex consilio senatus iudaeam missus census — XXXIII
CXCV OLYMPIAS — homunum possessionumq; describit.

xliiii — C. caesar amicitiam cum parthis facit. — XXXIIII
Sextus pythagoricus philosophus nascitur.
Augustus tiberium et agrippam in filios adoptat.
Iudas galileus ad rebellandum iudaeos cohortatur.

xlv — Herodes cum X. natiuitatem magorum iudicio co — XXXV
gnouisset. uniuersos bethleem paruulos iussit interfici.
Herodes morbo intercutis & scatentibus toto corpore
uermibus miserabiliter sed digne moritur.

xlvi — Asinius pollio orator et consularis qui de dalmatis trium — XXXVI
pharat Lxxx. aetatis suae anno in uilla tusculana moritur.

IIXX xlvii — In herodis locum filius eius archelaus ab augusto substituit — XXXVII
CXCVI OLYMPIAS — Et tetrarche fiunt quattuor fratres eius herodes

7

124

brought to Padua by Dandolo's predecessor as Bishop of Padua, Pietro Donato, who had been the president of the Council of Basel in the mid-1430s (Reichenau is situated not far from Basel). The manuscript is identifiable as no. 94 in the inventory of Donato's library, compiled probably between 1443 and 1445: '*Eusebius de Temporibus in littera vetustissima*' (Sambin, 1959, p. 56). It was later acquired and taken to England by John Tiptoft, Earl of Worcester, who was studying in Padua from 1459 to 1461. During the time that the Merton manuscript was in Padua several copies seem to have been made from it, which reflect both its unusual layout and its distinctive text. The Venice manuscript was probably one of these direct copies, and possibly the earliest. It is a very close copy of the text layout and decoration of the Merton manuscript, although the scribe added purple to the three colours – brown, red and green – used in that manuscript. He also added extra texts to the prefatory material which precedes the Chronicle proper, noting that one of these interpolations was found '*in alio exemplari*', in other words in a copy of the popular 15th-century 'Florentine' recension of the text, of which Donato had also owned a copy, now in Oxford (Bodleian Library, MS. Canon. Pat. Lat. 193).

Numerous later manuscripts appear to descend from Saraceni's version of the text, a copy of which the Paduan scribe Bartolomeo Sanvito (*c.* 1435-1512/13) seems to have taken with him when he went to Rome in 1464 (see de la Mare, 1984, pp. 252-3, n. 33). The best-known of these is British Library

Royal MS.14 C 3, copied in Rome by Sanvito himself for Bernardo Bembo, probably in the early 1480s (Evans, 1983, pp. 103-6). Another manuscript of this group, Vatican Library, MS. Vat. Lat. 743, copied by Giovanpietro Arrivabene, secretary of Cardinal Francesco Gonzaga, around 1470, contains a miniature of the Christ Child closely modelled on the one discussed here. Another family of manuscripts, which imitates the layout and colouring, but not the decoration, of the Merton manuscript, and does not include all the prefatory texts found in it, includes a copy made for Cardinal Bessarion, the papal legate to Bologna, in the early 1450s (Venice, Biblioteca Marciana, MS. Lat. Z. 348(2019)). This text, too, was later taken to Rome and generated further copies there, including one for Pope Pius II (Cambridge University Library, MS. Mm.1.3). A third copying of Merton is represented by Vatican Library, MS. Vat. Lat. 247, an undecorated copy made in a humanistic cursive hand on paper, which includes in the text corrections made to the Merton manuscript in a 15th-century hand after the earlier copies had been made. This manuscript appears to be a direct, diplomatic copy of Merton; it includes everything to be found in the manuscript, but nothing more.

In the Carolingian manuscript, the Old and New Eras were divided from each other by a miniature of the Cross with an inscription running across the page, within the border. This arrangement was copied in the Paduan Eusebius but, although the inscription is identical to that in the Oxford manuscript, it

now frames the image, which has been changed to the Christ Child in the manger. The new subject-matter, which in any event is justified by the text, was probably demanded by the patron, but could conceivably have been the artist's idea.

Because the manuscript is inscribed '*Patavii MCCCCL*' Meiss proposed that the illuminator must have been an artist from the circle of Squarcione and Mantegna. Marcon suggested someone working in Padua under the influence of Fra Filippo Lippi and Donatello. A good case can be made for Mantegna himself, not only in view of the extremely early date, when almost nobody in Padua was working in this new Renaissance style, but also in view of the sheer quality, which is evident in every minute stroke of the brush. Each hair and blade of grass is beautifully observed, as are such details as the red edging on the blue and white swaddling bands, and the star-shaped gilded radiance in the middle of the halo.

At this date, Mantegna's precocious talents were already making his name, as his *Adoration of the Shepherds* (cat. 8) painted for the Este of Ferrara underlines. A work on a miniature scale, such as the Eusebius, is stylistically not incompatible with the New York painting, and the dimpled chin and tender expression of the child, with his limbs showing beneath the drapery, compare well with those of his counterpart in the *Presentation in the Temple* (fig. 39; Gemälde-galerie, Berlin).

A.C. de la M. and D.E.

8

ANDREA MANTEGNA
The Adoration of the Shepherds

Tempera on canvas, transferred from panel:
40 x 55.6 cm (overall); 37.8 x 53.3 cm (original surface)

c. 1450-51

The Metropolitan Museum of Art, New York
(Anonymous Gift, 1932 32.130.2)

PROVENANCE

Este Collections, Ferrara(?); by 1603-21, Cardinal
Pietro Aldobrandini, Villa Aldobrandini a
Montemagnapoli, Rome (1603, inv. no. 24); 1621-38,
Cardinal Ippolito Aldobrandini (1626, inv. no. 23;
1638, inv. *f.* 102); 1638-81, Olimpia Aldobrandini
Borghese Pamphili (before 1665, inv. no. 24; 1682
inv. no. 303); 1682-1710, Giovanni Battista Pamphili;
1710-60, Cardinal Girolamo Pamphili; 1760-68, his
estate, 1768-92, Paolo Borghese Aldobrandini;
1792-1800, Giovanni Battista Borghese Aldobrandini,
Villa Aldobrandini; 1800-01, Alexander Day, London;
by 1808, William Buchanan, London (1808, cat. no. 5);
1808-24, Richard Payne Knight, Downton Castle,
Ludlow, Herefordshire; 1824-38, Thomas Andrew
Knight, Downton Castle; 1838-1909, Andrew Johnes
Rouse-Boughton-Knight, Downton Castle; 1909-24,
Charles Andrew Rouse-Boughton-Knight, Downton
Castle; 1924, A. Ruck, London; 1924-5, Duveen
Brothers, New York; 1925-32, Clarence H. Mackay,
Roslyn, Long Island, New York

REFERENCES

Agucchi, 1603, no. 24, in D'Onofrio, 1964, p. 207;
Vasi, 1794, I, p.338; Buchanan, 1824, II, p. 6, no. 12;
Yriarte, 1901, pp. 216-18; Kristeller, 1901, pp. 453,
459; Berenson, 1907, p. 354; Lemoisne, 1909, p. 36;
Borenius, in Crowe and Cavalcaselle, 1871, ed. 1912,
p. 85, n.; Graves, 1913, II, p. 745; Venturi, 1914,
pp. 143-6; Pacchioni, 1915, pp. 350-51; Holmes, 1930,
p. 65; Berenson, 1932, p. 327; Fiocco, 1937, pp. 31,
43-4; Tietze and Tietze-Conrat, 1944, p. 365; Popham
and Wilde, 1949, p. 174; Tietze-Conrat, 1955, pp. 180,
186, 190-91; Cipriani, 1962, pp. 24-5, 54-5; Meiss,
1957, pp. 47-8; Della Pergola, 1963, pp. 73, no. 303,
85, n. 303; D'Onofrio, 1964, p. 18; Camesasca, 1964,
pp. 15-16, 113-14; Ruhmer, 1966, pp. 31, 100;
Garavaglia, 1967, no. 7; Berenson, 1968, p. 240;
Fredericksen and Zeri, 1972, p. 118; Lightbown, 1986,
pp. 59-60, 403-4; Angelini, in Florence, 1986,
pp. 69-70; Marinelli, in Verona, 1986, p. 64;
Castiglioni, in Verona, 1986, pp. 196-7; Fredericksen,
1991, p. 117, n. 8; Christiansen, in Milan, 1991,
pp. 307-12

This is the earliest of Mantegna's pictures in which his fully developed style, combining an almost obsessive concern for precisely described detail and an austere but deeply felt current of emotion, is encountered in its completely realised form. The traces of Pizzolo's rough-hewn figure types, so much in evidence in the *St Jerome* (cat. 3) and the *St Mark* (cat. 5), are here replaced by a miniaturist's delicacy of touch and a refined taste for bright but subtly modelled colours that could scarcely be anticipated from Mantegna's earlier work. A comparison of the compact, carefully constructed rock formations and the peaceful river landscape in the *Adoration* with the wilder features of the *St Jerome* underscores the transformation, which seems to have been as abrupt as it was radical. The change is equally apparent in a comparison between the lunette of the Ovetari Chapel of *The Calling of SS. James and John* and *St James Preaching* (fig. 56), with their figure style inspired by Pizzolo and their somewhat disjunctive space, painted in early 1450 (shortly after the arbitration of 27 September 1449 which assigned them to Mantegna) and the more fluid space and elegant figures of the scenes below of *St James Baptising Hermogenes* and the *Trial of St James*. The *Adoration* bears closest comparison with the lower scenes, and must have been painted about 1450-51, though dates ranging as late as 1460 have been proposed (Pacchioni; Fiocco, 1937; Cipriani; Ruhmer).

The change is due not simply to an evolution of style but to Mantegna's response to a variety of artists and artistic traditions from outside Padua. Late in 1447 he was in Venice with Squarcione, where they quarrelled and separated for good. It must have been at this time that Mantegna first established ties with Jacopo Bellini, whose daughter Nicolosia he betrothed in 1452. The commission in the Ovetari Chapel put him in direct touch with the other leading Venetian painters, the partners Giovanni d'Alemagna and Antonio Vivarini, as well as with Bono da Ferrara, Pisanello's pupil, who by 1451 had absorbed some rudiments of the style of Piero della Francesca. In 1449 Mantegna apparently visited Ferrara to paint a portrait of Lionello d'Este (now lost; see Campori, 1875, p. 13). Lionello's court was the most progressive in northern Italy, presided over by Guarino da

Verona and frequented by Leon Battista Alberti (see p. 105, above). It has long been recognised that the shepherds in the *Adoration* were influenced by the works by Rogier van der Weyden he saw there. But of even greater importance than any specific pictorial source was the revival of ekphrastic literary conventions, with their emphasis on abundant descriptive detail, as practised and promoted by Guarino (Baxandall, 1963, 1964, 1965, 1971). Earlier, this literary tradition had had a formative impact on Pisanello and Jacopo Bellini, whose graphic work can only be understood in the context of the interests of Lionello's court. The *Adoration* holds a special place in this discussion in that there is circumstantial evidence that it was painted for Lionello's successor, Borso d'Este.

The picture is first listed in an inventory of the collection of Pietro Aldobrandini compiled in 1603 by Giambattista Agucchi (see D'Onofrio, 1964, p. 207; and Fredericksen, 1991, p. 117, n. 8). It can then be traced through various Aldobrandini inventories until 1800-01, when it was purchased by Alexander Day. Subsequently it was sold by Buchanan to Richard Payne Knight, in whose notebook it is specified as coming from the Aldobrandini collection. (This provenance is garbled in the literature: see Tietze-Conrat and Lightbown, who incorrectly confuse the Metropolitan picture with another, lost, painting of the *Nativity* sold from the collection of Charles I in 1653). The interest of this provenance lies in the fact that Pietro Aldobrandini's paintings came from three principal sources: those he inherited from Lucrezia d'Este, Duchess of Urbino (these were listed in an inventory in 1592 and do not include the *Adoration*); those he commissioned directly with the advice of Agucchi; and those he seems to have acquired from the Este collections following the devolution of Ferrara to the Papacy in 1598. Among the last group were the celebrated *Bacchanals* by Titian and Giovanni Bellini, and, it would seem, Mantegna's *Adoration* and the *Agony in the Garden* (National Gallery, London). The *Adoration* may be identifiable with the '*Prosepio de Andrea Mantegna*' listed among the decorations of the private chapel of Margherita Gonzaga, Duchess of Ferrara (see Venturi, 1888[1], pp. 425-6). Both of these pictures contain what are probably Este

devices. In the *Agony in the Garden* a large bird, probably intended to represent the Este eagle (though Lightbown, 1986, p. 61, calls it a vulture, the long beak recurs in other depictions of the Este eagle) is perched on a barren tree with one live branch. A similar device, without the live branch, occurs on the reverse of Pisanello's portrait medal of Lionello d'Este of 1444. An eagle combined with the dead tree with one branch in leaf is shown on the reverse of a portrait medal of Borso d'Este (see Boccolari, 1987, p. 60) and virtually the identical device appears at the bottom of *fol.* 233*v* of Borso d'Este's celebrated Bible (Biblioteca Estense, Modena). (The recurrence of an eagle motif, sometimes on a branch, in Jacopo Bellini's albums of drawings again suggests the degree to which they were inspired by the Este court.) Similarly, the wattle fence with the prominent gourd or squash in the *Adoration* may allude to Borso d'Este's favoured device of the *paraduro* (a wattle dike employed for water drainage) that figures so conspicuously and extensively throughout his Bible as well as on the Muse by Michele Pannonio (Museum of Fine Arts, Budapest) painted for his Studiolo (see Christiansen, in Milan, 1991).

In the minutely described background of the *Adoration*, with its cordial encounters between shepherds and angels, and its genre-like details of a woman seated against a wall spinning while chickens peck at the barren ground and a porter prepares barrels for transport on a barge moored on the opposite river bank, Mantegna raises to a new level of precision the descriptive detail in Jacopo Bellini's earlier *Virgin and Child adored by Lionello d'Este* (fig. 59), with its extensive landscape illuminated by the rays of the rising sun and enlivened with views of miniature walled cities, a farmhouse with a well and beehive, a hermit reading beneath a thatched shelter and galloping horsemen. At the feet of the Virgin kneels a diminutive figure of Lionello, so there can be no doubt that the picture was, like the *Adoration*, painted for the Este, probably in the early 1440s. Both of these pictures seem to have been conceived, in part, as a response to Guarino's insistence of the superior descriptive powers of poetry over painting.

In a dialogue written by another court humanist, Angelo Decembrio (see pp. 105-6 above), Lionello notes the vain attempt of painters to show the colours of dawn or the rising sun, and he praises pictures of small size which exceed the capacity of human senses and strain the eyes (see Baxandall, 1963, pp. 321, 325). In the *Adoration* Mantegna, like Jacopo Bellini and Pisanello before him, lays claim to the superiority of painting over poetry, but he also asserts, in a way they had not been able to, its affective powers – what Alberti, in his treatise on painting (one of the most accurate copies seems to have come from Ferrara), termed its ability to 'move the eyes and mind of the beholder'. These twin aspects of Mantegna's art, combined with his unmatched archae-ological interests, were to establish him as the foremost humanist painter of his day.

It would, nonetheless, be wrong to suggest that the sole connection with Jacopo Bellini's work was the cultural ambience of Ferrara. The curving river and rocky outcrops Mantegna employs to measure the depth of his extensive landscape are found repeatedly in Jacopo's albums, and it is only initially surprising to discover that their configuration reappears with little change in Giovanni Bellini's *Pietà* in the Museo Poldi Pezzoli, Milan (this relationship was brought to my attention by Keith Shaw). Infra-red reflectography suggests that Mantegna executed a detailed cartoon for the picture, and it may be that Bellini knew this or the picture itself. Alternatively, a drawing by Jacopo Bellini, now lost, may lie behind both works. Whatever the case, the picture testifies to the close and mutually beneficial relationship established between these artists around 1450.

It is curious that the attribution of the *Adoration* should ever have been doubted (Kristeller, Tietze-Conrat), for it is the first of Mantegna's pictures to have exerted a deep and widespread influence. Apart from the studio drawing made after the picture (cat. 9), a roughly contemporary painting, of which a fragment survives (formerly Martin Le Roy collection) is known, as well as a drawing, possibly Ferrarese, after the two shepherds (Royal Library, Windsor Castle, no. 12794: on the relationship of these, see

Christiansen, 1983). Girolamo da Cremona certainly knew the picture when he was at work on Borso d'Este's Bible, for among the illuminations he was commissioned to paint (on Mantegna's recommendation) in 1461 for a missal for Barbara of Brandenburg, Marchesa of Mantua, there is a Nativity derived from this work, and he twice revived the composition in illuminated initials for choirbooks painted in Siena between 1470 and 1474. Other, indirect reflections of the picture occur in a Gradual in Ferrara Cathedral (XIII, *fol.* 39*r*), an Antiphonary in the monastery of San Giovanni Evangelista, Parma (A n.8, *fol.* 39*v*), a Book of Hours of the *Officium Gloriosissimae Virginis* (Museo Civico, Bassano, *fol.* 17*v*: pointed out to me by Keith Shaw). Indeed, by the end of the century many of the features of Mantegna's early little masterpiece had become ubiquitous.

The *Adoration* was transferred from panel to canvas in Paris in 1924. This has inevitably effected the surface texture of the picture. There are two significant losses: in the veil of the Virgin, extending through her shoulder, and in the upper legs and exposed knee of the foremost shepherd. The halo of the Virgin has been reconstructed. Despite these damages, the overall state is extremely good, with the almost merciless precision Mantegna devoted to even incidental details preserved intact. It is usually assumed that the picture has been cropped, since the ass is omitted and the fragment (ex-Martin Le Roy) and the drawing at Windsor both include additional features at the right. However, following the cleaning of the picture in 1991 and the removal of the repainted borders, it is now possible to state with confidence that the top, bottom and the left edges of the painted surface are original; only at the right was the picture cropped. This means that the ass was, exceptionally, excluded. The reason for this is not apparent, but one wonders if the omission of this traditional symbol of Judaism carries an anti-semitic message.

K.C.

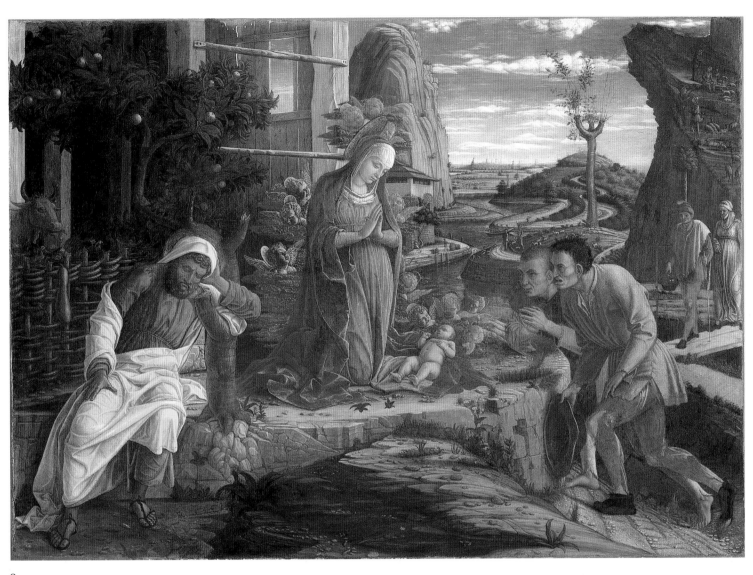

8

9

AFTER ANDREA MANTEGNA
Virgin Adoring the Christ Child

Silverpoint, brush and brown wash with white
heightening, with some yellow in the haloes and the
Virgin's belt and cuffs, on very pale blue-green
prepared paper
233 x 197 mm

Mid-15th century

Gabinetto di Disegni e Stampe, Galleria degli Uffizi,
Florence (397e)

REFERENCES
Kristeller, 1901, p. 453, 459; Popham and Wilde, 1949,
p. 174; Tietze-Conrat, 1955, p. 204; Byam Shaw,
1979, p. 18, no. 39; Petrioli Tofani, 1986, p. 176;
Florence, 1986¹, pp. 69-71, no. 55

This drawing corresponds all but exactly to
the figures of the Virgin and Child in
Mantegna's *Adoration of the Shepherds*
(cat. 8). Although it has been suggested that it
is an autograph preliminary study by
Mantegna (Florence, 1986¹), Byam Shaw was
probably correct in describing it as 'a good
studio record'. The lines of the painting are
followed meticulously, the only material
difference being the Virgin's left thumb that
protrudes clumsily from her hands clasped in
prayer. But the impression of the sheet is very
different from the painting, as is evident in
the lifeless expression of the head and the use
of chiaroscuro. In the drawing the areas of
shadow are extremely dark and the highlights
very marked, whereas in the painting,
especially in the Virgin's blue robe, the effect
is much more uniform, in spite of the use of
gilding.

Drawings such as this, the earliest of many
simili (drawings made as records) were
probably copied from original studies by
Mantegna and were preserved as part of his
workshop property. It was standard practice
in the Quattrocento to preserve drawings as
records of paintings; the existence of prints by
Mantegna's school after preliminary drawings
is added evidence that such drawings were
kept. However, in the early 1450s Mantegna
was not yet an independent master, and this
drawing may have been copied later, unless it
was made by another of Squarcione's pupils
for his master's celebrated visual archive.

D.E.

10

ATTRIBUTED TO
ANDREA MANTEGNA
Life and Passion of St Maurice

Manuscript, tempera on vellum, 39 *fols*;
folio. 187 x 130 mm

c. 1453

Bibliothèque de L'Arsenal, Paris (MS. 940)

PROVENANCE
Cathedral of Saint-Maurice, Angers, possession of the
suppressed order of the Crescent (inventories of 1505,
1525, 1532); by 1539 removed from the Cathedral;
c. 1590 Paul Petau; after 1614, Claude Ménard, Anjou,
sent to Nicolas-Claude Fabri de Peiresc at Aix and not
returned, untraced at his death in 1637; by 1695
Boucot; by 1763 Charles-Adrien Picard; sold 1781 to
Marquis de Paulmy

REFERENCES
Martin, 1900, pp. 229-67; Martin and Lauer, 1929,
pls 51-2; Wescher, 1947, pp. 59, 64, 98; Meiss, 1957,
passim; Fiocco, 1958, Moretti, 1958, pp. 58-66; Meiss,
1960, pp. 97-112; Levi d'Ancona, 1964, pp. 53-4;
Robertson, 1968, pp. 17-21, 28; Mariani Canova,
1969, pp. 16, 141; Alexander, 1977, pp. 54-9; Joost-
Gaugier, 1979, pp. 48-71; Lightbown, 1986, pp. 494-5;
Eisler, 1989, pp. 534-5; Fletcher, 1991, pp. 153-8

This manuscript was executed for Jacopo
Antonio Marcello, a Venetian general (see
p. 13), and sent by him to Aix as a present
for Jean Cossa, Seneschal of Provence and
councillor of René of Anjou, on 1 June
1453. On 26 August 1449 Marcello had been
elected to René's newly founded chivalric
Order of the Crescent; he was admitted to
the Order in 1450, with Cossa presiding as
annual senator. René aspired to take the
Kingdom of Naples back from the ruling
Aragonese dynasty, and he counted on the
help of Francesco Sforza, Duke of Milan
since 1450; Sforza, however, was at war with
Venice, and wanted support from René.
Marcello's lavish gift was apparently sent to
win the support of Cossa, and ultimately
René, against the Sforza.

The manuscript, written in a Renaissance
hand, narrates the life and passion – or
martyrdom – of St Maurice, the patron saint
of the Order of the Crescent. It contains six
small miniatures by an anonymous Lombard
illuminator. There then follows a poem in
Latin hexameters in praise of the Saint,
composed by Marcello himself, and written
by a different scribe from the rest of the
manuscript.

It was first pointed out by Meiss (1957) that
its four full-page miniatures, of the *Chapter of
the Knights of the Order (fol. Cv)*, *St Maurice
(fol. 34v)*, *Portrait of Jacopo Antonio Marcello
(fol. 38v)* and *An Allegory of Venice (fol. 39)*,
were of far greater artistic merit than the
other decorations of the manuscript. He
proposed that the *Chapter* and the *Portrait*
were autograph works by Mantegna, and that
the other two miniatures, and especially the
Allegory (which seems to be by a different and
lesser hand), had involved the use of assistants.
Robertson subsequently attributed the
St Maurice, the *Portrait* and the *Chapter* to
Giovanni Bellini, and remarked that 'Nobody
who has taken the trouble to examine the
manuscript could doubt that the miniatures
are the work of a major artist'. Indeed,
attempts to associate the manuscript with the
workshop of Jacopo Bellini, or with specific
but lesser figures such as Leonardo Bellini or
Girolamo da Cremona, have not carried
conviction.

A manuscript of Strabo's *Geographia*
(Bibliothèque Rochegude, Albi, MS. 4) dated
1459 was also commissioned by Marcello, and
given to René of Anjou. Meiss attributed its
two full-page miniatures to Mantegna's

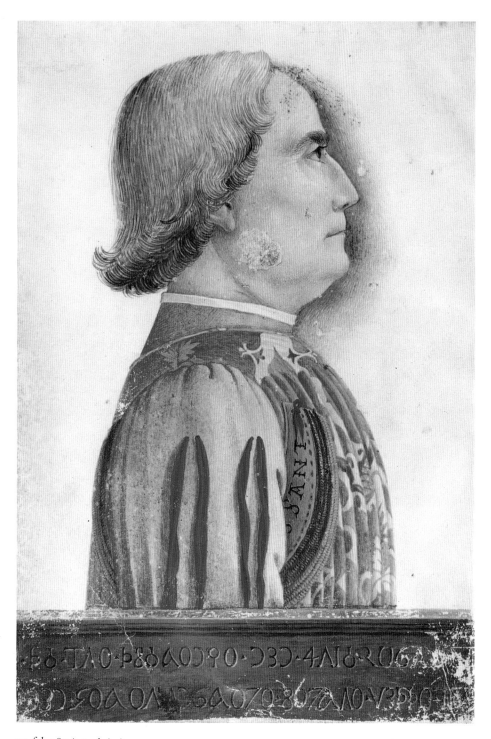

10 *fol.* 38*v* (actual size)

II

ANDREA MANTEGNA
Recto: St James Led to Execution

Pen and brown ink on pale pink prepared paper, with
some black chalk and a number of yellow and reddish
marks.
Inscribed in pencil at top left corner: *Mantegna* (?)

Verso: Head of a Man

Brush and black ink; inscribed *Mantegna* in pen
at top
155 x 234 mm
Collectors' marks of Earl Spencer (L. 1530) and
Sir Thomas Lawrence (L. 2445)

c. 1453

The Trustees of the British Museum, London
(1976-6-16-1)

PROVENANCE
Spencer coll.; Sir Thomas Lawrence; John Malcolm;
A. E. Gathorne-Hardy; 1976, sold to the British
Museum

REFERENCES
Kristeller, 1901, pp. 101-2; Popham, in London
1930-31, p. 42, no. 152; Clark, 1930, pp. 182-7;
Fiocco, 1933, pp. 185-94; Tietze and Tietze-Conrat,
1944, pp. 74, 84-5, no. A296; Mezzetti, in Mantua,
1961, p. 174, no. 129; Heinemann, 1962, II, p. 188,
pl 143 (mistakenly reproducing the Louvre copy);
Robertson, 1968, pp. 22-3; Wilde, 1971, p. 39; Clark,
1983, pp. 114-16; Byam Shaw, 1979, p. 16, no. 30;
Lightbown, 1986, p. 481, no. 176; Ekserdjian, 1989,
p. 229; Pope-Hennessy, 1991, p. 219

This drawing represents a first idea for the
fresco of *St James Led to Execution* (fig. 1),
formerly in the Ovetari Chapel. The fresco
was originally allocated to Niccolò Pizzolo,
who was murdered in 1453, so the drawing
must date from not long after that, and
certainly before January 1457, by which
month the fresco was completed.

This sheet was first published by Kristeller
as an autograph study for the fresco, and
accepted as such by most subsequent writers.
However, some critics, notably Fiocco and
Mezzetti, attributed it to Giovanni Bellini on
the grounds of its resemblance to a group of
drawings they believed were by him. In fact,
these sheets are by Mantegna, and this
drawing is fundamental for an understanding
of Mantegna as a draughtsman, given that it is
his earliest securely autograph drawing to
survive and one of his very few drawings
connected with a specific work. Whereas it
bears little resemblance to the few pen
drawings that can be attributed to Giovanni
Bellini, such as *The Nativity* (Seilern Coll.,
Courtauld Institute, London) it compares
well with a group of drawings by Mantegna
(cats. 23-8, 35), some of which are related to
prints attributed to him in this catalogue.

Clark (1983) suggested that Mantegna's
rapid and highly charged drawing style may
have been influenced by that of Donatello,
and compared this sheet with a pen drawing
of the *Massacre of the Innocents* (Musée des
Beaux-Arts, Rennes) associated with
Donatello. Certainly the wiry confidence of
the handling of the *St James* drawing is very
different from the more precise technique
encountered in Jacopo Bellini's albums.

Wilde and Lightbown noted that there
appears to have been a change of iconography
between the drawing and the fresco. Wilde
argued that the drawing represents the
moment when St James stopped on his way
to martyrdom and blessed and healed a
paralytic, as narrated in the *Golden Legend*.
He further suggested that the figure at the
extreme left of the fresco was Josiah, the
scribe who led St James by a rope and was
converted after witnessing the miracle of the
healing of the paralytic. Lightbown, however,
argued that whereas in the drawing the
kneeling figure is the paralytic, in the fresco
he has been replaced by Josiah, dressed,
according to Lightbown, 'in a scribe's long

robes and with an inkhorn hanging from his
belt'; the inkhorn seems to be a figment of
Lightbown's imagination, but it is likely that
this figure, both in the fresco and in the
drawing, represents Josiah, because the *Golden
Legend* refers to the scribe 'throwing himself
at the saint's feet', whereas the paralytic was
lying by the way. If this identification is
correct, then it is tempting to suppose that the
figure in the drawing who stands between the
Saint and the soldier with both hands on his
haunches (and was subsequently excised from
the fresco) represents the healed paralytic. In
any event, Mantegna's textual source need
not have been exclusively the *Golden Legend*,
given the numerous departures from it. Josiah
should have appeared in the previous scene of
the saint before Herod Agrippa, yet in that
fresco, as in this one, James was escorted by
two soldiers. Furthermore, the rope by which
he is led is around his waist rather than his
neck.

In the fresco there are various changes,
notably the more extreme *di sotto in sù*
perspective and the organisation of the
composition around a monumental triumphal
arch, but the basic ordering of the figures into
two groups divided by the pivotal soldier
remains constant. In the drawing, he and the
Saint, whose head was initially raised
Heavenwards in supplication, are by far the
most heavily worked-over figures. All the rest
of the figures, apart from the kneeling man,
whether Roman soldiery or the crowd being
restrained by them, are shown nude, and even
James's right leg and arm, whose outlines are
clearly visible beneath the drapery, suggest he
was initially drawn unclothed. Only on these
three figures does the hatching follow the
movement of the bodies: for the rest it is
simply a means of shading that is extended
indiscriminately over the background.

In the fresco St James is no longer at the
edge of the composition or in profile, but
instead shown much more frontally. These
features and, above all, the far more timid
perspective and the extreme freedom of the
handling, suggest that this drawing represents
a very early stage in Mantegna's thinking,
soon after he started to work on the
composition. An early copy of the sheet in
pen and ink (Louvre, Paris, RF.1870-525)
shows that the drawing has been cut on the
right. A pen drawing on pinkish washed

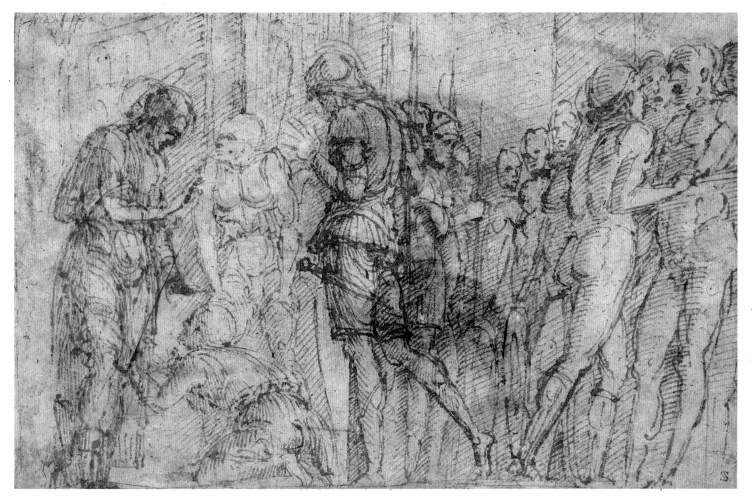

II *recto*

paper of a seated man (Boymans–van Beuningen, Rotterdam; reproduced in Robertson, 1968, p. 27, pl. 11B) is close in style to the standing man with his hands on his haunches in cat. 11. However, as Robertson suggested, the drawings do not seem to be by the same hand, and he preferred a tentative attribution to Giovanni Bellini.

There is a substantial area of black chalk to the right of the centre on the *recto* of the sheet which can be deciphered as representing the head and shoulders of a male figure, somewhat *all'antica*, in a roundel, the inner edge of which is reinforced, and which must have been produced with the assistance of a compass. Although not at all easy to read, it bears some resemblance to the nearly contemporary *St Euphemia* (cat. 13) of 1454, as well as to the much later busts of Roman Emperors on the ceiling of the Camera Picta (fig. 10).

The drawing on the *verso*, newly uncovered for this exhibition but previously visible when the paper was held up against the light, has been almost totally ignored. Were it not on the *verso* of an unassailable Mantegna drawing, it would certainly have been doubted. However, now that it is clearly visible, in this context it cannot be denied autograph status, and it thus puts to rest any lingering possibility of the *recto* being by Giovanni Bellini. It shows a male head, confidently and economically brought to life by the unusually thick strokes of black ink applied with a brush, and although its juxtaposition with the compositional study on the *recto* may be misleading in this respect, it is tempting to associate it with the two colossal heads formerly at the entrance to the

Ovetari Chapel and generally supposed to be self-portraits by Pizzolo and Mantegna (see cat. 6). Like the latter, the head in the drawing is turned to the left so that more of the right side is visible; unlike it, the mouth is shown open with the teeth drawn in. Here the expressive language is pushed to the extreme, with flashing eyes and gaping mouth, but there are many heads in the Eremitani cycle to parallel it. In the end, in his self-portrait, Mantegna decided to retain the beetling brows and eyes with heavy bags beneath them, but to aim for an effect of anxious repose instead of a grimacing physiognomical study. Whether such a connection is accepted or not, the head represents an important addition to Mantegna's graphic *œuvre*, not only because of its early date, but also because it is in a technique – brush without wash or white heightening – which is otherwise unknown among the surviving corpus of his drawings. A very damaged drawing in the Uffizi (1447E) deserves reconsideration. Executed in almost as summary and violent a pen technique as the *verso* of cat. 11, it, too, represents a grimacing, open-mouthed male head.

D.E.

11 *verso*

I2

ANDREA MANTEGNA
*Virgin and Child with Seraphim and
Cherubim (The Butler Madonna)*

Tempera on wood, 44.1 x 28.6 cm

c. 1454

The Metropolitan Museum of Art, New York
(Bequest of Michael Friedsam, 1931. The Friedsam
Collection. 32.100.97)

PROVENANCE
By 1891, J. Stirling Dyce, London; by 1901 – before
1910, Charles Butler, London and Warren Wood,
Hatfield; until 1926, Dr Hans Wendland, Basel; 1926,
F. Kleinberger & Co., New York; 1926-31, Michael
Friedsam, New York

REFERENCES
Yriarte, 1901, p. 209; Kristeller, 1901, pp. 120, 123,
437; Knapp, 1910, p. 179; Graves, 1913, II, p. 745;
Venturi, 1914, pp. 271, 308, 322, 356; M'Cormick,
1926, pp. 62; Berenson, 1932, p. 328; Fiocco, 1937,
pp. 32, 201; Richter, 1939, pp. 63-4; Suida, 1946,
p. 61; Tietze-Conrat, 1955, p. 191; Cipriani, 1962,
pp. 52-3; Meiss, 1957, p. 27; Paccagnini, in Mantua,
1961, p. 23; Arslan, 1961, p. 165; Gilbert, 1962,
pp. 6-7; Longhi, 1962, ed. 1978, p. 152; Camesasca,
1964, pp. 16-17, 114; Garavaglia, 1967, no. 19;
Berenson, 1968, p. 240; Pallucchini, 1971, pp. 40-41;
Fredericksen and Zeri, 1972, p. 118; Pope-Hennessy,
1976, ed. 1980, p. 82; Lightbown, 1986, p. 477;
Christiansen, 1987[1], pp. 173-4, 177, n. 38; De Nicolò
Salmazo, 1990, p. 496

This small, much damaged picture has been
recognised by most scholars, from Kristeller
on, as the earliest of Mantegna's devotional
images of the Virgin and Child, a theme he
treated relatively rarely in comparison with
his brother-in-law Giovanni Bellini, but one
to which he brought a similar depth of
feeling and perhaps even greater inven-
tiveness. The Virgin, wearing a fringed veil
attached at her breast with a jewelled clasp,
protectively holds her child behind the
inner moulding of an arched opening
foreshortened from a point in the lower half
of the picture field. The panel has been
cropped and probably showed the outer
frame of the arch as well, as in the *St Mark*
(cat. 5), *St Euphemia* (cat. 13) and in the
monumental fresco of the *Assumption of the
Virgin* in the Ovetari Chapel, painted
between 1454 and 1457.

As in those works, the arch here is used
illusionistically, with the Child's feet resting
on a raised sill behind the arch. The
background is filled with rows of seraphim
(to the left) and cherubim (to the right). This
motif is also found in two approximately
contemporary paintings of the Virgin and
Child by Jacopo Bellini (Accademia, Venice;
ex-Burns collection, London, sold Christie's,
London, 29-30 June 1979, lot 51), while the
fringed veil recurs in Jacopo's *Virgin and Child*
(Uffizi, Florence), probably dating from the
mid-1450s. In these works, as in Mantegna's
picture, Jacopo employs gold dots to model
the Virgin's garment, a technique he learnt
from his teacher, Gentile da Fabriano, and
evidently passed on to his son-in-law (Ames-
Lewis, in London, 1984, pp. 354-7). These
technical and iconographic analogies with the
work of Jacopo Bellini (already noted by
Kristeller) confirm a dating for the Butler
Madonna sometime around 1453, shortly
after Mantegna became related to the Bellini
family by marriage.

Yet, Jacopo's is neither the exclusive nor
even the predominant influence, for the
compositional source was almost certainly a
sculptural relief by Donatello. Pope-Hennessy
has pointed out the resemblance of the type
of the Virgin to Dontatello's ruined terracotta
relief (Bode Museum, Berlin) in which the
background is also filled with the figures of
cherubim. There are analogies with
Donatello's so-called *Verona Madonna* (fig. 71;
see Radcliffe, in Detroit, 1985, pp. 110-11).
Throughout his career – perhaps most
notably in the *Virgin and Child* in Berlin
(cat. 41) – Mantegna drew upon Donatello's
novel compositional formulas and his intense
depiction of emotion, but so free were his
interpretations that they rarely betray a
specific model. To some degree, this is also
true of this *Virgin and Child*. Nonetheless,
Donatello's Chellini *Virgin and Child*
(Victoria and Albert Museum, London),
given by Donatello to his physician Giovanni
Chellini in 1456, following a severe illness
(see Pope-Hennessy), provides a striking
analogy in the alignment of the Virgin and
Child along converging diagonal planes and
the conjunction of their heads. In the
roundel, a curved balustrade, overlapped by
the Virgin's veil, constitutes the illusionistic
device. It is even possible that the gilt,

pseudo-Cufic inscription around the edge of
the roundel inspired the Virgin's halo in
Mantegna's painting, which is conceived like
a bronze plate (interestingly, this device was
used by Jacopo Bellini in his contemporary
Virgin and Child in the Uffizi, but it was at
precisely this period that Jacopo also took
inspiration from Donatello: see Christiansen,
1987[1], pp. 174-7). Conceivably, Donatello
cast the roundel in Padua before returning to
Florence some time after November 1453, or
Mantegna knew a stucco cast such as the one
in the Museo di Castelvecchio, Verona. Also
dependent on Donatello are the under-sized
haloes of the cherubs, a feature of some of the
musician angels from Donatello's Santo altar.

Like the *Adoration of the Shepherds* (cat. 8),
this seemingly modest work had considerable
influence. The figures of the Virgin and
Child were repeated in a picture formerly in
the Steffanoni collection, Bergamo, published
by Longhi as evidence for the existence of a
common prototype by the young Giovanni
Bellini, an idea that carries little weight in
view of the relationship to the sculpture of
Donatello. In two other variants (Gemälde-
galerie, Berlin; The Philbrook Art Center,
Tulsa, Oklahoma) the pose of the Virgin is
closely repeated, but that of the child altered.
The Berlin painting, erroneously believed by
Kristeller (1901, pp. 120-21) to be by
Mantegna, is by Lazzaro Bastiani; it is set into
a painted frame decorated with putti bearing
instruments of the Passion whose poses are
inspired by Donatello's music-making angels
from the Santo altar. The veil of the Virgin
was adopted by Bartolomeo Vivarini in
several early works (see Pallucchini, who
erroneously ascribed the Berlin picture to
Bartolomeo). None of these derivative
pictures seems to utilise a preparatory cartoon
by Mantegna. Indeed, infra-red reflecto-
graphy establishes that Mantegna drew the
composition for the Metropolitan picture
freehand on the panel (fig. 26), employing, in
the cherubim and seraphim, a graphic style
strikingly similar to that of the preparatory
study for the *St James Led to Execution* (cat.
11) and the *Christ at the Column* (cat. 35). The
poses of some of the cherubim were modified
between the underdrawing and the painting
(most notably those to the right of the
Virgin), providing further proof that the
picture is autograph.

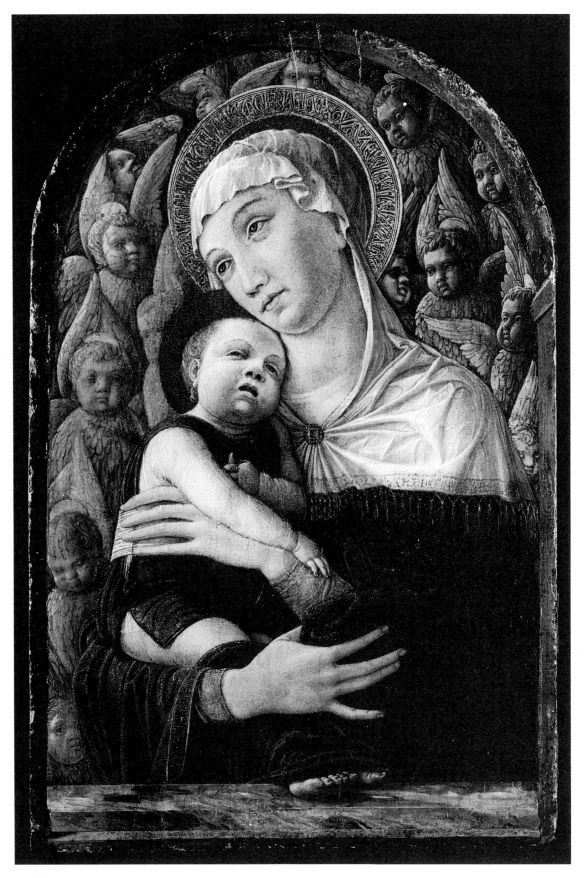

12 (before restoration)

The provenance of the picture is not known and cannot be established, although an inventory of the Este collections in Ferrara drawn up in 1493 lists a panel by Mantegna of a Virgin and Child with seraphim ('*uno quadro de legno depincto cum nostra dona et il figliolo cum serafini de mano del sopradicto Mantegna*': Campori, 1870, p. 1; for possible candidates for this picture see Lightbown, 1986, pp. 462, 477-8).

Given the hesitation some scholars have expressed over the authorship (see especially Gilbert, Tietze-Conrat, Lightbown, Paccagnini), it is worth pointing out that, before the cleaning undertaken for this exhibition, the heads of the Virgin and Child had been known in a wholly reconstructed state. The seraphim and cherubim are relatively free of restorations, but only the cherubim can be said to be in fairly good condition.

K.C.

13

ANDREA MANTEGNA
St Euphemia

Distemper (?) and gold on canvas, 171 x 78 cm
Inscribed (on arch): SANTA EVFEMIA; (on the *cartello*):
OPVS ANDREAE MANTEGNAE / MCCCCLIIII

Dated 1454

Museo e Gallerie Nazionali di Capodimonte, Naples
(Q. 61)
(Exhibited in London only)

PROVENANCE
Until 1804, Cardinal Stefano Borgia; 1804-17,
Museo Borgia, Velletri (inv. 1814)

REFERENCES
Seroux d'Agincourt, 1823, p. 120; *idem*, 1828, p. 142;
idem, 1840, p. 128; Crowe and Cavalcaselle, 1871,
ed. 1912, p. 29; Morelli, 1891, p. 231; Yriarte, 1901,
pp. 12-13, 247; Kristeller, 1901, pp. 137-40, 438;
Berenson, 1907, p. 255; Knapp, 1910, p. 174; Venturi,
1914, pp. 140-42, 160; De Rinaldis, 1928, pp. 176-8;
Berenson, 1932, p. 327; Fiocco, 1937, pp. 30, 200;
Tietze-Conrat, 1955, p. 208; Paccagnini, in Mantua,
1961, p. 17; Cipriani, 1962, p. 53; Camesasca, 1964,
pp. 23, 92, 114; Garavaglia, 1967, no. 18; Berenson,
1968, p. 240; Lightbown, 1986, pp. 46, 402-3;
De Nicolò Salmazo, 1990, p. 508

St Euphemia, a fourth-century virgin martyr of noble birth, was venerated throughout the Veneto. According to the *Golden Legend*, after undergoing numerous torments, she was thrown to three wild beasts, who 'came and fawned upon the virgin, and then linked their tails to form a seat whereon she might sit down'. Enraged, the executioner stabbed her to death. Mantegna shows the Saint crowned, holding the palm of martyrdom in one hand, the lily of purity in the other, a sword piercing her side and a lion fawning at her arm. When Seroux d'Agincourt saw the picture, probably between 1785 and 1789, it must have appeared considerably brighter, for he described it as a watercolour on canvas. The picture is now much darkened, both through the damage caused by fire and the successive layers of varnish (for an idea of its state, see the illustration in Yriarte). Kristeller rightly dismissed Morelli's contention that the inscription and date on the *cartello* are forgeries: an examination made by conservators at Naples indicates that they are genuine.

The commission was an exceptional one, requiring Mantegna to paint a life-size, isolated figure standing within an illusionistic frame. The scale of the saint exceeds that of the figures in the St Luke Altarpiece (Brera, Milan), commissioned in 1453, and of the later San Zeno Altarpiece (fig. 66; San Zeno, Verona), commissioned in 1456-7, and is, in this respect, comparable only to the frescoes in the Ovetari Chapel.

The viewpoint has been taken at the height of the lion's raised paw, and the arch is foreshortened so that the Saint's head overlaps the furthest edge of the vault; this has the effect of emphasising the figure's proximity to the viewer. It was a device Donatello employed repeatedly in his reliefs, beginning with the *Pazzi Madonna* (Staatliche Museen, Berlin), and including the Chellini *Virgin and Child* (Victoria and Albert Museum, London; see cat. 12). Mantegna had employed a more emphatic *di sotto in sù* view in his frescoed lunette of 1452 over the central portal of the Santo in Padua. But, although the illusionistic device derives from Donatello, the style does not. The figure is viewed frontally in an uncomplicated posture, in marked contrast with the St Giustina to the far right of the St Luke Altarpiece, a work that must be viewed as Mantegna's response to Donatello's altar in the Santo, in which life-size, free-standing bronze figures were grouped together on some sort of common podium. St Giustina strikes a *contrapposto* pose that combines the example of Donatello with the study of ancient sculpture (Meiss, 1957, pp. 20-21). By contrast, the soft, generalised features of *St Euphemia*, and the play of light over her blonde curls and richly patterned brocade dress – a singular feature in Mantegna's religious paintings paralleled only in the approximately contemporary *Presentation in the Temple* (fig. 39; Gemäldegalerie, Berlin) – recalls the work of Jacopo Bellini.

13

The *St Euphemia* was painted the year after Mantegna's marriage to Nicolosia Bellini, and in a sense it initiates what was to be an immensely profitable exchange between Mantegna's austere, sculptural vision and the more affective, optical manner of Giovanni Bellini, who made his own first tentative essays in a style independent of that of his father about this time (e.g. his compositions of the Virgin and Child in the Johnson Collection, Philadelphia, and the Pinacoteca Civica, Pavia). There is no record of the origin of the commission. It must, however, have served as an altarpiece. Although a Paduan provenance cannot be excluded, the church of Sant'Eufemia in Padua was in ruins in the 15th century (Bellinati and Puppi, 1975, II, pp. 318-19). The picture may have

been commissioned in Venice, where there is a church dedicated to St Euphemia on the Giudecca, or, less likely, for the church of Sant'Eufemia in Verona (no such picture, however, is mentioned in any early guidebooks or sources). Perhaps not coincidentally, a drawing for precisely this sort of altarpiece is found in Jacopo Bellini's album in the Louvre (*fol.* 32), where John the Baptist is shown standing in an architectural niche with a predella below. Jacopo's drawing suggests a sculptural rather than a pictorial project and, in fact, a decade later the sculptor Antonio Rizzo undertook two such commissions in San Marco, Venice, for altars dedicated to St James and St Paul (see Markham Schulz, 1983, pp. 18-24, 166-71). In them the architectural ornament is more

decisively classical than in Mantegna's *St Euphemia*, in which the polychrome marble decoration so favoured by Venetian architects is employed. Jacopo Bellini painted a canvas altarpiece of St Mark for the Scuola di San Marco before 13 April 1466 (see cat. 5, above). The *St Euphemia* may have played a significant role in the genesis of this sort of painting in Venice. Its composition is apparently reflected in Gentile Bellini's organ shutters with figures of SS. Mark and Theodore standing beneath foreshortened arches decorated with swags of fruit (Museo Diocesano a Sant'Apollonia, Venice); these are also on canvas and date from the mid-1460s (see Meyer zur Capellen, 1985, p. 140).

K.C.

14

ANDREA MANTEGNA
Four Saints

Pen and brown ink, traces of red chalk on book held by San Zeno
195 x 131 mm
Collector's mark, bottom right, of William, 2nd Duke of Devonshire (L. 718)

c. 1457

Collection of the J. Paul Getty Museum, Malibu (84.GG.91)

PROVENANCE
William Cavendish, 2nd Duke of Devonshire, Chatsworth; thereafter by descent; sold Christie's, London, 3 July 1984, lot 26

REFERENCES
Morelli, 1892-3, I, p. 271; Kristeller, 1901, pp.153-4, no. 1; Venturi, 1914, VII, 3, pp. 154-5; Longhi, 1927, p. 137; Tietze and Tietze-Conrat, 1944, pp. 74, 84, no. A295; London, 1953, p. 10, no. 19; Mezzetti, 1958, p. 240, n. 3; Mezzetti, in Mantua, 1961, p. 173; Popham, in Washington *et al.*, 1962-3, p. 24, no. 38; Robertson, 1968, pp. 22-3; Wilde, 1969, p. 39; Byam Shaw, 1979, p. 17, no. 34a; London, 1984¹, pp. 55-7, lot 26; Lightbown, 1986, p. 481, no. 177; Goldner, 1988, pp. 64-5, no. 22

This drawing is related to the left wing of Mantegna's triptych executed between 1456 and 1459 for the high altar of the Church of San Zeno in Verona (fig. 46), his only altarpiece still in its original location and original frame. SS. Peter, Paul, John the Evangelist and Zeno are portrayed in the same sequence as in the left-hand wing of the painting, and the picture field has been defined already by two ruled vertical lines, while the profiles and some of the fluting of the wooden half-columns of the frame are drawn in freehand and correspond exactly to the frame as executed. It was not unusual at this date for the design of the frame to precede that of the painting itself, and in this instance both were probably devised as an entity by Mantegna. The resemblances between the frame in San Zeno and Pizzolo's frame for his terracotta altarpiece in the Ovetari Chapel (Eremitani, Padua) suggest they may have shared a common prototype, in all probability the framing element of Donatello's high altarpiece for the Santo in Padua as it was originally installed.

14 (actual size)

144

Like many other early Mantegna drawings, this sheet was formerly attributed to Giovanni Bellini, in spite of its evident connection with a work by Mantegna. It was thought to be either a variation on Mantegna's original by Bellini or an invention by Bellini used by Mantegna; even Kristeller, who denied the connection with Bellini, regarded it as 'a mere imitation of the motives of the picture' and attributed the disputed group of drawings to 'different more or less able pupils and assistants of the young Mantegna'. Popham first re-attributed this drawing to Mantegna, and in spite of Robertson's reservations ('The graphic quality of the drawing does not seem very high, and it may be a student's copy after a lost drawing by Mantegna'), the attribution is now generally accepted, largely thanks to Wilde's analysis. He admitted the undoubted differences between this sheet and other early Mantegna drawings, but argued that they have nothing to do with its authorship or its date, but rather reflect the stage of the creative process at which the drawing was made. Whereas the other sheets of the group are swiftly drawn, full of experiments and changes of mind, here the artist was setting down what he intended to be his definitive design. Wilde even suggested that it may have been a *modello* for submission to the patron, although in fact Mantegna subsequently painted a markedly different composition.

The most obvious change between drawing and painting concerns the way the saints here are bundled together to leave a gap – probably for a distant landscape – between them and the central framing element. Furthermore, in the altarpiece three of the saints are given additional attributes

fig. 68 *St Peter*, brush drawing, 293 x 157 mm, *c.* 1457, Biblioteca Ambrosiana, Milan (F273, no. 35)

and are differently posed: St Peter holds his keys in his right hand and meets the spectator's gaze instead of being shown in profile; St Paul, clutching his sword of martyrdom, looks back at Peter instead of towards the Virgin and Child; and San Zeno holds his crozier, looks intently inwards rather than meditatively downwards, and has a halo behind his mitre. The figures in the painting have slightly larger heads in relation to their bodies, and their tunics fall in more orderly fluted folds. In both these respects the drawing is close in conception to the St Luke Altarpiece of 1453-4 (Brera, Milan); it may well date from before January 1457, by which time Mantegna had taken on the commission for the San Zeno Altarpiece, but had not started the painting. However, since artists must have been in the habit of making drawings before a contract was signed, and continued to do so afterwards, it would be unwise to be more precise. On the other hand, the sheet could hardly be more different from the study of *St James led to Execution* (cat. 11) of only a few years before, which should be a warning against an over-narrow conception of Mantegna as a draughtsman.

A study for the figure of St Peter in the Biblioteca Ambrosiana (fig. 68) discovered by Philip Pouncey, represents an intermediate stage between the Getty drawing and the altarpiece. Although it is primarily a coloured drapery study, the position of both the neck and chin – which presuppose a profile head – are far closer to the former than the latter. Furthermore, the right arm is lowered slightly below the horizontal, as in the drawing, not raised above it as in the painting. However, the detailed configuration of the drapery, which was necessarily rather summary in the pen study, is far more fully worked out here, and closer to the painting. The main difference is that whereas the Saint wears a rose mantle over a grey-green tunic in the drawing, in the painting

they are replaced by a yellow mantle over a carmine pink tunic. No other drapery studies of this type, executed with the brush in coloured washes, can be connected with paintings by Mantegna, which makes it hard to evaluate the Ambrosiana sheet: at worst, it could be a copy of a lost preliminary study by Mantegna in the same medium, but its delicacy of touch would seem to support the idea that it is an original.

D.E.

15

ANDREA MANTEGNA
The Infant Redeemer

Tempera (?) on canvas, 70.2 x 34.3 cm; painted surface
69 x 33.8 cm (including the largely new black border
of 0.8 cm at the top, 2 cm at the bottom, and 1 cm
right and left).

c. 1455-60

The National Gallery of Art, Washington, DC
(Samuel H. Kress Collection, 1146)

PROVENANCE
By 1901, Sir Francis Cook, Richmond, Surrey
(cat. 1913, no. 128); 1948, Contini Bonacossi,
Florence; Samuel H. Kress Collection

REFERENCES
Kristeller, 1901, p. 455; Knapp, 1910, p. 179; Borenius,
1913, p. 153; Berenson, 1932, p. 328; Fiocco, 1937,
pp. 67-8, 205; Suida, 1951, p. 68; Tietze-Conrat, 1955,
p. 201; Cipriani, 1962, p. 52; Camesasca, 1964, pp. 37,
119; Garavaglia, 1967, no. 37; Berenson, 1968, p. 242;
Shapley, 1968, II p. 25; Fredericksen and Zeri, 1972, p.
118; Shapley, 1979, pp. 298-9; Lightbown, 1986,
pp. 139, 424

This image of the infant Christ standing
before an inlaid marble background with his
feet planted on what must once have been a
pillow (now reduced to the bare canvas) is
one of Mantegna's most haunting creations,
despite the severe damage it has suffered. The
surface has deteriorated and is abraded, the
paint crushed as a result of an old relining,
and the colours are much darkened (partly
through the application of successive layers
of varnish). Technical analysis (perhaps
compromised by the state of the picture)
indicates that the medium is tempera rather
than distemper, which is surprising. There
can be no doubt that originally the colours
were as bright as those of the *Ecce Homo*
(cat. 61). The poor condition of the work is
the most likely explanation for its rejection
by Kristeller, Borenius and Knapp, and for
the various dates assigned to it. These range
from *c.* 1460 (Longhi, in Shapley, 1968;
Cipriani), *c.* 1465 (Garavaglia), *c.* 1475-80
(Camesasca), 1480-90 (Shapley) 1979, *c.* 1490
or later (Fiocco, Lightbown). Lightbown
compares the Child to that in the *Virgin and
Child* (fig. 36; Museo Poldi Pezzoli, Milan).
However, the type of drapery, with its small-
ridged, clinging folds, is unlike anything in
Mantegna's Mantuan work, and the Child
differs notably from the one late picture that
offers the closest iconographic analogy: the
Infant Christ holding an orb in the *Holy
Family* (National Gallery, London). On
balance, it probably dates to Mantegna's
Paduan period, somewhat later than the
Presentation in the Temple (fig. 39;
Gemäldegalerie, Berlin), and the *St Euphemia*
(cat. 113).

A chubby-legged child spectator in
Mantegna's fresco of *St James Baptising
Hermogenes* (fig. 57) wears an almost identical
short tunic fastened by a wide cummerbund,
together with a tight-fitting cap and slippers
(as Garavaglia noted). A child in a similar
outfit appears in the *Circumcision* (fig. 9;
Uffizi, Florence), dating from the 1460s, and
in Bellini's early, Mantegnesque *Virgin and
Child* (The Metropolitan Museum of Art,
New York, Robert Lehman Collection).
The affective power of this picture depends
in no small measure on this use of a con-
temporary child's dress in an otherwise
hieratic composition.

That the work might have been a Gonzaga
gift (Tietze-Conrat) seems rather doubtful,
and its elongated proportions would seem to
exclude its identity with a '*puttino vestito, alto
on. 20., largo 10., del Mantegna*' listed in an
18th-century inventory of the collection of
the Gonzaga di Novellara (see Campori,
1870, p. 642). Devotional statuettes of the
infant Christ became increasingly popular in
the 15th century, but the only pictorial
precedents for Mantegna's picture are in
German prints (see Kristeller, p. 326). For this
reason it may be worth referring to two
highly venerated images in Padua Cathedral
that Mantegna must have known well. In
one, the Virgin appears at an arched window,
presenting to the viewer the swathed Christ
Child, whose right hand is raised in blessing.
In the second, by Giusto di Menabuoi, the
window is eliminated, but the composition is
identical (see Padua, 1974, cats. 2, 51). One
of these pictures was used as part of an annual
mystery play of the Nativity, in which the
Child, rather than the Virgin, was the object
of veneration (see van Os, 1971, who,
however, was unaware of the earlier biblio-
graphy on the picture). The inscription on
one of the pictures, 'This is God and man
born of a virgin', would not be inappropriate
for Mantegna's picture, in which the Christ
Child holds the cross of redemption, further
emphasised by the vertical and horizontal
green marble bands of the background.

The lower right side of the background is
repainted, as is the black border, which seems
to cover the original tacking edge. The gold
is almost entirely renewed.

K.C.

15

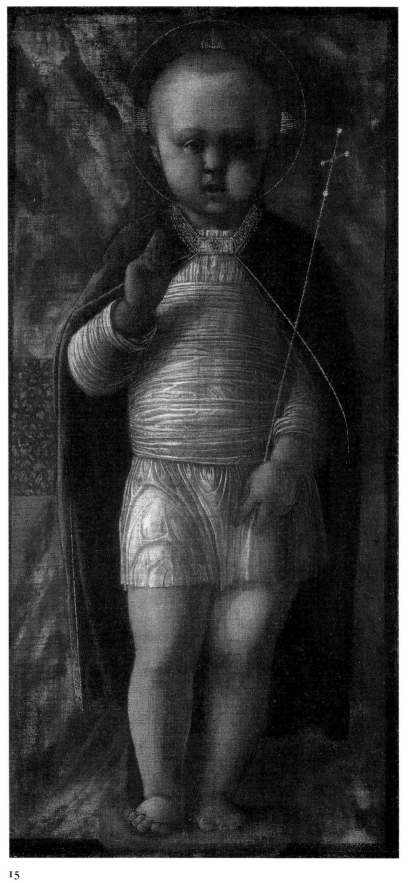

15

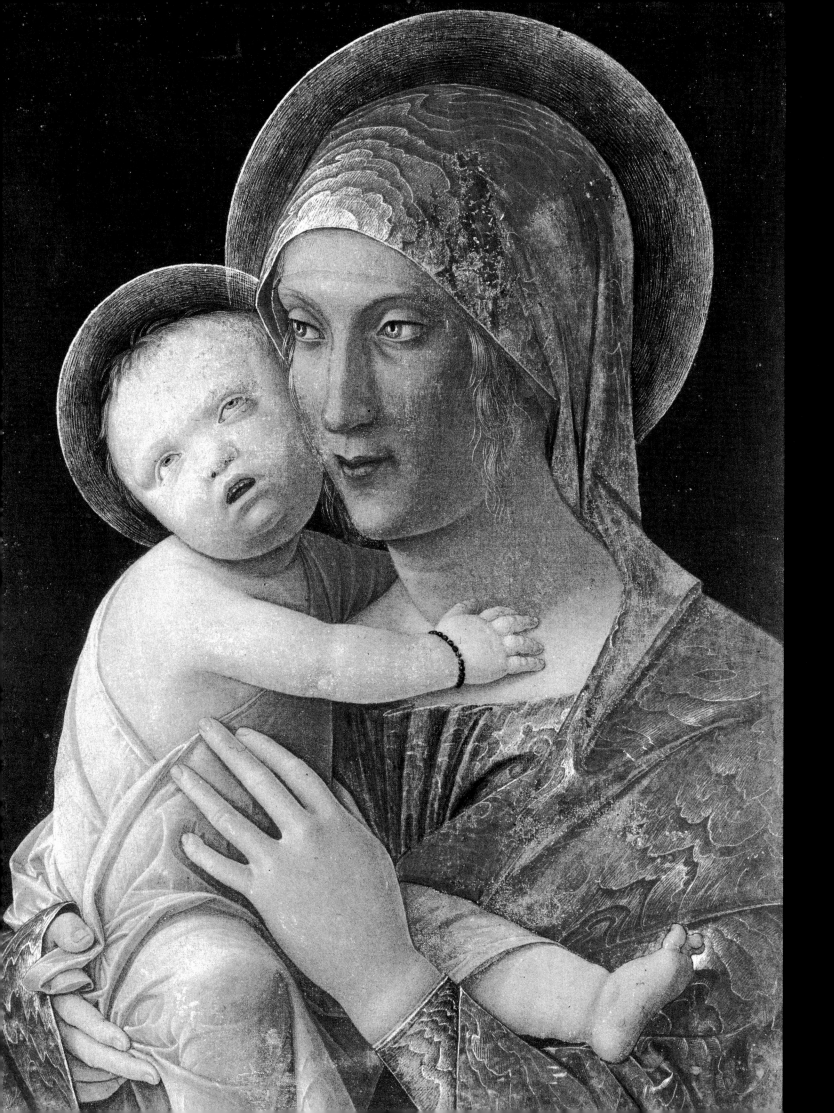

2 DEVOTIONAL WORKS: MANTUA

In the spring of 1460 Mantegna loaded his family and possessions on to a boat and made the 70-mile journey from Padua to Mantua, where for almost half a century he served three generations of Gonzaga rulers. Although barely thirty, he was already the most celebrated painter in northern Italy, whose works had established new norms in the art of painting. To secure his services, Ludovico Gonzaga had spent the better part of three years, promising Mantegna a stipend, lodgings and provisions for six people, and declaring, 'we are certain that you will find these the least of the awards you will receive from us'.[1] As a member of the Gonzaga household, Mantegna was also granted the privilege of using an armorial device with the motto *par un désir*.[2]

Ludovico had been educated by the outstanding teacher Vittorino da Feltre, himself a product of the university at Padua and a pupil of Giovanni di Conversino and Gasparino Barzizza. At the Casa Giocosa, the school set up in Mantua by Ludovico's father, Vittorino saw that his charges, who included Federico da Montefeltro and Gregorio Correr, patron of the San Zeno Altarpiece, were instructed in poetry, oratory, Roman history and the ethics of Roman stoicism, as well as mathematics, astronomy, music, physical exercise and the martial arts, thereby nurturing a generation of humanist-trained rulers who, increasingly, looked not to French courtly traditions, but to the authority of classical writers for cultural guidance. Until his death in 1455, Pisanello had been the favourite artist of the Gonzaga, and his cycle of frescoes in a large reception room of the palace, based on an Arthurian romance, took as its point of departure French tapestries

(French tapestry weavers were established in Mantua by 1420). Mantegna's arrival signalled the end of this essentially late-Gothic world, supplanted by an authentically Roman-inspired art that became the basis for a new visual language in European courts.

The importance of this association of a humanist-trained prince with the greatest humanist-inspired artist can hardly be exaggerated. Ludovico had already secured the services of the gifted Florentine architect Luca Fancelli. He also employed the Dalmatian architect Luciano Laurana, who was lured from Mantua by Federico da Montefeltro. In Alberti, who was in touch with Ludovico from at least 1459,[3] he found the most progressive and influential theorist-architect in Italy. For Ludovico, Alberti designed two churches, San Sebastiano and Sant' Andrea, and offered advice on other projects.[4] Alberti was in the city when Mantegna arrived, and his subsequent visits to Mantua had an incalculable effect on Mantegna's art. Yet, despite this broad, enlightened patronage, it was Mantegna who stood at the centre of artistic life in Mantua and who most visibly embodied the Marchese's cultural pretensions. For Ludovico and his successors Mantegna supplied advice and drawings for projects ranging from tapestries and vases to architecture and a monument to Virgil. Even book production was effected by his presence. It was at his suggestion that the brilliant, late-Gothic miniaturist Belbello da Pavia was replaced by Girolamo da Cremona, who had first studied Mantegna's work in Ferrara and was later to introduce a Mantegnesque style in Siena,[5] and it is Mantegna's shadow that falls across the beautiful miniatures illustrating a manuscript of Pliny written for Ludovico

between 1463 and 1468.[6] For his part, Ludovico procured for Mantegna from Florence a prized album of drawings after ancient works of art, and the Marchese's cultural and political pretensions, no less than the influence of Alberti, doubtless encouraged Mantegna's more studied and learned approach to Imperial Roman art after 1460.

From the outset, the Camera Picta and the *Triumphs of Caesar* (cats. 108-15) were recognised as heralds of a new age, and it is on these works that Mantegna's reputation still rests today. Yet, these large, complex commissions represented only one aspect of his work for the Gonzaga family, and constitute only part of his contribution to Italian painting. His first commission from Ludovico had been not for a cycle of frescoes with a secular theme, but the design and decoration of a private chapel in the Castello di San Giorgio. The chapel was destroyed in the 16th century, but according to Vasari it contained a small altarpiece or painting with narrative scenes, probably of the lives of Christ and/or the Virgin (see cat. 17): a work whose novelty was predicated on the style deployed rather than the subjects treated. Throughout his residence in Mantua, Mantegna continued to produce both large and small-scale devotional works to satisfy the needs of the Gonzagas or their circle of friends and acquaintances.

In 1485, for example, Eleonora of Aragon, Duchess of Ferrara and mother of Isabella d'Este, wrote to her future son-in-law, Francesco Gonzaga, in an attempt to speed up production of a painting of the Virgin and Child 'with some other figures'.[7] On 6 November the Marchese sent a note to Mantegna, whose slow rate of production was notorious, urging him to make haste: 'To satisfy this lady, we charge you to use diligence to finish it, applying your peculiar skills (*ingegno*),[8] as we believe you must do, and as soon as possible, so that the above-mentioned illustrious lady may be satisfied, which is our most ardent desire'.[9] Four days later Eleonora was writing again, suggesting that Francesco might bring the painting

to Ferrara with him, 'for beyond the very great desire we have in seeing you, the presence of your person with that work, worthy as we believe it will be, will assure all good and great satisfaction'.[10] A month later the picture was still not finished, and the Marchese again tried to hurry it along, informing Mantegna that since someone was going to Venice on business, now was the time to order varnish (which was normally purchased there), so that no further delays would occur on that account. How long these negotiations went on is not clear.[11] The resulting picture has frequently been identified with the *Virgin and Child with Seraphim* (Brera, Milan), but is perhaps more likely to have been a composition of the Holy Family with an attendant saint (see cat. 51).

These negotiations are of interest for a number of reasons. In the first place, they establish the high esteem this sort of work by Mantegna enjoyed throughout Italy by this date and the exceptional allowance made for his slowness − the natural consequence of his perfectionism; the same dilatory behaviour would hardly have been tolerated in a lesser artist. Second, the letters remind us that Mantegna was very much the Gonzaga family's court artist and that commissions were, as a matter of course, addressed initially to the Marchese and were dependent on his permission. In 1479 Mantegna declared to Marchese Federico Gonzaga that although he had received a request for work that would have brought him profit, he did not wish to undertake anything 'without permission from your Excellency, since it seemed to me my duty to act thus'.[12] So well established was this procedure that when, in 1505, a member of the Cornaro family of Venice wanted to commission a work from Mantegna, Niccolò Bellini (Mantegna's brother-in-law) was enlisted to approach Francesco Gonzaga, 'knowing such things to depend on your most Illustrious Lordship's wishes'.[13] Just a year before the negotiations over the Duchess of Ferrara's picture, Sixtus IV's nephew, Giovanni delle Rovere, had written in the hope of acquiring a painting. That request was denied on the

grounds that Mantegna had more work than he could handle: 'if it required no more than eight or ten days to make the image requested, he would have done it willingly, but seeing that it would take at least a month, it did not seem to him an honourable task'.[14] And in 1500 Francesco's wife, Isabella d'Este, refused the Prior of Santa Maria in Vado, in Ferrara, a work by Mantegna 'because we have not been able to obtain from his hands some things that he began for us some time ago'.[15]

By the same token, Mantegna's services could be lent out as a special favour. Thus, in 1488 the Marchese agreed, probably for ulterior reasons (see pp. 20-21), to send Mantegna to Rome to work for Pope Innocent VIII, despite the fact that the artist was then engaged on the *Triumphs of Caesar*. In 1499 the powerful Cardinal Georges d'Amboise expressed his desire to obtain a work by Mantegna – 'the first painter in the world' – at any cost, and later sent a drawing of what he had in mind to Isabella d'Este, stating that he would rather have a devotional picture by Mantegna than earn two thousand ducats. He appears to have been granted this favour, though the subject of the picture is not known.[16]

The number of surviving pictures by Mantegna of the Virgin and Child or the Holy Family with attendant saints is remarkably small: only six of the former[17] and less than half a dozen of the latter.[18] There could be no greater contrast to the prolific output of his brother-in-law Giovanni Bellini, for whom devotional pictures of the Virgin and Child were a primary source of income, to which the skills of a well-organised shop were assiduously applied. Bellini's pictures are remarkable not simply for their deeply affective qualities but for their inventive variety within a fixed genre. With the exceptions of Donatello, Luca della Robbia and Raphael, no other artist brought such a consistently fresh approach to the theme. Yet, Bellini's paintings of the Virgin and Child can seem somewhat conventional when compared to those of Mantegna, who painted not for a large market with fixed expectations, but for a select clientele who

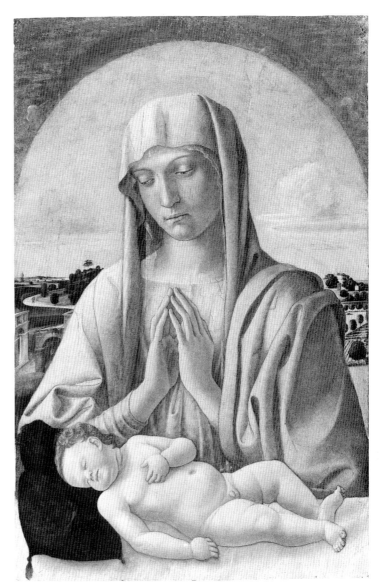

fig. 70 Giovanni Bellini, *Virgin Adoring the Sleeping Child (The Davis Madonna)*, tempera on panel, 72.4 x 46.3 cm, *c.* 1455, The Metropolitan Museum of Art, New York, Theodore M. Davis Collection

sought an example of his '*ingegno*', or those peculiar qualities of mind and hand that seemed to Francesco Gonzaga to lend lustre to his court.[19]

It had been Giovanni Bellini's father, Jacopo, who popularised throughout the Veneto the image of the Virgin behind a parapet on which the Christ Child is posed,[20] and it was to this formula, in myriad permutations, that Bellini applied his fertile imagination. Sometimes the Child lies asleep on the parapet, his head

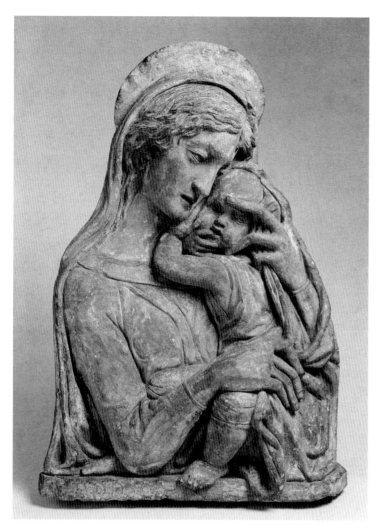

fig. 71 After Donatello, *Virgin and Child (The Verona Madonna)*, terracotta, 73.8 x 52.1 cm, The Metropolitan Museum of Art, New York

Donatellesque reliefs had been collected by his teacher, Squarcione, and were the source for a novel type of devotional image in northern Italy, in which the Virgin and Child were shown framed beneath an elaborate Renaissance arch or enshrined in a niche.[21] However, as often as not Squarcione's pupils and assistants – Marco Zoppo, Giorgio Schiavone, Dario da Treviso – were more interested in the decorative repertory than the expressive content of the reliefs. In his earliest surviving painting of the Virgin and Child (cat. 12) Mantegna also employed, exceptionally, a fictive frame, but it is unadorned and serves simply as an illusionistic device to focus attention on the touching image of a mother protectively embracing her vulnerable child. It was the psychological dimension of the subject that Mantegna probed to the exclusion of any interest in symbolic props or allusive settings. The *Virgin and Child* in Berlin (cat. 41), in which the figures rise from a solid base created by the Virgin's mantle to form a compact pyramid, is the pictorial equivalent of Donatello's so-called *Verona Madonna,* known from a number of terracotta replicas (fig. 71).[22] As in Donatello's relief, the Virgin, who poignantly rests her cheek against the head of her sleeping child, has been imagined as a young mother contemplating the many uncertainties of life. Viewed against a neutral background, the figures are unaware of the viewer, and enveloped in their own private world. This is the opposite of Bellini's pictures, in which the Child is openly displayed to the viewer as an object of worship, veneration and sympathy.

These pictures were not without influence. A picture closely related to the *Virgin and Child with Seraphim and Cherubim* (cat. 12) inspired two replicas (one in the Gemäldegalerie, Berlin, the other in the Philbrook Art Center, Tulsa, Oklahoma), which hint at the sort of pictures Mantegna might have produced had he been forced to earn a living as the head of a workshop in Padua, without the liberating stipend provided him by the Gonzaga family. Another picture, ascribed to Zenone

propped on a pillow (fig. 70); in others he is seated with a symbolic fruit in his hand; sometimes he stands, his delicate body protected by the Virgin, while a piece of fruit lies on the ledge; and in still others the parapet serves as a pictorial device dividing the viewer from the Virgin and Child beyond. In contrast with these contemplative images, whose appearance is closely tied to their function as aids to private devotion, Mantegna eschewed the traditional repertory of symbols in favour of a far more human interpretation. His model for this approach was the sculptural reliefs of Donatello.

Veronese (fig. 83; Louvre, Paris), seems to derive from a late work known only through a preliminary drawing (cat. 53). And one of Bellini's most beautiful creations, the so-called *Madonna Greca* (Brera, Milan), may owe something to his knowledge of Mantegna's treatment of the theme. It is not impossible that some of the un-ingratiating Mantegnesque pictures in museum store-rooms are inept attempts by Francesco Mantegna to capitalise on his father's reputation.[23] But on the whole, Mantegna's pictures were too personal to lend themselves to replication – except by the medium of engraving, for which Mantegna reserved what is, perhaps, his most memorable and personal treatment of the theme (cat. 48).[24]

Because of the psychological dimension present in all Mantegna's pictures of the Virgin and Child, there has been a tendency to treat them as if they were the product of a single moment. Yet, to no less a degree than his other work, they reflect the shifting interests imposed by the major enterprises in which he was successively engaged at the Gonzaga court. The palpable, portrait-like beauty of the *Virgin and Child* at Bergamo (fig. 69) is the outgrowth of Mantegna's concerns in the Camera Picta, with its depictions of the Gonzaga family and members of their household, while the exquisite delicacy and minute descriptiveness of the *Virgin and Child* in the Poldi Pezzoli (fig. 72) is the religious counterpart to the refined style of his mythologies for the Studiolo of Isabella d'Este.

Mantegna's work on the *Triumphs of Caesar* (cats. 108-15) directly inspired a novel treatment of the theme of Christ carrying the Cross as a half-length composition in which the crowd accompanying Christ, their profiles lined up one behind the other, moves from right to left.[25] Apparently at the same time Mantegna first conceived of adapting a Roman relief style to devotional images of the Holy Family in which two bust-length figures of saints are inserted behind the seated Virgin, shown three-quarter length supporting the standing Child. In what is

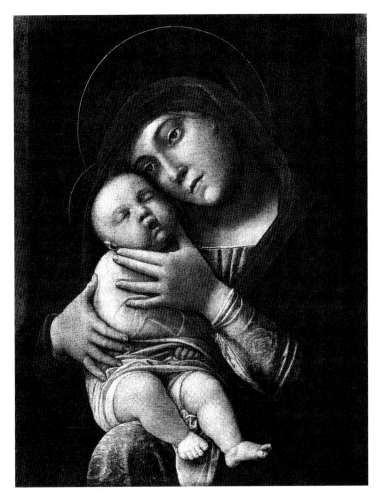

fig. 72 Andrea Mantegna, *Virgin and Child*, distemper on canvas, 43 x 45 cm, Museo Poldi Pezzoli, Milan

perhaps the earliest of these images, the *Holy Family with St Elizabeth and the Infant St John the Baptist* (cat. 51), the figures are still posed with considerable naturalness, but in the *Holy Family* in Dresden (fig. 73), the classical inspiration is in no doubt. Just as in his depictions of the Virgin and Child Mantegna appropriated the psycho-logical approach of Donatello, so in his paintings of the Holy Family he used the starkly simple, reticent effigies on ancient funerary reliefs to set off the touching in-timacy of the Virgin and her preternaturally athletic son.

The same sort of grave stele is behind one of Mantegna's most original creations: the half-length narrative, first explored (so far as is known) in his

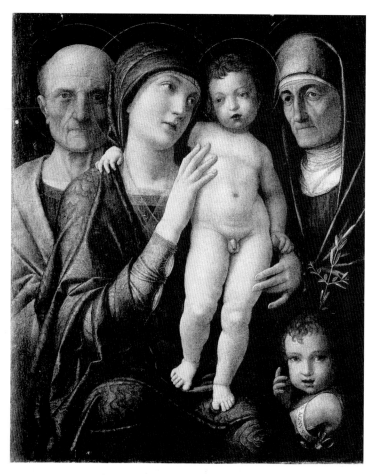

fig. 73 Andrea Mantegna, *Holy Family with St Elizabeth and the Infant St John the Baptist*, probably tempera on canvas, 75.5 x 61.5 cm, Gemäldegalerie, Dresden

Presentation in the Temple of about 1455 (fig. 39; Gemäldegalerie, Berlin),[26] and developed fully in the late *Adoration of the Magi* (cat. 56): either picture could be translated into marble with little difficulty. Mantegna's impact on his brother-in-law has long been the subject of debate, but in the case of the *Presentation* there can be no doubt of the direction and nature of the influence, for Bellini's battered but still beautiful (and completely autograph) version of the composition (Fondazione Querini Stampalia, Venice), dates from perhaps two decades later than Mantegna's picture.[27] Typically, in it Bellini abandons Mantegna's shallow, tightly compressed composition for a more spacious and pictorial treatment in which the enframing marble moulding is replaced by

an ample ledge, and the background (repainted in Mantegna's picture)[28] creates a sensation of deep, indeterminate space. It was the emotional character and interrelationship of the figures, not the relief-like treatment of Mantegna's composition, that interested Bellini.

'*Ingegno*' could mean a variety of things to a Quattrocento critic. In his laudatory verses devoted to Mantegna, Raphael's father, Giovanni Santi, associated specific skills with Mantegna's '*alto e chiar ingegno*': composition, or *disegno* ('the true basis of painting'); invention ('Nor has ever a man taken up the brush who was a truer successor to antiquity … '); diligence and beautiful colouring; foreshortenings 'that deceive the eye and cause art to rejoice'; and perspective.[29] His association of invention with ancient art is appropriate, given Mantegna's imaginative use of classical sources.

However, Mantegna's interest in Roman art was only one aspect of his genius, and plays no part in the devotional work that has come to epitomise his '*ingegno*': the *Dead Christ* (fig. 74). Surprisingly little is known about this great work, which was possibly painted for Ercole d'Este of Ferrara.[30] It must postdate Mantegna's visit to Florence in 1466 and, conceivably, was inspired by Uccello's depiction of the drunken Noah in the *chiostro verde* of Santa Maria Novella (Mantegna is reputed to have admired Uccello's work in Padua and must have examined it closely in Florence). But was it produced by means of Alberti's *velo*, a grid of strings that enabled the artist to plot the features of a figure or object viewed through it and transfer the results to a squared sheet of paper? Or are the inconsistencies of scale (the reduced size of the feet) to be understood as an adjustment motivated by a sense of decorum? Mantegna's haunting drawing of a model propping himself up on a table top or marble slab (cat. 43), which was unquestionably done without mechanical aids, demonstrates that the picture was anything but an academic exercise in foreshortening. The key factor in appreciating the enormous influence

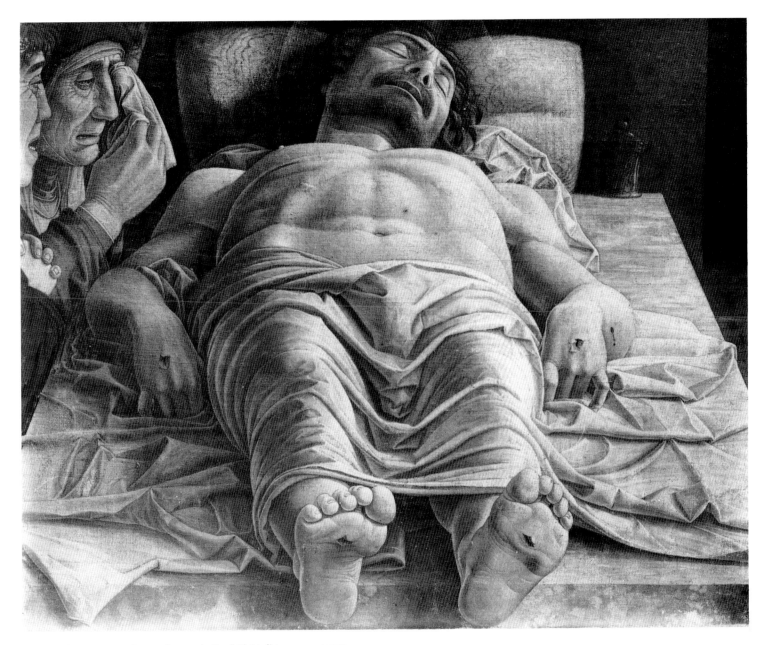

fig. 74 Andrea Mantegna, *Lamentation over the Dead Christ*, distemper on canvas,
68 x 81 cm, Pinacoteca di Brera, Milan

of the *Dead Christ* on subsequent generations of artists, from Sodoma[31] to Annibale Carracci,[32] is its manipulation of foreshortening for emotive effect: its fusion of 'ingegno' and pictorial content. This is true of all of Mantegna's devotional paintings, and makes a discussion of matters such as classicism and perspective in his work inseparable from the expressive goals implicit in the subjects treated. K.C.

NOTES

1. See Ludovico's letter to Mantegna of 15 April 1458; Kristeller, 1902, p. 516, doc. 11.

2. Letter of 30 January 1459; Kristeller, 1902, p. 518, doc. 14.

3. Alberti accompanied Pius II to the Congress at Mantua in 1459 and was still in the city in May 1460; see Mancini, 1911, pp. 385, 393.

4. For a convenient overview of Alberti's work in Mantua, see Borsi, 1977, pp. 200-75.

5. The transfer took place in 1461 on the advice of Mantegna; see Pacchioni, 1915, p. 370, doc. 9. For Girolamo's role in Siena, see Christiansen, in New York, 1988, pp. 23, 286-8.

6. See Conti, 1988-9, pp. 264-77, for the most recent view on this manuscript. The chief miniaturist was Pietro Guindaleri, who was employed by Ludovico from 1464. Conti proposed that Mantegna collaborated on the manuscript, now in the Biblioteca Nazionale, Turin (MS I.I.22-23). I cannot agree. There are, so far as I can see, only two hands present in the Pliny, neither identifiable with Mantegna. Some of the borders are unfinished (*fols.* 99r, 131r, 206v) and in others the drawing seems part of the intended effect. The second hand is especially evident in the landscapes (for instance, fols. 45v, and 46r). Conti's further suggestion that Mantegna is partly responsible for the frontispiece of a manuscript of Livy, also in Turin (MS J.11.5) is no more convincing.

7. Kristeller, 1902, p. 545, docs. 90-92; Lightbown, 1986, p. 462, no. 76.

8. The word '*ingenium*' meant more than simply 'skills' to a humanist audience. It implied the personal element of an artist's work, whence our own term 'genius': see Baxandall, 1963, p. 320, n. 53.

9. Kristeller, 1902, p. 543, doc. 91.

10. Kristeller, 1902, p. 543, doc. 92.

11. On the basis of a document no longer traceable, it has been thought that the picture was still not finished in 1495, but this seems improbable: see Brown, 1969², p. 541, and Lightbown, 1986, p. 462.

12. Kristeller, 1902, pp. 536-7, doc. 75.

13. Brown, 1974, doc. 1.

14. Kristeller, 1902, pp. 541-2, doc. 87.

15. Kristeller, 1902, pp. 567-8, doc. 155.

16. See Lightbown, 1986, p. 464, nos. 86-7.

17. These are, by my count and in roughly chronological order: the *Virgin and Child with Seraphim and Cherubim* (cat. 12); the *Virgin and Child* in Berlin (cat. 41); that in the Accademia Carrara, Bergamo (fig. 69); the *Virgin and Child with Seraphim* in the Brera, Milan; the magical *Virgin of the Stonecutters* (fig. 3) in the Uffizi, and the *Virgin and Child* in the Poldi Pezzoli, Milan (fig. 72).

18. These are the *Holy Family with St Elizabeth and the Infant St John the Baptist* (cat. 51); the ruined *Virgin and Child with Three Saints* in the Musée Jacquemart-André, Paris; the badly damaged *Holy Family with the Infant St John the Baptist* in the National Gallery, London; the *Holy Family with St Mary Magdalene* (cat. 55); and the *Holy Family with St Elizabeth and the Infant St John the Baptist* in Dresden (fig. 73). The *Virgin and Child with SS. Jerome and Louis of Toulouse* in the Musée Jacquemart-André I consider probably work by Giovanni Bellini of the late 1450s. The ruined but almost universally accepted *Holy Family with St Mary Magdalene* in the Museo di Castelvecchio, Verona, I consider a shop piece of strikingly mediocre quality. The lacklustre but finer half-length *Sacra Conversazione* in Turin is at least in part autograph.

19. See the letter addressed by the Marchese to Mantegna reprinted in Kristeller, 1902, p. 546, doc. 103.

20. This type of image has recently been provided a pseudo-etymology by Goffen, 1989, pp.24-8, that attempts to link Bellini's imagery to portraiture, on the one hand, and Byzantine icons, on the other. As developed by Jacopo Bellini, the half-length format was a Florentine importation.

21. For Squarcione's collection and the sort of work produced by his pupils, see pp. 96-9, above.

22. See Radcliffe, in Florence, 1986², pp. 152-3. The composition takes its name from a version installed in a street in Verona. Not surprisingly, it was a Veronese artist, Liberale da Verona, who translated the composition most directly into a painting, adding only a curtain behind the figures and a parapet with a vase in front of them. See Del Bravo, 1967, pl. CCII; and Lightbown, 1986, cat. 173.

23. Foremost among such pictures are two versions of the Holy Family with a female saint, one of which – reduced through overcleaning to a ruin, and with the background figures painted out – is in the Galleria Sabauda, Turin (no. 663): see Gonzalez-Palacios, 1961, pp. 58-60. The fact that two versions exist suggests that the figures of the Virgin and Child are based on a cartoon prepared by Mantegna.

24. Was this the '*quadretino*' sent as a gift by Francesco Gonzaga in 1491, rolled up and slipped in a sheath secured with a metal ring? See p. 51 for a discussion of the vague terminology employed in the three letters that relate in some fashion to an engraving. The letters are in Kristeller, 1902, pp. 550-51, docs. 112-14.

25. There are, to my mind, two autograph but ruined pictures by Mantegna of this theme at Christ Church, Oxford, and in the Museo di Castelvecchio, Verona. Both are usually dismissed as workshop products, despite the fact that one such picture – perhaps that at Christ Church – was listed in the 1627 Gonzaga inventories: see Lightbown, 1986; nos. 107, 145-6. David Ekserdjian has pointed out to me that in a picture of the theme by a follower of Mantegna (Bob Jones University Collection of Religious Art, Greenville, South Carolina; ascribed to Marco Palmezzano), the figure of Christ is based on a trophy bearer in canvas VI of the *Triumphs* (cat. 113).

26. See Ringbom, 1965, pp. 72-7; Jacopo Bellini's half-length depiction of the Lamentation within a tabernacle frame, in his album in the Louvre (*fol.* 7v), might be taken as a precedent were it not for its obvious derivation from images of the Man of Sorrows, for which the half-length format was conventional.

27. This is the date assigned to the picture by Robertson, 1968, pp. 75-6, who, however, incorrectly views it as unfinished rather than skinned in a harsh overcleaning. Visible throughout is an elaborate and accomplished underdrawing typical of Bellini's practice as recorded by Pino, 1548, ed. 1946, p. 106. Goffen, 1989, pp. 281-4, misguidedly dismisses Bellini's picture as in all probability a copy and even goes so far as to suggest that the idea for the composition may have originated with Bellini rather than Mantegna (she dates both Mantegna's work and the 'lost' Bellini prototype to the 1460s). Her arguments are predicated more on a

desire to champion Bellini as an innovator (a position no one would dispute) than on an understanding of his development and the complex, fluid nature of artistic influence.

28. This information was kindly provided by Andrea Rothe and Erich Schleier.

29. Giovanni Santi's passage on Mantegna occurs in his rhyming chronicle celebrating Federico da Montefeltro. It is reprinted in Kristeller, 1902, pp. 493-5.

30. The picture is usually identified with '*un cristo in scurto*' mentioned by Ludovico Mantegna among the pictures left by his father (Kristeller, 1902, pp. 583-4, doc. 190). That work was taken by Cardinal Sigismondo Gonzaga (Kristeller, 1902, pp. 585-6, doc. 198), but in 1531 was installed in the apartments of the new Duchess, Margherita Paleologa (Luzio, 1888, p. 184). It is last certainly listed in 1627 (Luzio, 1913, p. 115, no. 318). In 1603 a picture conforming in all respects to the Brera *Dead Christ* is listed in the Aldobrandini collection (see D'Onofrio, 1964, p. 207, no. 260: this inventory seems not to have been known by Lightbown, who mistakenly thought the Aldobrandini picture to be on panel rather than

on canvas: the 1665 inventory specifies that it was painted on a canvas mounted on a panel) and can be traced there in guidebooks until the late 18th century. The Brera picture was purchased in Rome in 1806 (see Lightbown, 1986, p. 421), at a time when the Aldobrandini were selling works from the collection. There is, therefore, a strong presumption that the Brera *Dead Christ* is the Aldobrandini picture, and that, like the *Adoration of the Shepherds* (cat. 8), it came from the Este collection in Ferrara. The mention of another painting of this theme raises the possibility that Mantegna retained a replica for himself. Another, obviously inferior, version of the composition, omitting the mourning figures, exists: see Lightbown, 1986, p. 422.

31. For Sodoma's derivation, see Bagnoli, in Siena, 1990, p. 238, with previous bibliography.

32. Annibale's picture is the *Dead Christ* in the Staatsgalerie, Stuttgart. Astonishingly, this marvellous early work, which was retained by Annibale and is listed in the inventory made after his death, has recently been attributed – without any basis that I can see – to Lorenzo Garbieri: see Brogi, 1989, pp. 15-17.

16

ANDREA MANTEGNA
Christ with the Virgin's Soul

Tempera on wood, 27.5 x 17.5 cm

c. 1460

Pinacoteca Nazionale, Ferrara

PROVENANCE
G. Barbacinti, Ferrara; until after 1934, Enea
Vendeghini, Ferrara; before 1961-75, Mario Baldi,
Ferrara

This much damaged fragment was first
attributed to Mantegna by Longhi (1926, ed.
1967, p. 92) and identified by him (1934, ed.
1968, pp. 70-73) as part of the upper portion
of the *Death of the Virgin* (see cat. 17, below).

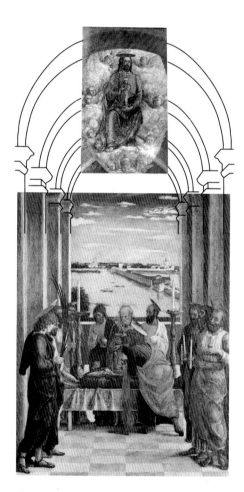

fig. 75 Reconstruction of the *Death of the Virgin*

17

ANDREA MANTEGNA
Death of the Virgin

Tempera and gold on wood, 54 x 42 cm

c. 1460

Museo del Prado, Madrid (no. 248)
(Exhibited in London only)

PROVENANCE
By 1586-1618, Margherita Gonzaga, Duchess of
Ferrara(?); until 1626, Ferdinando Gonzaga, 6th Duke
of Mantua; 1627, Vincenzo Gonzaga, 7th Duke of
Mantua (1627 inv., no. 330 or 484?); 1627-49, Charles I
of England (1639 inv, no.27); sold 1649/50; purchased
by John Baptist Gaspars); 1650-65, Philip IV of Spain;
Spanish Royal Collections

REFERENCES
Vertue, 1757, p. 9; Crowe and Cavalcaselle, 1871, ed.
1912, p. 97; Yriarte, 1901, pp. 225-8; Kristeller, 1901,
pp. 220-22, 440, no. 19; Berenson, 1907, p. 254; Fry,
in Lafarge and Jaccaci, 1907, pp. 164-7; Knapp, 1910,
pp. XLV, 175; Venturi, 1914, pp. 166-8; *idem,* 1924,
pp. 139-40; Longhi, 1926, ed. 1967, p. 92; Hendy,
1931, pp. 230-31; Berenson, 1932, p. 327; Longhi,
1934, ed. 1968, pp. 70-73; Fiocco, 1937, pp. 48, 203;
Tietze-Conrat, 1955, pp. 186-7; Millar, 1960, pp. 81-2,
nos. 28, 33; 209; Paccagnini, in Mantua, 1961, pp. 31-5;
Longhi, 1962, ed. 1978, p. 154, n. 2; Cipriani, 1962,
pp. 28, 59-60; Camesasca, 1964, pp. 27, 107-8, 115;
Garavaglia, 1967, no. 34; Berenson, 1968, p. 240;
Paccagnini, 1969, pp. 56-64; Millar, 1972, p. 266;
Hendy, 1974, p. 156; Angelini, in Florence, 1986[1], pp.
71-2; Lightbown, 1986, p. 86-8, 411-14; Ventura, 1987,
pp. 23, 26, 31-2

Despite its relatively small size and the fact
that it is reduced in height by one third (see
below), *The Death of the Virgin* ranks among
Mantegna's most sublime creations and one of
the masterpieces of Renaissance painting.
Although widely referred to as the death of
the Virgin, the scene in fact shows her
dormition or, rather, her obsequies, and
relates to the iconography of that scene as it
evolved in Venice in a well-known mosaic in
the Mascoli Chapel of San Marco (sometimes
ascribed to Mantegna but more likely
designed by Andrea del Castagno in the
1440s) and as treated by Jacopo Bellini in his
albums (British Museum, inv. 66; Louvre,
R.R. 1495). As in Bellini's drawings, the scene
takes place not in the open, as commonly
shown in earlier depictions (including
Castagno's), but in a vaulted interior of
Renaissance design, with the bier pushed to
the back of a flagged pavement. Behind the

bier, St Peter officiates, opening the pages of
a missal. One of his companions holds an
aspergillium, or vessel for holy water, and
raises his right hand in a gesture of blessing,
while the other looks on. A third apostle,
audaciously viewed from behind, bent over,
censes the Virgin's body. All but one of the
remaining apostles, aligned at the sides along
converging diagonals, hold lit candles and are
shown with their mouths open, singing,
according to Jacopo da Voragine's *Golden
Legend,* '*Exiit Israel de Aegypto, Alleluia!*'
St John holds the palm that Peter charged
him to carry before the bier, declaring, 'it is
fitting that the Virgin's palm be carried by a
virgin'. Above, in what was originally the
upper third of the scene, Christ was shown
seated in clouds amid seraphim holding the
soul of the Virgin (cat. 16).

Although features of Mantegna's scene are
indebted to earlier depictions of the subject,
nowhere else is this scene interpreted with an
equal eye to plausibility: an imaginative
re-creation of a specific moment rather than
an evocation of a theologically significant
event. And nowhere else do the Apostles take
on such individual personalities and dramatic
roles. This unprecedented feeling for actuality
gains further resonance from the view
through the arched opening, which has been
identified (Kristeller, 1901, p. 220) as showing
the lake that all but surrounds Mantua and the
bridge and Borgo di San Giorgio as seen from
the castle (see also Yriarte, 1901, p. 225 and
Tietze-Conrat, 1955, p. 187, for less plausible
identifications). This is unquestionably
Mantegna's most astonishing landscape,
depicted with a truth of tone and a quality of
geometric finality that has less to do with the
conventions of 15th-century painting than
with Seurat's views of the harbour at
Gravelines. As a topographical view, its only
precedents in Italian painting are Fra
Angelico's more generic rendition of Lake
Trasimeno in the predella of his *Annunciation*
(Museo Diocesano, Cortona) of the early
1430s, and Piero della Francesca's depiction of
Borgo San Sepolcro in the *Baptism,* painted
about 1450 for the church of San Giovanni
Battista in Sansepolcro (National Gallery,
London). Its most direct heir is the castellated
hill seen through the back of the throne of
Giovanni Bellini's *Coronation of the Virgin*
(Museo Civico, Pesaro: see Castelli, in

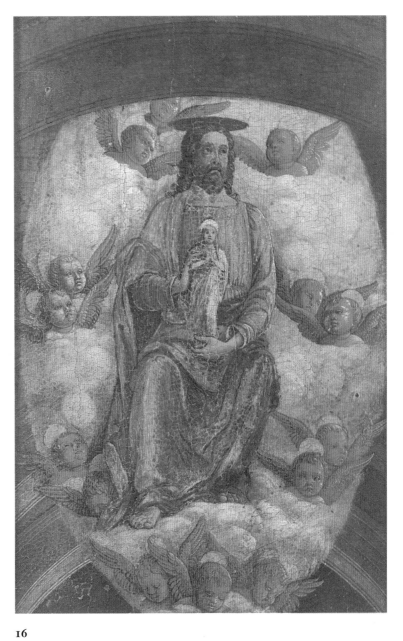

16

Pesaro, 1988, pp. 18-20). Mantegna certainly intended his view to be immediately recognisable, and we may suppose that it derived its full impact from the display of the picture in the castle, not far from one of the rooms looking out on to the lake. Only in this way would Mantegna's challenge to equal Nature be understood. The notion of equalling or even surpassing Nature was a topos of Renaissance criticism, and it was clearly among the chief goals Mantegna set himself in this miniature manifesto of his representational skills.

Ever since Longhi first published the fragment from the top of the picture and demonstrated that, originally, the measurements corresponded with those of two well-known paintings in the Uffizi, the *Ascension* and the *Circumcision* (figs. 76, 9; the panels, whose picture surface is intact, measure approximately 86 x 42 cm each; the measurements of the *Ascension* given by Lightbown are incorrect), parts of the so-called Uffizi triptych which includes a larger panel of the *Adoration of the Magi* (fig. 80), discussion has centred on whether the *Death of the Virgin* formed part of a series or an altarpiece with those panels and whether, by extension, it could have belonged to the decorations of the chapel that Mantegna designed for Ludovico Gonzaga in the late 1450s, not far from the room that was to become the Camera Picta. Unfortunately, information about the chapel is extremely sparse and the reconstruction of its decoration remains speculative, to say the least.

In May 1459 Ludovico wrote to Mantegna, then still at work on the San Zeno Altarpiece in Padua, urging him to come to Mantua to inspect a chapel that was being built according to Mantegna's specifications ('*facta al modo vostro*'). It was then nearing completion and Ludovico wanted Mantegna's approval (Kristeller, 1902, doc. 19). It may be that work had begun a year or so earlier, when the interior of the castle was restructured (see Ventura, 1987, p. 23). Certainly, it is suggestive that the person Ludovico sent as his intermediary was the architect Luca Fancelli. In June 1459 Ludovico again pressed Mantegna to come (Kristeller, 1902, doc. 20). By the time of Mantegna's arrival in Mantua in April 1460 construction must have been completed and

work begun on the interior decoration. In May 1461 Fancelli was seeing to the windows in the chapel, and in September 1462 gilding was being done within. On 26 April 1464 Mantegna wrote to Ludovico from Goito, north-east of Mantua, that it did not seem to him the right moment 'to varnish the pictures, since the frames are not gilt and I don't have here what is necessary, but as it pleases your Excellency, they can be finished in a few days. But I think they should be the last thing done in the chapel' (Kristeller, 1902, doc. 33). Unfortunately, it is unclear from the context whether the works in question were for the chapel in the castle in Mantua or whether, as Lightbown (1986, p. 412) claims, they were for a chapel in the Marchese's residence at Goito. Finally, in July 1466 an ancient alabaster vessel was offered to the Marchese to serve as a holy water font (see the documents assembled by Lightbown, 1986, p. 411). In 1492 the chapel was cited by Francesco Gonzaga as one of Mantegna's three greatest achievements (Kristeller, 1902, doc. 115). However, Vasari, who visited Mantua in 1545 and again in 1566, simply records that it contained a small altarpiece or painting with stories in which the figures were small but very beautiful ('*una tavoletta, nella quale sono storie di figure non molto grandi, ma bellissime*'), a comment that might aptly apply to the Uffizi and/or the Prado panels. According to Ridolfi (1648, p. 88) the altarpiece was stolen during the sack of Mantua in 1630, but in fact the chapel was probably destroyed not long after Vasari visited it (see Paccagnini, 1969, p. 64), and quite possibly the altarpiece was dismantled and its panels dispersed.

It is, therefore, not without interest that the earliest probable reference to the *Death of the Virgin* is in a list of pictures that had been installed in a small private chapel in Ferrara for Margherita Gonzaga, wife of Alfonso II d'Este, Duke of Ferrara, in 1586-8 (Venturi, 1888, pp. 425-6). Two other pictures by Mantegna are also mentioned: a Nativity (almost certainly cat. 8), and another of an unspecified subject. These were among 22 paintings by various artists that the Duchess had had arranged on the walls of her private chapel with stucco surrounds. Following the death of Alfonso in 1597 Margherita returned to Mantua, presumably bringing with her

those pictures that were regarded as her property (the *Nativity* was evidently not one of these, since it was purchased by Pietro Aldobrandini following the devolution of Ferrara to the Papal states: see cat. 8). The *Death of the Virgin* was acquired from the Gonzagas by Charles I in 1627 together with a painting of a *Sacra Conversazione* (Isabella Stewart Gardner Museum, Boston) that was regarded as its pendant (see Millar, 1960; Hendy, 1974). The Gardner picture was listed in the Gonzaga inventory of 1627 (Luzio, 1913, p 129, no. 580) and so, apparently, was the *Death of the Virgin* (see Lightbown, 1986, p. 414). Although unrelated in style and subject, the two pictures have almost the same dimensions, raising the possibility that the *Death of the Virgin* was cut down to make it a pendant to the Gardner painting in Margherita's chapel. A similar fate befell the *Nativity*.

The earliest notice of the Uffizi panels is in 1587, by which time they belonged to Don Antonio de' Medici (see Paccagnini, in Mantua, 1961, p. 31, and Lightbown, 1986, p. 412). Ventura (1987, p. 33, n. 12) has suggested that the paintings entered the Medici collections on the occasion of the marriage of Vincenzo Gonzaga with Eleonora de' Medici in 1584. They were first framed together as a triptych in 1827, and it is clear that their present arrangement is arbitrary. Whether they ever formed part of an altarpiece may be doubted. The *Adoration of the Magi* is painted on a concave panel 10 cm shorter than its companions (presumably it has been cut down), and in the two lateral panels the light falls from opposite sides, an inconsistency it is difficult to believe Mantegna would have introduced. The subjects shown are iconographically anomalous and, at the least, presuppose a larger series. For these reasons Paccagnini (in Mantua, 1961, pp. 32-3; 63-4) proposed that the lateral walls of Ludovico's chapel were divided into compartments framing scenes of the lives of Christ and the Virgin. According to this hypothesis, the *Ascension* and the *Death of the Virgin* would have been on one wall, with the *Circumcision* opposite and the *Adoration of the Magi* occupying a niche at the centre. Like other scholars, Paccagnini associated the four engravings of the Passion of Christ (cats. 29, 32, 36, 67) with the chapel decoration,

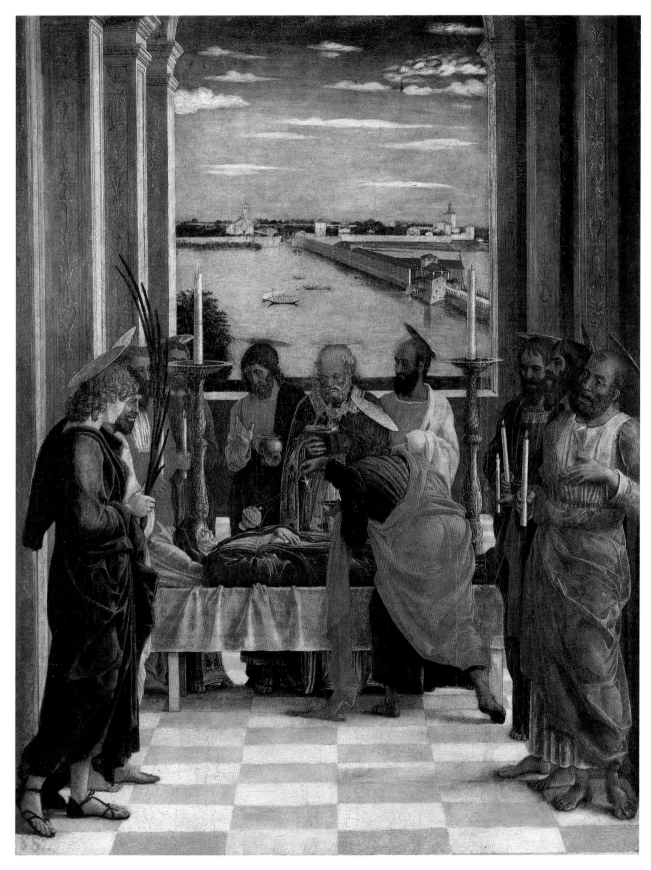

17

although there is, in fact, little to commend the idea that these prints derive from paintings rather than drawings (see Oberhuber and Sheehan, in Washington, 1973, p. 202). Paccagnini's theory implies, of course, that Vasari's description of the chapel is either fallacious, or that by the time he saw it a spurious altarpiece had been assembled from some of the panels that formerly decorated its walls. There is no evidence for the extreme view that the chapel decorations included large paintings or frescoes (Tietze-Conrat, 1943; 1955).

There is, however, reason to doubt the generally assumed association of the *Death of the Virgin* with the Uffizi panels. As both Yriarte and Kristeller noted, the wonderfully descriptive style of the *Death of the Virgin* is intimately related to that of the predella of the San Zeno Altarpiece. Instead of the dignified, statuesque beauty of the figures in the Uffizi panels, those in the *Death of the Virgin* reveal a naturalistic intention that is directly related to Mantegna's Paduan works. The drapery is varied in its arrangement rather than smoothed out and generalised. The white marble piers with their simple decoration are a far cry from the studiously archaeological re-creation of the richly decorated, Roman interior of the *Circumcision*. Whereas the design of the *Death of the Virgin* develops in depth, in the Uffizi panels the action is

confined to the foreground, with an intentional, frieze-like arrangement, even in the *Adoration of the Magi*, despite its deep landscape background. There is, moreover, an unparalleled concern for light and atmosphere in the *Death of the Virgin* which led Venturi (1924, pp. 139-40) to ascribe it to Giovanni Bellini. It is extremely difficult to imagine the suggestive, topographical view in the *Death of the Virgin* alongside the far more conventional background of the *Ascension*. Also notable is the fact that whereas the features and costume of the Virgin and St Joseph are studiously repeated in the Uffizi panels, those of the apostles in the *Death of the Virgin* do not recur in the *Ascension*. And whereas the haloes in the Uffizi panels, with the sole exception of that of the Virgin in the *Adoration*, are depicted as gold radiances, in the *Death of the Virgin* they are reflective gold discs. It might be added that instead of employing a carefully worked-out cartoon, as he did in the Uffizi panels, Mantegna drew in the figures of the *Death of the Virgin* free-hand, without a comparable concern for detail (see pp. 73-4, above).

It is, of course, possible that work on the altarpiece mentioned by Vasari (if, in fact, it was an altarpiece) was protracted over a number of years and that it had an *ad hoc* appearance. One might, for example, point out that in 1468 Mantegna was painting a

Descent into Limbo for Ludovico (Kristeller, 1902, doc. 39). But it is difficult to suppress the suspicion that the *Death of the Virgin* had nothing to do with the Uffizi panels. It certainly marks a different, earlier phase in Mantegna's development and helps to point up the transformation from his naturalistically based work of the Paduan years, with its romantic approach to antiquity, to the studied classicism of his Mantuan paintings.

In addition to being cut at the top, the picture has suffered solvent damage from past cleanings. The clouds are largely underpaint. Moreover, the general tonality has darkened, and this has affected the original crispness of execution. The picture's appearance was greatly improved by cleaning in 1990-91.

A drawing in the Uffizi (n. 1289 E.), in brown ink with white heightening on a yellow ground showing the figure of St John holding his palm, has recently been upheld as a preliminary study by Mantegna (Angelini, in Florence, 1986, pp. 71-2). Its self-consciously refined, even exquisite style has little to do with the character of Mantegna's preliminary underdrawing, and the fact that it simplifies the forms in the painting underscores that it is by a proficient, if uninspired, copyist.

K.C.

18

AFTER ANDREA MANTEGNA
Virgin and Child

Very faded brush with white heightening on green prepared paper. Irregularly cut and torn on all sides 280 x 99/100 mm (maximum dimensions)

Probably early 1460s

Kunsthalle, Hamburg (inv. 21263)

PROVENANCE
1863, bequest of E. Harzen

REFERENCES
Koopman, 1891, p. 41; Popham, in London 1930-31, p. 42, no. 153; Fiocco, 1937, p. 85; Tietze-Conrat, 1955, p. 205; Halm, Wegner and Degenhart, 1958, p. 24, under no. 8; Mezzetti, in Mantua, 1961, p. 166, no. 121; Lightbown, 1986, pp. 482-3, no. 181

This is one of a number of drawings executed in the same technique of brush and white heightening on prepared coloured paper. They all relate to individual figures, or groups of figures, in surviving paintings by Mantegna, and in each case the dimensions in both painting and drawing are identical. Furthermore, the poses of the figures are almost exactly the same. This drawing is related to the figures of the Virgin and Child in Mantegna's panel of the *Circumcision* (fig. 9; Uffizi, Florence), now the right-hand wing of a triptych, but usually assumed to have formed part of the decoration of the Chapel in the Castello di San Giorgio at Mantua, which Mantegna worked on in the early 1460s (see cat. 17).

Most writers have regarded these drawings as autograph preparatory studies by Mantegna, executed at a very late stage in the process of design. Fiocco and Tietze-Conrat, however, thought they were all *simili,* accurate replicas of finished drawings or paintings produced in Mantegna's workshop. Recent technical examination of the *Circumcision* supports this hypothesis. Infra-red reflectograms of the panel reveal traces of *spolvero* on the Virgin's mantle and in the capital of the background architecture, which proves that there must have been a detailed preliminary cartoon that was pricked for transfer. This drawing, however, cannot be that cartoon since it is not pounced.

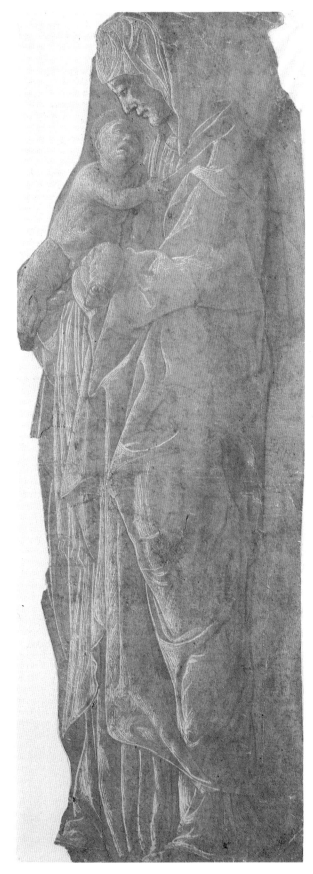

18

Although well executed, it does not give the impression of being a preparatory design, and never formed part of a larger whole with other figures. It might be argued that it is an auxiliary cartoon, that is to say a detailed drawing executed after the cartoon and before the painting, but there are a number of objections to this. First, such sheets are not known at this early date; second, when they do begin to be made, notably by Raphael, they tend to be meticulous studies of heads for larger-scale projects, either frescoes or altarpieces, and they invariably have black chalk dots that show they were based on a

cartoon. Only in one case do we find chalk dots in a drawing connected with a work by Mantegna (cat. 137) and that relates to a painting executed three decades later. The third problem is that, for a final preparatory drawing, this sheet contains a surprising number of minor, but not insignificant, differences from the painting. The Child's facial expression in the panel is more appealing and less vacuous, and his left leg lacks the three chubby tyres of fat. Similarly, the Virgin's face as painted is far more expressive of tender protection, and the folds of her drapery are not identical. Finally,

although the distribution of white heightening in the drawing more or less corresponds to the areas of gilded drapery in the painting, the division of light and shade is quite different, being much smoother and more logical in the latter. All these factors support the notion that this drawing is a *simile*, presumably either drawn from the painting or, rather more probably, from the lost cartoon.

D.E.

19

AFTER ANDREA MANTEGNA
Virgin and Child

Silver or lead point gone over with brush in black ink with white and yellow heightening on brown prepared paper
292 x 197 mm

Late 15th century(?)

The Hyde Collection, Glens Falls, New York

PROVENANCE
Until 1934, Paul Drey Galleries, Munich; 1934-63, Mrs Charlotte Hyde, Glens Falls

REFERENCES
Kettlewell, 1981, no. 12

This attractive drawing repeats the figures of the Virgin and Child from the *Adoration of the Magi* (fig. 80; Uffizi, Florence), a work dating from the 1460s and usually associated with an altarpiece seen by Vasari in the chapel of the Castello di San Giorgio in Mantua (see Lightbown, 1986, pp. 412-13). There is an engraving of the same figures (cat. 21), but a comparison of the drawing with the engraving reveals that the drawing is after the picture, not the engraving. For example, the fold of drapery on the Virgin's right leg, in front of the jewelled case, is the same in the painting and drawing but different in the engraving, and whereas the halo of the Christ Child is shown as a disc in the print, it is a radiance in the painting and drawing. Infra-red reflectography also enables a comparison of the underdrawing for the *Adoration* (which is based on a detailed cartoon transferred by means of pouncing) with the Hyde drawing, and here again it can be established that the drawing derives from the finished painting rather than the preparatory cartoon: the formation of the folds on the ground are considerably different in the underdrawing of the painting.

The drawing is, then, a copy after the painting, in which the forms are simplified and the foreshortenings somewhat misunderstood. The scale is minimally reduced (the Virgin in the drawing is approximately 8 mm smaller than in the painting). The figure and rocks were traced from another drawing (this is visible to the naked eye under raking light), while the tree, which does not occur in the painting, shows no sign of tracing. Most likely the artist first copied the composition freehand, making such corrections and adjustments as necessary, and then transferred the outlines on to the prepared paper to create what amounts to an independent work of art.

K.C.

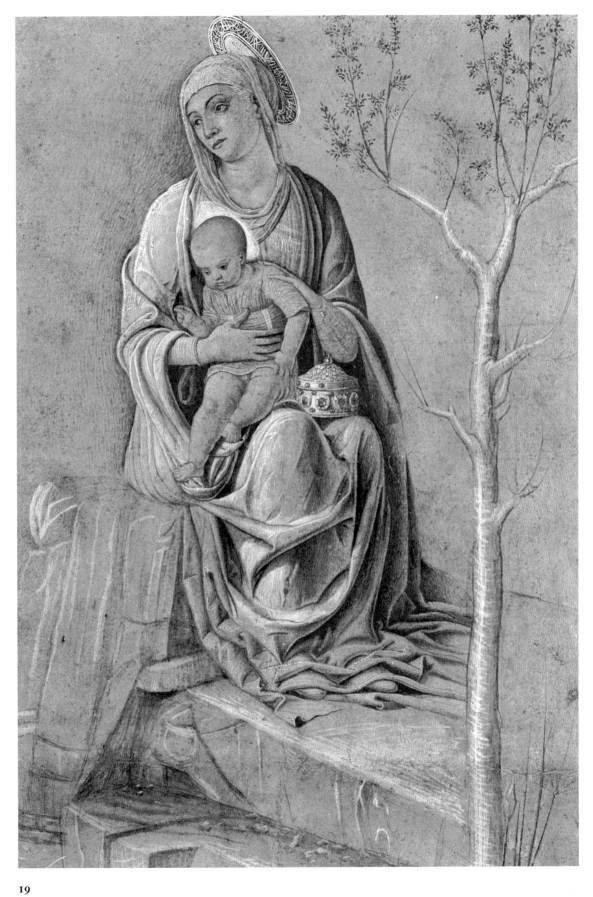

19

20

AFTER ANDREA MANTEGNA
*Eight Apostles Witnessing
the Ascension*

Pen and brown ink with white heightening on grey-
green prepared paper made up at bottom and left edges
290 x 218mm
Inscribed in black ink in bottom right corner: *Mantegna*

Probably early 1460s

Fogg Art Museum, Harvard University, Cambridge, MA,
gift of Mrs Isidor Straus in memory of her husband
Jesse Isidor Straus, Class of 1893 (1926-42-1)

PROVENANCE
Erizzo-Moscardo collection; Luigi Grassi
(L. Suppl. 1716); gift of Mrs Straus

REFERENCES
Pope, 1927, pp. 25-8; Popham, 1931–2, p. 62; Fiocco,
1937, p. 85; Mongan and Sachs, 1940, I, pp. 18-19,
no.24; Tietze-Conrat, 1955, p. 203; Mezzetti, in
Mantua, 1961, p. 166, under no. 121; Lightbown,
1986, p. 483, no. 182; Mongan, Oberhuber and Bober,
1988, no. 7

This is one of a number of drawings executed
in the same technique whose status has been
much disputed. It shows eight of the
Apostles, the entire group to the left of the
Virgin in Mantegna's painting of the *Ascension
of Christ* (fig. 76). The figures are on exactly
the same scale as those in the painting, which
it is usually assumed once formed part of the
decoration of a chapel in the Castello di San
Giorgio in Mantua (see cat. 17).

Mongan and Sachs, and Bober have argued
that this drawing is a highly finished
preparatory study for the painting, while
Fiocco and Tietze-Conrat believed it to be a
simile (see cat. 18, above). It does not seem to
be of great quality; the few faces fully visible,
with their peculiar white-ringed eyes, are far
weaker than those in the painting, the haloes
are drawn very clumsily freehand, and white
heightening is used to silhouette the figures,
but not to establish the ground-plane. It also
creates a very different division of light and
shade from that in the painting.

A recent technical examination of the
painting under infra-red light shows that in
certain areas, such as the hem and right foot
of the standing Apostle in blue, it is possible
to see traces of *spolvero*. This means that
Mantegna must have executed a cartoon on
the same scale as the painting for at least some
parts of the picture, pricked holes in it and
transferred the main lines of the design onto
the surface of the panel by dusting the
cartoon with powdered black chalk (*spolvero*).
This drawing is not pricked, so it cannot be
the cartoon.

The drawing is, in any case, an odd
fragment because the Virgin is omitted.
Almost exactly the same group of Apostles is
repeated in another drawing (Fitzwilliam
Museum, Cambridge, inv. 3046). However,
the fact that the drawing in the Fitzwilliam is
not a simple copy either of the painting or of
this drawing is suggested by such changes as
the omission of heads in the background and
the far more detailed treatment of the rocky
ground.

D.E.

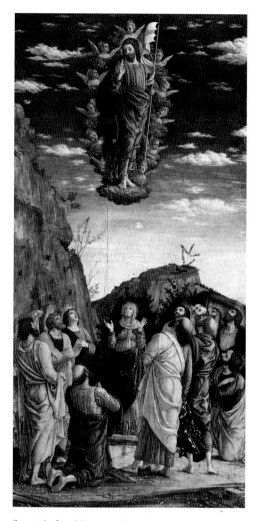

fig. 76 Andrea Mantegna, *Ascension*, tempera on panel,
left-hand wing of the 'Uffizi Triptych', early 1460s,
Galleria degli Uffizi, Florence

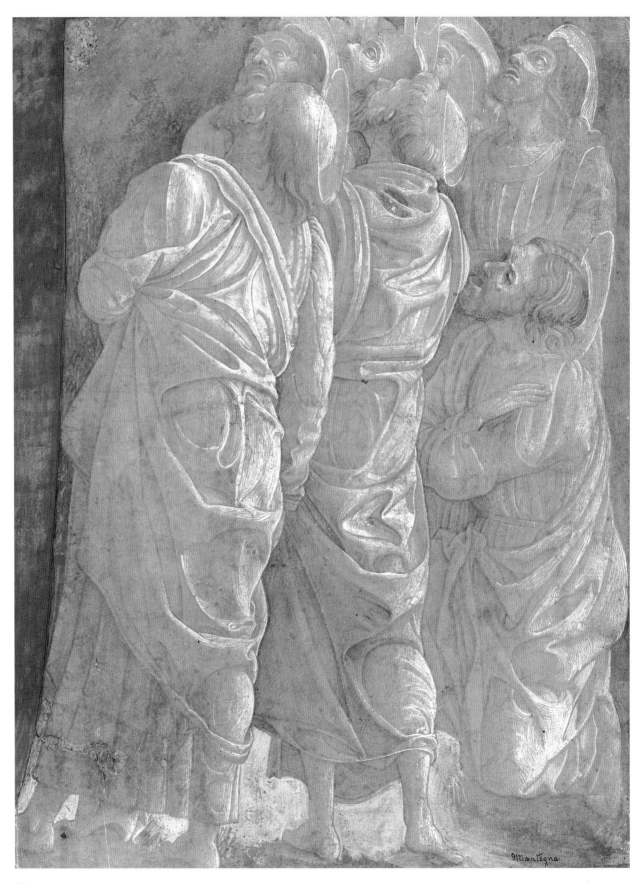

20

21

PREMIER ENGRAVER
Virgin and Child in the Grotto

Engraving, state 1 of 2
385 x 286 mm (sheet; plate 390 x 284/278 mm,
Vienna)
H.13
Watermark: Cardinal's Hat (no. 3)

c. 1500

R. Stanley and Ursula Johnson Family Collection

REFERENCES
Bartsch, 1811, XIII, 233.9; Hind, 1948, V, 22.13;
Sheehan, in Washington, 1973, no. 81; Riester, 1984,
p. 56

The *Virgin and Child in the Grotto* is unusual among prints after Mantegna in that apparently it is the only one in which the image is to the same scale as the painting to which it is related, the *Adoration of the Magi*, the central panel of the so-called Uffizi triptych (fig. 80). The print shows the lower right-hand section of the composition and, rather strangely, includes certain details, such as the radiant streak from the star that led the Magi and a fragment of the ox's ear and horn seen at the left behind the kneeling magus, which are virtually meaningless when divorced from the whole. A possible explanation for this is that the print was part of a projected multi-plate image that would have shown the entire composition, like, for example, the *Assumption of the Virgin* by Francesco Rosselli after Botticelli, on two plates, each about 513 x 460 mm (Hind, I, 141. B.III.10). The *Adoration of the Magi* measures 77 x 75 cm, so the print is roughly half its height, which might support this hypothesis; its width, however, is more than a third of that of the painting, so the left-hand part of the composition could not have been on plates of the same size as this. At any rate, no trace of an engraving of any other part of the composition is known, so if there was such a project, it presumably was abandoned.

The painting has a highly developed underdrawing, visible through infra-red reflectography, and pounce marks are also visible along some of the lines of the underdrawing; apparently a full-size cartoon was made for the painting, and the design was then transferred to the prepared panel by means of the pounce marks. The outlines and modelling lines of the print, however, do not conform to the lines of the underdrawing; a comparison of, for example, the areas of drapery over the Virgin's right arm (figs. 78, 79) makes this clear. A further comparison of the same area in print and painting (figs. 79, 77) shows a much closer correlation. Some of the heads of the angels have a noticeable shift in position between underdrawing and finished painting, and the character of several faces is quite different; again, in the print, positions and faces are those of the painting, not of the underdrawing. Thus, it is evident that the cartoon was not used in the preparation of the print. It seems probable that the print follows a line drawing made directly from the painting; if this is so, the print may be unique among those after Mantegna in having been made this way.

The unfinished quality of the print is puzzling, although it also might be explained by the plate having been part of an

fig. 77 Andrea Mantegna, *Adoration of the Magi*, detail, early 1460s, Galleria degli Uffizi, Florence

fig. 78 Andrea Mantegna, *Adoration of the Magi*, detail of the underdrawing seen with infra-red reflectography

fig. 79 Premier Engraver, *Virgin and Child in the Grotto* (cat. 21), detail

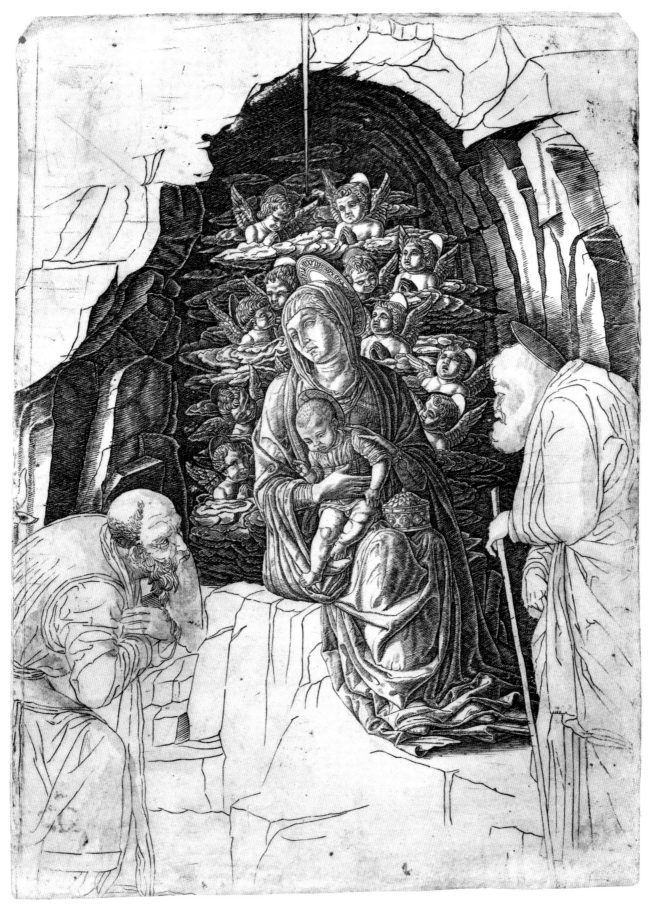

21

abandoned project to reproduce the whole painting. After a moderate number of impressions had been pulled – seven impressions of the first state are known, implying perhaps that at least twice that many once existed – a few shading lines were added on two small facets of rock, one near the centre about 20 mm from the bottom, the other in a triangular area above St Joseph's head (Riester, 1984). No other lines were ever added.

Bartsch listed the print as Mantegna's without comment, but since then no one has attributed it with any confidence. Hind wrote that it is 'somewhat in the manner of Zoan Andrea', and Sheehan, although she noted

'a certain hardness of effect' – a salient characteristic of certain of Giovanni Antonio's prints, such as the *Triumphs* copies (cats. 117, 121, 127) – nonetheless saw qualities to differentiate it from his work. She also noted 'a fine differentiation of strength in the contour lines'. The freedom of handling visible in the modelling lines, especially in the unfinished areas, is very similar to the work of Mantegna's Premier Engraver; the fact that the print does not derive directly from a Mantegna drawing has probably acted to obscure the relationship. Here this print is grouped with those of the Premier Engraver.

S.B.

22

AFTER ANDREA MANTEGNA
Virgin and Child in the Grotto

Engraving, state 1 of 2
600 x 420 mm (platemark)
H.13

c. 1500 (?)

Rijksprentenkabinet, Rijksmuseum, Amsterdam
(inv. no. OB1962)

REFERENCES
See cat. 21

This is the only known impression of an engraving after a work by Mantegna printed on vellum; the strong dark-greenish hue of the ink is also uncommon. It is difficult to judge the quality of an engraving on vellum since the printing often appears uneven and the surface of the skin is easily damaged by abrasion. This impression, which shows a complete platemark, is, however, still in the first state, suggesting it was printed not too late in the history of the plate.

S.B. and D.L.

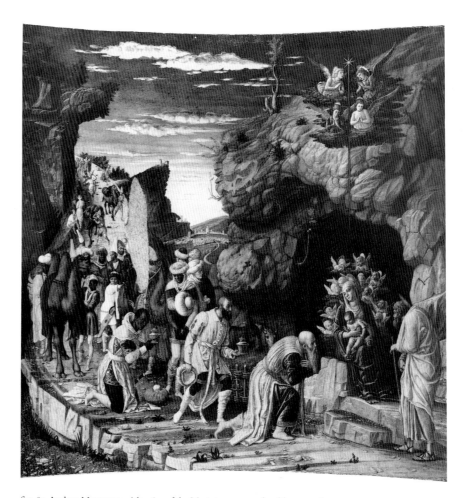

fig. 80 Andrea Mantegna, *Adoration of the Magi*, tempera and gold on panel, 77 x 75 cm, central panel of the 'Uffizi Triptych', early 1460s, Galleria degli Uffizi, Florence

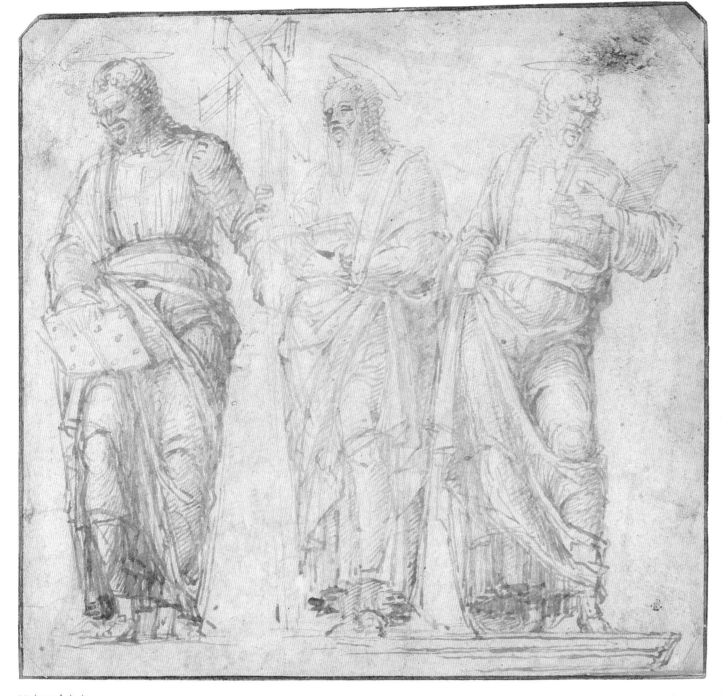

23 (actual size)

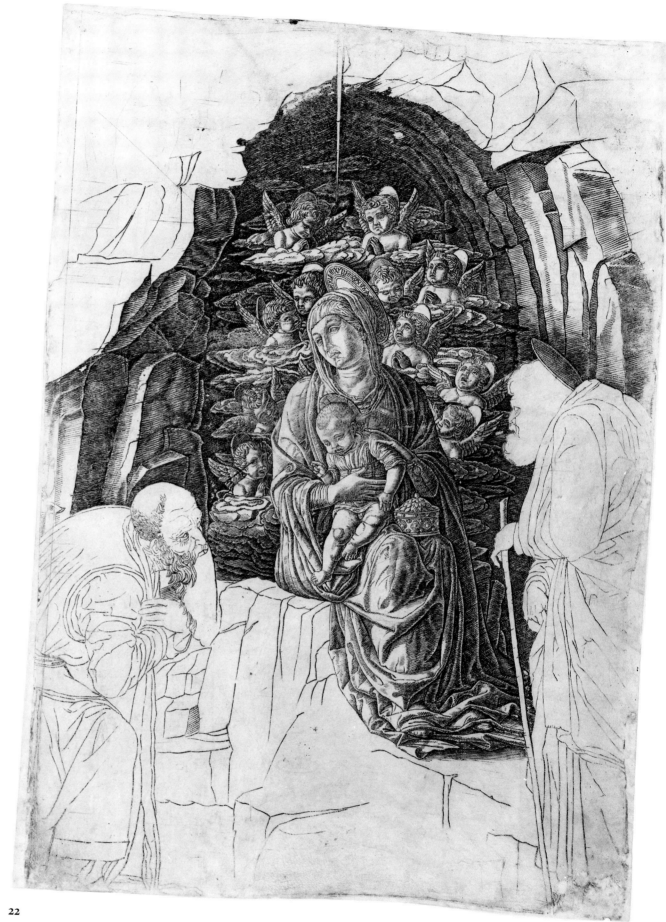

22

23

ANDREA MANTEGNA
Three Standing Saints

Pen and brown ink on pink prepared paper,
corners made up
178 x 188 mm
Bears collector's mark of Edmund Prideaux (L. 893)

Early 1460s

Pierpont Morgan Library, New York, Collection of
Eugene Victor and Clare Thaw

PROVENANCE
Edmund Prideaux (L.893 and suppl.); sold Christie's,
London, 7 July 1959, lot 70; Baron Hatvany; his sale,
Christie's, London, 24 June 1980, lot 3

REFERENCES
Heinemann, 1962, p. 84, no 338 *bis*; Degenhart and
Schmitt, 1968, II, p. 363, no. 13; Robertson, 1968,
p. 25, n. 6; Byam Shaw, 1979, p. 17, no. 34b; London,
1980, pp. 14-15, lot 3; New York, 1985, pp. 21-2,
no. 1; Lightbown, 1986, pp. 481-2, no. 178

Three saints, the one on the left on a slightly larger scale, are seen from below standing on what appears to be a moulded parapet. This sheet is closely related to the drawing of a *Standing Saint Reading* (cat. 24); both share an exceptionally confident application of the pen on a reddish-pink prepared ground. Presumably both drawings are studies for an altarpiece, or a fresco (as suggested by Lightbown), that is otherwise unrecorded.

A third drawing of *Four Standing Saints* (fig. 82), formerly in the Koenigs Collection, Rotterdam, can also be associated with the composition. Although that drawing was attached to an autograph sheet of *Two Studies of St John the Baptist*, its crudity and indecision, apparent even from a photograph, show it to be a copy after another Mantegna drawing for the same project. The figure of St Andrew holding his cross in the copy is remarkably similar to the same saint in this drawing, the only significant differences being that there he is shown slightly more in profile, and that his cross and book are in the opposite hands. It may also be the case that the second figure from the left in the Koenigs drawing (who carries a sword, identifying him as St Paul) is a study for the saint on the right of this sheet. Only St Peter, identified by the key he holds in his right hand, is not in both drawings. Everything suggests that the lost original of which the *Four Standing Saints* (fig. 82) is a copy preceded the Morgan drawing because, even allowing for the deficiencies of the copyist, who was particularly uncertain about the placing of the figures' feet, the poses of the saints are far less coherent and monumental.

Presumably the saints were intended to be grouped around a central figure or figures, possibly a Virgin and Child. However, at this stage in the evolution of the design, each figure is still being considered predominantly in isolation. Only St Andrew and the saint on the right of the sheet share a common ground-line; the third saint, who has a separate ground-line and whose left arm comes to an abrupt end when it encounters St Andrew's cross, appears to have been drawn afterwards. The lack of cohesion is especially evident if these sheets are compared with the tightly knit group of saints in the far more finished drawing for the San Zeno Altarpiece (cat. 14). This drawing shows the artist thinking and planning, whereas the San Zeno study is the final product of a train of thought and must have been preceded by drawings of this kind.

Byam Shaw and Lightbown dated this sheet and the *Standing Saint* to before the artist moved to Mantua in 1460. It is never easy to compare drawings whose degree of finish is very different, but the far more elongated proportions of the figures in the study for the San Zeno Altarpiece of 1456-9 suggest that these drawings are not of the same date. If earlier, they would have to be associated with the *St James* sheet (cat. 11), the only Mantegna drawing securely datable before the Getty sheet, and one of only two other drawings executed in pen on pinkish ground (the other is the *Studies of St John the Baptist and a Suppliant*, private coll; fig. 81). If later, they would have to be associated with

fig. 81 Andrea Mantegna, *Studies of St John the Baptist and a Suppliant*, pen and ink on faded pink prepared paper, 174 x 180 mm, Private Collection

fig. 82 Andrea Mantegna, *Two Studies of St John the Baptist*; after Andrea Mantegna, *Four Standing Saints*, pen and ink on two sheets of paper fastened together, 171 x 403 mm. Present whereabouts unknown, claimed by the State of The Netherlands (reproduced with permission of the Netherlands Office for The Arts)

the drawings of the 1460s, such as the three *Entombment* drawings (cats. 26, 27, 28) and the *Christ at the Column* (cat. 35), all of which have the same bold pen strokes, the same distinctive fringes of hair and the same proportions for the human figure, which would make this later dating seem plausible.

A further link with Mantua may be provided by the inclusion of St Andrew, the titular saint of one of the most important churches in the city.

D.E.

24

ANDREA MANTEGNA
Standing Saint Reading

Pen and brown ink on pink prepared paper;
bottom right and both top corners made up
172 x 70 mm
Bears the collector's mark of Sir Thomas Lawrence
(L. 2445)

Early 1460s

The Trustees of the British Museum, London
(1895-9-15-780)

PROVENANCE
Sir Thomas Lawrence; Sir J. C. Robinson;
John Malcolm

One of the group of pen drawings given either to Mantegna or to Giovanni Bellini, this study is closely related to the drawing of *Three Standing Saints* (cat. 23); both are evidently studies for the same work and share certain stylistic idiosyncrasies, such as the way

REFERENCES
Robinson, 1876, p. 119, no. 333; Colvin, 1908-9,
no. 6; Hadeln, 1925, p 48; Tietze and Tietze-Conrat,
1944,, pp. 74-5, p. 86, no. A 307; Popham and
Pouncey, 1950, p. 8, no. 11; Tietze-Conrat, 1955,
p. 205; Heinemann, 1962, p. 84, no. 340; Degenhart
and Schmitt, 1968, II, p. 363, no. 13; Robertson, 1968,
p. 25; Byam Shaw, 1979, p. 17 (under no. 34b); Wilde,
1971, p. 45; London, 1980, p. 15; Lightbown, 1986,
pp. 481-2

the fringe of hair along the brow is rendered as a succession of minute circles. The saint on the right of the Morgan drawing is almost identical to this figure, albeit in reverse; they share the same long, sharply pointed beard and strike the same elegant attitude in which the torso and the legs are counterbalanced. One slight difference is that in this drawing the saint holds his book with both hands as opposed to one. This drawing's marginally greater fluency and poise suggest it is a revision of the other. The technique of pen on a reddish-pink prepared ground is also found in the work of Pisanello.

D.E.

25

CIRCLE OF MANTEGNA
Standing Saint

Pen and brown ink
205 x 92 mm
Inscribed in pencil top right: *162*; in dark brown ink
bottom right: *Mantegna*

c. 1460-1500

Gallerie dell'Accademia, Venice (inv. 162)

PROVENANCE
Giuseppe Bossi

REFERENCES
Morelli, 1892-3, I, p. 271; Kristeller, 1901, p. 450;
Tietze and Tietze-Conrat, 1944, pp. 74-5, 90, no.
A.325; Heinemann, 1962, p. 83, no. 334; Robertson,
1968, p. 25

Although one of the original group of drawings assigned to Giovanni Bellini by Morelli, more recently this sheet has tended to be attributed to Mantegna. It shows a beardless young male saint, of a type which suggests St John the Evangelist, holding a book and standing on a shaded ground. It can be compared with the *Standing Saint Reading* (cat. 24), although the two drawings do not represent identical stages in the artistic process. The other saint is both more freely and more boldly executed; his legs, for instance, were drawn first and are still visible beneath the draperies subsequently drawn over them. By contrast, this sheet is both more worked out and more tentative, although here too an initial working of the figure in even thinner lines is visible beneath the definitive drawing. In some respects it is closer to the more finished drawing for the left wing of the San Zeno Altarpiece (cat. 14), but the correspondences are by no means exact. For, while the quality of this sheet is not negligible, the expressionless vacancy of the face is not impressive and the drapery folds, formed by juxtaposing very delicate hatching with areas of blank paper, are not characteristic of Mantegna, who invariably created form in a network of lines and added hatching later, even in his most finished studies. In the final analysis, although very close to Mantegna, the drawing does not appear to be autograph. If it is not by Mantegna, then it is not easy to suggest an alternative attribution (the Tietzes proposed the obscure Giovanni Minelli, but the comparison they suggest with a signed drawing by him is not convincing). The idea that it might be by Giovanni Bellini is not supported by comparison with those few sheets which have the best claims to be his autograph works, such as the *Pietà* (Louvre, Paris) or the *Nativity* (Courtauld Institute, London, Prince's Gate Coll.)

D.E.

24 (actual size)

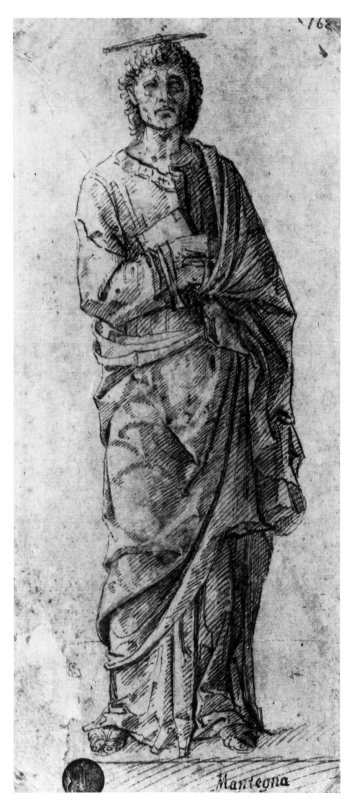

25 (actual size)

26

ANDREA MANTEGNA
Studies for the Entombment

Recto: The Dead Christ
Verso: Mourning Women

Pen and brown ink, slight fold in paper
122 x 89 mm

Early 1460s

The Trustees of The British Museum, London
(1909-4-6-3)

PROVENANCE
J.C. Blofeld

REFERENCES
Hadeln, 1925, p. 49; Clark, 1930, p. 187; Hadeln, 1932, pp. 229-30; Clark, 1932, p. 232; Tietze and Tietze-Conrat 1944, p. 87, no. A.311; Popham and Pouncey, 1950, p. 8, no. 12; Tietze-Conrat, 1955, p. 205; Robertson, 1968, p. 22; Wilde, 1971, p. 45

Von Hadeln first recognised the connection between the *recto* of this double-sided sheet and the study for an *Entombment* (cat. 27) and attributed both drawings to Giovanni Bellini; Clark linked them with the engraving of the *Entombment* (cat. 29). Although Clark himself subsequently recanted, the Tietzes and Wilde reasserted the attribution of the two drawings to Mantegna.

Certainly, the three studies of the dead Christ on the *recto* are closely related both to the drawing in Brescia and to the engraving of the *Entombment with Four Birds* (cat. 29), here attributed to Mantegna. The main difference is that here Christ is shown lying flat, as is made clear by the ground-lines drawn for the upper two studies, whereas in the other works he is being lowered into the tomb in a winding-sheet. The reason may well be that at this stage in his thinking Mantegna intended to show Christ laid out on the stone of unction, a rare iconography also found in his later *Dead Christ* (Brera, Milan) and in a painting by Carpaccio in the Gemäldegalerie in Berlin. At this early date there are so few finished works for which a substantial number of preparatory drawings survive that it is almost impossible to prove that artists experimented with subject-matter in this way. However, 16th-century drawings survive in greater numbers, and the studies for Raphael's *Entombment* of 1507 (Galleria Borghese, Rome), for example, include both these moments – and others. Earlier artists are unlikely not to have played similar variations on the most important episodes from the Passion of Christ.

The idea of showing the body at a diagonal to the picture plane is common to all three compositions, although both the principal study here and the Brescia drawing favour a more radically foreshortened solution than that adopted in the print. Mantegna experimented with the placing of the body, showing the body both head and feet foremost, and trying out the diagonal line from left to right and right to left. Finally, for the print, he decided to have the head foremost and the legs to the right, as in the uppermost study on this sheet, which is also the most schematic. In consequence the expressive potential of the face, so powerfully explored in the study at the bottom of the

sheet here and in the Brescia drawing, was of necessity diminished. Significantly, in an altarpiece of the *Entombment* (Brera, Milan) by the Pseudo-Boltraffio, in every other respect an exact copy of the print, the artist has made more of Christ's profile visible.

The drawing is executed with a thickish pen, and especially in the principal study Mantegna has gone over most of the major lines, producing a heavily shaded effect. Unresolved passages are apparent in some areas such as the right arm, yet the spiky fingers of the left hand were executed in the engraving as they were drawn here. Such features as the taut, muscular torso and the tightly curled ringlets of the hair are typical of Mantegna, and are found in the other drawings belonging to this group. In all three studies on this sheet, as in the Brescia drawing, Christ's arms hang limp by his sides, whereas in the engraving they are folded across his breast.

Although Popham and Pouncey saw no connection between the studies on the *verso* and any known work either by Mantegna or Bellini, the Tietzes were surely correct to relate them to the Holy Women supporting the swooning Virgin in the print of the *Entombment with Four Birds*. One woman is shown kneeling almost frontally, the other is seen in part profile from the back; at this stage they neither help to support Christ's body nor that of the Virgin, as in the Brescia drawing and the engraving respectively. The drawing was swiftly executed, with the intricate folds of the spreading draperies on the ground added as an afterthought. It is not easy to determine whether the two sides of this drawing preceded the Brescia sheet or not, since here the iconography of the *verso* is very close to the print, but that of the *recto* is very different. A date in the early 1460s, as advocated by Wilde, seems likely.

D.E.

26 *recto* (actual size)　　　　　　　　　　　　　　　**26** *verso* (actual size)

27

ANDREA MANTEGNA
Entombment

Pen and brown ink
130 x 95 mm

Early 1460s

Pinacoteca Tosio-Martinengo, Brescia, Brozzoni
Collection (inv. 147)

PROVENANCE
Brozzoni Collection; Tosi Collection

REFERENCES
Morelli., 1892-3, I, pp. 261, 271; Hadeln, 1925,
p. 47; Longhi, 1927, p. 137; Popham, in London,
1930-31, p. 45, no. 162; Hadeln, 1932, pp. 229-30;
Clark, 1932, pp. 232-5; Tietze and Tietze-Conrat,
1944, pp. 76, 83, no. A.291; Tietze-Conrat, 1955,
p. 203; Robertson, 1968, p. 22; Wilde, 1969, p. 40;
idem, 1971, p. 45; Byam Shaw, 1979, p. 17, no. 326

This drawing, like a number of other sheets now usually accepted as the work of Mantegna, was in the past attributed to Giovanni Bellini. Two other drawings of the same subject (cats. 26, 28) appear to date from the same period. This drawing, like cat. 26, gives every indication of being a first idea for the engraving of the *Entombment with Four Birds* (cat. 29), here attributed to Mantegna.

This sheet is particularly unusual in its treatment of the subject: Christ's body is being lowered on a winding-sheet supported by two of the Holy Women, one of whom cradles his head, while two men – presumably Joseph of Arimathaea and Nicodemus – stand within the tomb itself and almost disappear from view as the body is lowered down to them. A third woman, evidently the Virgin Mary, stands on the far side of the tomb, bending over the body of her son, her hands joined in supplication. In the engraving this figure remains, but is transformed into one of the lamenting Marys; the fainting Virgin supported by two of her companions form a separate group. In addition, the sarcophagus is raised above the ground, and the two men stand outside it to lower the body, in all respects a more conventional treatment of the subject than this. The only other difference is that in the print Christ's body is turned the other way around, so that his head is seen in *profil perdu*.

Although the penwork of this sheet shows that it was a rapidly executed creative drawing with countless changes of contour and other *pentimenti,* Mantegna manages to include an astonishing number of significant details and touches of characterisation. Christ's body is lifeless, the head flung back and the rib-cage drawn in Mantegna's typical horseshoe-shaped configuration, but two fingers of the left hand are stretched out while the other two are bent back on themselves. The nearer Mary's profile is made up of a couple of lines for a nose and a blob for an eye, while the further Mary was initially drawn with a hesitant, thinner line and there was some confusion between her legs and the tomb. Both the men are drawn over the lines of the tomb, but everything comes to life, and details are added, such as the metal clamp that joins the two blocks of the steps around the tomb. Thick, bold vertical and diagonal hatching is used to impart a heavy effect of chiaroscuro.

The drawing has been lifted for the exhibition to reveal on the *verso* a pen drawing of a candelabrum.

Various details, especially in the upper part, are comparable to features of the candelabra found in the *Death of the Virgin* (cat. 17), of approximately the same date, and even those in the later *Elephants* (cat. 112) from the *Triumphs of Caesar*. This candelabrum, however, was probably a first idea for a piece of ecclesiastical metalwork. It shows saints standing in round-arched and pedimented niches towards the top, a head in a roundel lower down, and on the base what appears to be another figure or figures also in a roundel. Elaborate larger-scale bronze candelabra of this type were by no means uncommon in the Renaissance. A pair of silver candelabra bequeathed to the Basilica of San Marco in Venice by Cardinal Zen in 1501 were close in design to this one. It is known through an 18th-century drawing (B. Jestaz, *La Chapelle Zen à Saint-Marc de Venise*, Stuttgart, 1986, p. 13 and fig. 7, a reference I owe to Dr Charles Avery).

In terms of draughtsmanship, there is no reason to doubt the attribution of this *verso* to Mantegna, for the quick, almost nervous touch is entirely characteristic of him. The only parallel for the tiny, schematic figures is in the drawing of the *Trumpeters* for the *Triumphs* (fig. 99), where a similar shorthand is employed for the figurative scenes on the banners. For what may be another, much more finished, design for metalwork, see cat. 50.

D.E.

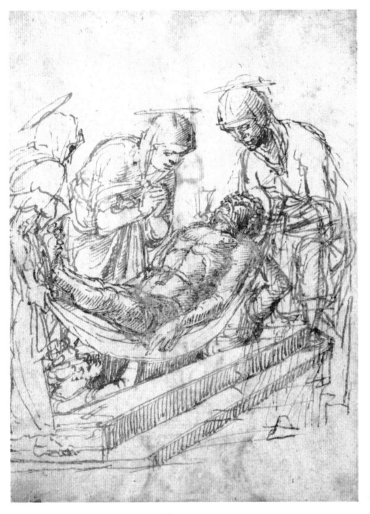

27 *recto* (actual size)

27 *verso* (actual size; during restoration)

28

ANDREA MANTEGNA
Pietà

Pen and brown ink, perhaps slightly cropped at the left
and bottom, although the composition tails away at
these points
127 x 98 mm
Inscribed in pencil top right: *115*; bears the mark of
the Accademia

1460s

Galleria dell'Accademia, Venice (inv. 115)

PROVENANCE
Giuseppe Bossi

REFERENCES
Morelli, 1883, p. 215, n. 1; *idem*, 1892-3, I, p. 271;
Hadeln, 1925, pp. 49-50; Popham, in London, 1930-
31, p. 46, no. 163; Tietze and Tietze-Conrat, 1944,
p. 89, no. 323; Robertson, 1968, p. 24; Wilde, 1969,
p. 40; Byam Shaw, 1977, pp. 16-17, no. 32a; Goffen,
1989, p. 82, p. 299, n. 54

There is still no unanimity in the attribution
of this drawing, which has been variously
given either to Mantegna or to Giovanni
Bellini (to the latter most recently by Goffen).
Yet, it is strikingly close, especially in the
treatment of Christ's torso and head (note the
identical ringlets of hair and schematic front-
to-back bisection of the skull), to the *recto* of a
study of the *Christ at the Column* (cat. 35)
which in its turn relates to a print here
attributed to Mantegna (cat. 36). Since even
those writers who attribute the drawings to
Bellini agree they are both by the same hand,
and since one of them is connected with an
engraving by Mantegna, it is hard to see why
Bellini's name is still frequently invoked for
this drawing. It is true that Bellini painted this
type of half-length frontal presentation of
Christ in the sarcophagus many times, and
that – as far as we know – Mantegna never
did, but the iconography was extremely
popular in northern Italy both for
independent paintings and for the pinnacles
of altarpieces. Ultimately it derives from
Donatello's bronze relief of the *Pietà* for the
high altarpiece of the Santo in Padua of
1445-50.

Whereas Donatello's treatment was
essentially passive, and showed the dead
Saviour flanked by weeping child-angels,
Mantegna here favoured a more dramatic,
emotionally charged solution which is closer
to some of the variations on the theme made
by his father-in-law, Jacopo Bellini, in his
albums. Christ, his face still racked by the
pain of the Crucifixion, is supported by the
Virgin, whose left arm is under his shoulder
and whose right reaches round his arm. Her
left hand is fully resolved and finished, while
her right is a mere flurry of lines. One of the
Holy Women is seen in profile at the side,
her mouth open and her arm stretching out
across Christ's body. In between the two
women is a third figure, probably St John the
Evangelist. At first glance this may appear to
be a woman wearing a head-dress, but in fact
the small circles ringing the face are a
favourite device of Mantegna's, and are
intended to suggest a fringe, as comparison
with other drawings demonstrates.

In spite of its small scale, this is an
exceptionally powerful and also highly
visually informative drawing. Thus, although
the hands of Christ are extremely schematic
and there are considerable changes of mind
around his left arm, most of the lines are
drawn with tremendous confidence. The
hatching was added at the end, so that,
whereas the holy woman's right arm was
drawn over the lines of Christ's arm and side,
it was already in place when the hatching was
applied and is not overlapped by it. The
tension and definition of Christ's torso, and
especially the collarbone, are remarkable, as is
the attention to such details as the wounds in
Christ's side and hands.

Like the *Flagellation* drawing, this sheet is to
be placed in the 1460s, close in date to the
two other studies for an *Entombment* (cats. 26,
27). However, it cannot be for the same
project, for whereas they are first ideas for the
engraving of the *Entombment with Four Birds*
and show the figures on a small scale and full
length, this sheet is intended as a preparation
for a half-length devotional image.

D.E.

28 (actual size)

29

ATTRIBUTED TO
ANDREA MANTEGNA
Entombment with Four Birds

Engraving
443 x 339 mm (platemark)
H.11b

c. 1465

Graphische Sammlung Albertina, Vienna
(inv. 1951-380)

REFERENCES
Bartsch, 1811, XIII, 228.2, no. 1; Hind, 1948, V, p.21,
no. 11b; Washington, 1973, p. 206, no. 79

Three related prints of this subject exist, two of them showing three birds rather than four (see cats. 30, 31). Most authors, while attributing them to Mantegna's school and suggesting they all derive from the same lost Mantegna drawing, agree that the present version is greatly superior in quality. They also agree that it was engraved by the same hand as the *Deposition* (cat. 32), since it shares its idiosyncratic 'angularity of forms and sharply pointed fingers', as Hind put it.

There can be little doubt that the present version is the prototype and the other two copies: cat. 30 belongs to the group of copies made by Giovanni Antonio da Brescia, while cat. 31 was probably engraved by the Master of 1515 and is, in turn, a copy of Giovanni Antonio's copy. It seems to the present writer that the exceptional quality of this print and of the *Deposition* suggests that Mantegna himself engraved them. Each figure in this *Entombment* is imbued with character, each face expresses a particular emotion, every gesture is convincing: a comparison with the two copies demonstrates the disparity in quality between a print engraved by the master and those engraved by his followers.

The stylistic difference between the *Entombment* and the other prints attributed to Mantegna can be explained by the fact that it is probably one of the two earliest plates he engraved (the other being the *Deposition*). Moreover, these two prints are divided from the others hitherto attributed to the artist by a considerable span of time. The angularity of forms may have much to do with Mantegna's incompetence with the burin on his first attempt to use it: unlike any of the later works, this print is characterised by very short strokes, all parallel and of similar depth and intensity. In a few small areas, such as on Christ's right leg, the engraver used thinner, longer lines which follow the anatomy of the figure: it is obvious, however, that both types of line were produced with the same tool. Inevitably, this engraving appears less subtle and refined than the prints produced at the height of Mantegna's powers as a printmaker, but one should bear in mind the extraordinary technical innovations he developed in the intervening years, as they completely transformed the appearance of his prints. For all its apparent crudeness, this *Entombment* is a beautiful print by a novice engraver.

The 'sharply pointed fingers' are a feature of Mantegna's works of the 1460s, and are present in the preparatory drawings for this print (cats. 26, 27). Its dating to this period is also confirmed by the close correlation between the *Entombment* and the *Deposition* mentioned above, which were engraved on two sides of the same plate (see Appendix 1) and the four paintings connected with the Chapel of the Castello di San Giorgio (see cat. 17). The rocks and clouds of this *Entombment* seem to come straight from the *Adoration of the Magi* (fig. 80), as does the small fig tree sprouting from above the grotto. The figure types, their scale and the landscape setting are also very similar, as is more fully discussed elsewhere (cat. 32). Finally, the presence of Longinus, who was particularly venerated in Mantua, suggests a date after 1460 (Wilde, 1971, p. 45).

D.L.

29

30

GIOVANNI ANTONIO DA BRESCIA
Entombment with Three Birds

Engraving
464 x 360 mm (platemark)
H.11

c. 1500–04

Staatliche Museen Preussischer Kulturbesitz,
Kupferstichkabinett, Berlin

REFERENCES
Bartsch, 1811, XIII, 228.2 (Mantegna); Hind, 1948, V,
20.11; Washington, 1973, p. 206, no. 79

As with the other copies made by Giovanni
Antonio, this is a very careful, faithful
rendition of its prototype, engraved in the
same direction on a plate of similar size. The
most noticeable difference is the presence of
three, rather than four, birds; other variations
include the omission of the letters '*INRI*' on
the tablet above Christ's Cross, the shading of
the crosses with diagonal, not vertical, lines, a
leaf on the lowest branch at the left of the fig
tree growing above the tomb touching a
small outcrop of rock (in the original there is
a gap of about two millimetres between
them) and the sharp edges of the indentations
in this rock (in the original they are more
rounded).

This *Entombment* was probably engraved on
the reverse of the plate used for the
Flagellation with a Landscape (cat. 37).

S.B.

30

31

MASTER OF 1515 (?)
Entombment with Three Birds

Engraving
464 x 330 mm (plate size unknown)
H. 11a

c. 1510

Duke of Devonshire and the Chatsworth Settlement
Trustees

REFERENCES
Bartsch, 1811, XIII, 229.2 (copy 2); Simon, 1929,
pp. 123-37; Hind, 1948, V, 21.11a; Dreyer and
Winner, 1964, pp. 53-94; Oberhuber, in Washington,
1973, p. 456; Zucker, 1984, p. 571; Agosti, 1990,
p. 130, n. 66; Fiorio, 1990, p. 9

This copy in reverse of the upright *Entombment*, of which only six impressions are extant, has been known to print cataloguers since Bartsch, although apparently no one has ever suggested an attribution. A comparison with the other versions makes it clear that this one follows Giovanni Antonio's copy rather than the original. The most obvious element is the presence of three, rather than four, birds, but the other discrepancies listed under cat. 30 are here, too. Bartsch observed that the 'S' visible on the tree at the right, noted by Hind, was in the original nothing more than a meandering line on the tree trunk; it gained a more pronounced reversed 'S' shape in Giovanni Antonio's copy, and was converted into an 'S' here.

The engraving style is crude, if vigorous, producing, in this instance, a not particularly attractive result. The faces, already less expressive in Giovanni Antonio's print than in the original, have become rigid and contorted here. The rocks seem as animated as the figures, and the interior modelling lines have a lively quality that competes against the forms as a whole; both of these traits tend to drain meaning from the composition. Lighting is harsh, almost violent. The engraver liked to use rounded lines and forms: the small pieces of rock strewn in the foreground, mostly jagged in Giovanni Antonio's engraving, are rounder here, and the contours of the mass of rock in the background are also smoother; the tree in the foreground is given volume by the use of regular, almost circular stripes.

These characteristics are all to be found in the work of the unidentified engraver known as the Master of 1515, to whom Hind (V, 279-90) ascribed 44 works, from which Dreyer and Winner subsequently removed three. The name derives from the date, 1515, on one of the prints. Neither of two attempts to identify this engraver has been generally accepted. Simon (1929) argued that the printmaker was Hermann Vischer of Nuremberg, and although Hind did not think it was possible to prove this identity, he was convinced the engraver came from northern Europe. Dreyer and Winner (1964) suggested that the engraver was the Lombard sculptor Agostino Busti, called Bambaia, because some of the drawings in a sketchbook in Berlin attributed to that artist correspond to fourteen engravings of details of classical architecture by the Master of 1515. This attribution, however, is far from universally endorsed (Oberhuber called the Master 'probably' Bambaia; Zucker wrote that 'recent discoveries … all but prove that he is … Bambaia' although 'a few doubts remain'; Fiorio did not comment on the attribution; and Agosti thought the identification unlikely). Here the traditional designation is used.

Four other prints after designs by Mantegna are here attributed to this engraver, including one hitherto unpublished engraving (cat. 80; see also cats. 78, 88, 92).

S.B.

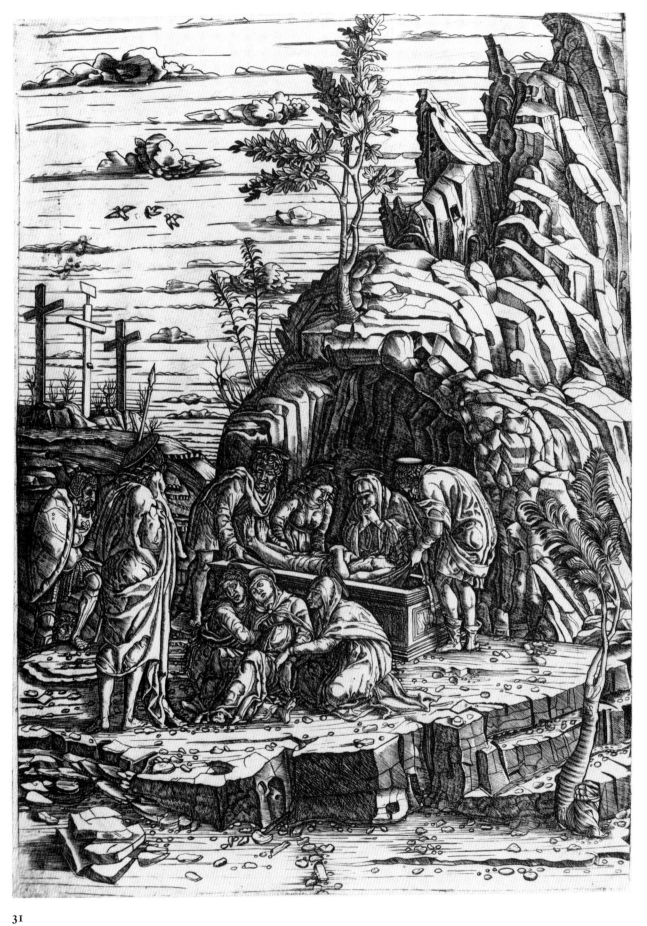

31

32

ATTRIBUTED TO
ANDREA MANTEGNA
Deposition

Engraving, state 2 of 3
452 x 362 mm (sheet)
H.10.1

c. 1465

The Trustees of The British Museum, London
(1845-8-25-599)

REFERENCES
Vasari, 1568, ed., 1878-85, III, p. 409; Bartsch, 1811,
XIII, 229.2; Hind, 1948, V, p. 19, no. 10

This print is known in three states, two of which are exhibited (see also cat. 33). The earliest state – a proof taken before much of the landscape had been engraved – has only survived in one damaged impression which was on the Italian art market in the mid-1970s, but whose present whereabouts is unknown. It is probable that the additions in the second and the third states were made in the 16th century after the plate had left the workshop, since their quality is significantly inferior to the rest of the print. This is confirmed by the early drawn copy (cat. 34), which lacks most of the background details.

This image was engraved on the back of the plate used for the *Entombment with Four Birds* (cat. 29), probably soon after that print was completed. It shows a greater mastery in the handling of the burin, with longer, thinner and more confident strokes, which create a more intense variety of tonal hues from white to black. Sadly Mantegna left it unfinished – it is likely that the untraced impression of the first state is the only surviving record of the print's appearance in Mantegna's time. Vasari included it in his list of the prints by the master, but it is almost certain that very few people, if anybody, saw an impression of it during Mantegna's lifetime.

Mantegna succeeded in endowing each face with an individual and wholly convincing expression, and each body with weight, volume and movement: while anguish or resignation characterise the features of the Holy Women who are attending the Virgin, a pensive older man stands at the left, while St John gestures in despair to Joseph and Nicodemus, who lower the body from the Cross. Only Mantegna at the height of his powers could have engraved the inert lifeless body and the dead weight of Christ's arm to such telling emotional effect.

This engraving is even closer in style to the paintings associated with the Chapel of the Castello di San Giorgio than the *Entombment with Four Birds*: it shares with all those paintings the scale and proportions of the figures, with rather elongated bodies and hunched backs (perhaps a reflection of the congenital deformities of the Gonzaga family). There is a particularly striking similarity between the woman at the extreme left of the print of the *Deposition* and the Virgin in the *Circumcision* (fig. 9). The rocky hill in the background of the print, the only part of the landscape likely to be by Mantegna, is very similar to that in the *Adoration of the Magi*, and the isolated, spindly tree is reminiscent of the drawing of the *Virgin and Child* (cat. 19).

D.L.

33

ATTRIBUTED TO
ANDREA MANTEGNA
Deposition

Engraving, state 3 of 3
447 x 358 mm (sheet)
H.10.II

c. 1465

Staatliche Museen Preussischer Kulturbesitz,
Kupferstichkabinett, Berlin

REFERENCES
Bartsch, 1811, XIII, 230.4; Hind, 1948, V, p. 19,
no. 10.II

This is an impression of the third state of the print described above (cat. 32), after the branches had been shaded and clouds added in the sky: these additions are likely to have been made sometime in the early 16th century. The third state of the print, although rare, is much more common than the second, of which only three impressions are recorded.

D.L.

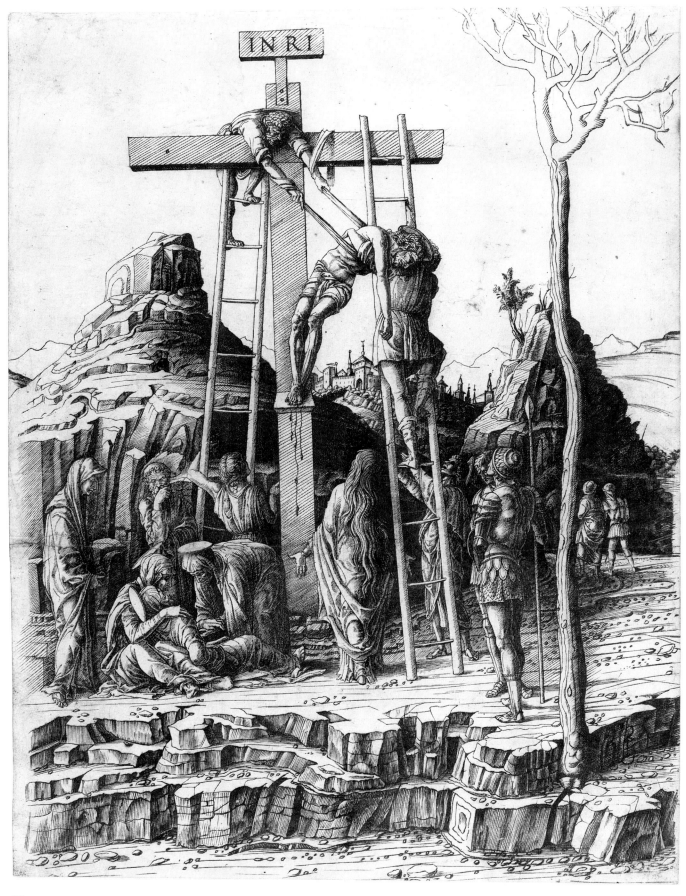

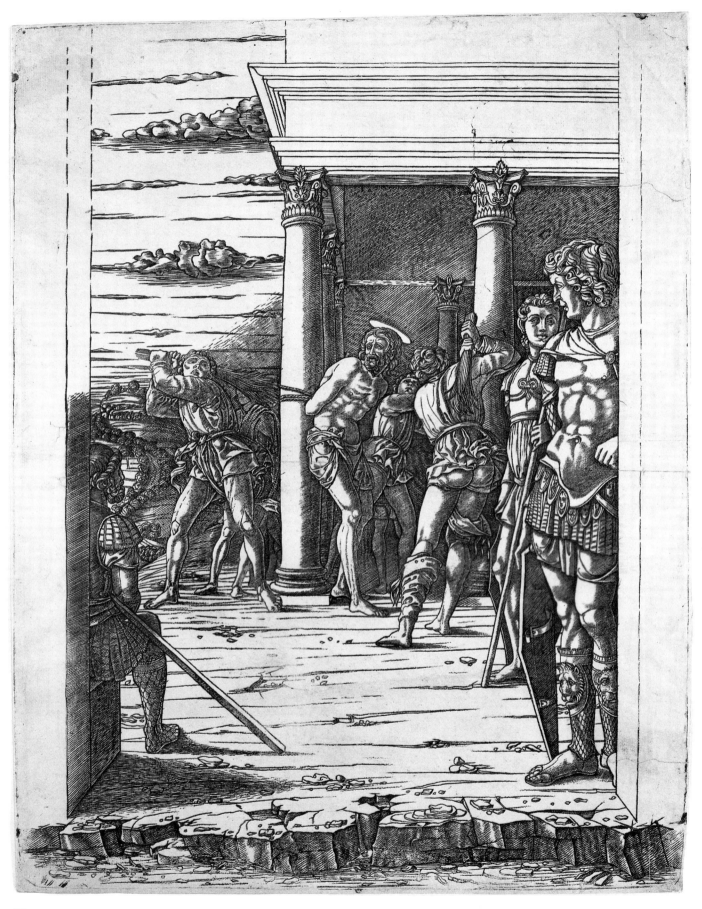

37

38

ANDREA MANTEGNA
Entombment

Drypoint, state 1 of 2
333 x 467 mm (sheet; plate 339 x 480 mm:
height Amsterdam, width Philadelphia)
H.2.1
Watermark: Basilisk (no. 1)

Early 1470s

Graphische Sammlung Albertina, Vienna

REFERENCES
Bartsch, 1811, XIII, 229.3; Hind, 1948, V, p. 10, no. 2;
Washington, 1973, p. 170, no. 70

This unsuccessful but extraordinary impression marks a crucial step in Mantegna's career as a printmaker. It shows him experimenting with a new technique in his search for a satisfactory way of reproducing tone by means of black lines on a white sheet of paper, thereby allowing the eye to understand the shape of things and the relationship between them.

After attempting to make four prints, three of which he abandoned unfinished, Mantegna must have come to the conclusion that by using a burin alone he would never be able to produce a rich variety of tone in his prints. However carefully he incised the plate it always resulted in an image in stark black on a white ground, an effect that does not exist in nature, and one from which he was also trying to get away in his paintings at that date.

Mantegna's solution was daring: he employed a new technique that could produce softness of tone. It is true that drypoint – in which a sharply pointed tool is used to incise the surface of a plate in a manner akin to that of drawing on paper with a pen – had been used by northern artists before this time: it is also well known that German prints were circulating in Italy in the last third of the 15th century, and there is no reason to doubt that some drypoints had reached Mantua by the 1470s. But no German printmaker had ever tackled a plate of the size and complexity of this one.

The advantage of drypoint is that the pointed tool leaves raised metal edges on either side of the groove which catch the ink as well as the groove itself, thereby generating blackness between any two contiguous black lines in the space which would otherwise have remained white. This gives the image a greater softness of tone. The main disadvantage of the technique, however, is that the raised metal edges are frail and they quickly break or are pushed back into the groove under the pressure of the press. This is why Mantegna attempted to print this plate not on a roller press, but on a less powerful press; this, however, not only failed to provide sufficient pressure to print the image

evenly, but also produced the disturbing horizontal striations which are obvious not only in this impression, but also in a number of other experimental prints made during this period.

Mantegna used drypoint in a new fashion. By varying the depth of the groove, and therefore the thickness of the layer of ink deposited in it, he obtained the effect of two different types of printed line: the deep grooves would produce immensely dark lines, the shallow grooves, lighter lines. The few areas of this impression where the printing has been successful, such as the feet of Christ or the drapery of St John, show what extraordinary effects could be achieved. The failure to obtain a better result – the survival of this impression suggests that no better print was pulled – led Mantegna to continue experimenting along the same lines, eventually developing a technique in which the two types of groove, deep and shallow, were produced with different tools: the shallow ones with the drypoint, the deep ones with the burin – a tool that removes neat and controllable amounts of copper, leaving the plate incised with grooves that are triangular in section.

That this particular experiment was short-lived is demonstrated by the fact that no other impression of any print by Mantegna was produced in precisely the same technique as this *Entombment*. An impression of the second state in Boston is printed on a paper with the same watermark, a Basilisk, found in this impression and on a number of other prints made by Mantegna during these years, as well as on the drawings of the *Risen Christ with St Andrew and Longinus* and *Mars, Diana and Iris(?)* (cats. 44, 146).

It is very likely that the *Entombment* was engraved on the back of the plate used for the print of the *Risen Christ* (cat. 44).

D.L.

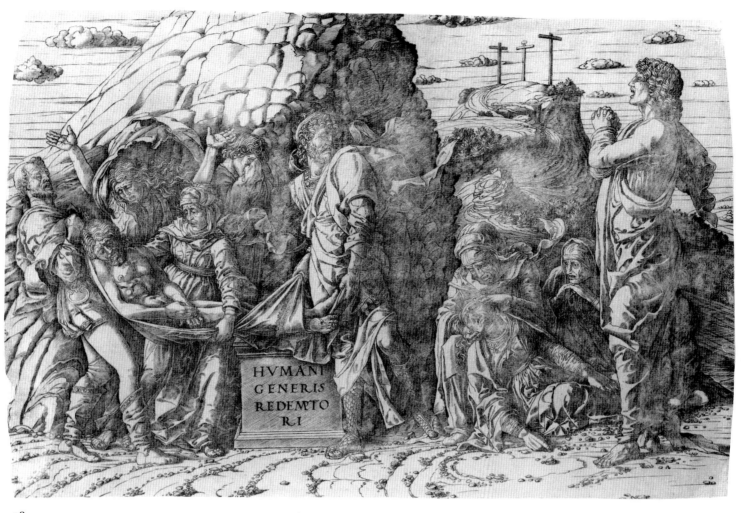

HVMANI
GENERIS
REDEMTO
RI

38

39

ANDREA MANTEGNA
Entombment

Engraving and drypoint, state 2 of 2
299 x 442 mm (sheet; plate 339 x 480 mm:
height Amsterdam, width Philadelphia)
H.2.II

Early 1470s

The National Gallery of Art, Washington, DC,
Washington Patrons' Permanent Fund

REFERENCES
Bartsch, 1811, XIII, 229.3; Hind, 1948, V, p. 10, no. 2;
Washington, 1973, p. 170, no. 70

This is the second state of the *Entombment*, after the plate had been entirely reworked with the help of a burin: every line was re-engraved but the only change immediately obvious to the eye is that made to the tablet over the central cross, which is no longer supported by a short stick. There are only two states of this print, not four, as has been claimed (Washington, 1973), but comparison of impressions of both states is illuminating. While some of the softness found in the Vienna impression of the first state is lost in this impression, Mantegna managed to create crispness and richness in the tonality by using a burin for the deeper lines and drypoint for the lighter ones. Once the drypoint disappeared, which must have happened very quickly, and only the deeper lines were printed – as is the case for almost all other surviving impressions – the print becomes a ghost of the earlier impressions, hard and unappealing.

It is likely that the two states followed each other quickly: this would be natural at a time when Mantegna was experimenting with different printmaking techniques. The dating of both states cannot be too far from that of the unfinished *Flagellation with a Pavement*, with which it shares the greater monu-mentality of the figures achieved by increasing their scale and bringing them closer to the foreground. A drawing of *Three Holy Women* (British Museum, London), almost certainly by Marco Zoppo, after part of the composition, offers a *terminus ante quem* of 1478, the year in which that artist died (Washington, 1973, p. 170).

Four geometrical shapes are engraved in the corners of the print. Similar shapes appear in six other prints, in some of which only one or two are clearly discernible (Hind, nos. 4, 8, 9, 10, 11 and 11b). Their function must be related to the transfer of the drawing to the plate: all are of different irregular shapes, which perhaps can be explained if they served as marks to align the drawing to the plate during the process of transfer. First the artist would have traced the drawing on to a transparent piece of paper (*carta oleata* or *carta lucida*). Then he would have used the tracing to transfer the image on to the copper plate. This would explain why none of the drawings shows any indentation marks; it may also be the reason why no geometric shapes appear on the drawings, since they would have been made on the tracing paper. The only drawing in the exhibition relating to a print with such marks is that for the *Descent into Limbo* (cat. 67), and unfortunately that is cut across the bottom right-hand corner where, in the print, a lozenge shape is visible.

D.L.

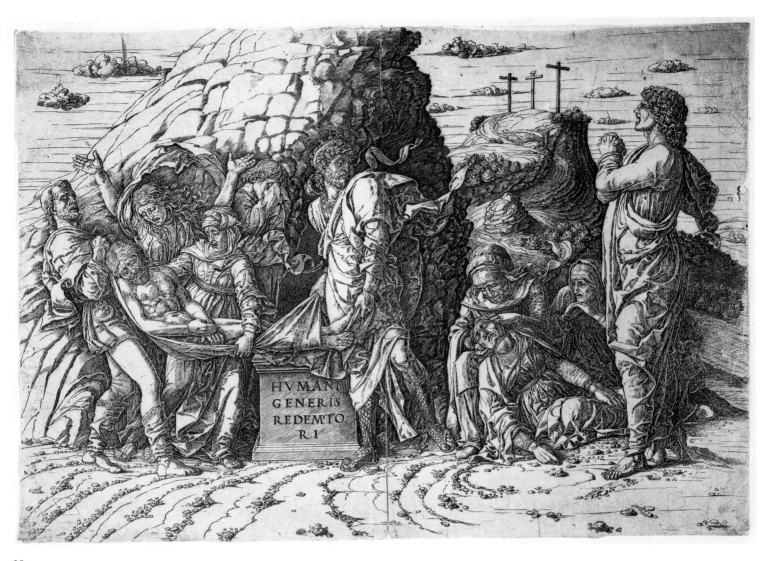

39

202

40

GIOVANNI ANTONIO DA BRESCIA
Entombment

Engraving
285 x 414 mm (sheet; plate 297 x 436 mm, Vienna)
H.2a
Watermark: Orb and Cross (no. 22)

c. 1509

Cabinet des Estampes, Bibliothèque Nationale, Paris

REFERENCES
Bartsch, 1811, XIII, 296.3; Hind, 1948, V, p. 12, no. 2a

As in the case of at least seven other copies made by Giovanni Antonio after Mantegna's prints, this engraving reverses the direction of its prototype. This was an easy short cut for the engraver, allowing him to copy the image from the original directly on to the plate without having to reverse it first. Sometimes, however, this produced unfortunate results, as in this case, where St John is seen at the left of the composition, whereas traditionally he should be on the right. Measurements taken of various parts of the composition in both prints confirm that this copy was made by tracing the lines of an impression of the original on to the plate.

The authorship of Giovanni Antonio da Brescia is confirmed not only by the fact that the history of the watermarks of the paper on which this copy is printed coincides with that of many other copies by Giovanni Antonio (see Appendix II), but also by the existence in Amsterdam of an impression of this *Entombment* printed on the *verso* of an indulgence published in Rome under Leo X (1513-21), when the printmaker presumably was living there. The dimensions of the plate on which this copy of the *Entombment* was engraved coincide with those of the *Flagellation* (Hind, 1948, V, p. 40, no. 13), signed by Giovanni Antonio in Latinate form: in fact, this is the fullest of all of Giovanni Antonio's signatures, reading *IO.ANTON/ BRIXIANV* on a *tabula ansata* broken at the right, so that the ends of the last two words are lost. The *Flagellation* is dated 1509, and it is likely that this copy of Mantegna's *Entombment* was also made around that date.

D.L.

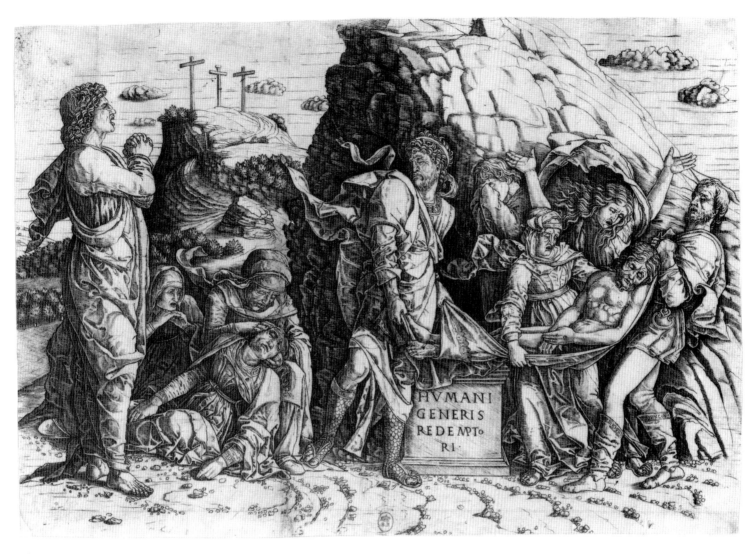

40

41

ANDREA MANTEGNA
Virgin and Child

Distemper on canvas, 43 x 32 cm

c. 1465-70

Gemäldegalerie, Staatliche Museen Preussischer
Kulturbesitz, Berlin (S.5)

PROVENANCE
Conte della Porta, Vicenza; by 1898-1904, James
Simon, Berlin

REFERENCES
Yriarte, 1901, pp. 193-4; Kristeller, 1901, pp. 124, 438;
Fry, 1905, pp. 91-2; Berenson, 1907, p. 254; Knapp,
1907, pp. XXXVI, 174; Borenius, in Crowe and
Cavalcaselle, 1871, ed. 1912, p. 109 n. 2; Venturi,
1914, p. 228; Berenson, 1932, p. 326; Fiocco, 1937,
p. 49; Tietze-Conrat, 1955, pp. 20, 179; Cipriani,
1962, pp. 26, 58; Pallucchini, 1957, p. 123; Paccagnini,
in Mantua, 1961, p. 30; Gilbert, 1962, p. 6; Longhi,
1962, ed. 1978, p. 154; Camesasca, 1964, pp. 37, 119;
Garavaglia, 1967, p. 108, no. 54; Berenson, 1968,
p. 239; Lightbown, 1986, p. 424; De Nicolò Salmazo,
1990, p. 496

This picture is distinguished from the five
other extant paintings in which Mantegna
treats this devotional theme by its disarming
simplicity and effect of naturalness. We seem
to be in the presence not of the Mother of
God but of a neatly coiffed, unprettified girl
lost in thought as she tenderly cradles her
sleeping child, whose tightly swaddled body
is wrapped in the brocaded veil that binds the
two together (this device was also used in the
Virgin and Child with Seraphim and Cherubim,
cat. 12). The absence of a halo enhances this
intensely human interpretation (a technical
examination undertaken in May 1991 found
no traces of a halo; nor does one appear in
x-radiographs).

The theme of the Christ Child asleep in
the Virgin's lap or in her arms was popular in
Venice and seems to have carried a variety of
meanings (see Meiss, 1954, ed. 1976, pp. 116-
19; 1966, ed. 1976, pp. 226-9). In Jacobello
del Fiore's *Virgin and Child* (Museo Corror,
Venice), a scroll beneath the half-length
figures reads, 'the seat of wisdom is in the lap
of the Virgin', while a scroll held by the
sleeping Christ Child in a picture by the
Florentine Neri di Bicci is inscribed with a
passage from the Song of Songs (5:2), 'I slept

but my heart is awake', an allusion to Christ's
constant vigilance. At other times, the
sleeping Child prefigured Christ's death. This
is the meaning usually attached to images in
which the infant Jesus lies asleep on a parapet,
but it is also pertinent to paintings in which
Christ has fallen asleep in the lap of the
Virgin, as in Cosimo Tura's *Virgin and Child*
(Accademia, Venice), in which goldfinches,
traditional symbols of Christ's Passion, peck
at clusters of Eucharistic grapes suspended
above the Virgin, while an inscription on a
parapet urges her to wake her son so that the
process of Redemption can begin. However,
the Florentine Dominican reformer Giovanni
Dominici recommended the subject of Christ
sleeping in his mother's lap for its appeal to
children (see Ringbom, 1965, pp. 32-3), and
as Meiss has pointed out, the theme could be
purely lyrical. In fact, the presence of
inscriptions or symbols in the three paintings
cited above suggests that the allusions were
sufficiently ambiguous to require explication
for contemporary viewers.

In Mantegna's image, the pensive
expression of the Virgin and the swaddling
clothes of the Child – reminiscent of a
winding sheet – may refer to Christ's death.
However, the swaddled child was a popular
motif in Paduan painting at least from the
14th century and may go back to a Byzantine
prototype (see Padua, 1974, cat. 2) or a piece
of sculpture: similar infants appear in a *Virgin
and Child* by Guariento (Metropolitan
Museum of Art, New York), one by Giusto
de'Menabuoi (Sacrestia dei Canonici, Padua
Cathedral: see Padua, 1974, cat. 51), and one
was introduced by Mantegna in his
Presentation (fig. 39; Gemäldegalerie, Berlin).
The motif can also be found in a few
terracotta reliefs of the Virgin and Child that
can be associated with Donatello (see
Florence, 1986², cats. 39, 41, pp. 150-54).
No less than was the case with the *Virgin and
Child with Seraphim and Cherubim* (cat. 12),
Mantegna was deeply indebted to such reliefs
for the composition and emotional tenor of
the Berlin painting – particularly for the
touching conjunction of the heads of mother
and child, for which Donatello's so-called
Verona Madonna offers a close analogy (see
Pope-Hennessy and Lightbown, 1964, I,
no. 69, pp. 84-5). The encircling veil of the
Virgin creates a strong base for the

composition that would not be unsuited to a
sculptural group; however, by comparison
with Donatello's reliefs, Mantegna created a
quieter, more self-contained interpretation of
the theme.

The date of the picture has been much
debated. It has been considered a work of the
Paduan period (Knapp, Tietze-Conrat); as
dating from Mantegna's first years in Mantua
(Fiocco, Cipriani, Gilbert); of *c.* 1475 or later
(Camesasca, Garavaglia); or a late work
(Berenson, Longhi, Lightbown). The relation
to Donatello's reliefs implies a date in
Mantegna's Paduan period or not long after
his move to Mantua. Crucial to any analysis is
the recognition that the naturalistic premise –
so distant from the formal character of the San
Zeno Altarpiece – is closely linked with his
work on the Camera Picta, where the task of
creating a narrative based exclusively on
portraiture led Mantegna to relax the tightly
controlled compositional schemes and
abandon the fixed figure types of the Ovetari
Chapel. The salient traits of this moment
emerge clearly in a comparison between the
portrait of *Cardinal Trevisan* (cat. 100), of
1460, with its allusion to Roman reliefs, and
the more naturalistically conceived *Portrait of a
Man* (cat. 102) of *c.* 1470-80.

Work in the Camera Picta began before
June 1465, by which time the vault was
presumably finished. The purchase in 1468 of
walnut and linseed oil is likely to have been
for finishing glazes for the court scene, which
was painted *a secco*. In 1470 two Milanese
ambassadors were shown the room and
admired the portraits on the chimney wall
(see Cordaro, 1987). It is with the less
formally conceived scene on the chimney
wall that this *Virgin and Child* bears closest
comparison, and the picture may be dated
c. 1465-70.

The picture is much darkened through the
application of varnish and a layer of dirt
between it and the paint surface. It has not
been cut (stretch marks are visible on all
sides). It is painted on a finely woven canvas
with no gesso preparation. The Virgin's head-
dress was painted in a dark colour on a light
ground. In places only the lighter
underpainting survives.

K.C.

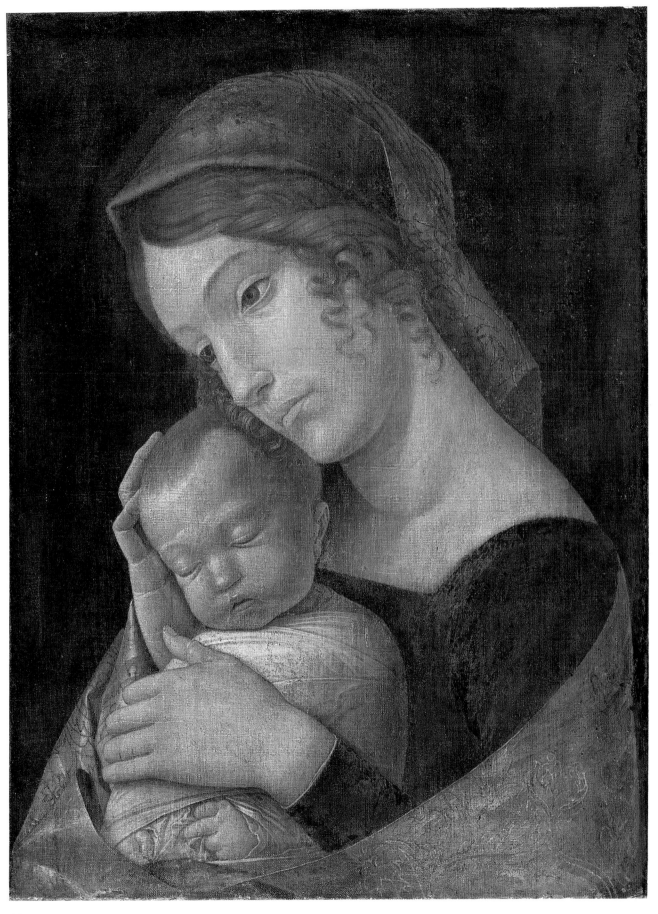

42

ANDREA MANTEGNA
St George

Tempera on wood, 66 x 32 cm

c. 1470–75

Galleria dell'Accademia, Venice (inv. 98)

PROVENANCE
Until 1856, Palazzo Manfrin, Venice

REFERENCES
Crowe and Cavalcaselle, 1871, ed. 1912, p. 90;
Morelli, 1891, p. 226; Kristeller, 1901, pp. 225-7, 440;
Fry, 1905, p. 91; Berenson 1907, p. 255; Knapp, 1910,
p. 175; Venturi, 1914, pp. 159-60; Berenson, 1932,
p. 328; Fiocco, 1937, pp. 55-6, 204; Moschini-
Marconi, 1955, pp. 139-40; Tietze-Conrat, 1955,
p. 199; Meiss, 1957, p. 21; Paccagnini, in Mantua,
1961, p. 37; Cipriani, 1962, pl. 60; Camesasca, 1964,
pp. 29, 108; Garavaglia, 1967, no. 41; Berenson, 1968,
p. 241; Lightbown, 1986, pp. 405-6

Despite various damages (due mostly to flaking) in the upper left sky, the Saint's cuirass and in the dragon, *St George* is one of Mantegna's most accomplished and engaging works; a picture whose small scale is belied by its conception – more akin to a fresco than to a devotional painting. Although sometimes compared with Mantegna's youthful frescoes in the Ovetari Chapel in Padua or with the life-size canvas of *St Euphemia* (cat. 13; Tietze-Conrat, Cipriani, Lightbown), the picture has little of the rough-hewn realism of the former and none of the abstract prettiness (inspired by Jacopo Bellini) of the latter. The Saint, with his youthful, idealised features, does not simply stand within the marble casement – as does St Euphemia – but fully inhabits it, his animated pose activating the space in a way for which there is no parallel in Mantegna's works of the 1450s. The curving path of the landscape, resolved into a rounded hill placed in counterpoint to the Saint, marks a decisive advance over the compartmentalised treatment found in the *Adoration of the Shepherds* (cat. 8) or the *St Sebastian* (fig. 5) in Vienna (the latter is likely to date from the late 1450s and may be the '*operetta*' Mantegna was working on for Jacopo Marcello in 1459). This type of landscape makes its first appearance in the predella panel of the *Agony in the Garden* from the San Zeno Altarpiece of 1457-60 and reaches its fullest realisation in the background of the fresco in the Camera Picta showing the meeting between Ludovico Gonzaga and his son Cardinal Francesco, dating from *c.* 1470-74.

No less notable is the treatment of light, which envelops and softens the forms (see Paccagnini). Mantegna has taken an obvious pleasure in describing the reflections on the Saint's armour (which, I am informed by Stuart Pyhrr of the Department of Arms and Armor at the Metropolitan, is a remarkably accurate depiction of mid-15th century armour), the contrast between the lit and shadowed portions of his face, and the metallic brilliance of his halo. In no other work does Mantegna exploit to a similar degree the conceit of the halo as a highly polished plate reflecting the back of the head. This is a leitmotif in the work of Andrea del Castagno, and was almost certainly inspired by Mantegna's trip to Tuscany in 1466 and

his study of works such as Castagno's fresco of *St Julian* in SS. Annunziata, Florence, and Domenico Veneziano's now damaged fresco from the rood screen of Santa Croce showing *SS. John the Baptist and Francis* beneath an arch, viewed off axis and *di sotto in sù*, with a sun-filled landscape background. Mantegna would especially have admired the latter, in which he would have seen so many of his own interests imaginatively exploited. And yet, Mantegna's knight belongs to a more aristocratic, idealised race than these rugged Florentine saints, and there is a real possibility that the ultimate source for his new-found synthesis of light, geometry and sculptural form was Piero della Francesca (the suggestion of Kristeller, 1901, p. 227, that we see here the influence of Bellini seems to me to miss the mark, since Bellini arrived at a similar solution somewhat later and almost certainly following his contact with Piero).

Although the devices Mantegna employs – the marbled casement in front of which is suspended a swag of fruit and nuts (quinces, apples, peaches, cherries and hazelnuts) – go back to his earliest Paduan works (the *St Mark*, cat. 5, and *St Euphemia*), the picture can hardly predate 1466 and is probably contemporary with the work on the west wall of the Camera Picta, which offers a close parallel for the integration of the landscape design with the figurative component and, indeed, with the conceit of the figures staged within a shallow arch.

There is no record of the picture before 1856, when it was acquired for the Accademia by Emperor Franz Josef from the Manfrin collection in Venice, but there is no reason to believe it once formed the lateral wing of a triptych (Tietze-Conrat). St George was a popular military saint throughout the Veneto, but especially in Ferrara and Mantua, where his martial virtues were well appreciated by successive generations of *condottieri*. Not only did Ludovico's castle bear the Saint's name, but in 1445-6 he struck a gold *marchesano* with the Saint's image (George was one of the patron saints of Mantua).

K.C.

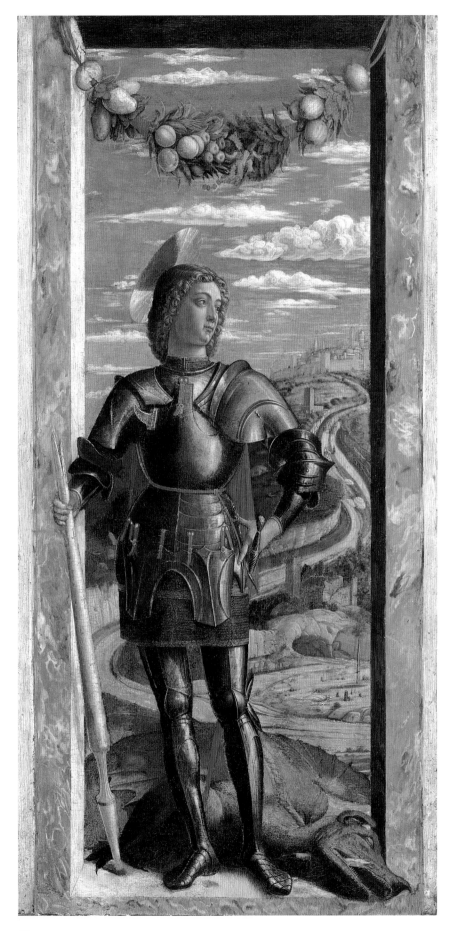

42

43

ANDREA MANTEGNA
Man Lying on a Stone Slab

Pen and brown ink over traces of black chalk;
a stain over the face
163 x 140 mm (203 mm high, including the strips
added at top and bottom)

1470s

The Trustees of The British Museum, London
(1860-6-16-63)
(Exhibited in London only)

PROVENANCE
W. Y. Ottley; Sir Thomas Lawrence; S. Woodburn;
sold Christie's, London, 6 June 1860, lot 545

REFERENCES
Selvatico, in Vasari, ed. 1849, V, p. 207; Morelli, 1883,
p. 87, n. 1; Selvatico, in Vasari; ed. 1878-85, III, p. 434;
Morelli, 1892-3, II, p. 177; Thode, 1897, p. 115;
Kristeller, 1901, pp. 405, 445; Berenson, 1902, p. 50;
Knapp, 1910, p. L; Popham and Pouncey, 1950, p. 94,
no. 155; Tietze-Conrat, 1955, p. 205; Byam Shaw,
1979, p. 17, no. 36; Lightbown, 1986, p. 483, no. 185

This drawing, whose attribution to Mantegna has never been seriously doubted (although Knapp thought it was copied from a print), shows a man lying on a slab trying to raise himself, seen foreshortened from the feet. As a result, it has been associated by various critics with the painting of the *Dead Christ* (Brera, Milan), Thode even going so far as to describe it as 'a preparatory study for, or variant of' that picture, an opinion with which Berenson concurred. However, as Popham and Pouncey observed, a direct connection is out of the question for the simple reason that the figure is alive, not dead. Furthermore, the viewpoint is quite different in the drawing: here the artist looked down on the slab from above and did not attempt such dramatic effects of foreshortening.

The subject of the drawing, therefore, remains unclear. Lightbown suggested it might represent the central figure from a composition of Christ restoring the son of the widow of Nain, or the Raising of Lazarus. However, it may simply be an academic exercise drawn from life, while the pose of the figure might suggest an antique derivation, specifically from a statue of the type of the Dying Gaul.

This drawing is very close to that of the *Risen Christ with St Andrew and Longinus* (cat. 44) both in technique, with its disciplined but wiry pen strokes, and in anatomy, with its inverted horseshoe rib-cage. Even minor details, such as the artist's mannerism of rendering a nipple with darker inner and paler outer concentric circles, or the way the thick, rope-like strands of hair fall in curls at the nape of the neck, are common to both. Both drawings may very plausibly be dated to the 1470s, probably early in the decade rather than late: the manner in which the hatching used for background shading is carried on through the figure is characteristic also of the engravings of the 1470s.

The drawing is executed in pen and brown ink over black chalk, which is most visible in the ruled orthogonal lines of the slab. The orthogonals must have been drawn in first, even though the shadow around the figure's left hand overlaps one of them rather illogically. The one on the right continues beyond the slab, and an earlier line is still visible close to the edge of the sheet. By contrast, the underdrawn line on the left has been more thoroughly eradicated, and the pen line was only added after the folds of drapery overlapping it. The man's face is somewhat disfigured by a stain, but the metallic corrugated folds of the drapery and the schematic circles of the toes afford some consolation.

D. E.

43 (actual size)

44

ANDREA MANTEGNA
*The Risen Christ between
St Andrew and Longinus*

Pen and brown ink with brown wash; a black chalk
guideline for the inscription at the base
350 x 285 mm
Inscribed (at base): *PIO ET IMMORTALI DEO*
(in brown ink): 340

1470s

Staatliche Graphische Sammlung, Munich (inv. 3065)

PROVENANCE
G.M. Jabach; sold at Hendrick de Leth, Amsterdam,
16 October 1753, lot 698; Gerard Hoet; sold at
Franken and Thol, The Hague, 25-8 August 1760, lot
974; bought by Lambert Krahe; Kurfürst Carl Theodor
von der Pfalz of Mannheim

REFERENCES
Selvatico, in Vasari, ed. 1849, V, p. 204; Passavant,
1864, V; Selvatico, in Vasari, ed. 1878-85, III, p. 433;
Morelli, 1883, p. 87; *idem*, 1892-3, II, pp. 116, 177;
Berenson, 1902, pp. 51, 98-9; Hind, 1909-10, II,
p. 343, under no. 7; *idem*, 1948, V, p. 16 under no. 7;
Byam Shaw, 1950, p. 159; Elam, in London, 1981,
p. 122, no. 31; Zucker, 1984, p. 87, n. 11

This drawing is classified in Munich as a copy
after Mantegna, although in the 19th century
it was widely accepted as an original. It first
appears to have been mentioned by Selvatico,
who recognised the connection between
it and the engraving of the same subject
(cat. 45) and regarded it as an autograph pre-
paratory study. Both Passavant and Morelli
accepted the attribution, the former de-
scribing it as 'worked with exquisite finesse',
the latter calling it 'very fine, and I believe
genuine'. Kristeller did not include it in his
monograph either as an original or as a copy,
but Berenson (1902) accepted it among the
eleven drawings to which 'a criticism at once
competent and cautious will scarcely refuse
the title of authenticity'. Hind twice rejected
it as a mere copy after the print, and only
Byam Shaw had the characteristic good sense
to wonder whether it might not be worthy of
revaluation. Disfigured by old staining and
faded as a result of having been exhibited in
the 19th century, it has been unjustly neglect-
ed, and has never even been reproduced. In
fact it is not a copy, but differs from the
engraving in a number of important respects.

The print lacks the inscription, whose
epigraphy may be compared letter for letter
with the text '*HVMANI GENERIS REDEMPTORI*'
on the sarcophagus in the autograph print of
the *Entombment* (cat. 38). The distances
between Christ's head and the banner, and
the banner and the cross on his staff, are
shorter in the drawing. Although there are
minute differences in the relative dimensions
between drawing and print, the sheets may
originally have been of the same dimensions
and become subsequently distorted.
(Andrew's cross measures 290 mm in the
drawing as against 285 mm in the print;
Christ's staff 300 mm as against 297 mm;
Longinus' spear 290 mm as against 285 mm.)
The armour protecting Longinus' forearms is
more elaborately patterned in the drawing;
the sarcophagus less so. In the print, the grain
of the wood of the cross overlaps St Andrew's
right thumb, whereas in the drawing it does
not. Even the three-dimensional quality of
Longinus' tunic and Christ's cruciform halo
are far more successfully rendered here.

In short, nothing about the sheet supports
the possibility that it is a copy after the
engraving. By contrast, its numerous felicities
of execution and its consistently high quality
speak in favour of its being Mantegna's final
study for the print. This is perhaps most
evident when such details as the facial
expressions, and even the rendering of hair
and beards, are compared.

There is, however, one feature that
confirms the attribution to Mantegna. This
concerns the correction, a *Klebkorrectur*, on
the head, neck and upper torso of Christ.
Close scrutiny reveals that this section has
been cut out of the original sheet, and a new
piece of paper has been inserted in its stead
and subsequently almost totally obscured by
another piece of paper, with the the head and
halo drawn on it, being stuck over the top. It
might reasonably be assumed that the artist
made three separate attempts at the head, but
examination of the drawing from behind
reveals that the only parts of the insertion that
are drawn on are those that are visible, and
that the paper behind the head and halo was
left blank. It would therefore appear that
Mantegna kept the head and halo from his
original drawing, and simply adjusted their set
on the torso by cutting out and redrawing the
relevant part of the sheet. The change seems

to have involved moving the head to the left
and making it slightly less upright. It may well
be significant that this section of the design
was to undergo further modification on the
copper plate. Such a meticulous correction
would be extremely surprising in a copy, but
makes perfect sense as the finishing touch to
an exceptionally punctiliously executed sheet.
Having got this far, the last thing Mantegna
would have wanted to do was start all over
again. A similar correction in which a section
of paper was cut away and replaced occurs in
the figure of Diana in *Mars, Diana and Iris (?)*
(cat.146).

The iconography of the sheet is Mantuan:
the most revered relic in the Church of Santo
Andrea was a phial of Christ's precious blood,
collected and brought to Mantua by
Longinus. The Risen Christ (marked by the
stigmata and carrying the banner signifying
victory over death) is flanked by St Andrew,
who holds the cross of his martyrdom, and
Longinus, the soldier who pierced Christ's
side with a lance and was then converted.
Although often revered as a saint –
acknowledged as such, for instance, in the
Golden Legend and endowed with a halo in
Mantegna's *Madonna della Vittoria* – here he
is shown without a halo. In view of the
Mantuan connection, a date after 1460 is
certain (the year in which Mantegna arrived
in the city and the idea of building a new
church was first mooted), but the foundation
stone of the new church of Sant'Andrea was
not laid until 1472. In any event, the
precision of the hatching and the figure types
suggest a date in the 1470s rather than earlier.
The drawing of a *Man Lying on a Stone Slab*
(cat. 43) provides an excellent point of
comparison, particularly in its treatment of
anatomy and its handling of the draperies.
The frescoed tondo of the *Risen Christ* from
Mantegna's school, once in the portico of
Sant'Andrea and now moved inside, is based
on the print (cat. 45) of the same subject.

A final link with Mantegna is provided by
the presence of a Basilisk watermark on this
sheet which is found on several early
impressions of engravings here attributed to
him (see cat. 38).

D. E.

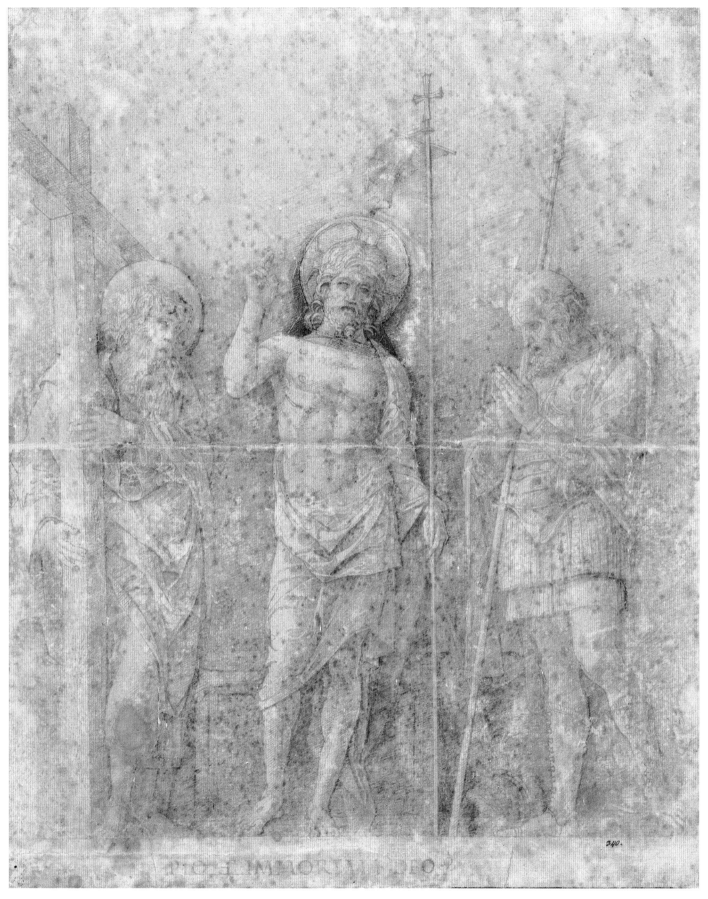

44

45

ANDREA MANTEGNA
*The Risen Christ Between
St Andrew and Longinus*

Engraving and drypoint
319 x 270 mm (sheet; plate size probably
480 x 342 mm, see below)
H.7

Early 1470s

Cabinet des Estampes, Bibliothèque Nationale, Paris

REFERENCES
Bartsch, 1811, 231.6; Hind, 1948, v, p. 16, no. 7;
Levenson, Oberhuber and Sheehan, in Washington,
1973, pp. 178-80, no. 72

This badly trimmed but marvellously tonal impression of *The Risen Christ* shows the richness of the chiaroscuro Mantegna succeeded in producing during his printmaking experiments in the 1470s. As in the case of the Washington *Entombment* (cat. 39), the burr produced by the thin drypoint lines – incised in between the wider, deeper lines produced by the burin – gives the darker areas of the print an effect of intense, even shade, while the passages between dark and light appear softened. The figures thus acquire roundness, volume and weight, and stand imposingly against the dark background.

For the first time in his printmaking career Mantegna did not attempt to place the figures in a realistic setting, which might have diluted the impact of the image: apart from one end of the tomb and its lid, only the step of a platform is visible. The figures are given monumentality by being seen *di sotto in sù*, with all the problems this generated for the position of Christ's head (see cat. 44), and the foot of St Andrew projects into the viewer's space. The same effect is achieved in the Camera Picta, simultaneously involving the spectator by including him in the same space yet cutting him off with the step, an insurmountable barrier beyond which only the members of the Gonzaga family and their entourage were admitted. Dating this print to the period of these frescoes would seem obvious. That the print was in circulation by *c.* 1480 is confirmed by the fact that Matteo Cesa, a painter active at Belluno until 1491, copied the figure of St Andrew in two altarpieces, both in the Bode Museum, Berlin. The earlier, signed, altarpiece copies St Andrew fairly closely and can be dated before 1480; the other altarpiece is somewhat later, and transforms St Andrew into a saint with helmet, spurs and a book, while Longinus from the same print becomes St Julian (see De Nicolò Salmazo, 1990, II, pp. 580-87).

The close relationship between the preparatory drawing and the print is confirmed by superimposing enlarged transparencies of the two. This reveals that the three figures were transferred to the plate by tracing or other mechanical means, probably using the same system employed for the *Descent into Limbo* (cat. 67): here the

contour lines of the figures, the main lines of their drapery and of the tomb were transferred exactly. It is also apparent that the figure of St Andrew, the chest, legs and right arm of Christ and the main lines of the setting were transferred in one session; the left arm of Christ with the staff and the figure of Longinus in a second session; and, finally, the head of Christ was transferred independently of any other part of the composition. The head of Christ in the print is in a completely different position in relation to his torso from that in the drawing. Mantegna obviously encountered considerable difficulties in positioning the head, and worked on the problem even when he was already engraving the plate; he finally settled for a solution quite different from that in the drawing. The intimate chronological relationship between the preparatory drawing and the print is further confirmed by the fact that the former is drawn on a sheet of paper bearing the watermark of the Basilisk also found on a number of early impressions of Mantegna's prints (see Appendix II).

The size of the plate on which this image was engraved is unknown, but the Amsterdam impression exhibited here shows a platemark at the bottom, on the right and along the top half of the left side; there appears to be no platemark at the top. The width of this plate is the same as the height of the plate of the *Entombment* (cat. 39), and thus it is possible that the two images were engraved on the two sides of the same plate. If this were the case, the height of the plate on which the *Risen Christ* was engraved would increase to 480 mm. Even if cut at the top and pulled from an already worn plate, the Amsterdam impression demonstrates the impact of the image when all or most of the white space of the plate around its engraved area is retained. The extremely long horizontal arm of the cross of St Andrew, by going well beyond the space of the print into that of the spectator, increases the sense of monumentality of the image. Unfortunately, by the time the Amsterdam impression was printed the thin lines incised with the drypoint had long disappeared, and one can only imagine what the impact would be of a print that combined the richness of the Bibliothèque Nationale impression and the size of this one. Early impressions of prints by

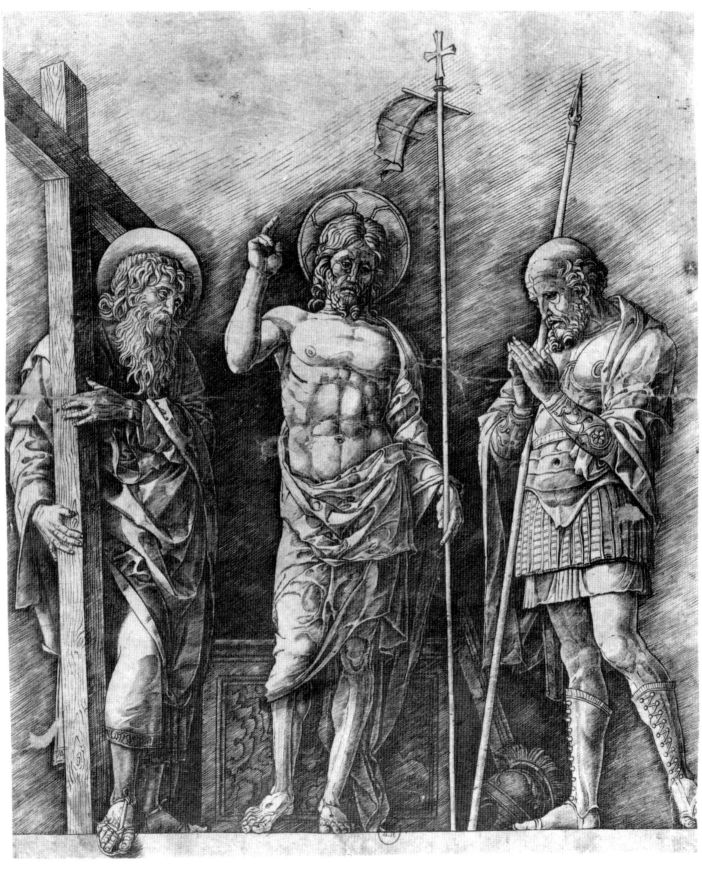

45

Mantegna are extremely rare, and later ones are extremely poor: the reason so few good impressions survive is almost certainly because very few were printed during the artist's lifetime, as only the earliest impressions would look the way Mantegna intended. The later impressions quickly became ghosts because all the plates were engraved on both sides, and each time one of the prints was being pulled through the press, its companion would suffer.

It is possible that a letter from Gerolamo Casio of 1506 lamenting the death of Mantegna six weeks earlier refers to this print: '...*più mi duole la morte de quello intagliò*

il Christo...' (Brown, 1974, pp. 101-3). It is unlikely that any other print would be identified as *il Christo*, although many depict events in his life. This could either suggest that the print was highly considered at the time, or that it was the only one that Casio knew. The fame of the print may have also been increased by the fact that the figure of Christ was used as a basis for a fresco painted by a member of Mantegna's school for the atrium of the church of Sant'Andrea in Mantua.

D.L.

46

ANDREA MANTEGNA
*The Risen Christ Between
St Andrew and Longinus*

Engraving and drypoint
439 x 339 mm (sheet; plate size unknown, see entry)
H.7
Watermark: Small Circle (no. 13)

Early 1470s

Rijksprentenkabinet, Rijksmuseum, Amsterdam
(inv. OB 1935)

REFERENCES
Bartsch, 1811, XIII, 231.6; Hind, 1948, V, p. 16, no. 7;
Washington, 1973, p. 178, no. 72

See cat. 45, above

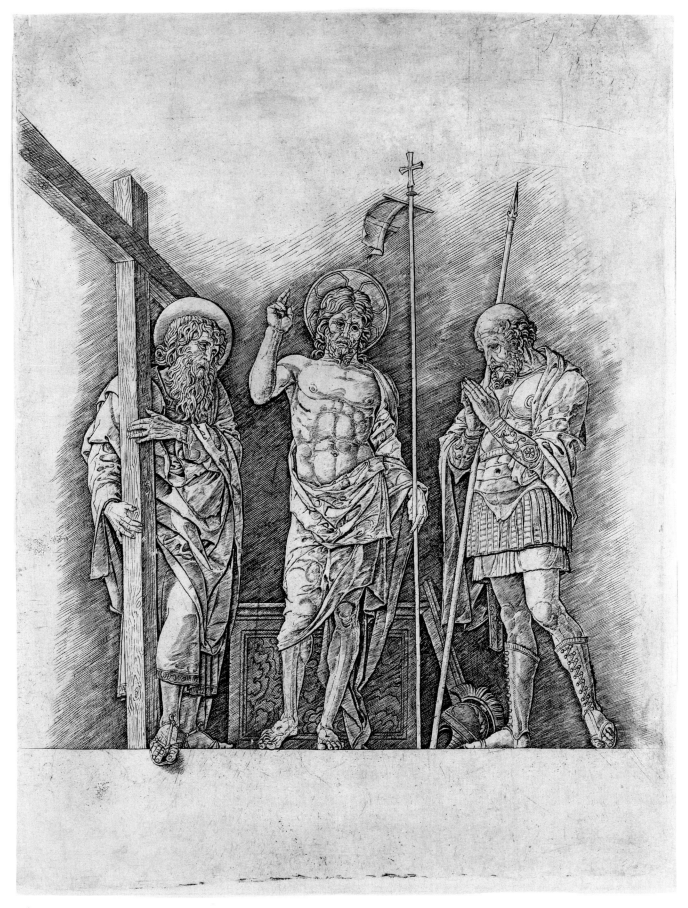

47

GIOVANNI ANTONIO DA BRESCIA
*The Risen Christ Between
St Andrew and Longinus*

Engraving, state 1 of 2
293 x 253 mm (sheet; plate 318 x 292 mm, Vienna)
H.7a
Watermark: Orb and Cross (no. 22)

c. 1500–04

Mrs Ruth Bromberg

REFERENCES
Hind, 1948, V, p. 17, no. 7a, and p. 87, no. 7

One of the copies Giovanni Antonio produced early in the 16th century, this is a rare impression of the print's first state, before the background was shaded with cross-hatching. Hind knew only the British Museum impression of the first state, which is much damaged and of lesser quality. There is an impression of this print in the Gabinetto Nazionale delle Stampe, Rome, which shows on its *verso* an offset of the *Four Studies for an Equestrian Statue* (Hind, 7, Leonardo School). This corroborates the evidence that identifies Giovanni Antonio as the engraver who monogrammed some plates 'ZA' (whose name was erroneously thought to be Zoan Andrea), and was the main engraver making prints after Leonardo, perhaps in Milan towards the end of the first decade of the 16th century.

D.L.

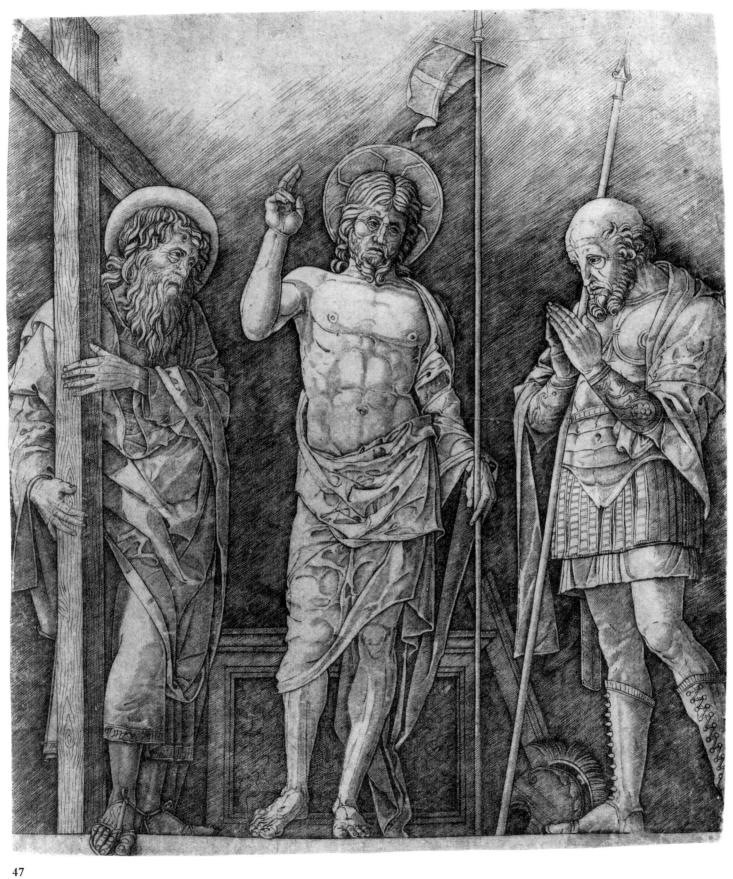

47

48

ANDREA MANTEGNA
Virgin and Child

Engraving and drypoint, state 1 of 2
210 x 222 mm (sheet; plate 348 x 274 mm, Munich)
H.1

c. 1480–85

Graphische Sammlung Albertina, Vienna

REFERENCES
Bartsch, 1811, XIII, 232.8; Kristeller, 1902, pp. 413,
550-51, docs. 112-14; Hind, V, 1948, p. 10, no. 1;
Washington, 1973, p. 194, no. 77

This is arguably the most beautiful print of the Italian Renaissance, and one of the most touching depictions of the Virgin and Child in the history of art.

This brilliant impression demonstrates how Mantegna had by this stage completely mastered the combination of engraving and drypoint, and could obtain every possible nuance of white, grey and black in a print, from the sparkling whiteness of the Virgin's shoulder to the deepest black in the folds of the drapery under her left arm, through the differing greys on the two touching cheeks, that of the Child being slightly darker.

Most surviving impressions of this print come from a reworked second state in which no trace is left of the drypoint lines. Only five early impressions survive; they all are badly trimmed and mostly in a poor state of preservation. The plate on which this image was incised was much larger than is generally understood, and, if complete to the platemark, this *Virgin and Child* would be about a fifth wider and about as much as a third higher than it appears. This difference plays a significant role in our perception and understanding of the image: whereas in a complete early impression the intimacy of the moment depicted would have been balanced by the monumentality of the figures set on high ground, the trimming of the print, as in this impression, highlights the loving closeness of mother and child, but entirely removes its sacred connotations. No wonder that Kristeller proposed that this was a depiction of a mother with her child rather than of the Virgin and Child, and that, early in the 16th century, it was felt necessary to add haloes, visible in later impressions.

This is Mantegna's greatest achievement in printmaking, and probably his last print. It is also the only print of those here attributed to him not to share its plate with another image. After the completion of this masterpiece Mantegna left the task of incising the plates to one, or two, professional engravers, depending on whether the Premier Engraver should be identified with Giovanni Antonio da Brescia or not. It is precisely because this other engraver was inspired by this *Virgin and Child* that all the prints he made in Mantua

try to emulate with their fine engraving tool the 'greyness' of Mantegna's highest achievement. When in 1491 Mantegna wrote to the Marchese Francesco Gonzaga that he would let him have another '*quadretino*' as he had the plate (*stampa*) for it – the word *stampa* here probably means plate, as in practically all 15th- and early 16th-century documents, not print – he was undoubtedly referring to a print, and possibly to one not engraved by himself. It was clearly a small print of which he was proud, but it would not have shown that miraculous combination of engraving and drypoint that makes the *Virgin and Child* such an unforgettable image. All the prints produced in the workshop were skilful, straightforward engravings, incised with a very fine tool which produced what is often called a 'silvery' tone. None, however, aspired to the richness achieved in the last works by the master.

D.L.

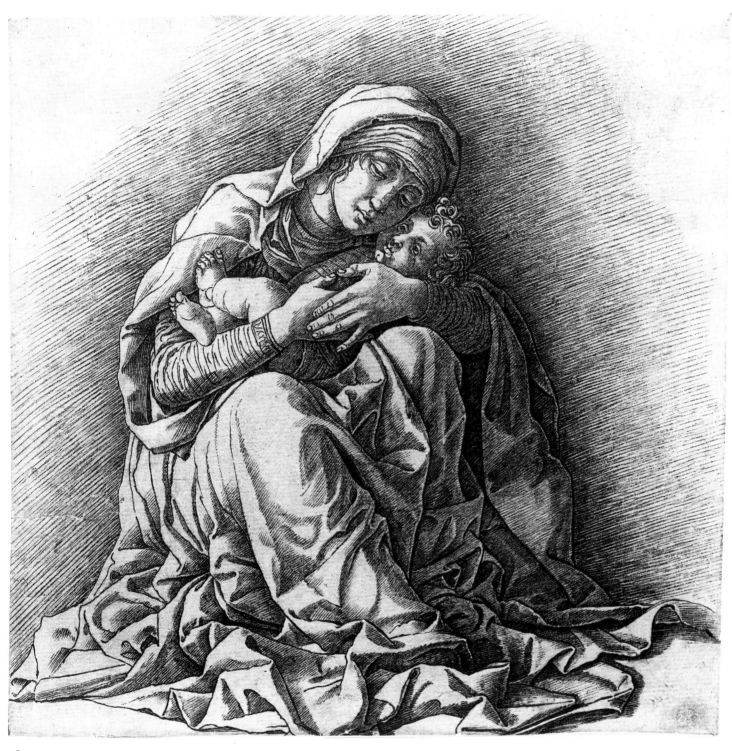

48

49

ANDREA MANTEGNA
*Virgin and Child Enthroned with
an Angel*

Pen and light-brown ink
197 x 140 mm

1480s

The Trustees of The British Museum, London
(1858-7-24-3)

PROVENANCE
Count Nils Barck; Tiffin

REFERENCES
Morelli, 1883, p. 87, no. 1; *idem*, 1907, II, p.177;
Kristeller, 1901, pp. 404-5, 444; Berenson, 1902,
pp. 50, 52-4; Popham and Pouncey, 1950, p. 99,
no. 159; Mezzetti, 1958, pp. 240-41; Pignatti, 1970,
p. 81; Lightbown, 1986, p. 484, no. 190

While this sheet has been universally accepted
as an autograph drawing by Mantegna, there
has been considerably less agreement as to its
date. Opinions have fluctuated between the
1460s and '70s (Kristeller, Berenson) on the
one hand, and 1495-6, the years of the
Madonna della Vittoria, on the other (Popham
and Pouncey, Mezzetti, Lightbown and
others). The temptation to place it late
probably derives in part from the desire to
connect it with the *Madonna della Vittoria*,
and given the fact that it is clearly for an
altarpiece, Lightbown has suggested that it
might even be a first idea for that particular
one. However, although it is true that we
know of no altarpieces of the Virgin and
Child with saints by Mantegna between that
for the high altar of San Zeno of 1456-9 and
the two executed in the mid-1490s, it is not
inconceivable that he began work on a
commission of this type. If so, it is extremely
unlikely to have been completed, not least
since no such work is documented.

Although nothing like as free as the
drawings of the disputed Mantegna/Bellini
group, here assigned to the early 1460s, it is
comparatively free in its use of pen strokes of
varying thicknesses. In this respect it differs
from the more rigorous handling of the
Man Lying on a Stone Slab (cat. 43) and the
Risen Christ (cat. 44), probably both of the
early 1470s, and comes closer to the later
drawings for the *Triumphs of Caesar*. By
contrast, the handling of the *Calumny of
Apelles* (cat. 154), with which Popham and
Pouncey compared this drawing, is slightly
thinner and more precise. Similarly, the *Judith*
of 1491 (fig. 109; Uffizi, Florence) seems to
belong to a later stage in the artist's
development, and supports a date for this
drawing in the 1480s.

The composition may well have been
intended for the central section of a triptych,
with the background shading tailing away
behind the angel, even though his wings
partially continue. The Virgin is shown seated
on a splendid voluted *all'antica* throne, the
angle of its left arm artfully corrected and
concealed by hatching. A roundel is set into
its base, presumably designed to contain
either a narrative scene in fictive relief or an

inscription of the type found in the *Madonna
della Vittoria*. Its detail ultimately goes back to
the throne of the Virgin in the San Zeno
Altarpiece, which has the same interlocking
pattern on its back, but is also comparable to
the sarcophagus in the *The Man of Sorrows with
Two Angels* (cat. 60), which must date from at
most a decade later than this drawing. The
Child, naked but for a sort of shift around his
shoulders, and raising his right hand in
benediction, has a diminutive dish-like halo
which is shown unforeshortened at the back
of his head: its highly distinctive type is found
in the *Virgin of the Stonecutters* (fig. 3; Uffizi,
Florence) but nowhere else in Mantegna's
œuvre. The musician angel was doubtless
intended to be one of a symmetrical pair.
He may be something of an afterthought, and
is certainly the most freely handled part of the
drawing, with his head being brought to life
by a few wonderfully economical strokes of
the pen, and his eyes reduced to a couple of
slits. If this drawing is late, as seems likely, it
demonstrates the fact that Mantegna's touch
remained capable of genuine spontaneity
longer than is generally suspected.

D. E.

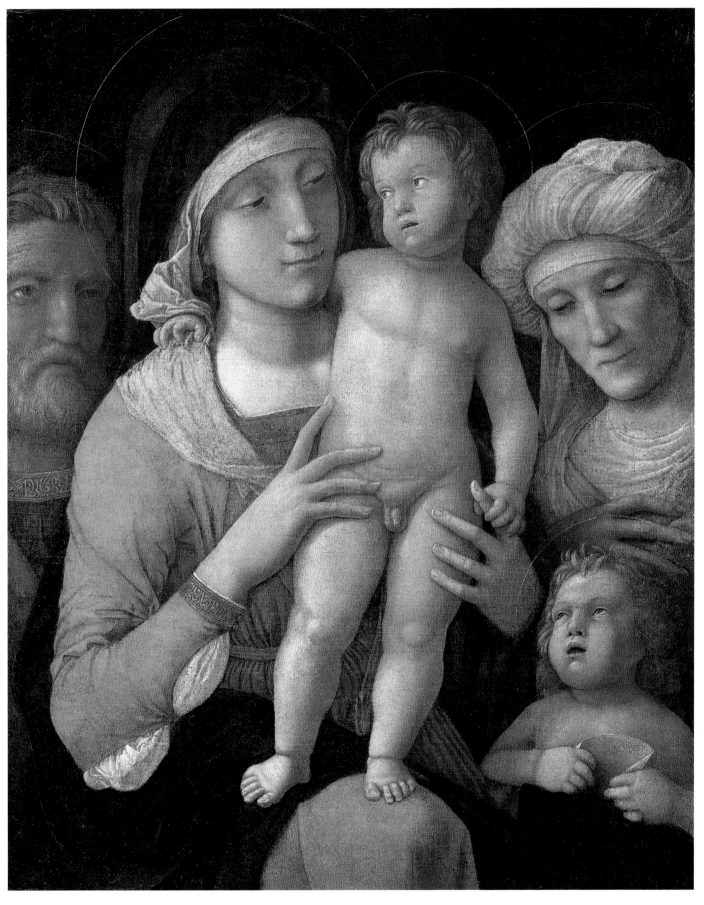

52

GIOVANNI ANTONIO DA BRESCIA
Holy Family with St Elizabeth and the Infant St John the Baptist

Engraving, state 1 of 2
302 x 265 mm (plate, according to Hind,
c. 305 x 270 mm)
H. GAB.4
Watermark: Orb and Cross (no. 22)

c. 1500

Cabinet des Estampes, Bibliothèque Nationale, Paris

REFERENCES:
Bartsch, 1811, XIII, 320.5; Hind, 1948, V, 38.4;
Washington, 1973, p. 240, no. 89; Lightbown, 1986,
p. 493, no. 227

The composition is close in both style and subject to Mantegna's paintings of the *Holy Family with St Elizabeth and the Infant St John the Baptist* (cat. 51) of about 1485-8 and, somewhat less, to the *Holy Family* in Dresden (fig. 73), dated about 1495-1500. The drawing upon which the print is based was almost certainly in the reverse direction, since the engraving strokes mostly go downwards to the right, thus reversing the normal direction for drawings associated with Mantegna; further, for all the prints that can be checked against a known painting (for example, those connected with the *Triumphs*, cats. 117, 127), those with strokes going downwards to the right invariably reverse the direction of the original. Thus, this composition by Mantegna was orientated the same way as the Fort Worth and Dresden paintings, with St Elizabeth and the Infant St John on the right. As in the Dresden painting, St John holds a flower, which he proffers to the Christ Child; in his other hand he holds three stalks of wheat, a Eucharistic symbol.

The spatial conception in this image, however, is unlike that in the two paintings, which share with the *Adoration of the Magi* (cat. 56) and the *Ecce Homo* (cat. 61) the tight clustering, almost squeezing, of half- or three-quarter-length figures together into a shallow, narrow space, derived from ancient funerary reliefs, that became characteristic of Mantegna's smaller devotional paintings after about 1490. In the print, however, the figures are shown full length and are set apart, thus diffusing the emotional intensity; Lightbown suggested that the design was for an altarpiece, perhaps one comparable with the *Virgin and Child with SS. John the Baptist and Mary Magdalene* (National Gallery, London). The placement of figures in the engraving is very similar to that altarpiece, as are the overall proportions of the composition and the stance of the Child; this is also close to that in the *Madonna della Vittoria* of 1495-6. The composition can be dated to around 1500.

A painting apparently based on this print was formerly attributed to Correggio, but recently definitively given to Giovanni Francesco Tura (Berzaghi, 1989, pp. 171-3). In it the figures have only minor variations and are the same size as those in the print; it is set in a landscape, and shows the Virgin raised upon a mound so that she and the Child are higher than the other figures. Another painting (Musée des Arts Decoratifs, Paris) includes this group in a larger composition, the size of which we have not been able to learn (Lapilly, 1907, pl. XXIII).

Bartsch first attributed the print to Giovanni Antonio da Brescia, and the attribution is surely correct. It is further corroborated by the presence, on the *verso,* of an impression of the second state at Cleveland, of an offset of Giovanni Antonio's copy of *The Corselet Bearers* (cat. 121). Although Giovanni Antonio usually copied prints based on Mantegna's designs rather than copying his drawings directly, no earlier rendition is known of the composition. It is one of his most beautiful prints, and may well have been made directly from a drawing by Mantegna.

In the second state the background is cross-hatched. Although the full plate dimensions for this print are not known, the image may have been engraved on the other side of the plate used for Giovanni Antonio's copy of the *Risen Christ* (cat. 47), since the dimensions of the plate are compatible.

S.B.

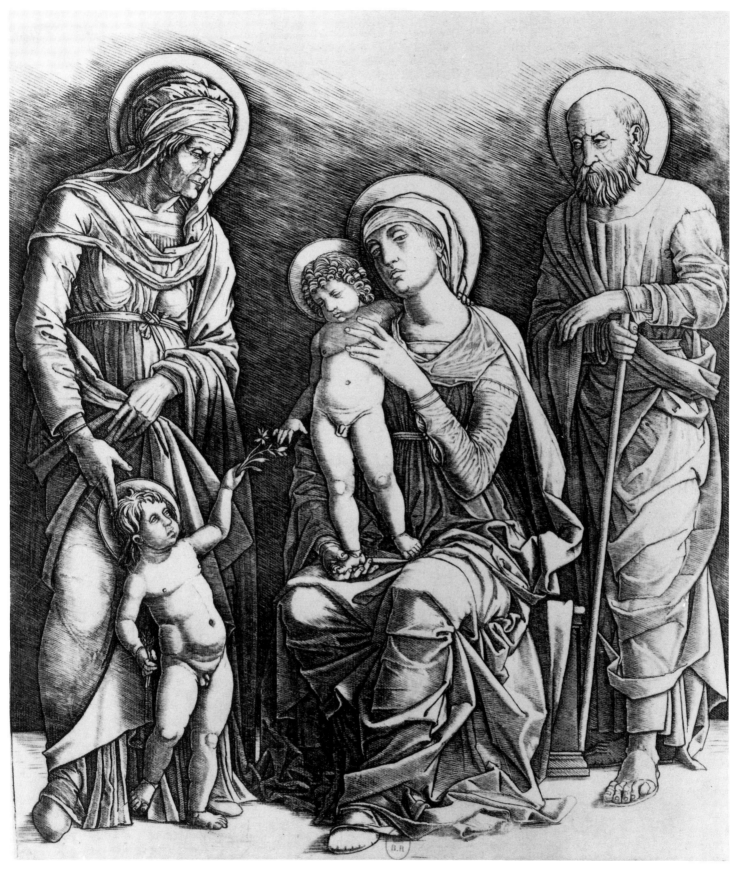

53

ANDREA MANTEGNA
Virgin and Child

Metalpoint heightened with white on a dark blue
ground; a plumb line down the centre of the sheet
168 x 121 mm

1490s

Fondation Custodia (Collection F. Lugt),
Institut Néerlandais, Paris (inv. no. 4983)
(Exhibited in New York only)

PROVENANCE
Padre Sebastiano Resta; Monsignor Giovanni Matteo
Marchetti, Bishop of Arezzo; his nephew Cavaliere
Marchetti da Pistoia; 1710, sold probably through
John Talman to John, Lord Somers; sold at Motteux,
Covent Garden, London, 16 May 1717; Jonathan
Richardson, Senior; sold Sotheby's, London,
19 February 1936, lot 63; Frits Lugt, Paris

REFERENCES
Popham,1936, pp. 8-9; Hennus, 1950, p. 84;
Byam Shaw, 1981, I, pp. 18-19, no. 23

fig. 83 Follower of Andrea Mantegna, *Virgin and Child
with the Infant St John the Baptist,* oil on canvas,
71 x 48 cm, Musée du Louvre, Paris (RF. 183)

Byam Shaw, one of the few scholars to have
recognised the importance of this sheet,
observed that it was of good quality although
its dark ground made it difficult to judge.
The drawing looks incomparably better in
the original than in reproduction. The fact
that the Virgin consists of little more than
her head and dismembered hands does not
suggest that it is a copy, and differentiates it
from the group of *simili* drawings (cats. 18-
20). It must at the very least be a copy from a
lost drawing in the same technique rather
than from a painting. In favour of its being
autograph are the contour *pentimenti* around
the heads, and especially the meticulous yet
lively application of white heightening. The
absence of authenticated autograph drawings
in this medium makes the status of the sheet
hard to evaluate, but there is no reason to
suppose that Mantegna never used metal-
point, and he certainly used prepared paper
(see cat. 24).

The sheet gives every indication of being a
late work, probably of the 1490s, as the
closeness of types to those in dated works,
such as the *Madonna della Vittoria* of 1496 and
the *Trivulzio Madonna* of 1497, suggests.

Byam Shaw further observed that although
the Virgin and Child do not correspond
exactly with any painting of the subject by
Mantegna, there are echoes in a school
painting in the Galleria Sabauda, Turin, and
in a Netherlandish copy after Mantegna in
the Akademie der bildenden Künste, Vienna.
In both the figures are seen in reverse, and
the Child is particularly close, if less
animated. The attitude of the Virgin's head is
quite different, however, and rather closer to
the upward glance of the Virgin in the
Dresden *Holy Family* (fig. 73). Her upper
hand is not the same, being placed lower
down the Child's thigh with her fingers
more splayed out.

Even more important than any of these
works in this connection, however, is a
painting in the Louvre (fig. 83), which has
not previously been associated with the
drawing. It is a Veronese work of the late
15th or early 16th century, and has been
variously attributed to Girolamo dai Libri,
Giovanni Francesco Caroto and Zenone
Veronese. Its two central figures are virtually
identical to their counterparts in the drawing,
the only divergences being that in the latter

the Virgin is shown looking upwards, and
that the Child's head is higher up and further
away from that of his mother. Nevertheless,
it is clear that the drawing is by a different
and incomparably more gifted artist, as is
particularly evident when the animation of
the Virgin's expression in the drawing is
compared with her vacant stare in the
painting.

It is by no means unlikely that a Veronese
painter should have copied a work by
Mantegna, since the artists of that school
were profoundly inspired by him, especially
around the turn of the century by his
Trivulzio Madonna, which was painted as the
high altarpiece of Santa Maria in Organo,
Verona. There remains the question of
whether the whole composition of the
Louvre painting is copied from a lost
Mantegna, or whether its Virgin and Child
derive from the drawing, and the rest was
invented by its artist. In view of the cutting
of the Virgin at the level of her knees as well
as the similarity of the putto heads to those in
the slightly earlier *Virgin and Child with
Seraphim and Cherubim* (Brera, Milan), and
even more to the fact that the Infant Baptist
is the double – in reverse – of his counterpart
in the *Holy Family* in Dresden of about the
same date, it seems more likely that the
painting in Paris is a generally accurate
reflection of a Mantegna invention. This was
in all probability a painting, now lost, but
may conceivably have been a highly finished
drawing. It is worth recalling that Vasari, in
his discussion of Caroto's apprenticeship with
Mantegna, states that 'he learnt so much
from him in a short time that Andrea sent
forth works by him as if they were his own'
(Vasari, ed. 1878-85, V, p. 280). However, it
is hard to believe that such works were not
executed to Mantegna's designs. If only the
attribution of the Louvre painting to Caroto
were more convincing, it would be tempting
to regard it as a case in point.

D.E.

53 (actual size)

54

ANDREA MANTEGNA
Christ the Redeemer

Distemper on canvas, 55 x 43 cm
Inscribed (on the book): *EGO SVM:NOLITE TIMERE;*
(on the casement, at left): *MOMORDITE VOS MET IPSOS
ANTE EFFIGIEM VVLTVS MEI;* (on the casement, bottom):
…IA.P.C.S.D.D.MCCCCLXXXX[III] ₽ JA

Dated 1493

Congregazione di Carità, Correggio

PROVENANCE
Until 1630, Don Giovanni Siro, Prince of Correggio;
from 1630, Giulio and Francesco Contarelli, Correggio;
the Contarelli family, Correggio; until 1851, Caterina
Contarelli, Correggio; 1851–c. 1916, Congregazione di
Carità, Correggio (inv. 1851/52); c. 1916–17, Marchese
Matteo Campori, Modena; from 1917, Congregazione
di Carità, Correggio

REFERENCES
Frizzoni, 1916, pp. 65–9; Venturi, 1926, p. 14; Bertolini,
1930, pp. 41–3; Quintavalle, in Parma, 1935, pp. 22–4;
Fiocco, 1937, pp. 76, 210; Tietze-Conrat, 1955, p. 181;
Quintavalle, 1959, pp. 8–9; Paccagnini, in Mantua, 1961,
p. 48; Cipriani, 1962, p. 67; Gilbert, 1962, p. 9;
Camesasca, 1964, pp. 40, 122, Garavaglia, 1967, no. 83;
Berenson, 1968, p. 239; Lightbown, 1986, p. 437;
Todini, in London, 1984², p. 61; ed. 1985, pp. 75–6

Like so many of Mantegna's paintings in distemper, the picture has suffered from past cleanings – the most unfortunate being that of 1916 (see the before and after photographs in Frizzoni). It is much darkened through successive applications of varnish, removed when it was cleaned for this exhibition. There are significant losses in the forehead, along the nose, in the cheek and the right proper shoulder. The right side of the face is particularly worn, and the date in the inscription has been badly damaged (the last three digits are no longer visible). Despite this, the painting remains a singularly moving and compelling image, an example of what Fry (1905) described as Mantegna's Christian mysticism. The picture was unknown to Mantegna scholarship before 1916.

Christ, shown behind a window casement lit from the left – a device Mantegna had used in the mid-1450s to heighten the emotional impact (see, for example, cat. 5) – confronts the viewer with averted eyes, his melancholic expression offered for contemplation. Conforming neither to the widespread iconography for the Man of Sorrows, who bears the wounds of his Passion, nor the Resurrected Redeemer (the *Salvator Mundi*), who confers his blessing (for a discussion of these types, see Ringbom, 1965), the figure is shown as a living person, both near and distant. This effect is underscored by the inscription on the book he holds, which reads, 'It is I, have no fear'. These are the words Christ addressed to his Apostles when he appeared to them miraculously walking on the water (Matthew 14:27) and in a closed room following the Resurrection (Luke 24:36). The inscription at the left, the configuration of which recalls that on the drawing of *Judith* of 1491 (fig. 109), exhorts the viewer to 'Mortify yourselves before this effigy of my face'.

The provenance of the picture can be traced to the 17th century, when it was owned by Don Giovanni Siro of Correggio. Bertolini has conjectured that it was a gift of the Gonzaga family to the lords of Correggio, but this is contradicted by the form of the signature, which declares the painting to be an offering by the artist. Frizzoni reconstructed the abbreviated inscription along the bottom of the painting as *[Andrea Mantin]ia p[inxit]* (or *p[ictor]*) *c[haritate] s[ua] d[ono] d[edit] MCCCCLXXXXIII d[ie] V Ja[nuari]* (Andrea Mantegna painted this out of charity and gave it as an offering on 5 January 1493), while Lightbown would read it as *[Andrea Mantin]ia P[alatinus] C[omes] d[ono] d[edit]…* (Andrea Mantegna Count Palatine gave this as an offering…). Lightbown omits the 's' of the inscription. Moreover, the reference he sees to the title granted the artist around 1484 might be thought inappropriate to the image and the occasion of a personal gift, presumably to a religious foundation.

There is a temptation to associate the picture with an event from Mantegna's life, perhaps a sickness or the death of a member of his family. Unfortunately, no such event presents itself, since the death of his purported son Bernardino in 1493 has been proven false (see Signorini, 1986¹, p. 234, n. 3).

K.C.

54

55

ANDREA MANTEGNA
*Holy Family with St Mary
Magdalene (The Altman Madonna)*

Distemper(?) and gold on canvas, 57.2 x 45.7 cm

c. 1495-1505

The Metropolitan Museum of Art, New York,
bequest of Benjamin Altman, 1913 (14.40.653)
(Exhibited in New York only)

PROVENANCE
Mid-1880s, Monsignor Andrea d'Aiuti, Munich and
Naples; until 1902, Count Agosto d'Aiuti, Naples;
1903, Dowdeswell and Dowdeswell, London; 1903-12,
Eduard F. Weber, Hamburg; sold Lepke's, Berlin,
20-22 February 1912, lot. 20; 1912, F. Kleinberger
and Co., New York; 1912-13, Benjamin Altman,
New York

REFERENCES
Bode, 1904, p. 134; Woermann, 1907, p. 21, no. 20;
Berenson, 1907, p. 254; Knapp, 1910, p. 180; de Ricci,
1912, p. 14; Venturi, 1914, pp. 262, n. 1, 483-4;
Monod, 1923, pp. 185-86; Berenson, 1932, p. 328;
Fiocco, 1937, p. 69; Tietze-Conrat, 1955, p. 191;
Cipriani, 1962, p. 80; Paccagnini, in Mantua, 1961,
p. 49; Camesasca, 1964, p. 128; Garavaglia, 1967,
p. 121, no. 105; Berenson, 1968, p. 240; Fredericksen
and Zeri, 1972, p. 118; Zeri and Gardner, 1986,
pp. 32-3; Lightbown, 1986, p. 471, no. 144

The composition of this lovely but badly
worn picture includes a number of motifs not
found in other, comparable devotional works
by Mantegna. Not only are the figures
viewed against a hedge of oranges – one of
Mantegna's favourite devices in his late
altarpieces – but the Virgin's head-dress
consists of a yellow fringed cloth gathered
around her hair and then wrapped around her
shoulders and neck. Both in the *Adoration of
the Magi* (cat. 56) and *The Families of Christ
and St John the Baptist* (cat. 64) the Virgin
wears an even more elaborate head-dress.
These turbans were doubtless attempts on the
part of Mantegna to endow his devotional
images with a convincingly antique cast. The
idea for the veil framing the demure female
saint certainly derives from Roman sculpture.
That the picture post-dates Mantegna's trip to
Rome in 1488-90 and his intense study of
ancient art is universally acknowledged.
What has been doubted is the ascription to
Mantegna rather than to an assistant (Knapp,
Monod, Tietze-Conrat), possibly his son
Francesco (Venturi, Cipriani, Garavaglia).

The doubts expressed about the attribution
are due in large part to the poor condition of
the painting, which has been irreversibly
darkened through the application of suc-
cessive coats of varnish. While cleaning in
1988-90 rid the surface of discoloured varnish
and the most disfiguring repaints, it also
revealed the extent of the damages. The
picture has lost all of its final paint layers and
glazes, the face of the Virgin has little
modelling, her blue robe is much repainted
and severe abrasion has reduced some of the
forms – the right hand of the Virgin and the
cushion on which the Christ Child stands –
to little more than coloured silhouettes.
Given that practically nothing remains of the
robe of St Joseph, the repaint was left. Yet,
even in this compromised state, the picture is
among Mantegna's noblest late pictures and
well beyond the capacities of any of his pupils
and assistants.

There is a possibility that this is the picture
seen by Marco Boschini in the sacristy of the
Spedale degli Incurabili in Venice (1664,
pp. 343-4; 1674, p.21; ed. 1733, p. 330), most
fully recorded as a 'small picture (*'quadretto'*)
of half-length figures with the Madonna,
Saints Joseph, and Mary Magdalene'. That
work was last recorded in 1797 by Zanetti
(1797, II, p. 21). The identification is
necessarily conjectural, since the Metropolitan
picture cannot be traced back before the mid-
1880s and since the female saint depicted in it
holds no attribute (see Zeri and Gardner,
1986). A painting in the Museo di
Castelvecchio, Verona, has also been
associated with Boschini's description (see
Lightbown, 1986, p. 447). That work is in
ruinous condition, but seems too weak both
in design and execution to be by Mantegna
(compare the banal, expressionless faces of the
Verona painting to those in the equally
damaged but autograph picture of the *Virgin
and Child with Three Saints* in the Musée
Jacquemart-André, Paris).

K.C.

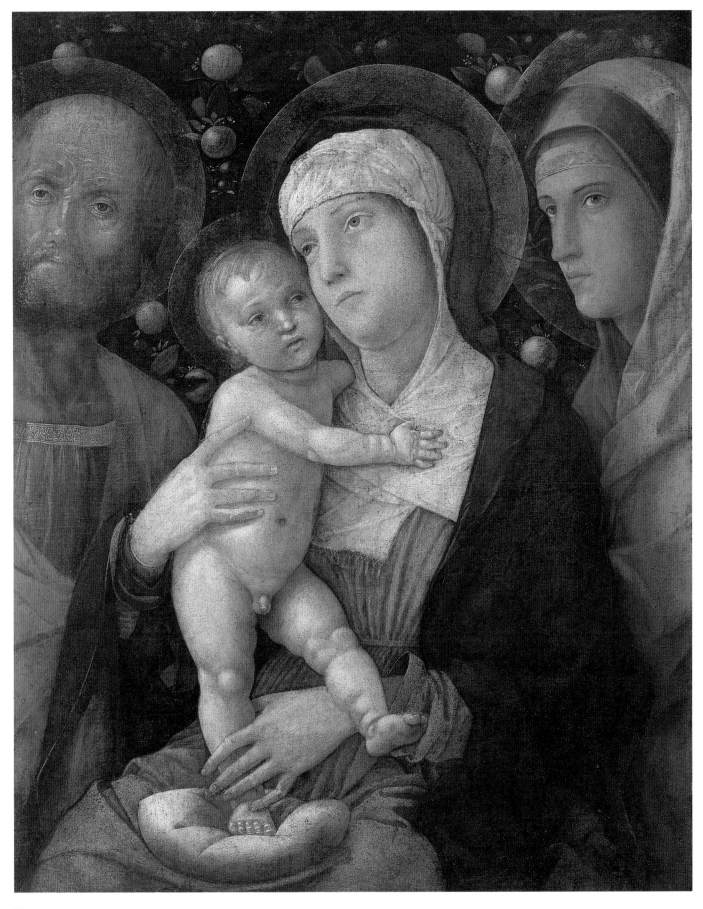

55

55a

ANDREA MANTEGNA
*Virgin and Child in Glory with
Saints and Angels
(The Trivulzio Madonna)*

Distemper on canvas, 287 x 214 cm
Inscribed (on exterior of scroll at left): *HIC VENIT
TES/TIMONIVM VT / TESTIMONIV[M] PE/RHIBERET DE
LVMI[NE]* (John 1:7); (on interior of scroll): *[EC]CE...
[QVI TOLLIT PECCATV]M / MVND[I]* (John 1:29); (on
St Gregory's cope): *SC MATHE[VS] / APOSTOLV[S]; SAN
APO.*
Signed and dated (on underside of sheet of music at
bottom): *A. Mantinia pi[nsit] / an[no]. gracie / 1497 . 15
augusti.*

c. 1494-7

Civico Museo d'Arte Antica, Castello Sforzesco, Milan

PROVENANCE
1497-before 1714, high altar of Santa Maria in Organo,
Verona; before 1770, Pertusati, Milan; by 1791 until
1935, Trivulzio collection, Milan; 1935, Civico Museo

REFERENCES
Vasari, 1550, ed. 1986, p.510; *idem*, 1568, ed. 1878-85,
III, p. 393; Ridolfi, 1648, p. 70; Crowe and
Cavalcaselle, 1864, ed. 1912, II, pp. 110-11; Cignaroli,
in Biadego, 1890, p. 41 n.; Yriarte, 1901, p. 128;
Kristeller, 1901, pp. 316-20, 441-2; Berenson, 1907, p.
254; Knapp, 1910, pp. XLIX, 176; Gerola, 1913, pp. 19-
20; Venturi, 1914, pp. 229-37; Berenson, 1932, p. 327;
Fiocco, 1937, pp. 72, 208; Tietze-Conrat, 1955, pp. 26,
189; Paccagnini, in Mantua, 1961, p. 61; Mellini and
Quintavalle, 1962, p. 19; Cipriani, 1962, pl. 135;
Camesasca, 1964, pp. 42, 124; Garavaglia, 1967, no. 94;
Del Bravo, 1967, p. 30; Brugnoli, in Puppi, 1972, p.
43; Trevisani, in Verona, 1978, p. 117; Cuppini, 1981,
pp. 387-8; 428; Rognini, 1985, pp. 19, 35, 37, 45-6;
Lightbown, 1986, pp. 184-5, 439-40; Pietropoli, in
Verona, 1986, p. 278; Fiorio and Garberi, 1987, p. 103;
Marinelli, 1990, pp. 627-9

The picture, which shows the Virgin and
Child with SS. John the Baptist, Jerome,
Gregory the Great and Benedict (who wears
the white habit of the Olivetan branch of the
Benedictine order; he is sometimes identified
as Romuald) was commissioned for the high
altar of the Olivetan church of Santa Maria in
Organo, Verona, as part of an extensive
remodelling campaign begun *c.* 1481 (see
Cuppini, 1981, pp. 305-6, 491).

In 1491 the great woodworker and architect
Fra Giovanni da Verona was placed in charge
of the remodelling of Santa Maria in Organo.

He began work in the choir in 1493, and
subsequently built a new sacristy and church
tower (see Rognini, 1985). For the choir he
created choirstalls decorated with elaborate
intarsie, a lectern and a paschal candlestick.
He also appears to have designed the frame
for Mantegna's altarpiece and acted as an
intermediary in the negotiations. Nothing is
known of the commission. However, on 14
February 1494 Fra Giovanni had already
received a small sum towards the altarpiece,
and on 26 February 3 *soldi* were used to buy
planks of wood for the frame (see Rognini,
1985, p. 45). Much of the wood was
purchased in Mantua, where we find Fra
Giovanni in April. Mantegna would have had
time during 1494-5 to work on the altarpiece.
By contrast, from November 1495 until
shortly before July 1496 he was occupied
almost exclusively with painting the *Madonna
della Vittoria* (Louvre, Paris). Only upon
completion of that work could he have
returned to or taken up the commission for
Santa Maria in Organo.

On 6 October 1496 Mantegna was
presented with a gift of a brace each of
pheasant, partridge and thrush. On
16 October ultramarine blue and shell gold
were bought 'for master Andrea Mantegna
for our altarpiece' (Kristeller, 1902, p. 492,
doc. 63). The blue was obviously for the
Virgin's cloak and the shell gold for the
haloes and such details as the watered silk on
her cloak, suggesting that work was already
well advanced. A hare and thrushes were
bought on 10 November and presented to
Mantegna by Fra Giovanni, and on
22 December Fra Giovanni received 19 *soldi*
to purchase containers for a present of olives
(Kristeller, 1902, p. 562, doc. 144; Rognini,
1985, p. 46). By this date Mantegna was
working on the *Parnassus* (fig. 106; Louvre,
Paris) for Isabella d'Este's Studiolo and can
have had little time to spare for the altarpiece.
On 15 May Fra Giovanni made another trip
to Mantua to purchase lime wood for the
frame and was there again in June. By this
date, and probably a good deal earlier, the
picture was finished: the date on the
altarpiece commemorates the dedication of
the altarpiece on the feast day of the
Assumption of the Virgin (the feast principal
of the Virgin, patron of the church) rather
than the date of completion.

The documents provide eloquent testimony
to the high esteem Mantegna enjoyed at this
date. They also demonstrate that the
altarpiece was considered an integral part of
Fra Giovanni's work in the choir of the
church, and there can be no doubt that this
setting was foremost in Mantegna's mind. In
the altarpiece, SS. John the Baptist and
Jerome are posed at the front of the notional
ledge of the frame, viewed from below, with
SS. Gregory the Great and Benedict behind
and therefore lower in the picture field. An
organ, the symbol of the monastery, is shown
sharply foreshortened, as though at the back
of the fictive ledge, behind and below which
are three singing angels (a motif later imitated
by the Veronese painter and miniaturist
Girolamo dai Libri). Two citrus trees – a
lemon on the left and an orange on the right
– frame the figure of the Virgin, who is
depicted as if seen in a vision against the sky,
seated in a mandorla. She is viewed straight
on, not *di sotto in sù*: a conspicuous example
of the suspension of the 'laws' of perspective
to underscore the religious significance of the
scene, for although she holds the Christ Child
on her lap, her suspension in mid-air clearly
alludes to her Assumption.

The sobriety of the Santa Maria in Organo
Altarpiece could not be more different from
the Madonna della Vittoria and obviously
results from Mantegna's understanding of its
monastic setting and function. To dismiss it as
a lacklustre work is to underestimate the
inventiveness of its composition (for which,
see Marinelli). The model of a church held by
St Jerome (his common attribute in northern
Italian painting) is usually described as a
model of Santa Maria in Organo, and its
design is ascribed to Fra Giovanni (Mellini
and Quintavalle, Lightbown, Pietropoli).
However, there is no reason that this simple
basilica structure articulated with neo-classical
gravity is not Mantegna's invention.

The picture, painted in distemper on three
vertical strips of canvas sewn together, is in
good condition, although the angels have
suffered some abrasion, as have the cherub
heads around the Virgin, where, to the right,
the bare canvas is partly visible. The thin final
paint layer is lacking. The picture was
restored in 1986-7.

K.C.

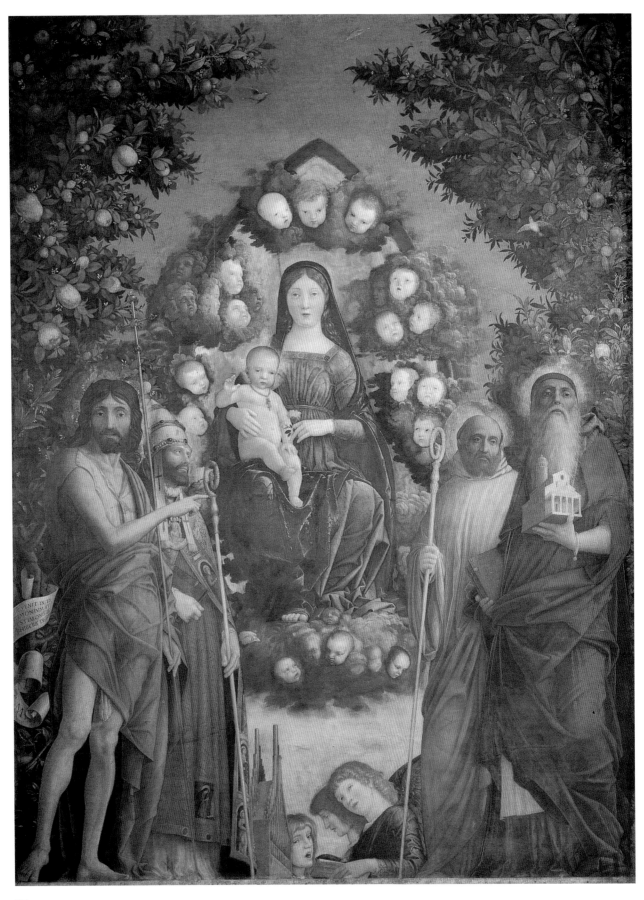

55a

56

ANDREA MANTEGNA
Adoration of the Magi

Distemper and gold on linen: 54.6 x 70.7 cm;
painted surface: 48.5 x 65.5 cm

c. 1497-1500

The J. Paul Getty Museum, Malibu (85.PA.417)

PROVENANCE
By 1871-1903, Louisa, Lady Ashburton; *c.* 1903-15,
Spencer Douglas Compton, Castle Ashby, Northants;
1915-78, William Bingham Compton, 6th Marquess
of Northampton, Castle Ashby, Northants; 1978-85,
Spencer Douglas David Compton, 7th Marquess of
Northampton, Castle Ashby, Northants; sold
Christie's, London, 18 April 1985, lot 16

REFERENCES
Kristeller, 1901, pp. 143-5; Yriarte, 1901, pp. 211-12;
Berenson, 1907, p. 254; Knapp, 1910, pp. 123, 177;
Venturi, 1914, pp. 476, 482-83; Berenson, 1932,
p. 328; Fiocco, 1937, pp. 68, 206; Tietze-Conrat, 1955,
p. 192; Paccagnini, in Mantua, 1961, p. 76; Cipriani,
1962, p. 82; Camesasca, 1964, p. 128; Spriggs, 1965,
p. 74; Garavaglia, 1967, no. 106; Berenson, 1968,
p. 239; Elam, in London, 1981, p. 122, no. 32;
Lightbown, 1986, pp. 445-6

One of Mantegna's most copied compositions – at least six variants are known, some with a landscape background (see Kristeller, 1901, p. 439, and Lightbown, p. 446)- the *Adoration of the Magi* is also Mantegna's most audaciously composed half-length narrative composition. The seated Virgin is shown to just below the knees while the old magus, bowed in reverence, is cropped below the shoulders with only the fingers of his left hand visible (a copy in the Johnson Collection, Philadelphia, establishes that the composition is only minimally cropped; some of the other variants expand the picture field). Although Mantegna abandoned the illusionistic window-frame motif employed some four decades earlier in the *Presentation in the Temple* (fig. 39; Gemäldegalerie, Berlin), he increased the scale of the figures, and the effect of proximity to the viewer is even greater. In accordance with his fully developed relief style, the picture plane is defined by such features as the right arm of the Virgin and the hand and shoulders of the old magus. Only in the approximately contemporary *Ecce Homo*

(cat. 61) is the notional space so shallow and the composition so densely packed. Coupled with these features is an austerity in the attitudes and expressions of the figures tempered only by the touching naturalness of the gesture of the Christ Child, depicted as though enshrouded.

Ringbom (1965, p. 91) has tentatively suggested that Mantegna may have known Flemish tapestries in which the subject was treated with half-length figures, and has further noted general similarities with a lost composition by Hugo van der Goes. Given the taste for Flemish tapestries in northern Italian courts in general, and in Mantua in particular, there is nothing inherently improbable in this idea. However, a comparison with northern examples emphasises the degree to which Mantegna's picture aspires to the spare effects of a sculptural relief and is independent of any known pictorial sources. There is an analogy for Mantegna's remarkable adaptation of Roman funerary reliefs to the requirements of narrative painting in Tullio Lombardo's *Bacchus and Ariadne (or Ceres?)* (Kunsthistorisches Museum, Vienna), in which Roman portrait conventions are applied to mythological themes (although the relief is sometimes interpreted as a double portrait, this seems to me to confuse the Roman sources with the ostensible subject: see Wilk, 1978, pp. 55-84).

As with so many of Mantegna's late devotional pictures, the attribution has been disputed (see, for example, Fiocco and Garavaglia). Venturi (followed, tentatively, by Cipriani) grouped it together with the *Ecce Homo*, the *Holy Family with St Mary Magdalene*, and *The Families of Christ and St John the Baptist* (cats. 55-64) as the work of Mantegna's son Francesco. This notion is based on a fundamental misunderstanding of the character of Mantegna's latest works, as well as an over-optimistic appraisal of Francesco's abilities as an artist (no documented work by him survives, but nothing leads one to believe that he was especially gifted). Yriarte correctly judged the picture as one of Mantegna's finest works. The picture was not well known before its inclusion in an exhibition in 1981, where it was correctly dated to the last decade of Mantegna's career (see Elam). It would seem to postdate the

Trivulzio Madonna, dated 1497, but is, perhaps, earlier than the latest paintings.

Although the picture cannot be identified with any painting in the Gonzaga inventories, the three vessels held by the magi closely link it with the collecting interests of Isabella d'Este. The blue ware bowl is either Chinese or Persian (related porcelain appears in Bellini's *Feast of the Gods,* National Gallery of Art, Washington, which was painted for Isabella d'Este's brother, Alfonso: see Spriggs, 1965, p. 74). The other two vessels appear to be made of jasper and agate (see Lightbown, 1986, p. 446 for alternative suggestions). Quantities of such objects, some with elaborate mounts, are listed in the 1542 inventory of Isabella's Grotta, where they were kept in cabinets (see Luzio, 1908, and, for a reconstruction of the contents, Brown with Lorenzoni, 1977, p. 161).

The picture was varnished at some time in the past, but the colours were not notably affected by this. Despite some abrasion, minor losses and a tear by the Child's head, the condition is unusually fine, and has been further enhanced by a sensitive cleaning and restoration by Andrea Rothe following its purchase by the Getty (see p. 85, above).

K.C.

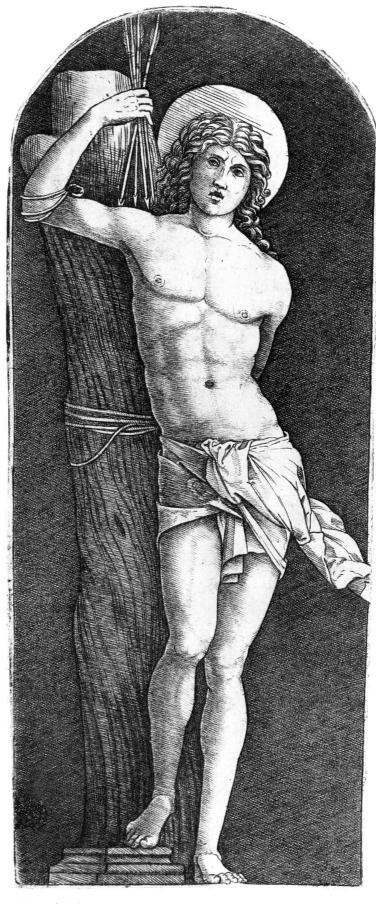

59 (actual size)

60

ANDREA MANTEGNA
*The Man of Sorrows with
Two Angels*

Tempera on wood, 78 x 48 cm
Inscribed (on base of sarcophagus): *ANDREAS MANTINIA*

c. 1500

Statens Museum for Kunst, Copenhagen
(R. M., Sp. no. 69)

PROVENANCE
By 1756, Cardinal Silvio Valenti Gonzaga, Rome;
1756-63, Marchese Carlo and Cardinal Luigi Valenti
Gonzaga, Rome (1756 and 1760 inv. no. 770); sold
Amsterdam, 18 May 1763, no. 68; purchased by
Gerhard Morell; 1763-66, King Frederick VII,
Copenhagen (1763, inv. no. 5); The Royal Danish
Collections

REFERENCES
Crowe and Cavalcaselle, 1864, ed. 1912, II, pp. 104-5;
Yriarte, 1901, p. 223; Kristeller, 1901, pp. 327-30, 442;
Madsen, 1904, pp. 85-6; Berenson, 1907, p. 254;
Vollmer, 1909, p. 550; Knapp, 1910, pp. L, 176;
Venturi, 1914, pp. 216-19; Moltesen, 1924-5,
pp. 89-112; Berenson, 1932, p. 326; Hartt, 1940, p. 33;
Fiocco, 1937, pp. 70-71, 208; Hind, 1948, V, pp. 31,
63; Olsen, 1951, pp. 96, 98, 101, n. 34; Hartt, 1952,
p. 332; Tietze-Conrat, 1955, pp. 180-81; Olsen, 1961,
p. 73; Pietrangeli, 1961, pp. 34, 69; Cipriani, 1962,
pl. 141; Camesasca, 1964, pp. 38, 120; Garavaglia,
1967, no. 69; Berenson, 1968, p. 239; Signorini, 1985,
pp. 155-8; Lightbown, 1986, pp. 220-22, 438; Cormio,
1986, pp. 56, 66, n. 53; Wamberg, 1991

This is the least familiar painting by
Mantegna, and the greatest religious work of
his last years, which combines his rapt
response to nature with his unique powers of
description.

The Man of Sorrows, in which Christ is
shown with the marks of the Passion but
abstracted from a narrative context (see
Panofsky, 1927), is a recurrent devotional
theme in Venetian and northern Italian art.
Its formulation in the 15th century was based
on Donatello's bronze relief for the Santo in
Padua showing a half-length figure of Christ
propped up within a sarcophagus and flanked
by two youthful angels. This painting is
unusual in showing Christ full length, his
wounded hands extended, his head poignantly
bent to one side, his expression of suffering
described with an exquisite sense of agony.

He is seated on the end of an elegant,
all'antica sarcophagus on which kneel two
angels (one with the red wings and robes of a
seraph, the other in the blue of a cherub),
supporting his Immaculate body. To the left
of the pebbly plateau lies the lid of the
sarcophagus, while behind and below is
Mantegna's most evocative landscape: at once
dry in its descriptive precision and
unprecedentedly evocative in its poetic force.

On Christ's right side is a view of verdant
fields traversed by a path on which two Holy
Women journey towards the tomb on Easter
morning. In the distance is the walled city of
Jerusalem, a cave-riddled rocky outcrop
(similar to that in the *Parnassus*; fig. 107), and
a series of mountain peaks. Three shepherds
tend their sheep, one leaning on his staff in a
pose familiar from early Christian sarcophagi,
while the heads and shoulders of other Holy
Women are just visible at the crest of the hill.
In contrast to this extensive pastoral
landscape, on Christ's left side the space is
abruptly closed off by the rocky hill of
Golgatha, crowned by three crosses silhouet-
ted against the golden light of dawn. In front
of a cave-like tunnel (not a newly prepared
tomb, as is sometimes asserted) are a group of
stonecutters. Three are at work on a marble
slab, two busy themselves on the shaft of a
column – one measures it, another chisels
away at a marble base – and yet another
carves a statue, with a marble basin at his side.
Other figures are visible in the tunnel passage,
which is illuminated at the back by a shaft
of light.

The sarcophagus is obviously intended to
suggest an altar table, and Christ's body
alludes to the Eucharist; it is probable that the
contrasting landscape views refer to his
Resurrection on the right (dexter) side and
death on the left (sinister), as in the *Virgin of
the Stonecutters* (see Hartt, 1952, pp. 330-2).
Conceivably, the activity of the stonecutters
signifies the vain labours of man, in
accordance with Psalm 127:1 'Except the
Lord build the house, their labour is but lost
that build it' (see also the elaborate and, on
the whole, unconvincing interpretation of
Hartt, 1952, and those of Wamberg and
Signorini). However, given that similar
figures appear not only in the *Virgin of the
Stonecutters* (fig. 3; Uffizi, Florence), but in
the background of the Camera Picta, such a

meaning is by no means certain: Mantegna
may simply be taking the occasion to depict a
favourite motif or he may be drawing an
allusion to his own art and that of the divine
image-maker, God, whom he showed carving
Adam from marble on the throne of the
Madonna della Vittoria. Interestingly, in one of
the prints based on this composition (cat. 58)
the details of the bilateral landscape as well as
the angels were suppressed and a crown of
thorns added in the foreground to create a
more conventional image, while in another
print, which retains the angels, the rocky mass
of the sepulchre replaces the landscape. In
both engravings the viewing point is lower
(in one it is distinctly *di sotto in sù*).

It is curious that this sublime painting has
been so little appreciated by 19th- and 20th-
century critics. Crowe and Cavalcaselle
described it as 'a splendid exhibition of skill in
the reproduction of nude and accessorial
detail, but too realistic to produce absolute
pleasure', and Berenson, who admired the
design, found the expression on Christ's face
'inane' and lamented the 'perfunctory
grimaces' of the angels. Like most of his
contemporaries, Mantegna believed that
emotional states should be precisely described,
not abstracted. It is the exactly described
expressions, like those in the *Pallas* (cat. 136)
and the *Descent into Limbo* (cat. 70), no less
than the icy, pale palette, that gives this
picture its peculiarly piercing accent, with the
fluttering piece of drapery held by one of the
angels providing a poignant *fioratura*.

The picture is generally dated between
c. 1490 and *c.* 1500 (for an earlier date,
possibly during Mantegna's Roman sojourn,
see Garavaglia). In view of the very close
relationship of style with the *Pallas* (cat. 136),
which shares the incisive drawing and pale
colours, a date of *c.* 1500 seems probable. It is
not possible to state with certainty for whom
the painting was made. It is first mentioned in
the collection of Cardinal Silvio Valenti in
Rome. The Valenti, a prominent Mantuan
family were granted the privilege of using the
Gonzaga name and arms in 1518. They had a
chapel in the church of San Francesco (see
Olsen, 1951, p. 99, n. 8). Possibly, the picture
was painted for them or for their chapel, but
there is no proof that it was not acquired by
Cardinal Valenti in the 18th century for his
extensive collection, which included works

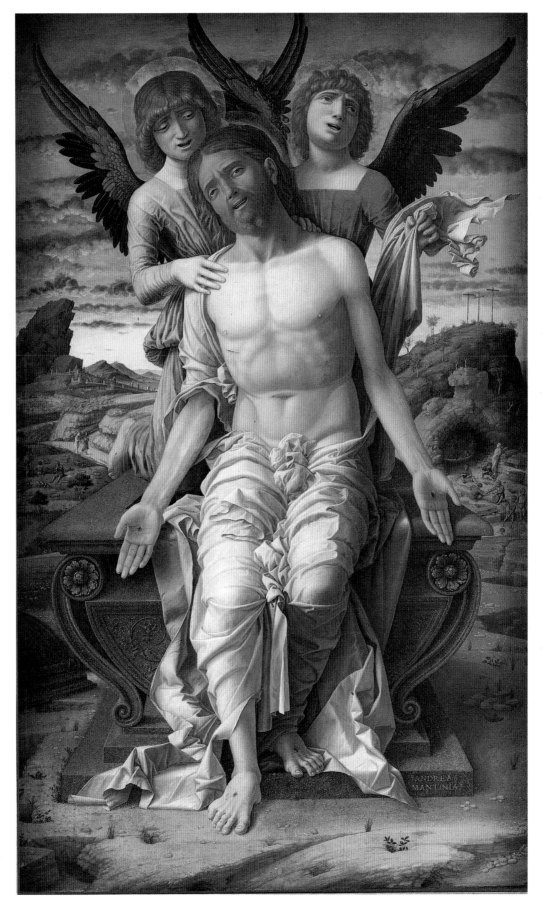

dating from the 15th to the 18th century. There is no evidence that it can be identified with a '*N[ostro] S[ignore] quando resusitò*' listed in a Gonzaga inventory of 1627 (D'Arco, 1857, II, p. 165: see Lightbown).

The picture is in very good condition, although there is some damage on Christ's chest, beard, right arm and drapery, and in the angels. The original edges of the picture surface are intact.

K.C.

61

ANDREA MANTEGNA
Ecce Homo

Distemper and gold on canvas mounted on a wooden panel, 54 x 42 cm
Inscribed (on fictive cartelli): *CRVCIFIGE EVM / TOLLE EVM / CRVCIFIGE CRVC[IFIGE]; CRVCIFIGE EVM / CRVCIFIGE TOLLE / EV[M] CRVCIFIGE*
(adapted from John 19:6, 15)

c. 1500

Institut de France, Musée Jacquemart-André, Paris (no. 1045)

PROVENANCE
Private collection, Milan(?); by 1891, Stefano Bardini, Florence; 1891-1913, M. and Mme Edouard André, Paris

REFERENCES
Yriarte, 1901, pp. 234-5; Kristeller, 1901, p. 325 n. 1; Borenius, in Crowe and Cavacaselle, 1871, ed. 1912, p. 109, n. 2; Venturi, 1914, pp. 262, n. 1, 482; Berenson, 1907, p. 255; Lafenestre, 1914, p. 14; Berenson, 1932, p. 328; Fiocco, 1937, pp. 76, 209; Tietze-Conrat, 1955, p. 196; Panofsky, 1956², pp. 114-16; Cipriani, 1962, p. 82; Camesasca, 1964, p. 128; Ringbom, 1965, p. 146; Garavaglia, 1967, p. 118, no. 92; Berenson, 1968, p. 241; Brown, 1987, pp. 60, 113

Depictions of Christ as the Man of Sorrows enjoyed widespread popularity in the 14th and 15th centuries (on their origin and evolution see especially Meiss, 1951, pp. 35-8; Panofsky, 1956²; Ringbom, 1965, pp. 30-52). They show Christ, viewed frontally, either bust- or half-length, as an object of devotion and meditation. In the third quarter of the 15th century this type of image was redefined by Antonello da Messina's paintings of a bust-length figure of Christ shown, portrait-like, usually behind a parapet, tied to a column (Collegio Alberoni,

Piacenza) with a noose around his neck (Galleria di Palazzo Spinola, Genoa) or with his arms bound behind him as in the *Ecce Homo* (The Metropolitan Museum of Art, New York), thereby directly evoking a particular narrative context while at the same time denying its temporal character. This *Ecce Homo*, one of the most sublime and personal masterpieces of Mantegna's late career, can be seen as the culmination of this evolution towards an ever more affective devotional image. In it, the narrative moment itself is abstracted, and the bound and tethered Christ is presented to the viewer by his accusers rather than by Pilate and his soldiers (it is not clear if this was intended by Mantegna as an ironical inversion).

Mantegna's picture depends for its effect on a purposefully exaggerated contrast between the long-suffering, transcendent nobility of Christ – his otherwise immaculate torso blemished by the lash-marks of his flagellation – and the brutally grotesque ugliness of his accusers, whose mute demands to 'crucify him, take him and crucify him', are recorded in letters of what might be described as searing elegance on creased pieces of paper that have been affixed, like indictments, above their heads. That the Jew on the left wearing a paper hat inscribed in pseudo-Hebrew (see Panofsky, 1956², p. 133, n. 53) closely resembles the bloated figure of Ignorance in Mantegna's *Pallas Expelling the Vices* (cat. 136) is hardly coincidental.

Perhaps the deeply disturbing effect this picture makes is responsible for the otherwise incomprehensible hesitancy many scholars have had in accepting Mantegna's authorship (Kristeller, Venturi, Berenson, Tietze-Conrat, Panofsky, Cipriani, Camesasca, Ringbom, Garavaglia, Brown). It is difficult to imagine who, other than Mantegna, would have

conceived of details such as the ear of the figure on the right, pressed down by the turban he wears, or the delicately bloodshot eyes of Christ. Or who would have been capable of describing the reflected light along Christ's nose. Apart from some local damage in the hands of Christ, this is one of the best-preserved works by Mantegna and a touchstone of his work in distemper on canvas. Except for some minor abrasion in the hands of Christ, it is in exceptionally fine state, having never been varnished. Miraculously, the canvas is still glued to what is likely to be its original panel backing (see p. 86, above).

Although sometimes dated *c.* 1460-70 (Panofsky, Ringbom, Brown), most critics (Lafenestre, Berenson – who considered it a workshop production – Cipriani, Garavaglia and Lightbown) have rightly recognised it as a late work. Comparison of the picture with the *Pallas Expelling the Vices*, with which it shares not only figure types but the conspicuous use of labelled scrolls to explicate the narrative, argues for a date of *c.* 1500. Together with the contemporary *Holy Family with the Infant St John the Baptist* in Dresden (fig. 73), the *Ecce Homo* marks the apogee of Mantegna's Roman relief style. The picture was certainly studied by Correggio, whose picture of the same theme (National Gallery, London) was inspired by it (x-rays of the London painting demonstrate that the soldier presenting Christ originally grasped Christ's shoulder with claw-like hands like those of the turbanned figure in Mantegna's painting).

The date of the picture to *c.* 1500 has the additional interest of suggesting a direct link with Leonardo's design for a composition of Christ carrying the Cross, known from a drawing (Accademia, Venice) and from derivations by Leonardo's Milanese pupils and

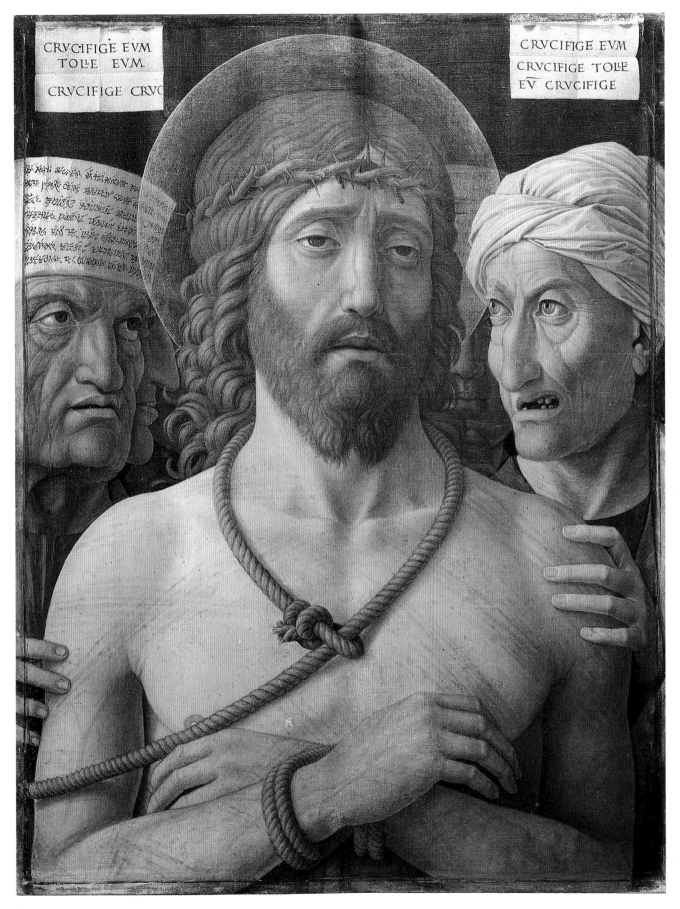

CRVCIFIGE EVM
TOLLE EVM

CRVCIFIGE CRVC

CRVCIFIGE EVM

CRVCIFIGE TOLLE
EV̄ CRVCIFIGE

61

followers (for recent bibliography, see Brown, 1987, pp. 88; 134-5, nn. 59-62). In that work Leonardo further explored his interests in physiognomic types by showing the ideally beautiful Christ surrounded by taunting figures of archetypal ugliness. The design is usually dated to Leonardo's last years in Milan, and is assumed to have influenced Giorgione's ruined canvas of *Christ Carrying the Cross* in the Scuola di San Rocco, Venice (the attribution of this picture has been disputed between Titian and Giorgione since the 16th century; this writer favours Giorgione). Leonardo was briefly in Mantua and Venice in 1499-1500,

at which time Isabella d'Este sat to him for a portrait, and it is hardly credible that Mantegna would have missed this opportunity to meet the only living artist of comparable stature and fame. Yet, if in this instance the expressive goals of the two artists coincided, their approach to painting was poles apart. Mantegna must have found Leonardo's work as distressingly imprecise in its use of *sfumato* as Leonardo would have found Mantegna's hard and literal.

Nothing is known of the painting before it was bought from the Florentine dealer Stefano Bardini in 1891 (*Catalogue itinéraire* [n.d.], p. 149), although it is reported to have

been in a Milanese collection (Yriarte, 1901). Lightbown (1986, p. 448) noted that the 1627 inventory of the Gonzaga collection lists 'a painting in which is depicted Our Lord *Ecce Homo* with a cord around his neck...' (Luzio, 1913, p. 117, no. 338). No author is mentioned, and given that the valuation is only about half that of a picture of the head of St Jerome ascribed to Mantegna (Luzio, 1913, p. 113, no. 297), the painting is unlikely to be this picture.

K.C.

62

AFTER ANDREA MANTEGNA
Recto: **Study of a Head and other Studies**

Verso: **Study for a Virgin and Child and other Figures**

Pen, brush, and brown wash
292 x 197 mm
Bears Boymans mark (L. 1857) on *verso*; various inscriptions

Museum Boymans-van Beuningen, Rotterdam (inv. 578)

PROVENANCE
1847, legacy of F.J.O. Boymans (L. 1857)

REFERENCES
Schmidt-Degener, 1910-11, pp. 255-6; Tietze-Conrat, 1955, pp. 207-8; Mezzetti, in Mantua, 1961, pp. 184-5, no. 139; Schmitt, 1961, pp. 96, 131, no. 70; Paris, Rotterdam and Haarlem, 1962, no. 24

Like its related drawing (cat. 63) this sheet combines small-scale, spidery figure and head studies in pen with larger studies in brush with extensive use of wash. All the drawings appear to be by the same hand, and the same artist was probably also responsible for the inscriptions. The principal studies on both sides relate to extant paintings, but it does not appear that this sheet was executed by either of the artists responsible for them.

The *recto* consists of one substantial head study, which fills the page, and which is surrounded and overlapped by no less than fourteen small studies of individual figures and heads, evidently executed subsequently. The majority of these are in the same direction as the head, but for four in the top left-hand corner the sheet was turned through 90 degrees. The two most imposing studies consist of a standing man in contemporary dress seen in profile, and a haloed nude male figure with his hands tied behind his back, presumably a St Sebastian. Indeed, the similarity between his pose and that of Mantegna's painting of the saint in Vienna (fig. 5) initially induced Tietze-Conrat to regard this sheet as a preparatory drawing for the panel. However, she subsequently recognised its links with a later phase of Mantegna's career. Both these studies have the thick, bold pen line and distinctively tapering legs ending in a point at the feet found on the *recto* of the related drawing (cat. 63).

The grotesque head, with its bloodshot eyes, gap-toothed mouth, and goitred neck, is altogether a highly arresting creation; it does not appear to have been pointed out that it bears a striking resemblance to the onlookers in the *Ecce Homo* (cat. 61). Although the head in this drawing and that of the Jew on Christ's right are not absolutely identical, the similarities between them suggest that the one is a preparatory study – or a copy of a lost preparatory study – for the other.

The initial impression of the *verso* is of an unfinished study of the Virgin and Child, but in fact, as Mezzetti was the first to recognise, this is deceptive. The Child's foot and leg do not connect up with his head, and furthermore the contour of a cheek and a delicately drawn eye with long eyelashes rests against his forehead. The explanation of all this is afforded by a painting of the *Virgin and Child with Four Saints* (fig. 84; National Gallery, London) generally given to Francesco Bonsignori, but attributed to Gian Francesco Caroto by Schmitt, in which the Child's head and foot and the Virgin's eye and cheek correspond, and in which the principal head is revealed as belonging to a martyred saint. With this knowledge in mind, some ringlets of hair may also be discerned on the right-hand side of the head in the drawing.

Three possibilities are suggested by the present sheet. It might be thought to be by

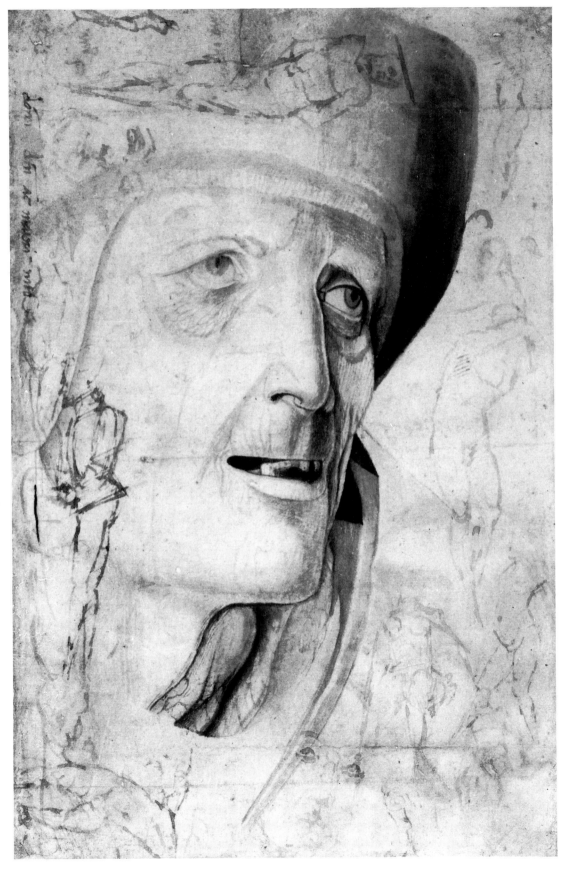

62 *recto*

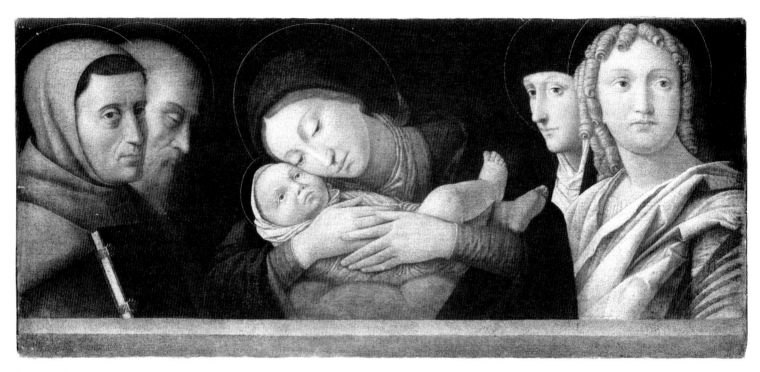

fig. 84 Attributed to Francesco Bonsignori, *Virgin and Child with Four Saints*, canvas, 48 x 107 cm, National Gallery, London

Mantegna himself, although the small pen sketches are very unlike his later drawings, and the *verso* in particular seems to be a compilation of details taken from other drawings rather than a creative study. This also makes it hard to believe the *verso* is Bonsignori's preparatory study for the London painting, and in any event an attribution to Bonsignori would not explain the links between the *recto* and Mantegna. The third, and most likely, possibility is that it is a school piece which combines various details taken from Mantegna drawings either as a record or for study purposes. In that case, the *recto* would be derived from a lost study for the *Ecce Homo*, and the *verso* from lost studies for a Virgin and Saints, which were also known to Bonsignori. Bonsignori's links with Mantegna are discussed elsewhere (see cat. 103), and in both cases the drawings are

of better quality than Bonsignori's paintings after them. If the original studies from which the *verso* was copied ever progressed beyond the planning stage, that work must have borne a resemblance both to Mantegna's engraving of the *Virgin and Child* (cat. 48) for the intimacy of its embrace, and to his painting of the same subject (fig. 69), which has the same sharp-featured facial types.

Particularly in view of the connection between the head on the *recto* and the *Ecce Homo*, whose virtual monochrome and violent characterisation mark it out as a late work, close in date to the Ca' d'Oro *St Sebastian*, it seems reasonable to place this drawing in the last decade of the 15th century or the first of the 16th.

D.E.

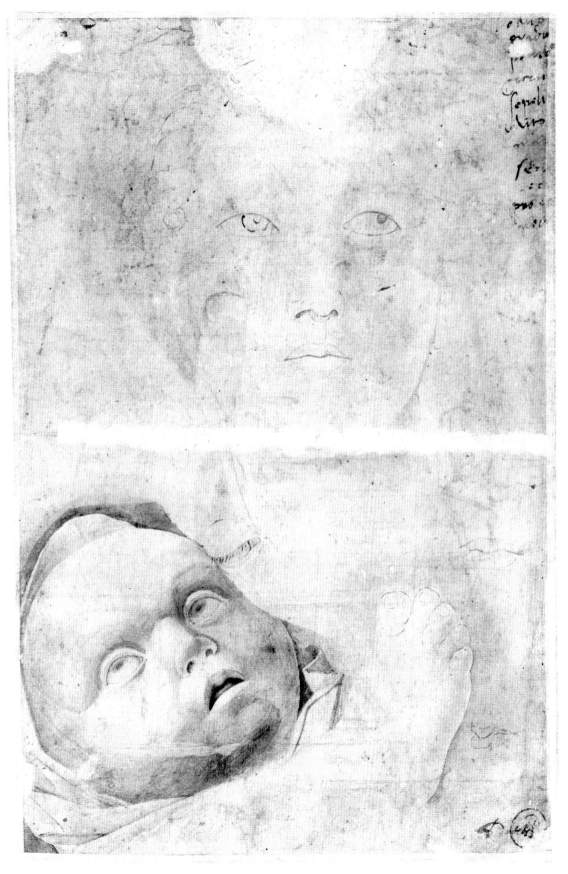

62 *verso*

63

AFTER ANDREA MANTEGNA
Recto: **Study for a Soldier of the Resurrection and other Figures**

Pen and light-brown ink; brush and grey wash with white heightening on orange-brown prepared paper

Verso: **Study of Drapery and Figures**

Pen and light-brown ink; black chalk with grey wash and white heightening
250 x 188 mm

Her Majesty The Queen (inv.12795)

PROVENANCE
Listed in George III's inventory A

REFERENCES
Popham and Wilde 1949, p. 174, no. 16; London, 1972-3, no. 7; Sydney, 1988. no. 2

63 *verso*

This sheet is closely related to another double-sided drawing (cat. 62). Both combine comparatively large and finished brush studies with wash, with small, spidery pen drawings of highly stylised figures, whose distinctive features are legs that taper away to a point at the feet. Both sheets give every indication of being by the same hand, and because of their similarity in scale it has been suggested that they must have come from the same sketchbook. However, there is no proof, whether in the form of stitch-holes or rubbing at the edges, that either of them was ever part of a bound volume.

Two factors speak against the attribution of this drawing to Mantegna himself. The first concerns the small pen studies on the *recto*, which appear to represent a prisoner being brought before a judge (there is a certain schematic resemblance to the fresco of *St James before Herod Agrippa* formerly in the Ovetari Chapel), and a figure being supported by two others, probably a first idea for a Deposition or an Entombment. Both of these are far more simplified and crude than any known drawing by Mantegna. The second factor is the lifeless quality of the larger-scale drawings, especially those in pen on the *verso*.

A more general connection with Mantegna is, however, not in doubt. The two soldiers on the *recto*, one only partially finished, whose general appearance is convincingly Mantegnesque, were almost certainly intended for guards in a *Resurrection*. They are not unlike those in a painting of the *Resurrection*, known in various versions (Museo Civico, Padua; Accademia Carrara, Bergamo), doubtless copies of a lost original by Mantegna. More telling is one of the details of the *verso*. In the top left-hand corner of the sheet are two haloed putti, accompanied by a bank of cloud. Not only do they closely resemble individual putti in the detached fresco of the *Risen Christ* from the portico of Sant' Andrea in Mantua, generally given to the school of Mantegna, but furthermore they are identical to two of the putti in another drawing from Mantegna's circle (Uffizi, Florence, inv. 1674F), of the

same subject. In all probability both drawings, which do not appear to be by the same hand, derived this insignificant detail from a common prototype in the form a lost drawing by Mantegna. On the other hand, there is no need to assume that every particular of cat. 63 goes back to the master himself, since it would not have been beyond the wit of an able pupil such as the artist of this sheet to invent the drapery study, presumably for a seated figure of the Virgin, and the foliate decoration on the *verso*. Both the figure style and the rather curious, dry quality of the penwork on the *verso* suggest a late date for this sheet, and this is confirmed by consideration of the related drawing in Rotterdam.

D.E.

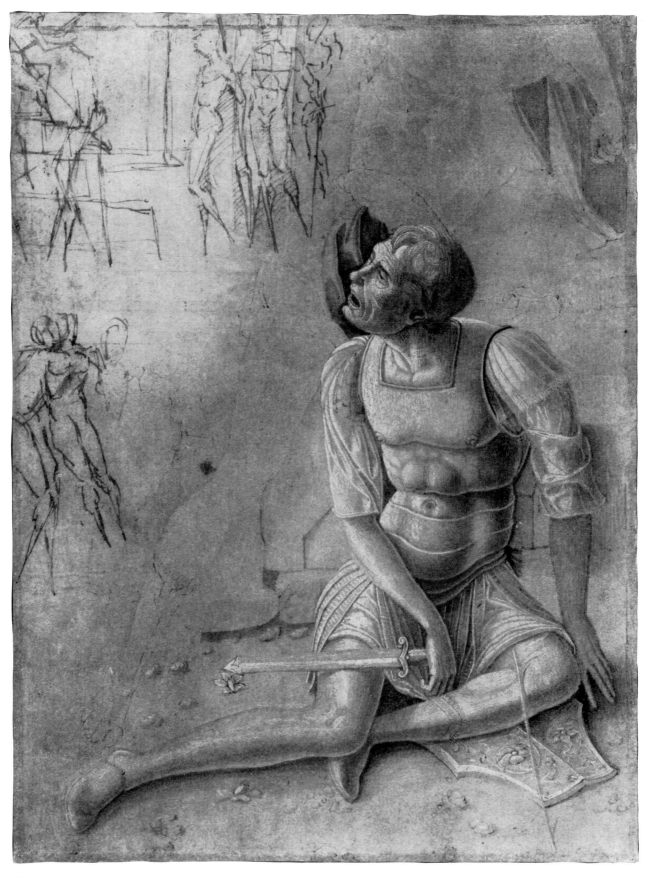

63 *recto*

64

ANDREA MANTEGNA
*The Families of Christ and
St John the Baptist*

Casein(?) and gold on canvas, 40 x 169 cm

c. 1504-6

Chapel of San Giovanni Battista, Sant'Andrea, Mantua

PROVENANCE
Chapel of San Giovanni Battista, Sant'Andrea, Mantua

REFERENCES
Donesmondi, 1616, II, pp. 47-8 (relevant passage in
Lightbown, 1986, p. 453); Ridolfi, 1648, p. 71;
Cadioli, 1763, pp. 53-4 (relevant passage in Lightbown,
1986, p. 453); Coddé, in Pungileoni, 1821, pp. 2-3;
Kristeller, 1901, pp. 332, 443; Yriarte, 1901, p. 172;
Berenson, 1907, p. 254; *idem*, 1932, p. 327; Fiocco,
1937, pp. 76, 209; Tietze-Conrat, 1955, p. 188;
Paccagnini, in Mantua, 1961, p. 59; Cipriani, 1962,
pl. 159; Camesasca, 1964, pp. 42, 124; Garavaglia,
1967, no. 111; Berenson, 1968, p. 240; Lightbown,
1986, pp. 248-9, 452-4; Perina and Carpeggiani, 1987,
pp. 121-2

In his testament drawn up on 1 March 1504
Mantegna provided for his burial in the
church of Sant'Andrea in Mantua 'in, or
before, the chapel constructed there in
honour of Saint John the Baptist' (the first
chapel on the left). The chapel was to be
endowed with 100 ducats, while 50 were to
be spent on a missal, chalice, cope and other
necessities for saying mass and a further 50
'for decorating said chapel with pictures and
other ornaments' (Kristeller, 1902, doc. 163).
There is no way of knowing how long
Mantegna may have had his eyes on the
chapel, which was consecrated in 1480, but
there can be little doubt that from the time
Alberti submitted his design for this his most
Roman-inspired church in 1470, Mantegna
must have watched its progress with
particular interest. On 11 August 1504 the
chapel was formally granted to him, and he
must have set about making plans for its
decoration. There are no further notices until
2 October 1506, following Mantegna's death,
when his son Ludovico wrote to Francesco
Gonzaga about the obligations he was bound
to by his deceased father, especially the 100
ducats for the endowment of the chapel and
the further 100 for its provisions and
decorations (Kristeller, 1902, doc. 190).
Judging from this letter, little if any work had
actually been done in the chapel, and, indeed,
the date 1516 appears beneath the mono-
chromatic scene of Judith and Holofernes in
one of the recesses below the vault. A
persistent tradition originating with the
17th-century writer Donesmondi ascribed
Correggio a role in these frescoes, but
according to a contemporary correspondence,
no longer traceable, Francesco Mantegna was
responsible for completing the decoration
(see Lightbown, 1986, pp. 247, 453; and,
for Correggio's participation, Gould, 1976,
pp. 30-32). The poor state of the frescoes
does not allow a definitive conclusion, but
the monochromatic scenes are inferior to the
figures of the four Evangelists in the spandrels
and the decoration in the cupola.

In his letter to the Marchese of 1506,
Ludovico Mantegna mentions several
paintings left by his father, including 'two
paintings that are for his chapel'. These are
doubtless the *Families of Christ and St John* and
the *Baptism* still *in situ*. In 1648 Ridolfi
described the *Baptism*, which he mistakenly
called a fresco, on a lateral wall, while the
Families of Christ and St John adorned the altar.
The subjects of both are appropriate to a
chapel dedicated to the Baptist. Despite this
well-documented provenance, critics have
judged both works harshly, especially the
Baptism, suggesting at least partial execution
by pupils after Mantegna's death.
Interestingly, no mention of their being
unfinished is made in Ludovico's letter,
which had the object of obtaining permission
from the Marchese to sell some of the works
left by Mantegna to Cardinal Sigismondo
Gonzaga in order to finance work on the
chapel and pay outstanding debts (presumably
the chapel paintings and their destination
were included in this list so as to exclude
them from the negotiations: see Brown,
1974). It would be surprising if Mantegna had
delegated a significant role to pupils in
carrying out the two principal adornments of
his funerary chapel.

The *Baptism* is in ruinous condition, with,
for the most part, only its preparatory layers
of paint preserved. In many areas the canvas is
exposed. Yet, its conception, with the figures
and background citrus tree blown, as it were,
by a spiritual wind, are consistent with an
attribution to Mantegna himself. The plants
in the foreground, which are reasonably well
preserved, are painted with considerable
delicacy. Curiously, however, in style this
work recalls the *Triumphs* (cats. 108-15), and
one wonders if Mantegna did not reuse
portions of the cartoons he presumably
created between 1488 and 1490 for the
Belvedere chapel he decorated in the Vatican
for Innocent VIII. This had on its altar wall a
fresco of the Baptism of approximately the
same dimensions but including more

subsidiary figures (see the descriptions reprinted in Müntz, 1889, pp. 482-3). The figure on the right holding a bucket has never been identified, but may provide a clue to the genesis of this marvellous composition.

With the *Families of Christ and St John*, there is, once again, no compelling reason to reject Mantegna's authorship, always bearing in mind the generally poor state of preservation and the technique, probably casein. In addition to the badly abraded surface, with significant losses exposing the canvas, successive varnishing has darkened the overall tonality irretrievably (already in 1821 Coddé, in Pungileoni, mentioned the picture as ruined by crude varnishing). The lateral figures, which have sometimes been ascribed to assistants or followers, have particularly suffered, their beards being almost entirely lost. The censer held by Zacharias gives some idea of their original beauty. The sky is reduced to a flat, faded tone, and the hedge, with its pomegranates and citrus fruits, preserves only the preparatory layers. The central figures have fared somewhat better, but even they lack most of their final layers and, consequently, the crispness one expects in Mantegna's work. Surprisingly, the sleeve and neckline of the Virgin's dress still retain much of the shell gold embellishment, which is of great refinement. The physiognomy of the Virgin is extremely similar to that of the late *St Sebastian* in the Ca' d'Oro, which was also among the pictures left in Mantegna's workshop at his death (Kristeller thought the *St Sebastian* was also completed by a pupil).

The subject of the meeting of Christ and St John is taken from the 13th-century *Meditationes vitae Christi*, where it is recounted that the two infants met following the Purification of the Virgin and before the Flight into Egypt. The event is depicted on a mid-13th-century dossal in the Pinacoteca Nazionale, Siena, with scenes from the life of St John the Baptist, in which the infants, seated on the laps of their mothers, facing each other, are set against a cityscape; the

fathers are omitted. The identification of the figure at the right of Mantegna's picture has been questioned (see Kristeller, 1901, p. 332), but he wears a priestly turban and holds the censer Zacharias was using when the birth of his son was announced to him by an angel in the temple. The Christ Child turns towards his cousin, who was six months his elder, and makes a gesture of blessing, while the Baptist crosses his arms on his chest in homage to Christ. The unusually elongated format of the altarpiece may have been chosen, in part, to ensure that the picture would not block the light that enters the chapel through a single circular window on the back wall. So concerned was Mantegna with the problem of sufficient light that he purchased a plot of land behind the chapel to ensure that no construction would block it. It is in consideration of the awkward, dossal-like format of the altarpiece and the inevitable line-up of figures it imposed that Mantegna's ability to introduce compositional interest through a subtle use of gesture and pose can best be appreciated. And although the colours and dry, descriptive style of the picture belong to the world of the Quattrocento rather than to the High Renaissance, the clear, geometric configurations – the triangle created by the two children inscribed within the arc of the mothers – marks the extreme of Mantegna's classicism.

K.C.

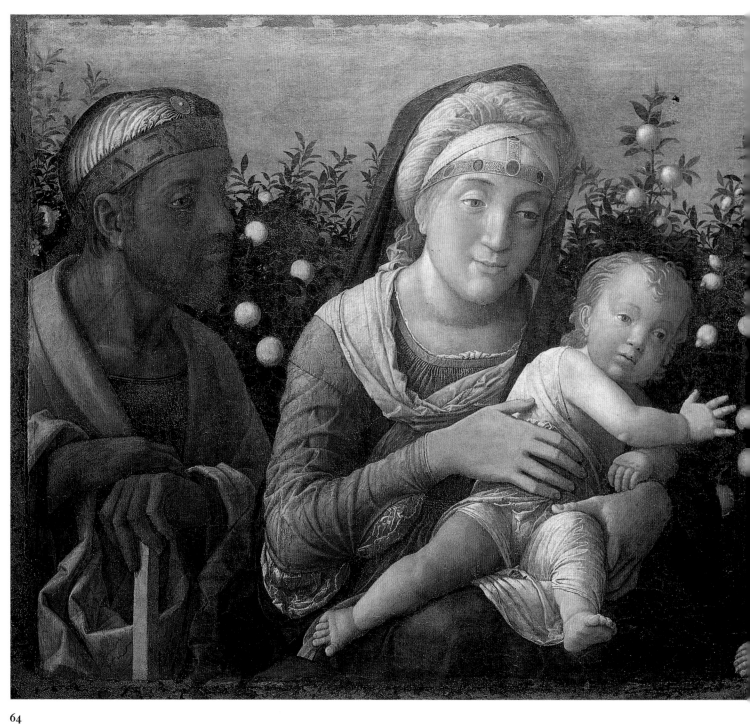

64

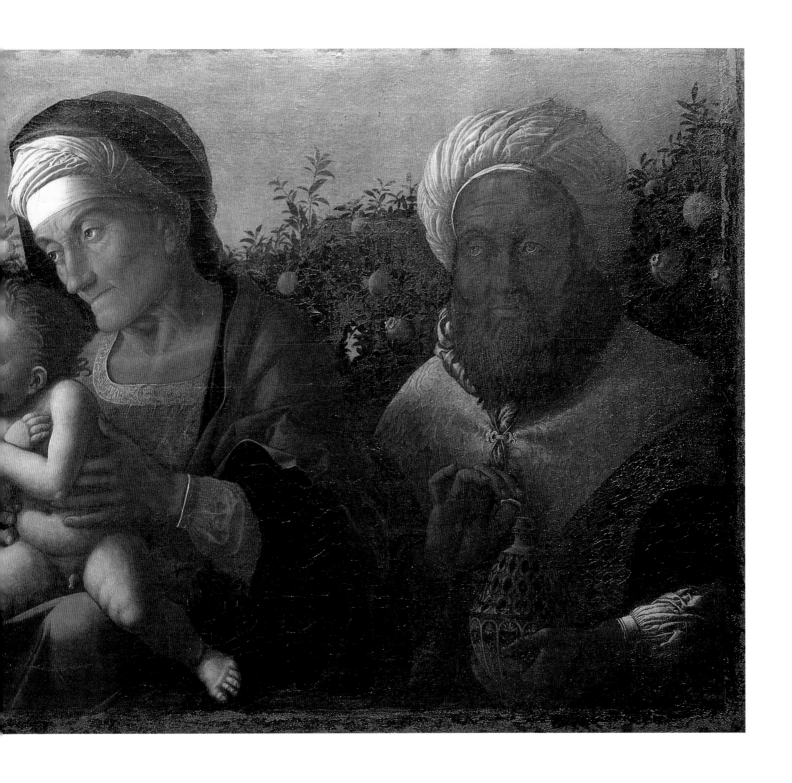

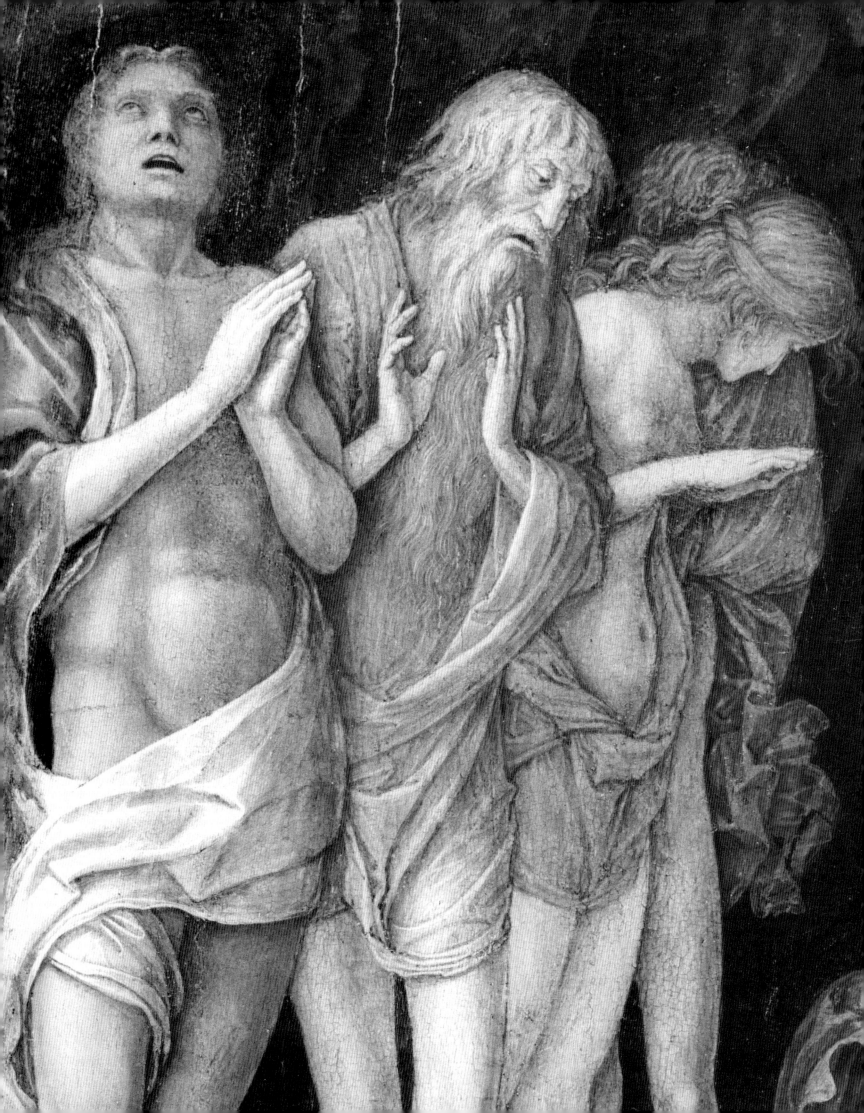

3 THE DESCENT INTO LIMBO

The episode of the Descent into Limbo (also known as the Harrowing of Hell) is nowhere recounted in the New Testament, but by the 15th century it was an established part of Christian belief. The time between Christ's death and resurrection was held to have been spent descending into Limbo, the neutral zone at the entrance to Hell. Among its inhabitants were those righteous souls, such as the Old Testament prophets and patriarchs, who were not damned, but could not gain admission to Paradise until the coming of Christ. He shattered the Gates of Hell, freed the righteous and signalled his triumph over death and the devil.

The Descent into Limbo is alluded to in the Creed ('He descended into Hell') and was narrated in embellished form in the apocryphal gospels and in works of popular devotion. Christ on the cross promises the Good Thief – subsequently called Dismas – 'Today shalt thou be with me in paradise' (Luke, 23:43), and for that reason he was often assumed to have accompanied Christ to Limbo.

The subject was not uncommon in Byzantine art, where it effectively stood for the Resurrection. Both Duccio and Giotto represented it (in small panels as part of larger works) in accordance with Byzantine conventions whereby Christ is shown on the left crushing a devil under the Gates of Hell and the elect wait in the mouth of Hell on the right; only Giotto included the Good Thief. Thereafter, the theme was seldom depicted, but two representations of it must have been of interest to Mantegna. The first is a small panel (Museo Civico, Padua), generally attributed to Jacopo Bellini and certainly based on a design in his Paris album, which has recently been associated with the predella of the altarpiece (now dismembered) of the Gattamelata Chapel, formerly in the Santo in Padua, which Jacopo and his sons Gentile and Giovanni signed in 1459 or 1460.[1] A near contemporary depiction of the subject, which could hardly have failed to interest Mantegna, was that by Donatello on one of the bronze pulpits in San Lorenzo, Florence – always assuming that he would have been able to see it during his visit to Florence in 1466, the year of the aged sculptor's death. In the relief Christ is virtually submerged by the throng of the blessed who crowd around him. In both these works the composition moves from left to right in the traditional manner. Mantegna was evidently fascinated by the subject, and represented it on a number of occasions and in various media. In all of them he adopted a radical perspective and showed Christ from behind, with the mouth of Hell directly in front of him, usually with devils above and the shattered gates beneath his feet.

In *De Pictura,* Alberti described a painting by Timantes of Cyprus of the *Immolation of Iphigenia.* The despair of Iphigenia's father was such that it was impossible to illustrate; in consequence the painter draped the figure so that his grief had to be imagined by the spectator.[2] Mantegna may have been inspired by this passage to show the figure of Christ from behind. The earliest version is a drawing (cat. 65), probably dating from not long after Mantegna's return from Tuscany in 1466 and differing from the other treatments in its less monumental and less classical figure style. It is tempting to associate it with a painting (*quadro*) of '*la instoria del linbo*' which he informed Ludovico Gonzaga he had

fig. 85 Andrea Mantegna, *Descent into Limbo,* cat. 70, detail

started in a letter of 28 June 1468, and which sounds as if it were an independent panel.[3]

The second conception of the *Descent into Limbo*, which must date from a little later, perhaps around 1470, is found in a drawing on vellum (cat. 66), which is in turn closely linked to a print, usually given to Mantegna's workshop, but here attributed to the master himself. This version has many features in common with the earlier drawing (cat. 65), the main difference being that the Good Thief and the elect have changed places. The print includes the sky and a distant landscape not present in the drawing on vellum, which suggests that Giovanni Bellini was aware of both versions when he produced his painting of the subject (cat. 69) – also on vellum – probably in the 1470s.

As far as we know, Mantegna only returned to the subject towards the end of his life. His painting of the subject (cat. 70), and the related drawing of the figure of Christ (cat. 71), have often been associated with the letter of 1468, but the style points to a date in the 1490s or even later; interestingly an 18th-century print after the design includes the date 1492. The rocky terrain studded with burrows is close to the rabbit-infested foreground of the *Parnassus* (fig. 107; Louvre, Paris), while the frontal figure on the left is close to the *St Sebastian* (Ca' d'Oro, Venice). Iconographically, the conception is simpler: although the picture has been cut down, especially at the top, the composition always lacked the shattered gate, the lamenting devils and the Good Thief.

D.E.

NOTES

1. Eisler, 1989, pp. 60-63.
2. Alberti, ed. 1972, p. 83.
3. Kristeller, 1902, p. 525, doc 40.

65

ANDREA MANTEGNA
Descent into Limbo

Pen and brown ink with brown wash
270 x 200 mm
Bears the collector's mark of J.P. Zoomer (L. 1511)

c. 1465-70

The Metropolitan Museum of Art, New York,
Robert Lehman Collection
(Exhibited in London only)

PROVENANCE
Jan Pietersz. Zoomer; John Skippe and his descendants; the Martin family; Mrs A.C. Rayner Wood; Edward Holland Martin; sold Christie's, London, 20 November 1958, lot 37

REFERENCES
Kristeller, 1901, p. 459; Popham, in London, 1958, p. 29, lot 37; Heinemann, 1962, I, p. 54, under no. 179; New York, 1965, no. 3; Hoffmann, 1971, p. 102; Washington, 1973, p. 210; Washington, Fort Worth and St Louis, 1974, pp. 5-6, no. 2; Los Angeles, 1976, pp. 40-42; Szabo, 1983, no. 15 (unpaginated); Paris, 1990, pp. 4-6

In composition this drawing is closer to the painting in the Johnson collection (cat. 70) than to the other related treatments of the subject. It shows a group of figures (three here, four in the painting) to Christ's left, and only one on his right. In other respects, however, the two works are very different: here, as in all the other versions, the single figure is the Good Thief, Dismas, who holds the cross, whereas in the Johnson painting he is Adam. Furthermore, in cat. 70, unlike the rest, there are no devils.

Although the stance of the Good Thief is tentatively and ineffectually rendered, the overall high quality and energy of this sheet do not suggest that it is a copy. This is particularly apparent when it is compared with an accurate but notably weaker 15th-century replica of virtually identical dimensions (272 x 198 mm) in the Bibliothèque Nationale, Paris (Ea 31a rés, box 1, no, 4), mentioned by Kristeller. It proves that the Lehman drawing has been slightly cropped at the bottom, where the rocks originally fell away to form a front edge to the composition. If the top was also cut down, as appears probable given the decapitation of the central devil and the amputation of the hands of his uppermost companion, then it must have been done at an early date, because the line is followed exactly in the Paris sheet.

The handling of the pen and the hatching are very characteristic of Mantegna's middle years, and a date in the mid to late 1460s, slightly earlier than the *Man Lying on a Stone Slab* (cat. 43) or the *Risen Christ* (cat. 44), seems most plausible.

Because this drawing differs so fundamentally from the other treatments of the subject, it seems likely to be either the earliest or the latest. However, when the handling of anatomy and the characterisation of facial expressions are compared with those of the drawing on vellum (cat. 66) and the print (cat. 67), this slighter, less confident

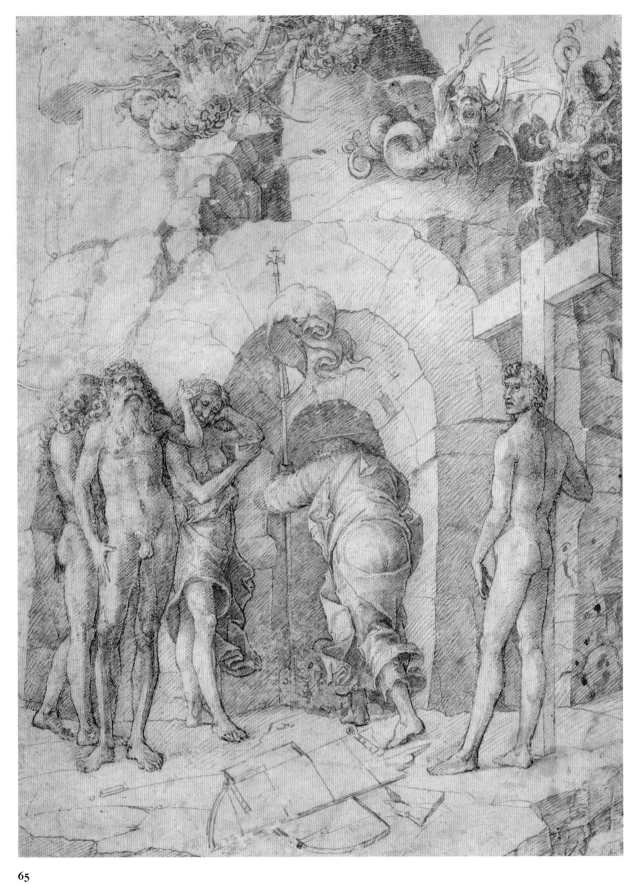

65

drawing emerges as a first rather than a last idea. Christ's stooping, almost lunging movement to the left with his banner curling into an S-shape (standing for *Salvator*), reminiscent of the attitude of the censing apostle in the *Death of the Virgin* (cat. 17), is unique. So is the relationship between the figures and their setting; here the figures are relatively large, not dwarfed by the Gates of Hell or the tall cross as they are in the other versions. Although the portal of Limbo is massive, its central opening is tiny, as the shattered fragments of the doors make plain. Here the devils are contorted into melo-dramatic attitudes of despair that bring to mind representations of angels lamenting over the dead Christ, as in Giotto's fresco in the Scrovegni Chapel in Padua, which Mantegna must have known. This transformation of the

holy into the hideous only makes them more grotesque, from the reptilian tips of their webbed fingers to the ends of their scaly tails. In the other versions of the subject they are hybrid – human from the waist up – and shown sounding trumpets. Here three rail against the harrowing of Hell, while a fourth – who survives in later treatments but in an inverted position – stretches his hands out towards the cross. The three figures to the left – Adam and Eve and a third unidentified figure – have already been set free. From the mouth of the cave two faces emerge from the shadows, one of an old man with a long beard, presumably an Old Testament prophet or patriarch.

D.E.

66

ANDREA MANTEGNA
Descent into Limbo

Pen, brown ink and brown wash on vellum. A section at the bottom and the right side on additional strips of vellum (or paper?) affects the original dimensions of the sheet. Rubbed and damaged in various places, with a substantial stain spreading down from the devil on the left to beyond the Gates of Hell
372 x 280 mm
Bears the mark of His de la Salle (L. 1332) at bottom left, and mark of the Ecole des Beaux-Arts at bottom right

c. 1470

Bibliothèque de l'Ecole Nationale Supérieure des Beaux-Arts, Paris (inv. 189)
(Exhibited in London only)

PROVENANCE
His de la Salle; 1869 donated to the Ecole des Beaux-Arts

REFERENCES
Ridolfi, 1648, I, p. 72; Kristeller, 1901, p. 103; Berenson, 1902, p. 51; Hind, 1948, V, p. 18, under no. 9; Byam Shaw, 1952, pp.157, 237; Popham, in London, 1958, p. 29, under lot 37; Heinemann, 1962, I, p. 54, under no. 179; Robertson, 1968, p. 25; Washington, 1973, pp. 208-10; Szabo, 1983, under no. 15 (unpaginated); Goffen, 1989, pp. 284-6; Paris, 1990, pp. 4-6, no. 2

Although the similarities between this drawing and the print of the same subject (cat. 67) are self-evident, it is even closer to the painting (cat. 69) now generally accepted as the work of Giovanni Bellini, which, like this drawing, is executed on vellum. Indeed, the extreme closeness of the two designs led Byam Shaw to attribute this drawing to Giovanni as well. However, Robertson argued that when the sheet is compared with Mantegna's pen drawings, especially those that can plausibly be dated in the 1470s and 1480s, there seems no reason to doubt its connection with him. For instance, the geological stratification of the rocks to the right is entirely characteristic of Mantegna, but does not occur in Bellini's work.

Three problematic features of the drawing have led scholars to cast doubt on its attribution to Mantegna himself. First, there are the completely unfinished passages of the head and bust of the female figure, presumably Eve, the left foot of the central figure in the group on the right, and the half-finished left arm of the Good Thief holding the cross. Second, the middle devil, the head and back of Christ and Eve's right arm are

drawn with pen alone. Finally, the shading of the left arm of the man screaming at the extreme right is weaker and more mechanical than other passages of the sheet.

Blank areas in some of Jacopo Bellini's drawings are explained by the fact that they were initially executed in leadpoint or black chalk and subsequently inked over only where they had been worn. As a result, what were the best preserved parts of the drawing, which have faded and vanished over the years, now appear blank. However, there is no indication that a complete or even a partial underdrawing, whether in leadpoint or black chalk, was ever executed for this sheet. As for the weak passages, it is tempting to wonder if they might not have been added by a pupil confronting an unfinished drawing, although if so it is odd for the original artist to have left as crucial a feature as the head of Eve incomplete. The print shows her as an aged crone, whereas Bellini in his painting made her young and beautiful.

What does seem clear, however, is that this is a creative drawing. The way the left devil's wings slightly clumsily overlap the arch of the gate and the cross does not suggest a copyist;

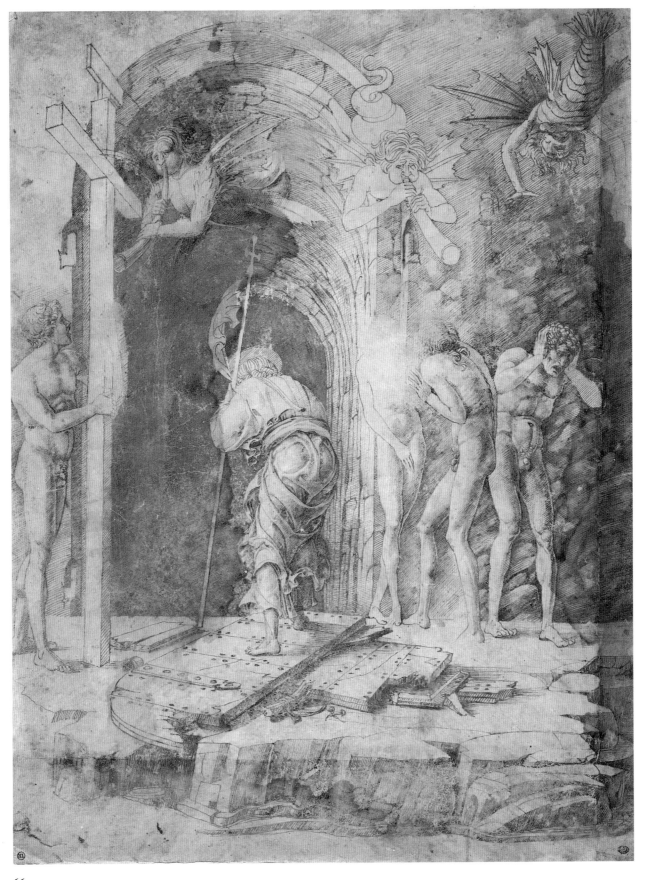

66

nor does the anatomically impossible right thigh of the wailing man. Perhaps even more telling is the fact that the artist seems to have experimented with a door hinge further to the right than the actual door. Furthermore, the quality of the best passages, such as the shattered fragments of the Gates of Hell in the foreground, is exceptionally high.

There remains the question of the relationship between this drawing and the other treatments of the subject. The Lehman drawing seems earlier, more unassuming in conception and the figures less assured. As discussed in the entry on the print (cat. 67), the contours of the figures (apart from the central demon) and the broken gates and arch were exactly transferred from the present drawing to the print. It may well be that the changes of detail between drawing and print, such as the bald and bearded central devil sounding a curved trumpet, were made directly on the plate. The same may have been true of the modifications to the landscape and the addition of a strip of sky to the right. An alternative explanation would be that one more, presumably highly finished, drawing intervened between this drawing and the print.

In the 17th century Ridolfi recorded an evidently highly prized drawing of this subject ('Christ freeing the Holy Fathers from Limbo') in 'chiaroscuro', possibly this sheet, as Berenson implied, in the collection of the Venetian inquisitor Anselmo Bresciano.

D.E.

67a, b

ATTRIBUTED TO
ANDREA MANTEGNA
Descent into Limbo

Engraving
(a) 420 x 321 mm (sheet; plate 445 x 346 mm, Vienna)
H.9

The Barbara Piasecka Johnson Collection
(Exhibited in London only)

(b) 440 x 353 mm (sheet; plate 445 x 346 mm, Vienna)
Watermark: Flower (no. 12)

National Gallery of Art, Washington, DC
(B-8, gift of W.G Russell Allen)
(Exhibited in New York only)

Late 1460s

REFERENCES
Bartsch, 1811, XIII, 230.5; Hind, 1948, V, p. 18, no. 9; Washington, 1973, p. 208, no. 80; Lightbown, 1986, p. 492, no. 216; Warsaw, 1990 pp. 78–81, cat. 11

Scholars are unanimous in attributing this engraving to a member of Mantegna's school rather than to the master himself. Indeed, it is quite different from the prints currently ascribed to the hand of Mantegna, but its status may be worth reconsidering.

First, there is nothing mechanical or tentative in the manner in which the figures are treated: Christ, Adam, Eve and the Good Thief are convincing both in their gestures and in their expressions, while above their heads the devils appear busily blowing their horns. Even the rock face, full of cracks and deep recesses where the light plays over the surface of the stones, is enlivened by the hidden profile of a fool in a cap (on a voussoir to the left of the keystone). This, an obvious joke on the viewer, would be surprising in a print not by the master. A further indirect confirmation that the print was engraved by Mantegna himself is provided by the fact that a hidden face also appears in the rocks of Bellini's version of the *Descent into Limbo* (cat. 69), an obvious response by the Venetian painter to his brother-in-law's joke.

Second, and more importantly, the print appears to develop from the drawing on vellum (cat. 66), rather than derive from it. There can be no doubt that the two are intimately connected: by superimposing enlarged transparencies of the two works, it becomes obvious that the image was transferred from one sheet to the other by tracing, or some other mechanical means. The contours of the figures, with the exception of the central demon, are exactly transferred, as are the broken gates and the arch. As the spatial relationship between the figures is not, however, maintained, it is easy to reconstruct that the figures of the Good Thief and of Christ were traced at the same time as the gates and arch, while the three figures at the right were traced in another session, and the two demons at top left and right were traced independently of each other and of any other part of the composition. Since the quality of the drawing in its well preserved parts is so high, and its attribution to Mantegna is hard to question, it is easy to exclude the possibility that the drawing is a tracing of the print. Thus, it appears likely that the drawing served as a point of departure for the print. It appears equally unlikely that an engraver from Mantegna's school could take so many liberties in copying the drawing as this engraver has. The figures are traced, but their position in the composition is changed. Moreover, there are other significant changes from the drawing to the print, such as the appearance of the demons and the shape of the cross.

Furthermore, the engraver has filled in those parts that are left blank in the drawing, and has succeeded in doing so with no diminution of quality. Unless one proposes the existence of another finished drawing by Mantegna, of identical dimensions, with figures traced from the Ecole des Beaux-Arts drawing and the blank areas minutely filled in – a somewhat improbable step for the artist to take since he could have more easily completed the sheet exhibited here – there can only be one explanation for the connection between the drawing and the print: the engraving is the final result of Mantegna's development of this version of the *Descent into Limbo*. The sheet in the Ecole des Beaux-Arts can thus be read as a preparatory drawing for the print, with small lacunae which Mantegna did not bother to complete because he could do so directly on the plate. In such circumstances, the

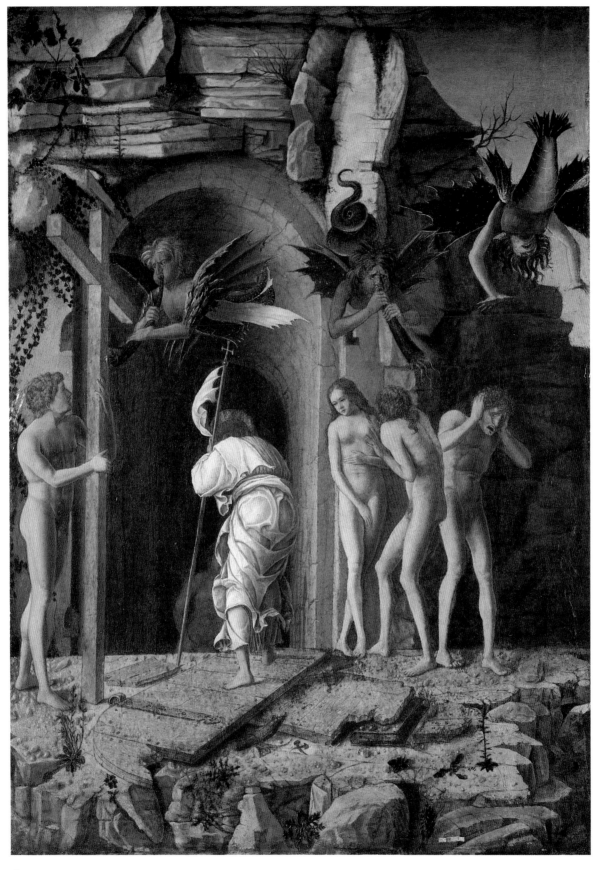

70

ANDREA MANTEGNA
Descent into Limbo

Tempera and gold on wood, 38.8 x 42.3 cm

1492(?)

The Barbara Piasecka Johnson Collection
(Exhibited in London only)

PROVENANCE
Until 1708, Ferdinando Carlo Gonzaga, Duke of
Mantua(?); until 1795, Marchese Jacopo Durazzo,
Genoa(?); from 1795, The Durazzo family, Genoa(?);
1930, Ernesto Bertollo; 1930, Agnew's, London;
1930-73 Sir Stephen Courtauld, Taynuilt, Argyll; sold
Sotheby's, London, 11 July 1973, lot 10); 1973-4,
Colnaghi & Co., London; 1974-88, J. de Beistegui
collection; 1988, Barbara Piasecka Johnson, Princeton,
New Jersey

REFERENCES
Fiocco, 1937, p. 77; Hind, 1948, V, pp. 18-19; Byam
Shaw, 1952, p. 158, n. 7; Tietze-Conrat, 1955,
pp. 197-8; Möhle, 1959, p. 170; Paccagnini, in
Mantua, 1961, pp. 169, 175; Cipriani, 1962, p. 79;
Garavaglia, 1967, no. 34; Berenson, 1968, p. 241;
Oberhuber and Sheehan, in Washington, 1973,
pp. 208-11; Elam, in London, 1981, p. 17; Lightbown,
1986, pp. 437-8; Kimmelman, 1988, pp. C1, C24;
Gentili and Labuda, in Warsaw, 1990, pp. 72-7

This exquisitely painted and deeply affective
picture first came to general attention in
1934, when it was exhibited at Burlington
House (Winter Exhibition, no. 23). It appears
to have been one of Mantegna's most ad-
mired works. Two painted copies of it exist:
one, formerly in the collection of Count
Valier, Asolo, now in the Blaffer Foundation,
Houston (see Pignatti, 1985, pp. 58-61, who
tentatively described the picture as a late
work by Mantegna, and dated the Johnson
painting to the late 1460s); the other,
formerly in the Zambeccari Collection, now
in the Pinacoteca Nazionale, Bologna. A
detailed drawing after the figure of Christ also
survives (cat. 71). Additionally, Hind lists four
later prints that repeat its composition (three
are certainly of the 18th century while one
may be later). One of these is signed '*Gio
de Pian*' and dated 1795: Giovanni de Pian
(1764-1800) was active in Venice as a
reproductive engraver before 1797.

Another is inscribed *1492/MA/AMF*. As Hind
and Borenius (1923, p. 52) suggested, it is
possible that this or the third print was carried
out by the painter-engraver Francesco
Novelli (1764-1836), who is known to have
made engravings after Mantegna's drawings,
studied his prints, and in January 1797 wrote
from Venice that he had seen a picture of this
subject by Mantegna in the collection of the
Marchese Jacopo Durazzo, Imperial
Ambassador in Venice from about 1774 until
his death in 1795 (Campori, 1866, pp. 325,
327). The engravings are of considerable
importance in establishing the celebrity of the
picture in the 18th century and its
provenance.

Before the picture reappeared, Kristeller
(1901, p. 103) had thought that these copies
and engravings derived from a lost drawing
by Mantegna of the 1450s. Hind, however,
realised that the Johnson picture was the
source for the engravings. Nonetheless,
because it had seldom been exhibited, doubts
about its status persisted. Fiocco preferred the
weak picture now at Houston; Berenson
listed it as after Mantegna's design; and
Oberhuber and Sheehan regarded it as a
copy. Most other specialists have,
understandably, reserved judgement.

A fresh evaluation was made possible by
the exhibition of the Johnson picture at the
Metropolitan Museum in 1988 (see
Kimmelman). There can no longer be any
serious doubts about either the status or the
late date of the painting. In facture and
emotional tenor it stands midway between
the *Virgin of the Stonecutters* (fig. 3; Uffizi,
Florence), which is painted on roughly the
same scale, and the *Man of Sorrows with Two
Angels* (cat. 60), in which the expressive
vibrato so characteristic of his paintings after
1490 achieves an almost unbearable
poignancy. Vasari (ed. 1878-85, III, pp. 401-2)
states that the *Virgin of the Stonecutters* was
painted in Rome, and it must therefore date
from *c.* 1500, while the *Pietà* seems to date
from *c.* 1495. The relationship of the Johnson
Descent into Limbo to these two works lends
credence to the date recorded on the 18th-
century engraving and raises the possibility
that the picture or its frame originally bore
Mantegna's monogram (*A[ndreas] M[antinia]
F[ecit]*) and the date 1492.

Any proper analysis of the picture must allow
for the fact that it has been cropped at the top
and at the left. Precisely how much is
impossible to say: the 18th-century prints
show the composition in its present state,
while the painted copies, which have a
vertical format, include the top of the cave,
although in one there are trees and in the
other the cave is bare. There are remnants of
two gold straps or part of a finial attached to
Christ's standard visible along the upper
border of the picture. Although the paint is
thin in places, on the whole the condition is
very good. The gold highlights on Christ's
blue cloak − a favoured technique of
Mantegna's that can be traced back to the
Adoration of the Shepherds (cat. 8) of
c. 1450-51 − is still intact, as is his halo.

Unquestionably, the most notable aspect of
this painting is the shift in mood from the
dramatic interpretation of the event in the
earlier print and drawings, where Christ's
arrival is heralded by blaring horns, and the
Gates of Hell lie splintered beneath his feet,
to a mood of silent expectancy, broken only
by the blast of wind issuing from the depths
of the cavernous opening, shown as a natural
rock formation rather than the carved
entrance of Mantegna's earlier designs. To
one side of the barren plateau pierced with
burrowed holes − a motif found in the
Parnassus but here made peculiarly eerie by
the absence of any animal − are aligned four
figures, two of whom are evidently Adam
(draped to cover his nudity) and Eve (for
alternative identifications, see Gentili in
Warsaw, 1990, p. 74). They greet Christ with
gestures of rapt devotion. To the other side,
evidently in reaction to the rescue of the
bearded man within the cave (whose pose and
type is reminiscent of Vulcan in the *Parnassus*)
and his almost invisible companion, an
ancient patriarchal figure breaks into an
excited dance, much as David did before the
Ark of the Covenant (II Samuel 7:14). No
longer is Christ's drapery gathered about his
body in those large, angular folds by which
Mantegna defined the underlying anatomy in
his works of the 1460s. Rather, the hem of
his robe and cloak eddy around his legs,
activated by the same wind that sweeps his
hair upwards and agitates the diminutive
banner. This fluttering drapery is a recurring

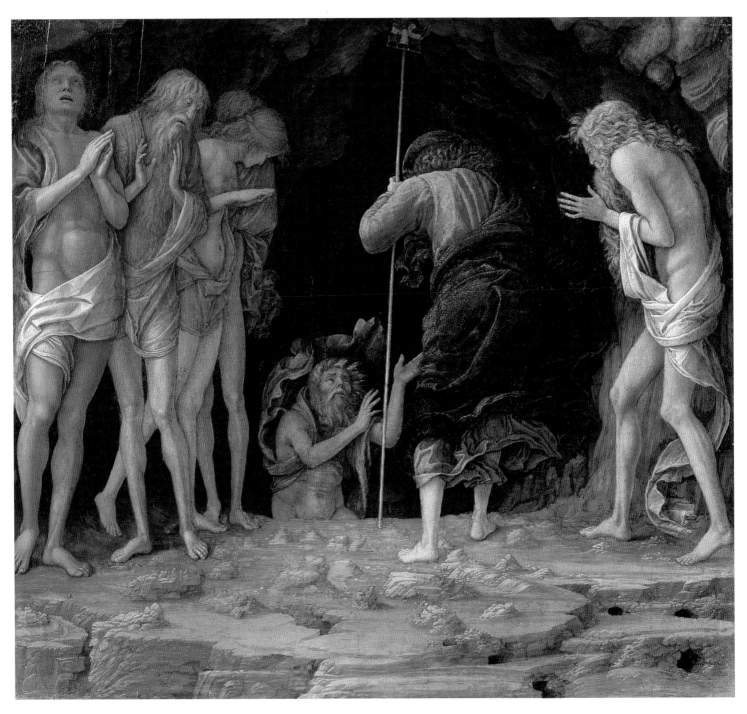

70

feature of Mantegna's work after *c.* 1490, but nowhere else does it have the same emotive effect.

Because of its late date, the picture can hardly be the '*instoria del linbo*' on which Mantegna was working for Ludovico Gonzaga in 1468 (Kristeller, 1902, doc. 39). It seems, nonetheless, to have been a Gonzaga commission. A '*G[esu] C[risto] che và al linbo fatto dal Mantegna*' is listed in a Gonzaga inventory of *c.* 1700-08 (D'Arco, 1857, p. 189) and again in 1709 (Luzio, 1913,

p. 317), when the dimensions are given as 2½ x 3 *quarte* (ie. 39.9 x 47.9 cm), more or less those of the panel as cut down. The Gonzaga picture was sold in Venice, and it was there that the Johnson picture must have been studied by two of the 18th-century engravers. According to Novelli's letters, cited above, it was removed to Genoa after the death of Jacopo Durazzo (see also Lightbown, pp. 437-8).

K.C.

71

AFTER ANDREA MANTEGNA
Christ Descending into Limbo

Pen and wash with white heightening on faded blue prepared paper. Somewhat cracked and spotted, but the figure is generally well preserved. A small '*f*' in the bottom right corner
283 x 201 mm

Late 15th century

Staatliche Museen Preussischer Kulturbesitz, Berlin, Kupferstichkabinett (KdZ 622)

REFERENCES
Kristeller, 1901, p. 103; Halm, Wegner and Degenhart, 1958, p. 24, under no. 8; Mantua, 1961, p. 169, no. 124; Lightbown, 1986, p. 488

This drawing is identical in every particular to the figure of Christ in Mantegna's painting of the *Descent into Limbo* (cat. 70), but it differs markedly from all the other treatments of the theme by the artist. The pose and every fold of the drapery are exactly reproduced, and even the white heightening in the drawing corresponds exactly to the gold leaf in the painting. It also repeats the outline of the mouth of Hell and the shadows cast by Christ's feet. Only the angle of Christ's staff is fractionally less vertical, and it does not have a banner at its top.

Even before the Johnson painting was accepted as Mantegna's original, however, this sheet was generally dismissed as a copy, principally on account of its hard and ponderous draughtsmanship. When it was shown together with the painting (in an exhibition at the Metropolitan Museum, New York, 1988) its derivative character was plain to see. From what we know of Mantegna's working methods it seems that he did not make highly finished preparatory drawings of individual figures in paintings. This drawing is not pricked for transfer, and yet, as with all the other Mantegnesque drawings in this technique, it is exactly the same size as the painting. It appears to be a *simile*, a drawing prepared in Mantegna's

workshop by a technically highly competent assistant, and then preserved as part of the artist's studio property, probably both for repetition and for study purposes. The proportionately high survival rate of such sheets as against working drawings seems to indicate that they were well looked after.

There is no reason to accept Lightbown's suggestion that this is the drawing mentioned by Ridolfi (1648) as having belonged to Anselmo Oliva: that sheet was presumably a compositional drawing, not a study of an individual figure; it may have been cat. 66.

D.E.

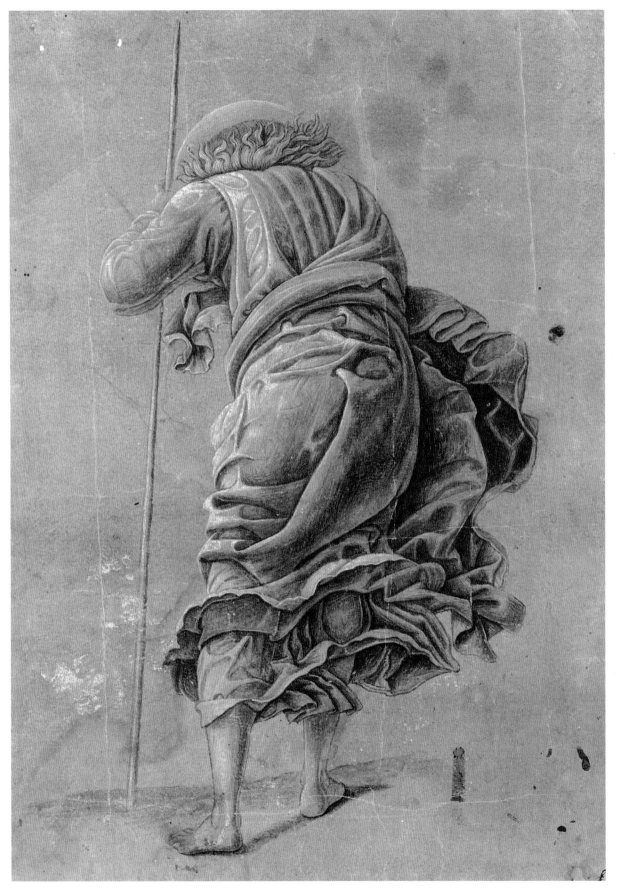

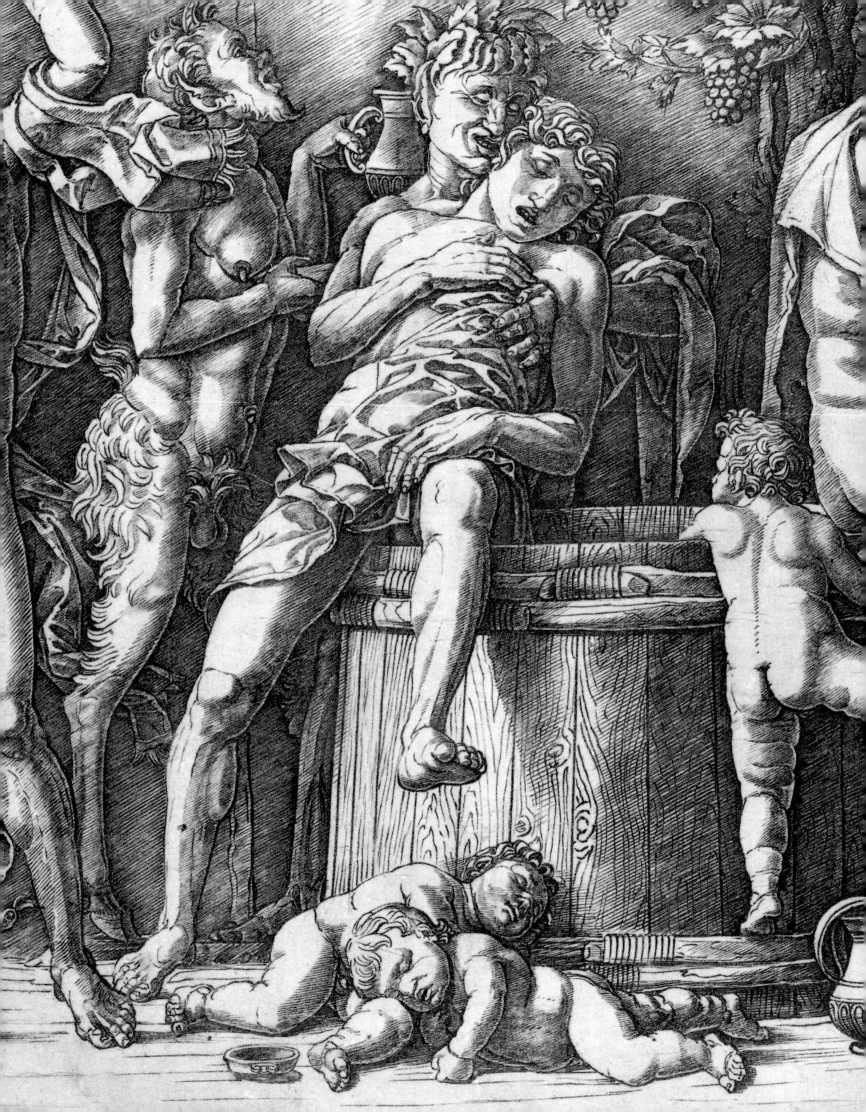

4 MYTHOLOGICAL AND CLASSICAL THEMES

Although Mantua, unlike Padua, had no Roman remains, once Mantegna settled there in 1460 in the service of the Gonzaga, he continued to take every opportunity to visit Roman sites, inspect ancient objects in the collections of his patrons and friends, and study drawings after the antique. His famous excursion to Lake Garda in 1464 (see p. 17) was made specifically to search for Roman inscriptions.[1] In 1472 Cardinal Francesco Gonzaga asked Mantegna to visit him at the baths at Porretta to discuss the Cardinal's collection of 'cameos, bronze figures and other fine antiquities',[2] and although this particular meeting may not have taken place (see p. 18), Mantegna clearly knew at least one highly prized gem in the Cardinal's collection (see below). A letter of October 1476 from the Gonzaga agent in Florence, Angelo Tovaglia, to Ludovico Gonzaga requested a 'book of pictures of certain antique sculpture, of which most are battles of centaurs, fauns and satyrs and also men and women on horseback and on foot'; Ludovico replied that the book had been in Mantegna's possession.[3] The book may have been something like the sketchbook described on p. 97, although that one also included drawings of Gothic and contemporary works as well as antique sculpture.[4] Mantegna himself made drawings of antiquities (cat. 45); his two beautiful drawings of birds (cats. 72, 73) may have been copied from antique fragments, although no specific source has been identified.

Among Mantegna's most famous compositions, reflecting his lifelong fascination with antiquity, are the Bacchanals and the *Battle of the Sea Gods* (cats. 74, 75, 79). Various conjectures have been made as to the purpose of these designs; it has been suggested that they were originally destined to decorate one of the Gonzaga country palaces;[5] one scholar has even proposed that a single room was intended to be decorated with the Bacchanals, the *Sea Gods* and the *Triumphs of Caesar*,[6] although this incongruous embarrassment of riches would seem implausible. It has also been suggested that the compositions were meant to exist only as prints.[7]

These compositions, both in form and subject, recall Roman sculptural reliefs, specifically sarcophagi carved in high relief.[8] The *Battle of the Sea Gods* (cat. 79) has been shown by Bober to have its principal source in a sarcophagus relief which was then in the della Valle collection in Rome.[9] The figure of Neptune on a pedestal in this same print, and perhaps other features of its composition, derive from the Felix Gem, a sard intaglio of the second half of the first century BC (Ashmolean Museum, Oxford), which was in the collection of Cardinal Francesco, perhaps acquired directly after the death in 1471 of its former owner, Pope Paul II.[10] Mantegna's reuse in the *Battle of the Sea Gods* of specific figures, as well as elements of the compositional structure of both relief and gem, is a prime example of the way his imagination worked to reformulate antique sources into an entirely original design.

A similar reuse of an antique visual source, hitherto unnoticed, occurred in the *Bacchanal with a Wine Vat* (cat. 74). The congruence between the figure of Bacchus – if that is the correct identification for the standing figure just to left of centre – in the *Bacchanal with a Wine Vat* and that of Mars, the central figure on a Roman sarcophagus of the *Judgement of Paris* (fig. 87), is striking, and the figures to the left of Bacchus in Mantegna's

fig. 87 Sarcophagus with the Judgement of Paris, Roman,
2nd century AD, Villa Medici, Rome

composition echo those to the left of Mars in the relief,
Although the earliest surviving drawing of the sar-
cophagus dates from the early 16th century, the relief,
which was also in the della Valle collection, was known
earlier, for elements of Mantegna's composition un-
questionably derive from it.[11] The same relief was used as
the basis for Raphael's *Judgement of Paris*, engraved by
Marcantonio Raimondi (Bartsch, XIV, 197.245). Another
sarcophagus, illustrating the story of Bacchus and
Ariadne, now in the British Museum, London, but at
Santa Maria Maggiore in Rome during the 15th century,
was copied by artists at that time, and several drawings of
it survive.[12] Some of its figures seem to have been
adapted for use in the *Bacchanal with Silenus* (cat. 75).
Mantegna's Silenus recalls the Silenus riding a donkey on
the relief, and the obese woman riding on the back of a
man is close to that of Pan and the figure holding him in
the *Chastisement of Pan*, depicted on the right end of the
sarcophagus.[13] When Marcantonio adapted the com-
position in an engraving (Bartsch, XIV, 231.305),[14] he also
made the figure riding piggyback a woman, probably
because he knew Mantegna's print.

In the instances where antique visual sources can be
identified, it can be seen that Mantegna recast his models
into compositions in his own idiom. In the same manner,
he (or his advisers) seldom specifically followed one
ancient literary text, but combined characters and ideas
from numerous sources. With some exceptions, for
example illustrations of the *Labours of Hercules* (see cats.
86-97) or *The Calumny of Apelles* (cat. 154), Mantegna
tended to treat themes inspired by classical literature or
art as moralising allegories. The Bacchanals are apparently
indictments of drunkenness, lust and sloth, although the
heroic character of Bacchus – if the principal figure is
indeed he – leaves some room for doubt.

The *Battle of the Sea Gods* (cat. 79) has been inter-
preted by Jacobsen as an allegory of envy.[15] Envy is
personified as an emaciated hag at the left of the com-
position, standing on the back of a sea creature, holding a
plaque inscribed with her name. According to Jacobsen,
the composition alludes to the Telchines, a race of artists,
primarily sculptors, who lived on the Greek island of
Rhodes, and who were described as envious and spiteful
in Strabo's *Geography* and Nonnus' *Dionysiaca*. The inter-

pretation is plausible: these texts were known in Mantua in Mantegna's day, and the theme of envy continued to obsess Mantegna until the last years of his life (see cat. 154). If the *Battle of the Sea Gods* is a depiction of envy on the part of a race of sculptors, it may also reflect Mantegna's own particular sense of *paragone* with sculptors (the debate of the relative merits of the work of painters and sculptors was anyway current at this date), and may be an ironic declaration of victory on his part. The sculptors are envious, presumably of Mantegna himself, who not only could create sculpture in two dimensions, but in these extraordinary compositions could recreate the sculpture of antiquity.

S.B.

NOTES

1. Kristeller, 1902, doc. 34; Lightbown, 1986, pp. 95-6
2. Kristeller, 1902, docs. 45-7.
3. Brown, 1973, pp. 158-9.
4. See Degenhart and Schmitt, 1960; *idem*, 1966, pp 13-17, 25-42; Cavallaro, in Rome, 1988, pp. 89-100.
5. Kristeller, 1901, p. 397. Battisti, 1965, pp. 25-31, associates a poem by Mantegna's contemporary Battista Fiera, which mentions Bacchic subjects painted in a Gonzaga palace on the Po, with the Bacchanals.
6. Vickers, 1978, pp. 365-70.
7. Jacobsen, 1976, p. 71; Zucker, 1984, p. 90.
8. See Bober and Rubinstein, 1986, p. 31.
9. Bober, 1964, p. 48; see Bober and Rubinstein, 1986, pp. 131-3, no. 100; Rome, 1988, pp. 159-60, no. 52.
10. The derivation was pointed out by Vickers, 1976, p. 831, n. 50; see also Vickers, 1983, pp. 98-9. For the Felix Gem, see Pollard, 1977, p. 574; Northampton, 1979, no. 8; Brown, 1983, p. 102; Lightbown, 1986, p. 116.
11. The sarcophagus was sold to the Medici in 1584. See Bober and Rubinstein, 1986, pp. 149-50, no. 119; and *idem*, 1986, pp. 479-80, for the della Valle collection.
12. Renaissance drawings of the sarcophagus are catalogued in Rubinstein, 1976, pp. 113-23; see also Bober and Rubinstein, 1986, pp. 116-19, no. 83; Rome, 1988, pp. 161-71.
13. This similarity was apparently first noticed by Simon, 1971-2, p. 28.
14. See also Bologna, 1988, p. 140, no. 26.
15. Jacobsen, 1976, pp. 102-24; *idem*, 1982.

72

ANDREA MANTEGNA
Bird on a Branch

Pen and brown ink
104 x 115 mm

Late 1460s

National Gallery of Art, Washington, DC
Andrew W. Mellon Fund.

PROVENANCE
J. Richardson, senior; A. Dyce; J. C. Robinson;
A. E. Gathorne-Hardy; sold Sotheby's, London,
28 April 1976, lot 7

REFERENCES
Popham and Pouncey, 1950, p. 99, no. 160; London,
1953, p. 10, no. 18 (Washington drawing); Mezzetti,
1958, pp. 240-42; London, 1976, lot 7; Lightbown,
1986, pp. 483-4, nos. 186, 187

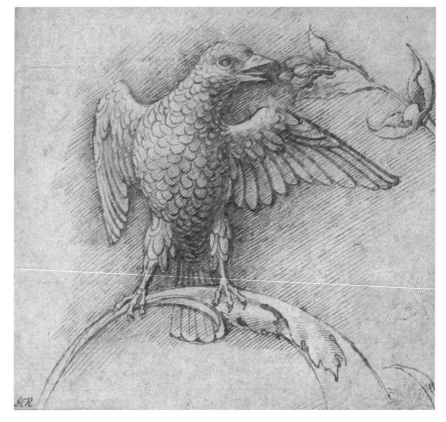

72 (actual size)

73

ANDREA MANTEGNA
Bird on a Branch Catching a Fly

Pen and brown ink, corners cut
128 x 88 mm

Late 1460s

The Trustees of The British Museum, London
(1945-7-13-7)

PROVENANCE
J. Richardson, senior; Sir Thomas Lawrence,
S. Woodburn; sold Christie's, London, 6 June 1860,
lot 552; Sir Thomas Phillipps; T. Fitzroy Fenwick

For references, see cat. 72, above.

These two drawings, which may have once
formed part of a larger single sheet, both
belonged to Jonathan Richardson, senior
(d. 1745), who correctly attributed them to
Mantegna. This ascription has not generally
been doubted, but there has been less
agreement about their dating. For Mezzetti,
they are early works executed in the circle of
Squarcione, and betray the same hardness of
touch as the Ovetari Chapel frescoes. By
contrast, Popham and Pouncey compared
the penwork with that of the drawing of the
Virgin and Child (cat. 49), while Lightbown

suggested that the studies must date from
Mantegna's Mantuan period, that is to say
after 1460.

There can be no serious doubt that
Lightbown's dating is correct, but it should
be possible to be more exact. The degree of
finish is not the only factor that distinguishes
these drawings from the group of sheets here
assigned to the early 1460s around the *Christ
at the Column* (cat. 35). There, the pen line is
both freer and less uniform; at its most
tentative much thinner, at its boldest much
thicker. But, by comparison with the late

pen drawings, such as the *Virgin and Child* (cat. 49) and the *Calumny of Apelles* (cat. 154), the pen line of the *Birds* is slightly heavier and more insistent. It thus seems reasonable to place them somewhere between the two dates, and in fact the drawings they have most in common with are the *Five Designs for a Cross* (cat. 50), the *Risen Christ* (cat. 44) and the *Man Lying on a Stone Slab* (cat. 43), all of which are here dated to the late 1460s or early 1470s. Within the sequence they may be the earliest, perhaps the first of Mantegna's drawings to employ fine diagonal hatching as a backdrop to the image. Such a dating also places them in the same period as the two compositional studies of the *Descent into Limbo* (cats. 65, 66), with which they do not appear to be incompatible.

Both studies show distinctly stylised birds, very different from those found in the work of Pisanello and in the north Italian tradition of nature studies, perched on acanthus branches, one of them about to devour a fly, while the other pecks at a berry. As Mezzetti pointed out, they are inspired by an Imperial Roman relief of a type known through an example in the Uffizi (Mansuelli, 1958, I, no. 1), although that particular relief was probably not Mantegna's source, since it appears not to have been discovered until 1568. She also pointed out that similar birds are found on the pilasters flanking the main portal of Sant'Andrea in Mantua, executed by the local sculptors Antonio and Paolo Mola towards the end of the 15th century. While Mantegna is unlikely to have made these drawings for the sculptors, there is no reason why they should not subsequently have availed themselves of the motifs, either through the drawings or by working directly from the antique prototype.

D.E.

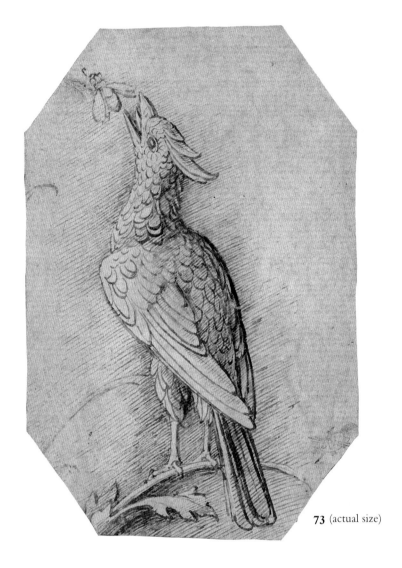

73 (actual size)

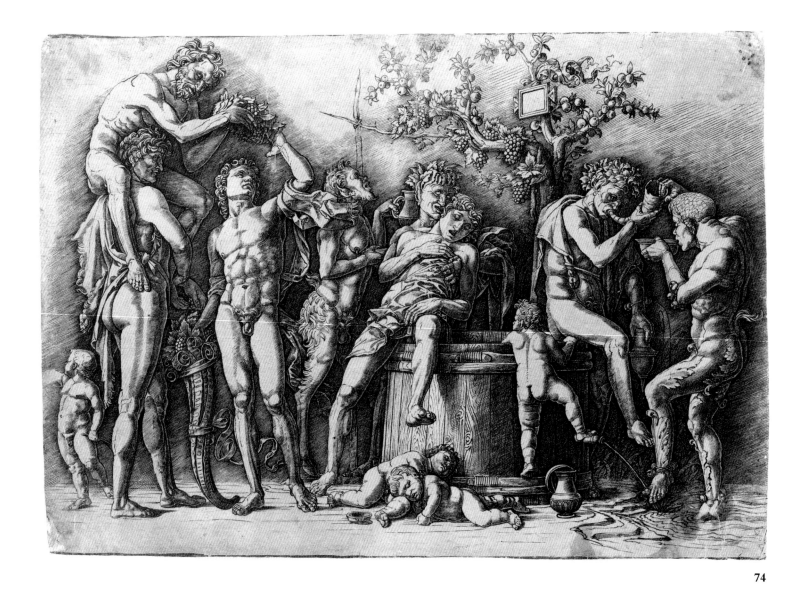

74

74

ANDREA MANTEGNA
Bacchanal with a Wine Vat

Engraving and drypoint
299 x 437 mm (sheet; plate 335 x 454 mm, London)
H.4

Early 1470s

The Metropolitan Museum of Art, New York,
Rogers Fund and the Elisha Whittelsey Collection,
The Elisha Whittelsey Fund, 1986 (1986.1159)

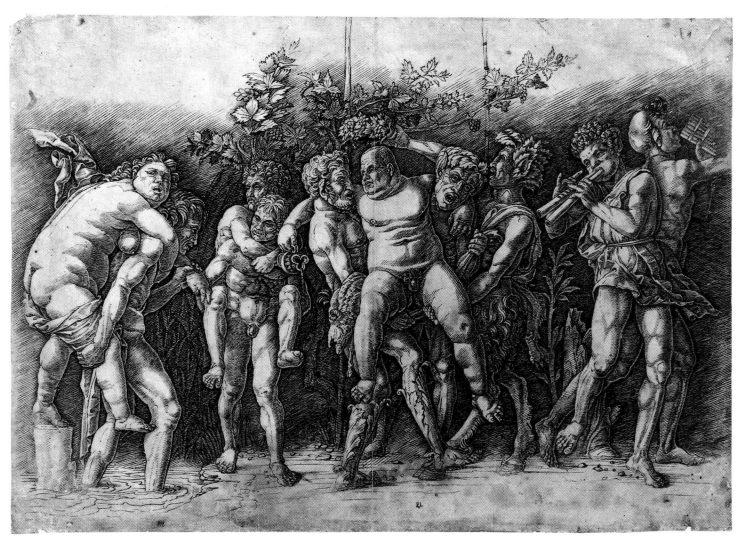

75

75

ANDREA MANTEGNA
Bacchanal with Silenus

Engraving and drypoint
299 x 437 mm (sheet; plate 335 x 454 mm, London)
H.3
Watermark: ?Basilisk (no. 1)

Early 1470s

Duke of Devonshire and the Chatsworth Settlement
Trustees

REFERENCES
Bartsch, 1811, XIII, 240.19 and 20; Hind, 1948, V,
pp. 12-13, nos. 3 and 4; Levenson, Oberhuber and
Sheehan, in Washington, 1973, pp. 182-6, nos. 73 and
74; Zorzi, 1988, p. 144 and pl. LXXXI

Slight stylistic differences between these two
prints have suggested to most scholars that
they were not conceived as a frieze, but
rather as pendants. It seems clear that the
Bacchanal with a Wine Vat was engraved
earlier than its companion: first, because the
scene seems to flow from left to right and it
would have been natural for Mantegna to
start engraving the left half (or left pendant)
first. Second, because the left scene is
engraved in a style closer to his earlier prints,
particularly the *Entombment* (cat. 29) and the
Risen Christ between St Andrew and Longinus
(cat. 45), which must have just preceded it.
Compare, for instance, the head of St John
in the former with that of the standing man

at the extreme left of this Bacchanal, or the
body of Christ in the latter with that of
Bacchus here. Third, because the engraving
technique seems to have developed between
the two prints, in that cross-hatching seems
to make its first substantial appearance in
Mantegna's prints in the *Bacchanal with
Silenus*: this device, previously avoided by
the artist, might have been used to impart a
greater blackness to the scene on the right, as
the light is coming from beyond the left edge
of the left half. Since the satyr on the
extreme right of the scene with the wine vat
dances in the same puddle of wine in which
the man carrying a woman is wading on the
left of the scene with Silenus, and as there

seems to be a balanced curve running from top left to top right across the two prints, punctuated at each third by the vine or its trellis, it seems possible that the two Bacchanals were intended as a frieze. The two scenes were engraved on either side of the same plate.

It would seem that these two prints were produced in that burst of printmaking activity that must have followed Mantegna's discovery of the combination of engraving and drypoint. They show further experimentation and subtlety in the handling of both tools, and achieve striking effects, which are only apparent in the very rare early impressions such as those exhibited: it is solely through the control of the shading obtained with the drypoint that the characters' faces are given that extraordinary appearance of total inebriation: few artists have portrayed the torpid stupor of drunkards so vividly. In later impressions, all the force of Mantegna's moralising message – surely, the very meaning of these two prints – is lost, and all that remain are the harsh and sober lines engraved with the burin.

The dating of the Bacchanals to the early 1470s is also confirmed by the fact that the two earliest impressions of the *Silenus* – the one exhibited here and that in the Museum of Fine Arts, Boston, – are printed on a paper with the Basilisk watermark (no. 1), the same as that which appears in the earliest impressions of both states of the *Entombment* (cat. 38) and the *Battle of the Sea Gods* (cat. 79), all of which I place in the 1470s. Further corroboration comes from a comparison with the figure in the contemporary drawing of a *Man Lying on a Stone Slab* (cat. 43), who is very close to the sleeping youth at the centre of the scene with the wine vat, both in his features and in the treatment of the chiaroscuro. A hitherto unnoticed *ante quem* date is provided by a miniature in a manuscript of Pliny's *Natural History* (Biblioteca Marciana, Venice), where a putto is copied precisely from that at the extreme left of the *Bacchanal with the Wine Vat*. The manuscript was completed in 1481.

D.L.

76

GIOVANNI ANTONIO DA BRESCIA
Bacchanal with Silenus

Engraving
304 x 440 mm (sheet; plate size unknown)
H.3a

c. 1500–04

Graphische Sammlung Albertina, Vienna (1951-358)

REFERENCES
Bartsch, 1811, XIII, 240.20, copy I; Passavant, 1864, V, 83.42 (Zoan Andrea); Hind, 1948, V, 13.3a

This very close copy of the *Bacchanal with Silenus* (cat. 75) can be distinguished from the original, as Bartsch pointed out, by the fact that three lines on the back portion of the right hoof of the satyr supporting Silenus are omitted. Other differences are the presence of eight whole grapes, rather than seven, in the leftmost bunch, and three whole grapes and two partial, as opposed to six whole grapes, below the small branch in the rightmost bunch. In general, the forms, especially of the vines, are simplified, as is usual in a copy, and the lines harsher.

Bartsch knew this engraving but did not venture an attribution. Passavant suggested Zoan Andrea (as for cat. 77), which Hind called 'possibly correct'. Although its technique is rather more animated than that of the general run of prints by Giovanni Antonio da Brescia, it seems likely that it was he who made the print. A watermark of a Profile Head (?) in a Double Circle on an impression of this print in Cleveland, one that is seen on some other prints by Giovanni Antonio, tends to confirm the attribution (see Appendix II).

A smaller copy of this composition (Hind V, 13.3b) bears a monogram that was read by Passavant as '1515', with the '5's in reverse; this seems reasonable. Although Hind wrote that 'the relationship in style of engraving is not sufficient to support an identification' to the Master of 1515, given the fact that several third-generation versions of Mantegna's images seem to have been made by this engraver, an attribution of that print to him is not implausible.

An impression of this print (Museo Schifanoia, Ferrara) appears to be in an undescribed later state; in it a tablet has been added to the bottom right (see Russo, 1990, ill. on p. 12).

S.B. and D.L.

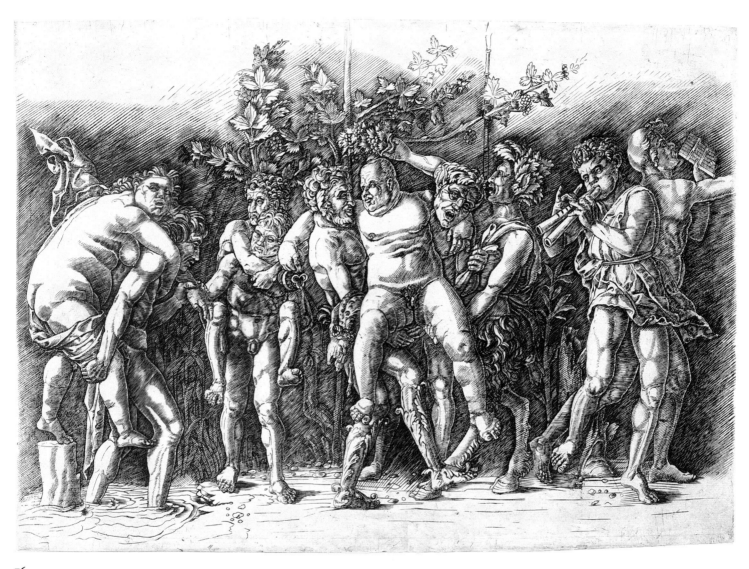

76

77

GIOVANNI ANTONIO DA BRESCIA
Bacchanal with a Wine Vat

Engraving, state 1 of 2
285 x 418 mm (sheet; plate 298 x 426 mm,
Bassano, see text)
H.4b
Watermark: Orb and Cross (no. 22)

c. 1500

Museum of Fine Arts, Boston, Harvey D. Parker
Collection (P. 1007)

REFERENCES
Passavant, 1864, V, 83.41 (Zoan Andrea); Hind, 1948,
V, 14.4b

Passavant attributed this print and the full-size copy of the *Bacchanal with Silenus* (cat. 76) to the same hand, which he called Zoan Andrea, and although Hind thought the other full-size copy of this print (cat. 78) and the *Silenus* copy were more likely to be by the same engraver, Passavant was surely correct; both these prints are here attributed to Giovanni Antonio. Although there is a certain crudeness in the engraving, the regularity of stroke and the hardness of effect are characteristic of Giovanni Antonio. Furthermore, this side of this plate was burnished and reused for the engraving of *Virtus Combusta* (cat. 148), here also attributed to Giovanni Antonio; finally, the one watermark found on an impression of this print, an Orb and Cross (on the impression exhibited), is also found on other prints by Giovanni Antonio (see Appendix II, c).

Giovanni Antonio's copy is close to cat. 74 but in reverse. Nonetheless, some differences can be discerned: a leaf on the apple tree touches the post supporting the grapevine, whereas in the original there is space between them; the *tabula ansata* slants at a steeper angle and, as Hind mentioned, here the binding on the upper of the two hoops near the base of the barrel is less regular in width.

The uncertainty in handling suggests that this print should be placed among the earliest of Giovanni Antonio's copies of designs by Mantegna; this is corroborated by the subsequent burnishing and reuse of the plate.

Although no impression of this image with a full platemark has survived, the dimensions of the few known impressions approach those of the plate used for the *Virtus Combusta*; the oblique right side of the plate, which slants inwards towards the bottom, is visible in both images, as are nail holes in the same places. Further, in the *Virtus Combusta*, in the shaded vertical face of the block on which the right foot of the man playing the bagpipes rests, the left heel and instep of the dancing faun in the present image can be seen, imperfectly burnished out. Given that only seven impressions of this image are known it seems probable that the plate was reused at an early date.

The other side of this plate seems to have been used first for Giovanni Antonio's copy of the *Four Dancing Muses* (cat. 139), which was then burnished and used for *Virtus Deserta*, the lower half of the *Allegory of Ignorant Humanity* (cat. 148).

S.B.

78

MASTER OF 1515 (?)
Bacchanal with a Wine Vat

Engraving
282 x 425 mm (sheet; plate size unknown)
H. 4a

c. 1510-15

Museum of Fine Arts, Boston,
Harvey D. Parker Collection (P.994)

REFERENCES
Ottley, 1816, II, 505; Hind, 1948, V, 14.4a

Ottley suggested that this print might be an early version of the subject by Mantegna himself, and Hind thought it was possibly by the same hand as cat. 76, which he tentatively called Zoan Andrea. It was not known to Bartsch. Here cats. 76 and 77 are attributed to Giovanni Antonio da Brescia; this print is certainly a copy of Giovanni Antonio's version, probably by the engraver known as the Master of 1515. That this version was copied from Giovanni Antonio's print rather than from the original is indicated by the occurrence of the same divergences as in that copy (see cat. 77). Thus, these three prints would be in the same relation as the three vertical prints of the *Entombment* (cats. 38, 39, 40) and the three smaller prints of *Hercules and Antaeus* (cats. 86, 87, 88); for other attributions to the Master of 1515, see cats. 31, 80, 88, 92.

This print displays the qualities characteristic of this engraver: the effect of light playing erratically over the forms, a certain undisciplined energy in the use of the engraver's tool, especially evident in the background shading, and sometimes exaggerated emphasis on the interior modelling lines. (For a discussion of the possible identity of the engraver, see cat. 31.)

If it is correct that this print and the copy of the left half of the *Battle of the Sea Gods* (cat. 80) are by the same hand, it is possible they were engraved on either side of the same plate, since their dimensions are similar. That print is known in a unique impression, this one in six, which might indicate that the plate was burnished for reuse at an early date.

S.B.

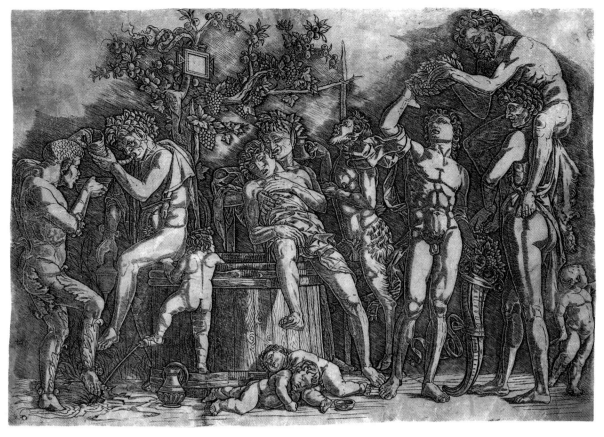

77

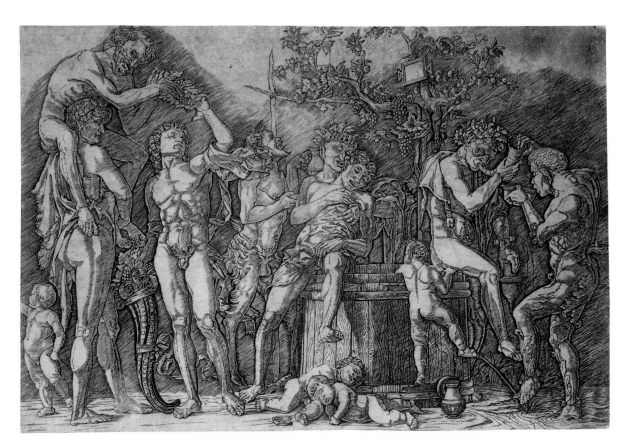

78

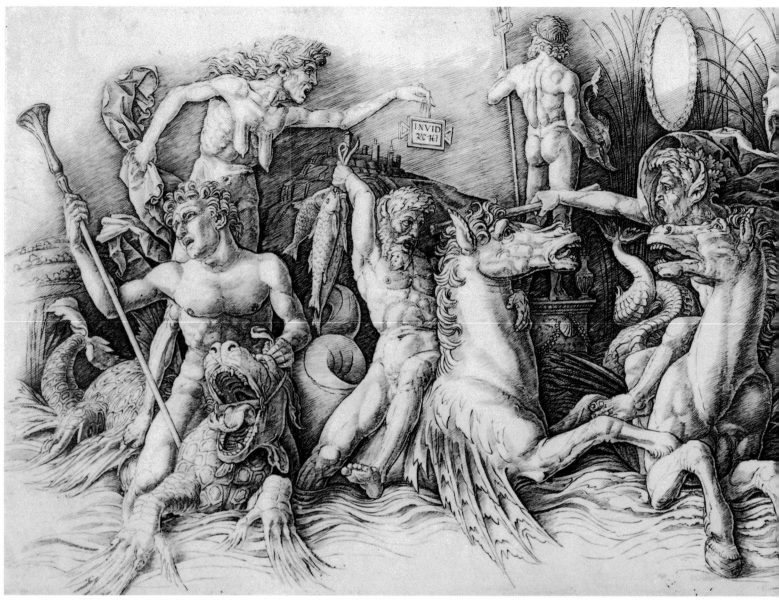

79

ANDREA MANTEGNA
Battle of the Sea Gods

Engraving and drypoint, state 1 of 3
283 x 826 mm overall (sheets; plates: left, 340 x 445 mm,
Paris; right, 340 x 454 mm, Minneapolis)
H.5 and 6

1470s

Duke of Devonshire and the Chatsworth Settlement
Trustees

REFERENCES
Bartsch, 1811, XIII, 239. 17 and 18; Hind, 1948, V,
p. 15, nos. 5 and 6; Bober, 1964, pp. 43-8; Brown, 1973,
p. 153; Levenson, Oberhuber and Sheehan, in
Washington, 1973, pp. 188-93, nos. 75 and 76;
Armstrong, 1981, p. 132, no. 46; Jacobsen, 1982,
pp. 613-28; Lightbown, 1986, p. 241

It has been suggested that the Bacchanals may
have been conceived as a frieze (see cat. 75),
although an element of doubt remains. No
such uncertainty applies to the two halves of
this allegory of human envy. Mantegna left
clear indications as to how to unite the two
halves. First, he cut the body of a sea god in
half; second, he engraved a clear, albeit thin,
borderline at the right edge of the left sheet;
third, he supplied a strip of blank paper,
16mm wide, beyond the borderline, so that
there would be room to paste the right half
on top of the left half; finally, he provided the
right sheet with a clear-cut left edge to the
image but no borderline, so that the scissors
could be applied at the right spot, the sheet
could be neatly pasted over the other and the

continuity of the image be preserved.

In this spectacular impression Mantegna
exploited to the full the technical expertise
gained in incising the plates of the
Entombment (cat. 38), the *Risen Christ Between
St Andrew and Longinus* (cat. 45) and the
Bacchanals (cats. 74, 75). The tremendously
rich play of light is achieved by the use of the
burin and drypoint, which gave the
impression that the print was printed in two
shades of the grey-brownish ink: in between
the strong, deeply inked burin strokes, the
shallow lines produced by the drypoint
generate an almost transparent, ethereal film
of grey tone, as if it had been applied with a
brush. This is lost in later impressions, which
look almost like tracings of the image.

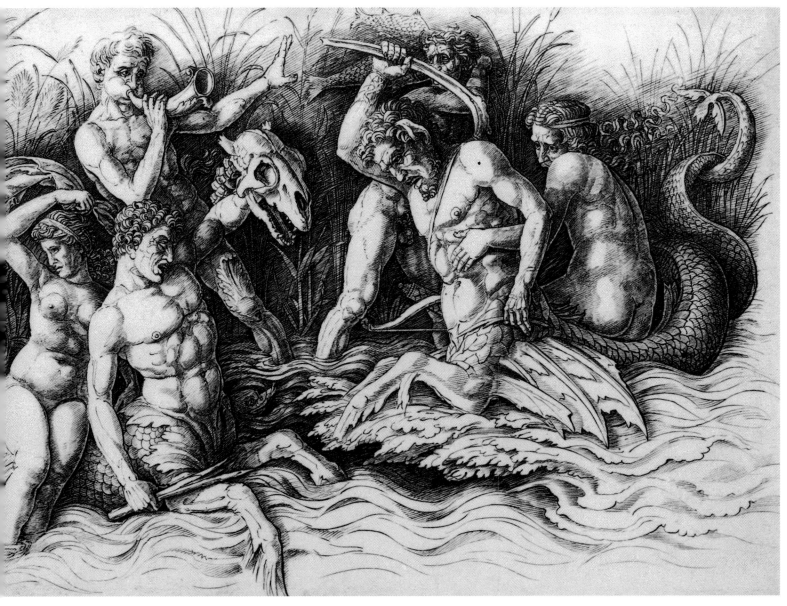

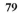

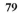 79

Moreover, sometime in the 16th century both plates were completely re-engraved by deepening with a burin the grooves that were becoming too shallow, a device that must have been employed on most plates by Mantegna and one that compromised their appearance for ever. In the case of the *Battle of the Sea Gods* we know that both halves were re-engraved, as traces of such work are apparent in some impressions: in the left half, these are mainly slipped strokes of the burin that were not present in earlier impressions, such as those on Neptune's trident or just to the left of the mouth of the sea monster on the left; a further, later, reworking is revealed by a roughly triangular patch of crude cross-hatching between the waves at the bottom

right, level with the top of the horse's left hoof. The reworking on the right half was described by Hind, who noticed that the flowers of the bullrushes were shaded when the plate was re-engraved.

With the exception of the late *terminus ante quem* of 1494, found on Dürer's copy of the right half of the print, there is little evidence to help place this composition within Mantegna's *œuvre*. A number of factors, however, suggest that it was made shortly after the Bacchanals, during the period in the 1470s in which it is suggested here that most of his prints were produced. A somewhat similar depiction of a *Triumph of Sea Creatures* – which even includes a figure of Neptune seen from behind holding a trident with one

hand and a dolphin with the other – by the miniaturist known as the London Pliny Master, testifies to the fashion for such subjects in the late 1470s, as Armstrong (1981) has pointed out. A similar taste is evident in a sketchbook containing copies after antique sculpture, evidently known to Mantegna, described in a letter from Angelo Tovaglia to the Marchese Ludovico Gonzaga in 1476 (see p. 274, above). It seems extremely likely that this *Battle* was based on a fragment of an ancient relief, now in the Villa Medici, Rome (Bober), and it is even conceivable that the relief was illustrated in the sketchbook and that the conversation with Ludovico about it might have led to the creation of these prints. If Jacobsen is right in

reading the meaning of the frieze as a depiction of envy between artists, Mantegna's recent problems with Zoan Andrea and Simone Ardizzoni (see pp. 48-51,) would have been further reason to choose the subject.

That the print was not produced too long after the *Entombment* and the Bacchanals is also suggested by their sharing, in the best impressions, the same watermark, the Basilisk (no 1; see Appendix II); five impressions of the *Sea Gods* are printed on such paper. That the frieze follows rather than precedes the

other prints is also confirmed by the fact that Mantegna was still experimenting with alternative methods of printing when making the others – there is an impression of the *Bacchanal with a Wine Vat* in Vienna showing the same striations evident in the *Entombment* (cat. 38). This, the earliest surviving impression of the *Battle of the Sea Gods*, was certainly printed with a roller press: not only are both sheets evenly and crisply printed, but at the top centre of the right half there is a small crease of the kind typically produced by such a press. This print, almost one metre

wide, is by far the largest and most ambitious produced by the 1470s, and an apt response to Pollaiuolo's *Battle of the Nude Men*. However comical their weapons – Lightbown has read the scene as a parody of a tourney – these sea gods are monumental and frightening, their rage and violence real. The viewer is dwarfed by their size and by the *di sotto in sù* perspective, and perhaps disturbed by the intrusion of the two fins of the left-hand sea monster into his own space.

D.L.

80

MASTER OF 1515 (?)
Battle of the Sea Gods (left half)

Engraving
266 x 424 mm (sheet; plate size unknown; see text)

c. 1510-15

The Visitors of the Ashmolean Museum, Oxford
(inv. SOL.54.10)

This is an unrecorded copy in reverse of the left half of the *Battle of the Sea Gods*. Its freshness identifies it as an early impression, and the fact that no other impression is known indicates that the plate was either lost or, more likely, soon burnished for reuse.

The handling is too bold for the print to have been made by Giovanni Antonio da Brescia, the chief copyist of Mantegna's designs, and it is here attributed to the engraver known as the Master of 1515. This engraver copied several of Mantegna's subjects, mostly from the prints – already copies themselves – by Giovanni Antonio rather than from the originals (see cats. 31, 78, 88, 92). In the present case, however, there is no known copy by Giovanni Antonio. The figures are to the same size as the original, and the differences between the prints are in approach, handling and the general effect rather than in specific details. Since in Giovanni Antonio's copies, details diverging from the originals can usually be found, it seems probable there never was a copy by Giovanni Antonio and that this print was copied directly from an impression of the left half of cat. 79.

The stylistic idiosyncrasies of this engraving – the sense of flashing light, the ferocious energy of the engraved line and the spirited quality of the interior modelling lines – are all typical of the work of the Master of 1515, whose *œuvre* would richly reward re-examination (see cat. 31 for a discussion of attempts to identify him as Hermann Vischer or Bambaia).

Since the dimensions of this image and those of the copy of the *Bacchanal with a Wine Vat*, here attributed to the same engraver (see cat. 77), are compatible, it is possible the two images were engraved on opposite sides of the same plate, although no full platemark for either print survives.

S.B. and D.L.

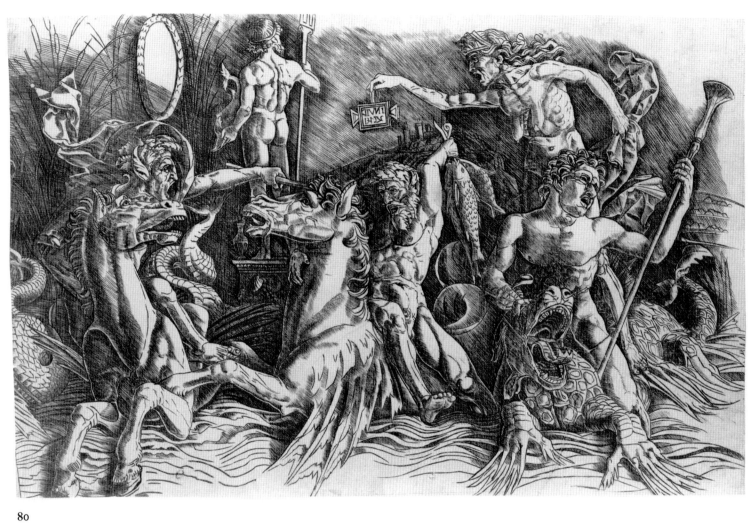

80

81

AFTER ANDREA MANTEGNA
Battle of the Sea Gods

Pen and brown ink; numerous damages made up
260 x 382 mm
Bears the collectors' marks of N.A. Flinck (L. 959) and
William, 2nd Duke of Devonshire (L. 718) in bottom
left corner.

Late 15th century

Duke of Devonshire and the Chatsworth Settlement
Trustees (inv. 897)

PROVENANCE
N.A. Flinck; 1723 bought by the 2nd Duke of
Devonshire.

REFERENCES
Waagen, 1854, III, p. 357; Kristeller, 1901, p. 404;
Berenson, 1902, pp. 51-2, 54-5; Knapp, 1910, p. L;
Tietze-Conrat, 1955, p. 204; Mezzetti, 1958, p. 240;
Mezzetti, in Mantua, 1961, p. 170, no. 125;
Washington *et. al.*, 1962-3, p. 24, no. 37; Washington,
1973, p. 192; Virginia *et. al.*, 1979-80, pp. 40-41,
no. 52; Ames-Lewis and Wright, in Nottingham and
London, 1983, pp. 246-9, no. 52 (repr. in colour,
pl. 17); Lightbown, 1986, p. 484, no. 189.

This celebrated drawing was praised by
Waagen; Kristeller described it as 'one of the
few undoubtedly genuine studies by Andrea',
and Berenson called it 'his least elaborated
drawing which he seems to have executed
with the greatest ease'. All believed it to be a
preparatory study for the left half of
Mantegna's engraving of the *Battle of the Sea
Gods* (cat. 79). In spite of this confidence,
most recently expressed by Lightbown, and
Ames-Lewis and Wright, there have also
been dissenting voices, and Knapp and
Mezzetti believed it was derived from the
print and was not preparatory for it.

Although it is a vigorous piece of
draughtsmanship and 'of high quality'
(Washington, 1973), it is too rough and
sketchy to be a final preparatory study for the
print, yet suspiciously close for it to be a first
idea for the composition. The variations – the
foreground horse's cloven hoof in the
drawing, the changed relation between the
central horse's head and the figure of
Neptune – are minimal, but the handling is
very free. The figure style suggests a date after
1470, when the print is generally dated, but
none of Mantegna's pen drawings of that
period, such as the *Man Lying on a Stone Slab*
(cat. 43), possesses such thick lines and
heavily reinforced contours. Furthermore, if
the drawing of the *Risen Christ between
St Andrew and Longinus* (cat. 44) is accepted as
a final preliminary study for the print, it
would suggest that Mantegna employed a
much more punctilious mode of preparation.
Here the figures are lacking in structure, and
details can only be fully understood by
reference to the print, as for instance with the
hill town behind the central triton, whose
head is far too small for his body. The

drawing's abbreviations are less easily
explained as the visual shorthand of a first
idea than as the clumsiness and incomprehen-
sion of a copyist. However, this copy is
unusually powerful and energetic, and its
author must have been intimately acquainted
with Mantegna's way of drawing. He was
presumably a pupil who executed the sheet as
an exercise in the workshop, perhaps under
the master's supervision. A good early drawn
copy of the right-hand half of the print was
sold at Sotheby's, London, in 1987
(6 July 1987, lot 16, pen and brown ink,
290 x 401 mm).

D.E.

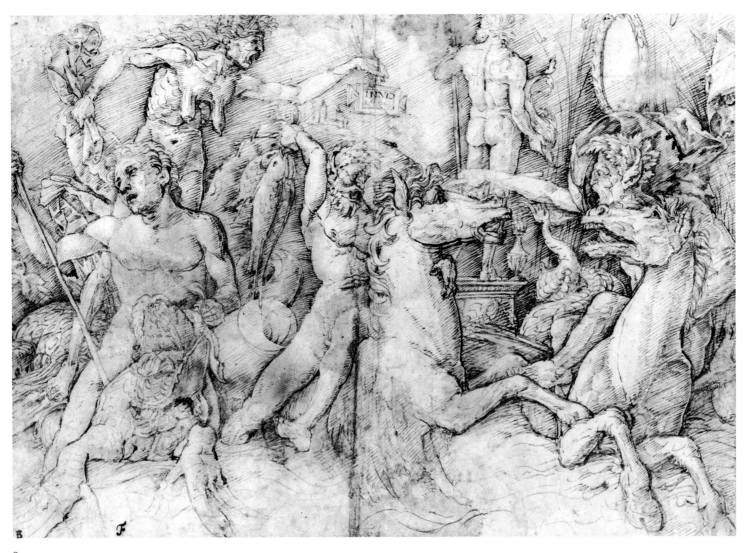

81

82

ANDREA MANTEGNA
Faun Attacking a Snake

Pen and brown ink, made up below and to
the right of the snake's tail and along parts of the top
and left edges; a dark stain on the faun's drapery at
the right edge
Maximum measurements 293 x 173 mm
Inscribed in ink at top in a later hand: *Mantegna*;
on back: '*March 23 1881 obtained this drawing from my
friend M. His de la Salle in exchange for a drawing by
Nicholas Poussin J.C. Robinson*'

1480-85

The Trustees of the British Museum, London
(1895-9-15-774)

PROVENANCE
Léon Feuchère; His de la Salle;
1861 J.C. Robinson; John Malcolm

REFERENCES
Robinson, 1876, p. 117, no. 327; Fiocco, 1937,
pp. 81-167; Hind, 1948, V, p. 26 (under no. 20);
Popham and Pouncey, 1950, p. 102, no. 163;
Tietze-Conrat, 1955, p. 205; Mezzetti, 1958, p. 243,
no. 25; Sheehan, in Washington, 1973, p. 230

This drawing is directly related to a print of
the same subject and in the same direction
(cat. 83) by an anonymous artist of
Mantegna's school. Given that the print is
inscribed '*DIVO HERCVLI INVICTO*', it has been
taken to represent Hercules and the Hydra,
although Sheehan proposed, improbably, that
it could be associated with the infant
Hercules' slaying of two serpents in his
cradle. However, the pointed ears of this
figure suggest he is meant to be a faun, and
link him with comparable nudes in the two
Bacchanal prints. As for the inscription, it has
been convincingly suggested that it refers to
Ercole d'Este, Duke of Ferrara, rather than to
the hero (see cat. 86).

There has been considerable disagreement
over the status of this drawing and its
relationship to the print. Hind dismissed it as
a copy of the engraving, whereas Popham
and Pouncey argued that it was the engraver's
preparatory drawing, and Fiocco, followed by
Mezzetti, regarded it as an original by
Mantegna. In fact, it has now been
demonstrated that the print was traced from
the drawing, or *vice versa*. The first issue to be
determined, therefore, is whether the sheet is
derivative or preparatory. In terms of quality
– in the power of the facial expression, in the
subtlety of the chiaroscuro and the precision
of the cast shadows – the drawing far surpasses
the print, all of which suggests that, as with
the *Virtus Combusta* drawing (cat. 147), this
was what the engraver had in front of him.
The extremely harsh and thick contour lines
may represent later reinforcements.

Popham and Pouncey, who labelled the
drawing School of Mantegna, argued that the
figure was copied by the engraver, and that
he extracted it from a more elaborate lost
composition by Mantegna in the manner of
the Bacchanals. This drawing is far closer in
style to Mantegna's own work than to that of
any of his known pupils, and yet does not
have any of the characteristics of a copy of a
lost drawing. The execution is the opposite of
dry and pedantic, despite the fact that this is

the final working out of the design, and the
different areas of the composition are not
uniformly handled. This is particularly evident
when one compares the meticulous treatment
and heavy shading of the faun's body with the
far more spontaneous freehand strokes that
evoke the scales of the serpent, which are
tellingly reminiscent of Mantegna's rendering
of birds' wings (cats. 72, 73). For all these
reasons, it seems reasonable to regard it as an
autograph sheet dating from the later part of
Mantegna's career.

Keith Christiansen has suggested that a
soldier in Ercole de' Roberti's destroyed
fresco of the *Crucifixion* (formerly Garganelli
Chapel, Bologna Cathedral, and known
through copies; see Bologna, 1985, pp. 127,
169) is based on this figure. The Chapel was
decorated between 1479 and 1485, so if the
connection is accepted, the drawing must
date from before 1485. In fact the drawing
compares particularly well both in its anatomy
and its billowing drapery with such slightly
later paintings as the *Man of Sorrows with Two
Angels* (cat. 60), *St Sebastian* (Ca' d'Oro,
Venice) and the *Parnassus* (Louvre, Paris), as
well as with the drawings of the *Man Lying
on a Stone Slab* and *Mars, Diana and Iris(?)*
(cats. 43, 146). The former, although certainly
earlier, is particularly telling for the taut
modelling of the torso, the intent, slightly
distorted facial expression and the complex,
metallic folds of the drapery. The same
features are also found in the torso of Mars in
the latter drawing, where even the genitals
and pubic hair are virtually identical. The
bolder pen line supports the idea that the
Faun can be dated between the other two
drawings.

D.E.

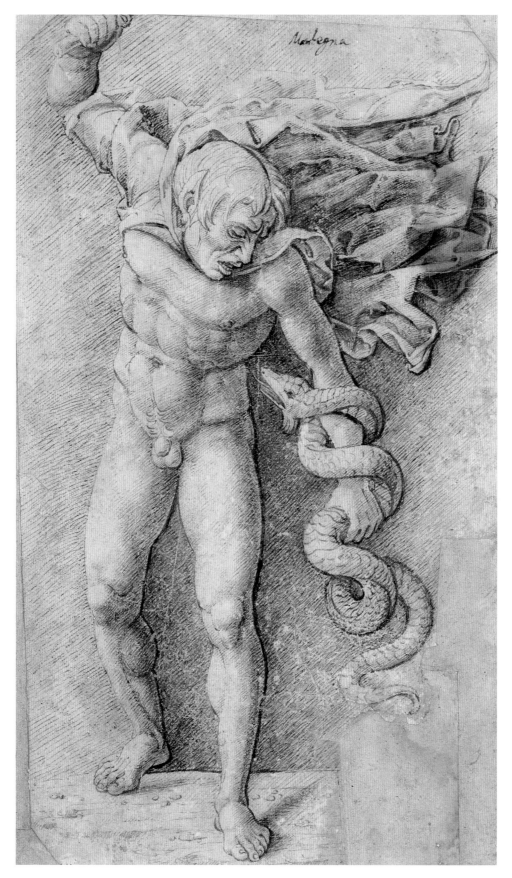

82

83

ANONYMOUS
Faun Attacking a Snake

Engraving
296 x 200 (platemark)
Inscribed: *.I.F.T.*; (vertically) *DIVO HERCVLI INVIC/TO*
H.20

c. 1500 (?)

Josefowitz Collection

REFERENCES
Bartsch, 1811, XIII, 324.12 (as Giovanni Antonio
da Brescia); Hind, 1948, V, 26.20; Sheehan, in
Washington, 1973, no.86; Ward-Jackson, 1979, no.12;
Bologna, 1988, pp. 358-62

One of the most attractive prints after
Mantegna's designs, this engraving directly
replicates a beautiful drawing by Mantegna
(cat. 82). By superimposing enlarged
transparencies of the drawing and an im-
pression of the print, it can be seen that the
two exactly coincide, and the conclusion
must be that the engraver traced either this
drawing or a tracing of it.

Who was this engraver? That, unfortunately,
is a question for which there is no persuasive
answer. The style seems to be distinct from
the hand here called the Premier Engraver
and is certainly not that of the chief copyist of
the Mantegna images, Giovanni Antonio da
Brescia. It also seems somewhat different from
that of the engraver who made two of the
seven plates related to drawings connected
with the *Triumphs of Caesar* (cats. 118, 123),
who, it is suggested, might be the young
Giulio Campagnola. The mesh of the shading
lines is somewhat tighter here, the parallelism
of the lines stricter and the use of the
engraving tool finer. But, for the same reasons
as with the prints related to the *Triumphs*, the
fact that if it is Campagnola, it is an early
work, and especially given that this print
follows a Mantegna drawing virtually line for
line, a stylistic argument is difficult; the
differences between this print and the two
attributed here to Campagnola are not
conclusive, so the possibility that the three
prints are by the same hand cannot be ruled
out, whether or not that hand turns out to
be Campagnola. (By the same token, the

possibility that this print is by Campagnola
and the other two by a different hand cannot
be eliminated either.)

Several other prints bear the inscription
DIVO HERCVLI INVICTO (cats. 86, 87, 88, 93,
97). In those, however, Hercules is depicted;
here he is not. Although the inscription led
Hind to call the print 'Hercules and the
Hydra', this figure has the ears of a faun and a
cloak rather than a lion's skin, even if his
weapon probably is a club. The inscription,
like that on the other prints, would seem to
be a dedication to Ercole I d'Este, Duke of
Ferrara (see cat. 86); it is not the title of the
print. It is not present on the drawing, and
most probably it was added by the engraver
both here and on the other prints. If an
attribution to Campagnola is considered, the
fact that the artist is known to have been in
Ferrara in 1499, and is presumed to have gone
there directly from Mantua (see cat. 118),
would be compatible with his having made
the print and dedicated it to Ercole.

The letters of this inscription are placed
alternately vertically and horizontally, as on
several other prints. In this case, however, the
extreme confusion in orientation (the 'E', 'L'
and 'V' are upside down, the 'R', 'N' and 'C'
backwards, and the final 'TO' reversed) would
suggest that the engraver was inexperienced
with lettering.

The other inscription on the print, the
initials '*I.F.T.*', has never been explained.
These letters could allude to some motto,
such as '*VIRTVTI S.A.I.*' in the *Allegory of
Ignorant Humanity* (cat. 148), although no
motto fitting those initials has been proposed.
Alternatively, they could be an engraver's
monogram. The only engraver active at the
time with initials that coincide in part is
Jacopo Francia, who signed eight of the
nineteen engravings assigned to him by Hind
with 'IF'. Although Jacopo's handling of the
burin is not totally incompatible with that in
this print, there are problems with the
attribution: Jacopo seems to have been born
late in 1486, and although his father and
teacher, Francesco Francia, was in communi-
cation with Isabella d'Este about various
portraits in 1505, 1511 and 1512, there does
not seem to have been an earlier connection
with the Este family (see Bologna, 1988).
Thus, if the print was made before Ercole
d'Este's death in 1505, Jacopo would still

have been under twenty; he also would have
had to gain access to the drawing or a tracing
of it; and there would have to have been a
reason for a dedication to Ercole.

The inscription '*I.F.T.*' is also present on a
drawing of Venus pouring a libation, with
two cupids (Victoria and Albert Museum,
London); there it is labelled 'School of
Mantegna', but in fact the figures seem closer
to the Francia family than to Mantegna.
Nonetheless, an attribution of the print to
Jacopo Francia at this time remains remote.

An impression of this print in the
Bibliothèque Nationale, Paris, is on paper
with a watermark from Troyes (see
Appendix II, no. 21); the indistinct watermark
on this impression may be the same, but it
cannot be discerned clearly enough to be
certain. In any case, the watermark indicates
that the plate travelled to France, but as this
particular watermark does not appear on any
impression taken from the other plates that
went to France, it cannot be said if this plate
travelled with those, or went separately.

S.B.

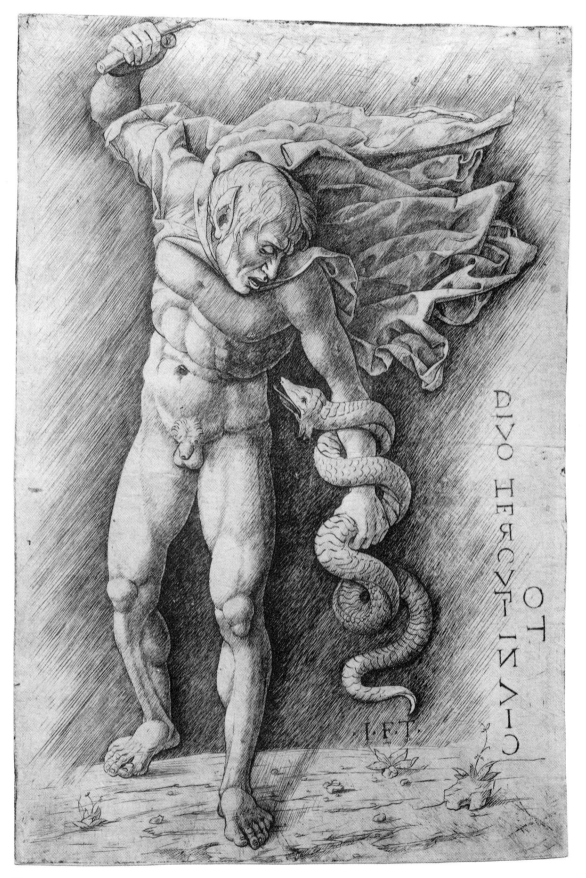

DIVO HERCVLI INVICTO

I·F·T·

83

294

84

PREMIER ENGRAVER
Silenus with a Group of Children

Engraving
163 x 236 mm (sheet; plate size unknown)
H.24a

c. 1490s

The Trustees of the British Museum, London
(1845-8-25-620)

REFERENCES
Passavant 1864, V, 82.39 (Zoan Andrea); Hind, 1948,
V, 29.24a

This print, a unique impression, and its copy by Giovanni Antonio da Brescia (cat. 85), reproduce a composition by Mantegna known in no other form, although there is a related drawing showing Silenus and six children on a triumphal car (Chatsworth) which would also seem to be derived from a composition by Mantegna. The subject of this print relates it to the Bacchanals (cats. 74, 75), and the figures are on exactly the same scale as their counterparts in those prints: the putto at the right measures 95 mm from back heel to top of head, as does the putto standing on the edge of the barrel in the *Bacchanal with a Wine Vat* (cat. 74). The two Silenuses also look alike. While on stylistic grounds it is not impossible that this composition was designed later than the Bacchanals, there is little change in Mantegna's putti from the time of the Camera Picta onwards, and it seems reasonable to date the Bacchanalian compositions around the same time. This print probably should be dated to the 1490s, when the Premier Engraver seems to have been active.

Bartsch knew only the copy by Giovanni Antonio (cat. 85), to whom he correctly assigned it; Passavant realised that this was the original and attributed it to Zoan Andrea. Hind noted that this print was engraved with 'somewhat more freedom and less precision

of cutting' than the other, but found no 'definite reason' to think that this one took precedence. However, the versatility combined with control in the handling of the engraver's tool suggests that this is the work of the Premier Engraver, while the more precise and timid strokes are those of a copyist.

The fact that this print is unique is one of the reasons why it has been suggested elsewhere that certain of the prints by Giovanni Antonio da Brescia may be copies of earlier prints no longer known to us (e.g. cats. 97, 117); if this one impression had not happened to survive, this would have been another instance where the version by Giovanni Antonio was the only one known.

The image may have been engraved on the back of the plate used for *Hercules and Antaeus* (cat. 86), a print known in only four impressions. No impression with a platemark for either of these prints has been found, but the dimensions are compatible.

S.B.

85

GIOVANNI ANTONIO DA BRESCIA
Silenus with a Group of Children

Engraving
168 x 244 (sheet; plate size unknown)
H.24
Watermark: Orb and Cross (?) (no. 22)

c. 1500-05

Graphische Sammlung Albertina, Vienna (1951-412)

REFERENCES
Bartsch, 1811, XIII, 327.17; Hind, 1948, V, 29.24

Giovanni Antonio's copy, in reverse, of the unique original by the Premier Engraver (cat. 84), is known in only four impressions. It is very faithful to the original; the omission of the veins on the leaves is the only obvious difference. Besides its being engraved, as Hind noted, in a more precise manner than the other print – a hallmark of a copyist – both this impression and one in the British Museum seem to be on paper with an Orb and Cross watermark, which is relatively common for Giovanni Antonio's prints (see Appendix II).

S.B.

84

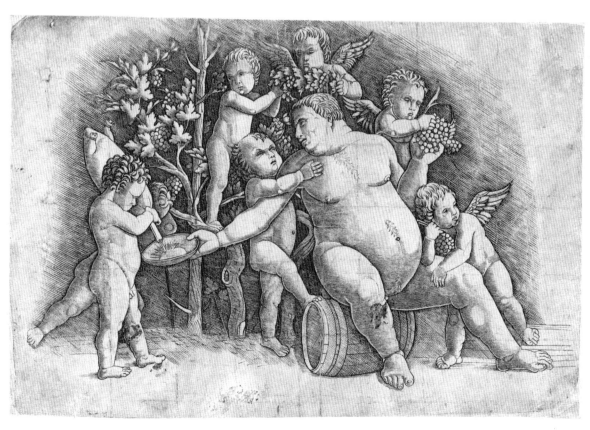

85

5 THE LABOURS OF HERCULES

Of all the heroes of classical mythology, Hercules was the most consistently popular with artists in the Renaissance. A son of Jupiter and a mortal woman, he achieved immortality after undergoing various painful trials (twelve of which became canonical in antiquity and are known as the Labours of Hercules). His story has obvious Christian parallels, and for that reason in the Middle Ages he was sometimes depicted as an antetype of Christ; on Nicola Pisano's pulpit in the Baptistery in Pisa, in the mid-13th century, Fortitude, one of the four Cardinal Virtues, is shown in the guise of Hercules.

Some of the later Roman emperors had identified with Hercules (a bust portrait of Commodus shows him dressed in a lion's skin and carrying a club; Palazzo dei Conservatori, Rome); further, Hercules was exemplary of the nobility of the *vita activa* as opposed to the *vita contemplativa*, so it is not surprising that Renaissance rulers also liked to draw parallels between the greatest of antique heroes and themselves. Hence the inclusion of some Herculean scenes on the vault of the Camera Picta for Ludovico Gonzaga and, even more appropriate, given his name, the adoption of Hercules as a kind of personal emblem by Ercole I d'Este, Duke of Ferrara, whose daughter Isabella married Francesco Gonzaga in 1490, thereby becoming Mantegna's chief patron during the last decade and a half of his life (see cat. 86 for a discussion of prints dedicated to Ercole d'Este).

The deeds of Hercules provided artists with the opportunity of depicting nude men in action, something in which Mantegna's father-in-law Jacopo Bellini had shown great interest (see Eisler, 1989, pp. 170-71; Louvre 85, 89); this opportunity was fully exploited by Mantegna, his Florentine contemporary Pollaiuolo, and others.

Some fifteen extant compositions by or after Mantegna show Hercules, but with the exception of the subjects in the Camera Picta, the chronology of their creation and their original destinations are uncertain. The five Labours of Hercules painted in six spandrels on the vault of the Camera Picta were made in the 1460s; he is said to have designed another series, also in the '60s, for the Gonzaga villa at Cavriana (Signorini 1985, p. 223) and there probably were more, since some compositions are considerably later in style (see cats. 93, 97).

The surviving prints and drawings derived from Mantegna's designs show only two subjects, both of which also appear in the Camera Picta. One is of Hercules' first Labour, the battle with the Nemean lion, a monstrous beast impervious to weapons; Hercules strangled it with his bare hands, and thereafter wore a lion's skin. The other subject is the wrestling match between Hercules and the giant Antaeus, the son of Neptune and Earth. Hercules flung Antaeus several times, but realised that every time Antaeus touched the Earth, his mother, he regained strength. Consequently Hercules lifted Antaeus in the air and squeezed him to death. This subject is not one of the canonical Labours, but to judge from its preponderance in Mantegna's *œuvre* (see below), it had great importance for his patrons. Allegorically, the subject can be interpreted as Virtue overcoming Lust, or, on a Neo-Platonic plane, as spirit overcoming flesh. Its significance for Ludovico Gonzaga is further underlined by its position in the Camera Picta over the entrance door.

At least one antique statue of this subject was in Rome in the 15th century (fig. 89; now Palazzo Pitti, Florence; see Bober and Rubinstein, 1986, p. 173, no. 137) and may have served as a model for Mantegna, and also for Antico (see cat. 90). All may have been based on Lucan's account of Hercules' first throw (*Pharsalia*, IV, 589-656), when Antaeus' head was flung back and Hercules, with his knee, struck him just below the hip.

A list of Herculean compositions by or after Mantegna is given below:

1 *Hercules having Shot an Arrow at Nessus*, and *Nessus with Deianira*; on adjacent spandrels (Camera Picta)

2 *Hercules and the Nemean Lion* standing (Camera Picta)

3 *Hercules and the Hydra* (Camera Picta)

4 *Hercules and Antaeus*, Antaeus held from behind (Camera Picta, fig. 90; drawing, cat. 90)

5 *Hercules and Cerberus* (Camera Picta)

6 *Hercules and Antaeus*, Antaeus held from behind, legs in the air (drawing, cat. 91)

7 *Hercules and Antaeus*, Antaeus held from behind turned one-quarter towards Hercules (print, Master of 1515, cat. 92)

8 *Hercules and Antaeus*, Antaeus held from the side, half turned towards Hercules (six prints: Premier Engraver, cat. 86; Giovanni Antonio da Brescia, cat. 87; Master of 1515, cat. 88; etched copy, see Hind, 1948, V, p. 37; also reverse copy, not in Hind; and Marcantonio Raimondi, Bartsch, XIV, 221.289; drawing, cat. 89; MS, Bib. Estense, Breviario d'Ercole I; two maiolica plates, Victoria and Albert, London; National Gallery of Art, Washington)

9 *Hercules and Antaeus*, facing each other, Antaeus seen from behind (four prints: Premier Engraver, cat. 93; Giovanni Antonio da Brescia, cat. 94; Nicoletto da Modena, Hind, 1948, V, 113.1; Hieronymus Hopfer, Hollstein, XV, 205.29; drawing, cat. 95)

10 *Hercules and Antaeus*, facing each other, Hercules seen from behind (print, Hind, 1948, V, 26.19)

11 *Hercules and the Nemean Lion* (three prints: Giovanni Antonio da Brescia, cat. 97; Marcantonio Raimondi, Bartsch, XIV, 221.291; Hieronymus Hopfer, Hollstein, XV, 205.30; two drawings: cat. 96; Louvre, Paris, inv. R.F. 39030)

12 *Hercules and Deianira* (print, Giovanni Antonio da Brescia, Hind, 1948, V, 62.1)

13 *Hercules and the Cretan Bull* (three prints: Nicoletto da Modena, Hind, 1948, V, 115.9; a *niello*, Duchesne 251; Marcantonio Raimondi, Bartsch, XIV, 221.292)

14 *Hercules and Nessus* (print, Marcantonio Raimondi, Bartsch, XIV, 221.290; maiolica dish, Metropolitan Museum of Art, New York, 1975.1.1000). The derivation of this composition from Mantegna is not certain, but its inclusion in a series of four Labours of Hercules by Marcantonio, of which three designs go back to Mantegna, argues for it.

fig. 89 *Hercules and Antaeus*, Roman marble group after a Hellenistic bronze original, now much restored, Cortile dell 'Ammannati, Palazzo Pitti, Florence

Also in the Camera Picta, Hercules was painted on the west wall on top of a column in the distance, and probably in the tympanum of the temple; he is even shown on a brooch clasping the cloak of Julius Caesar, again on the vault.

The coincidence of Hercules subjects treated by Mantegna and Antonio Pollaiuolo was probably not fortuitous. Pollaiuolo made three large paintings, now lost, for Lorenzo de' Medici in the early 1460s, of *Hercules and the Hydra*, *Hercules and Antaeus* and *Hercules and the Nemean Lion*. Three paintings by Pollaiuolo depict *Hercules and the Hydra*, *Hercules and Antaeus* (both Uffizi, Florence) and *Hercules and Nessus* (Yale University Art Gallery, New Haven).

S.B.

fig. 90 Andrea Mantegna, *Hercules and Antaeus*, fresco on the vault of the Camera Picta, *c.* 1465, Palazzo Ducale, Mantua

86

PREMIER ENGRAVER
Hercules and Antaeus

Engraving, state 1 of 2
199 x 140 mm (sheet; plate size unknown)
Inscribed: *DIVO HERCVLI INVICTO*
H.GAB.3a

1490s

The Trustees of the British Museum, London
(1845-8-25-704)

REFERENCES
Bartsch, 1811, XIII, 325.13, copy 2; Byam Shaw,
1936-7, p. 60; Hind, 1948, V, 37.3a

This print derives from the same lost Mantegna drawing as the drawn copy (cat. 89) and is to roughly the same scale; it reverses the drawing, but even had no copy of the drawing survived this could have been surmised from the direction of the engraving strokes, down towards the right. On stylistic grounds, this composition certainly predates the larger *Hercules and Antaeus* (cat. 93) and *Hercules and the Nemean Lion* (cat. 97); it is probably not as early as Mantegna's grisaille of *Hercules and Antaeus* in the Camera Picta (fig. 90) to which the other Uffizi drawing (cat. 90) is related, but it is difficult to date it more precisely than to the 1470s or 1480s.

Bartsch called this print a copy of the print by Giovanni Antonio da Brescia (cat. 87), while Hind used the more neutral 'another version', and said it is 'somewhat finer in technique'. Byam Shaw saw that the relation between this print and that by Giovanni Antonio was 'exactly parallel' to that between, on the one hand, the prints after the *Triumphs of Caesar* (cats. 120, 126), the *Silenus with a Group of Children* (cat. 84) and the *Four Dancing Muses* (cat. 138) and, on the other, the copies by Giovanni Antonio (cats. 85, 121, 127, 139). Without expressing an opinion as to which were the copies, Byam Shaw noted that those attributed by Bartsch to Giovanni Antonio da Brescia are 'rather neater and more timid in execution' – characteristics entirely in accordance with their being the copies – while the others are 'rather coarser and bolder'.

This print, the copy by Giovanni Antonio and two further copies bear the inscription *DIVO HERCVLI INVICTO*, roughly translatable as 'to the godlike and invincible Hercules' (the dative case implying that the inscription is a dedication). The inscription also appears on the prints reflecting the later composition of *Hercules and Antaeus* (cats. 93, 94), in abbreviated form on the drawing and print of *Hercules and the Nemean Lion* (cats. 96, 97), on the two prints of a *Faun Attacking a Snake* (cat. 83 and Hind, V, 31.27) and also on other derivations from some of these.

It has been suggested that the inscription – especially in the case of the two prints that do not seem to depict Hercules (cat. 83 and Hind, V, 31.27) – was added by the engraver, but no one has conjectured why. It seems highly possible that the inscription may be connected with Ercole I d'Este, Duke of Ferrara from 1471 to 1505, and father of Isabella d'Este.

Two medals of Ercole d'Este by Sperandio bear the inscription '*DIVVS HERCVLES FERRARIAE AC MVTINAE DVX SECVNDVS INVICTISSIMVS*' (Boccolari, 1987, p. 68, no. 42; p. 76, no. 50). Ercole also used the adjectives '*divus*' and '*invictiss[imus]*' (although not together) on coins: in Modena two *mezzi testoni* were issued, one depicting Hercules and Antaeus and inscribed '*DIVO HERC*', and one with Ercole's head and '*HERCVLES DVX INVICTISS*'; the latter shows Hercules and the Nemean Lion on the reverse (*Corpus*, 1925, pp. 190-91; nos. 6-12). These date from 1499 at the earliest, as the mint in Modena reopened late in 1498 after a century and a half of inactivity (Ravegnani Morosini, 1984, I, p. 136). In Reggio, a *testone* showing Ercole's head dates from 1495 (Ravegnani Morosini, 1984, I, p. 137), and *soldi* with the Este *impresa* of the *nassa da pesca* (fishing net), included the word '*DIVO*' (*Corpus*, pp. 661-2, nos. 4-8; p. 664, nos. 25-31). According to Manca (1989, p. 529), no other 15th-century ruler called himself *divus* on coins in mass circulation. This term was also applied in the dedication to Ercole of *De Sculptura* by Pomponius Gauricus, first printed in Florence in 1504 (ed. 1969, p. 39) and in at least two cases the word '*invictus*', in some form, was used to describe the Duke in a dedication: an early poem by Ercole Strozzi was dedicated

'*Excellentissimae Reginae Helionorae Aragoniae ad Invictissimum ducem herculem estensem*' (Biblioteca Marciana, Venice, MS Marc. Lat. XII.136 (4389); see Gundersheimer, 1973, p. 172), and Boiardo's 'Pastoralia' is inscribed '*Ad inclytum magnanimumque principem ac ductorem invictissimum D. Herculem Estensem...*' (Biblioteca Estense, Modena, MS 0.7.28 = Lat.64; see Fava and Salmi, 1950, p. 157). Sabadino degli Arienti in his *De triumphis religionis* of 1497, written almost entirely as if addressed to Ercole, described 'your statues sculpted in living rock, with armoured chest, like an absolutely invincible emperor (*come invictissimo imperatore*)' (Gundersheimer, 1972, p. 73). Other examples could be added.

This print is known in only four impressions. The image may have been engraved on the back of the same plate as *Silenus with a Group of Children* (cat. 84), itself known in a unique impression. *Hercules and Antaeus* seems to have been engraved on top of another image, remains of which are visible, for example, between the tree trunk and the inscription, but which it has not been possible to identify. Apparently, the Hercules image was also burnished out fairly soon, unless the entire plate was somehow destroyed. The composition of this print is reproduced in a Ferrarese manuscript Breviary made probably towards the end of Ercole's life, in the first years of the 16th century.

S.B.

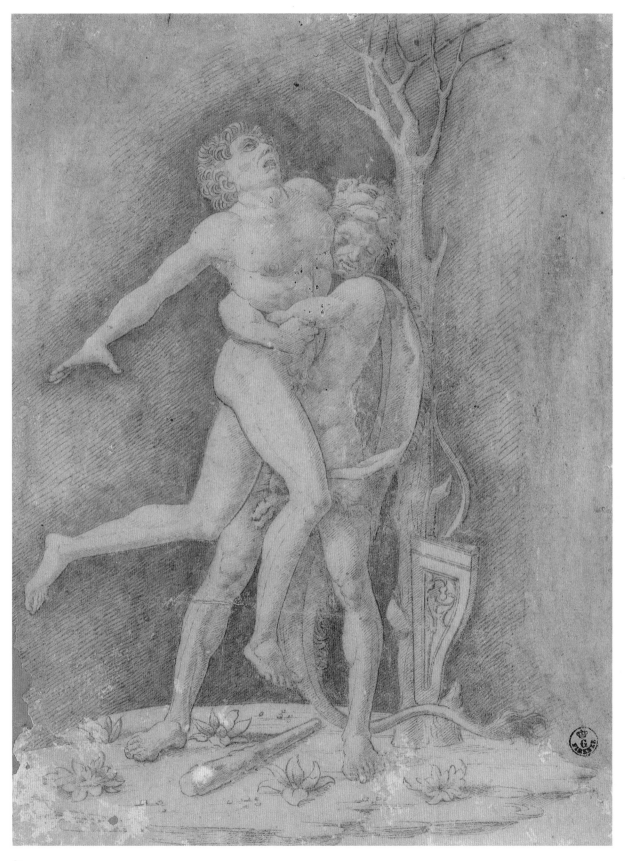

89

89

AFTER ANDREA MANTEGNA
Hercules and Antaeus

Pen and brown wash on paper partially washed
yellow-brown
246 x 184 mm

Gabinetto Disegni e Stampe, Gallerie degli Uffizi,
Florence (Inv. 395E)

REFERENCES
Selvatico in Vasari, ed. 1849, V, p. 204; *idem* in Vasari,
ed. 1878-85, III, p. 431; Kristeller, 1901, p. 460; Byam
Shaw, 1936-7, pp. 59-60; Sheehan, in Washington,
1973, p. 238, no. 88

This drawing is clearly related to three prints of the same subject, two in the same direction as this drawing, and one in reverse (cats. 86, 87, 88). When this drawing is compared with the prints, it immediately becomes apparent that it is closest to cat. 88, here attributed to the Master of 1515. Whereas, for example, the number and disposition of the plants at the combatants' feet are identical in both that print and cat. 87, only in cat. 88 do the detailed forms of the leaves and pebbles correspond with those in the drawing. There are minor differences between that print and this drawing, for instance in the configuration of the branches of the dead tree on which Hercules has tidily hung his bow and quiver. However, it is evident that the drawing is not a copy of the print since it conveys an impression of greater delicacy. This is apparent in the touch of the pen, but particularly tellingly in such details as Hercules' face, which is hardly grimacing at all, and Antaeus' body, which is far less muscular. Furthermore, Antaeus' eyes are open, not closed.

This invention is clearly related to Mantegna's treatment of the subject on the vault of the Camera Picta (fig. 90) painted between 1465 and 1474; it may even precede it. The quality of this particular sheet does not justify an attribution to Mantegna himself. Although Byam Shaw gave it to 'Zoan Andrea' and connected it with the other drawings he ascribed to that artist, they do not form a coherent group. Although the Master of 1515 was in the habit of copying earlier prints, it is tempting to assume that he used this drawing, or its prototype by Mantegna, as a model.

D.E.

90

AFTER ANDREA MANTEGNA
Hercules and Antaeus

Pen and brown wash with white heightening on
brown prepared paper, the stream executed in pale
blue wash; various losses, especially in the head of
Antaeus
264 x 164 mm

Gabinetto Disegni e Stampe, Gallerie degli Uffizi,
Florence (Inv. 1682F)

REFERENCES
Mezzetti, 1958, pp. 232-44; *idem* in Mantua, 1961,
pp. 218-19; Radcliffe, in London 1981, p. 136, under
no. 55; Signorini, 1985, pp. 220-22; Lightbown, 1986,
p. 483, no. 183; Bober and Rubinstein, 1986, pp. 173-
4, under no. 137

This drawing, arguably the most impressive surviving drawing of the subject of *Hercules and Antaeus* associated with Mantegna, was published by Mezzetti (1958) as an autograph work by Mantegna. She connected it with the grisaille fresco of the same subject on the vault of the Camera Picta in the Palazzo Ducale (fig. 90). She further noted a number of differences between the drawing and the fresco, such as the direction of the lighting, the position of Antaeus' right and left arms, and the details of the setting, and concluded that the drawing was not in a strict sense preparatory for the fresco. This is certainly correct, but there seems no foundation for Mezzetti's further argument that the sheet dates from the late 1450s. It seems more reasonable to associate its precision of handling with a date in the 1460s, and later in that decade rather than earlier. A date of 1465 incised into one of the window embrasures of the Camera is generally agreed to mark the start of work on the decoration of the room, and may well provide a good indication as to the approximate date of this invention.

Since its publication, cat. 90 has been widely accepted as an autograph drawing (e.g. by Signorini and Lightbown), although its rubbed state and certain losses do not make it easy to judge. Mezzetti implied that the position of Antaeus' left arm in the fresco can be discerned in the drawing as a *pentimento*, but this appears to be a mis-understanding, involving her having read Hercules' left arm as a first position for that of Antaeus. In any event, the lack of energy of the sheet, even in its better executed passages, such as the head of Hercules, is incompatible with the master. Rather, it is a copy of a lost original, whose function is not easy to establish, but which may – especially in view of the coloured wash – have been an extremely early example of a drawing made as a work of art in its own right. This might explain its unusually high degree of finish for an invention of its date.

As Mezzetti realised, Mantegna must have had recourse to an antique source. She suggested a marble group of the same subject, subsequently much admired by Antico, which was in Rome during the Renaissance

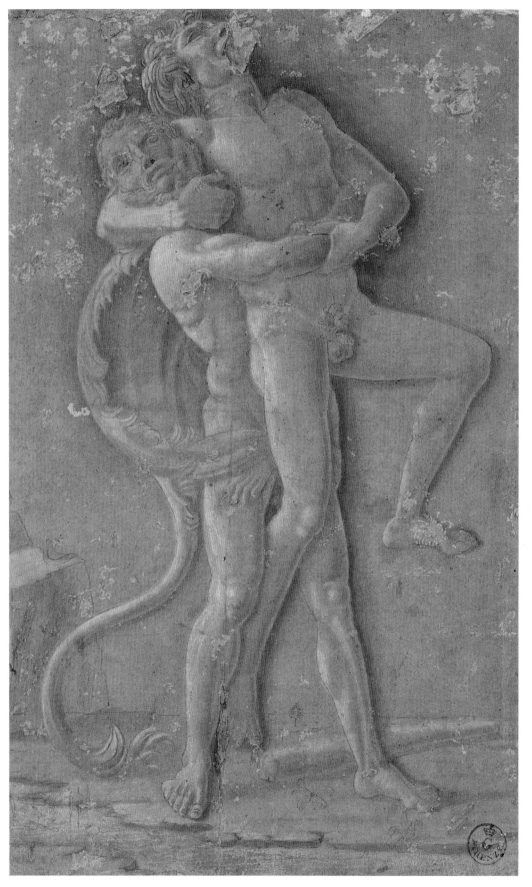

90

(fig. 89; now Palazzo Pitti, Florence), and which Mantegna could only have known through drawings before his Roman sojourn of 1488-90. Lightbown proposed a different and perhaps more accessible source that was certainly known in the Renaissance: a bronze medal of Hadrian with Hercules and Antaeus on the reverse (fig. 91), evidently derived from the same Greek original as the marble group. The marble group is now heavily restored; in the 15th century it lacked

Antaeus' head and arms and both figures' legs, whereas the medal showed the group in its complete state. However, not one of Mantegna's derivations follows the medal exactly: for example, his compositions of Hercules always have both legs straight as opposed to one bent, which either suggests that he was not familiar with it, or that he chose to depart from it in order to create fresh variations on a theme.

D.E.

91

CIRCLE OF ANDREA MANTEGNA
Hercules and Antaeus

Pen and light-brown ink with black chalk underdrawing reinforced in places with darker ink (e.g. hand of Hercules and right arm and hand of Antaeus); the outlines pricked; squared with a stylus
343 x 228 mm

Her Majesty the Queen (inv. 12802)

PROVENANCE
Mentioned in George III's inventory A (p. 15)

REFERENCES
Stix, 1930, p. 124; London, 1930-31, p. 157, no. 710; Popham and Wilde, 1949, pp. 174-5, no. 17; London, 1953, p. 8, no. 12; Ames-Lewis, in Nottingham and London, 1983, pp. 208-9, no. 43; Bober and Rubinstein, 1986, p. 173, under no. 137; Cappel, 1990, pp. 234-5

Two factors justify connecting this sheet with Mantegna's circle. The first concerns its technique: an underdrawing in black chalk was gone over with a wiry pen-line combined with close diagonal hatching. The second relates to the subject and its treatment. A drawing in the Uffizi (cat. 90) and the related fresco on the vault of the Camera Picta in Mantua show the same figures in similar, but not identical, attitudes. All these conceptions derive from an ancient prototype, known through a marble group then in Rome (fig. 89; see cat. 90, above). Both the fresco and cat. 91 are close to the antique prototype, although reversing it, which makes Cappel's observation that the pouncing on this sheet comes from the *verso* and preceded the execution of the drawing very significant. It means that this drawing was based on another drawing in the same direction as the original group, whose outlines were pounced on to the blank *verso* of this sheet before it was turned over and this drawing made.

When this drawing is compared with cat. 90, numerous differences emerge. Here Antaeus' left leg is outstretched and his right

is bent, whereas in the other drawing they are the other way round. The position of Antaeus' right arm, here gripping his own leg rather than trying to throttle Herculeses, and the extreme foreshortening of Antaeus' head, are also different. All these emendations suggest an artist aware of the earlier conception and not afraid to modify it, but they do not tell us if this is an instance of self-criticism by Mantegna, or the workings of another intelligence. It is tempting to suppose that the invention was Mantegna's, but the execution of this drawing is by another hand. Even without the evidence of the pouncing, the handling here is at once too disciplined for Mantegna's early period, yet too energetic for his later style. However, the proportions of the figures suggest a late date, even if the grimacing facial type of Hercules and the loose treatment of his hair and beard do not accord with Mantegna. For the time being this fascinating sheet must remain anonymous, but Popham was undeniably right when he laconically observed that 'it is not the work of a nonentity'.

D.E.

fig. 91 Reproduction of the reverse of a bronze medal of the Emperor Hadrian showing Hercules and Antaeus, from Du Choul, *Discours de la religion des anciens Romains*, Lyon, ed. 1567

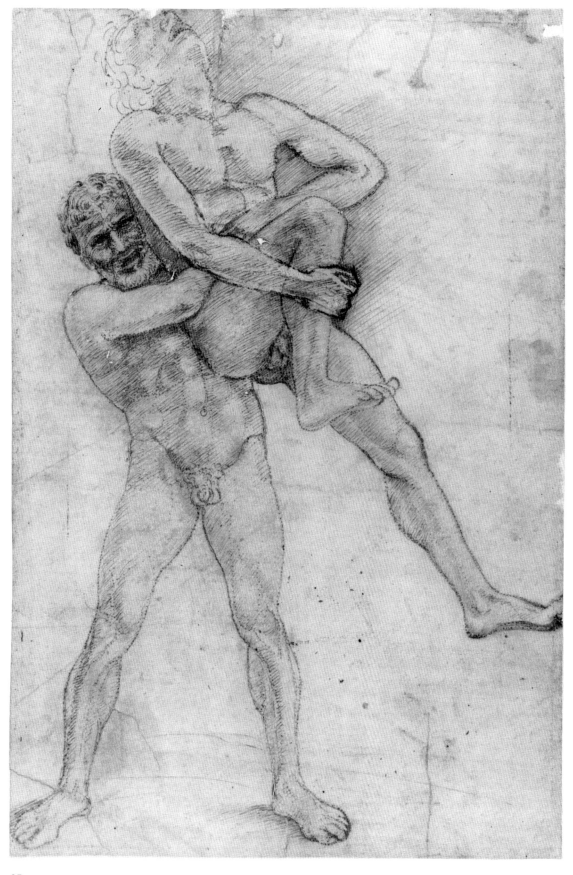

91

92

THE MASTER OF 1515 (?)
Hercules and Antaeus

Engraving
250 x 165 mm (platemark)
H.18

c. 1510

Graphische Sammlung Albertina, Vienna (1951-399)

REFERENCES
Bartsch, 1811, XIII, 202.1 (Pollaiuolo); Hind, 1948, V,
25.18

Each of the compositions of Hercules and Antaeus by Mantegna varies the pose of the two figures: here Hercules is seen from the front holding Antaeus from behind, with Antaeus' legs spread wide and his torso one-quarter turned towards Hercules, trying both to strangle him and wrest away from his hold. The composition is hard to date; it could conceivably reflect a study for the Camera Picta, and in fact the relation of the figures is not dissimilar to the final composition there (see fig. 90), or it could have been somewhat later. It certainly predates the *Hercules and Antaeus* face to face and *Hercules and the Nemean Lion* (cats. 93, 94, 97). The arched form of the composition could be evidence for its intended destination, but we know of no series of Hercules subjects in arched settings; the form could also have been the choice of the printmaker, or possibly he was using a plate already in his possession.

This print shows the same characteristics evident in several others (cats. 31, 78, 80, 88): harsh, dramatic, almost vibrant lighting; a tendency to break outlines into rounded segments; pronounced interior modelling lines, some of which approach a decorative effect (here visible principally in the faces). This print also displays the scratchy, rough effects that are a fundamental characteristic of the prints ascribed to the so-called Master of 1515. For these reasons it would seem that this print also may be by that engraver. This is the only known version of the composition. Since the other prints attributed in this catalogue to the Master of 1515 are all copies of earlier prints, it is possible that this, too, copies a print, no impression of which now survives; alternatively, the print could have been copied directly from a lost drawing.

S.B.

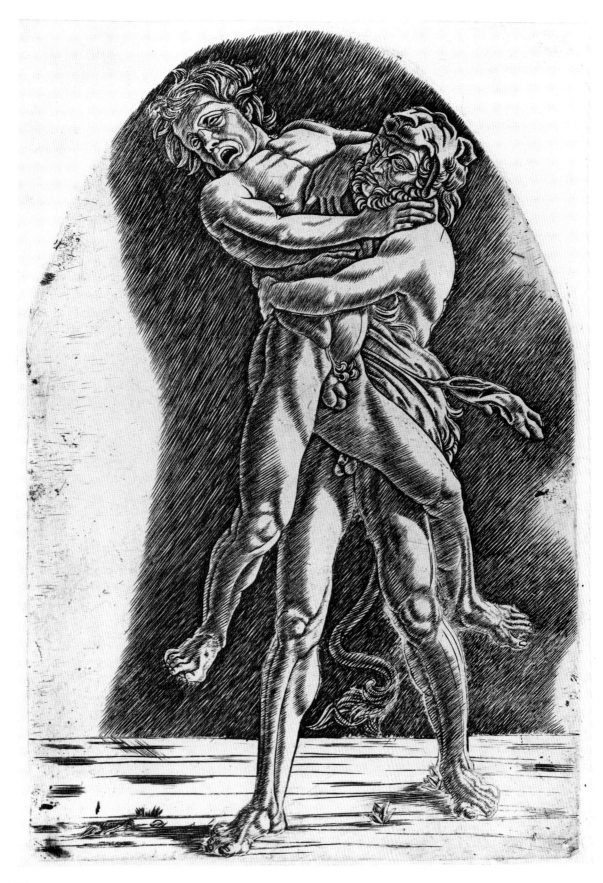

93

PREMIER ENGRAVER
Hercules and Antaeus

Engraving, outlines pricked for transfer
341 x 248 mm (sheet; plate 350 x 260 mm, Victoria
and Albert Museum, London)
Inscribed: *DIVO HERCVLI INVICTO*
H.17

c. 1497

The Metropolitan Museum of Art, New York,
Rogers Fund, 1918 (18.65.3)

REFERENCES
Bartsch, 1811, XIII, 237.16; Hind, 1948, V, 25.17;
Sheehan, in Washington, 1973, pp. 218-21, no. 83

This print shares with that of *Hercules and the Nemean Lion* (cat. 97) similar solid, squarely proportioned figures, and on stylistic grounds they must date from the 1490s at the earliest. The figures are to the same scale, suggesting that the two compositions may have been part of a series, although there is no record of such a series around this time. Sheehan observed that this composition, with Hercules and Antaeus face to face, was very common in the Quattrocento, one of the earliest examples being a relief on the Porta della Mandorla on Florence Cathedral, of about 1400 (Ettlinger, 1972, 1978).

A drawing of the same composition, to the same scale, in which Hercules is less muscular and the effect generally weaker (cat. 95), doubtless ultimately derives from the same original as this print. The superimposition of enlarged transparencies of the print and the drawing, however, confirms that there was no direct relationship between them; this drawing was not used by the engraver, nor did the draughtsman trace an impression of the print.

Both the outlines and the interior modelling lines of this impression have been pricked to transfer the image to another surface (see fig. 92). The technique of transfer by pricking and pouncing, a painstaking and time-consuming one that had been used since at least the mid-Trecento, was a method of replicating images, or parts of images, used by artists at all stages in the development of a painting (for a drawing that was actually created by pricking, see cat. 91). Its use for prints was much less common than for drawings, given that printmaking is another way of replicating images, and any number of replicas could be had from an engraved plate. It follows that if the technique was used on a print, the person using it did not have access to the plate from which the print was made.

Although there can be no absolute proof, there is a strong possibility that this very impression of this print was used by Giovanni Antonio da Brescia to make his copy of the image (cat. 94), since the areas that are not pricked – the ornament on the quiver and the lines describing the bark of the tree, for example – correspond to the areas that are significantly different in the copy. The fact that this pricked impression is an early one

also accords with this possibility, since the original plate went to France before it became very worn (see Appendix II).

The pricking was done densely, from the *recto*, with a very fine needle or stylus, producing approximately nine holes per centimetre. Significantly, the back of this print can be seen to have been rubbed with black chalk, and the following procedure can be reconstructed: once the lines had been pricked, the print would have been placed face down on another sheet, and the back rubbed with chalk dust (*spolvero*) contained in a small sack, so that the dust would sift through the holes, recreating the design on the second sheet in the form of dotted lines. This second design would be in the reverse direction from the original.

This second sheet would then have been placed, face up, on a printing plate, and its lines incised with a stylus, the craftsman exerting enough pressure for the lines to appear, at least weakly, on the plate. This process of incising a drawing on a plate is described in treatises on printmaking, although not until the 17th century. The process would most likely have destroyed the incised sheet, but the print itself would not have been ruined, and was still needed for putting finishing touches to the copy.

The copyist, Giovanni Antonio in this case, would then have gone over these lines to make them deeper, then added areas of shading. This he seems to have done by following the original print with his eye: Giovanni Antonio copied quite carefully the general shape of the shading, but there are slight differences in the results. When the process of engraving was finished, the plate was inked and printed, the reversed image on the plate resulting in printed impressions in the same direction as the original.

The image of *Hercules and Antaeus* was engraved on the back of the same plate as the *Four Dancing Muses* (cat. 138); this plate was one of the group that travelled to France (see Appendices I, II), where the images on both sides continued to be printed well into the 16th century.

For discussion of the inscription, see p. 86, above.

S.B.

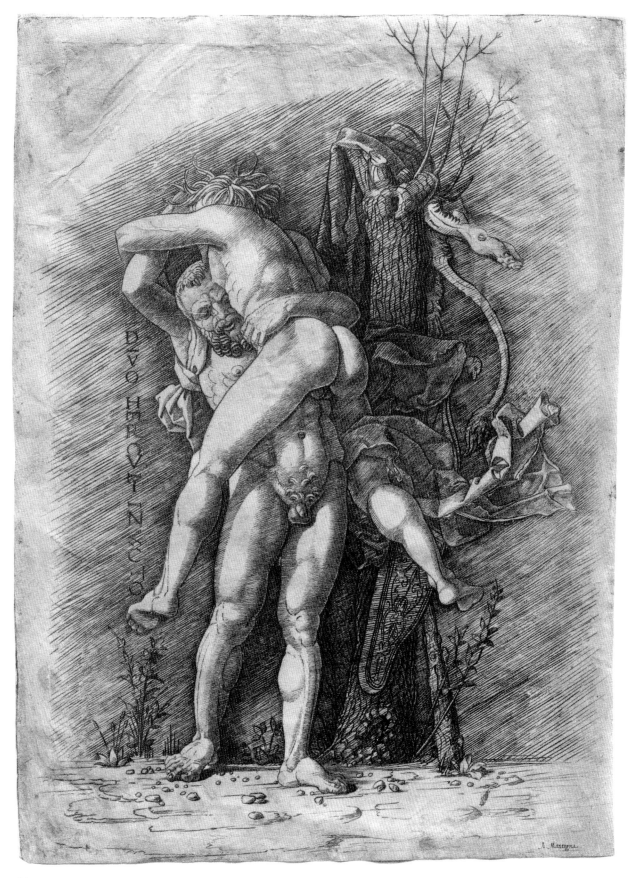

93

94

GIOVANNI ANTONIO DA BRESCIA
Hercules and Antaeus

Engraving
284 x 204 mm (sheet; plate 318 x 225 mm, Basel)
Inscribed: *DIVO HERCVLI INVICTO*; *IO.AN.BX.*
H.GAB.I
Watermark: Profile Head in Circle (no. 32)

1507 or later

The Metropolitan Museum of Art, New York,
Anonymous Gift, 1929 (29.44.21)

REFERENCES
Bartsch, 1811, XIII, 325.14; and 238.16, copy; Hind,
1948, V, 36.1

Giovanni Antonio might have made his copy
of this composition from the very impression
in the exhibition (cat. 93, where the method
of transfer is discussed). As mentioned there,
the details in which this print differs
significantly from the original – the plant
forms, the ornament on the quiver, the lines
indicating bark on the trees – are exactly
those where the lines of the original were not
pricked. The letters of the inscription are not
pricked either, and Giovanni Antonio's differ
in that the 'O's are more oval, more clearly
indicating their orientation, and the second 'I'
of *INVICTO*, which in the original was
apparently inadvertently left out and later
squeezed in, is given a full space.

The presence of Giovanni Antonio's
signature indicates that the print can be dated
to 1507 or later. Traces of an earlier image
seem to be visible on the plate, but it has not
been possible to identify it. As the dimensions
of this plate coincide with those of the plate
on which were successively engraved
Giovanni Antonio's copy of Dürer's *St Jerome*
(Hind, V, 68.20), *Judith with the Head of
Holofernes* (cat. 144) and *Venus, after the
Antique* (Hind, V, 41.14), it is probable that
this image was on the other side of that plate.
The fact that the plate held two images on its
obverse side and apparently at least one on
this side before *Hercules and Antaeus* was
engraved – which would imply that it was
run through the press many times – could, in
part, explain why there seems to be no
impression of this print of really high quality;
the present print was the best that could be
found; yet, when compared with some of the

outstanding impressions of Giovanni
Antonio's prints shown here (e.g. cat. 148),
it has a worn, lacklustre look.

S.B.

fig. 92 Premier Engraver, *Hercules and Antaeus,* the *verso*
of cat. 93, showing the drawing pricked for transfer.

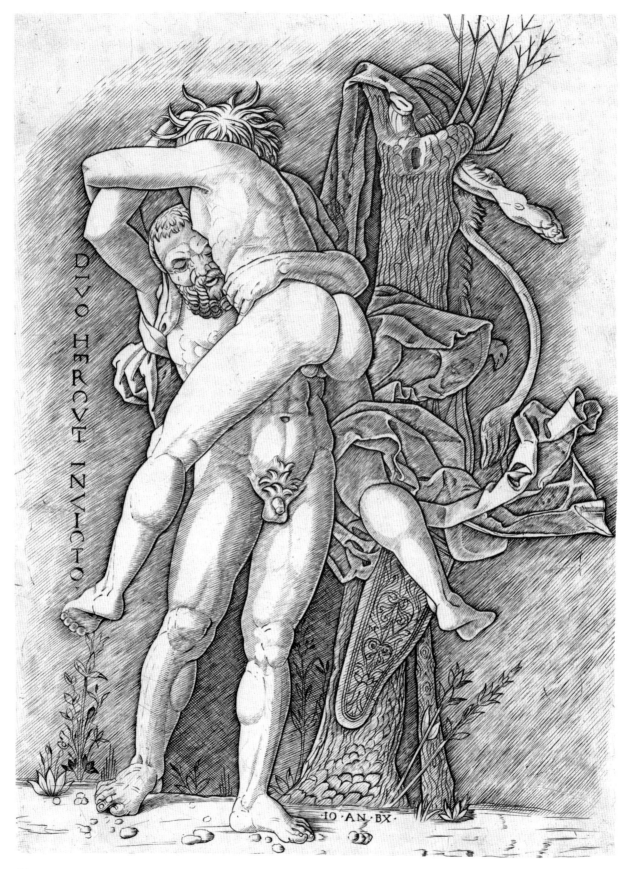

DIVO HERCVLI INVICTO·

IO·AN·BX·

94

316

95

AFTER ANDREA MANTEGNA
Hercules and Antaeus

Point of the brush in white and brown on yellow-brown prepared paper, corners cut
280 x 193 mm
Inscribed and then scratched out in ink in an early hand: *hercle da ferrara*

c. 1490-1506

The Trustees of the British Museum, London
(1895-9-15-782)

PROVENANCE
Count Gelosi; His de la Salle; John Malcolm

REFERENCES
Hind, 1909-10, II, pp. 350-51 (under no. 9); Hind, 1948, V, p. 25 under no. 17; Popham and Pouncey, 1950, p. 102, no. 162; Mezzetti, 1958, p. 234; Sheehan, in Washington, 1973, pp. 218-21; Byam Shaw, 1976, I, pp. 185-6

The figures in this drawing are virtually identical to those in an engraving after Mantegna (cat. 93) that was subsequently copied by Giovanni Antonio da Brescia (cat. 94). The only minor differences between the figures concern the chin of Antaeus, which in the print overlaps Hercules' head, and the lower half of Antaeus' left arm, which in the drawing is parallel with Hercules' arm, but more vertical in the print. However, in the print, while the drapery is less extensive and less elaborate than in the drawing, it is more Mantegnesque. It also contains many additions: the tree stump, Hercules' lion's skin, quiver and club, as well as an inscription. The differences between the two versions of the design support Popham and Pouncey's contention that neither is a copy of the other; rather, both derive from a common prototype, which is generally presumed to have been a lost drawing by Mantegna, and which probably only showed the figure group, as in this drawing.

As has been most fully argued by Mezzetti and Sheehan, the original of this design must date from Mantegna's last years for two reasons. First, because the figure types with their muscular, robust proportions suggest a date in the 1490s or 1500s. Second, because the closest analogies to this type of coloured drawing with white heightening come from such sheets as the *Mars, Diana and Iris (?)* (cat. 146), the *Virtus Combusta* (cat. 147) and the late grisaille paintings.

Both this drawing and the closely related drawing of *Hercules and the Nemean Lion* (cat. 96) may derive from lost originals that formed part of a series. The latter drawing is not, however, by the same hand.

D.E.

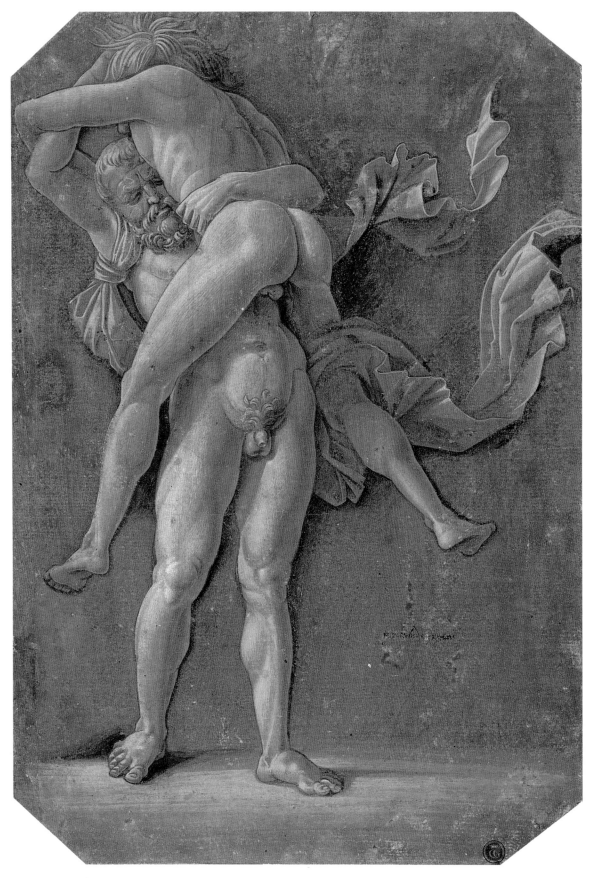

95

96

CIRCLE OF ANDREA MANTEGNA
Hercules and the Nemean Lion

Pen, brush and brown wash on yellow-brown prepared
paper, heightened with yellow and white (some
oxidised); the lower right corner has been torn away
and roughly made up
260 x 174 mm
Inscribed by the artist in white bodycolour:
.D./HERC/IN/VICTO

c. 1490–1510

The Governing Body of Christ Church, Oxford
(inv. 0266)

PROVENANCE
General John Guise; 1765 bequeathed to Christ Church

REFERENCES
Campori, 1870, p. 126; Kristeller, 1901, p. 460; Byam
Shaw, 1937, pp. 57–60; Hind, 1948, V, 36.2; Popham
and Pouncey, 1950, p. 102; Mezzetti, in Mantua, 1961,
p. 181, no. 136; Byam Shaw, 1976, pp. 185-6, no. 691;
idem, 1979, p. 18, no. 40 ; Paris, 1984, p. 9, under no. 2

This drawing is closely related in handling
and technique to the drawing of *Hercules and
Antaeus* (cat. 95). Byam Shaw described them
as 'almost certainly by the same hand', but
caution is required on this point, as Mezzetti
realised. Byam Shaw proposed that Giovanni
Antonio da Brescia, whose signed print in the
reverse direction (cat. 97) corresponds to this
drawing extremely closely, was also the
author of this sheet. The fact that the
drawing, with its dark ground and light
heightening, is a tonal negative of the print
need not influence a decision one way or the
other. However, it is interesting to note that
the distinction between white heightening
for Hercules and yellow for the lion is purely
descriptive, and is not reflected by lighter or
darker tones in the print. Furthermore,
although its general outlines are precisely
followed, the feel of the drawing is subtler
than that of the print. Not only does the
engraver simplify the shading – and hence the
musculature and the drapery – of the figure,
but he also omits such telling details as the
decorative leaves at the beginning and the
end of the inscription – which are also found
in the Uffizi drawing of *Judith* (fig. 109) – and
the lines parallel to the picture plane, which
establish a ground for the figures. There are
also additions, of which the most notable is
the area of shadow around the group, which
provides a kind of backdrop to the action.
Certainly this drawing was not used for the
related print (see cat. 97, below).

It is generally agreed that this sheet, together
with the *Hercules and Antaeus* (cat. 95), are
both copies of lost Mantegna drawings of the
1490s or 1500s. The comparative crudeness
of the facial expression, as well as the
treatment of the lion's mane and Hercules'
hair, certainly exclude the possibility of this
being an autograph Mantegna. The only
problem in regarding it as a copy of a lost
drawing by Mantegna is that for all its
meticulousness of handling, there is a major
pentimento in the contour of the hero's right
upper thigh.

The 1632 inventory of Roberto Canonici's
collection includes a drawing, said to be by
Mantegna, of '*Ercole, che squarcia il leone*'. A
damaged and inferior copy of this drawing
(Louvre, Paris, R.F. 39.030), which was
published as the model for the print (Paris,
1984), is almost identical in appearance, but
lacks the *pentimento* on the thigh, the yellow
heightening and the inscription.

D.E.

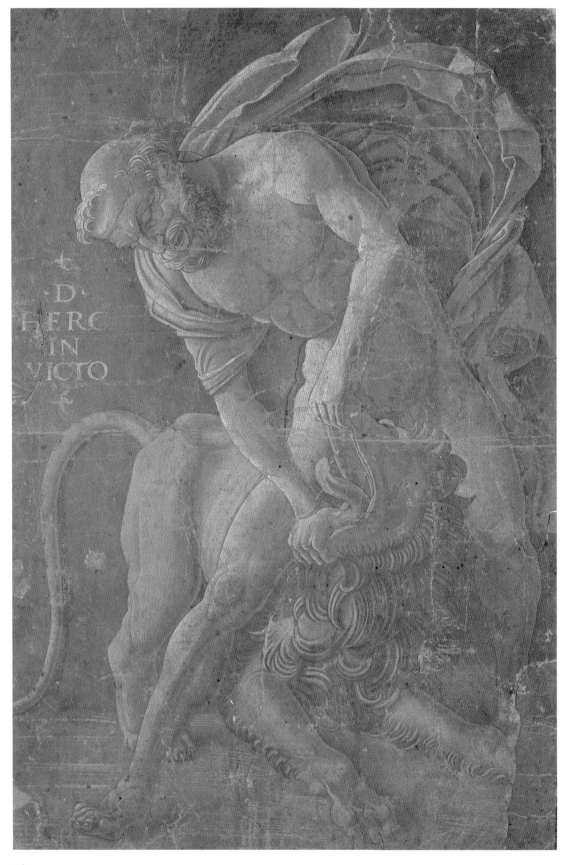

·D·
HERC
IN
VICTO

96

97

GIOVANNI ANTONIO DA BRESCIA
Hercules and the Nemean Lion

Engraving, state 1 of 2 (?; see text)
257 x 235 mm (sheet; plate 286 x 248 mm, New York)
Inscribed (at right): *.D./HER[C]/IN/VICTO.*; (at bottom): *IO.AN.BX*
H.GAB.2

1507 or later

Graphische Sammlung Albertina, Vienna (1952-292)

REFERENCES
Bartsch, 1811, XIII, 323.11; Hind, 1948, V, 36.2

This print, the pen and brush drawing (cat. 97) and a similar pen and wash drawing (Louvre, Paris, R.F. 39030) are the only surviving records of this composition by Mantegna. The scale of the figures is virtually identical in all these works, although the print is in the reverse direction. Hercules in the present print is exactly to scale with Hercules in the late version of *Hercules and Antaeus* showing the two face to face (cat. 93). The relatively short, square proportions of the figures date these compositions to the 1490s at the earliest; the figures show affinities with those in the late grisaille paintings (cats. 128-35), and it seems possible that these two compositions were originally part of a series of the Labours of Hercules that Mantegna designed late in his life, of which no other record survives.

It has been suggested that this print is based on one of the extant drawings, but the superimposition of enlarged transparencies of the print and the Christ Church drawing (cat. 96) demonstrates that no part of the composition was traced from one image to the other. It has not been possible to do this with a transparency of the Paris drawing, but it is doubtful that it was the direct model either; it seems more likely that this engraving is a copy of a print by Mantegna's Premier Engraver that no longer survives. It must date from 1507 or later, as that seems to be the year in which Giovanni Antonio began to use a Latinate form of signature (see pp. 57-61); it was probably made somewhat later, since the print shows part of what was presumably a signature, already in Latinate

form, incompletely erased when a previous image was burnished out, under the lion's right front paw: if the plate is turned sideways, the letters '*BX*' are legible. As there is no print known on a plate of this size with a signature in this position, apparently no impression survives of that image. The plate is inscribed with a dedication to Ercole d'Este (see cat. 86). Since he died in 1505 there would have been no reason to use the dedication after 1507. This adds further support to the hypothesis that an earlier print by the Premier Engraver once existed, of which this is a copy. Conceivably the *Laocoon* (Hind, V, 43.20) could have been engraved on the reverse of the same plate; the British Museum impression of that print measures 282 x 250 mm. That image also bears Giovanni Antonio's Latinate signature, and in any case could not date from before 1506, when the *Laocoon* was unearthed.

In this impression the marks at either side of the letters '*D*' and '*C*' of *D./HER[C]* do not appear: it is not certain if they had not been engraved when the print was made or simply had not been inked.

S.B.

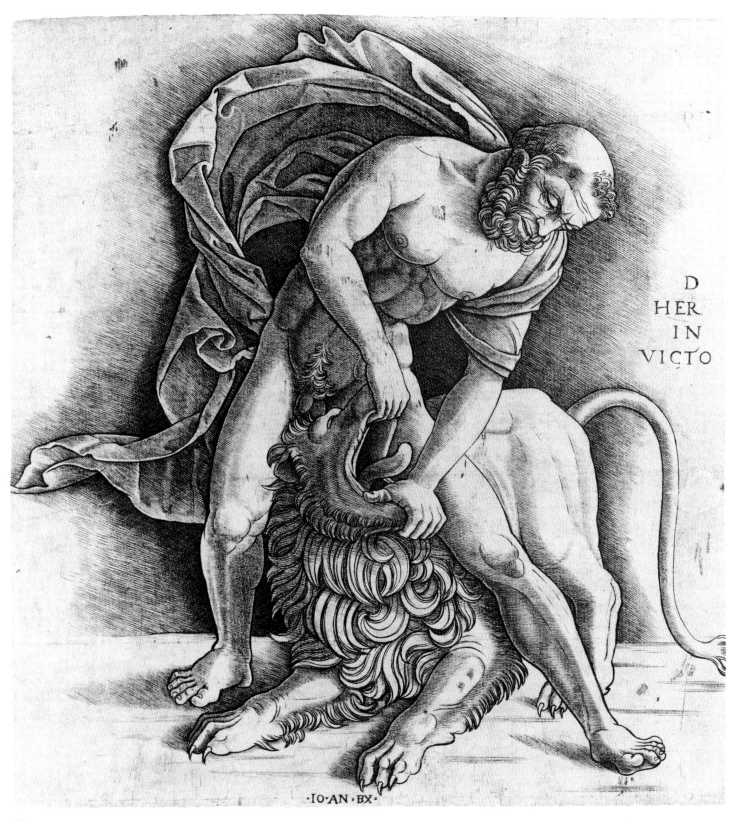

D
HER
IN
VICTO

·IO·AN·BX·

97

322

6 PORTRAITS

The first encomium of a work by Mantegna, dating perhaps as early as 1447-8, when the artist made his formal break with his master, Squarcione, in Venice, is directed not to an altarpiece or fresco cycle, but to a portrait of a nun 'of an angelic face beneath a veil... sculpted in paint, truly lifelike and true...'.[1] A decade later, in 1458, the Hungarian humanist Janus Pannonius addressed another poem to Mantegna in praise of a portrait showing him together with Galeotto da Narni, '...in one picture, breathing a knot of friendship'.[2] It was as a portraitist that Mantegna was known to Lionello d'Este, Marchese of Ferrara, and it was a portrait the worldly Cardinal Ludovico Trevisan commissioned from him in 1459-60 (cat. 100). Although Ludovico Gonzaga was later to claim, somewhat disingenuously, that Mantegna's portraits lacked grace, the principal task he gave the artist – one that required the better part of ten years to bring to completion – was the decoration of a room in the Castello di San Giorgio with a cycle of frescoes that, on one level, can be regarded as a monumental conversation piece showing the Marchese, his wife, children, relatives, retainers, servants, pet dogs and horses, engrossed in the business of governing the small state of Mantua. In the opening passage of the second book of the *De Pictura* – the work that brings us closest to the mainspring of Mantegna's art – Alberti defended the worth of painting using portraiture as his example. 'Painting', he declared, 'possesses a truly divine power in that not only does it make the absent present (as they say of friendship), but it also represents the dead to the living many centuries later, so that they are recognised by spectators with pleasure and deep admiration for the artist.'[3]

The urge to record and commemorate was the driving force behind 15th-century portraiture.[4] No less than eight portraits of prominent citizens and artists, including Squarcione (shown as a corpulent executioner), were introduced into the *Martyrdom of St Christopher* in the Ovetari Chapel (see p. 13). Mantegna recorded his own appearance in a remarkable series of self-portraits inserted in his works. The earliest, painted when he was perhaps not yet twenty, was a monumental head in monochrome at the base of the arch leading into the apse of the Ovetari Chapel (destroyed). It showed the artist, '*scolpito in pictura*', turned three-quarters, his lips parted, his eyes apprehensively staring out at the viewer. A few years later Mantegna reappeared as a morose Roman centurion, standing alone, to one side in the scene of the *Trial of St James* (fig. 94). We next come upon the still youthful artist as a curious spectator in the *Presentation in the Temple* (fig. 39; Gemäldegalerie, Berlin), his attention directed to the delicate figure of the Virgin hesitantly passing her tightly swaddled, frightened child into the hands of the intimidating old priest, Simeon. His face then disappears for almost two decades, re-emerging, chameleon-like, as part of the decoration of a feigned pilaster dividing two of the scenes on the north wall of the Camera Picta (fig. 95), where his averted glance, his tightly closed lips and disapproving, furrowed brow are readily recognisable.[5] It is difficult to believe that Mantegna did not show himself somewhere in the *Triumphs of Caesar* and that the ravages of time are not responsible for his disappearance from those works to which he attached such importance.[6] The last certain likeness we have of him is the bronze effigy that presides

fig. 93 Andrea Mantegna, *Madonna della Vittoria*, canvas, 280 x 166 cm, detail, 1495-6, Musée du Louvre, Paris

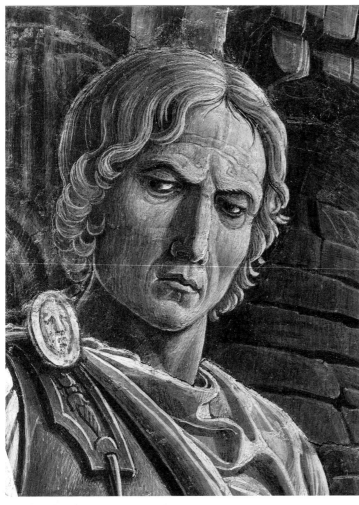

fig. 94 Andrea Mantegna, Self-portrait, detail from the *Trial of St James*, fresco,
c. 1450-54, formerly Cappella Ovetari, Chiesa degli Eremitani, Padua

over his funerary chapel (fig. 45), where the artist has, at last, fully metamorphosed into a stoic Roman philosopher, disdainful of the world in which he has lived, his accomplishments acknowledged by a wreath of bay grudgingly worn over his long, unkempt locks of hair (see cat. 1).[7]

Quite apart from the record these portraits provide of Mantegna's appearance, they constitute an autobiographical statement unique in the 15th century. In his *De Viris Illustribus* written in 1456, Bartolomeo Fazio stated his belief that painting required 'the representation not only of the face or countenance and the lineaments of the whole body but also, and far more, of its interior feelings and emotions...'.[8] It was a view taken from the Greek Sophist Philostratus, who in the *Imagines* had singled out as the foundation of art the ability 'to distinguish ... the signs of men's character, what is revealed in the state of their cheeks, in the expression of their eyes, in the character of their eyebrows and, in short, whatever has to do with the mind'.[9] Mantegna's self-portraits attest to an almost frightening gift for characterisation, which he employed most fully in the Camera Picta. Nowhere else do we seem so close to the individuals of a benignly despotic Renaissance court; this despite the fact that some of the figures portrayed never sat to Mantegna, who had to reconstruct their appearance from portrait medals or reports (this was not uncommon in the Renaissance).

To turn from that great cycle to the handful of surviving easel portraits that can be credibly ascribed to him is something of a disappointment, and it is understandable that the authorship of all but one, that of *Ludovico Trevisan* (cat. 100), has been doubted at one time or another. The reason for this has less to do with Mantegna's abilities as a portraitist, readily evident in the newly cleaned portrait from the Uffizi (cat. 102), than the restricting conventions and circumstances that governed their appearance. Court portraiture in Ferrara and Mantua had been determined in the preceding generation by Pisanello, and when Mantegna was required to portray the youthful Francesco Gonzaga (cat. 101), the profile format Pisanello had employed must have been imposed, just as it apparently was again in 1500, when Leonardo made his drawing of Isabella d'Este (Louvre, Paris). Profile portraiture was not, of course, confined to paintings. Lionello d'Este is known to have passed hours examining the heads of the Caesars on his bronze coins,[10] and under the impetus of Alberti, Pisanello had contributed to the creation of the Renaissance portrait medal.[11] These were viewed as a continuation of ancient practice, and answered a different

set of expectations from those that governed painted portraiture. No one who compares Pisanello's painted portrait of Lionello (Accademia Carrara, Bergamo) with his medals of the Marchese can fail to remark on the artificial appearance of the painting, in which Lionello's unmistakable profile is rhythmically disposed to form a decorative pattern against the rose hedge, and his ear is treated with the elegance of a pressed butterfly wing. Similarly, there is no painted equivalent to the medal of Ludovico Gonzaga cast in 1475 by the Mantuan Bartolomeo Melioli, in which the Marchese is shown in profile, bust-length, his armour used to form a socle *all'antica*. Even in the Camera Picta, a distinction is maintained between the feigned marble busts of Roman emperors, to a greater or lesser degree based on their known likenesses taken from ancient busts or coins, that decorate the vault, and the lifelike Ludovico and his family on two of the walls. Only in the putti supporting an inscribed stone tablet above a door, analogous to the *faux-marbre* cherubs who hold the roundels of the emperors (fig. 10), does he permit himself the conceit of statues that have, as if in the hands of Pygmalion, come alive to inhabit the room. Otherwise, it is in the frieze-like arrangement of the figures in the scene of Ludovico meeting his son Francesco, rather than their appearance, that one suspects the study of a Roman relief.

Verisimilitude was the first requirement of a portrait in the 15th century. When the ambassadors of the Duke of Milan were taken by Ludovico Gonzaga to see the Camera Picta before it was completed, the Marchese's two daughters were summoned so that Mantegna's success in depicting them could be better appreciated.[12] Nonetheless, judging verisimilitude was a highly subjective matter.

Perhaps the most enlightening episode of Mantegna's work as a portrait painter emerges from his unsuccessful depiction of Isabella d'Este, a notoriously vain and difficult patron. In 1493, the young Marchesa had decided to exchange portraits with her friend Isabella del Balzo,

Countess of Acerra. For this she made arrangements with Mantegna. It was his first commission from Isabella, and potentially of enormous importance for his future patronage. In April, two images of the Countess arrived: one on paper, presumably a drawing, and the other in wax. Isabella d'Este immediately wrote to thank the countess, 'even if, from what Jacopo [d'Atri] says and from our own judgement, they resemble you little. Yet, since we know how difficult it is to find painters who take a good likeness from life, we shall hold it most dear and frequently we shall look on it, supplementing the artist's deficiencies with the information of Margherita, Jacopo, and those who have seen you, so that we shall not be misled in our idea of you'.[13] Isabella urged the Countess to send a portrait painted on panel and promised to do the same in return, but on 20 April she announced that her plans had come to naught, since Mantegna had made a portrait 'that does not resemble us in the least'.[14] On the recommendation of her sister-in-law, the Duchess of Urbino, the commission was transferred to Giovanni Santi (the father of Raphael and an artist of astonishing mediocrity), who, surprisingly enough, had a reputation for making a good likeness. What was doubtless a bland portrait by modern standards seems to have pleased Isabella, who sent it on to the Countess of Acerra. In 1511, Isabella praised a portrait of herself by Francesco Francia, who had based his work on a drawing, since she refused to sit for any further portraits. This work, in turn, was used by Titian in 1534-6 to reconstruct the youthful appearance of the ageing Marchesa.[15]

This was not the first time a portrait of Mantegna had displeased the sitter. In 1475 it was reported to Ludovico Gonzaga that the Duke of Milan, Galeazzo Maria Sforza, was piqued at not being included in the newly completed Camera Picta. Ludovico reminded his informant that Sforza had been so displeased with some portrait drawings Mantegna had made of him that he had burnt them. The Marchese decided not to run the risk of

offending the Duke again. It was at this point that he added, obviously as an additional defence, that although Mantegna was a great artist, his portraits were perhaps lacking in grace.[16] Clearly, unadorned realism was not what these patrons expected.

The fact that the Countess of Acerra sent a portrait drawing to Isabella and that Mantegna's portraits of Sforza were also drawings demonstrates that not all surviving portrait drawings are necessarily preparatory to a picture. They were sometimes viewed as works of art in their own right. In 1477 Mantegna inquired of Ludovico whether the portraits he wanted were to be 'only drawn or coloured, on a wood panel or on canvas, and of what size'. He added that if they were to be sent any distance he could 'make them on fine canvas to permit them to be wrapped round a dowel'.[17] Pisanello had used black chalk to draw the features of the *condottiere* Niccolò Piccinino in 1439-40 (Louvre, Paris; inv. 2482), and it is in this medium that the finest northern Italian portrait drawings of the late 15th century were carried out (see cats. 103-7). Although their authorship remains controversial – they are most frequently ascribed to Giovanni Bellini or Francesco Bonsignori, who is known to have painted numerous portraits for the Gonzaga – there is no *a priori* reason why some of them should not be ascribed to Mantegna.[18] A comparison of the drawing of *Francesco Gonzaga* (cat. 105) with the profile portrait Mantegna included in the *Madonna della Vittoria* (fig. 93; Louvre, Paris) underscores the editing process by which these compellingly life-like studies were abstracted into a more formal image: a transformation of what contemporaries would have judged to be the raw material of nature into the realm of art.[19] Neither the Uffizi *Portrait of a Man* nor that of *Ludovico Trevisan* reveal any signs of an underdrawing when examined by means of infra-red reflectography, except in the collars of the sitters. Clearly, each must have been based fairly directly on a drawn likeness that can only be reconstructed on the basis of the chalk drawings presented here.

Although there is a tendency to isolate Mantegna's work from that of his contemporaries and to impose upon it an artificial uniformity, this would be a mistake with the portraits. The earliest one attributable to him (cat. 98), in which the sitter's ears are pressed outwards by the cap, his eye is set within a well-defined socket, and his chin has an uncomfortable stubble, is conceived in the realistic terms of Donatello's terracotta bust of *Niccolò da Uzzano* (Bargello, Florence), which incorporated a life-mask to achieve its effect of directness.[20] The novel conception of the *Ludovico Trevisan*, one of the earliest Italian portraits to repudiate a profile format, may derive its pose and lapidary modelling in part from ancient Roman portrait busts. Although Mantegna may have seen a Flemish portrait in 1449 at the court of Lionello d'Este, and in 1471 very probably met the court painter of the Duke of Milan, Zanetto Bugatto, who had trained in the workshop of Rogier van der Weyden,[21] he adopted the northern convention of including an inscribed parapet in front of the sitter only once: in the miniature portrait of Jacopo Marcello (cat. 10). In this respect his portraits differ decisively from those by Antonello da Messina, Giovanni Bellini and Francesco Bonsignori. There remains the possibility that the lighting in his Uffizi *Portrait of a Man* may owe something to Flemish practice. Yet, with all due allowance made for the different circumstances that affected the format and type of portrait he produced, Mantegna's stern, uncompromising cast of mind invariably makes itself felt.

K.C.

NOTES

1. Kristeller, 1902, p. 488. The date of the poem is not certain, but its reference to Mantegna's removal from his native city to that of the '*salse onde*' – presumably Venice – suggests that the picture was painted in that city. See, most recently, Shaw with Boccia-Shaw, 1989, p. 55, n. 84.
2. Kristeller, 1902, pp. 489-90.
3. Alberti, ed., 1972, p. 61.
4. The basic study on Italian portraiture remains that of Pope-Hennessy, 1966, ed. 1972, especially pp. 3-63.
5. See Signorini, 1976; *idem*, 1985, pp. 181-6.
6. See the letter addressed by Mantegna to Francesco Gonzaga in 1489 in which he recommends the *Triumphs*, 'which, in truth, I am not ashamed to have painted', to his care: Kristeller, 1902, pp. 545-6, doc. 102.
7. The bust is stated by Scardeone to have been made by Mantegna and is frequently thought of as a self-portrait. The most compelling analyses in favour of Mantegna's authorship – the modelling of the head but, of course, not the casting – are those of Middeldorf, 1978, p. 314, and Radcliffe, in London, 1981, pp. 121-2. Despite this, I find the idea difficult to credit. See cat. 1 for a review of opinions.
8. As translated by Baxandall, 1964, p. 98.
9. See Baxandall, 1964, p. 94, for an analysis of Fazio's sources and the passage in question.
10. See Angelo Decembrio's dialogue, translated by Baxandall, 1963, p. 324.
11. On Alberti's role, see especially Pope-Hennessy, 1966, ed. 1972, pp. 64-9.
12. See Signorini, 1985, p. 304, no. 8.
13. Kristeller, 1902, p. 553, doc. 119. Luzio, 1913, pp. 190-92, suggests that the commission had, perhaps, been transferred to Bonsignori, but there is no support for this notion, which seeks merely to protect Mantegna from the embarrassment he obviously had.
14. Kristeller, 1902, p. 554, doc. 120.
15. The various portraits commissioned by Isabella are amply documented by Luzio, 1913, pp. 183-238.
16. See the letters in Signorini, 1985, pp. 305-6, nos. 23-4.
17. Kristeller, 1902, p. 544, doc. 96.
18. As noted in the relevant drawing entries of this catalogue, the copies '*in carte chiaroscuro*' that Vasari states Bonsignori made of his painted portraits are unlikely to have anything to do with the chalk drawings that have come down to us, despite the contrary view of Campbell, 1990, p. 185. The term employed by Vasari implies drawings on paper prepared with a coloured ground with some sort of white heightening.
19. When Isabella received Francia's portrait, she wrote that by his art he had made her more beautiful than she in fact was. She nonetheless suggested some alterations, which Francia declined to make, claiming that it would be arrogant to make art superior to nature. See Luzio, 1913, pp. 212-13.
20. The authorship of the bust has been doubted but is now vindicated by the recent cleaning and restoration, for which see the report in Florence, 1985, pp. 246-61.
21. Kristeller, 1902, p. 527, doc. 44.

fig. 95 Andrea Mantegna, Self-portrait, *c.* 1474, fresco, detail from a pilaster in the Camera Picta, Mantua

98

ANDREA MANTEGNA
Portrait of a Man

Tempera on wood, 32.3 x 28.8 cm

c. 1448–50

Museo Poldi Pezzoli, Milan (inv. 1592/627)

PROVENANCE
By 1879, Gian Giacomo Poldi Pezzoli, Milan

REFERENCES
Bertini, 1881, p. 29; Berenson, 1894, p. 94; *idem*, 1932, p. 96; Suida, 1946, p. 65; Ruhmer, 1958, p. 47; Schmitt, 1961, p. 133; Paccagnini, in Mantua, 1961, p. 111; Del Bravo, 1962, p. 56; Longhi, 1962, ed. 1978, p. 155; Cipriani, 1962, p. 81; Camesasca, 1964, pp. 28, 116; Garavaglia, 1967, no. 29; Berenson, 1968, p. 240; Natale, 1982, p. 112; Lightbown, 1986, p. 478

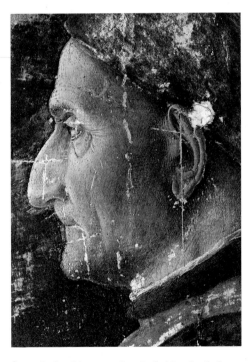

fig. 96 Andrea Mantegna, *Portrait of a Man*, detail after cleaning and before restoration, Museo Poldi Pezzoli, Milan (cat. 98)

This damaged but exceptionally fine portrait of an unidentified male sitter viewed in profile against an ultramarine blue background (once as brilliant as that in the miniature portrait of Jacopo Marcello, cat. 10, but now much darkened), has long been relegated to the periphery of Mantegna studies – not least because of extensive repainting that masked much of the surface; this was removed in 1974, enabling a revaluation of the picture (see fig. 96, taken after cleaning and before restoration). At one time considered the work of Cosimo Tura (Bertini) or a follower (Ruhmer, Schmitt), it was ascribed by Berenson to Francesco Bonsignori (see also Paccagnini), to whom a quantity of Mantegnesque drawings have been attributed on the strength of a single signed portrait in the National Gallery, London (see cats. 103-7). The attribution to Mantegna advanced by a number of scholars (Suida, Del Bravo, Longhi, Camesasca, Natale) has not found general acceptance. Lightbown rejected it and reproduced it before cleaning, noting that 'the treatment of the salient veins of the forehead and of the ear has no parallel in Mantegna's work, and the whole lacks Mantegna's strength of conception and execution'. If the date of *c.* 1460 or *c.* 1465 tentatively assigned to it by Natale and Cipriani could be demonstrated on the basis of the costume, this point of view would have much to recommend it, for the concern for descriptive detail, revealed in the veins and in the stubble on the chin and jowl, has little in common with the more generalised features of the miniature portrait of Jacopo Marcello, dating from 1453, and the somewhat later portrait heads in the fresco of the *Martyrdom of St Christopher* in the Ovetari Chapel (fig. 6), let alone the emphatically sculptural portrait of Cardinal Ludovico Trevisan (cat. 100). But, if the portrait is dated a decade earlier – more or less contemporary with the *St Jerome* (cat. 3) – then an attribution to Mantegna seems not only possible, but in many respects inevitable.

Mantegna established a widespread reputation as a portrait painter early on. In May 1449 a panel was prepared for him in Ferrara for a double-sided portrait of Lionello d'Este and his factor, Folco da Villafora. Possibly two years earlier Ulisse Aleotti

praised Mantegna's portrait of a nun (see p. 12). Pisanello's more or less contemporary portraits rely on a sharply defined profile and a few incisively described physiognomic details to communicate the character of the sitter. This is also true of the present portrait, which, however, is in a number of respects closer to Pisanello's portrait medals than to his painted portraits. The relief-like effect of the head is obtained by a sharp, raking light that emphasises the pronounced eye socket and cheekbone, and the strongly three-dimensional form of the ear. The same method, possibly reflecting some work painted by Filippo Lippi during his Paduan sojourn, was employed by Mantegna for the portrait heads in the Ovetari Chapel.

Sculptural analogies abound in Mantegna's work, but they should not blind one to the extraordinary sensitivity evident in this portrait to variations in light on the planes of the face and the elaborate folds of the head-dress (which find their closest analogy in the drapery of the *St Jerome*). The realistic touches of the bulging vein and unshaven chin seem, like the coarse features of the shepherds in the *Adoration of the Shepherds* (cat. 8), to reflect Mantegna's admiration for Rogier van der Weyden's works he would have seen in Ferrara (a triptych by Rogier in Lionello's collection contained a portrait of a donor).

It is tempting to believe that the portrait shows one of Mantegna's well-placed acquaintances with humanist tastes, such as Aleotti, who in terms of age (b. 1400) is a suitable candidate, but this cannot be demonstrated. Certainly the sitter does not resemble any of those depicted in the Ovetari Chapel, who are identified by Vasari. On the strength of the costume, Natale suggested that he is a Venetian magistrate, but an identical red cloak and magenta-coloured hat and stole (albeit doffed) are worn by Guarino in a dedicatory miniature illustrating a manuscript dated 1459 of Strabo's *Geography* (Bibliothèque Rochegude, Albi; see cat. 10). Lightbown has reasonably suggested that this may be the portrait of a jurisconsulist by Mantegna recorded in the collection of Giovanni Pietro Curtoni of Verona (d. 1656) (Campori, 1870, p. 196).

K.C.

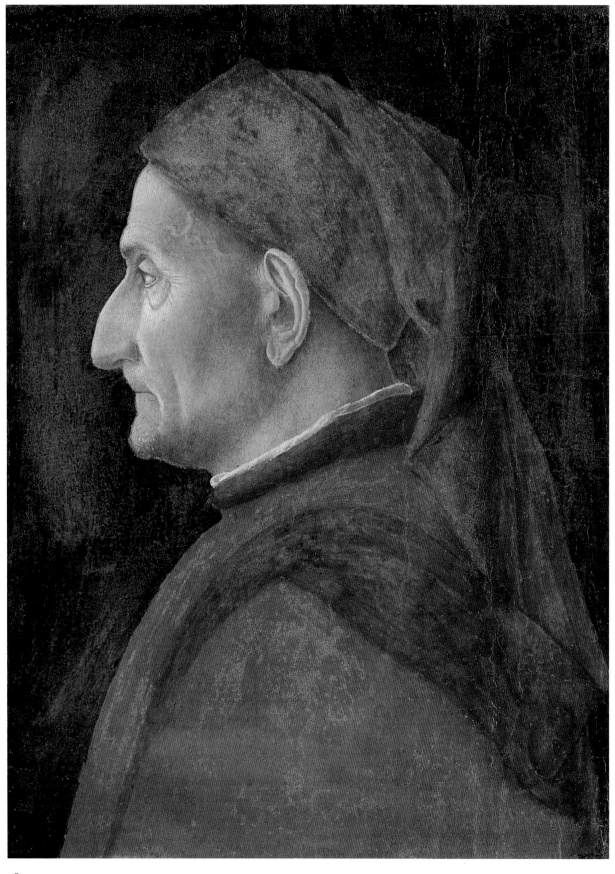

99

ANDREA MANTEGNA
Portrait of a Man

Tempera on masonite(?) backed with a cradled
mahogany panel, transferred from canvas, transferred
from wood. Overall: 25.1 x 19.8 cm; painted surface:
24.2 x 19.1 cm

c. 1455-70(?)

The National Gallery of Art, Washington, DC
(The Samuel H. Kress Collection, 1088)
(Exhibited in New York only)

PROVENANCE
Before 1906, Gaál, Balatonföldvár, Hungary; 1906-29,
Dr Ludwig Keleman, Budapest; after 1929-1950,
Jacques Seligmann, New York; 1950, Samuel H. Kress
Collection

REFERENCES
Frankfurter, 1939, no. 233; Suida, 1946, p. 63; *idem*,
1951, p. 70; Tietze-Conrat, 1955, pp. 190, 201; Boeck,
1957, p. 196; Meiss, 1957, pp. 26, 88, n. 41; Cipriani,
1962, pp. 29-60; Camesasca, 1964, pp. 37, 118;
Garavaglia, 1967, no. 42; Berenson, 1968, p. 242;
Robertson, 1968, pp. 19-20; Shapley, 1968, p. 25;
idem, 1979, pp. 297-8; Fredericksen and Zeri, 1972,
p. 118; Puppi, 1972, pp. 59, 63, n. 41; Natale, 1982,
p. 112; Lightbown, 1986, p. 478

Of the five portraits that have serious claim to
being by Mantegna, that at Washington is in
many ways the most problematic, mostly due
to its condition, for whereas the early portrait
at Milan (cat. 98) is damaged, there are,
nonetheless, passages in a relatively good
state. By contrast, this portrait has lost
virtually all its final surface layers, and
whatever crispness it may once have possessed
has been irredeemably compromised through
its double transfer. It may also have been cut
down (Meiss suggested that the figure was,
perhaps, shown behind a parapet, as in the
miniature portrait of Jacopo Marcello,
cat. 10). That the picture still commands
attention is testimony to its exceptional
quality – perhaps best exemplified by the only
plausible alternative attribution thus far
advanced: to Giovanni Bellini while under
the influence of Mantegna (Robertson). If,
however, the portraits (one of Jacopo
Marcello) in the 1459 manuscript of Strabo's
Geography (Bibliothèque Rochegude, Albi)
are by Giovanni Bellini – as this compiler
firmly believes after having examined them –
then any attempt to ascribe the Washington
portrait to Bellini must be abandoned.

There is, however, a second, more
pervasive, reason for the difficulties in
attributing and dating the Washington
portrait, and this has to do with the nature of
portraiture in the 15th century. Portraiture
was defined by fixed conventions and subject
to conditions imposed by the sitter and by
circumstance. Moreover, artists were not
always able to work from life: Mantegna
himself complained of this handicap and the
inevitable compromising effect it had on his
work (Kristeller, 1902, p. 534, doc. 69). Then
there was the matter of the degree to which
the artist was expected to idealise the sitter or,
at least, play down his less appealing physical
traits. On all these counts, the frescoed
portraits Mantegna included in the scene of
the *Martyrdom of St Christopher* in the Ovetari
Chapel, or the self-portrait in the *Presentation
in the Temple* (fig. 39; Gemäldegalerie,
Berlin), can offer only general indications for
Mantegna's portrait style in the 1450s. The
same is true of the portraits in the Camera
Picta, where their function as part of an
istoria, or narrative, determined their

character. The very considerable differences
between the austerely sculptural, three-
quarter view portrait of *Cardinal Ludovico
Trevisan* (cat. 100) and the more supple,
relaxed quality of the *Portrait of a Man* (cat.
102) demonstrate the latitude one must allow.

With these observations in mind, the
Washington portrait can be proposed as a
work by Mantegna painted between 1455
and 1470. Particularly noteworthy is the
volumetric treatment of the shoulder and
chest, and the way the white collar runs
around the neck rather than bisecting it. This
shows a decisive advance over the profile of
Jacopo Marcello. The eye socket is also
treated as a three-dimensional shape, and not
merely in terms of contour; there are
comparable features in the portrait of *Francesco
Gonzaga* (cat. 105).

Although a date in the 1450s is accepted by
all but a few scholars (Cipriani, Camesasca
and Garavaglia propose a date after 1460), a
Mantuan date cannot be ruled out, especially
in view of the suggestive, if inconclusive,
resemblance of the features of the sitter to
those of one of the two men viewed in right
profile behind Ludovico Gonzaga in the
scene in the Camera Picta showing Ludovico
meeting his son Cardinal Francesco. This
figure has been identified as a groom (see
Lightbown, pp. 109-10), but his dress differs
markedly from that of the grooms in the
adjacent scene, all of whom wear Gonzaga
livery and are separated from the Marchese
and his entourage, and he is more likely to be
a member of Ludovico's court. The
identification of the sitter as the Hungarian
humanist Janus Pannonius proposed by
Frankfurter has been disproved (see Tietze-
Conrat; Puppi; Lightbown, pp. 459-60, 478).

An examination of the picture with infra-
red reflectography reveals only summary
underdrawing for the contour of the chest
and profile, done with brush, and the hat,
apparently done in lead point and partly
outlined with brush. The underdrawing for
the hat is partly visible to the naked eye.

K.C.

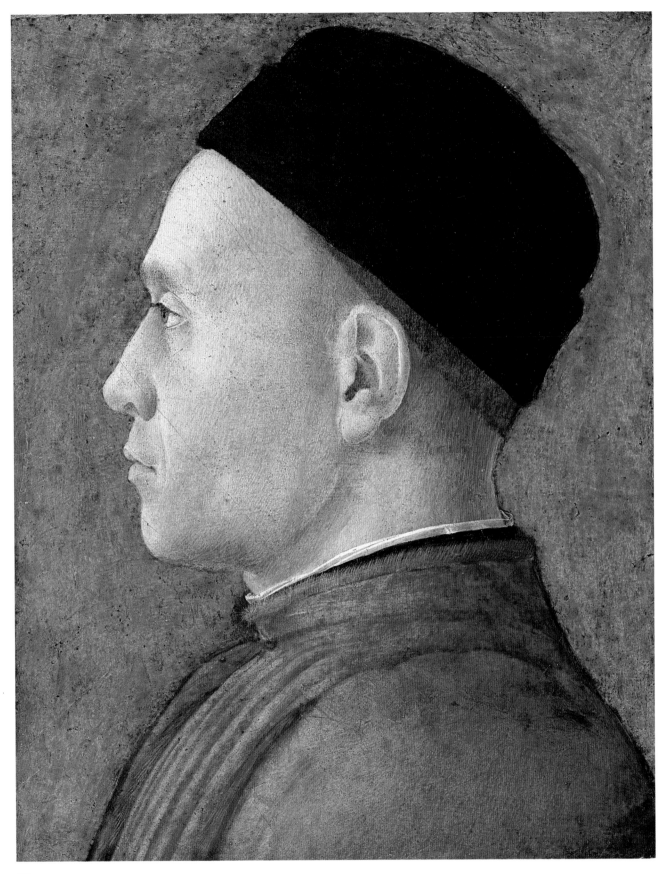

99

100

ANDREA MANTEGNA
Cardinal Ludovico Trevisan

Tempera on wood, 45.4 x 34.8 cm; painted surface,
44.8 x 33.9 cm

1459-60

Staatliche Museen Preussischer Kulturbesitz,
Gemäldegalerie, Berlin (no. 9)
(Exhibited in New York only)

PROVENANCE
Before 1630, Francesco Leone, Padua(?); after 1821-
1830, Edward Solly, Berlin; Königliche Museen, Berlin

REFERENCES
Waagen 1855, p. 6; Crowe and Cavalcaselle, 1871,
ed. 1912, p. 89; Morelli, 1880, pp. 432-3; *Repertorium
für Kunstwissenschaft*, III, 1880, pp. 236-8; Bode, 1898,
pp. 174-5, no. 9; Yriarte, 1901, p. 191; Kristeller, 1901,
pp. 170-73; Berenson, 1907, p. 254; Knapp, 1910,
pp. XLVI, 175; Venturi, 1914, pp. 136-8; Berenson,
1932, p. 236; Fiocco, 1937, pp. 47, 202; Tietze-Conrat,
1955, pp. 11-12, 180; Meiss, 1957, pp. 19-20, 26;
Paccagnini, in Mantua, 1961, p. 22; Gilbert, 1962, p. 6;
Cipriani, 1962, pp. 27, 57; Camesasca, 1964, pp. 26,
28, 115; Pope-Hennessy, 1966, ed. 1972, p. 86;
Hermann, 1967, pp. 14-15; Garavaglia, 1967, no. 26;
Berenson, 1968, p. 239; Lightbown, 1986, pp. 81-2,
408-10; Campbell, 1990, p. 228

When this, Mantegna's most forceful portrait,
was purchased by the English timber
merchant and collector Edward Solly
sometime between 1821 and 1830, the
identity of the sitter was unknown. An
abortive attempt was made to identify it as
Mantegna's friend Matteo Bosso (Crowe and
Cavalcaselle, 1871, ed. 1912, p. 89). That he
is the worldly and ambitious Cardinal
Ludovico Trevisan is established first, by a
copy bearing the sitter's name, his titles and
his arms (formerly in the Bromley Davenport
collection, untraced: see Lightbown, 1986,
p. 408); second, by a portrait medal ascribed
to Cristoforo di Geremia (Hill, 1930,
no. 736); and third, by an engraving in J.P.
Tommasini's *Illustrium Virorum Elogia* of 1630
purportedly based on a portrait by Mantegna
in the collection of the Paduan nobleman
Francesco Leone (the engraving is reproduced
in Lightbown, fig. 48). In the engraved
portrait Trevisan wears a short *mozzetta*, or

cape, rather than the open cloak shown in the
Berlin picture, and he faces to the right rather
than to the left. If it is allowed that the
reversal – a common phenomenon with
prints – and the change of costume were
introduced by the engraver, who adapted his
prototype to a standard, 17th-century oval
format, then it does not seem unlikely that
the Berlin portrait of Trevisan is the one seen
by Tommasini (*pace* Lightbown, p. 409, who
gives an over-close reading of Tommasini's
passage).

Ludovico Trevisan (*c.* 1402-65), who was
subsequently known as Mezzarota Scarampo,
played a prominent role in the church. Born
in Venice and educated in Padua, he had
been physician to Cardinal Condulmier, later
Pope Eugenius IV, before taking orders. From
that point he rapidly rose through the ranks,
becoming Bishop of Trau in 1435,
Archbishop of Florence in 1437, Patriarch
of Aquileia in 1439 and Cardinal in 1440,
following his command of the papal
contingent against the Milanese general
Piccinino at the Battle of Anghiari (see
Lightbown, 1986, pp. 409-10). In 1455
Calixtus III appointed Trevisan Legate and
Admiral of the Papal Fleet in the eastern
Mediterranean. Trevisan obtained a
significant victory against the Turks at
Mytilene in August 1457. He returned to
Rome in March 1459 and proceeded to
Mantua to attend the Congress convened
there by Pius II. At the Congress he actively
campaigned to defeat Pius's designs for a
crusade against the Turks, and the following
year, in Rome, he self-righteously opposed
enlarging the College of Cardinals to include
men less worthy than the incumbents (for his
astonishingly disingenuous speech, see Pius's
Commentaries, book IV). His great and much-
hated rival was the Venetian Cardinal Pietro
Barbo, whose election as Paul II in August
1464 was said to have hastened Trevisan's
death the following March.

Trevisan's humanist-antiquarian interests
may have been encouraged by his
acquaintance with the great scholar-collector
Niccolò Niccoli during Eugenius's exile in
Florence. Niccoli had assembled a fabled
collection of ancient coins, statues, antique
portrait busts, vessels, crystal cups, inscriptions
and reliefs. One of his most admired cameos
was, in fact, purchased by Trevisan for 200

ducats; it was later owned by Paul II and
Lorenzo the Magnificent (see Vespasiano da
Bisticci's biography of Niccolò Niccoli). He
corresponded with Ciriaco d'Ancona as well
as with other humanists, and the frontispiece
of his manuscript of St Jerome's *Lives of
Malchion and Paul the Hermit* (Bib. Marciana,
Venice, Cod. Lat. II, 39 2999) is decorated
with an inscribed Roman monument of the
sort drawn by Jacopo Bellini and favoured for
book illustrations by Felice Feliciano (Rome,
1953, no. 630; and Zorzi, 1988, p. 133).

In 1451 Trevisan purchased the Arena in
Padua for the site of a family palace, and it
may have been at this time that he first
became acquainted with Mantegna's work.
Scardeone (1560, in Kristeller, 1902, p. 502)
lists him among Squarcione's admirers. It was,
however, only in 1459-60, during the
Congress at Mantua, that he could have sat to
Mantegna. On the strength of Schivenoglia's
chronicle, it is usually supposed that the
portrait was taken during the cardinal's stay in
Mantua from 27 May 1459 until 8 February
1460. In late July 1459 Mantegna arrived in
Verona to supervise the installation of the San
Zeno Altarpiece (he received payments from
24 July until 21 January 1460: see Puppi,
1972, p. 73, doc. XVI; Herzner, 1974, p. 441).
During this time he almost certainly visited
Mantua to inspect the small chapel that had
been built according to his designs. However,
whether Trevisan was still in Mantua at that
time is uncertain. Pius II opened the Congress
on 1 June. In his *Commentaries* (book III) he
states that Trevisan abandoned the city,
travelling to Padua 'on the pretext of taking
the baths, and then to Venice. In both places
he set on foot many schemes against the
Cardinal of San Marco (Pietro Barbo) to
prevent his obtaining the church at Padua'.
It is thus possible that Mantegna drew and
painted Trevisan's likeness in either Verona
or Padua, conceivably to adorn the Cardinal's
palace. There is, however, no reason to
suppose the picture was commissioned by
Francesco Trevisan, the Cardinal's nephew,
as suggested by Lightbown (p. 410).

Apart from being the touchstone for
Mantegna's work as a portrait painter, this is
one of the landmarks of Italian portraiture.
Only Andrea del Castagno's *Portrait of a Man*
(National Gallery of Art, Washington), of
about 1450-57, certainly precedes it in

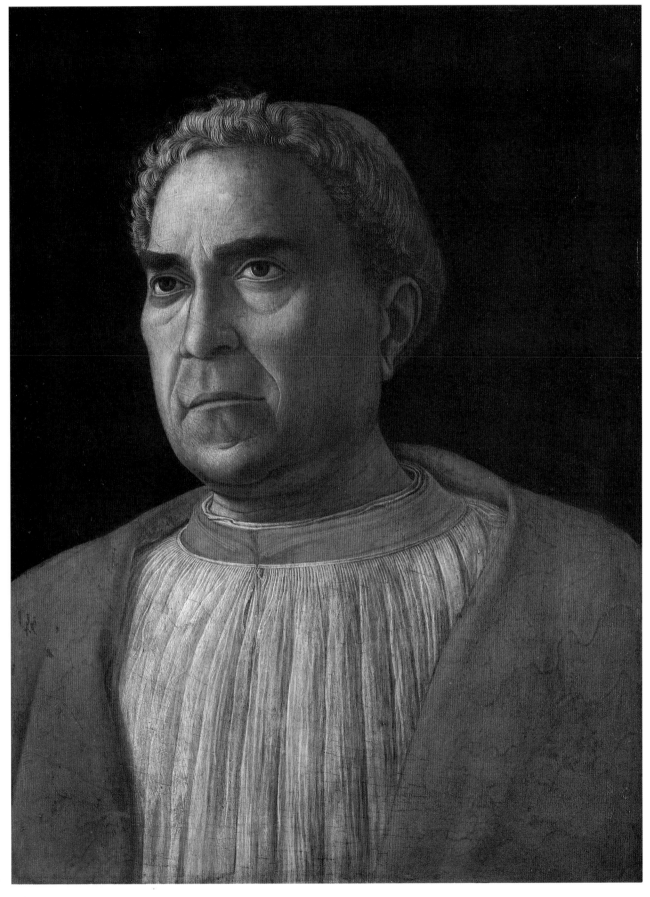

showing the sitter obliquely rather than in profile – the standard formula for Italian portraits in the first half of the 15th century. In the Netherlands, three-quarter view portraits were already the norm, and their example is sometimes cited as a reference point for both Castagno and Mantegna. However, Castagno's portrait, with its assertive three-dimensionality, its emphasis on sharply delineated forms and surfaces modelled in brightly lit planes, is best understood not as an attempt to emulate the subtle description of Flemish portraiture, but as a pictorial equivalent to contemporary Florentine marble and terracotta portrait busts. Mantegna's depiction, with the shoulders firmly anchored by the heavy folds of the cloak and the head turned at an angle that emphasises its volume, is also indebted chiefly to portrait busts, though to ancient

rather than contemporary ones. An analogy for the pose occurs in his feigned sculptural roundel of Augustus on the vault of the Camera Picta (which was based on a sculptural source), where the jowl and planes of the face are similarly treated. Mantegna has, of course, embellished his austerely sculptural conception with purely pictorial elements of surpassing beauty, such as the red watered silk and the semi-transparent white surplice through which the red cassock is visible. Nonetheless, there can be little doubt that ancient sculpture served as the prism through which the Cardinal's uningratiating personality was refracted. Schivenoglia described Trevisan when he entered Mantua in 1459 as 'small, dark, hairy, very proud and stern', and a comparison of the coarse features of Cristoforo di Geremia's portrait medal underscores the transforming power of

Mantegna's brush, which has interpreted raw pride and resolution as *virtù*.

The picture was acquired by an exchange made with Solly in 1830 (Hermann, 1967, pp. 14-15). There is a seal on the back bearing the imperial eagle and initials of the Emperor Francis II encircled with the inscription G[ALLERIA]. R[EALE]. ACCADEMIA DI MILANO. It has, unfortunately, not been possible to establish if the picture was among the works acquired from the Brera through exchange by Count Auguste-Louis de Sivry in 1820 and, like Carlo Crivelli's *Annunciation* in the National Gallery, London, sold to Solly (see Ricci, 1907, pp. 127-37; Davies, 1961, p. 160). The second seal on the painting is that of the Berlin gallery (*pace* Lightbown, 1986, p. 408).

K.C.

101

ANDREA MANTEGNA
Francesco Gonzaga

Tempera on wood, 25 x 18 cm

Probably 1462

Museo e Gallerie Nazionali di Capodimonte, Naples
(Q. 60)
(Exhibited in New York only)

PROVENANCE
Before 1760, Farnese collections, Rome (inv. 1760, no. 9); 1760-88, Charles Bourbon, King of Naples (son of Philip V of Spain and Elisabetta Farnese), Palazzo Reale di Capodimonte, Naples; 1788, Palazzo di Capodimonte and Palazzo degli Studi, Naples

REFERENCES
Frizzoni, 1895, IV, p. 24; Kristeller, 1901, pp. 173-5, 439; Filangieri, 1902, pp. 297-9; Berenson, 1907, p. 254; Knapp, 1910, p. 175; Venturi, 1914, p. 172; Berenson, 1932, p. 327; Tietze-Conrat, 1955, p. 190; Meiss, 1957, p. 26; Paccagnini, in Mantua, 1961, p. 28; Gilbert, 1962, p. 6; Cipriani, 1962, pp. 57-8; Camesasca, 1964, pp. 28, 225; Garavaglia, 1967, no. 31; Berenson, 1968, p. 240; Lightbown, 1986, pp. 85, 410-11

The earliest notice of this engaging work, the only independent portrait of an adolescent by Mantegna, occurs in a list of objects sent from the Farnese collections in Rome to Naples in 1760: 'no. 9. a small painting on wood, 1 *palmo* (ie. 22.34 cm). A young cardinal. manner of Gio[vanni] Bellini' (Filangieri, 1902, p. 297). The attribution to Mantegna and the identification of the sitter as Ludovico Gonzaga's second son Francesco (1444-83) is due to Frizzoni. There is no other surviving portrait of Francesco as a child, and the identification therefore depends on comparison with his almost full-face depiction in the Camera Picta, when he would have been about thirty, and Sperandio's even later medal, which shows the heavy-set Cardinal in profile (see Hill, 1930, no. 390). Despite the very considerable differences in age, and the weight the figure has put on in middle age, Francesco's full, sensuous lips, his wide-eyed, alert expression, and his large nostrils are readily recognisable. The only plausible alternative identification, tentatively suggested by Fiocco (1937, pp. 202-3), is with Francesco's youngest brother Ludovico (1460-1511), who appears

first as a nine to ten year-old and then as a fourteen year-old on the north and west walls of the Camera Picta, in both cases wearing the dress of a Papal protonotary, an office to which he was appointed at the age of nine (he is dressed identically on a medal attributed to Melioli of 1475 inscribed LODOVICVS GONZAGA PROTHO APOSTOLICVS: see Hill, 1930, no. 195).

The identification is crucial to dating the picture, for there can be little doubt that its formal character – the use of a time-honoured profile pose – was closely allied to a commemorative function. Francesco became Protonotary Apostolic on 11 February 1454 (Chambers, quoted in Lightbown, 1986, p. 411). During the Congress at Mantua in 1459, the Marchese exerted all his influence to secure his son's election as cardinal and later permitted a lie to circulate that Francesco was four years older than he really was, and thus eligible for the office of cardinal deacon (see Signorini, 1985, pp. 34-41). On 14 December 1461 word was sent to the Marchese via Bartolomeo Bonatti that the nomination had, in fact, taken place (the public announcement was made four days

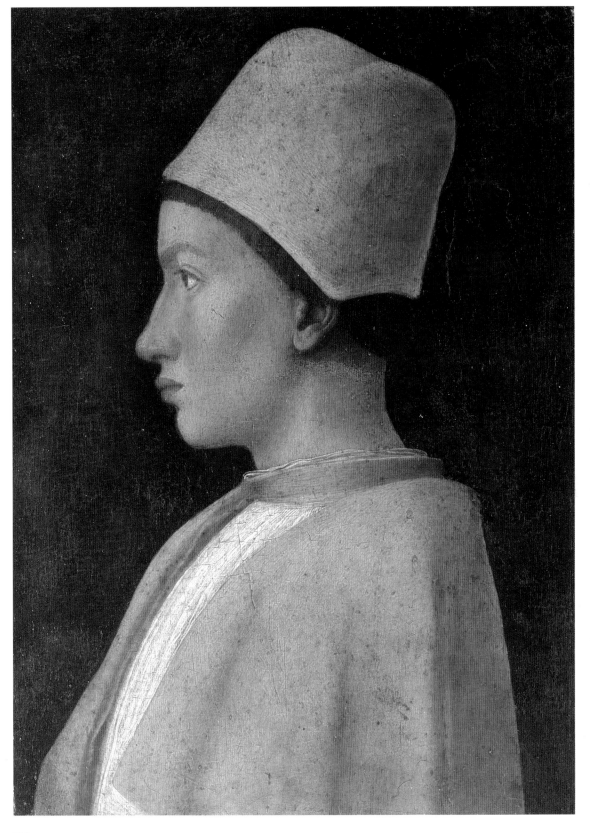

101

later). At the time Francesco was studying in Pavia. He returned to Mantua in January, leaving for Rome on 4 March, the day deemed most astrologically favourable, and received his cardinal's hat in Rome on 24 March (see Mazzoldi, 1961, II, pp. 20-21; Signorini, 1985, pp. 77, n. 113; 78, n. 121).

Since the youth does not yet wear a cardinal's hat, the picture could have been painted during Mantegna's brief visit to Mantua in 1459 or conceivably just before Francesco's departure for his studies in Pavia in April 1460. However, it is more likely to have been commissioned between January and March 1462 to commemorate his election and painted before he left for Rome.

The Naples portrait might seem an uncharacteristic work for Mantegna. It has, indeed, been suggested that it is a copy (Tietze-Conrat, Meiss, Gilbert). Gilbert went so far as to question whether Mantegna would have employed a profile format at this date. As stated elsewhere (cat. 98), 15th-century portraits present a special difficulty because of the conventions frequently imposed on the artist. In northern Italy, the convention for court portraits had been established by Pisanello, and in the middle years of the century Sigismondo Malatesta, Federigo da Montefeltro and Borso d'Este were all depicted in profile. In these cases, the official nature of the portrait must have been

a determining factor for the format, and this is likely to have been true of Francesco's portrait as well. In this respect, the earlier portrait of Cardinal Trevisan is exceptional.

Francesco was later to become both a friend of Mantegna and a notable collector (see p. 18), but in 1462 the two are unlikely to have been much more than acquaintances. It would be wrong to expect of this portrait some record of Francesco's character. Only by comparing it with earlier court portraits can Mantegna's ability to capture the youth beneath the ecclesiastical garb be appreciated.

K.C.

102

ANDREA MANTEGNA
Portrait of a Man

Tempera on wood, 41.3 x 29.5 cm; painted surface, 40.2 x 28.6 cm

c. 1470-75

Galleria Palatina, Palazzo Pitti (since 1925 in the Galleria degli Uffizi), Florence (inv. 8540)

PROVENANCE
By *c.* 1589, the Medici collection; until 1925, Galleria Palatina, Florence (inv. 375); since 1925, Galleria degli Uffizi

REFERENCES
Kristeller, 1902, p. 480; Suida, 1905, p. 190; Berenson, 1907, p. 254; Venturi, 1906, p. 64; Schaeffer, 1912, pp. 17-21; Venturi, 1914, p. 172; Berenson, 1932, p. 327; Fiocco, 1937, pp. 47, 202; Tietze-Conrat, 1955, pp. 182-3; Meiss, 1957, pp. 26, 88, n. 38; Paccagnini, in Mantua, 1961, p. 39; Gilbert, 1962, p. 6; Cipriani, 1962, pp. 29, 60; Camesasca, 1964, pp. 28-9, 116; Garavaglia, 1967, no. 39; Berenson, 1968, p. 239; Gilbert, 1968, p. 282, n. 5; Borsook, 1975, pp. 56-7; Langedijk, 1981, p. 330; Lightbown, 1986, pp. 96-7, 415

Excluding only the *Cardinal Ludovico Trevisan* (cat. 100), this is Mantegna's finest surviving portrait. Curiously, Kristeller at first omitted it (1901), and then included it as a copy after a lost work (1902). (Chiavacci listed it as anonymous in his guide to the Pitti of 1859, p. 162). Whereas the Trevisan portrait is based on antique funerary sculpture and the surfaces are modelled with a stone-like firmness, the Uffizi portrait takes its point of departure from the sitter himself, interpreted by Mantegna with a sternness and descriptive intent that would appear to make little concession to flattery.

Since 1912 the sitter has been widely identified as Carlo de' Medici (*c.* 1428-92), the illegitimate son of Cosimo de' Medici, reputedly by a Circassian slave he had purchased in Venice in 1427 (see Schaeffer, 1912). In 1450 Carlo was appointed a canon of Florence Cathedral. In the next decade, as Protonotary in Rome, he was responsible for enriching the Medici's collections with the purchase of medals (thirty of which he acquired from a pupil of Pisanello) and ancient artefacts (see Gaye, 1839, II, pp. 163-4). He became provost of the church of Santo Stefano in Prato in 1460, when Filippo Lippi was completing his cycle of frescoes on the walls of the choir (for his part in these frescoes see Borsook, 1975, pp. 56 ff.). The race of his reputed mother is

generally supposed to account for the swarthy complexion of Mantegna's sitter, and the portrait is usually dated to 1466, when Mantegna was in Florence on a mission for Ludovico Gonzaga.

Mantegna's picture was unquestionably used as a model for an engraved portrait of Carlo de' Medici in Martino Rota's family tree of the Medici of *c.* 1589, and it was used again for a contemporary small portrait in the Kunsthistorisches Museum, Vienna (Schaeffer, Langedijk). From this it has been deduced that the Uffizi picture may be the 'small painting (*quadretto*) of M. Carlo de' Medici provost of Prato' listed in the 1553 inventory of Duke Cosimo I. Nothing further is known of that picture.

Compelling though the case might seem for the identification with Carlo de' Medici, it has a weak point which, to this compiler's mind, seems insurmountable. This is the existence of another, remarkably dissimilar portrait in Filippo Lippi's fresco cycle in Prato with strong credentials to being accepted as a likeness of Carlo. Vasari (1568, II, p. 624) was the first to assert that Carlo was depicted there, and until recently it was universally accepted that the figure in question was the prominent prelate at the foot of St Stephen's bier in the *Funeral of St Stephen* (see Mendelsohn, 1909, p. 132). The well-fed, jowly face of this figure contrasts markedly

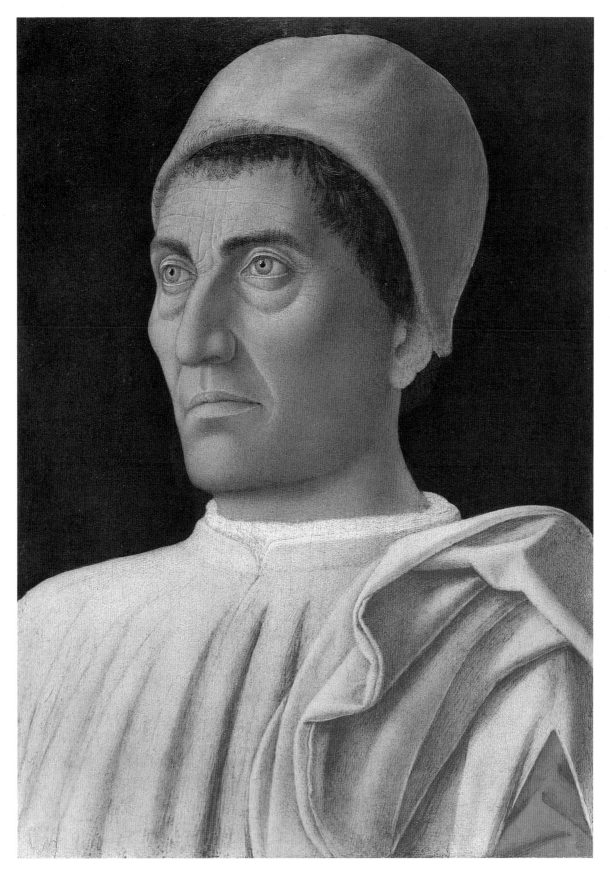

with the lean, large-boned features of Mantegna's sitter. In an effort to reconcile this disparity, an attempt has been made to identify the prominent figure as Pope Pius II and Carlo as a subordinate figure whose only similarity to the man in the Uffizi portrait is that he is thinner (Gilbert, 1968; Borsook; Langedijk, p. 332; Lightbown, p. 415). However, Vasari was in no doubt that the most prominent figure was Carlo; he was, after all, provost and had promoted the completion of Lippi's cycle. This emerges from the fact that the sculpted relief portrait by Vincenzo Danti on Carlo's funerary monument, carved between 1561 and 1564, shows the fat-faced figure in Lippi's fresco, but viewed from a different angle. Vasari was in direct communication with Duke Cosimo I on the project, and it must be assumed that the latter approved the pictorial source used for the portrait just as he reserved final approval of the dedicatory inscription (see the letters in Frey, 1923, CCCXLV, CDXXXIII). Either Danti adapted the pose in the fresco to suit his own purposes, or his source was not the fresco but the 'quadretto' owned by Duke Cosimo. If the point of reference was the 'quadretto', then this can only have been a work by Lippi, not Mantegna (as one would

expect, given Lippi's employment in Prato). Lippi's fresco was used as the model for Carlo's likeness in an early 18th-century painting in the sacristy of Prato Cathedral and for an engraving of 1761 (see Langedijk, 1981, p. 333, who is forced to reject these labelled pictures as likenesses of Carlo).

The matter may be summarised as follows: Lippi's fresco of the *Funeral of St Stephen* contains a portrait of a prominent ecclesiastic which one would, as a matter of course, assume to be the provost of the church, Carlo de' Medici. Vasari asserts that the fresco contains such a portrait. This same figure appears on a relief medallion of 1561-4 decorating Carlo's funerary monument, the design of which was worked out in consultation with Duke Cosimo I, who is known to have owned a portrait of Carlo. Neither portrait resembles the sitter in Mantegna's picture. A generation later Martino Rota used Mantegna's portrait for his model of Carlo's features – perhaps, like later critics, struck by the sitter's swarthy complexion (whether Carlo had the clear blue eyes of this sitter is not known). Subsequently, this identification (or mis-identification) was forgotten until Schaeffer revived it.

There is, therefore, good reason to question the identification of the sitter of the Uffizi portrait as Carlo de' Medici and reject the assumed date of 1466 – just six years after the very different portrait of *Cardinal Trevisan*. Rather, the portrait seems contemporary with the frescoes of the Camera Picta and may be dated about 1470-75 (as suggested by Suida). It results from the sort of studies from life that were undertaken for that cycle, works similar in kind to the drawings in this exhibition (cats. 103-7). Mantegna's interest in the texture and weight of the fabric, the furrowed brow of the sitter – described like a fissured rock – and the brilliant harmony of pinks, reds and vermillion, are without parallel in his earlier work. The face is gently illuminated from the left in a way that does not sacrifice surface description to effects of volume. It was this sort of portrait that served as the point of departure for Mantegna's pupil Francesco Bonsignori, who specialised in portraiture.

Examination of the picture with infra-red reflectography revealed no visible underdrawing. Presumably the features were worked out in a preliminary study and transferred to the panel mechanically.

K.C.

103

ATTRIBUTED TO
ANDREA MANTEGNA
Portrait of a Man

Black chalk on paper
361 x 262 mm

Shortly before 1487

Graphische Sammlung Albertina, Vienna (inv. 1a, 23)

PROVENANCE
Albert von Sachsen-Teschen

REFERENCES
London, 1930-31, p. 49, no. 176; Mezzetti, in Mantua, 1961, p. 186, no. 140; Schmitt, 1961, pp. 84, 125, no. 30; Koschatzky, Oberhuber and Knab, 1971, no. 18 (unpaginated); Lightbown, 1986, p. 461; Campbell 1990, p. 185

This drawing is of exceptional importance because it is the only one of the group of portrait drawings, all in black chalk, assembled here (cats. 103-7), that can be connected with a known painting. It corresponds closely with the so-called *Portrait of a Venetian Senator* (fig. 97; National Gallery, London), which is signed by Francesco Bonsignori and dated 1487. Unsurprisingly, the drawing has been universally attributed to Bonsignori. If it is accepted that it is by the same hand as the rest of the drawings in the group, then they must all be by Bonsignori as well. Martineau (London, 1981, pp. 130-31, 141-2, 178-9) argued this in regard to the Vienna, Oxford and Dublin portraits.

fig. 97 Francesco Bonsignori, Portrait of a Venetian Senator, panel, signed and dated 1487, 42 x 29.5 cm, National Gallery, London

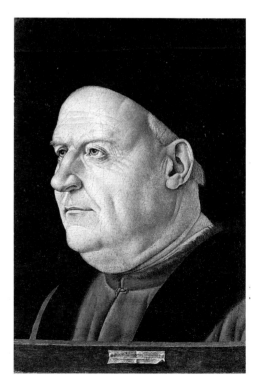

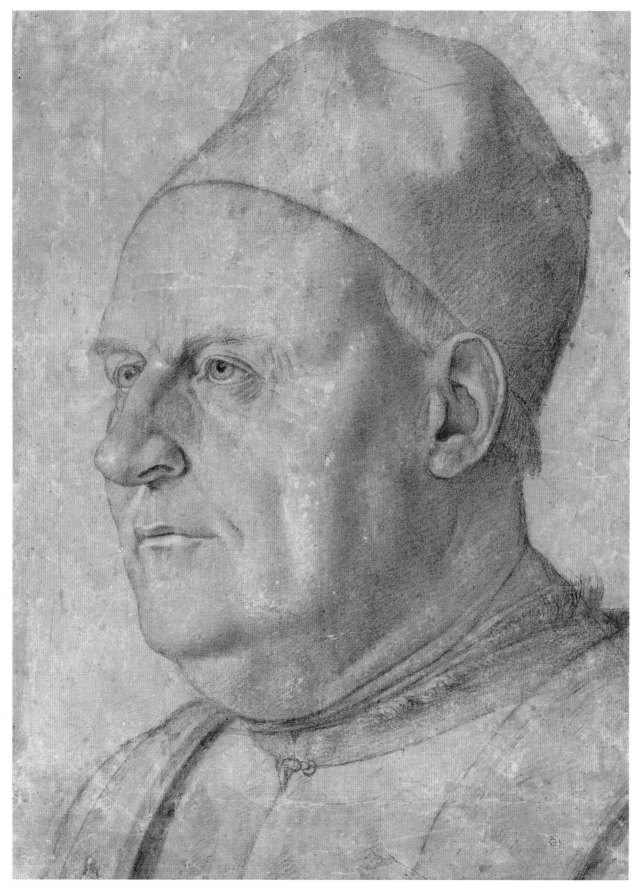

103

However, such a hypothesis is not without problems, mainly based on quality, because there is no evidence from Bonsignori's painted *œuvre*, which is reasonably well established, to suggest that he ever attained such heights of visual observation or physical description. Indeed, cat. 103 is notably finer than the painting as executed, and, although they are identical in scale, the minor changes in the eyelashes, the ear and the drapery on the left shoulder could hardly be described as improvements. Furthermore, this drawing is much more impressive than the only other – and considerably later – portrait drawing connected with a painting by Bonsignori. This is the admittedly much sketchier and smaller-scale profile of Isabella d'Este (British Museum, London) for the *Altarpiece of the Beata Osanna Andreasi* of 1511 (Museo del Palazzo Ducale, Mantua). Another problem is a portrait drawing probably of Gianfrancesco Gonzaga (Uffizi, Florence), generally attributed to Bonsignori, by whom Vasari saw such a likeness in Mantua. If the Uffizi sheet, which is strikingly lifeless and vapid, is by Bonsignori, then it is hard to see how cat. 103 can be by him too.

Discussion of the group of portraits has to be approached from two directions. The first issue is whether they form a coherent group. The second concerns the attribution of the group, or – if the sheets are not all by the same hand – of the various individual drawings.

That Mantegna executed portrait drawings for the Gonzaga is made explicit in a letter of 6 July 1477, when he wrote to Marchese Ludovico to ask whether he wanted some portraits to be 'only drawn, or coloured on panel or canvas' (Kristeller, 1902, p. 534,

doc. 69). Similarly, a letter of 30 November 1475 from Ludovico Gonzaga to Galeazzo Maria Sforza, Duke of Milan, refers to a drawn portrait of Galeazzo Maria by Mantegna, which the Duke did not find satisfactory, and burnt. A drawing must almost invariably have been a necessary preliminary before painting, and if time was of the essence, whether for the artist or for the impatient patron, a drawing may have sufficed.

In conversation, Oberhuber has suggested that the Albertina drawing is by Mantegna, and that it was used by Bonsignori for the painting in London, whether it had been made specifically with that intention in mind or not. If this drawing is by Mantegna, other drawings in the group might be given to Mantegna as well. There are two major difficulties about this attribution: first, that there are no certain portrait drawings by Mantegna; second, that the individual painted portraits accepted as his mostly date from somewhat earlier in his career (the Uffizi portrait, cat. 102, is the latest). Given that the *Portrait of a Man* in the National Gallery is dated 1487, this drawing must have been made by then. By way of compensation, there is a wealth of frescoed portraits in the Camera Picta, executed between 1465 and 1474 (the portrait of Gianfrancesco Gonzaga in the Court Scene represents a good precedent for this sort of likeness) as well as the donor portrait of the Marchese Francesco Gonzaga in the *Madonna della Vittoria* (Louvre, Paris).

In the past it has been generally agreed that these drawings are either preliminary studies for painted portraits or portrait drawings in their own right. Campbell, however,

referring to Vasari's statement that Bonsignori's heirs in Mantua kept 'chiaroscuro copies [*ricordi*] on paper', executed after his painted portraits, asserted that this drawing is such a record. However, preparatory drawings could also have been kept as records, and the slight contour *pentimenti* of the drawing, and the extension of the hat upwards do not suggest a *ricordo*. Given that Bonsignori died in 1529, his heirs are unlikely to have had direct evidence as to the original purpose of any drawings they may have had in their possession. It is argued in relation to the double-sided sheet in the Boymans Museum (cat. 62) that Bonsignori used drawings by Mantegna, and the same may well be true in this instance. Vasari, (ed. 1478-85, V, pp. 299-301) also stated that Bonsignori went to Mantua 'to find Mantegna'; he worked there as a court artist to the Gonzaga family until his death. However, Bonsignori is not securely documented in Mantua before 1492, although he is almost certainly the '*maestro Francesco*' referred to in letters of 1490, and may even be the 'Francesco de Verona' who was paid for unspecified work for the Gonzaga as early as 1485. Two altarpieces, both dated 1488, one in Verona and the other formerly in Venice, do not allow any definite conclusion concerning his domicile. Nor do they prove that he was not yet in Gonzaga service, since their apparently simultaneous completion may rather represent a desire to finish off uncompleted business.

D.E.

104

ATTRIBUTED TO
ANDREA MANTEGNA
Portrait of a Man

Black chalk, washed over, on paper originally white; the top corners are cut, and two old damages, one on the right of the sitter's neck, the other in the bottom right-hand corner of the sheet, have been made up. The eyes have been retouched.

391 x 280 mm
Inscribed on tunic: *IM NV*

1480s-90s

The Governing Body of Christ Church, Oxford (inv. 0263)

PROVENANCE
General J. Guise

REFERENCES
Berenson, 1901, p. 92; Popham, 1930-31, no. 177; Tietze and Tietze-Conrat, 1944, p. 88, no. A318; Mantua, 1961, p. 164, no. 131; Schmitt, 1961, p. 139, no. 105; Heinemann, 1962, p. 224, v.48; Byam Shaw 1976, pp. 188-90, no. 702; Martineau, in London, 1981, pp. 130-31, 141-2; Signorini 1985, p. 176

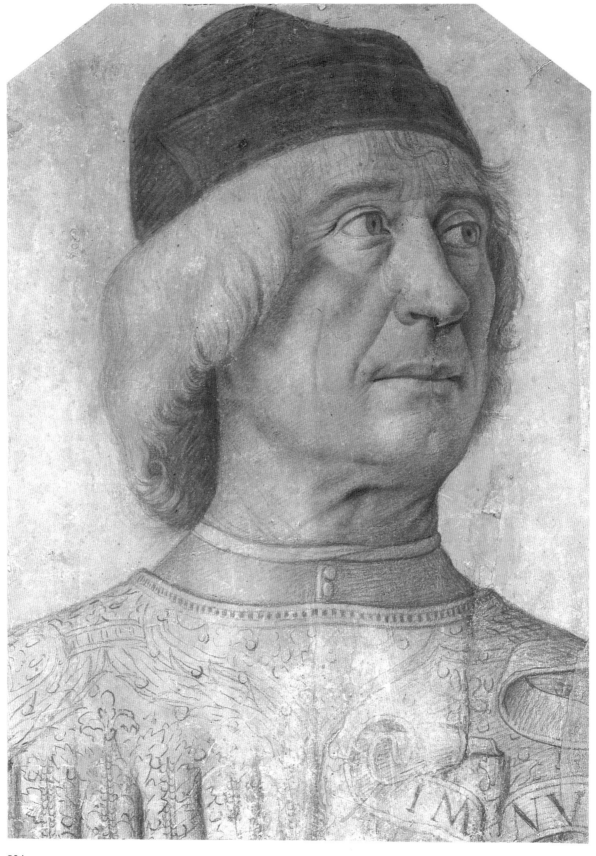

104

342

Although originally attributed to Alvise Vivarini (Berenson, Colvin), this portrait has been subsequently variously given to Mantegna, Giovanni Bellini and Francesco Bonsignori, although Heinemann ascribed it unconvincingly to Gentile Bellini. It would seem to be by the same hand as the Albertina drawing.

The extraordinary presence, the animation of the turn of the head and the wrinkled, loose flesh of the neck suggest that this is the work of an artist of a different and higher calibre than Bonsignori. Byam Shaw wrote: 'To be dogmatic in this case, where opinions are so varied, would be very unwise; but my feeling is that the choice of attribution lies between Giovanni Bellini and Mantegna, and that the minor claimants can be excluded'. He endeavoured to support his attribution to Bellini by arguing that it was a portrait of his brother Gentile, on the basis of a supposed resemblance between cat. 104 and a portrait medal of the latter in profile. However, even if the identification is accepted – and the presumed portrait drawing of Gentile in Berlin (KdZ.125170), variously given to Gentile himself and

Giovanni, should not be overlooked in this connection – it could just as easily be a drawing by Mantegna of his brother-in-law Gentile. What is more troubling is that none of Giovanni's numerous painted portraits, not even that of Doge Leonardo Loredan (National Gallery, London), is quite as confidently three-dimensional or monumental as this.

That leaves Mantegna, whose individual painted portraits date from the 1450s to around 1475, whereas cat. 104 must be placed in the late 1480s or 1490s at the earliest. Yet, if one juxtaposes a head such as this with that of King Christian I of Denmark in the Meeting scene of the Camera Picta, and makes allowances for the difference of technique, then definite resemblances emerge. It also becomes apparent that over the intervening years Mantegna's understanding of how to render expression and his purely technical gifts in mapping the surface of a face increased. Indeed, of all the sheets in the group, this is the most distinguished as a work of art.

The partial inscription on the sitter's breast and the coronet on his right shoulder have

not been explained satisfactorily. Martineau suggested that this drawing and cat. 105 may have formed part of a series of portraits, possibly with an inscription running across several of them, and suggested they might be connected with Vasari's statement that in 1499 Bonsignori painted 'some triumphs and many portraits of gentlemen of the court' for Francesco Gonzaga at Marmirolo. She also proposed that this may have been a series of '*Uomini famosi*', although court gentlemen were not generally accorded such treatment. In fact, a letter of 1492 from Bonsignori to Francesco Gonzaga referred to by Martineau mentions his having 'to go to portray his Excellency Signor Zuan Francesco and also all the other people that Your Excellency wants included in the Triumph of Fame', and points to an alternative explanation. Evidently the portraits were included in the triumph, and Vasari got the date wrong. By contrast, these drawings are obviously independent portraits, and never formed part of a larger whole.

D.E.

105

ATTRIBUTED TO
ANDREA MANTEGNA
*Francesco Gonzaga,
4th Marchese of Mantua*

Black chalk with some wash and white highlights on greenish paper, cut down on all sides
347 x 238 mm

The National Gallery of Ireland, Dublin (inv. 2019)

PROVENANCE
Richard Cosway; R. Houlditch; Rev. Dr H. Wellesley; his sale Sotheby's, 25 June 1866, lot 1800 (as Leonardo da Vinci); bought by Mulvany for the Gallery

REFERENCES
Byam Shaw, 1928, pp. 50-54; Tietze and Tietze-Conrat, 1944, p. 8, no. A297; Schmitt, 1961, pp. 92, 122, no. 20; Heinemann, 1962, I, p. 126, no. S247; London, 1967, p. 6, no. 2; Martineau, in London, 1981, p. 141, no. 63

This drawing was first convincingly identified as a portrait of Marchese Francesco Gonzaga by Byam Shaw, who gave it to Giovanni Bellini and observed that Francesco could have sat to Bellini in 1495 when he was in Venice before the Battle of Fornovo. Since then it has usually been attributed to one of three artists, Bellini, Mantegna or Bonsignori. Only Heinemann, who also denied the

identification, proposed another name, that of the Venetian painter Marco Marziale. Unsurprisingly, this suggestion has not gained any following.

While it appears to be by the same hand as the *Portrait of a Man* (cat. 104), it does not follow that they are both by Bonsignori (see cat. 103, above). If not, then the most obvious person to have produced a drawing of Francesco Gonzaga must be his first court painter, Mantegna. Certainly the psychological understanding and delicacy of touch displayed in this likeness are worthy of a great artist.

As in other drawings from the group, the black chalk is employed with notable tenderness and finesse for the face, and more freely for the elaborately bejewelled costume.

343

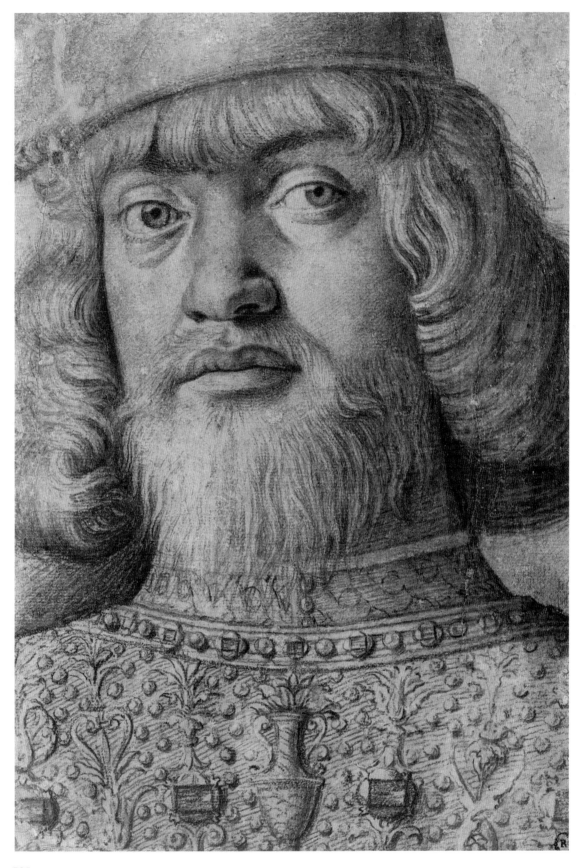

In this instance, to a far greater extent than in any of the other portraits in the group, the hair and especially the beard are rendered with silky smoothness. This might seem to suggest Bellini, but in fact none of his painted portraits blend penetration and relaxation in quite this way. For that, the dignified informality accorded to the Gonzaga court in the Camera Picta represents a far more convincing precedent.

In terms of style the drawing in Vienna and this portrait are not far removed in date, but judging by the appearance of Francesco (b. 1466) in the *Madonna della Vittoria* of 1496 (fig. 93), this drawing must have been executed around that time. Together with the *Portrait of a Man* (cat. 104), it is among the most impressive sheets in the group.

D.E.

106

ATTRIBUTED TO
ANDREA MANTEGNA
Portrait of a Man

Black chalk on greyish-brown paper, a number of small damages and a crease going up the middle of the drawing and into the sitter's face, the eyes are retouched; some brown spots
342 x 250 mm

1490s

Musée des Beaux-Arts et d'Archéologie, Besançon (inv. D.3101)

PROVENANCE
Gigoux Collection

REFERENCES
Berenson, 1895, pp. 114-17; London, 1931, p. 49 (under no. 177); Tietze and Tietze-Conrat, 1944, p. 83, no. A290; Laclotte 1956, pp. 227-8 (wrongly said to be in Rennes); Paris, 1956, p. 104, no. 146; Paris, 1957, p. 73, no. 164; Heinemann, 1962, I, p. 231, no. V.89

Berenson first published this sheet (and wrongly described it as executed in India ink); he associated it with the *Portrait of a Man* (cat. 107), and attributed them both to Alvise Vivarini. More recently, most scholars have accepted that both sheets are by the same hand, whether that of Mantegna (Pouncey), Giovanni Bellini (Byam Shaw) or Francesco Bonsignori (Popham), although Heinemann – implausibly – gave it to Giovanni Buonconsiglio of Verona.

The attribution to Francesco Bonsignori has been sustained by analogy with the Vienna portrait also given to him (cat. 103). However, the attribution of that drawing to Bonsignori is rendered doubtful in terms of quality. The sheer tension and imperiousness of this head makes it very different from even the most forceful of Bellini's portraits, such as the *Portrait of a Man*, recently identified as Giovanni Emo (National Gallery of Art, Washington). The idea that this drawing is by Mantegna has much to recommend it, and it compares well with earlier portraits, especially those in the Camera Picta (1465-74); it is certainly tempting to suppose that drawings such as this must have been used for the frescoes. The way in which the black chalk is handled may seem surprisingly free for Mantegna, as may the way it is rubbed to achieve a blurred effect. The sheer variety of touch is impressive, ranging as it does from the detailed hatching of the skin of the face and neck to the far looser strokes used to render the material of the mantle, presumably meant to be fur. The *Portrait of a Man* (cat. 102) is a rather earlier treatment of a

head seen at a similar angle, albeit looking in the opposite direction. Another, even more suggestive comparison, although it is related to a head that is a character study and not a portrait proper, is with the black-haired archer in the foreground of the *St Sebastian* in the Louvre (fig. 2), also of the 1480s. The deeply etched wrinkles round the eyes and mouth and on the forehead are strikingly close, as is the firm-jawed resolve of the facial expression. Both heads may well date from the same decade, although it is by no means inconceivable that this drawing, which definitely looks subtler and more refined, was executed in the 1490s.

D.E.

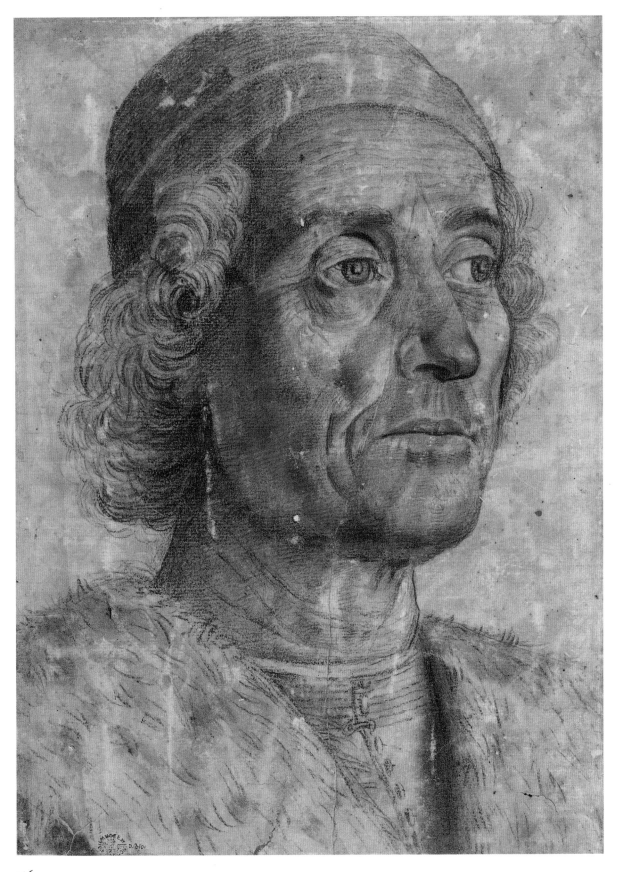

106

107

ATTRIBUTED TO
ANDREA MANTEGNA
Portrait of a Man in a Black Cap

Black chalk on discoloured greyish-brown paper,
the cap mostly in black chalk, but with what appears
to be some black wash added at the top to modify the
contour. The eyes retouched; four long vertical tears,
that on the left the worst
339 x 235 mm

Musée des Beaux-Arts et d'Archéologie, Besançon
(inv. D.3103)

PROVENANCE
Gigoux Collection

REFERENCES
Laclotte, 1956, p. 228; Paris, 1956, p. 109, no. 156;
Heinemann, 1961, I, p. 103, no. S.113

Previously called Venetian school of the 15th
century (Laclotte), this drawing of a tired old
man in a black cap was associated with
Mantegna by Philip Pouncey. It is exhibited
with a group of portrait drawings whose
attribution has been much disputed (see cat.
103, above). It was inexplicably attributed to
the Venetian painter Vincenzo Catena by
Heinemann.

This drawing is much fainter and more
delicate than its companion sheet at
Besançon, and comes closer to the portraits in
Dublin and Vienna (cats. 105, 103). The face
is built up with almost invisible hatching
lines, which combine together to create an
effect of three-dimensionality. The touch is
certainly softer than in any of the others of
the group, and the facial type, with its wistful
eyes weighed down by great bags, is not
quintessentially Mantegnesque. Nevertheless,
it would be unwise to separate it from the
rest, at least before they have been seen
together.

D.E.

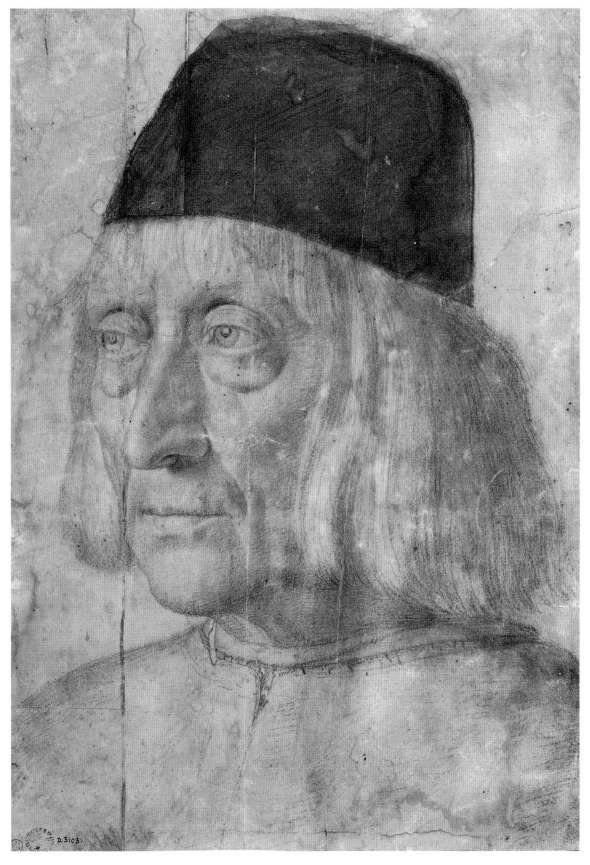

107

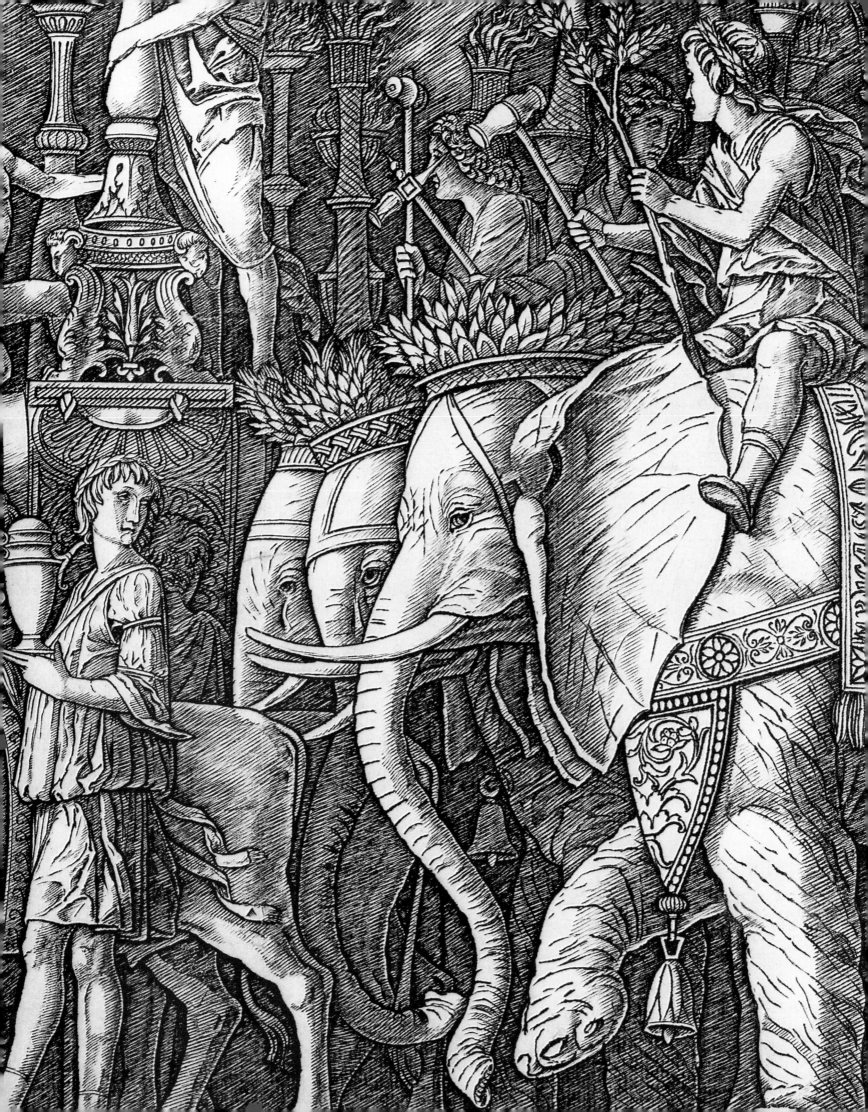

fig. 100 Andrea Mantegna, *Captives, Buffoons and Soldiers (The Captives)*,
canvas VII of the *Triumphs of Caesar*, distemper (?) on canvas, dimensions not recorded,
Royal Collection, St James's Palace, © Her Majesty The Queen

Roman triumphs by his friend Giovanni Marcanova, which no longer survives. Another possible source is Roberto Valturio's *De re militari*, published in Latin in Verona in 1472 and in Italian in 1483. This text could account for one detail in particular, the palm held by Caesar himself, although the association of palms with victory is so familiar that this could simply be Mantegna's own invention. But Valturio did not include the crucial passage of Appian, so even if Mantegna did use his book, it is almost certain that he also consulted another publication, Flavio Biondo's *Roma triumphans*, of which there was a copy in the Gonzaga library and which was first published in Mantua in or about 1472. This is much the fullest and most informative account of Roman triumphs to have survived from the 15th century, and it contains transcriptions or paraphrases of all the relevant ancient texts. Moreover, unlike Valturio, Biondo consistently indicated his sources, so it would have been easy enough for Mantegna to have checked the originals, as in one case he seems to have done. Although Biondo was unaccountably neglected in the scholarly literature on the series until the publication of Martindale's catalogue, it is difficult to imagine why Mantegna should have overlooked such a convenient source of information. Certainly the next artist to illustrate the Triumph of Caesar, Benedetto Bordone, who designed a series of woodcuts of this subject in 1503, which were actually made by Jacobus Argentoratensis, based his composition mainly on Biondo. Accordingly, the sources discussed in the catalogue entries below are taken from the *Roma triumphans* rather than from the standard classical editions, which sometimes give different readings.

In reading Biondo, Mantegna would soon have discovered that, while Roman triumphs did not follow a rigid formula, there was a degree of consistency in the elements which they included and the sequence in which these appeared, and that the character of such processions changed markedly after the time of Caesar. Since the various triumphs were discussed by Biondo in chronological order, he would have had little difficulty in finding the relevant texts, of which those of Plutarch and Appian were the most informative. While painting the earliest group of canvases, Mantegna made little effort to follow his sources closely. Thus, a copy of a preparatory drawing for canvas IX shows Caesar's chariot drawn by four horses (cat. 124), as specified by Biondo and Valturio, but in the actual painting there is only one horse, presumably because Mantegna thought it looked better that way. In this scene Mantegna also included several putti holding branches, which do not correspond to anything in the written sources. In canvas VIII, too, he did not follow his texts with any degree of fidelity, but he did so in canvas VII, *The Captives* (fig. 100). In the other two groups of canvases the arrangement of the principal groups of figures is much more consistently based on the ancient descriptions. When painting canvas II, indeed, Mantegna – or more probably some adviser – seems actually to have looked up a passage in Appian cited and paraphrased by Biondo.

Given Mantegna's relative indifference to historical accuracy in the earliest canvases in the series, it is clear that he did not start with the intention of producing an archaeologically correct reconstruction of an ancient triumph, let alone of any specific one, but an impressive series of paintings. To expect archaeological accuracy in a modern sense from 15th-century artists would be an anachronism; and Mantegna never seems to have aspired to it, either in the *Triumphs* or in his other paintings. He was content to follow the spirit rather than the letter of his sources. For example, in canvas III, where Plutarch described weapons arranged in heaps, he chose instead to show them on trophies, thus creating a far more exciting visual effect. Likewise, for the architecture, the weapons and booty, Mantegna did not confine himself to copying details from ancient monuments, of which he must have seen any number in Rome, but used his powers of invention to create a decorative idiom that was consistent

and historically distanced from the style of his own day. In doing so, he must have made some use of drawings of ancient objects and decorative motifs which seem to have circulated relatively widely at the period, but the number of specific parallels that has been identified between the *Triumphs* and extant drawings of this type is very small. The *Triumphs* are the product of Mantegna's imagination, not of scholarly pedantry.

The identity of the original patron has been much discussed. While it cannot be ruled out that the idea originated with Ludovico (d. 1480) or Federico Gonzaga (d. 1484), it seems more likely that the commission dates from the time of Francesco Gonzaga, a military man not known for his scholarly interests, but certainly well disposed towards Mantegna and enthusiastic about his paintings. Had the original intention been primarily archaeological, he would be the least plausible candidate, but, as we have seen, it seems that the earliest paintings in the series are the least archaeologically accurate. For this reason the shift in emphasis that subsequently occurred is more likely to have come from the artist than from his patron. It has occasionally been suggested that the paintings were intended as a glorification of the Gonzaga family, or of the Marchese himself, but in a narrow sense this is improbable, given the complete absence of allusions to the Gonzagas in the pictures themselves. Historical figures were then regarded as exemplary role models, and Julius Caesar, the greatest soldier of the Roman epoch, was an entirely appropriate subject for a series of historical pictures to decorate the palace of a ruler with military interests. Yet, given the scale and expense of the project, and the way in which it seems to have grown as Mantegna proceeded, we should surely see the *Triumphs* primarily as a pretext for Mantegna to display his unique talents. As such, they are a landmark in the history of artistic patronage in Italy.

C.H.

PROVENANCE

1486, some of the canvases in the Corte Vecchia, Palazzo Ducale, Mantua; *c.* 1506, some canvases in the Palace at San Sebastiano, Mantua; by June 1625, nine canvases in the Galleria della Mostra, Palazzo Ducale; 1629, dispatched from Mantua; October 1630, dispatched from Venice; by 1631, in the collection of Charles I, probably at Hampton Court; May 1650, moved to Somerset House; by 1659, returned to Hampton Court

REFERENCES

Valturio 1472, ed. 1534, pp. 351, 355; Biondo, ed. 1559, pp. 205D-206A, 210E; Kristeller, 1902, pp. 281-311; Law, 1921, *passim*; Nogara, 1927, p. 208; Luzio and Paribeni, 1940, *passim*; Tietze-Conrat, 1955, pp. 21-3, 183-4; Massing, 1977, pp. 42-52; Martindale, 1979, *passim*; Hope, 1985, pp. 297-309; Lightbown, 1986, pp. 140-53, 424-33; Berzaghi, 1990, pp. 63-6; Massing, 1990[1], pp. 2-21

108

ANDREA MANTEGNA
Canvas I: *Trumpeters, bearers of
standards and banners
(The Trumpeters)*

Distemper (?) on canvas, 2.66 x 2.78 m

Probably 1490s

Her Majesty The Queen
(Exhibited in London only)

REFERENCES
Martindale, 1979, pp. 133-8

Very little of the original surface survives.
A preliminary design for this canvas indicates
that Mantegna originally envisaged a rather
more closely packed group of slightly smaller
figures (fig. 99). In that drawing there are
banners inscribed '*Gallia C.*' and a tablet with
the words '*Gallia capta*', unambiguously
identifying the subject as Caesar's Gallic
triumph. At the sides are the profiles of
pilasters, indicating that this type of frame was
intended for the *Triumphs* from an early stage
(cf. cat. 120).

For this scene and canvas II Mantegna
seems to have drawn mainly on passages in
Biondo taken from Appian and Plutarch.
From Appian he derived the trumpeters
crowned with garlands (Biondo, ed. 1559,
p. 207A). This text refers to *tubae,* straight
trumpets, rather than *cornua,* curved ones; but
Mantegna included both types, perhaps on
the authority of various ancient reliefs in
Rome. The other figures are explained by
Plutarch's statement that the first day of the
triumph of Aemilius Paulus 'barely sufficed
for the transport of ensigns, pictures (*tabulae*)
and statues, which were carried on vehicles'
(p. 208H). There has been much speculation
about the paintings showing captured cities.
One possible source was Appian, who
referred to 'images of captured cities', but
Mantegna would also probably have read a
passage at the beginning of Biondo's chapter
on Roman triumphs, which includes a
description of the lesser ceremony of the
ovation. Here Biondo (p. 203A) quoted from
Livy, who recounted that when Marcus
Marcellus had entered Rome, before him was
borne his booty, consisting of 'a representa-
tion of captured Syracuse, catapults and
ballistae and every other instrument of war,

as well as the ornaments of lengthy peace and
royal opulence, vases of silver and bronze,
other household goods and precious robes,
and many noble statues ... '. A few pages later
Biondo quoted a brief extract from Cicero,
which again referred to 'representations
(*simulacra*) of cities' (p. 205A). As Martindale
has pointed out, the statues on poles are
probably Mantegna's rendering of the *signa*
or ensigns mentioned by Plutarch. Livy, in
another passage quoted in Biondo, also
mentioned *signa* of bronze and marble
(p. 207C). It is possible that Mantegna took
Livy's remark as a reference to ensigns, and
for this reason showed his soldiers carrying
small bronze statues; but because Livy also
referred to *signa* of marble, he may equally
well have realised that this passage was about
larger statues. There is nothing in the textual
sources to account for the presence of the
black soldier, or indeed of the black musician
in canvas VIII: in the preliminary design the
soldier is white. Mantegna may have included
such figures either to provide variety, or to
indicate the extent of Roman power.

C.H.

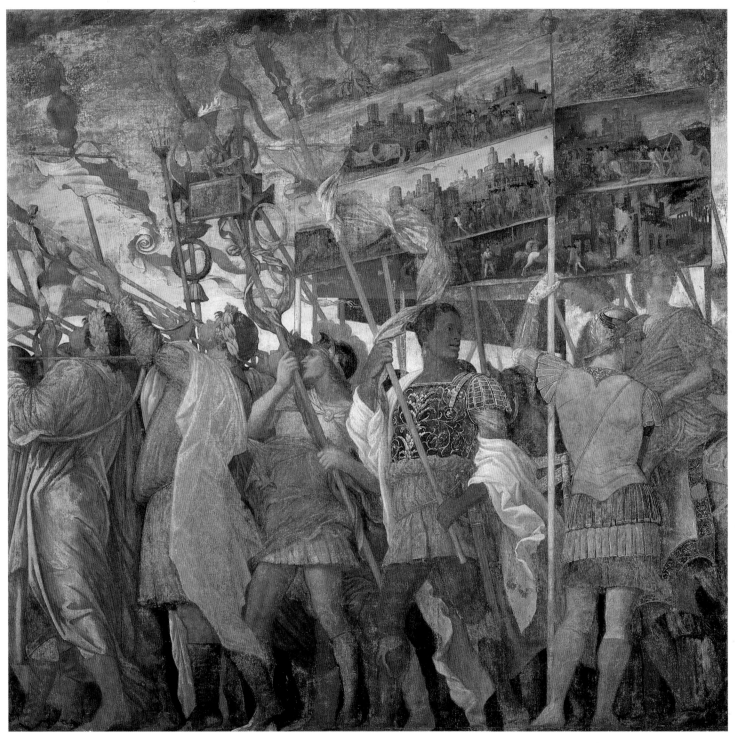

109

ANDREA MANTEGNA

Canvas II: *Captured statues and siege equipment, a representation of a captured city and inscriptions (The Triumphal Carts)*

Distemper (?) on canvas, 2.66 x 2.78 m

Probably 1490s

Her Majesty The Queen
(Exhibited in London only)

REFERENCES
Martindale, 1979, pp. 138-41, 178

The condition is far better than that of canvas I, particularly in the lower central area, but the head and limbs of the man carrying the statue at the right are largely by Laguerre. The principal source for this scene is Plutarch (Biondo, ed. 1559, p. 208H), and in particular his reference to statues being transported on vehicles, followed by other carts with piles of weapons (some of which appear in canvas III). Also relevant was Appian (p. 207A) with his account of carts bearing booty, followed by wooden towers and representations (*simulacra*) of captured cities. In the original Greek there follows by a slightly ambiguous reference to pictures being carried at this point in the procession. In the standard Latin translation of Appian by Pier Candido Decembrio, first published in 1477, these pictures become 'writings (*scripturae*) and images', which is presumably the source for Mantegna's very prominent inscriptions. In other respects Biondo followed Decembrio, whose translation he must have read in manuscript, but he omitted this passage entirely; so in this instance, rather unexpectedly, it would seem that Mantegna referred directly to Decembrio's text. The presence of siege machinery at this point could be justified by two passages from Livy in which material of this kind is mentioned, both quoted by Biondo (pp. 203A, 208E): the account of the ovation of Marcus Marcellus, already cited in connection with canvas I, and a brief reference to the triumph of Marcus Fulvius.

The carts bearing the colossal statues are not of authentic Roman design, but are much closer to Renaissance notions of appropriate triumphal vehicles, as seen for example in Caesar's own chariot in canvas IX. The rather strange architectural structures behind these statues are not real buildings, but the wooden towers and models of captured cities specified by Appian, as is made evident by their scale

in relation to the gigantic siege equipment in the backround. This feature does not suggest that Mantegna was either particularly interested in or knowledgeable about the practicalities of siege warfare: the only item whose function can be clearly identified is the huge battering ram.

The large bust in the foreground has caused some discussion. The figure has usually been identified as a representation of Cybele, on account of her mural crown, or even as the goddess Fortune, though this last interpretation is unconvincing. Most probably the mural crown is intended to identify her as the tutelary deity of a city or province (like the similar busts in canvas VIII); and since she is located immediately under a large inscription proclaiming that the occasion of the triumph was Caesar's conquest of Gaul, she is presumably a representation of *Gallia*. The identity of the full-length statue being carried by the man at the right is more obscure. The costume of the figure is similar to that of a youth in canvas V, who was almost certainly meant to be appropriately dressed for making a sacrifice; so this may be a representation of a priestess pouring a libation.

C.H.

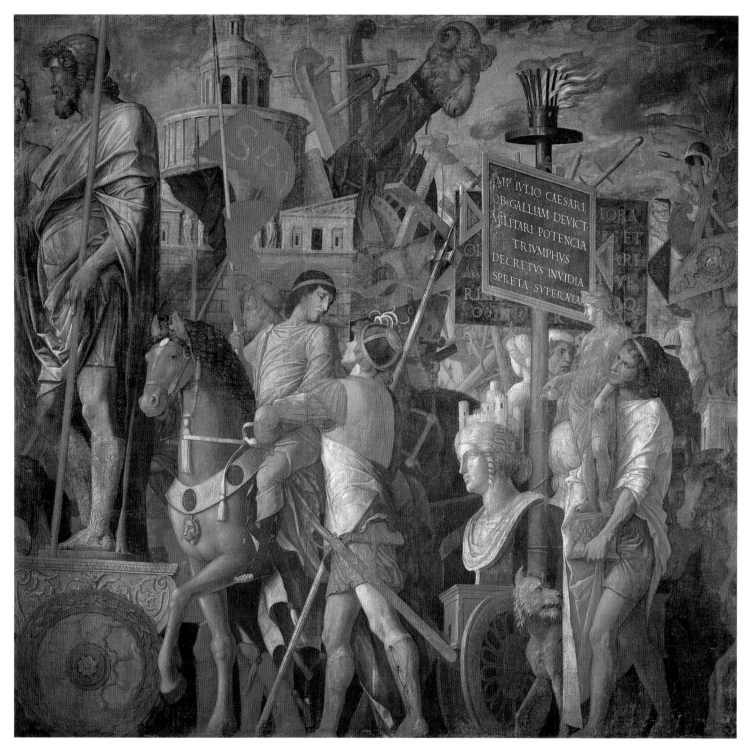

109

IIO

ANDREA MANTEGNA

Canvas III: *Trophies and bearers of coin and vases (The Trophy Bearers)*

Distemper (?) on canvas, 2.68 x 2.78 m

Probably 1490s

Her Majesty The Queen
(Exhibited in London only)

REFERENCES
Janson, 1961, pp. 254-66; Martindale, 1979, pp. 141-5

The figures are largely repainted, although some passages of Mantegna's original work appear in isolated areas, such as the statuette of Neptune at the right. In the preliminary design, known from a copy, the display of captured weapons was even more imposing (cat. 116). As has been noted above, in this design only the front pair of the group of four men at the right bearing the huge bowl of coins is shown. This implies that at that stage Mantegna intended to include the rear pair in canvas IV, thus linking the two compositions. He presumably moved the whole group to the left in order to avoid creating an awkward visual effect when this picture was first displayed, while he was still working on canvases IV-VI.

The elaborate assembly of captured weapons and armour is based, as Martindale has demonstrated in detail, on Plutarch (Biondo, ed. 1559, pp. 208H-209A), the only major discrepancy being that in the text they are described as being 'piled up, and arranged in such a way that they seemed to have fallen together by chance'. Mantegna instead chose to show them for the most part assembled on trophies, for which he would have found descriptions early in Biondo's chapter on Triumphs (p. 203B). His purpose, presumably, was to fill the upper part of the composition, as well as providing a visually far more interesting display of Roman armour. There were several ancient reliefs of such trophies in Rome, which he seems to have used in an inventive way. But it is revealing that Mantegna apparently made no attempt to show the armour of Gauls rather than Romans, which of course would have been historically more accurate.

After describing the captured weapons and armour Plutarch related how these were followed by 'three thousand men, who carried silver coin in three hundred and fifty vases. Each vase weighed some three talents; and four men carried individual vases. Others

bore silver drinking bowls, dishes and very ornate and immense cups, carefully arranged'. Appian (quoted by Biondo, p. 207A), too, mentioned gold and silver at this point in his account of the triumphal procession, as did Livy (pp. 203A, 207C). Ancient vases were sometimes represented on reliefs and on coins, but Mantegna does not seem to have attempted here to achieve archaeological accuracy. Closer parallels are to be found in contemporary sketchbooks, such as the so-called Mantegna Sketchbook (Kunst-bibliothek der Staatlichen Museen, Zeichnungssammlung, Berlin, Cod. OZ III), but no precise analogies have been found. In details of this kind one can particularly admire his ability to create a consistent decorative idiom, which, if not historically correct, none the less seemed to contemporaries entirely convincing.

The head in the sky at the upper right cannot be original, although there are indications in the early copies that something similar was always there. Mantegna showed other figures in clouds elsewhere in his work, probably even elsewhere in the *Triumphs*, almost certainly alluding to the notion, widespread in the later 15th and early 16th centuries, that artists might find inspiration in such images (Janson). It would surely be a mistake to seek for any very specific iconographic significance in this detail.

C.H.

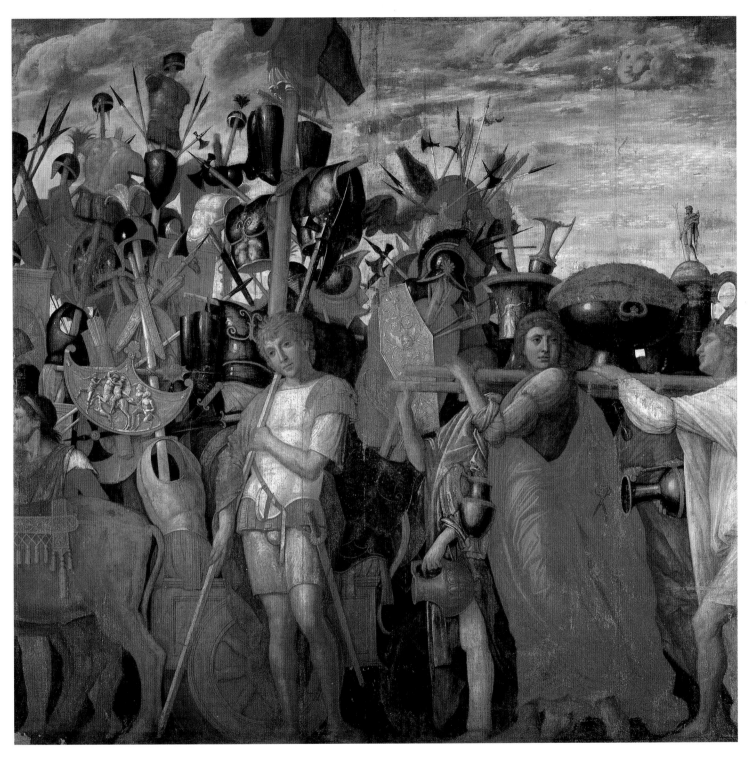

110

III

ANDREA MANTEGNA

Canvas IV: *Bearers of coins and vases, youths leading oxen, trumpeters (The Vase Bearers)*

Distemper (?) on canvas, 2.66–8 x 2.78–9 m

Probably *c.* 1500–06

Her Majesty The Queen
(Exhibited in London only)

REFERENCES
Martindale, 1979, pp. 145–7

Canvases IV–VI are, as a group, the best preserved of the entire series; and canvas IV is the finest of all, the only one which still retains, albeit much rubbed, parts of Mantegna's original sky. Of the figures, the two at the extreme left are substantially the work of Laguerre, while the youth in white at the right and the animals in the landscape behind still give an idea of the marvellous delicacy of the original painted surface of the *Triumphs*. By contrast, the trees seem to be almost entirely repainted, except those nearest to the ruins, which are also relatively well preserved.

The textual sources for the men carrying vases are discussed in the entry for canvas III. The pair of golden crowns lying next to the large bowl of coins can be related to a passage in Appian which immediately follows the text cited in the entry to canvas II, where he mentioned that crowns were given by cities as a reward for the virtue of the *triumphator*, and then went on to say that there followed white oxen and elephants (Biondo, ed. 1559, p. 207A). Plutarch said much the same thing, adding that the oxen were adorned for sacrifice and had gilded horns, that they were led by youths dressed for offering sacrifice and boys with sacrificial vessels; and he also indicated that they were preceded by trumpeters (p. 209A). Mantegna followed these passages with considerable fidelity, but mingled the trumpeters, all equipped with straight *tubae*, with the sacrificial oxen, presumably for reasons of visual effect.

The clearest indication of Mantegna's attitude to historical accuracy is provided by the buildings in the background, which, following his normal practice, do not correspond at all closely to any real Roman structures, but look ancient in their general form. It seems clear that a faithful reconstruction of ancient Roman topography was very far from his mind.

C.H.

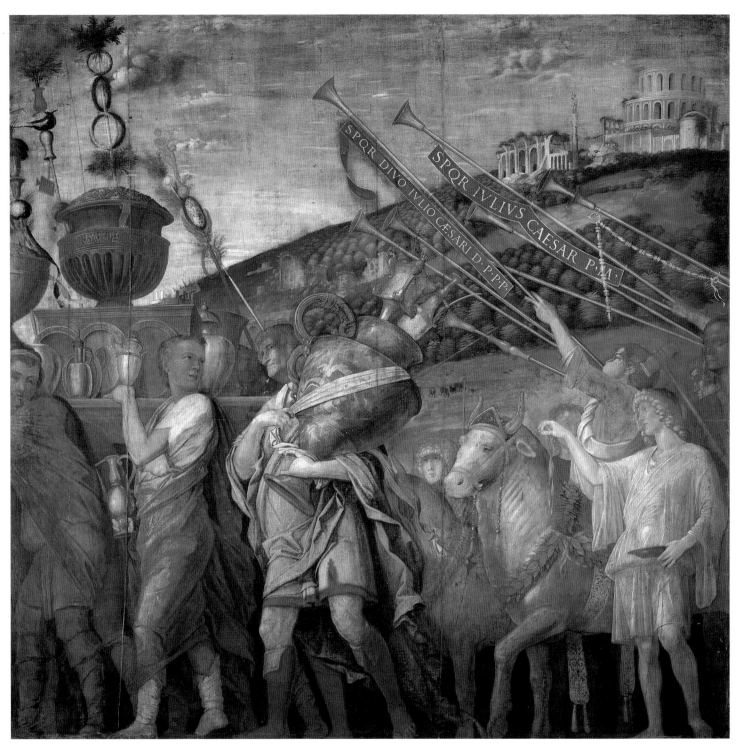

112

ANDREA MANTEGNA

Canvas V: *Trumpeters, youths leading oxen, elephants with attendants (The Elephants)*

Distemper (?) on canvas, 2.67 x 2.77 m

Probably *c.* 1500–06

Her Majesty The Queen
(Exhibited in London only)

REFERENCES
Martindale, 1979, pp. 147–9

Though badly faded and stained, perhaps as early as the 16th century, this canvas has been less radically repainted than some of the others. The passages still visible in which modelling still exists preserve Mantegna's intentions and, sometimes, his brushwork. A preparatory design for this scene is recorded in a drawing (cat. 119) and in two engravings (cats. 117, 118), which suggest that initially Mantegna did not envisage a landscape background. In its general character this first design was very close to the surviving preliminary designs for canvases I-III (fig. 99, cat. 116), strongly suggesting that the front six sections of the processions were all designed together. But when Mantegna came to paint canvases IV-VI, he decided to add a distant landscape, perhaps to lend variety to his procession. At the same time, he reduced the bulk and number of figures in the procession.

The textual sources for the trumpeters and oxen have already been discussed in relation to canvas IV. As we have seen, the elephants are mentioned by Appian (Biondo, ed. 1559, p. 207A), not Plutarch (p. 209A). But for these Mantegna must also have had recourse to a passage of Suetonius twice quoted by Biondo, to the effect that in his Gallic triumph Caesar 'ascended the Capitol by the light of forty elephants on the right and the left bearing lamps [*lychni*]' (pp. 204F, 210F). In 16th-century and later editions of Suetonius this passage (*De Vita Caesarum, Divus Iulius,* XXXVII) was emended in accordance with a suggestion of Poliziano, with the *lychni* replaced by *lychnuchi*, or candelabra. Although the strange objects which Mantegna actually painted on the elephants' backs fit Poliziano's version of the text better than that of Biondo, this is probably fortuitous. Certainly, it is difficult to find any precise ancient prototype

for them, or indeed for elephants with baskets of fruit on their heads, although Mantegna probably knew of a pair of statues of satyrs, or more properly, representations of Pan, who support similar baskets (Museo Capitolino, Rome). There is no textual basis for the long-eared Nubian goats. The landscape now appears predominantly rocky, whereas in canvas IV it is much more wooded. Martindale suggested that this discontinuity could have arisen if the canvases were removed from the studio as they were completed, and that Mantegna may have intended at some later date to correct them precisely to eliminate problems of this kind. If so, it would fit well with the hypothesis, proposed above, that canvases IV-VI are the latest of all, and only completed shortly before the artist's death. Alternatively, the differences between the two landscapes could be in part due to the intervention of later artists, or to damage.

C.H.

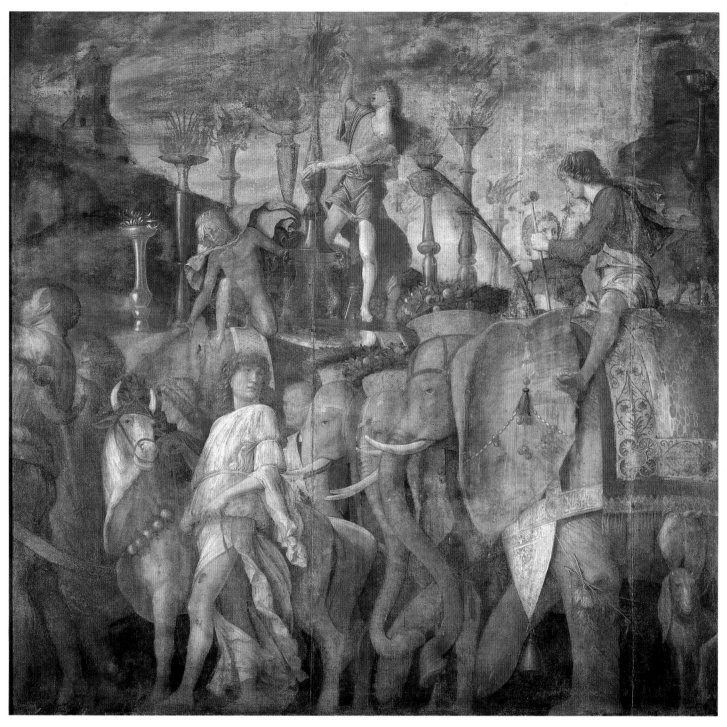

112

113

ANDREA MANTEGNA

Canvas VI: *Bearers of coins and plate, trophies of royal armour (The Corselet Bearers)*

Distemper (?) on canvas, 2.68 x 2.78 m

Probably *c.* 1500-06

Her Majesty The Queen
(Exhibited in London only)

REFERENCES
Martindale, 1979, pp. 149-56

Much of the background of this canvas has suffered, and the stooping figure to the right is now mainly the work of Laguerre, apart from his left foot. Otherwise, this scene is relatively well preserved, particularly the armour and booty, and notably much of the central figure with a trophy. As in the previous canvases, Mantegna here mainly followed the text of Plutarch (Biondo, ed. 1559, p. 209A). After the oxen, which appear in canvas V, Plutarch reported that there came men bearing vases of three talents in weight, containing coins of gold and silver. Then followed others carrying more vases, and after these the chariot and weapons of the captured king, Perseus. Although omitting the chariot, Mantegna followed the rest of the description quite closely, even including a couple of royal diadems which were specifically mentioned by Plutarch. The rather curious little table supporting the upper vase of coins may be derived from a somewhat similar feature on a famous relief of an ancient triumph on the Arch of Titus in Rome.

There has been much speculation about why Mantegna might have decided to divide his ancient armour at the waist, in a way that would seem to defeat its purpose. This has been seen as either a misunderstanding of certain ancient reliefs, or alternatively as due to the fact that he used Renaissance stage armour, which would have been broken in this way to allow the actors to move properly. If so, the stage designers and Mantegna were presumably unaware that classical armour of this design was made of leather, and thus flexible, rather than of rigid metal.

Like canvas V, this was one of the most famous sections of the *Triumphs*, because the preliminary design was reproduced in engravings; and as in that other canvas, Mantegna did not originally intend to include a landscape background. In the actual painting, as in the rest of the procession, he made little attempt at topographical accuracy. If we are supposed to imagine that the Capitoline Hill is located behind the main building in canvas VII (fig. 100), then the wall or aqueduct(?) in the background here may be meant to be built on the side of the hill. The column with the spiral relief, surmounted by an equestrian statue, distantly recalls the columns of Trajan and Marcus Aurelius in Rome, but in detail has no obvious prototype among the surviving monuments of antiquity.

The next canvas – VII – (fig. 100), showing captives, buffoons and soldiers seems to have been painted several years earlier. It has suffered so badly that nothing of Mantegna's original painting survives. But the composition does at least conform to the early copies, so it is presumably authentic. Most accounts of Roman triumphs mention the captives preceding the *triumphator*, and Biondo quotes Cicero to the effect that when the triumphal chariot swings round to leave the Forum for the Capitol, the captives are led off to prison, there to be executed (pp. 204H-205A). Although this is not accepted by Martindale, the building behind the captives is surely meant to be a prison, identified by its barred window (which is far more prominent in a preliminary design, fig. 101) and rustication. If so, the slightly odd perspective of the building in the right background, which seems either to be constructed on sloping ground or to recede towards the middle of the picture, could perhaps be meant to indicate the route to the Capitol which Caesar will shortly take.

For the group of captives, Mantegna certainly used the long description by Plutarch of the captured King Perseus and his family, and particularly the passage in which he mentioned 'two boys and one girl, not old enough to be aware of their misfortune – something which particularly aroused feelings of pity' (p. 209B). But whereas Plutarch said that the captives stretched out their hands to the Romans, Mantegna chose instead to

show them with their hands crossed, in the manner of various ancient statues of captured barbarians. The figures at the right mocking the captives are not mentioned by Plutarch, but Appian writes of a man 'wrapped in a cloak to his ankles, with fringes and bracelets gleaming with gold, [who] made various gestures and, insulting the conquered enemies, provoked laughter on every side' (p. 207A). It is typical of Mantegna's unpedantic attitude to his sources that he showed one mocking figure with a bracelet of bells, but did not trouble to follow Appian's description in detail. The foliage held by the Roman soldiers at the right provides the only compositional link with canvas VIII.

The general disposition of the group of captives in canvas VII is certainly reminiscent of various Roman reliefs, though no precise source has been identified with any degree of confidence. The prominent pyramid in the background is similar to a couple of such structures then to be seen in Rome, and often reproduced, although it does not exactly correspond to either of them. This might be taken as a further indication that the picture was painted before Mantegna's visit in 1488. By contrast, the prominent capital on the prison is a rather precise copy of a detail on the Porta dei Leoni in Verona, one of the most famous Roman buildings still surviving in the vicinity of Mantua.

C.H.

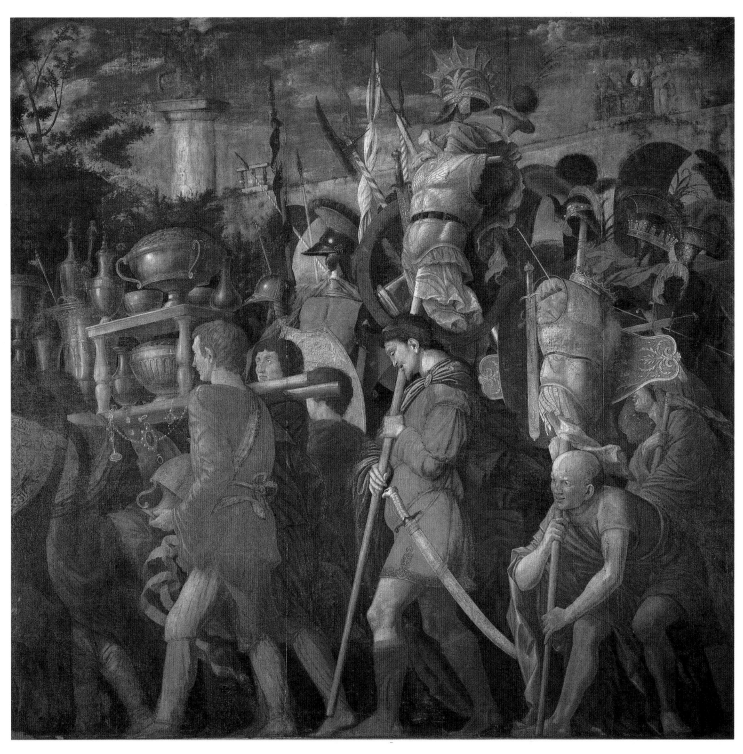

113

114

ANDREA MANTEGNA

Canvas VIII: *Musicians and standard bearers (The Musicians)*

Distemper (?) on canvas, 2.68 x 2.78 m

Probably *c.* 1484-92

Her Majesty The Queen
(Exhibited in London only)

REFERENCES
Martindale, 1979, pp. 156-7, fig. 150; Leoncini, 1988, pp. 73-94

Almost none of Mantegna's own painting survives in the figures, but some of the busts on poles are relatively well preserved. The presence of musicians coming after the captives in canvas VII conforms to Appian (Biondo, ed. 1559, p. 207A), and a copy after a preliminary design shows that Mantegna originally planned to include the two groups of figures in the same scene (fig. 101). Appian specified that the musicians were organised 'like an Etruscan procession'; perhaps this passage accounts for the exotic cloak of the black piper. Mantegna, however, did not follow Appian's account in every detail, omitting, for example, the lictors who ought also to have been included here. None of his sources explicitly referred to men carrying personifications of cities, or *tychai*, identifiable by their mural crowns; but Plutarch wrote that at this point in the procession were displayed four hundred golden crowns, 'which the Greek cities had given to Aemilius as rewards for his merit' (p. 209B). It is possible that Mantegna meant his *tychai* to be equivalent to these golden crowns. Appropriately enough, among them is a personification of Rome, without a mural crown, but clearly identified by the banner with the wolf inscribed *SPQ R*. Appian also mentions the presence of incense-bearers preceding the *triumphator*, but of these there is no trace here or in canvas IX. Instead, at the right of the picture, there is a Roman soldier holding a curious ensign in the form of a model of a building surmounted by an eagle. A similar ensign, but with a hand rather than an eagle, appears in canvas IX. No textual source can be found for these strange objects, which are presumably meant to signify Roman power over captured cities; but they correspond very closely to decorative details in a drawing in the so-called Mantegna sketchbook in Berlin.

C.H.

fig. 101 After Andrea Mantegna, The Captives, after a preliminary study for canvas VII of the *Triumphs of Caesar*, brown ink, 270 x 270 mm, Musée Condé, Chantilly (inv. Ecole Italienne II, 33)

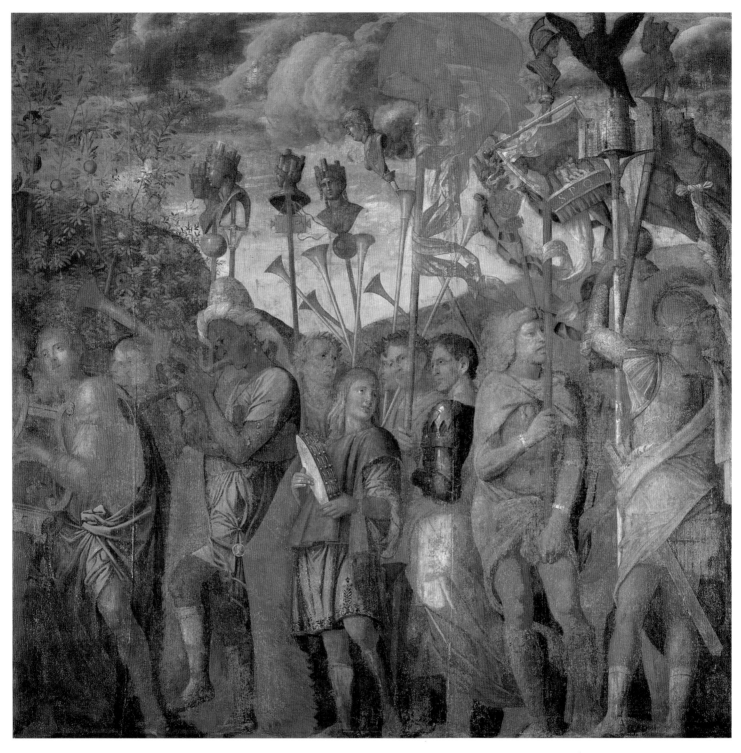

114

115

ANDREA MANTEGNA
Canvas IX: *Julius Caesar on his Chariot*

Distemper (?) on canvas, 2.68 x 2.79 m

Probably *c.* 1484-92

Her Majesty The Queen
(Exhibited in London only)

REFERENCES
Martindale, 1979, pp. 157-61; Leoncini, 1987, pp. 59-110

This is one of the less well preserved of the series, and one in which Mantegna diverged most markedly from his textual sources. As has been mentioned above, it is possible that one detail here, the palm branch held by Caesar, may come from Valturio (ed. 1534, p. 355), but other features suggest that even at this stage the artist also had access to Biondo. Thus, the latter tells us that Pliny relates that the *triumphator* was accompanied by a slave, who held a crown of gold over him; but Biondo then remarked that 'in surviving representations of triumphs in marble, a winged Fortune, not a slave, holds the crown' (Biondo, ed. 1559, p. 205A-B). This passage is usually taken, quite convincingly, as an explanation of the fact that the figure behind Caesar is winged.

In his discussion of the *triumphator*'s chariot, Biondo stated that this had two wheels and was drawn by four horses, citing the evidence of two ancient reliefs visible in Rome and the testimony of Livy (p. 204F). Mantegna followed his specification about the horses in a preliminary drawing (cat. 124), but not in the painting. The chariot itself is wholly unclassical, following instead the standard 15th-century formula used in painted representations of triumphal processions. This in itself strongly suggests that the picture predates the artist's visit to Rome. Caesar's costume, according to Plutarch (p. 209B) and Appian (p. 207A-B), ought to have been purple interwoven with gold, rather than pure gold; but Biondo also quoted Pliny to the effect that the *triumphator*'s costume was gold. The children holding branches are wholly inauthentic, and no written or visual source has been found that satisfactorily explains the relief showing Neptune, Mars and Concord(?) on the side of the chariot. But other features fit the available texts rather better. Biondo was not very explicit about the *triumphator*'s crown: near the beginning of his chapter he quoted Pliny to the effect that in early times this had been of gold, whereas in his description, taken from Josephus, of the triumph of Vespasian and Titus, which immediately follows his rather brief remarks about the five triumphs of Caesar, he reported that they were crowned with bay (p. 210G). The source for the man holding the inscription '*Veni, vidi, vici*' is easier to identify. This comes from Suetonius' account of

Caesar's Pontic triumph, which is quoted by Biondo (p. 210F).

The design of the arch in the background may again suggest that this canvas predates Mantegna's visit to Rome in 1488, because it does not correspond at all to any of the monuments he could have seen there. The most likely model, in fact, is an arch in Pula, which he could have known through a drawing. While the central sculptural groups on the top of the arch recall images on Roman coins, it was probably through drawings that Mantegna learnt about the *Horse-Tamers*, the famous and much copied pair of ancient statues on the Quirinal in Rome, which also appear here incongruously on top of the arch, and about the symbols which appear in the frieze. The most likely source here is a famous frieze, again often reproduced in drawings, which was then at the Roman church of San Lorenzo fuori le Mura. Various scholars have suggested that Mantegna's frieze was intended to be understood as a series of hieroglyphs, but no satisfactory interpretation has been provided. It is also likely, in fact, that he was following Alberti's specifications for a Corinthian frieze, in which, as in the Ionic, the Romans 'carved either vases and other sacrificial instruments, or heads of bulls' (Alberti, ed. 1966, II, pp. 591, 599). The unusual standard with a view of a city or citadel surmounted by a hand is discussed in connection with canvas VIII.

Biondo provided a certain amount of information about the route of ancient triumphs, but there is nothing in his text to justify the inclusion of the arch. Apart from possibly suggesting in canvas VII that the triumphal procession ended on the Capitol, Mantegna evidently did not attempt to provide a topographically accurate setting for his procession, so the presence of the arch here is most easily explained simply on the grounds that it looked ancient and was appropriate to the subject.

C.H.

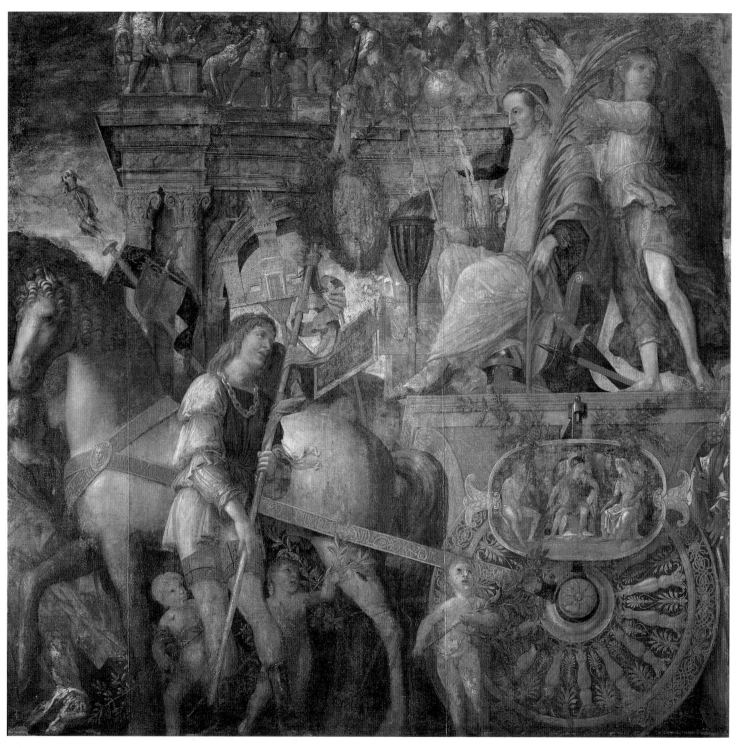

115

116

AFTER ANDREA MANTEGNA
The Trophy Bearers

Pen and brown ink; damage to the bottom right-hand
corner has been made up
260 x 261mm
Inscribed (on the car to the left): PONTIFEX M
IMP/DANT./IIII.V./TR./NIVM; (on the chest): QVESTRI
(?) (for equestri). A small margin along the bottom
bears an old inscription: *Andrea Mantegna*

Late 15th – early 16th century

Graphische Sammlung Albertina, Vienna (inv. 2584)

REFERENCES
Wickhoff, 1891, p. cclii; Kristeller, 1901, p. 441;
Martindale, 1979, pp. 77-82, 164, no. 53; Hope, 1985,
pp. 300, 306; Lightbown, 1986, pp. 425, 432

The chronology of the *Triumphs* has been
much debated, and it might be hoped that
the preliminary drawings could afford some
assistance with the problem. Two factors,
however, militate against this. First, although
Mantegna must have executed a considerable
number of preparatory drawings, only one
autograph study, *The Trumpeters* (fig. 99;
Rothschild Collection, Louvre, Paris), for
canvas I, has come down to us; the rest are
copies after lost drawings, and the possible
differences of style of the copyists have to be
taken into account. Second, Mantegna's own
drawing style and figure types did not change
very significantly over the relevant period.
Furthermore, however long drawn-out the
execution of the canvases, the intention must
have been to create a uniform impression,
particularly for such elements as the scale of
the figures. It has been suggested (see. p. 353,
above) that part of the series (canvases VII-IX)
was completed before Mantegna planned the
rest, but although there are differences
between the various drawings, they would
rather tend to support the idea that
preparatory drawings for all ten projected
canvases were done at the outset. For
instance, the unmonumental figures in *The
Trumpeters* are hard to conceive of as having
been invented after the painting of any of the
canvases. However, it seems unwise to make
deductions about the place of the drawings in
the sequence of the work on the basis of their
closeness to, or distance from, the finished
paintings.

With the exception of the drawing of
Caesar on his Chariot (cat. 124), which is in
pen over red chalk with coloured washes, all
the drawings are executed in pen and brown
ink. In addition, they are all on the same
scale, but do not give the impression that
they are by the same hand. As has been
convincingly argued by Martindale, these
sheets, all of which differ significantly from
the finished canvases, must be copies of
Mantegna's preliminary designs, now lost;
they do not seem to derive from the prints
after the series.

The most important differences between
this drawing and its corresponding painting
(canvas III in the series) are, proceeding from
left to right: the drawing shows more of the

oxen and has a fragmentary inscription which
does not exist in the canvas; the display of
the trophies is more massive and their
disposition is different, while the decoration –
unsurprisingly – is more detailed in the
painting. The attitude of the central soldier
remains much the same, but he holds an axe
as opposed to a scythe and is additionally
equipped with a sword. At the right, the two
urn bearers in the drawing are bare-legged,
whereas in the painting they wear full-length
togas.

It has been suggested (Hope, 1985) that in
this drawing a link was intended with the
fourth composition, but that this continuity
was abandoned when Mantegna came to
paint the relevant canvases. It is true that
canvas III shows more of the litter, but in both
it and the drawing two figures are prominent
in the foreground. The real difference is that
this whole section of the design is less
compressed in the paintings, and the last urn
in this drawing appears almost unchanged in
canvas IV.

Comparison with the autograph *Trumpeters*
drawing suggests that the copyist here has
managed to imitate Mantegna's graphic
manner tolerably accurately, although the
facial expressions are exaggerated to the point
of caricature. The varying thicknesses of the
pen-lines were probably a feature of the lost
original, since even in sheets with this degree
of finish Mantegna invariably avoided a flat
uniformity of handling. It is hard to believe,
on the other hand, that the disembodied legs
were as baffling in the original as in the copy,
and tempting to suspect that the author of
this drawing misunderstood Mantegna's
intentions.

D.E.

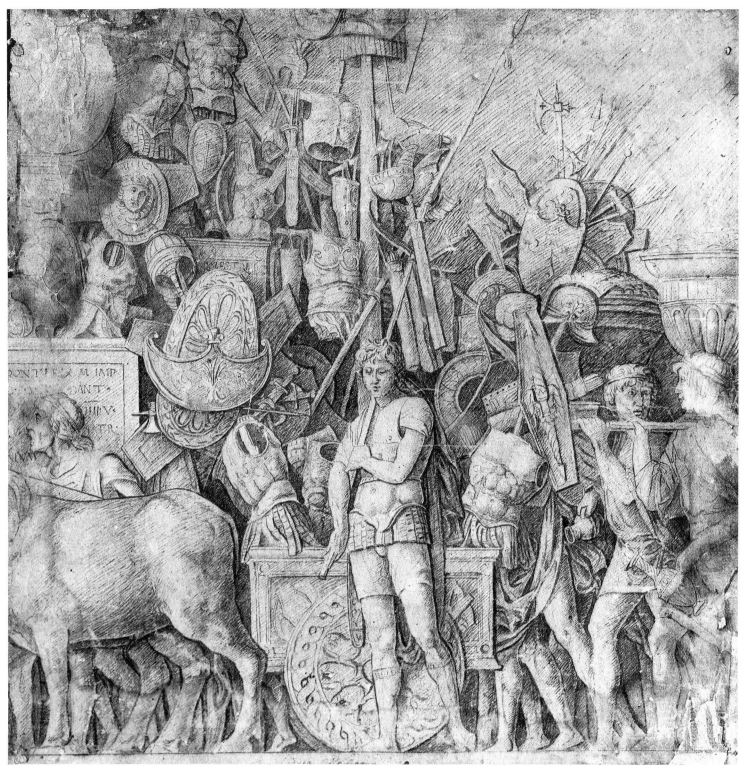

116

117

GIOVANNI ANTONIO DA BRESCIA
The Elephants

Engraving
281 x 281 mm (sheet; plate size unknown)
H.14a
Watermark: Orb and Cross (no. 22)

c. 1500

Musée du Petit Palais, Paris

REFERENCES
Bartsch, 1811, XIII, 322.8 and 236.12, copy; Hind,
1948, V, 23.14a

Seven prints, by three different hands, record drawings made in preparation for the *Triumphs of Caesar*. Only three of the compositions, however, were reproduced in the seven prints: two (this and cat. 118) reproduce a composition preparatory to *The Elephants*, canvas V (cat. 112); three (cats. 120, 121, 122) show a design very close in overall composition to *The Corselet Bearers*, canvas VI (cat. 113), although many of the facial types were ultimately changed; and two (cats. 126, 127) record a design, *The Senators*, that was never developed into a painting.

Two of the prints (cats. 120, 126) are by the Premier Engraver of Mantegna's works (see p. 64, above). Two other prints, one showing this same composition but with differences in detail (cat. 118) and one that is related to canvas VI and seems to be unfinished (cat. 123), are here tentatively attributed to Giulio Campagnola. The other three (this and cats. 121, 127) are copies by Giovanni Antonio da Brescia.

Of the three subjects related to the *Triumphs* that Giovanni Antonio copied, *The Corselet Bearers* (cat. 121) and *The Senators* (cat. 127) strictly follow the two prints by the Premier Engraver (cats. 120 and 126), but there seems to be no 'original' for this print. The other engraving that reproduces this composition (cat. 118) shows too many differences from this print to have been its model: in cat. 118 the leaves in the elephants'

head-dresses are much less regular, and two of the candelabra at the front of the procession are decorated, as is the elephant's harness beneath the naked boy. In Giovanni Antonio's print these areas are left blank. No such obvious differences occur between the two prints by Mantegna's Premier Engraver and their copies by Giovanni Antonio, and it seems plausible that an earlier print of *The Elephants* once existed, no impression of which is now known to survive – perhaps because the plate was damaged or reused early – from which Giovanni Antonio made this copy. It is also possible that Giovanni Antonio copied a drawing, now lost; the surviving drawing of this subject (cat. 119), however, seems to be a copy of cat. 118.

S.B.

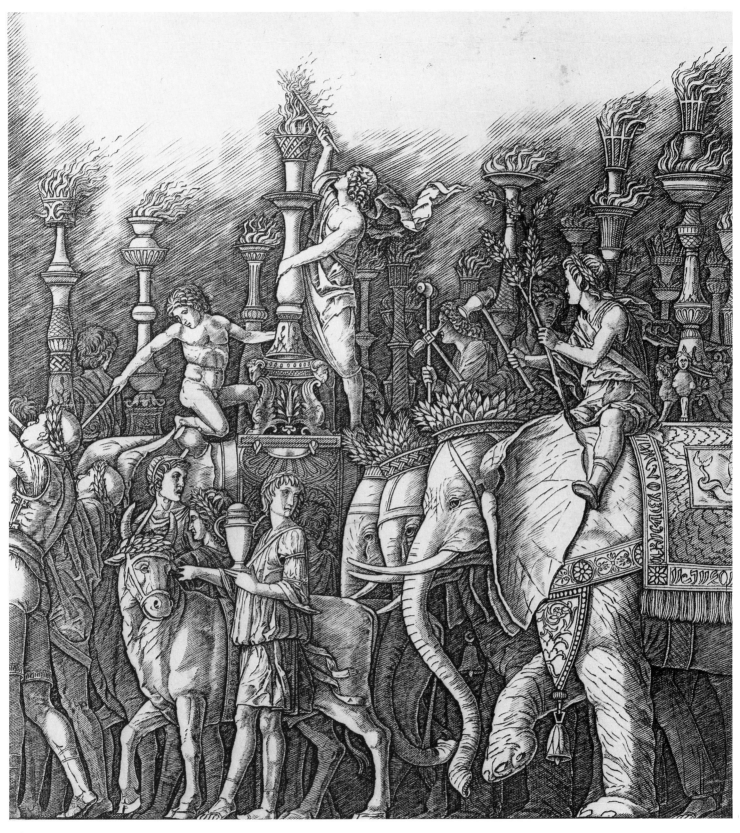

117

118

GIULIO CAMPAGNOLA ?
The Elephants

Engraving
286 x 260 mm (sheet; plate 318 x 318 mm; see entry)
H.14

c. 1498

The Duke of Devonshire and the Chatsworth Settlement Trustees

REFERENCES
Bartsch, 1811, XIII, 235.12; Hind, 1948, V, 22.14

This print and cat. 123 are by the same hand, one that apparently does not recur among the prints after Mantegna. The engraving style is characterised by a free handling of the burin for the main lines and a somewhat casual use of shading lines; although these go predominantly in one direction – up towards the right – they are less systematic than those of the Premier Engraver. The approach to the rendition of details, such as hair and ornament, is also freer, as a comparison of the heads or the decorated border of the circular shield in cats. 123 and 126 makes evident.

It seems possible that these two prints are the work of the young Giulio Campagnola. Most probably at the behest of Giulio's father, Girolamo, Michele de Placiola wrote a letter on 10 September 1497 to Hermolao Bardellino requesting that Giulio, then fifteen years old, be received at the court of the Marchese Francesco Gonzaga; the letter extolled his precocity in a multitude of subjects: languages, music and art, including miniature painting, drawing and engraving (Luzio, 1888, p. 184). Assuming Giulio did go to Mantua, he would have stayed there for about a year, for early in 1499 he was already in Ferrara. Pomponius Gauricus, in his *De Sculptura*, published in 1504, states that Giulio is praised for his 'beautiful imitations' of the 'brawl of Pallas' and the *Triumphs of Caesar* (ed. 1969, p. 101). The 'brawl of Pallas' presumably refers to *Pallas Expelling the Vices* (cat. 136), although no print after it is known. In any case, the 'imitations' might have been paintings, not prints.

Grounds for stylistic argument are elusive, considering that, in the first place, the prints follow drawings by Mantegna, so there is no basis for comparison with Giulio's compositional methods, and secondly, no earlier prints by Giulio are known; the prints among his attributed *œuvre* that are probably the earliest, the *Saturn* (Hind V, 195.2),

Ganymede (H. V, 196.4) and *St Jerome* (H. V, 197.7), are so different in scale, compositional organisation and drawing style that they provide little basis for comparison, and the prints of Giulio's mature style, with their use of flicks and dots, even less. Still, the delicacy and freedom of handling and a certain unmethodical quality in shading lines in Giulio's known prints are also features of these two prints, and for these reasons, and the circumstantial evidence cited above, an attribution to Giulio is worth consideration.

This print probably copies a preliminary study for canvas V (cat. 112), one that was relatively close to the final painting. The only known drawing of this subject (cat. 119), however, seems to be a copy of this print, as it was drawn on French paper bearing a watermark that is found on 16th-century impressions of the group of plates – including the plate on which this image and cat. 123 were engraved back to back – that went, apparently from Mantua to France (see Appendices I, II). The dimensions of this plate given above are derived from an impression in Frankfurt. Giovanni Antonio da Brescia's print (cat. 117) shows this same composition but seems to be a copy not of this print but more likely of another that has not survived.

S.B.

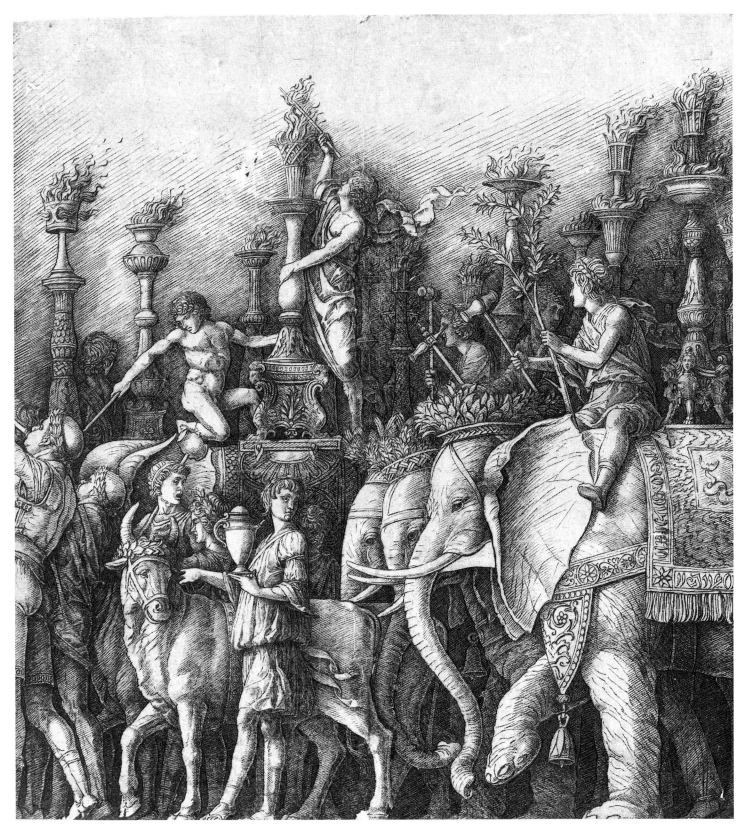

118

119

AFTER ANDREA MANTEGNA
The Elephants

Pen, brown ink and brown wash, some brown stains,
slightly cut along the upper margin
252 x 260 mm

Late 15th – early 16th century

Private collection

REFERENCES
Martindale, 1979, pp. 77-82, 164, no. 52; Hope, 1985,
p. 305; Lightbown, 1986, p. 433

This drawing is connected with Mantegna's preparations for canvas V of the *Triumphs of Caesar* (cat. 112). Martindale correctly noted how closely it resembles a print of the same subject (cat. 118) and suggested that this drawing was the one used by the engraver to produce the print. However, as discussed in that entry, its watermark suggests a date after the earliest impressions of the plate. It may be that both it and the print were copied from the same original study by Mantegna.

The date of the paper means that this sheet cannot be an original preparatory drawing by Mantegna himself, but is rather a copy of such a sheet, now lost. Certain weaknesses of handling, for instance, the disappointing right hand of the foreground youth, already noted by Hind (1948, V, 22.14) in connection with the print, suggest that the drawing is not by Mantegna. It is also striking how lifeless this sheet looks when it is compared with the autograph drawing for the canvas of *The Trumpeters* (fig. 99). For all its confidence and precision, *The Trumpeters* shows an artist working out an idea, and the thickness and thinness of the pen-line is subtly varied. In contrast, the overall effect of the present drawing is far more uniform, not because it represents a more finished stage in the artist's thinking, but because it is a copy. No doubt Mantegna's lost original was very exact, even though he departed from it in a number of ways in the canvas, and this drawing is our best record of it, certainly better than the print, which, for instance, leaves an area beneath the most prominent elephant's tusks blank. Only in the detail of the fourth candelabrum on the right, which emerges out of a dark patch of shading and appears to have no base, are there grounds for suspecting a minor misunderstanding on the part of the copyist. Other early drawn copies (Isabella Stewart Gardner Museum, Boston; Teylers Museum, Haarlem; Biblioteca Ambrosiana, Milan) reproduce the lower left section of the print.

D.E.

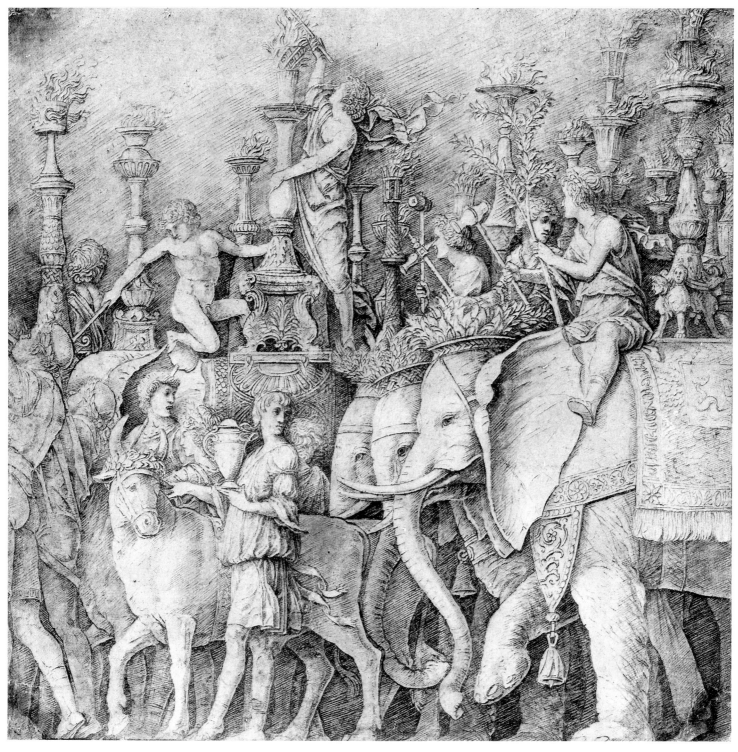

119

120

PREMIER ENGRAVER
The Corselet Bearers

Engraving
267 x 314 mm (plate 303 x 351 mm, Boston)
H.15b

c. 1495

The Duke of Devonshire and the Chatsworth
Settlement Trustees

REFERENCES
Bartsch, 1811, XIII, 236.14; Kristeller, 1901, p. 279,
n. 1; Hind, 1948, V, 23.15b

fig. 102 Giovanni Antonio da Brescia,
Design for an Ionic Pilaster, engraving, 271 x 55 mm,
British Museum, London

This print shares the characteristics of
cat. 126, and both are here attributed to
Mantegna's Premier Engraver. This artist
showed an extraordinarily flexible use of the
engraving tool, so that the outlines and
modelling lines vary greatly in width,
seeming almost to twist and wriggle; he used
densely packed parallel lines to create the
darkest of the shaded areas, while areas of
medium density were made by strokes of
medium weight crossed by lighter ones at a
very acute angle (sometimes described as
'return strokes'). Both prints reverse the
direction of the drawings from which they
must have been copied (the paintings,
cats. 108-15, and drawings are in the opposite
direction); this can also be deduced from the
direction of the shading strokes, which go
downwards to the right, reversing the
direction in which Mantegna (and his
copyists) invariably drew.

The only known drawing related to this
composition (cat. 122) is to the same scale,
but has enough differences in detail to make
it doubtful that it could have been the
drawing from which this engraving was
made: in the print the sword and the sceptre
above the head of the bent man have small
balls at the top, but not in the drawing; the
corselet he carries has six pairs of rivets
beneath the armhole in the print, eight in the
drawing; the decoration of the elephant's
saddle cloth is more complex and detailed in
the print, and many further differences could
be enumerated. In most cases, the details in
the other print of *The Corselet Bearers*
(cat. 121) are closer to those in the drawing
(although, to confuse the matter, that print
has seven pairs of rivets on the armour); the
drawing from which the present print was
made could well have been destroyed in the
making of the print.

A foliated Ionic pilaster is shown to the
right of the composition, engraved on the
same plate; it has been suggested, plausibly,
that this might represent Mantegna's design
for a pilaster to separate the canvases in their
intended setting, in much the way that
foliated Corinthian pilasters separate scenes in
the Camera Picta. Kristeller and others
suggested that the final design of the pilasters
used when the paintings were installed in
1506 in the Palace of San Sebastiano was

probably similar to the various Corinthian
pilasters shown in the woodcuts of the entire
series of *Triumphs* made by Andrea Andreani
at the end of the 16th century. See also
p. 351, above.

This image was probably engraved on the
back of the same plate as cat. 126; the
dimensions coincide almost exactly, and
impressions are printed on paper with the
same series of watermarks (see Appendix II).
The copy by Giovanni Antonio da Brescia
(cat. 121) clearly follows this print, and not
cat. 123.

S.B.

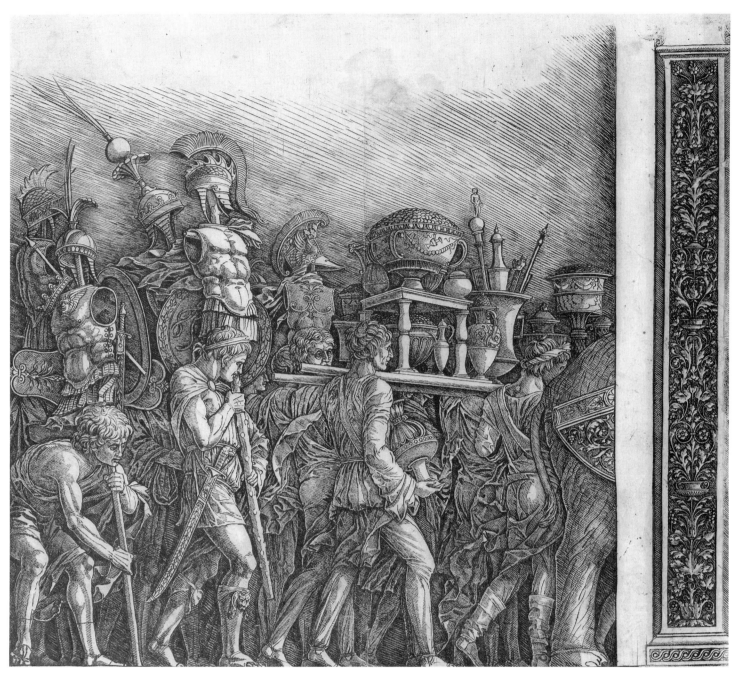

120

121

GIOVANNI ANTONIO DA BRESCIA
The Corselet Bearers

Engraving
293 x 256 (plate size unknown)
H.15a

c. 1500–04

Staatliche Museen Preussischer Kulturbesitz,
Kupferstichkabinett, Berlin

REFERENCES
Bartsch, 1811, XIII, 322.9 and 237.14, copy; Hind,
1948, V, 23.15a

Giovanni Antonio's print of this composition
clearly follows cat. 120; where there are
differences between cat. 123 and cat. 120, this
print shows the variation of the latter. Some
specific differences are that the sword and the
sceptre above the head of the bent man both
have a small ball at the top in cat. 120 and this
print, but not in the other; the corselet this
man carries has six pairs of rivets in these two
prints, seven in the other; other details could
be enumerated, but in general a comparison
of almost any ornamented area – the helmet
and shield near the right edge of this print,
the round shield and sword of the man in the
foreground second from the right (from the
left in cat. 120), the knots in the wood of the
staff carried by this same man, or any of the
soldiers' hair – shows a close correspondence
between cat. 120 and this print, but not with
cat. 123.

The copy reverses the direction of cat. 120
and thus corrects it, something Giovanni
Antonio often did (e.g. cats. 87, 127, 139).

Giovanni Antonio also copied the pilaster,
reversing its direction, but on a different
plate. The copy (fig. 102), whose capital is
slightly changed and which has a palmette at
the top of the decorative panel, is of the same
size as the pilaster in cat. 120. On the same
plate is another ornament panel, including a
greater variety of forms: tritons, a pair of
leopards and the motto *AB OLYMPO* (Mount
Olympus was a Gonzaga *impresa*). This may
well also record a design by Mantegna,
possibly another thought for a pilaster
intended to separate the *Triumphs* canvases.

This print is signed *IA* in the first state,
perhaps the first indication that Giovanni
Antonio was considering Latinising his name;
he seems to have thought better of it at that
time, however, for he went back to *ZA* in the
second state.

S.B.

122

AFTER ANDREA MANTEGNA
The Corselet Bearers

Pen and brown ink
260 x 260 mm

Late 15th – early 16th century

The National Gallery of Ireland, Dublin (inv. 2187)

PROVENANCE
Earl Spencer; William Esdaile; Rev. Dr H. Wellesley;
sold Sotheby's, 25 June 1866, lot 884; bought by
Mulvany for the National Gallery of Ireland

REFERENCES
London and New York, 1967, p. 7, no. 3; Martindale,
1979, pp. 77–82, 166, no. 57; London, 1981, p. 143,
cat. 67; Lightbown, 1986, p. 433

A closely corresponding but unfinished print
(cat. 123) of this composition for canvas VI
appears to be based on this drawing. As
Martindale has stressed, the drawing's
superior understanding of the effects of light
and shade on forms, especially in the armour
at the right margin of the composition,
reinforces its primacy over the print.
Interestingly, some of the minor divergences
between drawing and print, especially clear in
the angles of the heads of the hindmost litter
bearer and the upright trophy bearer seen in
profile, suggest that the engraver may also
have looked at Mantegna's finished canvas.
Its more monumental figure style may,
however, suggest that the lost original
drawing from which this derives was of a
later date than the other original drawings of
which copies survive.

Although there are numerous changes
between this drawing and the painting – of
the two trophy bearers on the right of the
drawing, one becomes bearded and the other

bald-headed in the canvas – the overall
disposition of the figures and the nature and
extent of their booty is modified less than in
most other cases. It would be unwise,
however, to deduce from this that the lost
original drawing was more finished than its
fellows: rather, it appears that Mantegna was
less dissatisfied with its conception when he
came to translate it into paint.

It seems right to follow Martindale and
regard this drawing as a copy after a lost
original rather than an autograph study by
Mantegna; the slightly blurry handling is not
nearly crisp enough for the master.
Paradoxically, another point against the
drawing is that it strives to make explicit the
sort of background details Mantegna himself
left vague in his preliminary drawings. This
may suggest that it was made with the
engraver in mind.

D.E.

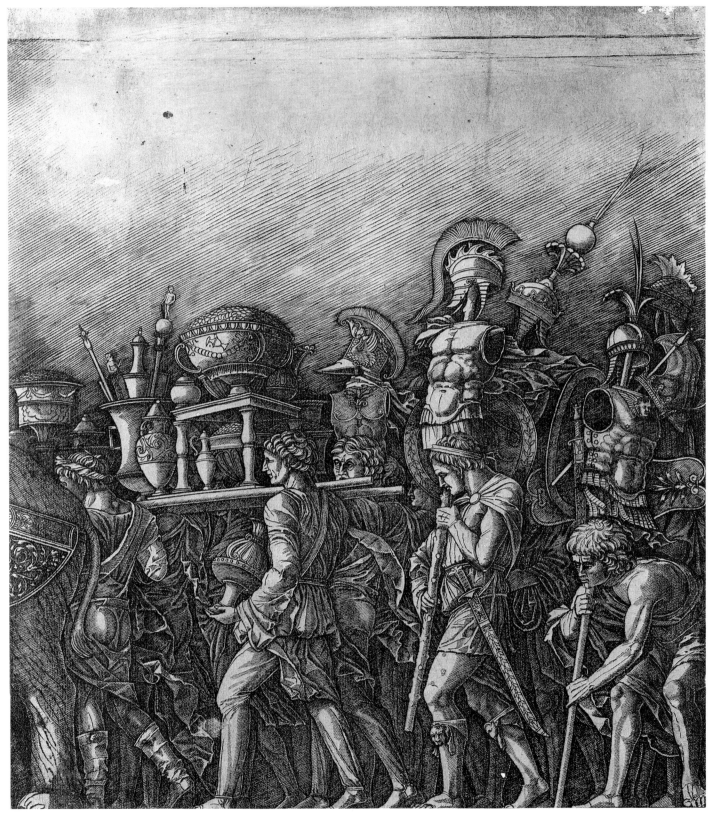

121

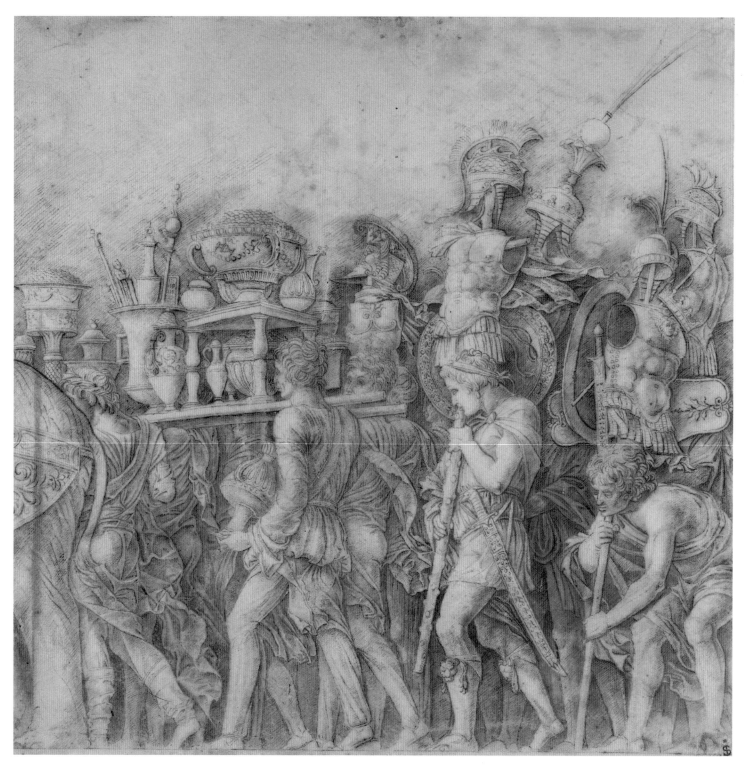

122

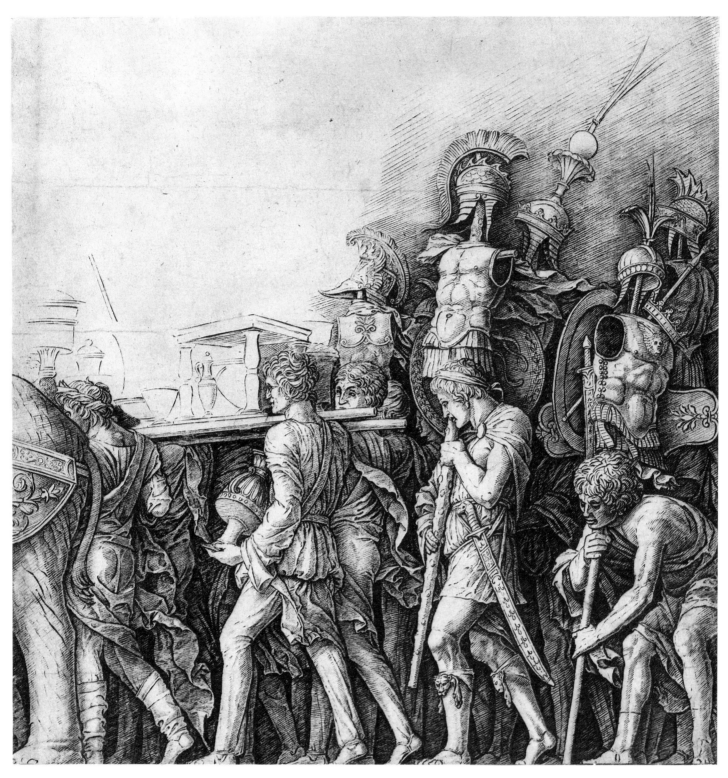

123

GIULIO CAMPAGNOLA ?
The Corselet Bearers

Engraving
260 x 258 mm (sheet; plate 318 x 318 mm, Frankfurt)
H.15
Watermark: Cardinal's Hat (no. 4)

c. 1498

Print Collection, The Miriam and Ira D. Wallach
Division of Art, Prints and Photographs, The New
York Public Library, Astor, Lenox and Tilden
Foundations

REFERENCES
Bartsch, 1811, XIII, 236.13; Hind, 1948, V, 23.15;
Oberhuber and Sheehan, in Washington, 1973,
pp. 214- 17, no. 82

This print and cat. 118 are by the same hand,
which is here tentatively identified as that of
Giulio Campagnola.

As already stated, the copy by Giovanni
Antonio da Brescia (cat. 121) follows cat. 120,
not this one, and neither this nor cat. 120 is a
copy of the other. This print could have been
made after the drawing of *The Corselet Bearers*
(cat. 122), although that shows no physical
evidence of having been copied. The print
was left unfinished for unknown reasons.

This image and cat. 126 were almost
certainly made on the two sides of the same
plate. The plate must have been made in
Mantua, as it seems to have travelled with the
group of plates including the *Flagellation*

with a Pavement (cat. 36), the *Descent into
Limbo* (cat. 67), the Bacchanals (cats. 74, 75),
The Corselet Bearers and *The Senators* (cat. 126)
and others that were taken to France in the
16th century (see Appendices I, II).

S.B.

124

AFTER ANDREA MANTEGNA
Julius Caesar on his Chariot

Pen and brown ink and some red chalk washed
with brown, yellow, and green wash, with white
heightening
262 x 273 mm

Late 15th – early 16th century

The Trustees of The British Museum, London
(1895-9-15-773)

PROVENANCE
Rev. Dr H. Wellesley; sold Sotheby's 25 June 1866,
lot 887; John Malcolm

REFERENCES
Campori, 1870, p. 645; Robinson, 1876, p. 117,
no.326; Kristeller, 1901, p. 441; Popham and Pouncey,
1950, p. 105, no. 169; Martindale, 1979, pp. 77-82,
164-5, no. 54; London, 1981, pp. 143-4, no. 68; Hope,
1985, p. 306; Lightbown, 1986, p. 433

Although Popham and Pouncey described
this drawing as 'an old but feeble and
unfinished variant of the Hampton Court
cartoon of *Caesar in his Triumphal Car*', they
conceded that it is an instructive record of a
lost preparatory drawing by Mantegna.
Although this drawing is unfinished, the lost
original was very probably finished. Given
that only one surviving drawing (fig. 99) for
the *Triumphs* is generally accepted as
autograph, all the copies of Mantegna's
preliminary ideas for the commission gain
considerably in importance. This is
particularly true of this drawing, for which
there is no related print.

The differences between this drawing and
the painting are considerable. Here the
chariot is drawn by four horses instead of
one, as in the painting, and although the
position of the foremost horse is the same,
there are no putti between its legs. The man
with the standard, the *signifer*, in front of the
horse is completely transformed in the
finished canvas. However, as was pointed out
by Popham and Pouncey, this figure in the
drawing is much closer to a man in canvas
VIII, whose pose and costume are virtually
identical. The inference must be that, at some
point between the making of the drawing
and the painting, the artist decided to transfer
the figure from one composition to the other.

The triumphal chariot remains basically the
same, although details such as the larger
volutes and simpler wheel-spokes of the
drawing were subsequently altered in the
painting. The main difference is that, instead
of showing the bottom part of the chariot
through the spokes, an elaborate medallion
covers this area in the painting. In the
drawing the figure of Caesar is shown in
purer profile, and his head is held upright.

Unlike the other drawings connected with
the *Triumphs*, which are executed in plain
brown ink, this sheet is touched with
substantial areas of coloured wash. This could
of course simply be a caprice of the copyist,
but it is more likely that it was a feature of the
lost original. It would scarcely be surprising if
Mantegna, who must have executed a
considerable number of drawings for this
immense project, had experimented with
watercolour in his preparatory drawings.
An inventory of 1728 of the collections at
Novellara lists '*un trionfo in acquerello ... del
Mantegna*'.

D.E.

124

125

AFTER ANDREA MANTEGNA
The Senators

Pen and brown ink
250 x 268 mm

Late 15th – early 16th century

Graphische Sammlung Albertina, Vienna (inv. 2585)

REFERENCES
Wickhoff, 1891, p. cclii; Kristeller, 1901, p. 441;
Martindale, 1979, pp. 165-6, no. 56; Hope, 1985,
pp. 305-6, Lightbown, 1986, pp. 429, 433

This sheet, together with the engraving of the same subject in the reverse direction (cat. 126) and the copy of the latter in the same sense as the drawing (cat. 127), represents our only record of what must have been planned as an additional canvas for the *Triumphs of Caesar*, intended to follow the final canvas, *Caesar on his Chariot*. Martindale pointed out that it is clearly superior to the print and cannot, as some earlier writers were inclined to suppose, be a mere copy after it.

As with the other drawings related to the *Triumphs*, the question arises as to whether this is an original study by Mantegna or a copy of a lost preliminary drawing by him. If compared to the drawing of *The Trumpeters* (fig. 99), widely accepted as an autograph drawing, or to the drawings universally acknowledged as Mantegna's of approximately the same period and type, it is evident that it cannot be by Mantegna. Compared with autograph drawings, even extremely highly finished ones, it lacks energy and dynamism, is over-neat, and the pen-line tends to be uniform and lifeless. As Martindale noted, the perspective of the main building is defective, with the loggia being seen from the left and the window above slightly from the right. Furthermore, the cornice of the palace in the background on the right does not maintain a straight line when it emerges from behind the round tower. Last, the popping eyes and staring expressions are inconceivable for Mantegna. The quality of the drawing, however, is not negligible as copies go, and there seems no reason to doubt that it gives a basically accurate representation of the lost original.

D.E.

126

PREMIER ENGRAVER
The Senators

Engraving
284 x 271 mm (sheet; plate 305 x 356 mm; see text)
H.16

c. 1495

National Gallery of Art, Washington, DC

REFERENCES
Bartsch, 1811, XIII, 234.11; Hind, 1948, V, 24.16;
Martindale, 1979, p. 66; Lightbown, 1986, p. 432

This print and cat. 120, both reversing the direction of the preparatory drawings, are the only ones by Mantegna's Premier Engraver reproducing compositions of the *Triumphs*; they were probably engraved on two sides of the same plate. The plate dimensions given were reported to the late A. Hyatt Mayor of the Metropolitan Museum at an unknown date, probably in the 1950s or '60s.

The traditional title for this image, *The Senators*, already used by Bartsch, who in turn had much of his information from Mariette, may be something of a misnomer. Martindale identified the figures as secretaries and aides who would have walked behind the triumphal chariot, followed by the first rank of the army, although Lightbown affirmed that the first two rows of men are senators.

This print is very close to the drawing of *The Senators* (cat. 125), and to the same scale. A few details differ, such as the branch of bay, which forks below the top of the helmet beyond it in the drawing, above it in the print; some of the facial expressions are different, most noticeably that of the fourth man from the left in the print, and the figure beside the man holding a tablet who turns to look behind him. When enlarged transparencies of the drawing and the print are superimposed, it becomes clear that the engraver may well have transferred this particular drawing either by tracing or by other mechanical means although no sign of tracing was evident on the drawing. The print was copied by Giovanni Antonio da Brescia (cat. 127).

S.B.

127

GIOVANNI ANTONIO DA BRESCIA
The Senators

Engraving
288 x 270 mm (sheet; plate size unknown)
H.16a

c. 1500

Graphische Sammlung Albertina, Vienna (1951-396)

REFERENCES
Bartsch, 1811, XIII, 321.7 and 235.11, copy; Hind,
1948, V, 25.16a

Giovanni Antonio's copy of cat. 126 closely conforms to that print, although reversing it.

S.B.

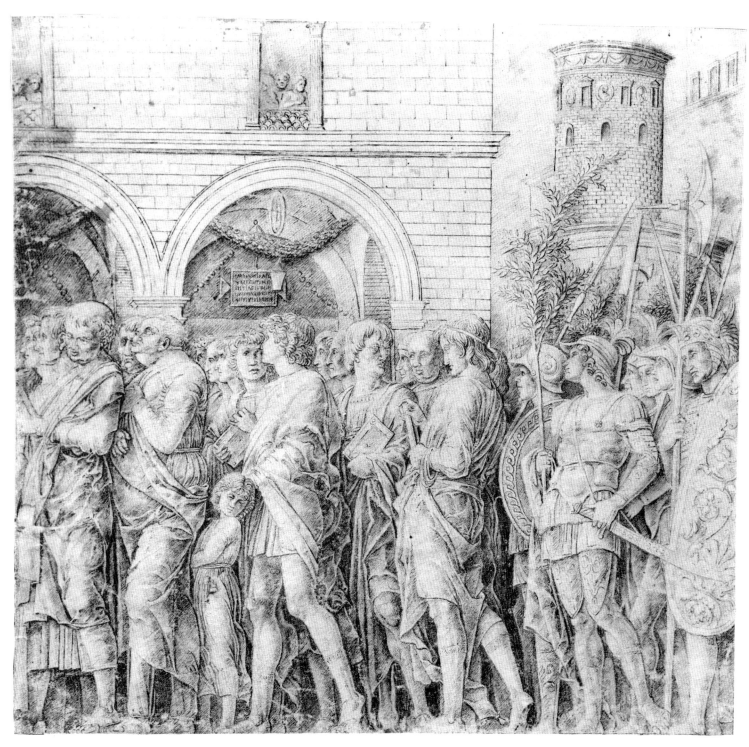

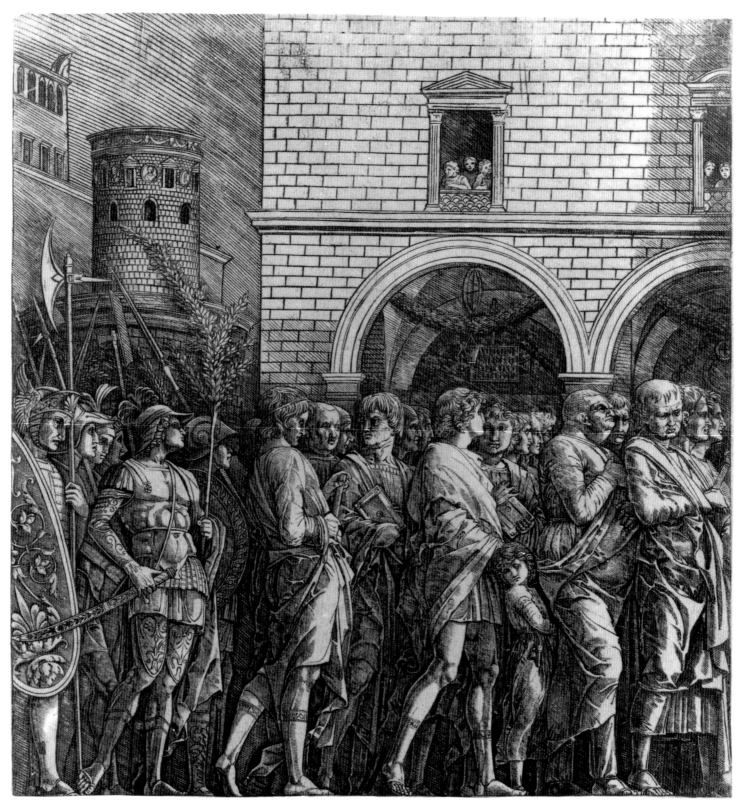

126

391

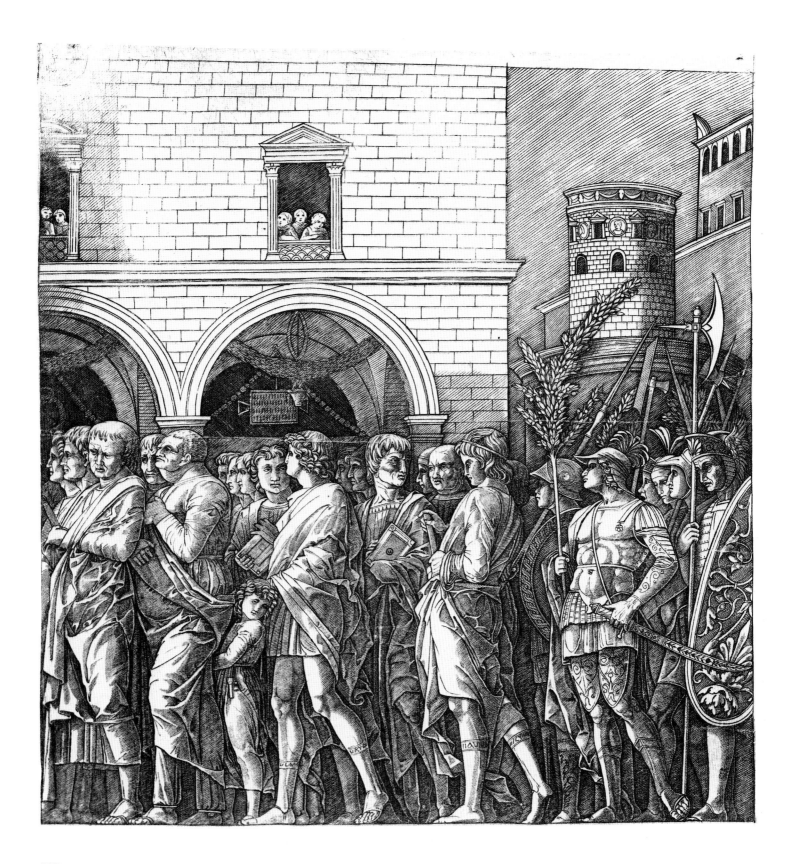

127

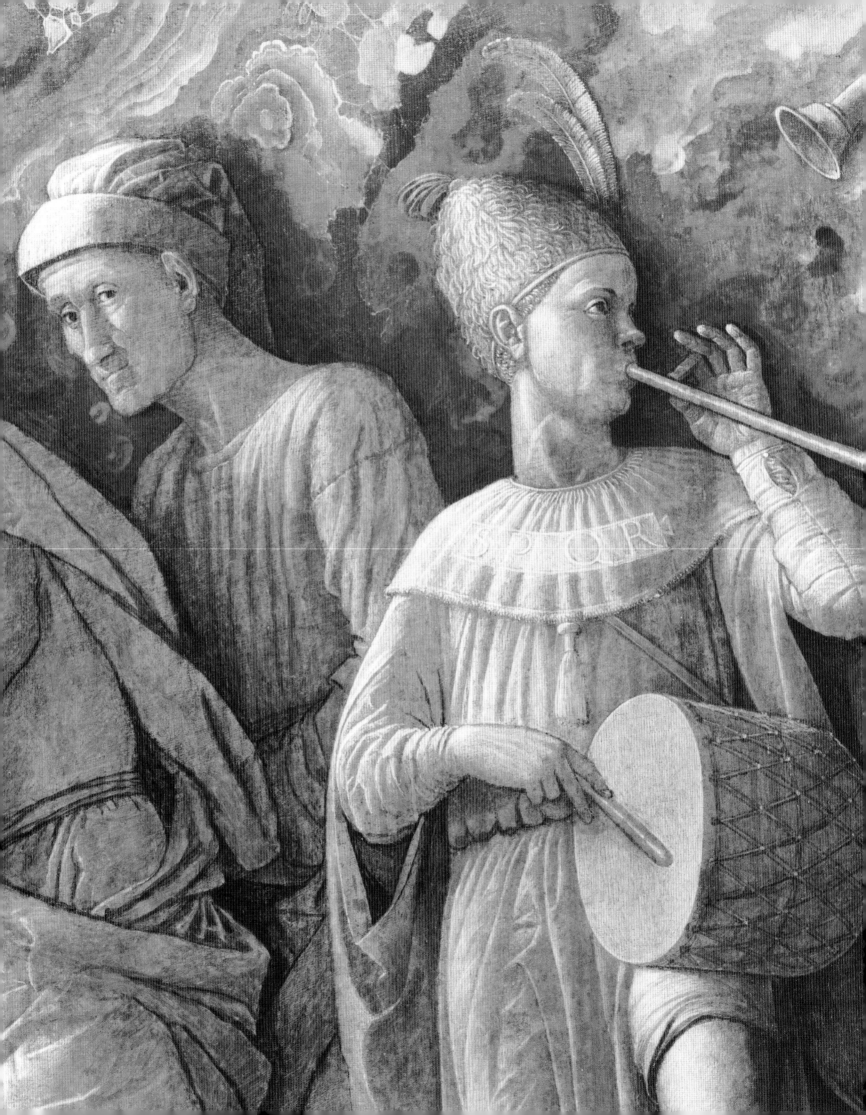

8 PAINTINGS IN GRISAILLE

In the great altarpiece known as the *Madonna della Vittoria* (Louvre, Paris), painted to commemorate the deliverance victory of Francesco Gonzaga in the battle against the French army of Charles VIII at Fornovo in July 1495, Mantegna characteristically lavished as much care on the details of the setting as on the figures of the Virgin, her attendant saints and the portrait of the Marchese kneeling in thanksgiving at her feet. The Virgin is seated on a throne, the inlaid wood back of which is exposed to view while the jasper armrest is visible beneath her suspended cloak.[1] Her feet rest on a bronze footstool decorated, *all'antica*, with lions' paws, acanthus leaves and a porphyry disc inscribed in Roman letters with an antiphonal verse in her praise. In turn, the throne and footstool are raised on a circular dais, the top of which is of richly veined marble or alabaster, while the drum is divided by mouldings and colonettes into three decorative panels of serpentine on which are applied gilt bronze figures illustrating scenes from the book of Genesis. The whole is placed on a hexagonal platform made of marble resembling *breccia rossa policroma lumachellata*.[2] The central scene on the dais shows the Fall, with Adam and Eve disposed to either side of the Tree of Knowledge, the branches of which spread out over the stone mouldings (fig. 93; the wreaths of leaves the figures wear seem to be later additions). The flanking compartments, only partially visible, show on the right the wings, one leg and the fluttering drapery of an angel that is obviously based on a Roman figure of a winged Victory – part of the scene of the Expulsion; and on the left, the Creation, represented in an unprecedented fashion by the outstretched hand of God wielding a

chisel as he carves Adam from stone.[3] The sculptural source of the Expulsion and the iconography of the Creation are as indicative of Mantegna's artistic interests as the conceit of the throne itself. By the one he affirmed his life-long study of Roman art. By the other, he seemingly asserted the primacy in his art of sculpture and sculptural effects.

Mantegna's passion for Roman sculpture, fostered in the workshop of his teacher Squarcione, is evident not only in the fragments of Roman sculpture and ruined monuments that he repeatedly incorporated into his paintings, or by the depictions of figures busy quarrying or carving marble in the hills behind the portraits of Ludovico Gonzaga and his son Cardinal Francesco in the Camera Picta and in the landscapes of the *Virgin of the Stonecutters* (fig. 3; Uffizi, Florence) and the *Man of Sorrows with Two Angels* (cat. 60), but in the lapidary precision of his figure style. It is reported that Squarcione, when called upon to appraise Mantegna's fresco cycle in the Ovetari Chapel in Padua, criticised his use of colour and the resemblance of his figures to Roman statuary rather than to nature (a criticism that, in various guises, has echoed down the centuries, from Vasari to Berenson and Longhi).[4] In response, Mantegna is said to have softened his style somewhat. But sculpture remained for him a paradigm for those qualities of three-dimensionality ('*rilievo*') that were so prized by 15th-century commentators. In effect, he established his own '*paragone*' (or comparison), between the sister arts of painting and sculpture, and he did so with a sense of ironic intelligence that must have struck a responsive chord in his sophisticated patrons.

fig. 103 *The Introduction of the Cult of the Cybele in Rome*, cat. 135, detail

Thus, in the San Zeno Altarpiece (fig. 66), the viewer is invited not simply to admire the imaginative recreation of an ancient Roman hall housing the Virgin and her court, or such archaeological details as the carved medallions that decorate the massive, marble-encrusted piers (each derived from a recognisable ancient source), but to measure the tactility of the music-making cherubs surrounding the Virgin against their feigned sculptural counterparts bearing swags in the frieze above and those decorating the podium of the Virgin's throne, partly hidden by an Anatolian carpet (a conceit that Mantegna's patron, the Protonotary Gregorio Correr, must have appreciated). To a similar end, both of his depictions of St Sebastian, that in Vienna (fig. 5) of the late 1450s and the large altarpiece in the Louvre (fig. 2), apparently painted in the early 1480s,[5] include a sculptural fragment of a foot near the blood-stained ones of the arrow-pierced Saint, thereby transforming an emblem of the demise of the ancient world, reduced to ruins, into a visual pun about art and its representational powers. 'Why gaze on the statues of Myron and Lysippus? Why do the seemingly alive marbles of Praxiteles and the statues of Euphronius detain you? The genius of Polycletus is tarnished and loses all lustre when compared to that of Andrea', declared the Carmelite Battista Spagnoli in a laudatory poem dedicated to Mantegna.[6] We are also reminded of the fact that such fragments were avidly sought by collectors: the inventory taken in 1542 of Isabella d'Este's Grotta in the Corte Vecchia of the ducal palace at Mantua lists three antique marble feet beneath a table and another on a window-ledge.

It is tempting to view Mantegna's grisaille paintings, in which the terms of sculpture are so vividly evoked, as an extension or the culmination of his fascination with sculpture and the world of antiquity, but this is only partly true. They are, like the sculptural details in Mantegna's paintings, each a *tour de force* of representation: art imitating art rather than nature, and thereby raising its powers to another, more abstruse level

(the effects of *trompe l'oeil* painting had the sanction of ancient writers through Pliny's anecdote that the great Zeuxis had met defeat in a competition with Parrhasius, when he was duped into attempting to draw back a *trompe l'oeil* painted curtain to expose a non-existent picture).[7] They also revive an ancient practice recorded by Pliny, who noted that Zeuxis made monochromatic paintings in white.[8] But, in order to understand their function and Mantegna's intentions, as well as to appreciate their particular qualities, it is necessary to approach the grisailles not merely as intellectual conceits, but as what they purport to be: substitute sculptural reliefs. As such, they drew on a tradition that, in Padua, could be traced back to Giotto's relief-like depiction of Virtues and Vices in the Arena Chapel, part of the *faux-marbre* revetment around the base of the walls. However, their appearance in Mantegna's career in the 1490s coincides, on the one hand, with the arrival in Mantua of the sixteen-year-old Isabella d'Este and her subsequent campaign to collect ancient and modern works of sculpture to decorate her Studiolo in the Castello (see cat. 136),[9] and, on the other, with the rise of a classicising pictorial relief style in Venice at the hands of Tullio Lombardo and the creation in Mantua of no less classicising bronze medallions and exquisitely wrought bronze statuettes based on ancient prototypes by Pier Jacopo Alari-Bonacolsi, whose nickname Antico testifies to the sort of work at which he excelled.

Tullio Lombardo's reliefs were conceived as decorative embellishments to architecture or monumental wall tombs, but their traits – smoothly polished figures sculpted in low to high relief inhabiting a shallow, perspectively constructed space – were developed by his brother Antonio into a highly refined means of treating classical themes suitable for the decoration of domestic interiors. Those grisaille paintings by Mantegna, in which the figures and setting are executed in tones of grey against a coloured, veined marble background, bear direct comparison with these reliefs.[10] Indeed, in the

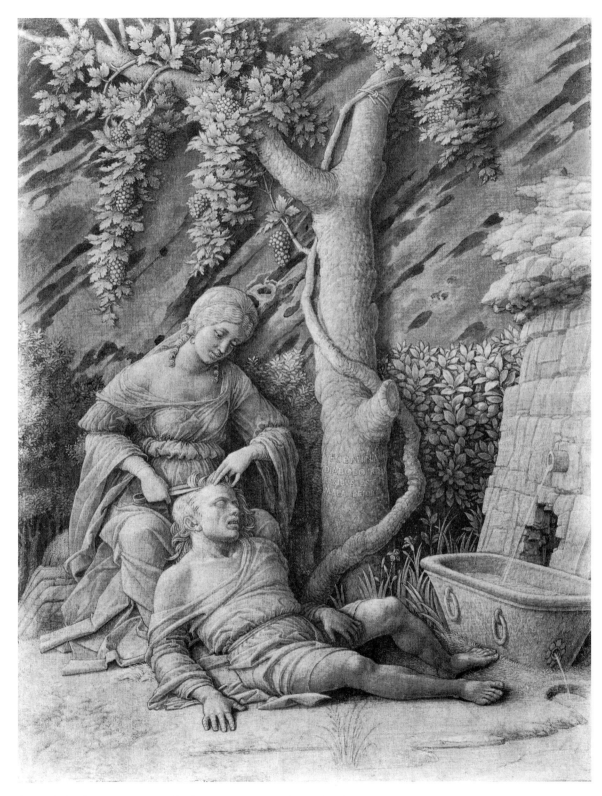

fig. 104 Andrea Mantegna, *Samson and Delilah*, linen, 47 x 37 cm, National Gallery, London

finest of them, the *Samson and Delilah* (fig. 104; National Gallery, London) and its companion, *Judith with the Head of Holofernes* (cat. 129), Mantegna resorts to many of the same devices employed by the Lombardi. In the *Samson and Delilah*, a fountain composed of a receding stone wall and an antique basin viewed in foreshortening define the depth of the 'relief', while the back is closed off by a hedge in front of the *africano* marble inset and the upper area is filled with grape-laden vines tied to the trunk of a leafless tree.[11] Yet, despite the suggestive similarities, none of Antonio Lombardo's small marble reliefs can be dated earlier than 1506, when he moved from Padua to Ferrara to undertake work for Alfonso d'Este's *Studio di Marmo*. It would therefore seem that Mantegna was the first to realise the potential of this novel sort of relief for the decoration of private rooms or studies, and it is not without interest that actual reliefs of this type make their appearance in Mantua on the marble doorframe of Isabella d'Este's Studiolo executed, it would seem, by Giancristoforo Romano between 1497 and 1505 (fig. 105).[12] The doorframe is decorated with eleven circular reliefs (four on the front face and seven on the jambs) and inset panels of rare marble (the current ones are largely replacements) of the sort that Mantegna simulates as the background for his own fictive reliefs and that Isabella collected with such passion.[13]

Mantegna was not alone in painting such grisailles. Giovanni Bellini provided the companion piece to Mantegna's *Introduction of the Cult of Cybele in Rome* (cat. 135), and around 1500 Cima da Conegliano experimented in the grisaille technique in a small panel of *Daniel in the Lions' Den* (Pinacoteca Ambrosiana, Milan).[14] In each case, however, Mantegna seems to have provided the inspiration.

Mantegna's grisailles are not, of course, merely exercises in *trompe l'oeil* or in imitating ancient practice. Nor are they strictly imitative of the technical limitations of relief sculpture. In them the ground plane is extended forward and details are included that no sculptor could

fig. 105 Giancristoforo Romano, *Poetry*, marble relief from the doorframe from Isabella d'Este's Studiolo, 1497–1505, Palazzo Ducale, Mantua

carve. But, to a surprising degree the conventions Mantegna observed are those of relief sculpture. A comparison of the *Samson* with the small devotional panel of the *Virgin of the Stonecutters* demonstrate his self-imposed limitations. What is true of the *Samson* is also true of the *Sacrifice of Isaac*, the *David with the Head of Goliath* (cats. 131, 132) and the *Judgement of Solomon* (cat. 130), all of which are based on designs by Mantegna.

In another type of grisaille the figures, isolated from a complex setting but similarly viewed against a veined

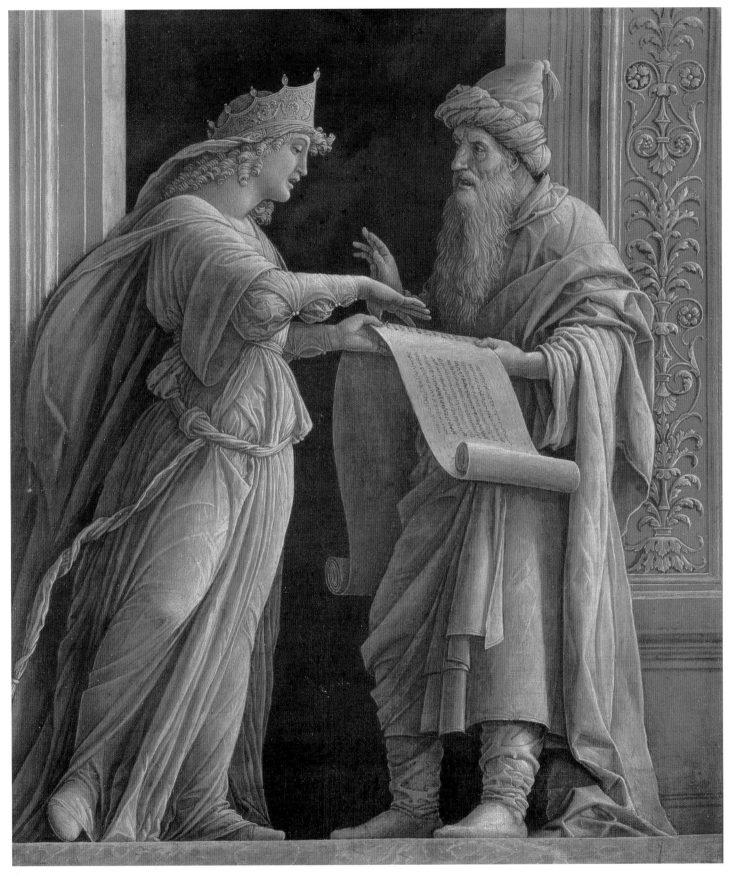

Pietro Aldobrandini's collection, the picture may, like the *Adoration of the Shepherds* (cat. 8), have been among the works he obtained when Ferrara was absorbed into the Papal States. This raises the possibility that it was painted for Isabella d'Este's father, Ercole, or another member of the Este court. Alternatively, it could have been brought from Mantua to Ferrara, possibly by Margherita Gonzaga, the wife of Alfonso II d'Este, who is known to have brought a number of pictures to Ferrara for her private chapel. The picture already had its present dimensions in the Aldobrandini collection (i.e. 2¼ *palmi*, which equals approximately 50 cm).

Whatever the solution – and unfortunately it is not possible to press the matter beyond the realm of conjecture – one of the most singular features of the composition is its apparent reference to Donatello's bronze doors, with their panels of pairs of disputing figures, for the Old Sacristy of San Lorenzo, which Mantegna must have studied with interest when he visited Florence in 1466. Mantegna reinterpreted Donatello's figures in his more archaeologically based, classicising language of the last decade or so of his career.

K.C.

129

ANDREA MANTEGNA
Judith with the Head of Holofernes

Distemper on canvas, 48.1 x 36.7 cm

c. 1495–1500

The National Gallery of Ireland, Dublin (inv. 442)
(Exhibited in London only)

PROVENANCE
1842–91, Hon. Lewis Strange Wingfield; before 1896, John Malcolm of Poltalloch; 1896, P. & D. Colnaghi; The National Gallery of Ireland

REFERENCES
Crowe and Cavalcaselle, 1871, ed. 1912, II, p. 105; Yriarte, 1901, pp. 205-7; Berenson, 1901, p. 97; Kristeller, 1901, pp. 373, 444; Berenson, 1902, pp. 57-8; Duncan, 1906, pp. 7-8; Knapp, 1910, p. 124; Kristeller, 1911-12, p. 40; Venturi, 1914, pp. 244, 247; Schwabe, 1918, p. 215; Berenson, 1932, p. 327; Fiocco, 1937, pp. 68, 206; Kleiner, 1950, p. 11; Tietze-Conrat, 1955, p. 181; Paccagnini, in Mantua, 1961, p. 69; Davies, 1961, p. 334; Gilbert, 1962, p. 6; Cipriani, 1962, p. 80; Camesasca, 1964, pp. 44, 47, 122; Garavaglia, 1967, no. 75; Berenson, 1968, p. 239; Keaveney, in London, 1985, pp. 4-5; Lightbown, 1986, pp. 449, 451

The picture, which is in an exceptionally fine state, having never been varnished or relined (it is mounted on a piece of cardboard), provides valuable insight into Mantegna's grisaille technique. It is a true '*guazzo*', (see p. 84, above), being painted in an extremely liquid medium (almost certainly a glue size) on a fine linen canvas with no gesso ground. The predominating warm, greyish tonality is due to an even coat of paint that was applied directly to the sized canvas in much the same way that, in the 15th century, paper was given a coloured ground for silverpoint drawings with white heightening. This grey preparation provides the middle tones for the highlights of white (probably somewhat stained with ingrained dirt) and brown shadows, the intensity being varied almost exclusively by the dilution of the pigment. Colour accents – ochre, pale lavender and apricot – are limited to the veined marble background (a *breccia pavonazza*?). The technique did not permit changes in design or major corrections (the only, extremely minor, ones are where the drapery covers a part of Judith's left foot initially laid in with brown, and in the folds of the trousers of the servant). Given this fact, it is not surprising that along the outside contour of Judith's right leg, the inside of the thigh and the left

and right edges of the tent, there are the faintest signs of an impression made when the composition was transferred from a drawing by means of tracing with a stylus (visible under magnification). To no less a degree than the '*bronzi finti*' painted in shell gold (see cats. 133, 134), this is a technique that does not reproduce well, and in evaluating the various opinions on the authorship of the picture it is important to bear in mind that as often as not they have been formulated on the basis of photographs.

Equally important for a proper evaluation of the picture is its conception not as a monochromatic painting but as a pictorial relief. To this end, the tent is conceived as a flat form raised slightly from the marble background, its left edge evenly lit, its right edge casting a shadow. Similarly, Holofernes' foot and bed are a simple silhouette, as in a *rilievo stiacciato*. For all that, the picture is not a *trompe l'oeil*. Mantegna has taken considerable licence, not troubling himself with defining the ground plane as a raised plateau or ledge such as one would expect in a piece of sculpture, and allowing the flag and Judith's pennant to flutter in a way that even Antonio Lombardo or the virtuoso Bambaia would have had difficulty carving. If the allusion to sculpture in low to high relief explains some

403

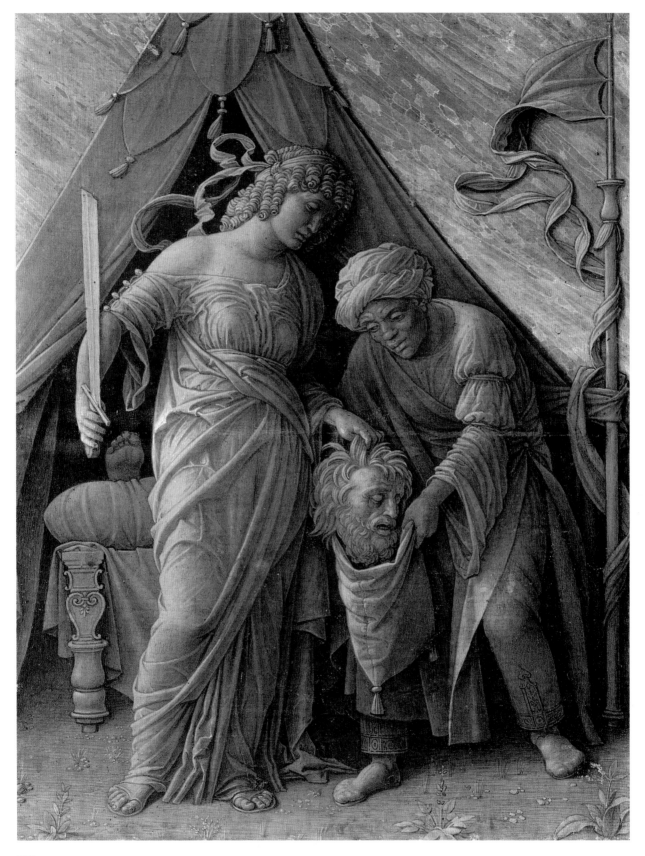

of the more obvious differences of conception with the great Uffizi drawing of the same subject (fig. 109), the simulation of marble rather than bronze figures distinguishes this picture from the two paintings in Montreal (cats. 133, 134), with their highly chased and gilt surfaces.

No one has doubted that the design of this work, with the imaginative, off-centre tent employed as a primary compositional device, is due to Mantegna, but a number of critics (Kristeller, Venturi, Schwabe, Tietze-Conrat) found its execution too weak for the master. As already noted, some of the perceived weaknesses (for example, an apparent lack of strength in the definition of the forms) are, in fact, technical characteristics. Under magnification, Judith's head is modelled beautifully and with great delicacy, while the twists of the scarf are defined with a wonderfully free use of the brush. Even areas treated in a seemingly perfunctory fashion – the bed of Holofernes, the sack into which his head is being stuffed, the dull tassels on the sack and tent, and the pole at the right –

show delicacy and precision of handling under magnification. The fact that the design was transferred from a drawing raises the possibility of execution by a talented assistant. However, the work is far superior to comparable, highly finished drawings by students derived from cartoons, such as the *Christ Descending into Limbo* (cat. 71), the *Eight Apostles* (cat 20), or the *Dancing Muse* (cat. 137).

Duncan first associated the *Judith* with the *Samson and Delilah* (fig. 104; National Gallery, London), and the *Judgement of Solomon* (cat. 130), a list to which Davies conjecturally added the *David* and *Isaac* (cats. 131, 132). This association has been called 'improbable' (Lightbown, p. 449), and it is, indeed, difficult to see what the *David* and *Isaac* have in common with the *Judith* beyond their similar dimensions. By contrast, there are technical and iconographic reasons for associating the *Judith* with the *Samson and Delilah*. The dimensions are close and the technique identical. The *Samson and Delilah* has the same black border found in the *Judith*

and both have similar damages along their horizontal axis (this was noted by Duncan; contrary to the assertion by Keaveney, the *Judgement of Solomon* does not show signs of this sort of damage). Equally important, the veining of the related but different types of marble runs in opposite directions (this is also true of the Montreal pendant pictures). In one picture, a virtuous heroine defeats a tyrant by feigning love; in the other a Hebrew is humiliated through the beguiling advances of a Philistine beauty. The *Samson and Delilah* bears an inscription, 'a bad woman is three times worse than the Devil', underscoring the moralising intent. Whether the two were part of a larger series contrasting virtuous and villainous women and the wiles of love cannot be established, but it is possible. Such a theme would certainly have appealed to Isabella d'Este and would have provided a complement to the pictures in her Studiolo.

K.C.

130

WORKSHOP OF MANTEGNA
Judgement of Solomon

Distemper on canvas, 46.5 x 37 cm

c. 1495-1505

Musée du Louvre, Département des Arts Graphiques, Paris (inv. 5068)

PROVENANCE
By 1640-50, Paolo Coccapani, Bishop of Reggio Emilia (inv. no. 96); 1650-1797, the Dukes of Modena (inv. 1751, no. 390); from 1797, Musées Nationaux

REFERENCES
Kristeller, 1901, pp. 370-71, 443; Berenson, 1907, p. 255; Knapp, 1910, p. LI; Berenson, 1932, p. 328; Fiocco, 1937, pp. 68, 206; Tietze-Conrat, 1955, p. 194; Davies, 1961, p. 334; Paccagnini, in Mantua, 1961, p. 71; Gilbert, 1962, p. 6; Cipriani, 1962, p. 84; Camesasca, 1964, pp. 44, 125; Garavaglia, 1967, no. 86; Berenson, 1968, p. 241; Keaveney, in London, 1985, pp. 4-5; Lightbown, 1986, p. 470; Sérullaz, in Paris, 1988, p. 44, no. 21; Bentini, 1989, p. 17

The picture illustrates the tale of Solomon's wisdom recounted in I Kings 3:16-28. Two mothers presented infants, one dead and one alive, to Solomon, each claiming the living child was theirs. As a ruse, Solomon ordered a guard to cut the live child in half and divide it between the two claimants. The rightful mother, shown to the left attempting to stop the soldier, was revealed by her efforts to stop the execution, while the pretender passively accepted this apparently aberrant command.

The picture, described as executed in distemper ('*guazzo*') and ascribed to Mantegna, was owned by Paolo Coccapani, Bishop of Reggio, in about 1640 (Campori, 1870, p. 148, no. 96). Interestingly enough, Coccapani also owned a drawing of the theme by Mantegna (Campori, 1870, p. 154; this seems to have escaped the notice of Bentini). It is, however, not possible to state what relation the drawing may have had to

the painting. This is unfortunate, for the Louvre picture must derive from a compositional drawing by Mantegna, although it shows no sign of transfer from a cartoon. Its squared pavement, the positioning of the foreshortened dead child and the foreshortened edge of the podium to establish the pictorial depth, are consistent with Mantegna's practice. The helmet of the soldier to the right, the crown of Solomon and the trousers of one of the soldiers are an imaginative attempt to lend the scene archaeological authority. No less indicative of Mantegna's mind is the idea of showing Solomon in near-profile on a raised throne with the figures below, an obvious derivation from a Roman coin or relief, and the overlapping profiles in the background, dependent on a classical gem or cameo. Despite these features, it is inconceivable that Mantegna could have painted so inarticulate a figure as the Solomon, whose body lacks

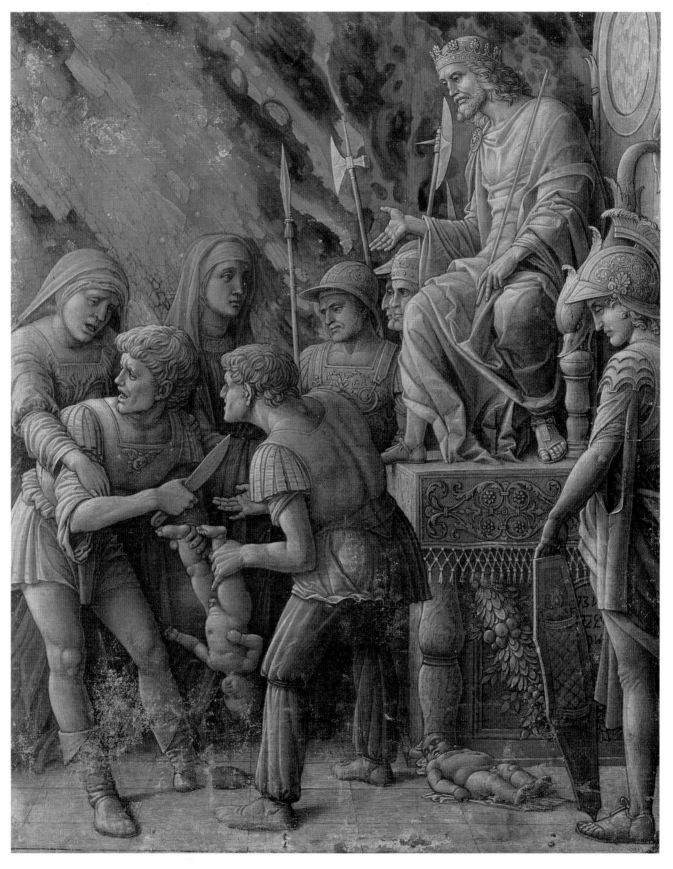

any structural coherence, or the oversized, blank-faced mother in the background, who reads as an insertion and completely spoils the dramatic tension of the scene. To an even more marked degree than in the *Sacrifice of Isaac* and the *David with the Head of Goliath* (cats. 131, 132), the lifeless execution falls far short of Mantegna's work. Workshop participation on the picture is generally recognised, but in this case it seems extremely unlikely that Mantegna actually had any hand in the painting. At the same time, its quality is vastly superior to the *Mucius Scaevola* (Staatliche Graphische Sammlung, Munich), which has sometimes been associated with it. The crude design and execution of the

Munich picture are the result of a feeble attempt by a pupil or follower to capitalise on a type of painting created and perfected by Mantegna. There are compositional similarities with the oblong grisaille frescoes in Mantegna's funerary chapel in Sant'Andrea, datable by an inscription to 1516 and, according to a lost letter, painted by Mantegna's son Francesco (see Lightbown, 1986, pp. 148-50; 453).

Although the *Judgement of Solomon* employs the same technique as the Dublin *Judith* (cat. 129) and the *Samson and Delilah* (National Gallery, London) and is close in size (it has been cut slightly on all sides and, in consequence, lacks the black border found

in those works), there is no compelling reason to believe that it was painted as part of the same series, as has sometimes been proposed (see, for example, Fiocco, Davies, Keaveney). Not only is the execution lower in quality; the subject is not related. There is also no sign of the damage along the horizontal axis found in those two pictures (aside from abrasion and some losses at the bottom, the picture is in very good state and has never been varnished). The primary interest of the picture, then, is the evidence it provides that the demand for Mantegna's grisailles exceeded his ability to produce them.

K.C.

131

WORKSHOP OF MANTEGNA
David with the Head of Goliath

Distemper on canvas, 48.5 x 36 cm

c. 1495-1500

Kunsthistorisches Museum, Gemäldegalerie, Vienna (inv. 1965)

The youthful David, having slain the Philistine giant Goliath, cuts off his head in victory. The story is from Samuel 18:51. See cat. 132.

132

WORKSHOP OF MANTEGNA
Sacrifice of Isaac

Distemper on canvas, 48.5 x 36.5 cm

c. 1495-1500

Kunsthistorisches Museum, Gemäldegalerie, Vienna (inv. 1842)

PROVENANCE
until 1627, possibly Gonzaga collection, Mantua (inv., 1627, nos. 381 and 509); 1627-49, probably Charles I; 1650(?)-62; Archduke Leopold Wilhelm of Austria (1659 inv. nos. 408 and 409); Imperial collections

REFERENCES
Berger, 1883, p. CVIII; Kristeller, 1911-12, pp. 42-4; Luzio, 1913, p. 119, no. 381; p. 124, no. 509; Berenson, 1932, p. 329; Fiocco, 1937, pp. 68, 206; Tietze-Conrat, 1955, pp. 200-01; Oberhammer, 1960, p. 77; Paccagnini, in Mantua, 1961, pp. 68, 70; Davies, 1961, pp. 334; Gilbert, 1962, p. 6; Cipriani, 1962, p. 83; Camesasca, 1964, p. 44; Garavaglia, 1967, nos. 79-80; Berenson, 1968, p. 242; Lightbown, 1986, pp. 210, 213, 470

The depiction differs from the biblical account in Genesis 22:1-13 in several respects. Abraham is prevented from sacrificing his son not by an angel but by the outstretched hand of God, and the ram appears on the altar rather than 'caught in a thicket by his horns'. The altar itself is an elaborate structure of Roman design, and the fire has already been lit. Mantegna also preferred the intervening hand of God to a figure of an angel in the feigned sculptural relief decorating the temple in his *Circumcision* (fig. 9), but there the ram is shown standing behind Abraham.

Of the grisaille paintings that may be associated with Mantegna, the pair in Vienna pose most acutely the problems of function and manner of production. In the 1659 inventory of the Archduke Leopold Wilhelm of Austria the two pictures, framed together, are listed as 'in oil on linen, grey on grey, the first of the Offering of Abraham and the other David with Holofernes [*sic*] Head in the left Hand ... Original by Mantegna' (Berger). Kristeller first suggested that the *David* may be identical with 'a small painting in *chiaroscuro* showing David who has cut off the head of Goliath, by the hand of Mantegna' listed in the 1627 Gonzaga

inventory (Luzio, p. 119, no. 381). This picture may, in turn, be linked conjecturally with four other pictures by Mantegna 'lavorati a guazzo' – a Tobias, Esther, Abraham and Moses – that are listed in the same inventory with the same valuation (Luzio, p. 124, no. 509). The *David* was kept in one cabinet, the four others in another in the same room, together with numerous other small pictures (the *David* was in a walnut frame, the four others in black and gold frames). Though it need not be accepted that all five pictures formed a single set, some at least are likely to have belonged together, since all depicted Old Testament figures. The pictures were presumably sold to Charles I, from whose estate Archduke Leopold Wilhelm is known to have purchased a number of objects, including some of Antico's bronzes from Isabella d'Este's Studiolo and Grotta (see Leithe-Jasper, in Washington, Los Angeles and Chicago, 1986, p. 78, for a good summary).

The further suggestion that this hypothetical series also included the *Samson and Delilah* (National Gallery, London), the *Judith* at Dublin (cat. 129), as well as the *Mucius Scaevola* (Staatliche Graphische Sammlung, Munich) and the *Judgement of Solomon* (cat. 130; Fiocco, Oberhammer, Paccagnini), is less likely, despite the fact that

the dimensions of the Vienna pictures (which have suffered extensive damage along the bottom edges) are compatible with the other paintings. Thematically, those pictures belong to two series and employ different types of simulated marble backgrounds from the Vienna grisailles. If one were to imagine a setting for an extensive series of Biblical figures in simulated relief, the most obvious place would be a private chapel similar to those Mantegna worked on for the Gonzaga family in Mantua and Goito in the 1460s. Simulated relief sculpture with figures of Tobias, Judith and David are, in fact, included in Mantegna's own funerary chapel in Sant'Andrea, Mantua, together with *faux-marbre* panelling. Mantegna is not known to have worked on a Gonzaga chapel in the 1490s, but that a series that included the Vienna pictures was created for this or a similar purpose seems probable. Isabella's apartments included a chapel, or oratory, but virtually nothing is known about its decoration (see Gerola, 1929, p. 259).

It has long been recognised that the Vienna pictures are inferior to the *Samson and Delilah.* They are also less finely painted than the Dublin *Judith,* and must be products of Mantegna's workshop in the late 1490s. As pointed out by Paccagnini, the *David,* especially, is inferior, the hair having a

disturbing wig-like appearance, the body being over generalised, and the head of Goliath curiously flat (see, by comparison, the severed head of Holofernes in either the Montreal or Dublin *Judith*). Weaknesses are also observable in the *Isaac,* including the disturbing flatness of the altar. Yet, the pictures are of considerable beauty and are plainly by someone of talent. There are traces of an underdrawing visible in the *Isaac* but none in the *David,* which may well have been transferred with a stylus from a design prepared by Mantegna.

During these years, Mantegna was besieged with major commissions – the completion of the *Triumphs,* the altarpiece of the *Madonna della Vittoria* and that for Santa Maria in Organo, Verona, and the paintings for Isabella's Studiolo – and he must have made extensive use of his workshop. Quite apart from his son Francesco, we know that Giovanni Francesco Caroto worked with him in these years and Vasari reports that Mantegna passed off some of Caroto's work as his own. The problem is suggested in the 1627 inventory itself, where in another cabinet there is listed a version of the *David,* also in chiaroscuro but not ascribed to Mantegna, and with less than half the valuation (Luzio, p. 129, no. 582).

K.C.

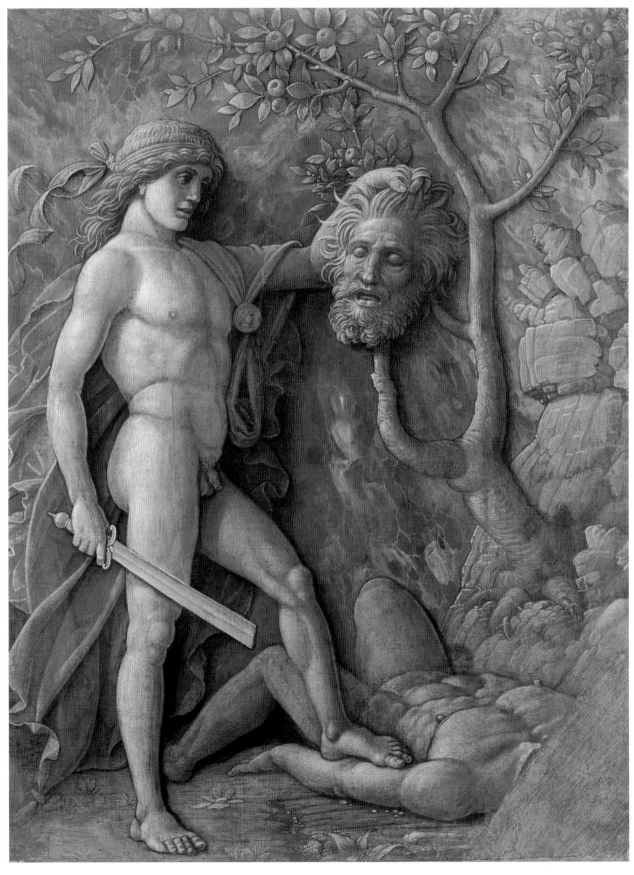

133

ANDREA MANTEGNA
Judith with the Head of Holofernes

Distemper and gold on canvas, 65.3 x 31.4 cm

c. 1500-05

The Montreal Museum of Fine Arts Collection
(purchase John W. Tempest Bequest. 920.103)

PROVENANCE
By 1901-12, John E. Taylor, London; sold Christie's,
London, 5 July 1912, no 26; 1912, Thomas Agnew,
London; 1920, Reinhardt & Son, New York

REFERENCES
Yriarte, 1901, pp. 209-22; Kristeller, 1901, pp. 372-3,
444; Berenson, 1901, p. 98; Kristeller, 1911-12, p. 40;
Venturi, 1914, p. 248; Schwabe, 1918, p. 215; Fiocco,
1937, p. 68; Tietze-Conrat, 1955, pp. 181, 190;
Paccagnini, in Mantua, 1961, p. 74; Cipriani, 1962,
p. 71; Garavaglia, 1967, nos. 76-7; Berenson, 1968,
p. 240; Oberhuber, in Washington, 1973, p. 386; Paris,
1975, p. 30, no. 94; Rosenfeld, in Montreal, 1979,
pp. 32-44; Lightbown, 1986, pp. 177-9, 450; Radcliffe,
1989, p. 98

Of all the grisaille paintings ascribed to
Mantegna, the *Judith* and *Dido* are the two
that most closely correspond to the suggestive
term '*bronzi finti*', or feigned bronzes. Possibly
from a series showing virtuous or heroic
women of antiquity and the Old Testament,
they are painted on a finely woven canvas
that has been thinly primed and then given an
overall coat of pinkish-brown colour used as a
middle tone, with black glazes brushed on for
the shadows, shell gold for the lights, and
darker brown and green used to create the
veined marble background (a sort of *africano
verde*). The effect is of highly chased, gilt
bronze figures, much like those the sculptor
Antico produced for members of the Gonzaga
family at this time. Indeed, the figures in
these paintings could be translated into
bronze statuettes with few adjustments or
simplifications.

That these qualities were intentional can be
demonstrated by comparing the head of Dido
to that of the marble bust of Cybele depicted
in the *Introduction of the Cult of Cybele*
(cat. 135), which shares the same generalised
modelling and sculpted hair with two cork-
screw curls – one falling above the ear, the
other from behind the neck. Both heads

must, indeed, be derived from a Roman
statue or bust such as Antico specialised in
replicating, employing the same exaggerated
emphasis on such details as the rivulets of hair
or sharply cut drapery. The pictures must, to
a degree, be viewed as substitute statuettes. It
is hardly coincidental that Antico's bust of
Cleopatra (Museum of Fine Arts, Boston)
shows many of the same features as the *Dido*,
including a similar crown, the long curl of
hair and the type of dress. The three curls
that hang over the fillet on Judith's head also
have precise analogies in Antico's work and,
again, probably derive from a specific Roman
bust. Radcliffe has noted the further, highly
suggestive compositional similarity of the
rectangular brooch worn by Dido to a
plaquette, possibly cast by the Mantuan
Cristoforo di Geremia, showing a sacrifice to
Priapus (the subject of the brooch is
uncertain). Yet, the matter goes well beyond
the mere use of specific sculptural sources: in
none of Mantegna's other grisaille paintings
did he pursue the conceit of sculptural reliefs
so single-mindedly.

These considerations should not lead us to
minimise the exquisite beauty and refinement
of execution, which could hardly be due to
anyone other than Mantegna. The shell gold
has been applied with consummate skill,
creating glinting highlights, subtle middle
tones and delicately drawn contours that
suggest reflected light. The pearl earring
worn by Judith is something of a *tour de force*,
and no less so is the head of Holofernes, his
shock of hair firmly grasped in Judith's hand.
One cannot help but feel that those who
rejected these paintings have either not
studied them first hand (they do not
reproduce well) or have failed to understand
their special character (see, for example,
Kristeller, Venturi, Schwabe, Paccagnini,
Garavaglia).

The closest analogy of style is with the
figures that decorate the dais of the throne of
the *Madonna della Vittoria* (Louvre, Paris) of
1495-6, which have gilt highlights (see
Lightbown, pp. 177-9 for a summary of the
history of this altarpiece). Given the close
relationship with the sculpture of Antico,
they are likely to date after 1500. In 1501
Isabella d'Este commissioned the first of a
number of statuettes from Antico to place
above a door in a room in the Castello di San

Giorgio; according to an inventory of 1542,
she later displayed other statuettes on a
cornice. The same inventory relates that
above one of the doors of her Studiolo was a
'painting in feigned bronze … by master
Andrea Mantegna showing four figures'
(Luzio, 1908[2], p. 423). It is not impossible
that these pictures were displayed in this
fashion in one of the palace rooms, although
the lack of a *di sotto in sù* viewpoint might
argue against this.

Lightbown (nos. 52, 53, 138) has suggested
that they may be from a set of pictures that
belonged to Ferdinando Carlo Gonzaga, the
last duke of Mantua. According to an inven-
tory of 1709, these consisted of 'four pictures
(each 2 x 4 *quarte*) done in chiaroscuro, of the
Beautiful Judith and other figures by the hand
of Mantegna' (see Luzio, 1913, p. 318). The
dimensions, equivalent to 31.9 x 63.8 cm (the
Mantuan *braccio* equalled 63.8 cm; a *quarta* was
one fourth), correspond closely. These
pictures seem pretty certainly to have been
acquired by Count Schulenburg of Zell, in
whose sale catalogue (Christie's, London,
13 April 1775, lot 17) are listed 'Mantegna,
four paintings, imitations of basso-relievo'
(see Lightbown, p. 450, no. 53).

There are some minor differences in
execution between the two pictures, the
Judith being somewhat bolder and broader in
handling, with stronger highlights and more
brilliant contrasts, the *Dido* being more muted
and *sfumato* in effect. Both pictures are
exceptionally well preserved, though the
figure of Dido has suffered from minor
abrasion in her shoulder and neck, and there
are several small tears. In 1991, the thick
varnish obfuscating their surfaces was
removed, and they are now unvarnished.
The green marble background has been
irreversibly darkened due to the effects of the
glue lining and past applications of varnish.

Infra-red reflectography has revealed on
the reverse of the original canvases the
inscription AND.A.MANTEGNIA.P. Although
interpreted as a signature (Rosenfeld, p. 44),
the letters are too coarse for Mantegna's and,
like that on the reverse of the *Sibyl and a
Prophet(?)* (cat. 128), were probably added
later in the 16th or early 17th century.

K.C.

134

ANDREA MANTEGNA
Dido

Distemper and gold on canvas, 65.3 x 31.4 cm

c. 1500-05

The Montreal Museum of Fine Arts Collection
(purchase John W. Tempest Bequest. 920.104)

The Queen of Carthage stands before her
funeral pyre, holding a sword and a vase.
According to Virgil, she committed suicide
when her lover, Aeneas, departed for Rome
(see cat. 133, above).

135

ANDREA MANTEGNA
*The Introduction of the Cult of
Cybele in Rome*

Distemper on canvas, 73.5 x 268 cm
Inscribed (on drummer-boy's collar): *SPQR*;
(on tombs): *SPQR/ GN SCYPIO/ NI CORNELI/ VS F.[ILIVS]
P.[OSVIT]; P SCYPIONIS / EX HYSPANIENSI / BELLO
RELIQVIAE.*; (along bottom): *S HOSPES NVMINIS IDAEI C.*

1505-6

The Trustees of the National Gallery, London (902)
(Exhibited in London only)

PROVENANCE
1506, Cardinal Sigismondo Gonzaga; 1507-46,
Francesco Cornaro, Palazzo Cornaro, Venice; 1546-
after 1815, Palazzo Cornaro, later Mocenigo a San
Polo, Venice; after 1815-before 1835, Antonio
Sanquirico; by 1835-after 1871, George Vivian; by
1873, Captain Ralph Vivian; from 1873, The National
Gallery

REFERENCES
Moschini, 1815, II, p. 237; Waagen, 1854, II, p. 248;
D'Arco, 1857, II, pp. 57, 70, 72-4; Crowe and
Cavalcaselle, 1871, ed. 1912, p. 112; Vasari, ed.
1878-85, III, p. 424; Cook, 1888, p. 183-4; Yriarte,
1896, p. 226; *idem* 1901, p. 203; Kristeller, 1901,
pp. 361-9, 443; *idem*, 1902, docs. 190, 196, 198;
Berenson, 1907, p. 255; Knapp, 1910, p. 176; Graves,
1913, pp. 744-5; Venturi, 1914, p. 248; Berenson,
1932, p. 327; Fiocco, 1937, pp. 67, 205; Suida, 1951,
p. 82; Robertson, 1953, p. 28; Tietze-Conrat, 1955,
pp. 185-6; Davies, 1961, pp. 330-34; Cipriani, 1962,
pp. 41, 71; Camesasca, 1964, pp. 44 and 126;
Garavaglia, 1967, no. 96; Berenson, 1968, p. 239;
Robertson, 1968, pp. 132-3; Tátrai, 1972, p. 245;
Braham, 1973, pp. 457-63; Brown, 1974, pp. 101-3;
Knox, 1978, pp. 79-84; Shapley, 1979, pp. 52-5;
Romano, 1981, pp. 22-4; Lightbown, 1986, pp. 214-
18, 451-2; Goffen, 1989, pp. 238-42

On 15 March 1505, Cardinal Marco Cornaro,
a member of the patrician Venetian family,
wrote to Francesco Gonzaga to secure a
commission from Mantegna, 'knowing that
in such matters he is dependent on the wishes
of your most Illustrious Lordship, being
dedicated and bound to your service'
(Brown, 1974, p. 102 doc. I.). As an added
inducement, Cornaro sent as his messenger
Niccolò Bellini, 'relation of said Mantegna
and a member of our household' (he was
Mantegna's brother-in-law). The work in
question, destined for Marco's brother,
Francesco Cornaro, is not specified, but there
can be no doubt that it was *The Introduction of
the Cult of Cybele in Rome*, which still
belonged to the Cornaro family in the early
19th century (Davies, 1961).

Mantegna seems to have begun work
shortly thereafter, for on 1 January 1506
Pietro Bembo wrote to Isabella d'Este on
Cornaro's behalf, stating that Mantegna was
now insisting on more than the agreed upon
price of 150 ducats for the canvases ('*telari*');
an indication that the commission was for
more than one picture. Isabella replied on
31 January that Mantegna was ill and unable
to work; he, in fact, died that September,
upon which Isabella and Cardinal Sigismondo
Gonzaga staked out claims to pictures in his
workshop (Brown, 1974, p. 103 doc. IV).
From a letter addressed to the Marchesa by
Mantegna's son Ludovico, we learn that
among the works left by Mantegna was 'that
work of Scipio Cornelius undertaken for
Mess. Francesco Cornaro' (Kristeller, 1902,
doc. 190). Cardinal Sigismondo acquired the
picture from Ludovico, and was only induced
to restore it to Francesco following the plea

of Cardinal Marco Cornaro to Francesco
Gonzaga and the pressure the Marchese
brought to bear on his brother (see Brown,
1974, p. 103 docs. VIII, X, XI). From other
letters it emerges that Mantegna had prepared
four canvases for the commission but only
completed one (Kristeller, 1902, docs. 196,
198). Giovanni Bellini's picture illustrating
another *Episode from the Life of Publius
Cornelius Scipio* (National Gallery of Art,
Washington) was certainly painted as a
companion and would indicate that following
Mantegna's death the commission was
transferred to his brother-in-law (for the
interpretation of this picture, see especially
Knox, 1978, pp. 82-3). An attempt has been
made to associate two '*bronzi finti*' showing
Tuccia and *Sophonisba* (National Gallery,
London) with the cycle (Longhi, in Suida
1951; Braham, 1973, p. 458; Knox, p. 82),
but this may be discounted: those two
pictures are in a different medium (true
tempera with gold highlights); they are on
panel supports; they simulate bronze rather
than marble; and they are viewed straight on
rather than *di sotto in sù*. Moreover, the
correspondence makes it plain that Mantegna
finished only one work (it is inconceivable
that the *Tuccia* and the *Sophonisba* would not
have been mentioned by Ludovico among
the works left by his father).

Marco Cornaro (or Marco Cornelio, as he
was known), traced his ancestry to the great
Roman Cornelia family and hence claimed as
his forebear the family of the commander
Publius Cornelius Scipio, known from his
victory over Hannibal in Africa as Scipio
Africanus. The commission to Mantegna was
intended to celebrate this illustrious lineage in

133

134

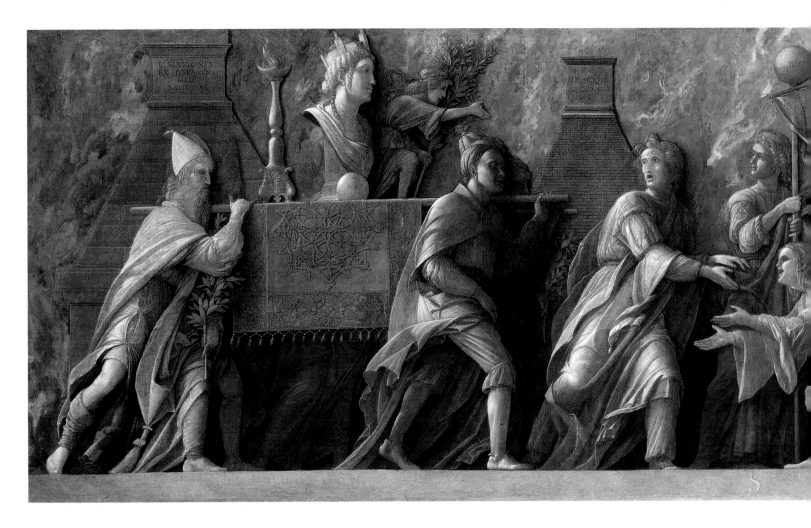

an appropriately *all'antica* fashion by simulating a continuous Roman relief illustrating outstanding deeds of the '*gens Cornelia*'.

The story depicted by Mantegna is told variously, by Livy (XXIX, xiv), Ovid (*Fasti*, IV, 247-348) and Appian (*Roman History*, IX, 56). During the Punic war in 204 BC, the Sibylline Books were consulted. They advised introducing Cybele, the Mother Goddess from Mount Ida, to Rome, where she was to be received by the worthiest man. Scipio Nasica, the cousin of Scipio Africanus, was designated by the Senate for this honour. When, however, the ship bearing the Goddess arrived at Ostia, it ran aground and was only freed when a Roman matron, Claudia Quinta, used a rope, or her girdle, to pull it, thereby incidentally vindicating her chastity, which had been doubted. The next day Scipio Nasica received the Goddess into the city.

To the left, on a litter borne by 'a hoary-headed priest in purple robe' (Ovid, *Fasti*, IV, 339-40) and his acolytes (one a Moor wearing Mantegna's version of a Phrygian cap), is the image of the Mother Goddess, her head

adorned 'with a mural crown, because embattled in excellent positions she sustains cities' (Lucretius, *De rerum natura*, II, 606-7). An incense burner blazes next to her and she is accompanied by an acolyte or devotee. Behind the litter are two tombs identified by their inscriptions as those of Scipio Nasica's father, Gnaeus Scipio, and his uncle, Publius Scipio the Elder, both of whom had died in Spain. In front of her a group of dignified men form a semicircle and point to a kneeling youth who raises his hands towards the Goddess. This is clearly the key figure of the composition, and beneath him is the inscription proclaiming, 'by decree of the Senate, host of the Phrygian Deity' (or conceivably, 'Scipio Cornelio, host of the Phrygian Deity'). To the right, on stairs leading to the Goddess's dwelling, a eunuch or, to judge from his hat, a Phrygian shepherd, beats his drum and blows a flute, in conformity with Ovid's description (*Fasti*, IV, 180-86; 342): 'Let Titan thrice yoke and thrice unyoke his steeds, straightway the Berecyntian (or Phrygian) flute will blow a blast on its bent horn and the festival of the Idaean Mother will have come. Eunuchs will march and thump their hollow drums, and cymbals clashed on

cymbals will give out their tinkling notes: seated on the unmanly necks of her attendants, the goddess herself will be borne with howls through the streets in the city's midst'.

Mantegna's picture is not an illustration of a specific passage or text, but an imaginary scene intended to honour the Cornaro family. This doubtless accounts for his use of inscriptions to clarify the subject and, in all likelihood, to identify the protagonist (Bellini's canvas also employs an inscription to clarify the meaning). It has, nonetheless, been argued that the kneeling figure who is the focus of the picture is not Scipio Nasica, as the inscription implies, but Claudia Quinta, and that Scipio is possibly not even shown (Davies, pp. 331-3, especially n. 4). It has further been maintained that the subject is intended to honour female chastity rather than Scipio (Braham, 1973, p. 461). To this Lightbown (p. 217) has responded that the genuflecting figure has an Adam's apple and hence must be a man: 'a self-castrated votary of the goddess, who has assumed female dress and become her servant'. It is difficult to understand why Mantegna would have made

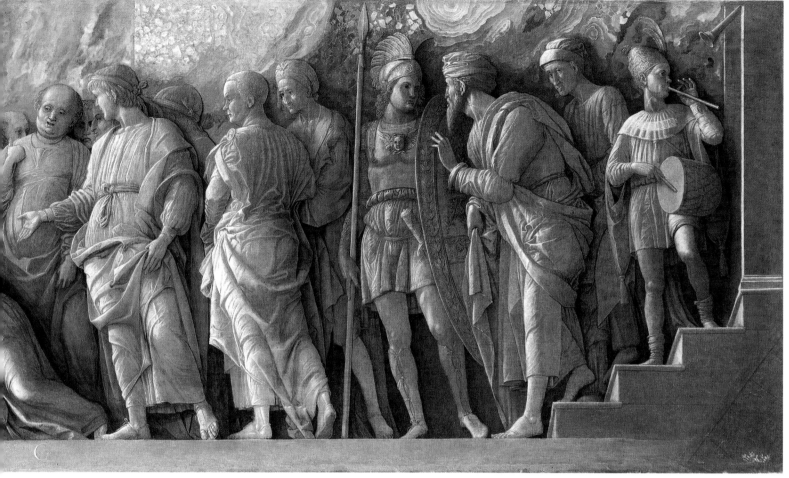

either Claudia Quinta or a eunuch the focus of the composition and why an inscription referring to Scipio Nasica, who Livy states was 'not yet of an age to be quaestor', should appear below it (see Robertson, 1953). Moreover, the costume, hardly archaeologically accurate, differs little from the male figure who directs the litter (identified by Lightbown as a 'young chief priest', and by Knox as Scipio himself). The central figure must be Scipio Nasica, and it is possible that the senatorial figure who indicates him with outstretched hand while turning his head inwards may be Scipio Africanus addressing his fellow consul Licinius Crassus (Knox). In this way, no fewer than four members of the Cornelia family would be honoured.

The dispute between Mantegna and Cornaro over the fee for the series has been interpreted by Lightbown to indicate that Mantegna had not received sufficient instructions on the subject (this plays a part in the complicated reading he then puts forward), whereas it is pretty clear that the aged artist was simply haggling for more money, having realised that the commission involved more work than he had anticipated. Lightbown further suggests that Mantegna 'sketched out all four canvases' and that Bellini may even have worked to Mantegna's design. There is no evidence for either suggestion, both of which seem implausible (see the pertinent remarks in Robertson, 1968, pp. 132-3).

The picture, which has suffered various damages and has been cut at the right (for a detailed report, see Davies, p. 331), is conceived not like one of the small, independent sculptural reliefs, but a frieze viewed *di sotto in sù* against a rich marble veneer. The full effect can only be appreciated if the picture is imagined high up in a small room or study, separated from its companion canvases by classical architectural elements, rather like the original arrangement of the *Triumphs* (cats. 108-15; see also Knox, p. 83). As in that series, Mantegna used the classical theme as an opportunity to display his classical learning. The litter and its attendants derive from a Roman relief (see Lightbown, p. 217), while the bust of Cybele, seen from the opposite side in canvas II of the *Triumphs* (cat. 109), is modelled on an actual piece of sculpture. The figure behind Scipio Nasica seems also to be derived from a Roman statue. Whatever the merits and beauty of Bellini's picture at Washington, it lacks this remarkable assimilation of classical sources and single-minded adaptation of a pictorial vocabulary to a sculptural conceit, which in this instance lies at the root of Mantegna's *'invenzione'*, and we may sympathise with Lorenzo da Pavia's judgement that 'for invention, no one can approach Andrea Mantegna, who in truth is most excellent and the first, but Bellini is excellent in colour' (Brown, 1982, doc. 92).

Like the other grisailles, the picture was not intended to be varnished. When it was cleaned in 1961, a layer of grime was found on the picture surface, indicating that for a long period it had not, in fact, been varnished. It now has a thin layer of synthetic resin for protection. The medium was confirmed by analysis as glue size, or a true *'guazzo'* (I would like to thank Jill Dunkerton for this information).

K.C.

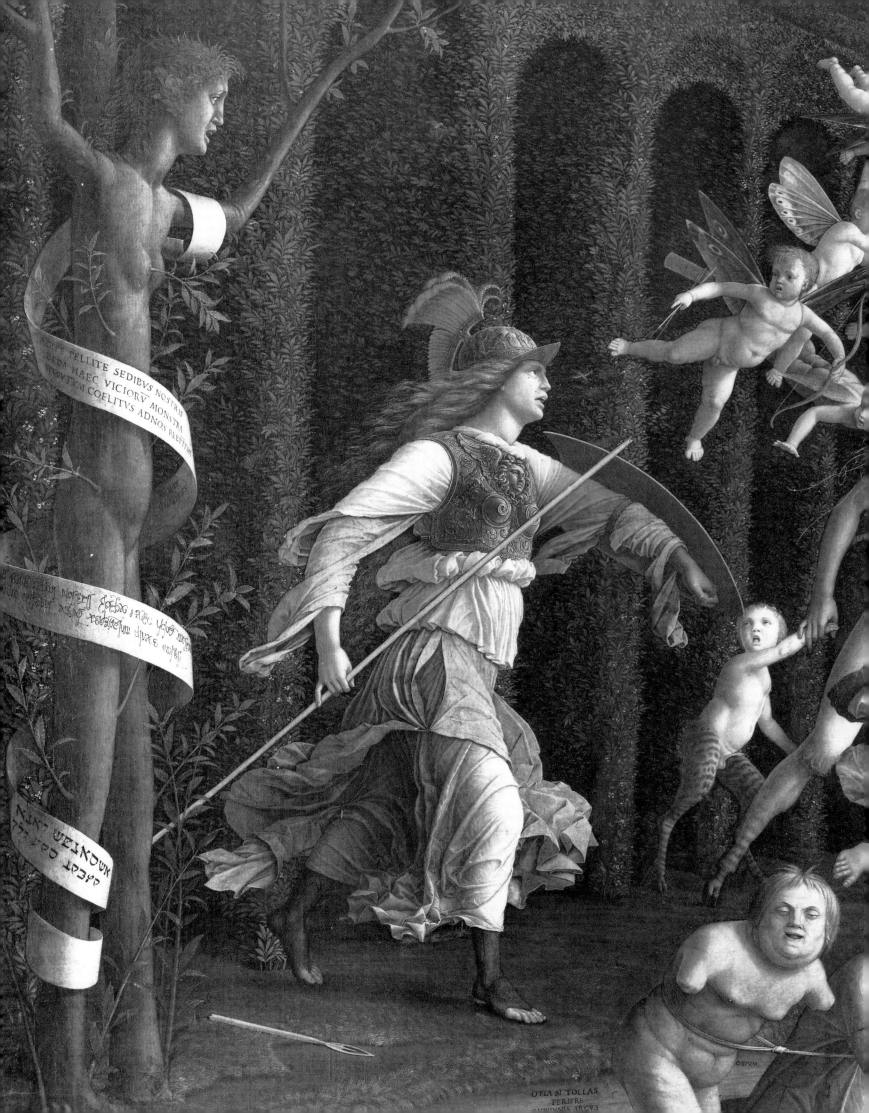

9 THE STUDIOLO OF ISABELLA D'ESTE AND LATE THEMES

In September 1490 Mantegna returned to Mantua after a two-year sojourn in Rome, where he had decorated a private chapel for Pope Innocent VIII in the Villa Belvedere in the Vatican. He found the city unchanged in all but one respect: earlier that year Francesco Gonzaga had taken as his wife the young and talented Isabella d'Este, daughter of Ercole d'Este, Duke of Ferrara, and Eleonora of Aragon. Brought up at one of the outstanding courts of northern Italy and educated by some of the most gifted humanists of the day, Isabella had arrived with a retinue of Ferrarese artists that included Ercole de' Roberti (the trip up the Po made Roberti seasick, and he hastily retreated to Ferrara). This cannot have boded well for Mantegna, who had ruled the artistic scene in Mantua with an iron fist. So preoccupied was he with the new situation that he procured a letter of recommendation from the Marchesa's first tutor, Battista Guarino. Thirty years of service to three generations of Gonzaga rulers had made Mantegna an adept courtier, but the prospect of trying to please the fashion-conscious Isabella, then only sixteen, cannot have been pleasant.

On the surface, Mantegna's life resumed its old rhythm. He took up the *Triumphs of Caesar* (cats. 108-15) with renewed enthusiasm, bringing to the task the additional knowledge he had garnered from his exploration of the ruins of ancient Rome; he moved into the Roman-inspired house he had begun in 1476 (in 1501 he was obliged to exchange it with Francesco Gonzaga for another residence); and he continued to receive outstanding commissions, such as that for the votive altarpiece of the *Madonna della Vittoria* (Louvre, Paris) and another for the high altarpiece of the church of

Santa Maria in Organo, Verona. Nor did his work go unrecognised. In February 1492 Francesco Gonzaga issued a decree granting Mantegna a plot of land as a reward for 'the admirable works he formerly painted in the chapel and *camera* of our castello and the triumph of Julius Caesar he is now painting for us with figures that seem almost alive and breathing ... '.[1] Yet, despite these outstanding commissions and the praise that continued to flow from all sides, it was the winning of Isabella's favour that seems to have preoccupied him.

Upon her arrival in Mantua, Isabella was given apartments in the south-east tower of the Castello di San Giorgio, near the Camera Picta, with a view similar to that depicted in Mantegna's *Death of the Virgin* (cat. 17). She had barely moved in when she set about creating a private retreat, or Studiolo, to which she might retire with her most intimate friends and in which she might house the objects she collected with an enthusiasm bordering on obsession. It was for this modest-sized room (*c.* 5.28 x 2.72 x 5 metres high) that Mantegna eventually painted two, small-scale, *all'antica* feigned bronze reliefs ('*bronzi finti*': see cats. 133-4), the so-called *Parnassus* (fig. 107; Louvre, Paris) and *Pallas Expelling the Vices from the Garden of Virtue* (cat. 136). What set these works apart from Mantegna's earlier production was not only the intimate scale of the room they decorated (the chapel Mantegna designed for Ludovico Gonzaga had also been small: see cat. 17), but their mythological and allegorical subject-matter conceived by Isabella's humanist advisers, and the emphasis on an elegant, almost precious execution consonant with the Marchesa's exacting tastes. Just as

fig. 106 Andrea Mantegna, *Pallas Expelling the Vices from the Garden of Virtue*, cat. 136, detail

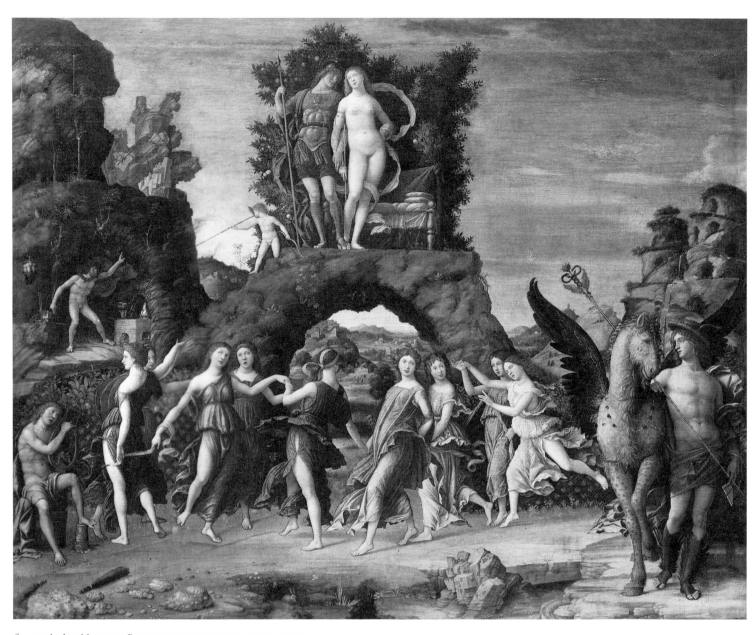

fig. 107 Andrea Mantegna, *Parnassus*, tempera on canvas, 150 x 192 cm,
c. 1497, Musée du Louvre, Paris

important was the fact that, for the first time, Mantegna was openly competing for favour with other celebrated artists: Giovanni Bellini, Perugino, Lorenzo Costa and Francesco Francia. His involvement with the Studiolo occupied him on and off until his death, and the project determined the late, almost neo-Attic, style of his final pictures. Although a reconstruction of the Studiolo is beyond the scope of this catalogue, an outline of its complicated building history and Isabella's negotiations with various artists is necessary in order to understand her intentions and the nature of the pictures Mantegna painted.

To speak of the Studiolo and the Grotta as though they were well-defined projects would be incorrect.

The construction and decoration of the rooms occupied Isabella for thirty years, when her apartments and the contents of the Studiolo were relocated in the Corte Vecchia of the Ducal Palace. The appearance of the rooms in the Corte Vecchia can be reconstructed on the basis of a detailed inventory drawn up in 1542.[2] By contrast, the arrangement of the Studiolo in the Castello remains conjectural.[3]

The first notice dates from July 1491, when colours were ordered for the decoration of the Studiolo by the Mantuan painter Luca Liombeni (the adoptive father of Lorenzo Leonbruno, who was later involved with reinstalling the Studiolo in the Corte Vecchia). Liombeni was to decorate the interior of some cabinets and paint a decorative frieze with motifs relating to the famous Gonzaga horses.[4] In November, Isabella, who was staying with her parents in Ferrara, threatened to throw Liombeni into the dungeon if work was not complete when she returned. The following March, 1492, Mantegna made his bid for work on the project, letting it be known through Isabella's secretary, Silvestro Calandra, that he hoped that when the Studiolo was completed it would not lack something by him.[5] The offer seems to have had no immediate issue, though in January 1493 Isabella commissioned a portrait from him – an inauspicious beginning, since it was rejected in favour of one by Raphael's father, Giovanni Santi (see p. 326, above).

Projects of this sort were frequently drawn-out affairs, and in this case Isabella's youth, her desire to keep abreast of the latest fashions and to outshine her contemporaries – whether in dress or patronage – and a lack of ready funds, conspired to keep matters in a state of perpetual flux. The Marchesa's shifting plans were inevitably affected by the things she saw during the visits she paid to her relatives. It was, for example, during her first trip to Milan in 1491 to visit her sister, Beatrice d'Este, Duchess of Milan, that she admired the work of the sculptor Giancristoforo Romano, but only years later did

she succeed in employing him on the Studiolo.[6] Her stay with her sister-in-law, Elisabetta Gonzaga, Duchess of Urbino, at the Montefeltro palaces at Urbino and Gubbio, with their unsurpassed Studioli, in March 1494, made an indelible impression and led to the replacement of the rat-infested wooden floor of her own study with ceramic tiles from Pesaro.[7] Although the Studiolo was certainly functional within a short time – in January 1493, for example, Isabella wrote to Elisabetta that she passed her time alone in her Studiolo bemoaning the lack of company[8] – it only became a showplace after 1497, and even then Isabella continued to introduce improvements and changes.

A major new initiative followed a visit to Ferrara in May 1495, when Isabella had an opportunity to inspect the newly completed apartments of her mother.[9] Plans of Isabella's own Studiolo were sent to her, and the following year marble was purchased for a doorframe and window moulding[10] and Bernardino da Padua (i.e. Parenzano, or Parentino) was brought to Mantua 'to paint our said Studiolo'.[11] It was at this juncture that Mantegna's services were enlisted.[12] Later that year Isabella was also in touch with Giovanni Bellini on what proved to be an abortive attempt to secure a painting for the Studiolo.[13] By this date Mantegna must have been well advanced on his canvas for, during a visit to Mantua in December 1496, the instrument maker and, later, agent for Isabella, Lorenzo da Pavia, agreed to purchase varnish for it in Venice. He sent this in two shipments in June and July 1497, and the picture was installed later that month, when Alberto da Bologna informed his mistress, then in Ferrara, that nothing was lacking in the Studiolo.[14] A poem written by the physician and humanist Battista Fiera identifies the picture unequivocally as the *Parnassus*.[15]

It is evident from the documents that the *Parnassus* was displayed in the Studiolo for five years without a companion. From the outset the picture must have been viewed both as the first of a potential series of pictures

and as a work that could – and did – stand alone. This helps explain its very different character when compared to the pictures later commissioned as companions, for far from being a programmatic illustration of a philosophical conceit, it utilises familiar mythological themes – the illicit love of Mars and Venus, from whose union Cupid was born, and the dance of the Muses in their grove on Mount Helicon, with its waterfall fed by the Hippocrene that burst forth when Pegasus struck the ground with his hoof[16] – to allude to the harmony of mind and spirit necessary for the arts cultivated by Isabella, whom one contemporary described as being 'completely dedicated to the Muses'.[17] To judge from Fiera's poem, probably written in 1498 or 1499, at least some contemporaries actually saw in the picture a veiled depiction of Isabella (Venus), Francesco Gonzaga (Mars) and the flourishing of the arts (Apollo and the Muses) under their reign – a biographical reading that apparently offended Isabella and which Fiera hastened to correct.[18] The Studiolo of Isabella's uncle Lionello d'Este had been decorated with a cycle of muses, and a *'tempietto delle Muse'* in the palace of her sister-in-law at Urbino was being decorated by Giovanni Santi and Timoteo Viti, so we should not be surprised that these personifications of the liberal arts also figure prominently in her first picture. Nor should we be disturbed by the light-hearted, even jocular tone struck by the introduction of the figure of Vulcan (the legitimate husband of Venus), whose genitals are the target of a bean-shooting Cupid. The work was, after all, destined for the private retreat of Isabella, where she read, played the lute specially fashioned for her voice by Lorenzo da Pavia,[19] and examined at leisure her collection of works of art. When it was moved to the Corte Vecchia, the picture hung opposite the *Pallas* – as was also the case in the Castello – and had as a pendant an *Allegory of Isabella d'Este* by Lorenzo Costa (Louvre, Paris), in which a figure obviously intended to be identified with Isabella enters a garden enclosure to be crowned by Cupid with a wreath of myrtle,[20] the plant

sacred to Venus. That some of the motifs of the *Parnassus* – most conspicuously the string of dancing Muses and the Mercury in his feathered boots – should derive from drawings Ciriaco d'Ancona made during his travels to Greece and the Peloponnese half a century earlier, is in keeping with the learned tastes of Isabella and the humanist contacts Mantegna had forged in his youth.[21]

There is strong internal evidence that the picture retained a special meaning for the Marchesa even after it became part of a larger series, for whereas the *Pallas Expelling the Vices* has survived more or less in the form in which it left Mantegna's studio, the *Parnassus* underwent an extensive revision in the early 16th century.[22] The artist responsible for repainting large portions of it is likely to have been Lorenzo Leonbruno, who was charged with decorating the rooms adjacent to the Studiolo and the Grotta when Isabella's apartments were moved to the Corte Vecchia in 1519-22. It is a landscape similar to those Leonbruno painted in one of these rooms (the Scalcheria) that fills the background of the *Parnassus*, breaking through the lattice fence that once fully enclosed the Muses' grove, and submerging Mantegna's precisely rendered meadow beneath a sea of green oil paint that laps uncomfortably at the contours of the dancing figures. This artist also repainted the heads of Apollo and several of the Muses, not to camouflage damages, but to soften their features in accordance with 16th-century standards.[23] Even Venus did not escape reworking. However much we might regret this revision or artificial updating of the picture – reminiscent of the metamorphosis of Bellini's *Feast of the Gods* (National Gallery of Art, Washington) at the hands of Dosso Dossi and Titian – it testifies to the importance Isabella d'Este attached to the painting.

In 1497 Alberto da Bologna may have considered the Studiolo complete, but Isabella had more ambitious plans. Apart from the contact established with Bellini in November 1496, she inquired the following April as to whether Perugino was alive and would be willing to

paint a picture.[24] In the event, the matter was not actively pursued until September 1500, and the picture – a *Battle between Chastity and Lasciviousness* (Louvre, Paris) in the guise of Pallas and Diana battling against Venus and Cupid – was only delivered, after many delays, in June 1505.[25] Similarly, it was only in February 1500 that Isabella reopened negotiations with Bellini, first through the art collector and music patron Michele Vianello, then through Lorenzo da Pavia, and lastly through Pietro Bembo – all to no avail.[26] In March 1501 she approached Leonardo da Vinci about the possibility of 'making a painting for our study';[27] this too came to nothing. Between those dates her attention turned to the purchase

of sculpture to complement her collection of engraved gems and cameos,[28] and work on the Studiolo seems to have been confined to hunting down a strip of verdure tapestry in Venice just under 9 metres long and 1.75 metres wide to use as a '*spalliera*' – that is, as covering for the wall above what were probably low cupboards and, conceivably, a bench of some sort.[29]

It was during the new flurry of activity at the turn of the century that Mantegna probably began work on his second canvas, the *Pallas Expelling the Vices*. In April 1500 Isabella refused Mantegna's services to the prior of Santa Maria in Vado, in Ferrara, 'because we have been unable to obtain from him things he began for us some

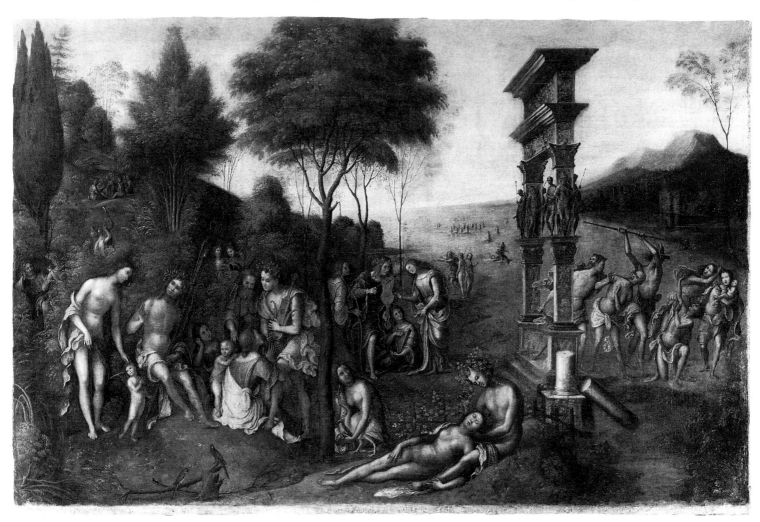

fig. 108 Lorenzo Costa, *Comus*, tempera on canvas, 152.5 x 238.5 cm, *c.* 1506, Musée du Louvre, Paris

time ago'.[30] This may be a reference to the *Pallas* and/or two pictures in simulated bronze ('*bronzi finti*') that were listed in the 1542 inventory of the Studiolo as overdoors (see cat. 133). The *Pallas* was certainly finished in the summer of 1502, when varnish was purchased for it.[31] When he died in 1506, Mantegna was at work on yet another canvas for Isabella, showing Comus, the god of festive mirth, together with two Venuses, one clothed and the other naked.[32] This work, which has as its theme love and music, was eventually supplied instead by Lorenzo Costa (fig. 108), who in 1504-5 had painted the *Allegory of Isabella d'Este*, and who succeeded Mantegna as court painter.[33] Aside from two tentative bids to commission a work from Francia, first in 1505 and again in 1510, no further paintings were commissioned until the relocation of the Studiolo in the Corte Vecchia. Instead, Isabella's efforts were directed to the decoration of the Grotta and to purchasing antiquities.[34] In 1502, for example, she acquired Michelangelo's *Sleeping Cupid* (now lost), followed four years later by an ancient work of the same theme ascribed to Praxiteles for which she had been negotiating since 1498. She established ties with the Mantuan sculptor Antico, who not only advised her on purchases of ancient sculpture but produced a number of bronze statuettes based on ancient prototypes, including two that Isabella set above the door of the Studiolo,[35] and she did not hesitate to press the sick and debt-ridden Mantegna for his beloved ancient Roman bust of Faustina.[36]

It seems fairly clear from this survey that Isabella's plans were subject to constant revision and that there never existed a programme for the decoration of the Studiolo. Rather, her approach seems to have been first to seek outstanding painters (she stated as much in a letter to Francesco Malatesta in 1502[37]) and, once agreement was reached, to ask her adviser(s) to devise a theme, or '*invenzione*', as she termed it. Isabella negotiated to secure Perugino's participation for two years before he agreed, and only then was he sent instructions. Similarly, only

after Lorenzo Costa accepted the invitation to paint a picture for her in 1504, did Isabella turn for the subject to her friend, the Mantuan nobleman and humanist Paride da Ceresara, apologising for bothering him yet again (he had been responsible for the theme of Perugino's picture the preceding year[38]). Even so, further changes were introduced. In February 1504, Perugino was informed that alterations in the Studiolo necessitated modifying the dimensions of the picture he had in hand,[39] and in April 1505, after engaging Francia to paint a picture, Isabella requested that the '*historia*' composed for it be returned for changes.[40] In the event, she dropped the idea of having Francia paint a picture and concentrated renewed efforts on Bellini, who was to be allowed to choose his subject after consulting with Pietro Bembo.[41] Some of this same freedom in exercising his '*fantasia*' was allowed Mantegna in composing the *Comus* he left incomplete at his death.[42] In those pictures that were actually painted, the allusive approach of the *Parnassus*, with its utilisation of well-known mythological stories, was abandoned. Mantegna's *Pallas* initiates a more didactic, illustrative treatment that became the dominant feature of the remaining canvases.

Although there is every reason to doubt that Isabella had a fixed number of canvases in mind and a carefully worked-out programme when she began the decoration of the Studiolo, it is nonetheless clear that each picture commented upon its predecessor(s). Thus, the *Pallas* balances the *Parnassus* by showing what can happen if vigilance is relaxed and the 'garden of the mind', presided over by Prudence, falls prey to laziness, ignorance, jealousy, suspicion and sensual pursuits. Appropriately, the next picture to be commissioned was one from Perugino that Isabella described as depicting 'a battle of Chastity and Lasciviousness, that is Pallas and Diana combating vigorously against Venus and Cupid'.[43] And Mantegna's last commission for the Studiolo, the *Comus*, utilised a number of thematic motifs from his earlier work. Once again there was a garden or grove, this time

closed off by a portal in front of which figures of Janus (the guardian of gates) and Mercury fought back Envy and other vices, while within music was played under the aegis of Comus and the two Venuses.[44] Moreover, following the installation of the *Pallas* in the Corte Vecchia opposite the *Parnassus*, Correggio was commissioned to paint two companion pictures for the abutting wall (both Louvre, Paris). That adjacent to the Pallas shows the protagonist of Mantegna's picture, the goddess Pallas, seated in the hedged garden she has recaptured while a flying Victory crowns her with bay and offers her the palm of victory. At her right is a female figure personifying the virtues of Prudence, Temperance, Justice and Fortitude.[45] A third figure has been thought to show intellectual virtue, Science, or Astrology.[46]

Correggio's picture, painted over two decades after Mantegna's, serves to underscore the unified character of Isabella's (or rather Paride da Ceresara's) thought, also reflected in the subjects of the carved medallions ornamenting the marble door usually ascribed to Giancristoforo Romano (see fig. 105).[47] Yet, it requires only a cursory comparison of Mantegna's picture with those painted by Perugino and Costa to appreciate that its coherence and clarity are an extension of those same qualities of mind possessed in the highest degree by Mantegna. It is in the two paintings for the Studiolo that Mantegna most closely approached the goals of that later devotee of classicism, Nicholas Poussin, who actually painted a series of Bacchanals that were installed with Mantegna's pictures in the château of Richelieu in 1636-7. Like Poussin, Mantegna combined a lifetime's study of ancient art and literature and close friendship with leading scholars and poets with a refined feeling for beauty, derived in large measure from the example of classical sculpture. And as with Poussin, these traits were subservient to a sense of moral purpose that allowed him to express himself in a way that is at once authoritative and alluring.

There was, moreover, a meaningful coincidence between Isabella's '*invenzione*' and Mantegna's feeling that his own genius was not sufficiently appreciated. In Rome, he had become disillusioned with the stinginess of Pope Innocent VIII. Writing to Francesco Gonzaga in January 1489, he declared his belief that 'he who dreads dishonour does not fare well in these days, but the presumptuous and bestial triumph. Wherefore ignorance always opposes virtue' ('*Quoniam virtuti semper adversatur ignorantia*').[48] Two years later he expressed the same feelings, adding to the Latin epithet, 'envy rules in men of little worth, who are enemies of virtue and of good men'.[49] These sentiments obviously shaped the imagery in the *Pallas*, where we find Avarice and Ingratitude – the traits Mantegna ascribed implicitly to the Pope – bearing their ruler, Ignorance, and similar themes are illustrated in two of his most beautiful and highly finished drawings, the *Calumny of Apelles* (cat. 154) and the *Virtus Combusta* (cat. 147). Whether or not the *Calumny* was intended as the cartoon for an engraving cannot be said, but there is little doubt that, beyond the ancient pedigree of the story, recounted by Lucian and recommended to artists by Alberti in the *De Pictura*, Mantegna was obsessed by the application of the theme to his own situation – at least as he saw it.

There is something pathetic in Mantegna's identification of a grotesquely corpulent figure of Ignorance wearing a crown as the source of his problems, which largely stemmed from the ill-tempered character and demonstrable mediocrity of his sons Ludovico and Francesco, as well as financial difficulties. But it is characteristic that he was able to objectify these feelings of intense disappointment in images of consummate beauty. The *Calumny* aspires to the simplicity and angular rhythms of an Attic relief, and it is not impossible that the *Virtus Combusta*, with its frieze-like arrangement of figures on a shallow platform portrayed against a black background, was inspired by red-figure vases of Greek or Etruscan origin (see cat. 147). One wonders how much

the brilliant, sharply modelled hues of the *Parnassus* and the *Pallas*, with their emphasis on elegant silhouettes, owe to Mantegna's knowledge of Roman fresco painting, newly visible to artists in Rome from the 1480s.[50] The great drawing of *Judith* (fig. 109; Uffizi, Florence), which treats in the guise of a Biblical story the theme of Virtue triumphant over bestiality, partakes of these same qualities and serves as a reminder that it was in these years and at least partly in response to Isabella's collecting tastes that Mantegna created his grisailles and '*bronzi finti*' (see pp. 394-9, above). One cannot help feeling that, on the threshold of the High Renaissance, with its emphasis on grandeur of statement and an openly synthetic approach to composition, Mantegna espoused, instead, a self-consciously abstracting style that in many respects prefigures the simplicity of the 'Greek' manner propounded by Jacques-Louis David's *The Sabine Women* (Louvre, Paris) and pursued by the young Ingres.

K.C.

NOTES

1. Kristeller, 1902, doc. 115.
2. See especially the publications of Brown with Lorenzoni, 1977, 1978.
3. This is so despite the studies of Gerola, 1929; Verheyen, 1971; and Liebenwein, 1977, ed. 1988, pp. 81-102.
4. See Brown with Lorenzoni, 1977, p. 170, n. 7.
5. Gerola, 1929, p. 256, n. 2. The notice has been interpreted as evidence that Mantegna had already begun work on his canvases or that Isabella had approached him on the matter: see Gerola, 1929, p. 256; Paris, 1975, pp. 22-3. He was simply pursuing his campaign to reassert the artistic hegemony he had enjoyed in Mantua before Isabella's arrival. Yriarte, 1895-6, XIV, p. 395, misconstrued a payment for pigments in 1493 as having to do with Mantegna's work: see Kristeller, 1902, doc. 121.
6. See Venturi, 1888, pp. 50-54, 58-9, 107-8.
7. See Gerola, 1929, p. 255, n. 3, and Verheyen, 1971, p. 11, n. 21.
8. See Luzio, 1893, p. 62.
9. Liebenwein, 1977, ed. 1988, pp. 81-3.
10. Verheyen, 1971, p. 12, n. 25.
11. What Parenzano did is not certain. However, the attractive suggestion of Billanovich, 1981, pp. 393-6, that he worked not in the Studiolo but in the Grotta, which has a blue painted vault beneath its gilt wooden ceiling, seems not to be correct: see De Nicolò Salmazo, 1987, pp. 55-6.
12. Verheyen, 1971, p. 12.
13. See Brown, 1982, p. 157, doc. 1.
14. For the payments for varnish, see Brown, 1982, docs. 11, 12, 14. For the letter, see Kristeller, 1902, doc. 146.
15. See Jones, 1981.
16. Lehmann, 1973, pp. 139-42; Lightbown, 1986, pp. 194-5.
17. See especially Tátrai, 1972, pp. 5 ff., and Gombrich, 1963. Despite the tightly argued case of Lightbown, 1986, pp. 191-201, I cannot believe that the amorously entwined figures of Mars and Venus before a bed backed with myrtle, Venus' sacred plant, express 'the extinction of sensual lust and the primacy of celestial love'. See, by contrast, the remarks of Förster, 1901, pp. 156-9, and the fascinating analysis of Tátrai, 1972, pp. 235-9, on the amorous nature of the theme. Romano, 1981, p. 37, describes the scene as showing 'the union of Venus and Mars under the sign of celestial Love (or Anteros), [that] generates the harmony of the world, the rhythm of which is revealed by the dance of the muses, the music of Apollo, song, and thus of poetry through music'. It may be significant that Mantegna intended Mars and Venus to be separated from Apollo, the Muses and Mercury and Pegasus by the low hedge of citrus plants. The opening in the hedge is due to an early 16th-century repainting (see n. 22, below).
18. See Battisti, 1965, pp. 42-3, Tátrai, 1972, p. 5, and Jones, 1981.
19. See Brown, 1982, doc. 13.
20. See the readings of Tátrai, 1972, p. 234, and Romano, 1981, p. 38.
21. For these sources see especially Lehmann, 1973, pp. 100-31.
22. Laclotte, 1962, p. 92, first called attention to the fact that the canvas had been heavily reworked.

He suggested Costa as the author of these changes. X-rays and cross sections were published in 1975 (see Delbourgo, Rioux and Martin, 1975). Unfortunately, the evidence of the x-rays was not co-ordinated with the definitive results of the cross sections, which have been overlooked by later authors. A full technical report together with x-rays and infra-red reflectography was kindly made available to me by the conservation staff of the Louvre, whom I would like to thank, particularly Mme Faillant-Dumas, who was most generous with her time and expertise. Mantegna's portions are painted in tempera. There are traces of the original varnish, above which are the repaints in oil.

23. The repainting is particularly conspicuous on the Muse at the extreme left, whose face was originally shown in lost profile, on her companion in red and on the third Muse from the right, where the artist covered Mantegna's face (in three-quarters view, facing left), and redrew it so that the Muse now looks backwards. The underdrawing for this Muse is visible in infra-red reflectography.
24. Brown, 1982, docs. 8, 9.
25. Canuti, 1931, docs. 305-78.
26. See Brown, 1982, pp. 149-54, especially n. 3, and related documents.
27. Venturi, 1888³, p. 45.
28. See Brown with Lorenzoni, 1976, p. 331.
29. Verheyen, 1971, p. 14, thought the fabric was to decorate the wall not covered by Mantegna's paintings, which he presumed, against the evidence of the documents, were two in number at this date (in response, see Brown, 1977, pp. 170-71). Verheyen's reconstruction of the Studiolo is plagued by a wilful reading of the documents, which are frequently imprecise. An analogy for the use of verdure tapestries as a 'spalliera' may be found in Carpaccio's *Arrival of the Ambassadors* (Accademia, Venice), one of the scenes for the St Ursula series. Another picture from that same series, the *Dream of St Ursula*, shows a cloth hung above a low bench and around a small cupboard with inlaid or painted doors. See also Carpaccio's *Birth of the Virgin* (Accademia Carrara, Bergamo) and, indeed, the *St Augustine* (Scuola di San Giorgio, Venice), in which, once again, the cloth is hung below a cornice, and the cupboard is small. It is not unlikely that the cupboards Liombeni was charged to paint were like these rather than the tall, elaborate ones imagined by Verheyen.
30. Kristeller, 1902, p. 567-8, doc. 155.
31. Brown, 1982, docs. 60, 62. For a response to Verheyen's implausible hypothesis that the *Parnassus* and the *Pallas* were both painted by 1498, see Brown with Lorenzoni, 1977, pp. 170-71.
32. Kristeller, 1902, p. 580-81, doc. 180. Verheyen, 1971, pp. 19-20, 46, argued, somewhat speciously, that the *Comus* was not intended for the Studiolo. In view of the fact that Costa later supplied a painting of the same subject for the Studiolo, there really can be no question of the purpose of Mantegna's picture: see Liebenwein, 1977, ed. 1988, pp. 172-3, n. 411. On 13 July 1506 Mantegna reported that he had almost finished drawing the composition (Kristeller, 1902, p. 577, doc. 174, where the date is incorrectly given as 13 January). Two days later Giovanni Calandra went to Mantegna's studio to negotiate the purchase of his ancient bust of

Faustina. He reported back to Isabella that he saw the picture ('la tabula') on which the principal figures were apparently already drawn (Kristeller, 1902, p. 580-81, doc. 180). On the basis of this notice it has been maintained that Costa used Mantegna's canvas and followed his design (see, for example, Kristeller, 1901, pp. 358-60, and Lightbown, 1986 pp. 208-9, 443-4). While a technical examination has demonstrated that, like Mantegna's two paintings, the picture is in tempera rather than oil – the medium Costa employed for his *Allegory of Isabella d'Este* – there is no visible underdrawing, and the x-rays give no indication of two hands (see the report in Delbourgo, *et al.*, 1975, pp. 15-18, 27, 31-2, where the technical information is given a forced interpretation). The differences between the *Allegory* and the *Comus* are attributable to this change in technique, and while it cannot be excluded that Costa reused the canvas on which Mantegna had drawn out his design, there is no basis for believing that the spindly figures and loosely organised composition are due to anyone but Costa.

33. See Brown, 1968, pp. 321-4.
34. See the summary in Perina, 1961, pp. 177-8; Gerola, 1929, pp. 257-8; and the comments of Brown, 1976, pp. 331-2.
35. Carpaccio's *Dream of St Ursula* (Accademia, Venice) offers an analogy for the placement of statuettes above marble doorways.
36. See Brown, 1976, pp. 332 ff. for an overview of these activities.
37. Canuti, 1931, doc. 308.
38. *Ibid*, docs. 312, 316, 346.
39. *Ibid*, doc. 333.
40. Brown, 1967-8, p. 320.
41. Cartwright, 1915, I, pp. 354-8.
42. Kristeller, 1902, p. 577, doc. 174.
43. Canuti, 1931, doc. 316.
44. See Tátrai, 1972, p. 235.
45. See Förster, 1901, p. 179; Wind, 1948, p. 52; and Lightbown, 1986, p. 58. The picture was described in the 1542 inventory as showing 'three Virtues, that is Fortitude, Justice, and Temperance', but the attributes of these personifications as well as of Prudence (a serpent, bridle, sword, and lion's skin) are all borne by the single figure to the right of Pallas.
46. For a summary of views, see Paris, 1975, p. 53.
47. There has been no study of the iconography of these medallions, with four allegorical figures on the face and seven animals in the jambs. These include Minerva or Pallas paired with an owl, a personification of Music paired with a bird, Fame with a peacock, and Poetry with a monkey. The remaining three medallions of the jambs show a stork with a snake in its mouth (a reference to Virgil's *Georgics*?), turtle doves on a cloth with a Greek inscription, and a leopard. Giovanni Agosti has called my attention to the fact that on the stand before the personification of Music is an inscription, barely legible, reading ISAB[ELLA].
48. Kristeller, 1902, p. 545-6, doc. 102.
49. *Ibid*, p. 550, doc. 112.
50. See Dacos, 1969, who points out (p. 58, n. 2) that the descriptions of Mantegna's frescoes in the chapel of Innocent VIII suggest the possible use of grotesque decoration.

136

ANDREA MANTEGNA
*Pallas Expelling the Vices from
the Garden of Virtue*

Tempera on canvas, 160 x 192 cm
(for the inscriptions, see entry)

c. 1499-1502

Musée du Louvre, Département des Peintures, Paris
(inv. 371)

PROVENANCE

1502-39, Isabella d'Este, Marchesa of Mantua, Castello
di San Giorgio and Palazzo Ducale, Mantua; 1539-40,
Federico Gonzaga, 1st Duke of Mantua, Palazzo
Ducale, Mantua; 1540, Margherita Paleologa, Duchess
of Mantua, Palazzo Ducale, Mantua; 1540-1627/29,
The Dukes of Mantua (inv. 1542); 1627/29-42,
Armand-Jean Du Plessis, Cardinal and Duke of
Richelieu, Paris? and the Château de Richelieu,
Poitou; 1642-1715, Armand-Jean de Wignerod Du
Plessis, Duke of Richelieu, Château de Richelieu;
1715-88, Louis-François-Armand de Wignerod Du
Plessis, Duke of Richelieu, Château de Richelieu;
1788-1801, Château de Richelieu; 1801, Musée
Napoléon, Paris

REFERENCES

Gauricus, 1503 (printed 1504), ed. 1969, p. 101;
Toscano, 1587; Crowe and Cavalcaselle, 1871,
ed. 1912, pp. 109-10; Yriarte, 1895-6, XIV, pp. 395-8;
idem, 1901, pp. 229-31; Kristeller, 1901, pp. 356-8,
443; Förster, 1901, pp. 159-63; Cartwright, 1903,
ed. 1915, I, p. 162; Knapp, 1910, pp. XXIII-XXXIII, 173;
Berenson, 1907, p. 255; Luzio, 1908, p. 423; *idem*,
1913, pp. 301-2; Venturi, 1914, pp. 137-9; Gerola,
1929, pp. 256 and *passim*; Berenson, 1932, p. 328;
Fiocco, 1937, pp. 135-6, 209; Seznec, 1953, ed. 1972,
pp. 5-6, 109; Wind, 1948, pp. 17-19; Tietze-Conrat,
1955, pp. 29, 195-6; Paccagnini, in Mantua 1961,
pp. 66-8; Janson, 1961, ed. 1973, pp. 61, 66; Cipriani,
1962, pl. 151; Longhi, 1962, ed. 1978, p. 154;
Camesasca, 1964, pp. 43, 111, 126; Battisti, 1965, p. 44;
Garavaglia, 1967, no. 91; Berenson, 1968, p. 241;
Verheyen, 1971, pp. 10, 14, 30-35, *passim*; Tátrai,
1972, pp. 234, 242-8; Clough, 1973, p. 533; Béguin, in
Paris, 1975, pp. 23, 28, 36-8, 59, 61; *idem*, 1975, pp. 30,
34, n. 11; Hours and Faillant, 1975, p. 8; Delbourgo,
Rioux and Martin, 1975, pp. 22-3; Debout, 1975, pp.
227-9; Brown with Lorenzoni, 1977, pp. 158, 170-71;
Liebenwein, 1977, ed. 1988, pp. 91-5; Romano, 1981,
pp. 30-40, and *passim*; Lightbown, 1986, pp. 186-208,
440-43

The *Pallas* is the second of the two pictures
Mantegna painted for Isabella d'Este's
Studiolo (see pp. 418-25, above). Although
frequently compared unfavourably to the
earlier work, the so-called *Parnassus* (fig. 107),
it is arguably Mantegna's most idiosyncratic
masterpiece, and the one in which he most
fully embraced the 15th-century humanist
view of painting as the exposition of a
philosophical idea. It is first mentioned in
1503 by Pomponius Gauricus, who records
that the engraver Giulio Campagnola had
done prints after 'that brawl of Pallas by our
Mantegna' (see Lightbown, 1986, pp. 427,
442). Giulio Campagnola was in Mantua in
1497, before the picture is likely to have
been commissioned, and his knowledge of
the composition must date from a later trip.
Gauricus's use of the Greek *Pallas* rather than
the Latin *Minerva* to indicate the protagonist
('*Palladiam illam turbam*') certainly reflects the
thinking of Isabella's remarkable adviser
Paride da Ceresara, whose knowledge of
Greek and Hebrew is evident in the
inscription on the banderole at the left of the
picture (the analysis of Lightbown, 1986, pp.
190-91, seems to me definitive on this point;
he also thoroughly discusses the possible
contribution of other figures in Isabella's
circle). Paride is known to have later
furnished Perugino and Lorenzo Costa with
the subjects for their contributions to the
Studiolo, and he probably provided
Mantegna with a working scheme as well.
By the same token, the *Pallas* shares a
number of features with other contemporary
works by Mantegna, and the artist must have
been allowed the same freedom he later had
in designing a third canvas, showing *Comus*
(never completed), to vary the initial idea
according to his '*fantasia*'. Pallas Athene was
the daughter of Zeus and, like him, was
renowned for her prowess in war. She
presided over the moral and intellectual side
of human life. As such, she was a natural
choice for Isabella's Studiolo.

As in the engraving of the *Virtus Combusta*
(cat. 148), the drawing for the *Calumny of
Apelles* (cat. 154) and the grisaille *Introduction
of the Cult of Cybele in Rome* (cat. 135),
inscriptions are employed to identify the
principal figures, and to enable Isabella's
guests to read the picture as a narrative – an

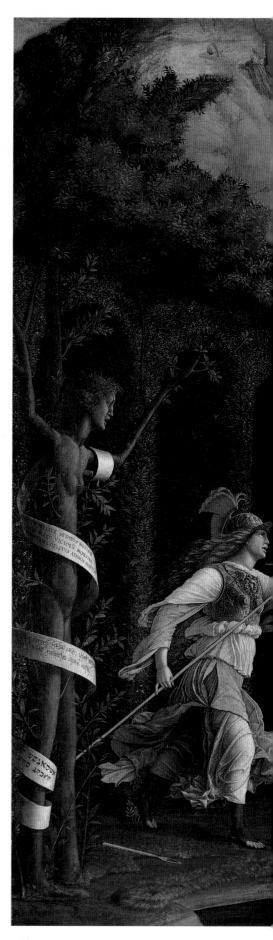

136

Albertian *istoria* – rather than a rebus. (It is on this fundamental point that Verheyen's discussion of the picture goes astray, for he sees no action and no conflict.)

As in the *Parnassus*, the setting is a garden, marked off on two sides by a trained hedge, in front of which is a low lattice fence, here containing rose bushes. The third side is defined by a stone wall, the opening of which has been bricked up. The helmeted figure of Pallas Athene makes its vigorous entrance through the arches in the hedge at the side, holding the shaft of a broken spear in one hand while with the other she raises her shield against a swarm of armed cupids. (Lightbown, 1986, p. 204, has explained that in chivalric terms her broken lance signifies victory, as in the *St George*; cat. 42.) At her advance a host of figures scatter, some fleeing over land while others make their way through the stagnant waters of a swamp or moat. To the left, dominating the picture by her height, appears a figure who has been transformed – Daphne-like – into a bay (*laurus nobilis*) or olive tree (see Förster, 1901, p. 161, and Lightbown, 1986, p. 202, who identify it as an olive, which Isabella considered the sacred tree of Pallas, and, for the identification as a bay, Tátrai, 1972, p. 245, and cat. 114; Mantegna has not been botanically accurate, but the leaves more closely resemble bay than olive). Her branches upraised in supplication, her head turned towards the figures fleeing in disarray, she has around her trunk a scroll lettered in Latin, Greek and Hebrew with the plea, 'Come, divine companions of the Virtues who are returning to us from Heaven, banish these foul monsters of Vices from our seats' *(AGITE PELLITE SEDIBVS NOSTRIS / FOEDA HAEC VICIORV̄ MONSTRA / VIRTVTVM COELITVS ADNOS / REDV̄TIVM / DIVAE COMITES)*. She has the same features as the figure labelled *Virtvs Deserta* in the engraving after Mantegna (cat. 148), and symbolises the desertion of the garden by the four cardinal Virtues, three of whom appear in a mandorla of clouds in the sky: Temperance, who waters down her wine; Justice, with her scales and sword; and Fortitude, who holds a column and club and wears Hercules' lion skin. Her appearance may well be inspired by Alberti's dialogue *Virtus et Mercurius*, in which Virtue complains to Mercury that she would rather

be any tree trunk than a goddess suffering at the hands of Fortune (Janson, p. 61).

The flight of the Vices through the swamp is led, at the far right, by a lean woman with hanging breasts labelled Avarice *(AVARICIA)*. Assisted by Ingratitude *(INGRATITVDO)*, she carries the gross, crowned figure of Ignorance *(INIORANCIA)*, whose features are identical to her counterpart in the print of *Virtus Combusta* (here, again, we see the degree to which Mantegna's '*fantasia*' has shaped the '*invenzione*' he was given). In the background landscape the same figures can be seen taking refuge.

Immediately behind this group is a hideous satyr clasping an infant on his arm (described by Lightbown, 1986, p. 102, as a cupid shorn of his wings), over which is slung a bear skin to underscore his lustful nature; Mantegna evidently felt that his appearance required no explanatory label. Further to the left is shown a monkey-like hermaphrodite, ominously designated as Immortal Hatred, Fraud, and Malice *(IMMORTALE ODIVM / FRAVS ET MALITIAE)*, who has suspended from its shoulders four bags containing the seeds *(SEMINA)* of evil *(MALA)*, worse evil *(PEIORA)*, and worst evil *(PESSIMA)*, an obvious reference to the three traits he personifies. Additional labels ascribe to this sub-human creature the attributes of jealousy (rendered in Greek: see Debout, 1975, pp. 227-9) and suspicion *(SVSPICIO)*. Lagging behind is Idleness *(OTIVM)*, an armless figure unable to work or, indeed, to move without her companion, Sloth *(INERTIA)*, who leads her by a rope. On the bank below Minerva an inscription from Ovid's *Remedia amoris*, 139, admonishes: 'If you banish idleness, you defeat Cupid's bows' *(OTIA SI TOLLAS / PERIERE / CVPIDINIS ARCVS)*. And, indeed, not one of the cupids shoot at Pallas.

In the midst of this grotesque group, distinguished by her calm bearing and manicured beauty, is a female figure standing shamelessly on a centaur, her hair crimped and braided, her green cloak billowing behind her. Renaissance writers distinguished between two Venuses, and this figure has been identified as the goddess of sensual love, the sister of the Celestial Venus, who here personifies Luxuria, or Lust (see Lightbown, 1986, p. 204, who notes her resemblance to a description in the *De calamitate temporum* of

Battista Spagnoli, one of Isabella's favoured Mantuan poets). Luxuria's languorous pose resembles that given to personifications of Fortune or Inconstancy – a fitting contrast to the active resolve of Pallas. The centaur is a common symbol of lust, also alluded to by the family of satyrs that flees Pallas on land. The figure of Venus/Luxuria is preceded by Cupid holding aloft the torches of love, and she is followed by two splendidly attired women, apparently running in pursuit. They bear no definitively identifying attributes and have, in consequence, been thought to show either the goddess Diana (with her bow) and Chastity (with the extinguished torch) assisting Pallas (Förster, 1901, p. 159), or, less convincingly, deceitful nymphs of Venus (Lightbown, 1986, p. 206).

Below the sealed opening in the stone wall flutters a small banderole inscribed with the imploring message, 'And you, O gods, succour me, the Mother of Virtues' *(ET MIHI VIRTVTV̄ MATRI / SVCCVRRITE DIVI)*. Who this immured Mother of Virtues is has been much debated. Förster (1901, pp. 160-61) identified her as Truth, but Lightbown (1986, pp. 202-3) is probably correct in arguing that she is the fourth cardinal virtue, Prudence, who has been imprisoned by the wanton vices under the direction of Venus/Luxuria.

Recondite though the various components of this *istoria* seem (and some elements continue to resist explanation), the thematic thrust is clear, even to a modern viewer uninitiated into the intricacies of Renaissance thought. In the 1542 inventory it was concisely described as 'virtue who puts to rout the vices, among whom is idleness led by sloth and ignorance carried by ingratitude and avarice' (Luzio, 1908, pp. 423-4). Mantegna seems to suggest that even Nature – in the guise of the erupting rocks at the left (a motif he favoured, but which may be included here as a reference to the rock formation behind Vulcan's cave in the *Parnassus*) and a bank of clouds that have the form of men's heads (a conceit Mantegna exploits elsewhere and that may be inspired by ancient writers: see Janson) – conspire to rid the tended garden of those vices that drag down the human spirit. Whether the mountain is intended to evoke Etna and the anger of Vulcan (Tátrai, 1972, p. 238) is uncertain.

It was, perhaps, inevitable that, in comparison to Mantegna's *Pallas*, Isabella would find the companion canvas painted by Perugino, with its small, doll-like figures and feathery trees spaced at regular intervals in a nondescript, vast landscape, 'well designed and coloured' but lacking the 'care' ('*diligentia*') of Mantegna's two paintings, 'which are unsurpassably clear' (Canuti, 1931, doc. 376). And we may also appreciate Lorenzo da Pavia's remark that 'for invention, no one can approach Andrea Mantegna' (Brown, 1982, doc. 92), by which contemporaries would have understood the ability to give visual form to a literary idea. What received little comment in Mantegna's day and continues to be overlooked is the quality of observation that accompanied his high intellect and almost oppressive sense of *virtù* (a combination of rectitude, valour and strength of character):

the still surface of the marsh, dotted with lily pads; the crisply billowed drapery of the female figures; the delicacy of the citrus trees that punctuate the arched hedge; and, perhaps most remarkable, the succession of fields, copses of trees, the river valley and the overlapping hills that make up one of the most suggestive landscape backgrounds in Quattrocento painting. Only in the background of the approximately contemporary picture of the *Man of Sorrows with Two Angels* (cat. 60) did Mantegna surpass the poetic effect he achieved in the *Pallas*, and we can only regret the loss of his background in the companion *Parnassus* (overpainted in the 16th century: see p. 421, above).

According to a technical analysis undertaken in 1975, the picture is painted in tempera (not distemper, as is the case with the grisailles) and was varnished to achieve a vitreous surface that greatly enhances the brilliant colours that Mantegna preferred towards the end of his career (Brown, 1982, docs. 60, 62). Curiously, the *Parnassus*, which is both damaged and repainted, has been reported as though it were in good condition, while the *Minerva*, which is well preserved, has been called 'worn, and affected by many repaints' (Béguin, 1975, pp. 29-30). The figures in the lower right portion of the composition do, indeed, show myriad small losses (particularly in the face of Ignorance), and these also affect the right, proper side of Venus/Luxuria. But the area around Pallas Athene and the satyr family is in excellent condition and gives a true indication of Mantegna's extraordinary '*diligentia*'.

K.C.

137

AFTER ANDREA MANTEGNA
Dancing Muse

Pen and brown wash with white heightening over
black chalk pouncing on brown prepared paper;
the sheet is irregularly cut, wrongly aligned and made
up all round
527 x 261 mm
Inscribed (on an addition at bottom left):
Andrea Mantegna

Staatliche Graphische Sammlung, Munich, (inv. 3066)

PROVENANCE
By 1780 Kürfurst Carl Theodor;

REFERENCES
Selvatico, in Vasari, ed. 1849, V, p. 206; *idem*, in Vasari,
ed. 1878-85, III, p. 433; Morelli, 1883, p. 87; Kristeller,
1901, p. 443; Berenson, 1902, pp. 50, 59-60; Clark,
1930, p. 187; Popham, in London, 1930-31, p, 44, no.
155; Tietze-Conrat, 1955, p. 207; Halm, Wegner and
Degenhart, 1958, pp. 23-4, no. 8; Dreyer, 1979, no. 14
(Berlin *Muse* repr. in colour); Harprath, in Munich
1983, pp. 30-31, no. 20; Lightbown, 1986, pp. 484-5,
no.191

It has long been recognised that this drawing
is connected with the central dancing Muse
in Mantegna's canvas of *Parnassus* (fig. 107;
Louvre, Paris), painted for the Studiolo of
Isabella d'Este, and probably completed in
1497. It is one of a number of sheets
depicting individual figures, or groups of
figures, in paintings by Mantegna, all of
which are in the same technique of brush and
white heightening on prepared paper (see
cats. 18-20, 71). It is very close in appearance
and identical in scale to the corresponding
figure in the painting, as is a drawing of
another of the Muses (Berlin Kupferstich-
kabinett, KdZ 5058; see Dreyer). These two
sheets have tended to share the same
attributional fate, whether positive or
negative; but unlike the Berlin *Muse* and the
other drawings of this type, this *Muse* has
been drawn over traces of pounced black
chalk that are still clearly visible. This means
that it was made after the full-scale drawing
for the picture – the cartoon – had been
pricked for transfer, and that its outline and
other details, such as the modelling of the
drapery, were derived from that very finished
drawing.

This fact suggests two possibilities, neither
of which is without its problems. The first is
that the drawing is what is generally called an
auxiliary cartoon, a repetition of a detail of a
painting made by the artist who wanted to
revise it with particular care at a late stage in
the evolution of the design. The second is
that it is a studio copy, or *simile*, executed
from the cartoon by an assistant, and
presumably intended to be preserved as a
workshop record of the figure. In the
painting the Muse's coiffure is more
elaborate, her mouth is closed, not smilingly
open, and the facial expression is totally
changed (Berenson had the bizarre notion
that it was a portrait of Isabella d'Este).
However, x-rays reveal that the head of this
Muse, and of others, have been repainted,
and that they were originally shown singing.
Initially the Muse looked more like the
drawing, but the plaited hair in the painting is
original and is not present in this drawing.

More significantly, as Harprath has stressed,
it would be odd for a copyist to repeat the
abrupt cropping of the figure's right hand,
which in the canvas is masked by the linked
hand of the adjoining Muse. The point is well
taken, but in the last analysis the fundamental
issue remains whether the quality of the
drawing is worthy of Mantegna.

It might be objected that its degree of finish
makes this a very particular type of drawing,
and that what may seem lifeless and even
pedantic about it is explained by its function.
But neither the damage it has suffered, nor
the accident of its being wrongly aligned to
make the figure more upright in stance, can
conceal its prime weakness, the Muse's head.
This is vacant and lacking in animation, not
only by comparison with the painting,
unreliable as it now is, but also by comparison
with a no less highly finished late drawing
such as the *Mars, Diana and Iris(?)* (cat. 146)
The same dryness is also apparent in the
treatment of the drapery, where the white is
sensitively applied but bears no relation to the
chiaroscuro of the painting.

A print of *Four Dancing Muses* (cat. 138),
which must be based on a lost preparatory
drawing by Mantegna, shows that at an earlier
stage in the conception of the design this
Muse was seen in profile.

D.E.

137

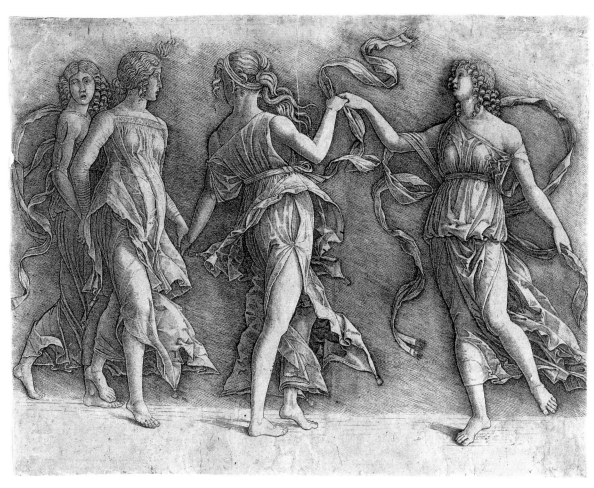

138

138

PREMIER ENGRAVER
Four Dancing Muses

Engraving
248 x 320 mm (sheet; plate 260 x 350 mm, New York)
H.21
Watermark: Cardinal's Hat (no. 3)

c. 1497

Museum of Fine Arts, Boston, Helen and Alice
Colburn Fund (M28357)

REFERENCES
Bartsch, 1811, XIII, 305.18 (Zoan Andrea); Hind, 1948,
V, 27.21; Sheehan, in Washington, 1973, pp. 228-9,
no. 85

The composition seems to reflect a
preliminary drawing for the four central
dancing Muses in Mantegna's *Parnassus*
(fig. 107, Louvre, Paris), the first of

Mantegna's paintings for the Studiolo of
Isabella d'Este to be completed, probably in
1497. The engraving reverses the drawing.
The figures are roughly 40 per cent of their
final size (the Muse with her back to the
viewer is 207 mm high here and about
500 mm in the painting), and in the painting
a fifth figure appears between the two Muses
with their hands held high (to the right in the
engraving; to the left in the painting).
Numerous other differences exist between
this composition and that of the painting,
most importantly the position of the heads of
the Muses respectively second from left and
on the far right in the engraving, drawn in
profile and near profile here but both looking
out towards the viewer in the painting.

From x-rays of the painting it can be seen
that the figure on the right in the engraving
was painted by Mantegna with her head in
the position seen here; it was later repainted

by another hand (see p. 00), more or less full
face, with eyes cast upwards and slightly to
her right. The entire figure of the Muse with
her head in profile was significantly altered,
apparently by Mantegna, between the time of
the study reflected in this print and the
making of the painting: she leans backwards
with her weight thrown onto her hindmost
foot and her head turned towards Pegasus and
Mercury. The dancer at the far left in the
engraving seems, from the x-rays, to have
been originally painted by Mantegna in
approximately three-quarters view; this face,
too, was repainted by someone other than
Mantegna and now also looks towards
Pegasus and Mercury.

The image was engraved on the back of the
same plate as the *Hercules and Antaeus* (cat. 93);
it was copied by Giovanni Antonio da Brescia
(cat. 139).

S.B.

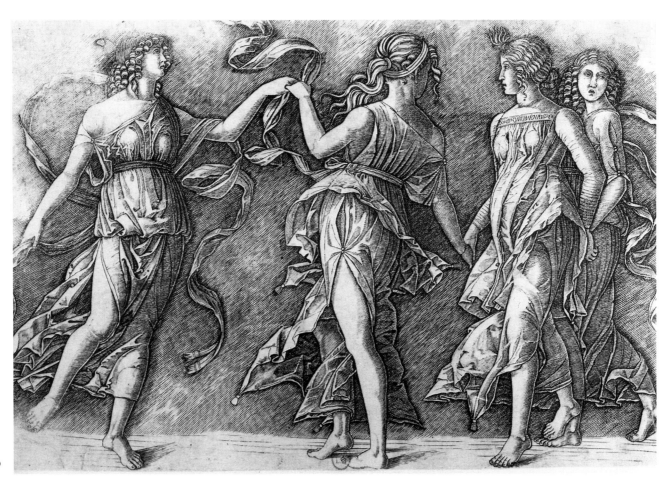

139

139

GIOVANNI ANTONIO DA BRESCIA
Four Dancing Muses

Engraving
210 x 316 mm (plate size possibly 299 x 436 mm;
see text)
H.21a
Watermark: Orb and Cross (no. 22)

c. 1500–05

Cabinet des Estampes, Bibliothèque Nationale, Paris

REFERENCES
Bartsch, 1811, XIII, 328.20 and 305.18, copy;
Hind, 1948, V, 27.21a

Giovanni Antonio da Brescia's copy of
cat. 138. This image may have been engraved
on the other side of the same plate as
Giovanni Antonio's copy of the *Bacchanal
with a Wine Vat* (cat. 77), as that image was
engraved on the plate later used for *Virtus
Combusta* (cat. 148), and traces of the *Dancing
Muses* seem to be discernible under *Virtus
Deserta* (cat. 148) (the two *Virtus* images were
engraved on opposite sides of the same plate).
The early obliteration of these images
accounts for their rarity; only seven im-
pressions of the *Bacchanal* and thirteen of the
Muses are known. It also accounts for there
being no impression of the *Muses* with a full
platemark; for images that were, like this one,

significantly smaller than the plate they were
engraved on we have found no early im-
pressions with the blank paper around the
image preserved. It seems clear there was no
particular value attached to the mark of the
plate; only the image itself commanded
interest.

The *Bacchanal* copy is technically inferior to
this but nonetheless attributable on stylistic
grounds to Giovanni Antonio; obviously, it
preceded this print of the *Muses*. Its
precedence can also be assumed since the
engraved plate is just the size of that image;
presumably, if the *Muses* had been engraved
first, a smaller plate would have been used.

S.B.

140

AFTER ANDREA MANTEGNA
Judith with the Head of Holofernes

Tempera, gold and silver on wood, 30.6 x 19.7 cm;
(painted surface): 30.1 x 18.1 cm
Inscribed (on reverse, in a later hand): *AN: MONTEGN*

After *c.* 1490

National Gallery of Art, Washington, DC,
Widener Collection (inv. 638)
(Exhibited in London only)

PROVENANCE

Before 1624, Charles I (?); until 1630, William Herbert,
3rd Earl of Pembroke; 1630-1917, Pembroke
collection, Wilton House, Wiltshire (cats. 1751, p. 74,
no. 5; 1758, p. 51; 1776, p. 106; 1907, pp. 184 ff.);
sold, Sotheby's, London, 5-10 July 1917; 1917,
Agnew's and Duveen; 1917-21, Carl Hamilton, New
York; 1921-3, Duveen; 1923-42, Joseph E. Widener,
Lynnewood Hall, Elkins Park, Pennsylvania

REFERENCES

Waagen, 1854, III, p. 151; Crowe and Cavalcaselle,
1871, ed. 1912, p. 105, n. 3; Yriarte, 1901, p. 208;
Kristeller, 1901, p. 375, n. 453; Berenson, 1901,
pp. 97-8; *idem*, 1907, p. 255; Venturi, 1914, pp. 242,
247; Schwabe, 1918, pp. 215-16; Berenson, 1932,
p. 328; Fiocco, 1937, pp. 68, 206; Tietze-Conrat, 1955,
p. 201; Cipriani, 1962, pp. 28-9, pl. 108; Camesasca,
1964, pp. 37, 46-7; Garavaglia, 1967, no. 74; Berenson,
1968, p. 242; Fredericksen and Zeri, 1972, p. 646;
Oberhuber, in Washington, 1973, pp. 386-8; Shapley,
1979, pp. 296-7; Lightbown, 1986, p. 435

In addition to references to pictures of Judith
in *chiaroscuro* or feigned bronze by Mantegna
(see cats. 129, 133), there is a notice in the
1492 inventory of Lorenzo de' Medici's
collection of 'a small panel (*tavoletta*) in a box
(*cassetta*) showing Judith with the head of
Holofernes and a servant, the work of Andrea
of Squarcione (*sic*, i.e. Mantegna': see
Lightbown, 1986, pp. 462-3). Whether this is
the same picture listed in a 16th-century
inventory of Don Antonio de' Medici (for
which see Lightbown, 1986, p. 466) cannot
be said. The Washington *Judith* is, in any case,
the only surviving picture of this sort with a
claim to being by Mantegna. An *objet de luxe*,
it is painted on a thin panel (5 mm thick), the
back of which is decorated in simulated
marble, and it once had an engaged frame
(there is a lipped edge to the paint surface on
all sides). The blue robe of Judith is
highlighted in silver, while the bedpost is
enhanced with shell gold.

The picture differs from those at Dublin
and Montreal (cats. 129, 133) not only in its
smaller scale, brilliant colours, miniaturist-like
execution and medium and support, but in
basic elements of its composition and
interpretation of the theme. Foremost among
these is the accentuated *contrapposto* of Judith,
who rests her weight on one leg, bending the
other, and extends her left arm in front of her
body to deposit Holofernes' head in the sack.
A similar pose occurs in three drawings (cat.
143, one in Rotterdam, and in a feeble
drawing in Washington) and in an engraving
by Girolamo Mocetto (see Oberhuber, in
Washington, 1973, no. 148), all of which
depend on a design by Mantegna. In cat. 143
and the engraving the *contrapposto* stance is
articulated with greater understanding – the
opposite rather than the same leg and arm are
advanced – and Judith fixes her gaze on
Holofernes' head rather than averting it in a
curiously detached manner. The pose
obviously derives from an antique marble
statue, the *Venus Felix* (Vatican Museums,
Rome), which Mantegna studied during his
stay in Rome between 1488 and 1490
(Oberhuber). The same statue was the basis of
Antico's bronze statuette of *Venus* (Kunst-
historisches Museum, Vienna; see Leithe-
Jasper, in Washington, Los Angeles and
Chicago, 1986, pp. 72-5).

A scarcely less significant difference
distinguishes the Washington *Judith* from the
painting in Dublin (cat. 129), where Judith is
again shown in front of a tent, and from two
prints (cats. 141, 144). In all of those works
the outer bedpost and the exposed foot of
Holofernes are used to close off the com-
position and suggest a notional centralised
space within the tent and behind Judith. In
the Washington picture, the inner bedpost is
shown and the notional space as well as
Holofernes' body lie outside the picture
surface and beyond the confines of the tent.
This is not the only incomprehen-sible
interpolation. Equally anomalous is the
inexplicably diminutive size of Judith's ser-
vant – who does not have the African features
Mantegna seems generally to have preferred –
and the flatness of the black tent with its
tassels (in the Dublin picture the flatness is a
function of the relief sculpture conceit).

All in all, there is good reason to question
the now widely accepted status of this
superficially attractive but ill-conceived
picture, which was considered by Kristeller
(1901, p. 453) to be the 'feeble work of a late
imitator' but has recently been judged
'certainly an autograph work of *c.* 1490'
(Lightbown, 1986, p. 435). Berenson wavered
in his opinion, at first judging the picture the
work of an imitator (1901, pp. 97-8) and then
(1907, p. 255) listing it as autograph. Tietze-
Conrat (1955, p. 201) rightly called attention
to the fact that miniature copies, both on
vellum and on panel, are known to have been
made after works by Mantegna in the early
16th century. This still seems the best line of
investigation, for the picture is executed with
a miniaturist's feeling for delicacy at the
expense of formal definition. The paint is
applied in minute, parallel brushstrokes,
frequently unresponsive to the forms they
describe. It is difficult to suppress the
suspicion that we have here the work of a
pasticheur, quite possibly a miniaturist such as
Pietro Guindaleri, who worked for the
Gonzagas from 1464 until his death in 1506
and was associated with Mantegna.

Infra-red reflectography reveals no
underdrawing. Presumably the composition,
based on motifs culled from various works of
Mantegna's, was worked up in an elaborate
cartoon that was transferred mechanically.

K.C.

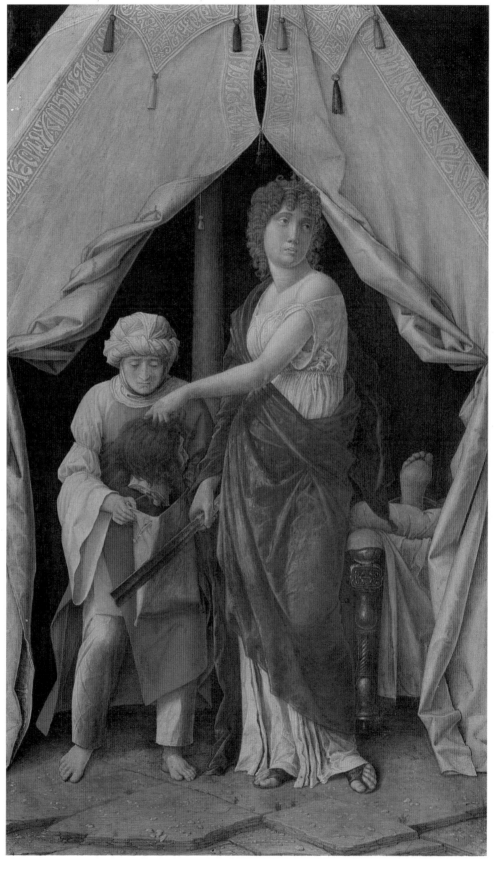

141

PREMIER ENGRAVER
Judith with the Head of Holofernes

Engraving
319 x 261mm (plate)
H.ZA.5a

c. 1497–1500

Graphische Sammlung Albertina, Vienna

REFERENCES
Bartsch, 1811, XIII, 295.1 copy; Zani, 1817-24, II, 4,
p. 55; Passavant, 1864, V, p. 80; Hind, 1948, V, 64.5a;
Popham and Pouncey, 1950, p. 100; Zucker, 1984,
p. 258

The composition of this print is very close to
that of a drawing at Chatsworth (cat. 142);
the two correspond in scale and both seem
ultimately to derive from the same original by
Mantegna. The drawing, probably a copy
after a lost design of Mantegna's, is dated
1472, but the figural proportions in the print
are slightly heavier than in the drawing, and
the composition would seem to have been
made considerably later than that date.

Most cataloguers have assumed that this
print was a copy of the version by Giovanni
Antonio da Brescia (cat. 144), or *vice versa*,
but while the compositions are close, they are
distinct, and it seems more likely that they are
based on different drawings. Bartsch,
Passavant and recently Zucker believed that
this print was the copy. Hind called it
'another version', although still assuming that
one plate was based on the other. Popham
and Pouncey found it 'more probable that
Zoan Andrea's [i.e. Giovanni Antonio's]
engraving is copied from the anonymous
print rather than *vice versa*'. Zani also assumed
that one print was a copy of the other, but
he, too, found this to be the original, and
linked it with those traditionally given to
Mantegna. The stylistic qualities – the vitality
and expressiveness of the faces, and the
versatility and control in, for example, the
complex folds in Judith's drapery – are on a
higher level than those of the print by
Giovanni Antonio and conform with those of
the prints by Mantegna's Premier Engraver.
This is perhaps the latest of his prints after
Mantegna, for it shows not only areas of
parallel strokes going in many different
directions, as in the *Virgin and Child* (cat. 48),

but it also has considerable cross-hatching,
probably reflecting the influence of northern
prints by Schongauer, and especially by
Dürer, which were beginning to be known
in Italy in considerable numbers by the end
of the Quattrocento, as is proved by their
being copied by Italian engravers.

Although no watermark on any impression
of this print has been found, the relatively
close spacing of chain lines, about 22–25 mm
apart on the three impressions examined,
indicates that the paper was made in France.
Thus, this plate must have travelled there,
doubtless along with the seven or eight others
after Mantegna's compositions (see
Appendices I and II). Perhaps because of a
flaw in the plate, discernible at the left margin
of this impression, it apparently was not
printed for long; only nine impressions are
known.

S.B.

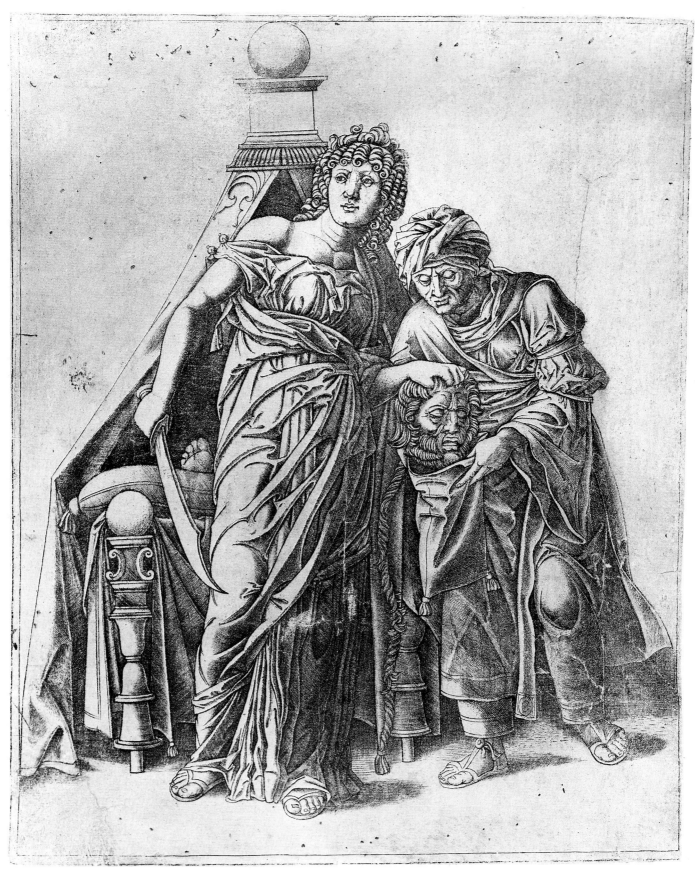

141

438

142

AFTER ANDREA MANTEGNA
Judith with the Head of Holofernes

Pen and brown wash
395 x 278 mm
Inscribed on tent: *ANDR/EAS/MANT/INIA*
MCCCCLXXII.IV

The Duke of Devonshire and the Chatsworth
Settlement Trustees (Case 58. no. 3)

PROVENANCE
N.A. Flinck; 2nd Duke of Devonshire, thence by
descent

REFERENCES
Waagen, 1854, III, p. 356; Kristeller, 1901, p. 375,
no., 458; Hind, 1909-10, p. 386; *idem*, 1948, v,
pp. 63-4, nos. 5, 5a; Popham and Pouncey, 1950,
p. 100; Mezzetti, in Mantua, 1961, p. 183, no. 138;
Lightbown, 1986, p. 493

Although this drawing is inscribed with
Mantegna's name, it is too weak to be an
original from his hand and must rather be a
copy of a lost drawing by him, as Kristeller
recognised. If the signature and date here are
to be believed, then the original, which was
presumably intended to stand as a work of art
in its own right, was executed in 1472. The
subject of Judith and her maidservant with
the severed head of Holofernes was a
favourite of Mantegna's later career, and there
are numerous variations of the theme both by
him and his school. This drawing comes
closest in scale and treatment of the motif to
the engravings here attributed to the Premier
Engraver and Giovanni Antonio da Brescia
(cats. 141. 144) and the small painting in
Washington (cat. 140), although the figure of
the maid is strikingly similar to her
counterpart in the Dublin and Montreal
paintings (cats. 129, 134). Although Hind
thought that this drawing and the print by
Giovanni Antonio (cat.144) were particularly
closely linked, the print by the Premier
Engraver (cat. 141) is even closer. Since the
print by Giovanni Antonio shows Judith
clutching her sword in her left hand as
opposed to the right, which would be more
natural, it must have been based on a design
in the opposite direction, and Popham and
Pouncey argued that this was the print now
attributed to the Premier Engraver.

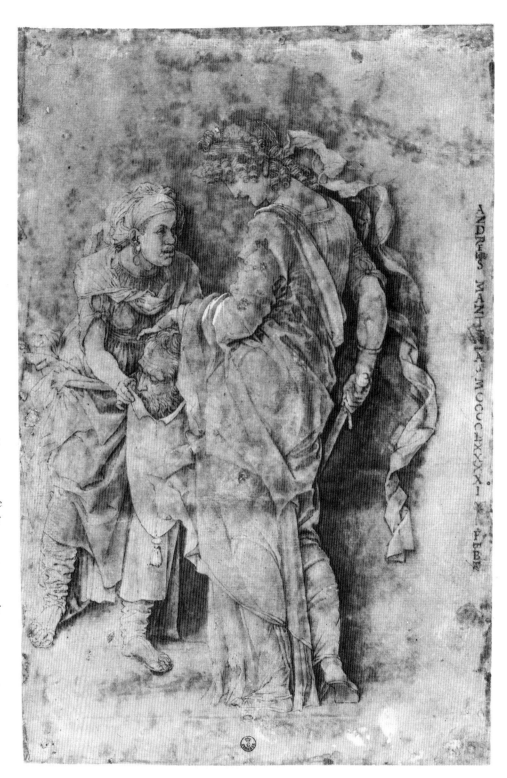

fig. 109 Andrea Mantegna, *Judith with the Head of Holofernes*,
pen, brown wash with some heightening in white on paper,
388 x 258 mm, signed and dated 1491, Gabinetto Disegni e Stampe,
Galleria degli Uffizi, Florence (404E)

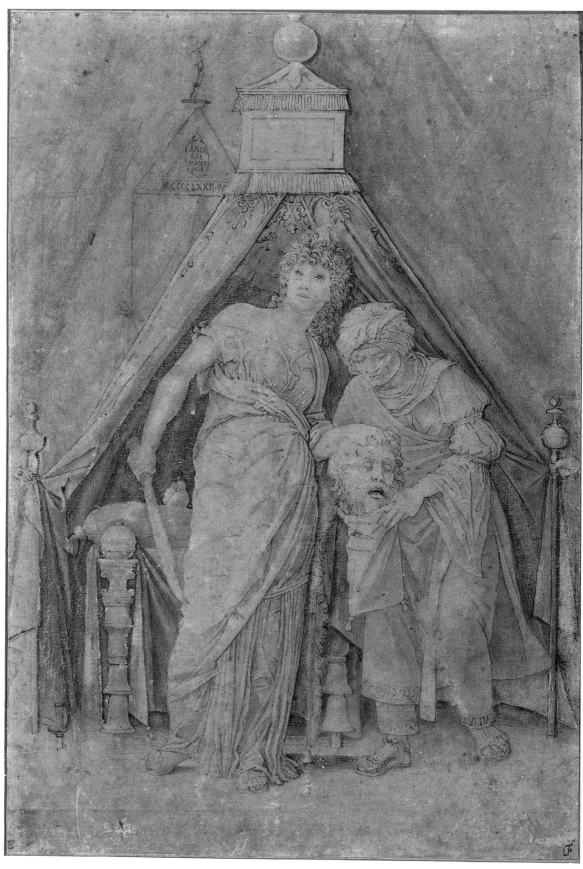

142

Therefore, although Mezzetti thought this drawing was derived from the print by Giovanni Antonio, the obvious conclusion is that it and the two prints depended on a common prototype, or prototypes, by Mantegna, now lost. There are numerous, if minor, differences between all three. These concern the direction and expression of Judith's gaze, the detail of her drapery folds, the particulars of the candelabra-like bedposts and the form and dimensions of the pinnacle of Holofernes' tent. In the drawing both edges of Holofernes' tent are shown, and additional tents are dimly visible in the

washed background, one of them bearing the inscription and date.

When this drawing is compared with the Washington painting, there are many similarities, and it seems unreasonable to doubt that the upward twist of Judith's head in the painting grew out of the same motif in the lost original drawing of which this sheet is a copy. Interestingly, it is only in its placing of the maidservant on Judith's right-hand side that the print by Giovanni Antonio and the painting have more in common. That painting is generally dated to the 1490s or 1500s, but the design of neither drawing nor

painting look that late, especially when compared with the autograph drawing of *Judith* (fig. 109), which is signed and dated 1491. Whether the date of 1472 is accurate for the original design or not – and it may seem surprising in view of the hardness and thinness of line and the extensive use of wash – an earlier dating would allow for the possibility that the Washington panel, or its prototype, is that listed in the Medici inventory of 1492.

D.E.

143

AFTER ANDREA MANTEGNA
Judith with the Head of Holofernes

Pen and brown ink with carmine-red wash
368 x 245 mm
Inscribed (on Judith's sword): *ANDREAS MANTINIA MCCCCLXXXII*

Duke of Devonshire and the Chatsworth Settlement Trustees

PROVENANCE
2nd Duke of Devonshire, thence by descent

REFERENCES
Waagen, 1854, III, p. 356; Kristeller, 1901, p. 375; Popham, in London, 1930-31, p. 43, no. 156; Tietze-Conrat, 1955, p. 208; Washington, 1973, pp. 385-9; Lightbown, 1986, p. 474

This is one of three drawings recording a lost composition of *Judith with the Head of Holofernes* by Mantegna (the other, inferior, variants are in the National Gallery of Art, Washington, no. 289, Kress 325, and in the Boymans–van Beuningen Museum, Rotterdam, inv. I.488). This invention does not appear to have been quite as celebrated as the composition of the autograph sheet dated February 1491 (fig. 109; Uffizi, Florence), but it was well-enough known for Girolamo Mocetto to make a print of it that reverses the design (see Washington, 1973, no. 148).

In this drawing Judith's sword is inscribed with Mantegna's name and the date 1482, (not 1486, as supposed by Kristeller and Lightbown), whereas in the other two versions the sword is blank. This would place the design nearly a decade earlier than the *Judith* in the Uffizi, whereas the related paintings (cats. 129, 133) are generally dated to the 1490s. It follows either that the copyist misread the date, or that the pictures are earlier than has been supposed.

This form of Mantegna's signature is found in late autograph works, such as *The Man of Sorrows Supported by Angels* (cat. 60) and the altarpiece for Santa Maria in Organo, Verona, but a letter of 30 June 1474 is already signed 'Andrea Mantinia'. Of the painted versions of the subject, those in Dublin and Montreal (cats. 129, 133) are particularly close. The figures are shown in reverse in those versions,

with Judith's maidservant behind and to her left, but the similarity of action, and the closeness of the facial types of the two heroines, are striking: the angles of their heads and their wistful and reflective expressions have a great deal in common. The painting at Montreal is closest to this drawing, both in the exclusion of background detail and in showing Judith's sword lowered, rather than raised in triumph as in the Dublin picture.

Of the three drawings of the design, this one is the highest in quality. Popham believed in the Rotterdam drawing, and Berenson (1968, I, p. 242) and Longhi (quoted by Shapley, 1979, p. 300) regarded the Washington sheet as autograph, but Tietze-Conrat was right to see it as a copy after a lost original. Comparison with the superlative *Judith* drawing in the Uffizi supports the notion that all three must be copies of a lost drawing, which was very probably intended as a work of art in its own right – an idea that gains plausibility from the signature on this drawing as well as its use of coloured wash. The other possibility, that this was a highly finished final preparation for a painting in grisaille, is less convincing. The numerous minor differences between this design and the Mocetto engraving suggest that he must have had access to another, perhaps less evolved, variant by Mantegna.

D.E.

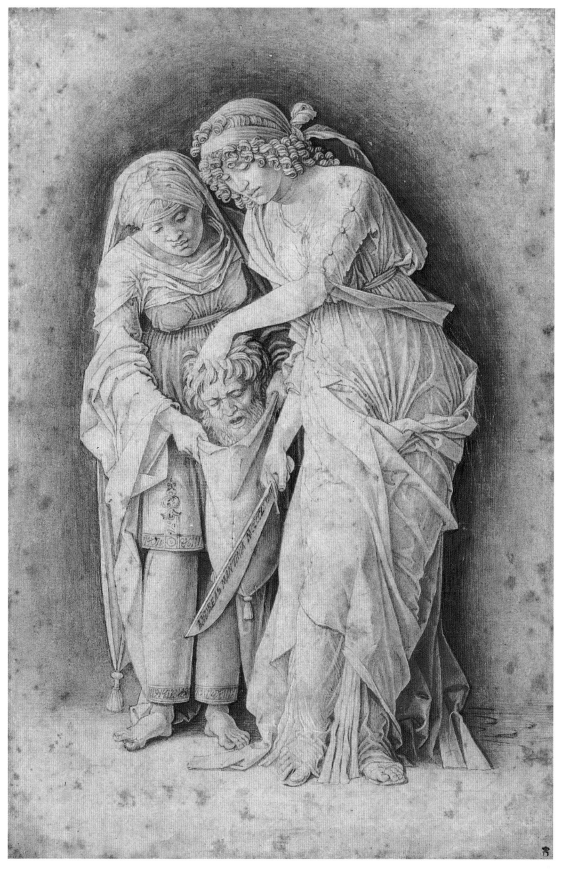

143

144

GIOVANNI ANTONIO DA BRESCIA
Judith with the Head of Holofernes

Engraving
309 x 220 mm (sheet; plate 317 x 226 mm; see text)
H.ZA.5
Inscribed (at top of tent): *.DIVA./.JVDIT.*
(on bedpost): *.Z.A.*
Watermark: Ox Head with Serpent and Cross (no. 24)

c. 1506-7

Graphische Sammlung Albertina, Vienna

REFERENCES
Bartsch, 1811, XIII, 295.1; Zani, 1817-24, II, 4, p. 55;
Passavant, 1864, V, p. 80; Hind, 1948, V, 63.5; Popham
and Pouncey, 1950, p. 100; Zucker, 1984, p. 258

Although this print and cat. 141 have been discussed as if one might be a copy of the other, they seem to derive from different drawings, even if, as is possible, the drawings were connected with the same project. A review of the pairs of originals and Giovanni Antonio da Brescia's copies after them makes it clear that this pair is not in the same relation as the others. Probably most important is the actual size of the figures: Judith, in cat. 141 and in the drawing of a very similar composition (cat. 142), measures just over 250 mm from toe to headband, whereas in this print the corresponding distance is over 280 mm. All the other copies by Giovanni Antonio are of virtually the same size as the originals.

The question arises as to whether there was an 'original' of this composition by Mantegna's Premier Engraver, now lost; while there is no proof one way or the other, it is a possibility. It seems probable that Giovanni Antonio's prints of *The Elephants* (cat. 117) and the *Hercules and the Nemean Lion* (cat. 97) were based on prints that are no longer extant.

The inscription *DIVA JVDIT* is probably best translated as 'Excellent' Judith rather than as 'Divine' or 'Blessed'. It is the first time such an epithet was applied to the Old Testament heroine in a print, although there may be precedents in manuscripts.

This plate provides crucial evidence that proves that the engraver who used the monogram 'ZA' is one and the same as Giovanni Antonio da Brescia (see pp. 56-62). Because of Giovanni Antonio's practice of burnishing off his engraved plates to reuse them for other images, and especially because the burnishing here was incomplete, it was possible to see that this side of this plate was used at least three times. First came the copy, monogrammed ZA, of Dürer's *St Jerome* (Hind, V, 68.20), which presumably postdates 1497, the usual date given for Dürer's print.

Next came the present print, also monogrammed ZA, in which the tail of St Jerome's lion and the previous monogram can still be discerned towards the bottom of the image; this can be dated *c.* 1506-7 because those were apparently the last years in which Giovanni Antonio used the monogram in that form; it can also be assumed that the image, obviously designed by Mantegna, would not bear anyone else's monogram had Mantegna still been alive. Giovanni Antonio reused the plate once again for *Venus* (Hind, V, 41.14), in which Judith's feet can still be perceived, again towards the bottom (see p. 60); this print is monogrammed *IO.AN.BRIXIA?*.

Ten impressions of the *Judith* are known, as opposed to only six for the other two images, and while the difference is not great, it may indicate that the image of *Judith* was on the plate longer than the others. On the other side of the plate, Giovanni Antonio's copy of the larger *Hercules and Antaeus* (cat. 94) may well have been engraved, because the plate dimensions correspond; since, however, it bears his Latinate signature it was presumably made at a later date (see pp. 60-61).

S.B.

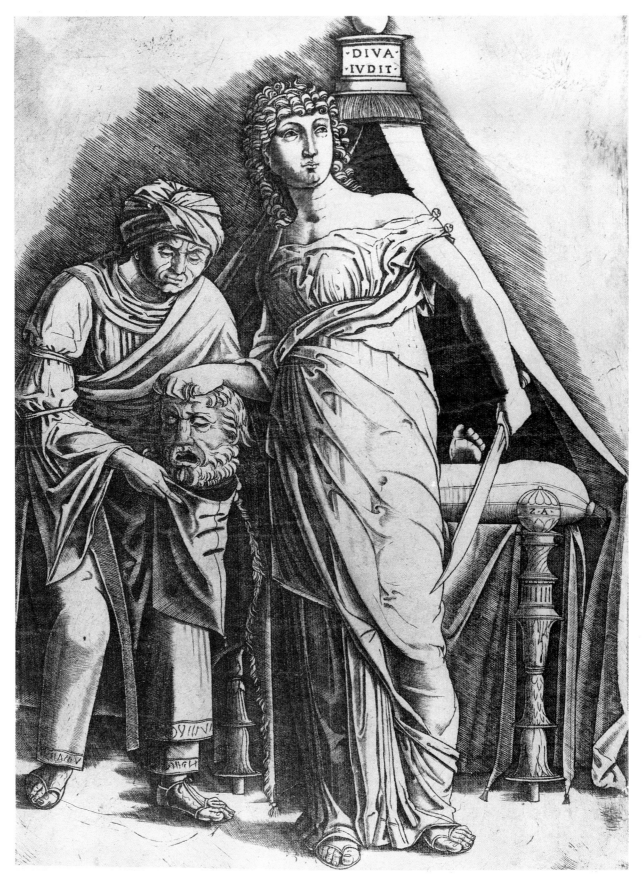

DIVA
IVDIT

145

ANDREA MANTEGNA
Recto: *A Trajanic Frieze*

Black chalk with brown ink and some blacker ink
189 x 273 mm
Inscribed in pencil at bottom left: *139* and in pencil at
bottom left and centre: *andrea mantegna*. Collector's
mark of Sir Peter Lely at bottom right

Verso: *A Reclining Woman*

Black chalk with some brown ink and wash
Inscribed in brown ink below figure: *aroma; andrea
mantegna 10.3*; at bottom right: *R.20/41(?) 2*

1488-90

Graphische Sammlung Albertina, Vienna (inv. 2583)

PROVENANCE
Sir Peter Lely (L. 2092)

REFERENCES
Stix and Spitzmüller, 1941, no. 17, p. 5; Oberhuber,
1966, p. 227; Koschatzky, Oberhuber and Knab, 1971,
no. 16, unpaginated; Martindale, 1979, p. 72, n. 3;
Bober and Rubinstein, 1986, p. 191, no. 158, iii;
p. 231, no. 191, p. 231, no. 198

This drawing, given to Jacopo Ripanda in
the old Albertina catalogue, was first
attributed to Mantegna by Oberhuber; an
idea that was accepted by Martindale, and by
Bober and Rubinstein. The *recto* represents a
section of a frieze showing *Trajan's Victorious
Combat against the Dacians* (fig. 110), from a
relief of the 2nd century AD, probably
originally in the Forum of Trajan, but since
the 4th century incorporated into the west
side of the central passage of the Arch of
Constantine in Rome. The *verso*, now very
rubbed, shows a detail from a Graeco-
Roman relief based on a Hellenistic
prototype of a mourning woman whose feet
are being anointed by a female servant (fig.
111; see Florence, 1984[3], no. 8. I am grateful
to Ruth Rubinstein for this photograph,
which will also appear in the revised edition
of Bober and Rubinstein). Since the 17th
century, and possibly earlier, she has been
thought to represent a bride being prepared
for marriage and has been known as the
'Nova Nupta', although this is not the real
subject.

The *recto* was first executed in faint black
chalk, and then gone over again in ink. This
was a common practice and was used by
Jacopo Bellini in his albums, especially the
one in the Louvre. The albums also afford an
explanation of the penwork of this sheet,
because some of their drawings, like this one,
were inked over by more than one hand, and
some were left unfinished. In this case, it has
rightly been argued that most of the penwork
may be given to Mantegna, but that all of the
soldier on the left carrying a standard below
shoulder-level and the shield on the far right,
where the ink is blacker and the line thinner,
were added by another hand. If they are
ignored, then the uniformly high quality of
the rest of the execution, both in chalk and in
pen, is readily apparent.

Mantegna's model is carved out of two
blocks of marble, and almost all of his
drawing concerns the left half. His repetition
is in the main accurate, and consequently
particularly fascinating for its occasional
omissions and emendations. Thus, the
composition is deliberately faded out to the

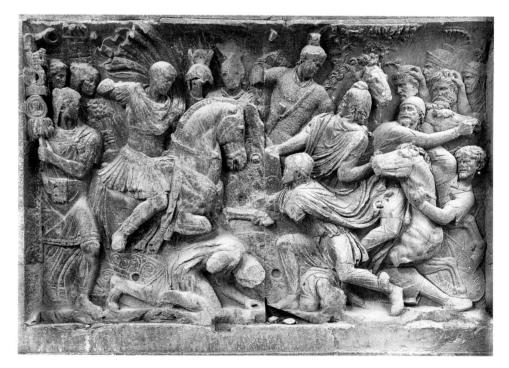

fig. 110 Trajan's Victorious Combat against the Dacians, relief, frieze in four sections,
probably from the Forum of Trajan, 2nd century AD, Arch of Constantine, Rome

145 *recto*

fig. 111 Mythological Scene (the *'Nova Nupta'*), from a marble sarcophagus, 47 x 72 cm,
from Palazzo del Drago Albani alle Quattro Fontane, Rome

right, where the supplicant figure on the
right-hand block of the relief is excluded.
The close-cropped coiffure of the mounted
emperor in the relief is replaced by flowing,
windswept hair, but the drawing's sculptural
derivation is made explicit by the fact that
both the emperor and the helmeted soldier on
the extreme right lack their right hands, and
the emperor's steed lacks most of one leg.
The horse is also less upright, his mane is
flowing free, and shown in a less rigid profile.

The figure on the *verso* appears to be more
closely copied, albeit without her attendant.

The inscription *'aroma'* (*a Roma*) is in a hand
that – on the basis of his numerous extant
autograph letters – appears to be Mantegna's,
and there seems no reason to doubt that both
sides were executed during his years in
Rome, that is to say between the end of 1488
and September 1490. As such, the sheet
becomes a peculiarly important document for
any attempt to reconstruct Mantegna's career
as a draughtsman, being that greatest of
rarities, a closely datable drawing.

Mantegna's taste for introducing shattered
fragments of invented Roman sculpture into

pictures remained a constant for much of his
life, from the Ovetari Chapel, and the *St
Sebastian* in Vienna (fig. 5) to the *St Sebastian*
in the Louvre (fig. 2). This love of antique
sculpture culminated in the grisailles: painted
imitations of sculptural reliefs (cats. 128-35).

Finally, it is interesting to note that pre-
cisely this section of the Trajanic relief was
copied by Mantegna's near-contemporary,
Bernardino Parentino, in a fresco formerly in
Santa Giustina, Padua (now Museo
Malaspina, Pavia).

D.E.

447

145 *verso*

146

ANDREA MANTEGNA
Mars, Diana and Iris (?)

Pen and brown ink and brown wash with some white
heightening; the central figure is shaded with the point
of the brush in crimson; that on the right in blue.
The right arm and bow of the figure on the left are on
a separate sheet of paper, small areas made up near
right edge
364 x 317 mm

1490s

The Trustees of the British Museum, London
(1861-8-10-2)

PROVENANCE
'The late Mr Strange'; C. M. Metz; sold, T. Philipe,
6 May 1801, lot 91; J. Heywood Hawkins; Colnaghi

REFERENCES
Milanesi, in Vasari, ed. 1878-85, III, p. 434; Morelli,
1883, p. 87, no. 1; *idem*, 1892-3, II, p. 177; Kristeller,
1901, pp. 374, 444; Berenson, 1902, pp. 50, 60;
Popham and Pouncey, 1950, pp. 94-5, no. 156; Tietze-
Conrat, 1955, p. 206; Clark, 1960, p. 374; Elam, in
London, 1981, p. 171, no. 124; Lightbown, 1986,
p. 486, no. 194

The attribution of this drawing to Mantegna
in the later part of his career has not seriously
been questioned. Popham and Pouncey
adduced iconographic and formal
connections with works of the 1490s: they
pointed out that the paintings for Isabella
d'Este's Studiolo, notably Mantegna's
Parnassus (fig.107) of 1497, share similar
mythological subject-matter, and compared
the two goddesses with the figures of Venus
and the leftmost Muse in that painting.
Other parallels might be drawn between the
motif of a torch being extinguished and
Perugino's *Battle of Love and Chastity* for the
Studiolo, the rocks on which the central
figure sits and those in the *Virgin of the
Stonecutters* (fig. 3), and – most telling of all –
between the pose of the goddess on the left
and the figure of St John the Baptist in the
late painting signed by Mantegna, the *Virgin
and Child with SS. John the Baptist and the
Magdalene* (National Gallery, London). All
these factors suggest a date in the 1490s, as
indeed does comparison with the signed and
dated drawing of *Judith* (fig. 109) of 1491.

The identities of the three figures are not
easy to establish. The central man, who is
repeated in a painting by Lorenzo Leonbruno
(see Meiss, 1976, fig. 242; Garavaglia, 1967,
no. 110), is shown holding a spear in his right
hand and a sceptre in his left, with a shield, a
dagger and a helmet at his feet. Although his
characterisation is utterly different from that
of his counterpart in the *Parnassus*, he is
almost certainly Mars. To his right is a female
figure, who holds a bow in her right hand,
and a burning torch, flame downwards, in
her left. The bow and the quiver slung over
her shoulder, not to mention the torch being
extinguished, support her identification as
Diana, goddess of the hunt and of chastity.
Mantegna cut a section from the left-hand
side of the sheet, including Diana's bow and
right arm and replaced it with another piece
of paper, which he then drew on. The third
figure is the hardest to identify: in such
company, it is tempting to assume that she
must be Venus, but no attribute supports this
presumption. Rather, if the curving form
behind her, which she appears to be holding
in her left hand, is a rainbow, then she must
be Iris, although – as Popham and Pouncey
pointed out – one might expect her to be
winged. Clark noted the undeniable
resemblance between this figure and one of
the Graces in Botticelli's *Primavera* (Uffizi,
Florence). If Mantegna stopped at Florence
on his way to or from Rome in 1488 or
1490, he might have seen the picture, or a
drawing for it. In fact Iris's pose – especially
with regard to the legs – is also close to that
of the figure of Judith in the drawing of 1491
and to one of the men in the *Introduction of the
Cult of Cybele* (cat. 135). Although Elam
tentatively suggested that a moral choice, like
that of Hercules at the Crossroads, may be
represented, no narrative connection between
the trio need be sought in a work of this
kind: rather its figures share the iconic
isolation of its formal model, namely the type
of altarpiece which shows the seated Virgin
between two standing saints. Indeed, the
altarpiece in the National Gallery serves as a
particularly close compositional parallel, the
major difference being that whereas there the
Virgin's lower height, which ill accords with
her greater status, is compensated for by her
canopy, here Mars is physically larger than

the goddesses, as a comparison of the size of
his head with theirs demonstrates.

There remains the question of the purpose
of such a drawing. It has been argued that
Mantegna's elaborately signed and dated
Judith drawings, known through copies, on
one of which (cat. 143) a single colour wash
was added, were conceived and understood as
works of art in their own right. Although
they may have been connected with projects
for paintings, or may indeed subsequently
have been engraved, it is hard to believe that
they were made as intermediate stages in the
evolution of a design. A sheet such as this,
especially in its employment of coloured
washes (here red, white and blue, and
therefore conceivably an illusion to the
Gonzaga heraldic colours), together with its
meticulous finish, appears to represent an
early and remarkably successful example of a
drawing conceived as a finished composition
in its own right. It is impossible to say
whether Mantegna executed such drawings
for the Gonzaga family to keep or give as
presents, or – as was the case at a later date
with the so-called Presentation Drawings of
Leonardo and Michelangelo – whether they
were created as private gifts for personal
friends. They may even, less probably, have
been designed for his own delight. Certainly
the care lavished upon them is not in doubt,
and paradoxically – as in the case of the
drawing of the *Risen Christ* (cat. 44) – the
cutting out and replacement of part of the
sheet only emphasises its finality. In both cases
Mantegna preferred to mutilate and patch up
his original drawing, rather than start all over
again.

D.E.

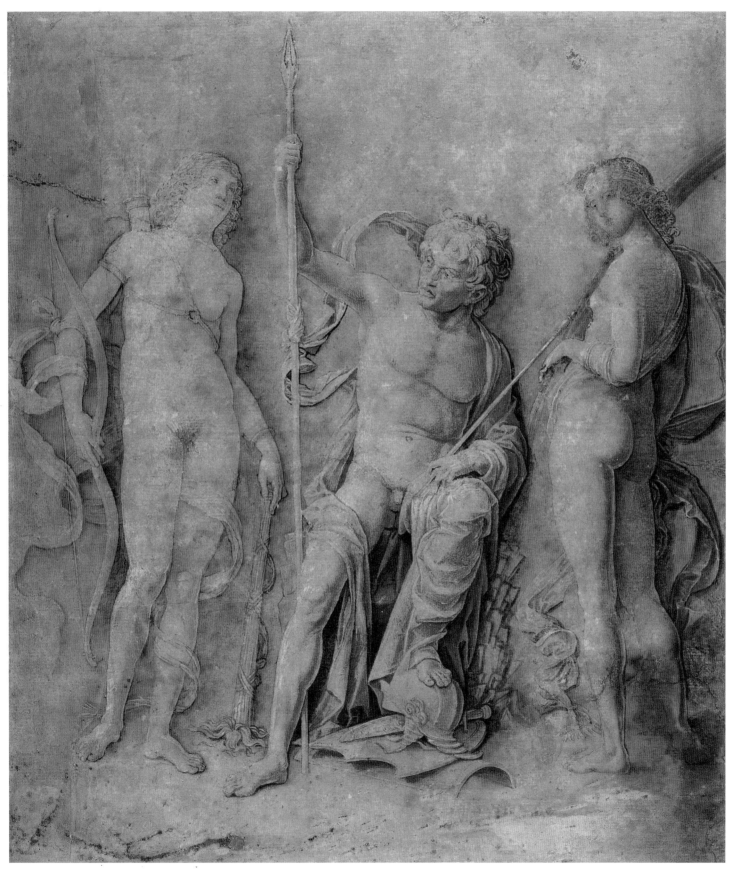

147

ANDREA MANTEGNA
Allegory of the Fall of Ignorant
Humanity (Virtus Combusta)

Pen and ink and point of the brush on a brown
ground, heightened with white, the background black
over red. The blind woman and one of the sphinxes
are shaded with red; the fire on the right and the scarf
descending from the head of the blindfolded woman
also in red. Some white has oxidised and some appears
to be either a correction or a later addition. Pale blue-
grey wash under the rudder
287 x 443 mm (including a strip about 13 mm wide
added, or reattached, to the lower edge,
Inscribed: *VIRTVS COMBVSTA; AM*

c. 1490-1506

The Trustees of the British Museum, London
(inv. Pp. 1-23)
(Exhibited in London only)

PROVENANCE
Casa Giovanelli, Venice; purchased by John Strange;
sold, 19 March 1800; C. M. Metz; sold, T. Philipe,
6 May 1801, lot 92; 1824, Payne Knight bequest

REFERENCES
Waagen, 1854, I, p. 227; Selvatico, in Vasari, ed. 1849,
V, pp. 296-7; *idem*, in Vasari, ed. 1878-85, III,
pp. 433-4; Förster, 1901, p. 85; Berenson, 1902, pp. 50,
60-61; Popham and Pouncey, 1950, pp. 95-7, no. 157;
Tietze-Conrat, 1955, pp. 205-6; Massing, in London,
1981, p. 172, no. 125; Massing, 1990², pp. 177-84

This composition, which forms the upper half
of an engraving here attributed to Giovanni
Antonio da Brescia (cat. 148), is inscribed in
the bottom right-hand corner, both here and
in the print, with the words '*VIRTUS*
COMBVSTA'. It is one of a group of highly
finished late drawings executed in the 1490s
or 1500s, and associated both in terms of
iconography and figure style with the
paintings executed by Mantegna for the
Studiolo of Isabella d'Este. This drawing is
particularly close, especially in terms of its
recondite subject-matter, to the canvas of
Pallas Expelling the Vices (cat 136). For an
interpretation of the allegory see cat. 148,
below.

Michelangelo Biondo described a lost work
by Mantegna that he saw in the Palace of San
Sebastiano in Mantua as follows:
'On a sheet of paper on canvas he painted
Mercury with Lady Ignorance, and he

appeared to drag her down with a large
number of other ignorant people representing
various sciences and arts ...' (Biondo, 1549,
fol. 18*r*, L). This passage, allowing for a slight
misunderstanding by Biondo, who mistakes
one of the Ignorant for Lady Ignorance
herself, corresponds with the lower half of
the design. Massing, who discussed the
iconography exhaustively and convincingly,
assumed Biondo was describing a painting,
for which this drawing was a preparatory
study. But it is worth underlining the fact that
the support was paper stuck on canvas ('*carta*
... *sopra una tella*'), which suggests a coloured
drawing, for which the verb '*dipinse*' would
be entirely appropriate.

The generally high degree of finish of the
sheet, the fact that the finish is not uniform,
and the use of a red wash as well as the more
common white heightening have all been
used to suggest that cat. 147 is a working
drawing, whether for a grisaille painting or a
print. In the latter case colour might have
been used to heighten the chiaroscuro, and
the sheet might have been left unfinished in
view of the fact that the engraver could
extrapolate the same degree of finish
throughout. However, there are objections to
both these views. First, Mantegna appears to
have produced signed and dated drawings,
such as the *Judith* of 1491 (fig. 109), which
were intended to be thought of as finished
works of art. The other is that in Biondo's
time the lower half of the design, which had
become separated from the upper half (even if
there were always two sheets, they were
designed to be seen together), was regarded as
a work of art in its own right.

However, whatever its original purpose,
the drawing was certainly used by the
printmaker. There are close affinities between
this drawing and the upper half of the
engraving of the *Allegory*. When enlarged
transparencies of the two works are
superimposed, it becomes obvious that each
of the figures was transferred from the
drawing to the print individually, with the
exception of the figures of Ignorance (the fat
woman sitting on the globe) and Ingratitude
(the blindfolded woman to her right), which
were transferred together in one session. This
practice is at slight variance with all the other
instances of transfer from drawing to print in
Mantegna's workshop, where we have found

147

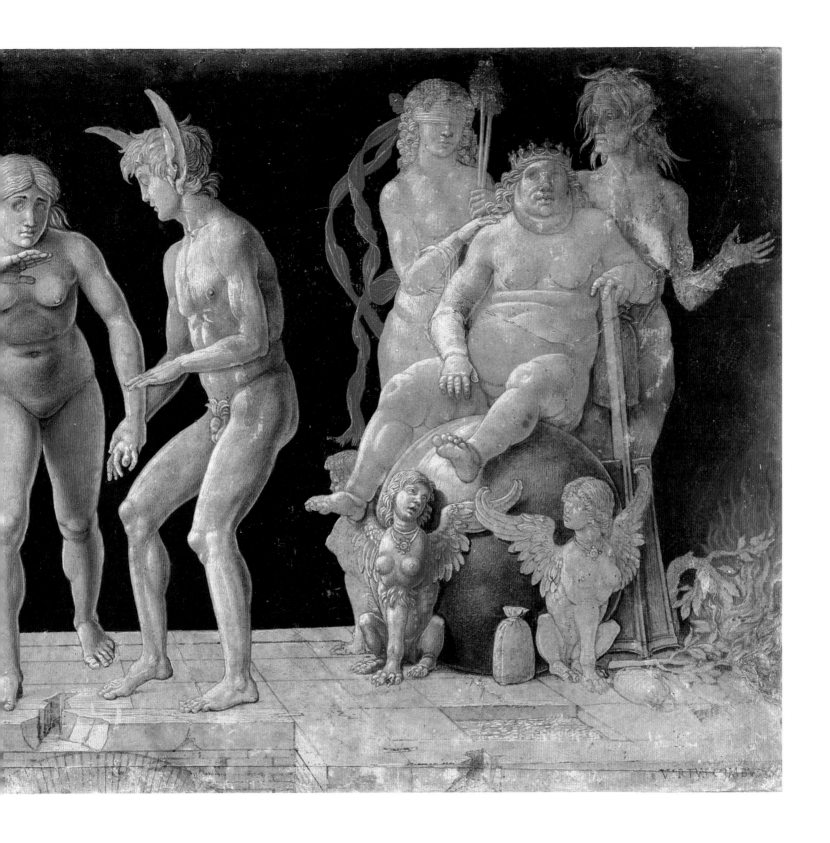

that the composition was broken down into at most four parts (see cats. 45, 67). Moreover, for almost every figure there are some small changes introduced in the print, mostly in the position of a limb in relation to the body, or in the inclination of the head. There are no other instances where so many details are different between drawing and print. A direct comparison between the two works reinforces the results obtained by superimposing the two transparencies. There are a number of differences between the two images, and it appears that all the *pentimenti* in the drawing – such as the break in the stone at the foot of the blind woman – are introduced in the print, while there are a number of further changes in the print which must have been introduced at the time of engraving the plate, since they are not in the drawing. The main change is the fact that all the unfinished parts of the drawing, including the two figures at the extreme left, are completed in the print. The second change is that the engraver has clad the left foot of one of these two figures, probably representing Fraud (with the sack over his head), with a sandal or, as Massing interprets it, with a piece of wood. The position of the knees remains unchanged between the drawing and the print, which might initially suggest a mistake in the drawing. However, the printmaker has,

in fact, not only added the sandal, but also modified the figure's stance. His feet are closer together in the print; the left foot is further forward than in the drawing, as can be verified by comparing their position on the grid of the pavement.

This is an iconographical addition of the type that one would not expect an engraver to make of his own initiative: bearing in mind the number of other changes that occurred between drawing and print, it is tempting to conclude that the engraver was working under the direct supervision of Mantegna when making this print. The implications of such a conclusion are important, as they suggest that Giovanni Antonio was working at some point in Mantua, in Mantegna's workshop, something that most scholars have assumed to be the case, but that cannot be confirmed on the basis of documentary evidence.

A final point in favour of this being an unfinished 'presentation drawing' is the fact that it appears to be coloured in emulation of red-figure vase paintings. This would be an extremely odd coincidence if the work it prepared – whether painting or print – was not to have that effect. It is impossible to prove that Mantegna had seen red-figure vases, although Etruscan ware had certainly been excavated in Italy by this date, and some

Greek red-figure vases may have been too. Ristoro d'Arezzo, in his *Composizione del Mondo* (1282), and Giovanni Villani (d. 1348), in his *Cronaca Fiorentina*, both refer to Etruscan ware (Weiss, 1969, p. 189). Cook writes that 'in general ancient painted pottery escaped the attention of the writers and collectors of the Renaissance' (Cook, 1960, p. 288), but there were exceptions. Vasari records that his grandfather – also called Giorgio – 'looking for vases in a place where he thought the ancients might have worked, found three arches remaining from the ancient kilns, and around them many broken vases of that ware, and four whole ones. These he presented to Lorenzo de' Medici when he visited Arezzo' (Vasari, ed. 1878-85, II, p. 558; III, p. 433). And Zaccaria Barbaro presented a Greek vase to Lorenzo in 1491 (Weiss, 1969, p. 189). Two drawings by Antonio Pollaiuolo (Ettlinger, 1978, nos. 35, 36), with similarly dark backgrounds, may also have been inspired by ancient pottery. It seems likely that Mantegna, the most classically inclined artist of his age, would have come across such ware, and would have studied it with enthusiasm.

D.E. and D.L.

148

GIOVANNI ANTONIO DA BRESCIA
Allegory of the Fall of Ignorant Humanity (Virtus Combusta) and *Allegory of the Rescue of Humanity (Virtus Deserta)*

Engravings, state 1 of 2 (? see text)
299 x 433 mm (platemarks; on two sides of the same plate)
Inscribed: (top half) *VIRTVS COMBVSTA*;
(bottom half) *VIRTVS/DESERTA VIRTV-/-TI/.S.A.I.*
H.22

*c.*1500-05

Josefowitz Collection

REFERENCES
Bartsch, 1811, XIII, 303.16; 304.17 (Zoan Andrea); Förster, 1901, pp. 78-87; Hind, 1948, V, 27.22; Popham and Pouncey, 1950, pp. 95-7, no. 158; Tietze-Conrat, 1955, p. 205-6; Panofsky, 1956, pp. 44-8; Battisti, 1965, p. 35; Levenson and Sheehan, in Washington, 1973, pp. 222-7, cat. 84; Massing, in London, 1981, pp. 171-2, nos. 125, 126; Lightbown, 1986, p. 485-6; Massing, 1990[2], pp. 180-84

Attempts to interpret the allegory illustrated in this composition (formed by two engravings, placed one above the other) have been made at least since the time of Bartsch; a major contribution was made by Förster (1901), and, more recently, Massing (1990[2]) has presented a convincing analysis of the iconography. He observed that earlier writers tended to become enmeshed in attempts to pinpoint a specific classical text as the sole, or at least the major, source of the allegory, whereas 'rather than illustrating an antique text, Mantegna composed, as for the Studiolo, an allegory that would throw into relief a moral idea, in this case the hold of Ignorance on humanity' (p. 184).

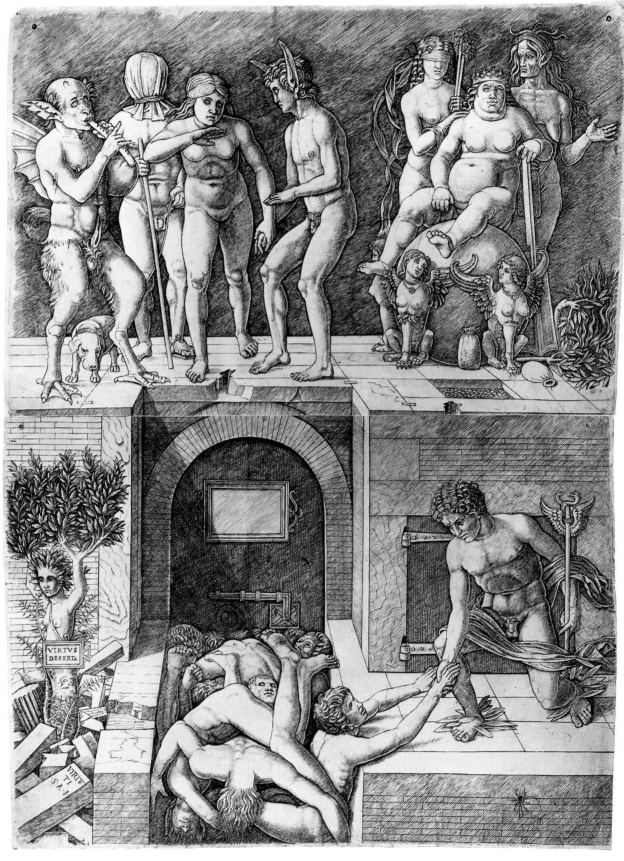

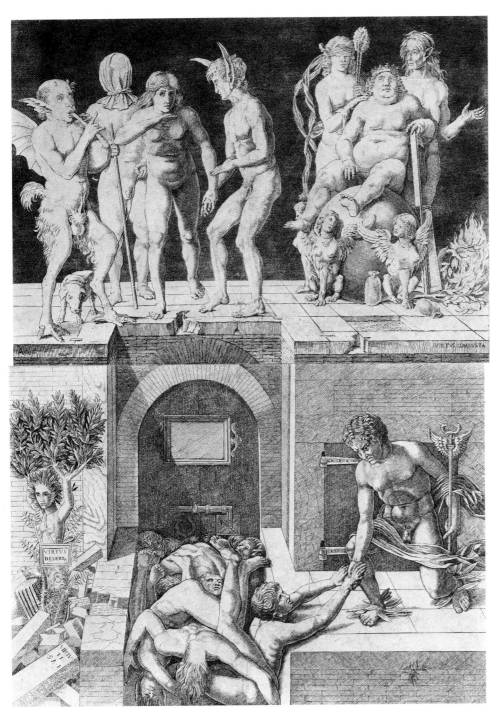

fig. 112 Anonymous Italian, *Allegory of the Fall and Rescue of Humanity*, engravings, two sheets, 306 x 443 mm and 301 x 440 mm, 18th century, The Harvard University Art Museums, Cambridge, MA (ac. FA3-4)

That the meaning of the composition was not self-evident is shown by the existence of another, much later, engraved version, also on two plates but smaller, with the inscriptions removed but with 21 letters (A to X) on the figures and objects, presumably referring to an explanatory key, now lost.

In the top half of the composition Ignorance, a fat, crowned female, seated on a globe and holding a rudder, reigns. The globe is supported by tripod-legged sphinxes, also symbolic of ignorance. The unstable globe and the rudder are attributes of Fortune, and it is likely that a conflation of that personification with Ignorance was intended. Serving Ignorance, standing behind her throne, are Ingratitude (the blindfolded younger woman) and Avarice, a skinny crone with rats-tail hair and enormous ears; because she resembles Envy in the engraving of the *Battle of the Sea Gods* (cat. 79) and in the drawing of *The Calumny of Apelles* (cat. 154), there is again almost certainly a conflation of concepts. To the left, a man with ass's ears, symbolising Error, guides an unsuspecting woman, literally as well as figuratively blind, towards the edge of a pit. He is encouraged by two others, an ithyphallic satyr with bat's wings and bird's feet playing the bagpipes, symbolising Lust, and a man with a cloth over his head and tied around his neck, holding a dog by a leash; this man feigns blindness and thus may well be Fraud. At the far right are branches of bay (*Laurus nobilis*), commonly called laurel, in flames. Massing (1990[2], pp. 177, 192, n. 48) states that they are olive leaves, but then implies (p. 181) that they are laurel. Certainly the leaves are bay (laurel) rather than olive (we are grateful to Dr Rupert Barneby for his help). The branches are symbolic of *Virtus*: virtue in the modern sense and also *virtù* in the Renaissance sense of creative ability, or merit, which is annihilated in the realm of Ignorance; the inscription *VIRTVS COMBVSTA* confirms the symbolism.

In the lower half of the composition is the pit into which the woman is about to fall, already piled with bodies, most seeming to have fallen head-first. At the left, a female figure in the process of metamorphosing into a tree is labelled *VIRTVS DESERTA*. In the *Dialogo della Virtù contro la Fortuna*, written by

Alberti in the 1450s in imitation of a dialogue by Lucian (and thought to be by that ancient Greek writer until well into the 19th century), Virtue prefers to be changed into a tree rather than suffer the unending attacks of Fortune (Massing, 1990², p. 175). A parallel can be drawn between Virtue and Daphne, who was changed into a bay tree rather than be forced to yield to the desire of Apollo. Thus, the specific virtue of Chastity is conflated with the more generalised *Virtus*. The tree is not only abandoned, but surrounded by thorns. Inscribed on a piece of cut stone nearby are the words *VIRTUTI S.A.I.*, standing for *virtuti semper adversatur Ignorantia* (Ignorance is always opposed to Virtue). This is a phrase Mantegna used in two letters to the Marchese Francesco Gonzaga in 1489 and 1491. At the lower right, however, the allegory has an optimistic outcome (assuming the composition reads from left to right and top to bottom). Mercury, inventor of the arts and god of knowledge, logic and eloquence, pulls one of the humans from the pit, implying that salvation can be found if only humanity seeks it in Reason.

Thus, the composition can be seen to illustrate the antagonism between Virtue and Ignorance, which is conflated with that between Virtue and Fortune (and also between Mercury and Ignorance/Fortune). Other associations should not be excluded, for example the contrast between Lust (the man playing the bagpipes) and Chastity. Mantegna's composition thus combines the ideas in Alberti's pseudo-Lucianesque *Dialogo della Virtù…* with those of Lucian's *Calumny*, which begins 'Ignorance is a deadly malady, and the source of most evils that afflict humanity'.

The description by Biondo (1549, *fol.* 18) of a work then in the Palace of San Sebastiano is to be identified with this composition, whether it was actually a drawing mounted on canvas or a painting (see cat. 147). As the Palace was being built in 1506-7, it is unlikely that this was the work's original location. The composition has many affinities with the *Pallas Expelling the Vices* (cat. 136), and conceivably it also could have been created for the Studiolo, although as Lightbown pointed out, the repetition of motifs is rather an argument against this hypothesis. Similar concepts are the subject of *The Calumny of*

Apelles (cat. 154), and the two compositions were presumably created at most a few years apart.

This print was traditionally attributed to 'Zoan Andrea', that is, the hand generally thought to be of finer quality than Giovanni Antonio's; in fact it is one of Giovanni Antonio's best works. No earlier print of the composition is known.

Another printed version of the composition, also from two plates on two sheets that were intended to be shown one above the other, and of the same size as the prints by Giovanni Antonio da Brescia, almost certainly dates from the 18th century (fig. 112). This pair shows a curious disjunction. Whereas the lower half replicates Giovanni Antonio's print virtually line for line – almost deceptively, in fact – the top half does not reproduce Giovanni Antonio's top section, but rather reproduces the drawing (cat. 147), and much more closely than does Giovanni Antonio's print. The salient difference is the block under the foot of the man with a cloth over his head, which is absent in the drawing and the 18th-century print; also obvious is the length of the hair of the emaciated attendant of Ignorance and the woman stepping into the pit; it is short in the drawing and the 18th-century print, long in Giovanni Antonio's print. The shapes of the breaks in the pavement and the line beneath the right foot of the man with ass's ears are among a number of other details that link this print with the drawing, and the facial expressions and the tonal background make these two much closer to each other than either is to Giovanni Antonio's print.

Platemarks visible on some impressions and the nail holes in the corners make it evident that the two images were engraved on opposite sides of the same plate; the plate is larger at the top in both images, showing that the same edge was used as the top. The dimensions and nail holes also make it possible to identify the plate as having been used previously, under *Virtus Combusta*, for Giovanni Antonio's copy in reverse of the *Bacchanal with a Wine Vat* (cat. 77); the nail holes and slight narrowing of the plate towards the bottom are visible on the impression exhibited, and the heel and arch of the foot of the faun at the left in the *Wine Vat* copy are discernible in the shaded vertical face

of the wall below the right foot of the figure playing the bagpipes. Giovanni Antonio's copy of *Four Dancing Muses* (cat. 139) might have been under *Virtus Deserta*; although no impression of this print with a platemark has come to light: an incompletely erased heel some two centimetres below Mercury's left leg and a meaningless mark through the left forearm of the man being rescued seem to correspond to the backmost heel of the dancer on the right and the drapery behind the left knee of the dancer in the centre. Few impressions of the the *Wine Vat* and the *Four Dancing Muses* are known, as would be expected if the images were burnished off so that the plate could be reused.

There are two states of the *Virtus Deserta*, and possibly also of *Virtus Combusta*. In the second state of *Virtus Deserta*, the whole plate has been finely and carefully reworked, so that it is very difficult to highlight an area in which there is a clear difference; the only obvious change is that a major *pentimento* at the outside of Mercury's left foot has been burnished out, as have most of the traces of the previous image, particularly across the arms of the man being helped out of the pit.

S.B.

149

AFTER ANDREA MANTEGNA
Putti Playing with Masks

Pen and grey-brown ink, with extensive use of crimson wash; some olive-green wash around the outstretched leg of the fallen putto, and in the right eye-socket and below the arm and beardless mask of the putto at the right, cut on the right-hand side
208 x 178 mm

c. 1485-95

Musée du Louvre, Département des Arts Graphiques, Paris (inv. 5072; nouveau 2854)
(Exhibited in London only)

PROVENANCE
Jabach collection (inv. I, no. 3); 1677, Cabinet du Roi; Musée du Louvre

REFERENCES
Kristeller, 1901, p. 461; Tietze-Conrat, 1955, p. 249; Kurz, 1959, pp. 277-83; Heinemann, 1962, I, p.260; Romano, 1985, fig. 88; Bauer-Eberhardt, 1989, pp. 49-83 ; Holberton, 1989, pp. 296-300

fig. 113 After Andrea Mantegna, *Putti Playing with a Barrel*, pen and ink with grey-brown wash, 180 x 304 mm, Museum Boymans–van Beuningen, Rotterdam (inv. I.499)

Kristeller first mentioned this drawing in print, describing it as a copy of a lost drawing by Mantegna, and recognised its connection with an ekphrastic description of a work by Mantegna in Jacopo Sannazaro's *Arcadia* (see pp. 19-20). Kurz, in his important article, discussed the iconography more fully and attributed the drawing to Mantegna himself. Heinemann, followed by Romano, implausibly attributed it to Girolamo Mocetto.

Sannazaro described a wooden vase awarded to the victor in a shepherds' wrestling match in ancient Arcadia, but there can be no doubt that it is based on this composition. The vase was painted with 'many things by the hand of the Andrea of Padua, the most clever and ingenious of artists'. Among other things there was 'a naked nymph, all of whose limbs were most beautiful, apart from the feet, which were like those of a goat. She was seated on a swollen bladder, and suckled a little satyr, and looked at him with such tender wonderment that she seemed totally overcome by affection and love. The boy, meanwhile, suckled at one breast, and stretched out his sweet little hand to the other, and looked at it, as if afraid that it would be taken from him. A short way from them were to be seen two boys, also naked, who had donned two horrible face masks, and were sticking their little hands through the mouth-holes of them to frighten two others, who were standing in front of them. One of these latter turned round as he fled, and cried out in fright. The other had already fallen to the ground in tears, and unable to help himself in any other way, stretched out his hand to scratch the mask'.

Kurz thought the description must have referred to two separate drawings, but in fact – as Holberton recognised – the hairy leg of the nymph and the bladder on which she sits are visible at the right margin of the sheet. Holberton further pointed out that Sannazaro knew a description of a painting of a satyr family by Zeuxis in Lucian's *Zeuxis*. The motif of putti playing with masks, according to Kurz, is first found in late Hellenistic art.

The same motif is found in a feeble drawing (fig. 113, Boymans–van Beuningen Museum, Rotterdam), which must nevertheless reflect a lost original by Mantegna. It also occurs in a miniature in a copy of Eusebius (British Library, Royal MS. 14 C III, *fol. 2v*), recently attributed to Lauro Padovano (Bauer-Eberhardt), reappears in a drawing by Michelangelo Anselmi (British Museum, London) and survives at least until the 17th century in the form of a print by Stefano della Bella. The putti are especially close to their counterparts in the *Virgin and Child with Seraphim* (Brera, Milan).

When compared with the two coloured drawings of *Mars, Diana and Iris (?)* (cat. 146) and *Virtus Combusta* (cat. 147), it is evident that this drawing is not of the same superlative quality. This is apparent not just in the weak passages, such as the bird, lion's skin and tree in the background, but also in the pen line, and especially in the application of the coloured washes. It is, however, a good copy. The lost original must have dated from about 1485 to 1495 and it must have been the only Quattrocento drawing – as opposed to painting – to be honoured with a detailed contemporary literary description. The fact of its having been copied at an early date is one further testimony to the drawing's celebrity.

D.E.

149

150

AFTER ANDREA MANTEGNA
Penitencia

Pen and grey-brown wash with white heightening, with some traces of black chalk underdrawing on brownish prepared paper. There are five holes in the paper, as well as some brown spots and areas of fading
185 x 180 mm
Inscribed (at right margin): PENITENCIA;
(on passepartout): *Ligozzi(?)*

c. 1490–1506

Musée du Louvre, Département des Arts Graphiques, Paris (E22676)
(Exhibited in London only)

PROVENANCE
Jabach collection; 1671, Cabinet du Roi;
Musée du Louvre

The attribution of this drawing is extremely difficult to establish, not least because of its damaged condition. However, even when allowance is made for this, the balance of probability favours its being a good quality copy of a lost and otherwise unrecorded original by Mantegna. Both the figure type and the tree are strongly reminiscent of his work, while the inscription, with some letters at ninety degrees to the horizontal, is a trademark of the master in the 1490s – as in the *Judith* (fig. 109) of 1491 and the *Christ the Redeemer* (cat. 54) – and of his school. The technique of pen and brush with white heightening over black chalk is also characteristic of Mantegna.

An aged woman is seated on a rock with what appears to be a carved block under her raised left foot. She wears a turban and ragged clothes, which expose her sagging left breast. The most obvious comparison, and a convincing one both with regard to style and approximate date, is with the Vices in Mantegna's *Pallas expelling the Vices* (cat. 136), possibly completed in 1502. The closest visual analogies are the figures of Inertia, whose clothes are similarly tattered, and that of Avarice with comparably drooping breasts, shared by the figure of Envy in the *Battle of the Sea Gods* (cat. 79). The woman in the drawing holds a whip in her right hand, and rests her chin on her left as she gazes resignedly into the distance. Penitence is represented in a traditional manner, as is demonstrated by a number of correspondences with the characterisation given in Cesare Ripa's *Iconologia* of 1593, where she is described as a 'woman wearing a greenish-grey dress which should be all torn and ripped. She should be shown weeping mournfully, with a bundle of thorns in one hand'. Ripa goes on to detail other requirements, but the weeping woman with torn clothes and a whip (albeit in Ripa's description made up of thorny twigs, as

opposed to the thongs of this drawing) are common to both. That her appearance in Mantegna's drawing of the *Calumny of Apelles* (cat. 154) is only broadly similar is hardly surprising, given the particular textual demands of that subject.

By Penitencia's side is a stumpy tree, some of whose branches are adorned with leaves and buds, and possibly with flowers. That the treatment of the foliage here is also consistent with Mantegna's work of the 1490s and 1500s is amply demonstrated by comparing it with the foliage in such paintings as the *Madonna della Vittoria* and the altarpiece for Santa Maria in Organo, as well as some of the late grisailles, especially *Tuccia* and *Sophonisba* (both National Gallery, London). An even more telling comparison, however, is with the drawing of an *Orange Tree in a Vase* (fig. 114; Rothschild Coll., Louvre; see Jean-Richard, in Paris, 1987). That drawing, convincingly dated to late in Mantegna's career, and therefore of approximately the same date as the lost original of this drawing, also serves to underline the fact that this is indeed a copy, lacking that haunting combination of energy and discipline typical of Mantegna's final period.

A painting of *An Allegory* (Uffizi, Florence, no. 3400), there attributed to Leonbruno, combines the sleeping nymph from Mocetto's print with the figure of Mercury from the *Virtus Deserta* (cat. 148).

D.E.

fig. 114 Andrea Mantegna, *Orange Tree in a Vase*, pen and brown ink, 312 x 142/50mm, collection E. de Rothschild, Musée du Louvre, Paris (inv. 776 DR)

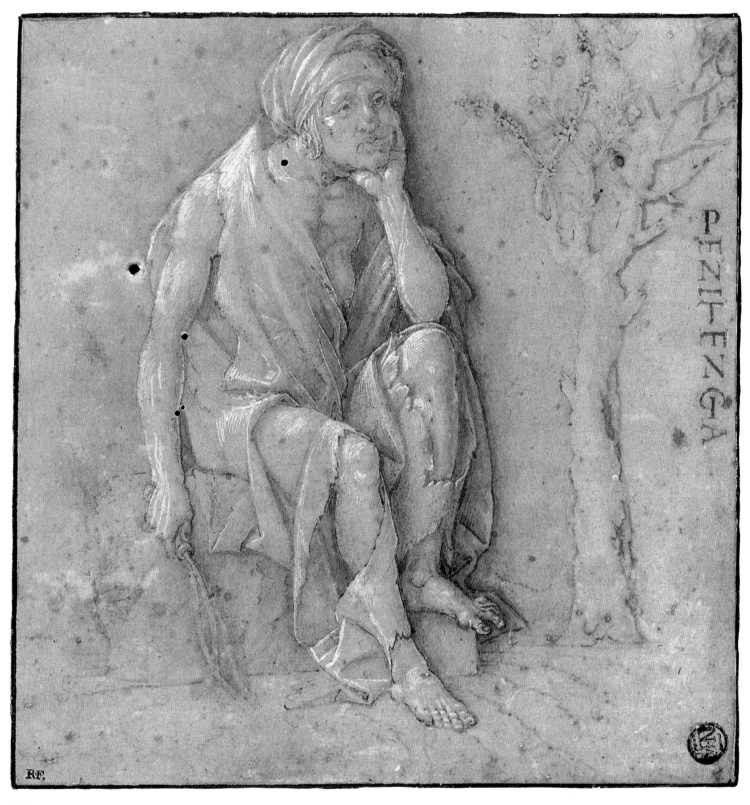

PENITENGA

RF.

150

151

CIRCLE OF ANDREA MANTEGNA

Recto: *A Man and Woman Asleep on a Bed, a Sleeping Cupid, and Two Satyrs*

Drawn and shaded with the point of the brush in brown on brownish paper, heightened in places with white, the outlines pricked for transfer. The drawing is on two pieces of paper joined together, the join running vertically through the man's right arm. A large section in the bottom right-hand corner, which cuts across the woman's right foot, is a restoration. The whole sheet is rubbed

Verso: *A Child Breaking a Stick across his Knee; A Child Seated on a Sea Monster*

Point of the brush and brown wash

287 x 472 mm

c. 1490-1506

The Trustees of the British Museum, London (1895-9-15-783)

PROVENANCE
Rev. Dr H. Wellesley; sold, Sotheby's, London, 25 June 1866, lot 886; John Malcolm

REFERENCES
Hind, 1909-10, I, p. 467, under no. 10; Byam Shaw, 1936-7, p. 57; Hind, 1948, V, p. 167; Popham and Pouncey, 1950, pp. 99-101, no. 161; Meiss, 1960, 1976, pp. 220-24

The drawing on the *recto* of this sheet is related to two other compositions: a print of the *Metamorphosis of Amymone* engraved by Girolamo Mocetto, for which there is an autograph drawing in the Pierpont Morgan Library, New York, and a painting of the same subject (see Meiss, 1976, figs. 241-2; Garavaglia, 1967, nos. 108-10; the painting is now in three pieces) which was attributed by Popham and Pouncey to Lorenzo Leonbruno. Both print and painting are very similar, but the latter makes various changes and includes two quotations from works by Mantegna: the figure of Envy from the *Battle of the Sea Gods* (cat. 79) and the figure of Mars from the drawing of *Mars, Diana and Iris(?)* (cat. 146). However, in addition to general points of contact between all three works, especially in the attitude of the sleeping woman and the two satyrs, there is one very specific link between the drawing and the painting which differentiates them from the print. In Mocetto's print the nymph's legs are crossed, whereas in this drawing and the painting attributed to Leonbruno they are not.

Byam Shaw attributed this drawing together with others, including the *Hercules and Antaeus* (cat. 89), to Zoan Andrea, whose true identity is established elsewhere in this catalogue (pp. 56-60); but Popham and Pouncey rightly doubted the coherence of the group, objecting that whereas Zoan Andrea was in contact with Mantegna from around 1475, this drawing and most of the others in the group must date from considerably later. Indeed, numerous authorities have correctly adduced connections with the paintings for Isabella d'Este's Studiolo, which date from the late 1490s and early 1500s, and with the two coloured drawings of the same period (cats. 146, 147). Popham and Pouncey were inclined to regard this drawing as a copy of a lost work by Mantegna, but the close links with the two *Amymone* images, taken in conjunction with the slightly gauche figures on the bed and the rather whimsical satyrs, may rather suggest that it is a free variation by an artist of Mantegna's school. Leonbruno is not known as a draughtsman, but he is at least a possible candidate.

Popham and Pouncey accepted Byam Shaw's suggestion that the theme of the drawing is amorous, but pointed out that the solicitous satyrs are hardly lascivious (one providing pillows for the man; the other fanning and unveiling the woman), as Byam Shaw proposed, not least since one of them is breeched. As in Botticelli's *Mars and Venus* (National Gallery, London), the comic moral seems to be that sleep ensues when all passion is spent. Even Cupid – inspired by an ancient statue of *Sleep*, as observed by Popham and Pouncey – slumbers: Meiss suggested this was either because his task is impossible or because his work is done, but the second reading seems to be the right one. The poppy seeds, which are the classical attributes of Hypnos, the God of Sleep, underline the theme.

The two studies on the *verso* would appear to be by the same hand as the *recto*.

D.E.

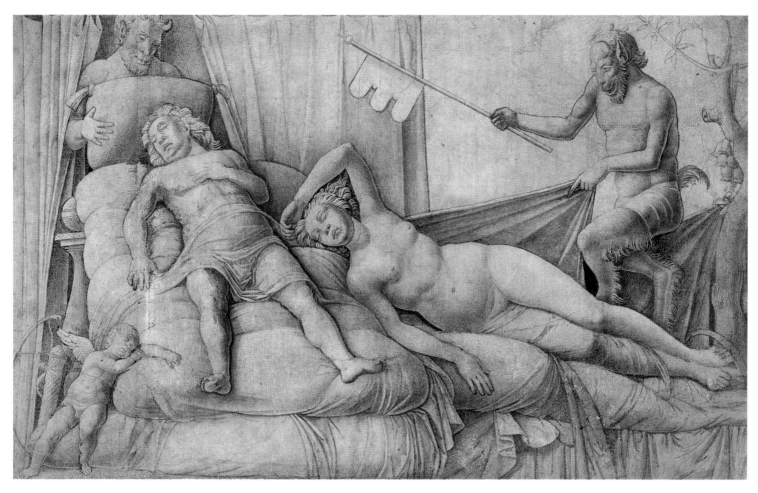

151 *recto*

152

AFTER ANDREA MANTEGNA
Design for a Fountain

Pen and brown ink with brown wash and some white
heightening, partly oxidised
292 x 222 mm

1490s

The Trustees of the British Museum, London
(1910-2-12-32)

PROVENANCE
Unknown collector's mark (GG?) in circle on *verso*;
J. Goll van Franckenstein (L. 2987: no. 3109 in red on
verso); Earl of Warwick (L. 2600); sold Christie's,
London, 20 May, 1896, lot 225; George Salting
Bequest

REFERENCES
Kristeller, 1901, p. 462; Popham and Pouncey, 1950,
p. 103; no. 164

This design most probably represents an
architectural fantasy. Neither this drawing nor
an almost identical but inferior version of the
design in the Uffizi (Santarelli, no. 8945), is
of sufficient quality to be by Mantegna
himself. However, in spite of Gamba's
attribution of the drawing in Florence to
Andrea Riccio (in Olschki, 1912-21, III, p. 1,
no. 4), there seems every reason to suppose
that both sheets are derived from a lost
prototype by Mantegna. The principal figure
of the water-pourer himself is reminiscent of
Mantegna's types, not only in the classically
inspired musculature of the torso, but more
particularly by virtue of the inverted
horseshoe pattern of the ribcage, which
almost amounts to a signature in Mantegna.
As Popham and Pouncey pointed out, the
lower half of the figure is almost identical to
that of the standing youth in the *Bacchanal
with a Wine Vat* (cat. 74). Furthermore, the
elaborate and involved folds of the drapery
that flutter around the body suggest
connections with late drawings such as the
Uffizi *Judith* of 1491 (fig. 109) or the *Mars,
Diana and Iris (?)* (cat. 146). Similarly, the
effect of the marbling on the fountain's basin,
which resembles watered silk, is typical of
Mantegna, as are the decorative details of the
base. The full-breasted sphinxes compare
particularly well with those found on the
drawing of *Virtus Combusta* (cat. 147), while
the central, grotesque mask is not unlike the
face of Mantegna half-hidden in the foliage of
one of the decorative pilasters of the Camera
Picta (fig. 95). A comparable combination of
the motifs of a sphinx and mask is found in a
sheet of classicising studies in Bayonne (Bean,
1960, no. 210, Paduan school). It is never
easy to date a lost original on the basis of a
copy, but in this case the meticulous
penwork and the treatment of the drapery
suggest a late date, probably in the 1490s at
the earliest.

Mantegna was involved with other sculptural
projects. The most celebrated of these was for
a statue of Virgil, which Isabella d'Este
intended to erect, and concerning which she
consulted the Neapolitan humanist Giovanni
Pontano in 1499 (see Martineau, in London,
1981, pp. 152-3, no. 92). The best-known
reflection of Mantegna's involvement with
the scheme is a reworked but weak school
drawing in the Louvre (Mantua, 1961,
p. 144), to which should be added a ruined
sheet in the Uffizi (1672F; reproduced in
Heinemann, 1962, II, p. 199, pl. 154). It
shows the same figure holding a book and
standing in a very similar pose, the main
differences being that he looks to his left, not
right, and that it is hard to discern any trace of
a bay wreath. The Uffizi drawing is now too
rubbed to allow a definitive judgement, but
may possibly have been by Mantegna himself.

D.E.

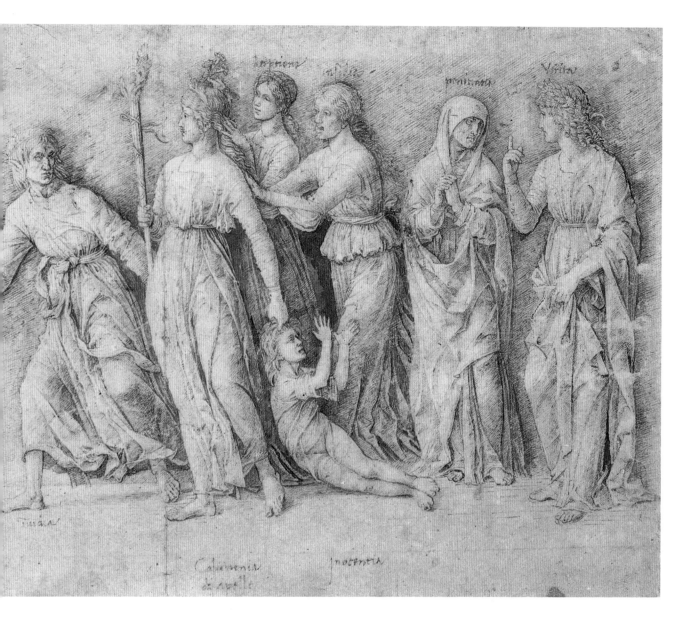

154

design in reverse, but various factors speak against this. Popham and Pouncey observed that the engraving after this design by Girolamo Mocetto does not reverse it, nor does the engraving after the *Allegory of the Fall and Rescue of Ignorant Humanity* (cat. 148) reverse its model. Similarly, the final drawing for the *Risen Christ* (cat. 44) is in the same direction as the print. Finally, in spite of the reversal of the hands of the figure of Calumny, it is surely significant that all the gestures of command or of ex-postulation are right-handed. In reverse they would have been the wrong way round, something that Mantegna would presumably have avoided. Furthermore, a left-to-right progression, following the enumeration of the text, would

have come naturally, as in Bordon's illumination of the scene in the edition of 1494.

In spite of occasional expressions of dissent, notably by Kristeller and Berenson, there seems no reason to doubt that this is an important late drawing by Mantegna. Not only are the inscriptions in his hand and in the same inks as the drawing, but the feel of the penwork is characteristic, as are the facial types and draperies. Yet, if this drawing is compared with those connected with the *Triumphs of Caesar*, or even more with the late *Virgin and Child Enthroned with an Angel* (cat. 49), a slight difference emerges: the pen strokes are even more thin and spidery, and the hatching is applied with greater delicacy. This may serve to confirm Popham and

Pouncey's suggestion that this sheet is especially close, not least in its frieze-like composition, to the *Introduction of the Cult of Cybele in Rome* (cat. 135) of 1504-6. As such, whether it was intended to stand as a work of art in its own right or was preparatory for a print, it is very probably the last pen drawing by Mantegna that has come down to us. It was copied by Rembrandt (British Museum, London).

D.E.

APPENDIX I: ENGRAVED PLATES

Cat.		Title	Dimensions of platemark
		By or attributed to Mantegna	
29		*Entombment with Four Birds*	
32		*Deposition*	*c.* 454 x 364 mm
36	F	*Flagellation with a Pavement*	
67		*Descent into Limbo*	*c.* 445 x *c.* 346 mm
39	F	*Entombment* (horizontal)	
45		*Risen Christ*	*c.* 337 x *c* 478 mm
74	F	*Bacchanal with a Wine Vat*	
75		*Bacchanal with Silenus*	*c.* 335 x 454 mm
79		*Battle of the Sea Gods* (both halves)	*c.* 340 x 445 mm
		Premier Engraver	
84	(?)	*Silenus with a Group of Children*	163 x 236 mm, sheet, London
86		*Hercules and Antaeus* (smaller)	206 x 140 mm, sheet, London
93	F	*Hercules and Antaeus* (larger)	
138		*Four Dancing Muses*	*c.* 350 x 260 mm
120	F	*The Corselet Bearers*	
126		*The Senators*	*c.* 304 x *c.* 350 mm
		Attributed to Giulio Campagnola	
118	F	*The Elephants*	
123		*The Corselet Bearers*	*c.* 318 x 318 mm
		Giovanni Antonio da Brescia	
30	(?)	*Entombment with Three Birds*	*c.* 470 x 365 mm
37		*Flagellation with a Landscape*	*c.* 470 x 365 mm
68	(?)	*Descent into Limbo*	*c.* 405 x 323 mm, sheet, Boston
76		*Bacchanal with Silenus*	*c.* 304 x 440 mm, sheet, Vienna
47	(?)	*Risen Christ*	318 x 292 mm
52		*Holy Family with St Elizabeth and the Infant St John the Baptist*	*c.* 305 x 270 mm (according to Hind)
77	(?)	*Bacchanal with a Wine Vat*	299 x 433 mm
139		*Four Dancing Muses*	222 x 356 mm, sheet, Paris

The plate with the *Bacchanal* was reused for:
Allegory of the Fall and Rescue of Ignorant Humanity: Virtus Combusta and *Virtus Deserta* (both halves)

By comparing the measurements and the coincidence of watermarks on prints it has been possible to establish that certain pairs of prints were engraved on either side of the same copper plate. Only when both prints of a pair are in the catalogue are they listed; other pairs, or possible pairs, are mentioned in entries.

In some cases the dimensions combine information from more than one impression; details are given in the catalogue entries.

If the plate size is unknown the dimensions of the largest known sheet are given (not necessarily those of the impression in the exhibition).

A question mark indicates that it is possible, in some cases probable, that the two images were engraved on the same plate. 'F' indicates that the plate was taken to France (see Appendix II).

S.B. and D.L.

Cat.	Title	Dimensions of platemark
85	*Silenus with a Group of Children* (?)	254 x 180 mm
87	*Hercules and Antaeus* (smaller)	173 x 255 mm, sheet, Vienna
94	*Hercules and Antaeus* (larger)	
144	*Judith with the Head of Holofernes*	318 x 226 mm

Attributed to the Master of 1515

78	*Bacchanal with a Wine Vat* (?)	299 x 429 mm, sheet, London
80	*Battle of the Sea Gods* (left half)	266 x 424 mm, sheet, Oxford
	Bacchanal with Silenus (mentioned under cat. 78) (?)	147 x 223 mm, sheet, London
88	*Hercules and Antaeus*	250 x 188 mm (according to Hind)

APPENDIX II: WATERMARKS

The watermarks in the charts are those that appear on more than one impression of a print in the catalogue; they also include a few watermarks seen on only one impression, if the impression is of exceptionally high quality. Otherwise, watermarks seen on only one impression are listed after the charts. There are three charts: A: Italian watermarks excluding those seen primarily on prints by Giovanni Antonio da Brescia; B: French watermarks; C: Italian watermarks seen primarily on prints by Giovanni Antonio da Brescia. The first category, however, includes some prints that are by Giovanni Antonio, and the third category some that are not. The plates that were taken to France form a distinct group; only fine, early impressions of these prints have Italian watermarks (see A). In each chart watermarks are listed in order of apparent priority; that is, the best impressions are first, and others follow in descending order of quality. In some cases, however, several different watermarks were found on impressions of similar quality, so the order should not be regarded as absolute. The prints follow the order of the catalogue, except in cases where two images are known, or thought, to have been engraved on reverse sides of the same plate they are placed together (see Appendix I).

At least nine plates were taken to France. Six had images on both sides (see Appendix I); only the *Virgin and Child* (cat. 48), the *Faun Attacking a Snake* (cat. 83) and the *Judith with the Head of Holofernes* (cat. 141) were engraved on plates for which it is not known what – if anything – was on the reverse. Although we have seen no watermark on an impression of *Judith,* the narrow space between chain lines of the papers on which it was printed is typical of French papers (see watermarks 12-21). Who took these plates to France and when is not known. The small Flower (no. 12), the earliest of the French watermarks, was found by Briquet on documents dating from 1503, and the Metropolitan Museum, New York, owns French books published in 1501 and 1517, but also as late as 1538, with this watermark; it is also found on some prints of the School of Fontainebleau, made in the 1540s. The next French watermark, the Small Circle (no. 13), is also known as early as the late 15th century and appears on many prints of the School of Fontainebleau. Thus, the plates could have gone to France at any time during the first few decades of the 16th century. It might be possible that they were taken by Francesco Primaticcio (1504-70), who worked under Giulio Romano in Mantua before going to Fontainebleau to work for King François I in 1532. An extraordinary burst of printmaking production took place at Fontainebleau in the 1540s, which is thought to have been instigated by Primaticcio; perhaps it was inspired by Mantegna's prints. The hypothesis at this point, however, can be no more than conjecture.

The watermarks in Part C, especially the Orb and Cross and High Crown (nos. 22, 23), turn up frequently on the prints here attributed to Giovanni Antonio da Brescia. They corroborate the evidence of style, adding confidence to our attribution to Giovanni Antonio of many of the Mantegna 'School' copies, and also the group of prints formerly given to Zoan Andrea.

The watermarks are shown actual size, with at least two chain lines for each. All except those from Paris and Washington, and one from Boston, are reproduced directly from beta-radiographs. We are grateful to all the people and institutions who allowed us to look at watermarks on their prints, and to those who provided us with Beta-radiographs. Special thanks must go to Rose-Helen Breinin, without whose meticulous volunteer work these charts would never have reached their final form; Betty Fiske of the Metropolitan Museum, who made the Beta-radiographs from the Metropolitan's collection and some others, and redrew for publication the watermarks from Paris and Washington; Gisèle Lambert of the Bibliothèque Nationale, Paris, who allowed five watermarks from that collection to be shown here in advance of her own forthcoming publication; Annette Manick of the Museum of Fine Arts, Boston, who made Beta-radiographs on our behalf of many more watermarks than the nine finally used here, some presenting considerable difficulties; and Mark Trowbridge, intern at the Metropolitan Museum, who looked for watermarks on every piece of French 16th-century paper in the Department of Prints and Photographs.

The places and dates cited by Briquet (and Heawood), here listed with each watermark, refer to the locations and dates of papers in archives or published books; they are not the place and date of manufacture of the paper.

S.B. and D.L.

KEY TO WATERMARK CHARTS

A. Italian Watermarks (excluding those primarily on prints by Giovanni Antonio da Brescia)

1. Basilisk. Cf. Br.2629-79 (Northern Italy, last third 15th century)
2. Anchor in Circle with Star. Cf. Br.478-94 (Bergamo 1502 – Udine 1542)
3. Cardinal's Hat. Close to Br.3404 (Udine 1503)
4. Cardinal's Hat. Cf. Br.3389, 3390 (Florence 1480-87)
5. Cardinal's Hat. Close to Br.3391 (Florence 1491, Venice 1497)
6. Crown with Cross. Close to Br.4763 (Mantua 1489)
7. Scales in Circle. Cf. Br.2538 (Ferrara 1497), Br.2554 (Udine 1499)
8. Anchor in Circle. Cf. Br.465 (Salzburg 1490)
9. Fleur-de-lys 'Epanouie' in Circle. Cf. Br. 7313 (Palermo 1485), Br.7315 (Fano 1528)
10. Siren in Circle with Star. Cf. Br.13899 (Naples 1524-8, Rome 1526), Br.13900 (Naples 1533)
11. 'N' or Butterfly in Circle

B. French Watermarks

12. Flower (variant: with small vertical line from bottom petal). Cf. Br.6327 (Besançon 1503)
13. Small Circle (variant: with lines extending up on right, down on left). Cf. Br.2925-7 (Nantes 1484 – Troyes 1552)
14. Arms of Troyes with Letters (IP?) below. Br.1048 (Bruges 1526-7)
15. Shield with Flower above, Letter 'N' below. Br.9863 (Chablis 1538)
16. Pot with Cross. Br.12502 (Troyes 1533)
17. Crowned Shield containing Letters 'PS' (variant: without crown). Br.9666-9 (Paris 1541-57, Arras 1539, St-Denis 1552)
18. Letters 'PI' (?).
19. Letters 'PM'.
20. Small Fleur-de-lys (variant: with flower above). Cf. Br. 6954 (St Malo 1551), Br.7038 (Troyes 1560)
21. Arms of Nicolas Lebé. Close to Br.8080 (Nancy 1578), Br.8081 (Rouen 1582)

C. Watermarks Primarily on Prints by Giovanni Antonio da Brescia

22. Orb and Cross. Cf. Br.3057-68 (Venice 1493 – Brescia 1543)
23. High Crown. Cf. Br.4895 (Leipzig 1498), Br.4899 (Bergamo 1501-3)
24. Ox Head with Serpent and Cross. Br.15375 (Vicenza 1492)
25. Ox Head with Flower and Triangle. Br.14874 (Brescia 1489)
26. Star in Circle. Cf. Br.6085 (Bergamo 1522-8)
27. Crown in Circle. Close to Br.4867 (Treviso 1520)
28. Anchor in Circle. Cf. Br.471 (Prague 1527), Br.475 (Mantua 1520)
29. Fleur-de-lys in Circle with Star (variant: without star). Cf. Br.7116 (Florence 1530)
30. Bow and Arrow
31. Fleur-de-lys in Circle with Letters (?) below
32. Profile Head in Circle. Cf. Br.15658 (Ferrara 1553)
33. Profile Head in Double Circle
34. Anchor in Circle with Star. Cf. Br.548-65 (Verona 1559-95 *et al.*)
35. Three Mounts in Circle with Star. Close to Br.11932 (Rome 1578)

ABBREVIATIONS

Amst	–	Rijksprentenkabinett, Rijksmuseum, Amsterdam
Balt	–	Baltimore Museum of Art
Bolo	–	Gabinetto delle Stampe, Pinacoteca Nazionale di Bologna
Bost	–	Museum of Fine Arts, Boston
Brom	–	Mrs Ruth Bromberg
CamF	–	Fogg Art Museum, Harvard University, Cambridge, MA
Chat	–	Duke of Devonshire and the Chatsworth Settlement Trustees
Chic	–	Art Institute of Chicago
Cinc	–	Cincinnati Art Museum
Clev	–	Cleveland Museum of Art
CMen	–	Christopher Mendez
Coln	–	Wallraf-Richartz Museum, Cologne
Darm	–	Hessisches Landesmuseum, Darmstadt
Fran	–	Graphische Sammlung, Städelsches Kunstinstitut und Städtische Galerie, Frankfurt
Hamb	–	Hamburger Kunsthalle, Hamburg
Jnsn	–	R. Stanley and Ursula Johnson Family Collection
Laub	–	August Laube, Zurich
Lond	–	Trustees of the British Museum, London
Melb	–	National Gallery of Victoria, Melbourne
Midd	–	Davison Art Center, Wesleyan University, Middletown, CT
Minn	–	Minneapolis Institute of Arts
Mun	–	Staatliche Graphische Sammlung, Munich
NewH	–	Yale University Art Gallery, New Haven, CT
NYCH	–	Cooper-Hewitt Museum, New York
NYMM	–	Metropolitan Museum of Art, New York
NYPL	–	New York Public Library, New York
Otta	–	National Gallery of Canada, Ottawa
PaBN	–	Bibliothèque Nationale, Paris
PaDt	–	Musée du Petit Palais, Collection Dutuit, Paris
PCIt	–	Private Collection, Italy
PCNY	–	Private Collection, New York
Phil	–	Philadelphia Museum of Art
Prin	–	The Art Museum, Princeton University
StLo	–	St Louis Art Museum
Stog	–	Courtesy of Nicholas Stogdon
Toro	–	Art Gallery of Ontario, Toronto
Vien	–	Graphische Sammlung Albertina, Vienna
Wash	–	National Gallery of Art, Washington, DC
Zur	–	Kunsthaus, Zurich

A. ITALIAN WATERMARKS
(excluding those primarily on prints by Giovanni Antonio da Brescia)

Cat.	Title	1*	2	3	4	5	6	7	8	9	10	11
22	*Virgin in the Grotto* (H.13)			Bost1 Jnsn1 PaDt1				Amst1 Chic2 **Stog1**				
29	*Entombment with Four Birds* (H.11b)								**NYMM**	Jnsn		
32	*Deposition* (H.10)				Bost3					PaBN3		
38	*Entombment* (H.2)	Bost2 Vien1					NYMM2					
48	*Virgin and Child* (H.1)					NYMM2						
52	*Holy Family* (H.GAB.4)			NewH2								
75	*Bacchanal with Silenus* (H.3)	Chat PaBN		**Bost**								
79	*Battle of the Sea Gods*, left (H.5)	Bost CamF Lond NewH **NYMM**	Amst Chic					Balt Cinc Hamb			**Bost**	PaBN **Wash**
79	*Battle of the Sea Gods*, right (H.6)	CamF	**NYMM**	Amst Hamb **NYMM** Toro Wash							Amst PaBN	
93	*Hercules and Antaeus* (H.17)			Amst								
138	*Four Dancing Muses* (H.21)			Bost								
118	*Triumphs: Elephants* (H.14)			Bost PaBN								
123	*Triumphs: Corselet Bearers* (H.15)				NYPL							
120	*Triumphs: Corselet Bearers* (H.15b)			PaBN								
144	*Judith and Holofernes* (H.ZA.5)			Bost								
148	*Allegory: Virtus Combusta* (H.22 top)		Amst									
148	*Allegory: Virtus Deserta* (H.22 bottom)		Amst									
153	*Fountain* (ZA.3)		Amst	Wash								

Bold = impression illustrated
Number after collection abbreviation = print state
* This watermark is also on two drawings: *Risen Christ* (cat. 44) and *Mars, Diana and Iris(?)* (cat. 146)

B. FRENCH WATERMARKS

Cat.	Title	12	13	14	15	16	17	18	19 ★	20	21
36	*Flagellation with Pavement* (H.8)	Bost CamF Lond PaDt	Bost PaBN Wash	Fran Mun Phil Wash Zur	**NYMM**			Amst	Amst		
67 / 67b	*Descent into Limbo* (H.9)	CamF Darm Otta Wash Wash	Amst Bost Chic Minn Mun PaBN		Lond Zur	NewH					
38	*Entombment* (H.2)	Bost2 Bost2 CamF Darm2 **NYMM2** NYMM2	Balt2 Cinc2 Phil2 PCIt2	Amst2	Fran2 Minn2 PaBN2		Zur2	Phil2 Fran2	Mun2	Amst2 Lond2 NewH2	
45	*Risen Christ* (H.7)	Balt Bost CamF2 Chic NYPL PaDt PCNY StLo Wash	Amst Fran Phil	Lond	Cinc	Bost		Amst	Minn	PaBN Zur	
48	*Virgin and Child* (H.1)		Lond2 PaBN2 PaBN2 Midd2				Amst2 Laub2	Bost2 CamF2 Fran2			
74	*Bacchanal with Wine Vat* (H.4)	Balt Minn PaBN Zur	Amst Wash	**Bost** Lond	Bolo Phil Prin		Wash	Amst **Bost** CamF Fran Mun NYCH			
75	*Bacchanal with Silenus* (H.3)	Darm	Bost	Amst Bolo Mun		Bost	Fran	CamF			
83	*Faun Attacking a Snake* (H.20)										Amst **PaBN**
93	*Hercules and Antaeus* (H.17)	CamF NewH		Melb	Zur			Fran	NYPL PaBN Phil		
138	*Four Dancing Muses* (H.21)	Lond Wash	Fran PCIt Zur		Bost	Clev	NYPL	PaBN	Amst Cinc Phil		
118	*Triumphs: Elephants* (H.14)	NYMM	CamF				**Bost** Darm	Fran	**NYMM**		
123	*Triumphs: Corselet Bearers* (H.15)	Amst CamF Clev	**NYMM**	Mun			Chic **Wash**		**NYMM**		
120	*Triumphs: Corselet Bearers* (H.15b)	Midd			StLo	**Bost**		CMen NYMM			
126	*Triumphs: Senators* (H.16)			Fran				Darm	CamF	Zur	

★ This watermark is also on the drawing *The Elephants* (cat. 119).

474

C. WATERMARKS PRIMARILY ON PRINTS BY GIOVANNI ANTONIO DA BRESCIA

Cat.	Title	22	23	24	25	26	27★	28	29	30	31	32	33	34	35
22	*Virgin in the Grotto* (H.13)							PaBN1		Wash2		NYMM2			
37	*Flagellation with Landscape* (H.8a)	Bost					Bost Lond				CamF				
68	*Descent into Limbo* (H.9a)		Bost		**Clev**										
76	*Bacchanal with Silenus* (H.3a)												Clev Phil		
40	*Entombment* (H.2a)	PaBN													**Clev** Wash
47	*Risen Christ* (H.7a)	Brom1	Clev2 Otta2	Coln2											
52	*Holy Family* (H.GAB.4)	Bost1 PaBN1 Wash1	Mun1 **NYMM**1 **NYPL**1			Clev2									
77	*Bacchanal with Wine Vat* (H.4b)	Bost													
139	*Four Dancing Muses* (H.21a)	Bost Lond PaBN PaBN Wash													
148	*Allegory: Virtus Combusta* (H.22 top)								PaBN **Wash**	CamF	**Clev** Hamb				
148	*Allegory: Virtus Deserta* (H.22 bottom)									CamF **Clev**	Hamb		**Bost**		
79	*Battle of the Sea Gods*, left (H.5)						Amst Fran								
79	*Battle of the Sea Gods*, right (H.6)						Fran								
85	*Silenus with a Group of Children* (H.24)	Lond ?Vien													
87	*Hercules and Antaeus* (H.GAB.3)													Lond2 **NYPL**2	
94	*Hercules and Antaeus* (H.GAB.1)											**NYMM**			
144	*Judith and Holofernes* (H.ZA.5)	PaBN		Lond Vien Vien											
97	*Hercules and the Nemean Lion* (H.GAB.2)			Lond PaBN											
117	*Triumphs: Elephants* (H.14a)	Cinc PaDt Phil	Bost Chic Fran Lond PaBN					**Clev**							
121	*Triumphs: Corselet Bearers* (H.15a)	Bost Coln PaBN	Bost	Lond											
127	*Triumphs: Senators* (H.16a)	**Clev** Phil Zur		**Bost**			Mun **NYMM**								
153	*Fountain* (H.ZA.3)		Lond												

★ The illustration of this watermark is taken from the Metropolitan Museum's impression of
The Flagellation (H.GAB.13), signed by Giovanni Antonio da Brescia. As the design of this print
is not by Mantegna, the print is not included in the chart.

WATERMARKS SEEN ON ONLY ONE IMPRESSION

A. Italian

36. High Crown with Letters 'MD'. Br.4907 (Gresen 1518, Vicenza 1522), Br.4908 (Salzburg 1519), on *Triumphs: Corselet Bearers* (H.15) **Bost**
37. Crossbow in Circle. Cf. Br.739-49 (Italy 1469-1548), on *Deposition* (H.100) Fran3 (no ill.)
38. Hunting Horn. Cf. Br.7855-7 (Rome 1513 – Pisa 1539), on *Hercules and Antaeus* (H.GAB.3a) **PaBN**

C. Giovanni Antonio da Brescia

39. Fleur-de-Lys in Circle with (?) above, on *Entombment with Three Birds* (H.11) **Wash**
40. Armorial Band. Cf. Br.1006, 1007 (Northern Italy 1477-1515), on *Entombment with Three Birds* (H.11) PaDt (no ill.)
41. Anchor in Circle with Star. Cf. Br.587 (Bamberg 1506), on *Flagellation with Landscape* (H.8a), **Chic**
42. Wheel. Cf. Br.13228 (14th century), on *Bacchanal with Silenus* (H.3a), Lond (no ill.)
43. Three Mounts with Cross. Cf. Br.11808 (Innsbruck 1490-1501), Br, 11811 (Regensburg 1497-8), on *Hercules and Antaeus* (H.GAB.1), **PaBN**
44. Anchor in Circle with Trefoil. Close to Br.568 (Verona 1591-3), on *Hercules and Antaeus* (H.GAB.1), **PaBN**
45. Winged Horse in Circle. Cf. Heawood 2784 (Florence 1588), on *Flagellation with Landscape* (H.8a), PaBN (no ill.)
46. Scales in Circle. Close to Br.2488 (Treviso 1467-8), on *Hercules and Antaeus* (small) (H.GAB.3), **Wash** 2
47. Scales. Close to Br.2401 (Venice 1437), on *Hercules and Antaeus* (H.GAB.3), **Jnsn** 2
48. Gothic 'P' with Flower. Close to Br.8593 (Troyes 1458-61), Br.8594 (Namur 1462), on *Hercules and Antaeus* (H.GAB.3), Mun2 (no ill.)
49. Crown. Cf. Br.4872 (14th century), Br.4879 (Ferrara 1458), on *Hercules and Antaeus* (H.GAB.3), Fran2 (no ill.)
50. Letters 'GMI'. On *Hercules and Antaeus* (H.GAB.3), **NYMM** 2

bold = illustrated

Br. = C.-M. Briquet, *Les filigranes. Dictionnaire historique des marques du papier dès leur apparition vers 1282 jusqu'en 1600*, 4 vols., Geneva, 1907; reprint Amsterdam, 1968.

Heawood = E. Heawood, *Watermarks, Mainly of the 17th and 18th Centuries*, Monumenta Chartae Papyraceae, Historiam Illustrantia, vol. I, Hilversum, 1950.

4

5

6

10

11

12

13

14

15

16

18

19

20

21

22

17

17/var

23

24

25

26

27

31

32

28

29

30

33

34

35

36

38

39

44

46

47

41

50

43

LENDERS TO THE EXHIBITION

Amsterdam
Rijksprentenkabinet, Rijksmuseum: 22, 46

Berlin
Staatliche Museen Preussischer Kulturbesitz
 Gemäldegalerie: 41, 100
 Kupferstichkabinett: 4, 30, 33, 36, 71, 121

Besançon
Musée des Beaux-Arts et d'Archéologie: 106, 107

Boston, MA
Museum of Fine Arts: 66, 77, 78, 138

Brescia
Pinacoteca Tosio Martinengo: 27

Bristol Museums and Art Gallery: 69

Mrs Ruth Bromberg: 47

Cambridge, MA
Fogg Art Museum, Harvard University: 20

Chatsworth
Duke of Devonshire and the Chatsworth
Settlement Trustees: 31, 75, 79, 81, 118, 120, 142, 143

Cincinnati Art Museum: 128

Copenhagen
Staatens Museum for Kunst: 60

Correggio
Istituto Cantarelli: 54

Dublin
The National Gallery of Ireland: 105, 122, 129

Ferrara
Pinacoteca Nazionale: 16

Florence
Galleria degli Uffizi
 on deposit from the Galleria Palatina,
 Palazzo Pitti: 102
 Gabinetto Disegni e Stampe: 9, 89, 90

Fort Worth
Kimbell Art Museum: 51

Frankfurt
 Städelsches Kunstinstitut: 5
 Graphische Sammlung im Städelschen
 Kunstinstitut: 50

Glens Falls, NY
The Hyde Collection: 19

Hamburg
Kunsthalle: 18, 37, 88

Her Majesty the Queen: 63, 91, 108, 109, 110, 111, 112, 113, 114, 115

The Barbara Piasecka Johnson Collection: 67a, 70

**R. Stanley and Ursula Johnson
Family Collection**: 21

Josefowitz Collection: 83, 148

London
The Trustees of the British Museum: 2a, 2b, 11, 24, 26, 32, 34, 43, 49, 73, 82, 84, 86, 87, 95, 124, 146, 147, 151, 152, 153, 154

London
Courtauld Institute Galleries
(Prince's Gate Collection): 35

London
The Trustees of the National Gallery: 135

London
The Trustees of the Victoria and Albert Museum: 1

Madrid
Museo del Prado: 17

Malibu
Collection of the J. Paul Getty Museum: 14, 56

Mantua
Basilica di Sant' Andrea: 64

Milan
Museo Poldi Pezzoli: 98

Montreal
The Montreal Museum of Fine Arts: 133, 134

Munich
Staatliche Graphische Sammlung: 44, 137

Naples
Museo e Gallerie Nazionali di Capodimonte: 13, 101

New York
The Metropolitan Museum of Art
 European Paintings Department: 8, 12, 55
 Prints and Photographs Department: 74, 93, 94
 The Lehman Collection: 65

New York
The Pierpont Morgan Library: 23

New York
The New York Public Library, Print Collection: 123

Oxford
Visitors of the Ashmolean Museum: 80

Oxford
The Governing Body of Christ Church: 96, 104

Padua
Parrocchia degli Eremitani: 6

Paris
Bibliothèque de l'Ecole Nationale Supérieure
des Beaux-Arts: 66

Paris
Bibliothèque de l'Arsenal: 10

Paris
Cabinet des Estampes de la Bibliothèque Nationale: 40, 45, 52, 139

Paris
Fondation Custodia, Institut Néerlandais: 53

Paris
Institut de France, Musee Jacquemart-André: 61

Paris
Musée du Louvre
 Département des Arts Graphiques: 130, 149, 150
 Département des Peintures: 136

Paris
Musée de Petit Palais: 117

Rotterdam
Museum Boymans-van Beuningen: 62

São Paulo
Museu de Arte: 3

Venice
Biblioteca Nazionale Marciana: 7

Venice
Gallerie dell'Accademia: 25, 28, 42

Vienna
Graphische Sammlung Albertina: 29, 38, 48, 58, 59, 76, 85, 92, 97, 103, 116, 125, 127, 141, 144, 145

Vienna
Kunsthistorisches Musem, Gemäldegalerie: 131, 132

Washington DC
National Gallery of Art: 15, 39, 57, 67b, 72, 99, 126, 140

and other owners who wish to remain anonymous

PHOTOGRAPHIC CREDITS

The exhibition organisers would like to thank all the people and institutions who made photographs available for the catalogue.

Amsterdam, Rijksmuseum-Stichting: cats. 22, 46

Berlin, Jörg P. Anders: cats. 4, 30, 33, 36, 41, 71, 100, 121, figs. 13, 49

Michael Bodycomb: cat. 51

Bologna, Antonio Guerra: cat. 16

Boston, Museum of Fine Arts: cats. 68, 77, 78, 138

City of Bristol Museum and Art Gallery: cat. 69

Cincinnati Art Museum: cat. 128

Correggio, Marco Ravenna: cat. 54

Prudence Cuming Associates Ltd: 31, 75, 79, 81, 118,120, 142, 143

Dublin, The National Gallery of Ireland: cats. 105, 122, 129

Florence, Archivi Alinari: figs. 1, 4, 6, 10, 12, 16, 46, 52, 54, 56, 57, 58, 60, 64, 66, 87, 89, 94, 110

Florence, Gabinetto Fotogragrafico, Soprintendenza Beni Artistici e Storici: cats. 9, 89, 90, 102, figs. 3, 9, 30, 31, 32, 76, 77, 78, 80, 109

Frankfurt, Städels Kunstinstitut: cat. 5, 50

The Hague, The Netherlands Office for Fine Arts: fig. 82

Hamburg © Elke Walford: cats. 18, 37, 88

Harvard University Art Museums, Photographic Services: cat. 20

Luiz Hossaka: cat. 3

London, The Trustees of The British Museum: cats. 2, 11, 24, 26, 32, 34, 43, 49, 73, 82, 84, 86, 87, 95, 124, 146, 147, 151, 152, 153, 154

London, Courtauld Institute, University of London, London: cat. 35, fig. 81

London, The National Gallery: cat. 135, figs. 84, 97, 103, 104

London, Royal Collection, St James's Palace. © Her Majesty The Queen: cats. 108, 109, 110, 111, 112, 113, 114, 115, fig. 100

London, Warburg Institute, University of London: figs. 91, 111

Madrid, Museo del Prado: cat.17

Malibu, J. Paul Getty Museum: 14, 56

Mantua, Archivio di Stato: fig. 8

Mantua, Giovetti Fotografia e communicazione visive: cats. 6, 64, fig. 90

Milan Museo Poldi Pezzoli: cat. 98

Milan, Soprintendenza Beni Artistici e Storici di Milano: figs. 25, 74

Montreal, MMFA, Christine Guest: cats. 133, 134

Munich, Staatliche Graphische Sammlung: cats. 44, 137

Naples, Pedicini,: cats. 13, 101

New York, Scott Bowron Photography: cat. 126

New York, Saratoga Springs Joseph Levy: cat. 19

New York, The Metropolitan Museum of Art: cats. 8, 12, 55, 65, 74, 93, 94

New York, The Trustees of the Pierpont Morgan Library: cat. 23

Oxford, Ashmolean Museum: cat. 80

Oxford, The Governing Body, Christ Church: cats. 96, 104

Paris, Bibliothèque Nationale, Service Photographique: cats. 40, 45, 52, 139

Paris Gerard Dufrene: cats. 106, 107

Paris Photographie Bulloz: fig. 53

Paris, Ecole Nationale Supérieure des Beaux-Arts: cat. 66

Paris, Fondation Custodia, Institut Néerlandais: cat. 53

Paris, Musée du Louvre, © Photo RMN: cats. 130, 136, 149, 150, figs. 2. 7. 59, 61, 63, 83, 93

Paris, Musée de la Ville de Paris © by SPADEM 1991: cat. 117

Paris, Photographie Giraudon: figs. 15, 50, 101

Hans Petersen: cat. 60

Rome, Biblioteca Apostolica Vaticana, Archivio Fotografico: fig. 62

Rome, Gabinetto Fotografico Nazionale: fig. 95

Rotterdam, Frequin Photos: cat. 62

Bob Rubic: cat. 123

Venice, Osvaldo Böhm: fig. 55

Vienna, Photobusiness/Meyer, Leopoldsdorf: cats. 131, 132

Washington DC, National Gallery of Art: cats. 15, 39, 57, 72, 99, 140

Windsor Castle, Royal Library, © 1991. Her Majesty The Queen: cats. 63, 91

Other photographs were provided by the owners of the works.

AGOSTI, 1990 G. Agosti, *Bambaia e il classicismo lombardo*, Turin, 1990.

ALBERTI, ed. 1966 L.B. Alberti, *L'architettura (De re aedificatoria)*, ed. G. Orlandi and P. Portoghesi, Milan, 1966.

ALBERTI, ed. 1972 L.B. Alberti, *De pictura*, ed. and trans. C. Grayson as *Leon Battista Alberti on Painting and Sculpture*, London, 1972.

ALEXANDER, 1969 J.J.G. Alexander, 'A Virgil illuminated by Marco Zoppo', *The Burlington Magazine*, CXI, 1969, pp. 541-5.

ALEXANDER, 1977 J.J.G. Alexander, *Italian Renaissance Illuminations*, London, 1977.

ALEXANDER, 1988 J.J.G. Alexander, 'Initials in Renaissance Illuminated Manuscripts', *Renaissance – und Humanistenhandschriften*, ed. J. Autenrieth, Munich, 1988, pp. 145-52.

ALEXANDER and DE LA MARE, 1969 J.J.G. Alexander and A.C. de la Mare, *The Italian Manuscripts in the Library of Major J. R. Abbey*, London, 1969.

AMADEI, 1955 F. Amadei, *Cronaca universale della città di Mantova*, ed. G. Amadei, E. Marini, L. Mazzoldi and G. Pratico, II, Mantua, 1955.

ANDERSON, 1988 J. Anderson, *La pittura in Italia: Il Cinquecento*, ed. G. Briganti, 2 vols, Milan, 1988.

ANDERSON, 1968 L. Anderson, 'Copies of Pollaiuolo's Battling Nudes', *The Art Quarterly*, XXXI, 1968, pp. 155-67.

ARMSTRONG, 1976 L. Armstrong, *The Paintings and Drawings of Marco Zoppo*, New York, 1976.

ARMSTRONG, 1981 L. Armstrong, *Renaissance Miniature Painters and Classical Imagery: The Master of the Putti and his Venetian Workshop*, London, 1981.

ARSLAN, 1961 E. Arslan, 'Il Mantegna a Mantova', *Commentari*, XII, 1961, pp. 163-75.

ASHMOLE, 1959 B. Ashmole, 'Cyriac of Ancona', *Proceedings of the British Academy*, XLV, 1959, pp. 25-43.

BANDERA BISTOLETTI, 1989 S. Bandera Bistoletti, *Il polittico di San Luca di Andrea Mantegna (1453-1454) in occasione del suo restauro*, Florence, 1989.

BANZATO and PELLEGRINI, 1989 D. Banzato and F. Pellegrini, *Da Giotto al tardogotico: Dipinti dei Musei Civici di Padova del Trecento e della prima metà del Quattrocento*, Rome, 1989.

BAROLSKY, 1978 P. Barolsky, *Infinite Jest: Wit and Humor in Italian Renaissance Art*, London, 1978.

BARTSCH, 1811 A. Bartsch, *Le peintre-graveur*, XIII: *Les vieux maîtres italiens*, Vienna, 1811; 2nd ed., Leipzig, 1866; 21 vols, Vienna, 1808-24; 2nd ed., Leipzig, 1854-76.

BASCHET, 1866 A. Baschet, *Ricerche di documenti d'arte e di storia negli archivi di Mantova ed analisi di lettere inedite relative ad Andrea Mantegna*, Mantua, 1866.

BASSI, 1971 P.A. Bassi, *The Labors of Hercules*, ed. K. Thompson, Barre, MA, 1971.

BATTISTI, 1965 E. Battisti, 'Il Mantegna e la letteratura classica', in *Arte, pensiero e cultura a Mantova nel Primo Rinascimento in rapporto con la Toscana e con il Veneto*, Atti del VI convegno internazionale di studi sul rinascimento, Florence, 1965, pp. 23-56.

BAUER-EBERHARDT, 1989 U. Bauer-Eberhardt, 'Lauro Padovano und Leonardo Bellini als Maler, Miniatoren und Zeichner', *Pantheon*, XLVII, 1989, pp. 49-83.

BAXANDALL, 1963 M. Baxandall, 'A Dialogue on Art from the Court of Lionello d'Este', *Journal of the Warburg and Courtauld Institutes*, XXVII, 1963, pp. 304-26.

BAXANDALL, 1964 M. Baxandall, 'Bartholomaeus Facius on Painting', *Journal of the Warburg and Courtauld Institutes*, XXVII, 1964, pp. 90-107.

BAXANDALL, 1965 M. Baxandall, 'Guarino, Pisanello and Manuel Chrysoloras', *Journal of the Warburg and Courtauld Institutes*, XXVIII, 1965, pp. 183-204.

BAXANDALL, 1971 M. Baxandall, *Giotto and the Orators: Humanist Observers of Painting in Italy and the Discovery of Pictorial Composition, 1350-1450*, Oxford, 1971.

BEAN, 1960 J. Bean, *Les dessins italiens de la collection Bonnat*, Paris, 1960.

BEGUIN, 1975 S. Béguin, 'Commentaires', *Laboratoire de recherche des musées de France: Annales*, 1975, pp. 29-34.

BELLINATI and PUPPI, 1975 C. Bellinati and L. Puppi, eds., *Padova: Basiliche e chiese*, Vicenza, 1975.

BENTINI, 1989 J. Bentini, *Disegni della Galleria Estense di Modena*, Modena, 1989.

BERENSON, 1894 B. Berenson, *The Venetian Painters of the Renaissance*, New York and London, 1894.

BERENSON, 1895 B. Berenson, *Lorenzo Lotto: An Essay in Constructive Art Criticism*, New York and London, 1895.

BERENSON, 1901, ed. 1920 B. Berenson, *The Study and Criticism of Italian Art*, London, 1901; 2nd ser., 1920.

BERENSON, 1907 B. Berenson, *The North Italian Painters of the Renaissance*, New York and London, 1907.

BERENSON, 1932 B. Berenson, *Italian Pictures of the Renaissance*, Oxford, 1932.

BERENSON, 1968 B. Berenson, *Italian Pictures of the Renaissance: Central and North Italian Schools*, London, 1968.

BERGER, 1883 A. Berger, 'Inventar der Kunstsammlung des Erzherzogs Leopold Wilhelm von Osterreich', *Jahrbuch der kunsthistorischen Sammlungen des allerhöchsten Kaiserhauses*, I, 1883, pp. LXXIX-CLXXVII.

BERTINI, 1881 G. Bertini, *Fondazione artistica Poldi Pezzoli: Catalogo generale*, Milan 1881.

BERTOLINI, 1930 E. Bertolini, *Le opere artistiche del principato di Correggio*, Reggio Emilia, 1930.

BERTOLOTTI, 1890 A. Bertolotti, *Figuli, fonditori e scultori in relazione con la corte di Mantova*, Milan, 1890.

BERZAGHI, 1989 R. Berzaghi, 'Tre dipinti e un nome per il "Maestro Orombelli" ', *Dal Correggio a Giulio Romano: La committenza di Gregorio Cortese*, ed. P. Piva and E. del Canto, Mantua, 1989.

BERZAGHI, 1990 R. Berzaghi, 'Francesco II e Vincenzo Gonzaga: Il Palazzo di San Sebastiano e il Palazzo Ducale', *Paragone*, n.s., XLI, 1990, pp. 62-73.

BIADEGO, 1890 G. Biadego, *Miscellanea della R. Dep. di Storia Patria*, XI, Venice, 1890.

BILLANOVICH, 1981 M.P. Billanovich, 'Bernardino da Parenzo pittore e Bernardino (Lorenzo) da Parenzo eremita', *Italia medioevale e umanistica*, XXIV, 1981, pp. 385-404.

BIONDO, ed. 1559 F. Biondo [Blondus], *Triumphantis Romae liber primus (-decimus)*, [Mantua, 1472?]; ed. cit., Basle, 1559.

BIONDO, 1549, repr. 1873 M.A. Biondo, *Della nobilissima pittura*, Venice, 1549; repr. as *Von der hochedlen Malerei*, ed. A. Ilg, Vienna, 1873.

BLUM, 1936 I. Blum, *Mantegna und die Antike*, Strasburg, 1936.

BOBER, 1964 P.P. Bober, 'An Antique Sea-Thiasos in the Renaissance', *Essays in Memory of Karl Lehmann*, *Marsyas*, Studies in the History of Art, Supplement I, ed. L. F. Sandler, New York, 1964, pp. 43-8.

BOBER and RUBINSTEIN, 1986 P.P. Bober and R. Rubinstein, *Renaissance Artists and Antique Sculpture: A Handbook of Sources*, London, 1986.

BOCCOLARI, 1987 G. Boccolari, *Le Medaglie di Casa d'Este*, Modena, 1987.

BODE, 1889 W. Bode, 'Die Bronzebuste des Battista Spagnoli im Koniglichen Museum zu Berlin, ein Werk mutmasslich des Gian Marco Cavalli', *Jahrbuch der Koniglich-preussischen Kunstsammlungen*, X, 1889, pp. 211-6.

BODE, 1898 W. Bode, *Beschreibendes Verzeichnis der Gemälde*, Berlin, 1898.

BODE, 1903-4 W. Bode, 'Mantegna und sein neuester Biograph', *Kunstchronik*, XV, 8, 1903-4, pp. 129-35.

BOECK, 1957 W. Boeck, review of E. Tietze-Conrat, *Mantegna*, in *Zeitschrift für Kunstgeschichte*, XX, 1957, pp. 196-207.

BOLOGNA, 1985 *Tre artisti nella Bologna dei Bentivoglio: Francesco del Cossa, Ercole Roberti, Niccolò dell'Arca*, exh. cat., Bologna, 1985.

BOLOGNA, 1988 *Bologna e l'umanesimo 1490-1510*, exh. cat., ed. M. Faietti and K. Oberhuber, Pinacoteca Nazionale, Bologna, 1988.

BORENIUS, 1913 T. Borenius, *A Catalogue of the Paintings at Doughty House Richmond and Elsewhere in the Collection of Sir Francis Cook Bt, 1: Italian Schools*, ed. H. Cook, London, 1913.

BORENIUS, 1923 T. Borenius, *Four Early Italian Engravers*, London, 1923.

BORENIUS, 1938 T. Borenius, ' "St. Jerome in the Wilderness" by Andrea Mantegna', *The Burlington Magazine*, LXXII, 1938, pp. 105-6.

BORSI, 1977 F. Borsi, *Leon Battista Alberti*, New York and London, 1977.

BORSOOK, 1975 E. Borsook, 'Fra Filippo Lippi and the Murals for Prato Cathedral', *Mitteilungen des kunsthistorischen Instituts in Florenz*, XIX, 1975, pp. 27ff.

BOSCHINI, 1664 M. Boschini, *Le minere della pittura*, Venice, 1664.

BOSCHINI, 1674 M. Boschini, *Le ricche minere della pittura veneziana*, Venice, 1674.

BOSCHINI ed. 1733 M. Boschini, *Descrizione de tutte le pubbliche pitture della città di Venezia*, ed. A. M. Zanetti, Venice, 1733.

BOSKOVITS, 1977 M. Boskovits, 'Una ricerca su Francesco Squarcione', *Paragone*, XXVIII, 325, 1977, pp. 40-70.

BOSSHARD, 1982 E.D. Bosshard, 'Tüchleinmalerei: eine billige Ersatztechnic?', *Zeitschrift für Kunstgeschichte*, XLV, 1982, p. 41.

BRAGHIROLLI, 1869 W. Braghirolli, 'Leon Battista Alberti a Mantova: Documenti', *Archivio storico italiano*, 3rd ser., IX, 1869, pp. 3-31.

BRAHAM 1973 A. Braham, 'A Reappraisal of "The Introduction of the Cult of Cybele at Rome" by Mantegna', *The Burlington Magazine*, CXV, 1973, pp. 457ff.

BRIQUET, 1907, repr. 1968 C.-M. Briquet, *Les Filigranes: Dictionnaire historique des marques du papier dès leur apparition vers 1282 jusqu'en 1600*, 4 vols, Geneva, 1907, repr. Amsterdam, 1968.

BROGI, 1989 A. Brogi, 'Lorenzo Garbieri: un "incamminato" fra romanzo sacro e romanzo nero', *Paragone*, XL, 471, 1989, pp. 3-25.

BROWN, 1968 C.M. Brown, 'The Church of S. Cecilia and the Bentivoglio Chapel in Bologna', *Mitteilungen des kunsthistorischen Instituts in Florenz*, XIII, 1968, pp. 317-24.
BROWN, 1969¹ C.M. Brown, 'Little-known and Unpublished Documents Concerning Andrea Mantegna, Bernardino Parentino, Pietro Lombardo … ', *L'Arte*, VI, 1969, pp. 140-64.
BROWN 1969² C.M. Brown, 'New Documents concerning Andrea Mantegna and a Note regarding "Jeronimus de Conradis pictor"', *The Burlington Magazine*, CXI, 1969, pp. 538-44.
BROWN 1969³ C.M. Brown, 'Comus, dieu des fêtes: Allégorie de Mantegna et de Costa pour le studiolo d'Isabella d'Este-Gonzague', *Gazette des Beaux-Arts*, XIX, 1969, pp. 31-8.
BROWN, 1972 C.M. Brown, 'New Documents for Mantegna's Camera degli Sposi', *The Burlington Magazine,* CXIV, 1972, pp. 861-3.
BROWN, 1973 C.M. Brown, 'Gleanings from the Gonzaga Documents in Mantua: Gian Cristoforo Romano and Andrea Mantegna', *Mitteilungen des kunsthistorischen Instituts in Florenz*, XVII, 1973, pp. 153-9.
BROWN, 1974 C.M. Brown, 'Andrea Mantegna and the Cornaro Family of Venice', *The Burlington Magazine*, CXVI, 1974, pp. 101-3.
BROWN, 1976 C.M. Brown, ' "Lo insaciabile desiderio nostro de cose antiche": New Documents on Isabella d'Este's Collection of Antiquities', *Cultural Aspects of the Italian Renaissance: Essays in Honor of Paul Oskar Kristeller*, ed. C. Clough, Manchester, 1976, pp. 324-53.
BROWN, 1982 C.M. Brown, *Isabella d'Este and Lorenzo da Pavia*, Paris, 1982.
BROWN, 1983 C.M. Brown, 'Cardinal Francesco Gonzaga's Collection of Antique Intaglios and Cameos: Questions of Provenance, Identification and Dispersal', *Gazette des Beaux-Arts*, 6th ser., CI, 1983, pp. 102-4.
BROWN with LORENZONI, 1977 and 1978
C.M. Brown, with A. M. Lorenzoni, 'The Grotta of Isabella d'Este', *Gazette des Beaux-Arts*, LXXXIX, 1977, pp. 155-71; XCI, 1978, pp. 72-82.
BROWN, 1987 D.A. Brown, *Andrea Solario*, Milan, 1987.
BRUN, 1876 C. Brun, 'Neue Dokumente über Andrea Mantegna', *Zeitschrift für bildenden Kunst*, XI, 1876, pp. 23-6.
BUCHANAN, 1824 W. Buchanan, *Memoirs of Painting*, London, 1824.
BYAM SHAW, 1927-8 J. Byam Shaw, 'Giovanni Bellini', *Old Master Drawings*, II, 1927-8, pp. 50-4.
BYAM SHAW, 1936-7 J. Byam Shaw, 'A Group of Mantegnesque Drawings, and their Relation to the Engravings of Mantegna's School', *Old Master Drawings*, XI, 1936-7, pp. 57-60.
BYAM SHAW, 1950 J. Byam Shaw, review of A. M. Hind, *Early Italian Engravings*, in *Connoisseur*, CXXV, 1950, pp. 58-60.
BYAM SHAW, 1952 J. Byam Shaw, 'A Giovanni Bellini at Bristol', *The Burlington Magazine*, XCIV, 1952, pp. 157-9; 'A Further Note on the Bristol Bellini', *ibid.*, p. 237.
BYAM SHAW, 1979 J. Byam Shaw, *Mantegna*, Biblioteca di Disegni, III, Florence, 1979, pp. 16-18.
CALMETA, 1959 V. Calmeta, *Prose e lettere edite e inedite …*, ed. C. Grayson, Bologna, 1959.
CAMESASCA, 1964 E. Camesasca, *Mantegna*, Milan, 1964.
CAMPBELL, 1990 L. Campbell, *Renaissance Portraits: European Portrait-Painting in the 14th, 15th and 16th Centuries*, London and New Haven, 1990.
CAMPORI, 1866 G. Campori, *Lettere artistiche inedite*, Modena, 1866.
CAMPORI, 1870 G. Campori, *Raccolta di cataloghi ed inventarii inediti*, Modena, 1870.
CANUTI, 1931 F. Canuti, *Il Perugino*, 2 vols, Siena, 1931.

CAPPEL, 1990 C.B. Cappel, *The Tradition of Pouncing Drawings in the Italian Renaissance Workshop: Innovation and Derivation*, Ph.D. diss., Yale University, New Haven, 1988, Michigan, 1990.
CARTWRIGHT, 1903, ed. 1915 J. Cartwright, *Isabella d'Este, Marchioness of Mantua, 1474-1539: A Study of the Renaissance*, New York 1903, ed. 1915.
CAST, 1981 D. Cast, *The Calumny of Apelles: A Study in the Humanist Tradition*, New Haven and London, 1981.
CENNINI, ed. 1960 C. Cennini, *The Craftsman's Handbook*, trans. D. V. Thompson, New York, 1960.
CHAMBERS, 1977 D.S. Chambers, 'Sant'Andrea at Mantua and Gonzaga Patronage', *Journal of the Warburg and Courtauld Institutes*, XL, 1977, pp. 99-127.
CHAMBERS, 1984 D.S. Chambers, 'Giovanni Pietro Arrivabene (1439-1504): Humanistic Secretary and Bishop', *Aevum*, III, 1984, pp. 397-438.
CHAMBERS, 1992 D.S. Chambers, *A Renaissance Cardinal and his Worldly Goods: Francesco Gonzaga (1444-83)*, London, 1992.
CHRISTIANSEN, 1982 K. Christiansen, *Gentile da Fabriano*, Ithaca, 1982.
CHRISTIANSEN, 1983 K. Christiansen, 'Early Renaissance Narrative Painting', *The Metropolitan Museum of Art Bulletin*, XLI, 1983.
CHRISTIANSEN, 1987¹ K. Christiansen, 'Venetian Painting of the Early Quattrocento', *Apollo*, CXXV, 1987, pp. 166-77.
CHRISTIANSEN, 1987² K. Christiansen, 'La pittura a Venezia e in Veneto nel primo Quattrocento', *La pittura in Italia, I: Il Quattrocento*, ed. F. Zeri, Milan, 1987, pp. 119-46.
CIPRIANI, 1962 R. Cipriani, *Tutta la pittura del Mantegna*, Milan, 1962.
CLARK, 1929-30 K. Clark, 'Andrea Mantegna', *Old Master Drawings*, IV, 1929-30, pp. 60-2.
CLARK, 1930 K. Clark, 'Italian Drawings at Burlington House', *The Burlington Magazine*, LVI, 1930, pp. 174-87.
CLARK, 1932 K. Clark, 'Giovanni Bellini or Mantegna?', *The Burlington Magazine*, LXI, 1932, pp. 232-5.
CLARK, 1956, ed. 1960 K. Clark, *The Nude: A Study of Ideal Art*, London 1956, 2nd ed. 1960.
CLARK, 1983 K. Clark, 'Mantegna and Classical Antiquity', in his *The Art of Humanism*, London, 1983, pp. 107-40.
CLOUGH, 1973 C. Clough, 'Renaissance Studies', *Apollo*, XCVII, 1973, pp. 533-6.
COLVIN, 1903-7 S. Colvin, *Drawings of the Old Masters in the University Galleries and in the Library of Christ Church*, Oxford, 3 vols, Oxford, 1903-7.
COLVIN, 1908-9 S. Colvin in *The Vasari Society for the Reproduction of Drawings by Old Masters*, 1st ser., IV, 6, 1908-9.
CONTI, 1988-9 A. Conti, 'Andrea Mantegna, Pietro Guindaleri ed altri maestri nel 'Plinio' di Torino', *Scritti in ricordo di Giovanni Previtali*, I, Florence, 1990, pp. 264-78 (this is a special volume of *Prospettiva*, no. 53-6, April 1988 – January 1989).
COOK, 1888 E.T. Cook, *A Popular Handbook to the National Gallery*, London, 1888.
COOK, 1960 R. M. Cook, *Greek Painted Pottery*, London, 1960.
CORDARO, 1987 M. Cordaro, 'Aspetti dei modi di esecuzione della "Camera Picta" di Mantegna', *Quaderni di Palazzo Te*, VI, 6, 1987, pp. 9-18.
CORMIO, 1951 S. Cormio, 'Il Cardinale Silvio Valenti Gonzaga promotore e protettore delle scienze e delle belle arti', *Bollettino d'Arte*, LXXI, 1951, pp. 49-63.
CORPUS, 1925 *Corpus Nummorum Italicorum, IX, Emilia 1a: Parma e Piacenza, Modena e Reggio*, Rome, 1925.
CROWE and CAVALCASELLE 1871, ed. 1912
J.A. Crowe and G.B. Cavalcaselle, *A History of Painting in North Italy*, 1871, ed. T. Borenius, II, London, 1912.

CUPPINI, 1981 M.T. Cuppini, 'L'Arte a Verona tra i secoli XV e XVI', *Verona e il suo territorio*, IV, 1981, pp. 243ff.
DAL POZZO, 1718 B. Dal Pozzo, *Le Vite de'pittori degli scultori, et architetti veronesi*, Verona, 1718.
DACOS, 1969 N. Dacos, *La découverte de la Domus Aurea et la formation des grotesques à la Renaissance*, London, 1969.
D'ARCO, 1827 C. D'Arco, *Monumenti di pittura e scultura trascelti in Mantova*, Mantua, 1827, pp. 7-8.
D'ARCO, 1857 C. D'Arco, *Delle arti e degli artefici di Mantova*, 2 vols, Mantua, 1857.
DAVIES, 1961 M. Davies, *The Earlier Italian Schools: National Gallery Catalogues*, London, 1961.
DEBOUT, 1975 M.-A. Debout, 'La représentation des Vices par Mantegna: L'Hermaphrodite à tête de singe', *La Revue du Louvre*, 3, 1975, pp. 227-330.
DE FABRICZY, 1888 C. de Fabriczy, 'Il Busto in rilievo di Mantegna attribuito allo Sperando', *Archivio Storico dell'Arte*, I, 1888, pp. 428-9
DEGENHART, 1966 B. Degenhart, *Disegni del Pisanello e di maestri del suo tempo*, Vicenza, 1966.
DEGENHART and SCHMITT, 1960 B. Degenhart and A. Schmitt, 'Gentile da Fabriano in Rom und die Anfänge des Antikenstudiums', *Münchner Jahrbuch der bildenden Kunst*, XI, 1960, pp. 59-146.
DEGENHART and SCHMITT, 1968 B. Degenhart and A. Schmitt, *Corpus der italienischen Zeichnungen, 1300-1450*, II, Berlin, 1968.
DEGENHART and SCHMITT, 1984 B. Degenhart and A. Schmitt, *Jacopo Bellini: The Louvre Album of Drawings*, New York, 1984.
DEGLI AGOSTINI, 1752 G. Degli Agostini, *Notizie istorico-critiche intorno la vita, e le opere degli scrittori viniziani, … 1752*, I, p. 132, no. XIV.
DELABORDE, 1875 H. Delaborde, *Le Département des estampes à la Bibliothèque Nationale: Notice historique, suivie d'un catalogue des estampes exposées dans les salles de ce département*, Paris, 1875.
DE LA MARE, 1984 A.C. de la Mare, 'The Florentine Scribes of Cardinal Giovanni of Aragon', *Il libro e il testo: Atti del convegno internazionale, Urbino, 1982*, ed. C. Questa and R. Raffaelli, Urbino, 1984, pp. 245-89.
DELBOURGO, RIOUX and MARTIN, 1975
S. Delbourgo, J.-P. Rioux and E. Martin, 'Etude analytique de la matière picturale', *Laboratoire de recherche des musées de France: Annales*, 1975, pp. 21-8.
DEL BRAVO, 1962 C. del Bravo, 'Sul séguito veronese di Andrea Mantegna', *Paragone*, XIII, 147, 1962, pp. 53-60.
DEL BRAVO, 1967 C. del Bravo, *Liberale da Verona*, Florence, 1967.
DELLA PERGOLA, 1963 P. della Pergola, 'Gli inventari Aldobrandini', *Arte antica e moderna*, VII, 1963, pp. 425ff.
DE NICOLO SALMAZO, 1987 A. De Nicolò Salmazo, 'La pittura rinascimentale a Padova', *La pittura in Italia, I: Il Quattrocento*, ed. F. Zeri, Milan, 1987.
DE NICOLO SALMAZO 1989 A. De Nicolò Salmazo, *Bernardino da Parenzo: Un pittore 'antiquario' di fine Quattrocento; Quaderno de Seminario di storia dell'arte moderno*, II, Padua, 1989.
DE NICOLO SALMAZO, 1990 A. De Nicolò Salmazo, 'Padova', *La pittura nel Veneto: Il Quattrocento*, Milan, 1990, II, pp. 481-540, 580-7.
DE RICCI, 1912 S. De Ricci, 'Le Mantegna de la Vente Weber', *Les Arts*, April 1912, p. 14.
DE RINALDIS, 1928 A. De Rinaldis, *Pinacoteca del Museo Nazionale di Napoli*, Naples, 1928.
DETROIT, 1985 *Italian Renaissance Sculpture in the Time of Donatello*, exh. cat., Detroit Institute of Arts, 1985.
DONATI, 1958 and 1959 L. Donati, 'Del mito di Zoan Andrea e di altri miti grandi e piccoli,' *Amor di libro*, VI, 1958, pp. 3-12, 97-102, 147-54, 231-6; VII, 1959, pp. 39-44, 84-8, 163-8; repr. *Biblioteca degli eruditi e dei bibliofili*, XXXVI, Florence, 1959.

DONESMONDI, 1616 I. Donesmondi, *Dell'istoria ecclesiastica di Mantova*, II, Mantua 1616.

D'ONOFRIO, 1964 C. D'Onofrio, 'Inventario dei dipinti del cardinal Pietro Aldobrandini compilato da G.B. Agucchi nel 1603', *Palatino*, 8, 1964, pp. 15-211.

DREYER, 1979 P. Dreyer, *I grandi disegni italiani del Kupferstichkabinett di Berlino*, Milan, 1979.

DREYER and WINNER, 1964 P. Dreyer and M.P. Winner, 'Der Meister von 1515 und das Bambaja-Skizzenbuch in Berlin', *Jahrbuch der Berliner Museen*, VI, 1964, pp. 53-94.

DUCHESNE, 1819, 1823 J. Duchesne, *Notice des estampes exposées à la Bibliothèque du Roi contenant des recherches historiques et critiques sur ces gravures et sur leurs auteurs*, Paris, 1819; 2nd ed., 1823.

DUCHESNE, 1826 J. Duchesne, *Essai sur les nielles, gravures des orfèvres florentines du XIVe siècle*, Paris, 1826.

DUCHESNE, 1837, ed. 1841 J. Duchesne, *Notice des estampes exposées à la Bibliothèque Royale, formant un aperçu historique des produits de la gravure*, 3rd ed., Paris, 1837, repr. 1841.

DUCHESNE, 1855 J. Duchesne, *Description des estampes exposées dans la galerie de la Bibliothèque Impériale formant un aperçu historique des productions de l'art et de la gravure*, Paris, 1855.

DUNCAN, 1906 E. Duncan, 'The National Gallery of Ireland,' *The Burlington Magazine*, X, 1906, pp. 7-23.

DUNKELMAN, 1980 M. Dunkelman, 'Donatello's Influence on Mantegna's Early Narrative Scenes', *Art Bulletin*, LXII, 1980, pp. 227-35.

EDGERTON, 1966 S. Edgerton, 'Alberti's Perspective: A New Discovery and a New Evaluation', *Art Bulletin*, XLVIII, 1966, pp. 367-79.

EISLER, 1989 C. Eisler, *The Genius of Jacopo Bellini: The Complete Paintings and Drawings*, New York, 1989.

EKSERDJIAN, 1989 D. Ekserdjian, review of R.W. Lightbown, *Mantegna*, in *The Burlington Magazine*, CXXXI, 1989, pp. 228-9.

ETTLINGER, 1972 L.D. Ettlinger, 'Hercules Florentinus', *Mitteilungen des kunsthistorischen Instituts in Florenz*, XVI, 1972, pp. 119-42.

ETTLINGER, 1978 L.D. Ettlinger, *Antonio and Piero Pollaiuolo*, Oxford and New York, 1978.

EVANS, 1983 M. Evans, 'Italian Manuscript Illumination, 1460-1560: 13. Eusebius, Chronica', in *Renaissance Painting in Manuscripts: Treasures from the British Library*, ed. T. Kren, New York, 1983, pp. 103-6.

FACCIOLI, 1962 E. Faccioli, *Mantova, Le lettere*, II, Mantua, 1962.

FAVA and SALMI, 1950 D. Fava and M. Salmi, *I manoscritti miniati della Biblioteca Estense di Modena*, 2 vols, Florence, 1950.

FELICIANO, ed. 1960 F. Feliciano Veronese, *Alphabetum Romanum*, ed. G. Mardersteig, Verona, 1960.

FIERA, 1515 B. Fiera, *Coena, Hymni divini, Silvae, Melanysius, Elegiae, Epigrammata, de iusticia pingenda*, Mantua, 1515.

FIERA, ed 1957 B. Fiera, ed. J. Wardrop, *De Iusticia Pingenda: On the Painting of Justice*, London, 1957.

FILANGIERI DI CANDIDA, 1902 A. Filangieri di Candida, 'La Galleria Nazionale di Napoli (Documenti e Richerche)', *Le Gallerie Nazionale Italiane*, V, 1902, pp. 297-9.

FIOCCO, 1927, repr. 1959 G. Fiocco, *L'Arte di Andrea Mantegna*, Bologna, 1927, repr., Venice, 1959.

FIOCCO, 1933 G. Fiocco, 'Mantegna o Giambellino?', *L'Arte*, n.s., IV, 1933, pp. 185-94.

FIOCCO, 1936 G. Fiocco, 'Andrea Mantegna e il Brunelleschi', *Atti del 1° Congresso N. di storia dell'architettura*, Rome, 1936, pp. 179-83.

FIOCCO, 1937 G. Fiocco, *Mantegna*, Milan, 1937.

FIOCCO, 1940 G. Fiocco, 'Andrea Mantegna scultore', *Rivista d'Arte*, XXII, 1940, pp. 224-8.

FIOCCO, 1954 G. Fiocco, 'Notes sur les dessins de Marco Zoppo', *Gazette des Beaux-Arts*, XLII, 1954, pp. 221-30.

FIOCCO, 1958 G. Fiocco, review of M. Meiss, *Andrea Mantegna as Illuminator*, in *Paragone*, IX, 99, 1958, pp. 55-8.

FIORIO, 1981 M.T. Fiorio, 'Marco Zoppo et le livre padouan', *Revue de l'Art*, LIII, 1981 pp. 65-73.

FIORIO, 1990 M.T. Fiorio, *Bambaia: Catalogo completo delle opere*, Florence, 1990.

FIORIO and GARBERI, 1987 M.T. Fiorio and M. Garberi, *La Pinacoteca del Castello Sforzesco*, Milan, 1987.

FLETCHER, 1991 J.M. Fletcher, 'The Painter and the Poet: Giovanni Bellini's Portrait of Raffaele Zovenzoni Rediscovered', *Apollo*, CXXXIV, 355, 1991, pp. 153-8.

FLORENCE, 1966 *I disegni del Pisanello e della sua cerchia*, exh. cat. by M. Fossi-Todorow, Galleria degli Uffizi, Florence, 1966.

FLORENCE, 1985, *Omaggio a Donatello, 1386-1986: Donatello e la storia del museo*, exh. cat., Museo Nazionale del Bargello, Florence, 1985.

FLORENCE, 1986¹, *Disegni italiani del tempo di Donatello*, exh. cat. by A. Angelini, Galleria degli Uffizi, Florence, 1986.

FLORENCE, 1986², *Donatello e i suoi*, exh. cat., Forte del Belvedere, Florence, 1986.

FLORENCE, 1986³, *L'Opera ritrovata: Omaggio a Rodolfo Siviero*, exh. cat., Palazzo Vecchio, Florence, 1986.

FLORENCE, 1990, *Pittura di Luce: Giovanni di Francesco e l'arte fiorentina di metà Quattrocento*, exh. cat., Casa Buonarroti, Florence, 1990.

FÖRSTER, 1887, 1894, 1922 R. Förster, 'Die Verleumden der Apelles in der Renaissance', *Jahrbuch der Königlich-preussischen Kunstsammlungen*, VIII, 1887, pp. 27-56, 89-113; XV, 1894, pp. 27-40; XLIII, 1922, pp. 126-33.

FÖRSTER, 1901 R. Förster, 'Studien zu Mantegna und den Bildern im Studierzimmer der Isabella Gonzaga', *Jahrbuch der Königlich-preussischen Kunstsammlungen*, XXII, 1901, pp. 78-87; 154-80.

FOSSI-TODOROW, 1962 M. Fossi-Todorow, 'Un taccuino di viaggi del Pisanello della sua bottega', *Scritti di storia dell'arte in onore di Mario Salmi*, Rome, 1962, pp. 133-61.

FOSSI-TODOROW, 1966 M. Fossi-Todorow, *I disegni del Pisanello e della sua cerchia*, Florence, 1966.

FRANKFURTER, 1939 A.M. Frankfurter, *Masterpieces of Art*, New York, 1939.

FREDERICKSEN, 1991 B. Fredericksen, 'Leonardo and Mantegna in the Buccleuch Collection', *The Burlington Magazine*, CXXXIII, 1991, pp. 116-8.

FREDERICKSEN and ZERI, 1972 B. Fredericksen and F. Zeri, *Census of Pre-Nineteenth-Century Italian Paintings in North American Public Collections*, Cambridge, MA, 1972.

FREY, 1923 K. Frey, *Der Literarische Nachlass Giorgio Vasaris*, Munich, 1923.

FRIZZONI, 1895 G. Frizzoni, in *Napoli Nobilissima*, IV, 1895, p. 24 ff.

FRIZZONI, 1916 G. Frizzoni, 'Un dipinto inedito di Andrea Mantegna nella Galleria Campori di Modena', *L'Arte*, XIX, 1916, pp. 65-9.

FRY, 1905 R. Fry, 'Mantegna as Mystic', *The Burlington Magazine*, VIII, 1905, pp. 87-98.

GARAVAGLIA, 1967 N. Garavaglia, '*L'Opera completa del Mantegna*, Milan 1976.

GASPAROTTO, 1979 C. Gasparotto, 'Alla origine del mito della tomba di Antenore', *Medioevo e Rinascimento Veneto, con altri studi in onore di Lino Lazzarini*, I: *Dal Duecento al Quattrocento*, Padua, 1979, pp. 3-12.

GAURICUS, 1503, (1504), ed. 1969 P. Gauricus, *De Sculptura*, 1504, ed. A. Chastel and R. Klein, Geneva, 1969.

GAYE, 1839 G. Gaye, *Carteggio inedito d'artisti dei secoli XIV, XV, XVI*, Florence,1839.

GEROLA, 1913 G. Gerola, *Le antiche pale di S. Maria in Organo di Verona*, Verona, 1913.

GEROLA, 1929 G. Gerola, 'Trasmigrazioni e vicende dei Camerini di Isabella d'Este', *Atti e memorie dell'Accademia virgiliana di Mantova*, XXI, 1929, pp. 253-90.

GIANNETTO, 1985 N. Giannetto, *Bernardo Bembo, umanista e politico veneziano*, Florence, 1985.

GILBERT, 1962 C. Gilbert, 'The Mantegna Exhibition', *The Burlington Magazine*, CIV, 1962, pp. 5-9.

GILBERT, 1968 C. Gilbert, review of J. Pope-Hennessy, *The Portrait in the Renaissance*, in *The Burlington Magazine*, CX, 1968, pp. 278-85.

GIOS, 1984 P. Gios, 'Aspetti di vita religiosa e sociale a Padova durante l'episcopato di Fantino Dandolo', *Riforma della chiesa, cultura e spiritualità nel Quattrocento Veneto: Atti del convegno per il VI centenario della nascità di Ludovico Barbo, 1382-1443, Padova, Venezia, Treviso, 1982*, ed. F.G. Trolese, Cesena, 1984.

GNOLI, 1971, ed. 1988 R. Gnoli, *Marmora Romana*, Rome, 1971, ed. 1988.

GOETHE, 1823 J.W. von Goethe, *Kunst und Altertum*, IV, i, ii, 1823, trans. by J. Gage as *Goethe on Art*, Berkeley, 1980, pp. 150-65.

GOETHE, ed. 1962 J.W. von Goethe, *Italienische Reise*, trans. W.H. Auden and E. Mayer, London 1962; repr. 1970.

GOFFEN, 1989 R. Goffen, *Giovanni Bellini*, New Haven and London, 1989.

GOLDNER, 1988 G.R. Goldner, *European Drawings I – Catalogue of the Collections, The J. Paul Getty Museum*, Malibu, 1988.

GOMBRICH, 1963 E.H. Gombrich, 'An Interpretation of Mantegna's "Parnassus" ', *Journal of the Warburg and Courtauld Institutes*, XXVI, 1963, pp. 196-8.

GOMBRICH, 1972 E.H. Gombrich, 'Icones Symbolicae', in his *Symbolic Images: Studies in the Art of the Renaissance*, II, Oxford, 1972, pp. 123-95.

GONZALEZ-PALACIOS, 1961 A. Gonzalez-Palacios, 'Sul dipinto n. 13 della mostra del Mantegna', *Paragone*, XII, 143, 1961, pp. 58-60.

GOULD, 1976 C.H.M. Gould, *The Paintings of Correggio*, Oxford and Ithaca, 1976.

GRAVES, 1913 A. Graves, *A Century of Loan Exhibitions, 1813-1912*, London, 1913.

GRAYSON, 1964 C. Grayson, 'Alberti's "costruzione legittima" ', *Italian Studies*, XIX, 1964, pp. 14-27.

GRONAU, 1949 H.D. Gronau, 'Ercole Roberti's "St. Jerome" ', *The Burlington Magazine*, XCI, 1949, pp. 243-4.

GUERRINI, 1937 P. Guerrini, *Memorie storiche della diocesi di Brescia*, Brescia, 1937.

GUNDERSHEIMER, 1972 W. Gundersheimer, *Art and Life at the Court of Ercole I d'Este: The 'De triumphis religionis' of Giovanni Sabadino degli Arienti*, Geneva, 1972.

GUNDERSHEIMER, 1973 W. Gundersheimer, *Ferrara: The Style of a Renaissance Despotism*, Princeton, 1973.

HADELN, 1925 D. von Hadeln, *Venezianische Zeichnungen des Quattrocento*, Berlin, 1925.

HADELN, 1932 D. von Hadeln, 'Giovanni Bellini or Mantegna?', *The Burlington Magazine*, LXI, 1932, pp. 229-30.

HAHNLOSER, 1962 H. Hahnloser, 'Pietro Calzettas Heiligblutaltar im Santo zu Padua, Niccolò Pizzolo und das Berner Hostienmühlefenster', *Scritte di storia dell'arte in onore di Mario Salmi*, Rome, 1962, pp. 377-93.

HALM, WEGNER and DEGENHART, 1958 P. Halm, W. Wegner and B. Degenhart, *Hundert Meisterzeichnungen aus der Staatlichen Graphischen Sammlung München*, Munich, 1958.

HARTT, 1940 F. Hartt, 'Carpaccio's "Meditation on the Passion" ', *Art Bulletin*, XXII, 1940, pp. 24-35.

HARTT, 1952 F. Hartt, 'Mantegna's "Madonna of the Rocks" ', *Gazette des Beaux-Arts*, XL, 1952, pp. 329-42.

HARTT, 1959 F. Hartt, 'The Earliest Works of Andrea del Castagno', *Art Bulletin*, XLI, 1959, pp. 159-81.

HEAWOOD, 1950 E. Heawood, *Watermarks, Mainly of the 17th and 18th Centuries*, Monumenta Chartae Papyraceae, Historiam Illustrantia, I, Hilversum, 1950.

HEINEMANN, 1962 F. Heinemann, *Giovanni Bellini e i Belliniani*, 2 vols, Venice, 1962.

HENDY, 1931 P. Hendy, *Catalogue of the Exhibited Paintings and Drawings*, The Isabella Stewart Gardner Museum, Boston, 1931.

HENDY, 1974 P. Hendy, *European and American Paintings in the Isabella Stewart Gardner Museum*, Boston, 1974.

HENNUS, 1950 M.F. Hennus, 'Frits Lugt, Kunstforser, Kunstkeurder, Kunstgaarder', *Maandblad voor Beeldende Kunsten*, XXVI, 1950, pp. 77-140.

HERMANN, 1967 F. Herman 'Who was Solly?: Part II, The Collector and his Collection', *Connoisseur*, CLXV, 1967, pp. 12-8.

HERMANN, 1909-10 H.J. Hermann, 'Pier Jacopo Alari-Bonacolsi, genannt Antico', *Jahrbuch der Kunsthistorischen Sammlungen des allerhöchsten Kaiserhauses*, XXVIII, 1909-10, pp. 201-88.

HERZNER, 1974 V. Herzner, review of L. Puppi, *Il trittico di Andrea Mantegna*, in *Art Bulletin*, LVI, 1974, pp. 440-42.

HERZNER, 1980 V. Herzner, 'Die "Judith" der Medici', *Zeitschrift für Kunstgeschichte*, XLIII, 1980, pp. 139-80.

HILL, 1930 G. Hill, *A Corpus of Italian Medals of the Renaissance Before Cellini*, London, 1930.

HIND, 1909-10 A.M. Hind, *Catalogue of Early Italian Engravings Preserved in the Department of Prints and Drawings in the British Museum*, ed. S. Colvin, 2 vols, London, 1909-10.

HIND, 1948 A.M. Hind, *Early Italian Engraving: A Critical Catalogue with Complete Reproduction of all the Prints Described*, 7 vols, vols I-IV, London, 1938, vols V-VII, London, 1948.

HIRSCHFELD, 1968 P. Hirschfeld, *Mäzene: Die Rolle des Auftraggebers in der Kunst*, Munich, 1968.

HOFFMANN, 1971 K. Hoffmann, 'Dürer's Darstellungen de Höllenfahrt Christi', *Zeitschrift des deutschen Vereins für Kunstwissenschaft*, XXV, 1971, pp. 75-106.

HOLBERTON, 1989 P. Holberton, *Poetry and Painting in the Time of Giorgione*, Ph.D. diss., Warburg Institute, University of London, 1989.

HOLMES, 1930 C. Holmes, 'The Italian Exhibition', *The Burlington Magazine*, LVI, 1930, pp. 55 ff.

HOPE, 1985 C. Hope, 'The Chronology of Mantegna's "Triumphs" ', *Renaissance Studies in Honor of Craig Hugh Smyth*, ed. A. Morrogh, F. Superbi Gioffredi, P. Morselli and E. Borsook, Florence, 1985, II, pp. 297-309.

HORSTER, 1953 M. Horster, 'Castagnos Fresken in Venedig un seine Werke der vierziger Jahre in Florenz', *Wallraf-Richartz-Jahrbuch*, XV, 1953, pp. 103-34.

HOURS, 1969 M. Hours, 'Etude comparative des radiographies d'œuvres de Costa et de Mantegna', *Gazette des Beaux-Arts*, XIX, 1969, pp. 39-42.

HOURS and FAILLANT, 1975 M. Hours and L. Faillant, 'Etude radiographique', *Laboratoire de recherche des musées de France: Annales*, 1975, pp. 5-20.

HUMFREY, 1983 P. Humfrey, *Cima da Conegliano*, Cambridge, 1983.

JACOBSEN, 1976 M.A. Jacobsen, 'The Engravings of Mantegna', Ph.D. diss., Columbia University, New York, 1976.

JACOBSEN, 1982 M. Jacobsen, 'The Meaning of Mantegna's "Battle of Sea Monsters" ', *Art Bulletin*, LXIV, 1982, pp. 623-9.

JANSON, 1957, repr. 1973 H.W. Janson, *The Sculpture of Donatello*, 2 vols, Princeton, 1957; repr. in *16 Studies*, New York, 1973, pp. 53-69.

JANSON, 1961 H. W. Janson, 'The Image Made by Chance', in *De artibus opuscula XL: Essays in Honor of Erwin Panofsky*, ed. M. Meiss, New York 1961, pp. 254-66.

JOANNIDES, 1987 P. Joannides, 'Masaccio, Masolino and "Minor" Sculpture', *Paragone*, XXXVIII, 451, 1987, pp. 3-24.

JONES, 1981 R. Jones, ' "What Venus Did with Mars": Battista Fiera and Mantegna's "Parnassus" ', *Journal of the Warburg and Courtauld Institutes*, XLIV, 1981, pp. 193-8.

JONES, 1987 R. Jones, 'Mantegna and Materials', *I Tatti Studies: Essays in the Renaissance*, II, Florence, 1987.

JOOST-GAUGIER, 1973 C. Joost-Gaugier, 'A Contribution to the Paduan style of Giovanni Francesco da Rimini', *Antichità viva*, XII, 3, 1973, pp. 7-12.

JOOST-GAUGIER, 1979 C. Joost-Gaugier, 'A Pair of Miniatures by a Panel Painter: The Earliest Works of Giovanni Bellini?', *Paragone*, XXX, 357, 1979, pp. 48-71.

KETTLEWELL, 1981 J. Kettlewell, *The Hyde Collection Catalogue*, Glens Falls, 1981.

KIMMELMAN, 1988 M. Kimmelman, 'A Mantegna Masterpiece at the Met', *The New York Times*, 24 June 1988, pp. C1, C24.

KLEINER, 1950 G. Kleiner, *Die Begegnungen Michelangelos mit der Antike*, Berlin, 1950.

KNABENSHUE, 1959 P.D. Knabenshue, 'Ancient and Mediaeval Elements in Mantegna's "Trial of St. James" ', *Art Bulletin*, XLI, 1959, pp. 59-73.

KNAPP, 1910 F. Knapp, *Andrea Mantegna: Des Meisters Gemälde und Kupferstiche*, Klassiker der Kunst, Stuttgart and Leipzig, 1910.

KNOX, 1978 G. Knox, 'The Camerino of Francesco Corner', *Arte Veneta*, XXXII, 1978, pp. 79-84.

KOKOLE, 1990 S. Kokole, 'Notes on the Sculptural Sources for Giorgio Schiavone's Madonna in London', *Venezia Arti*, IV, 1990, pp. 50-6.

KOOPMAN, 1891 W. Koopman, 'Einige weniger bekannte Handzeichnungen Raffaels', *Jahrbuch der preussischen Kunstsammlungen*, XII, 1891, pp. 40-9.

KOSCHATZKY, OBERHUBER and KNAB, 1971 W. Koschatzky, K. Oberhuber and E. Knab, *I grandi disegni italiani dell'Albertina di Vienna*, Milan, 1971.

KRISTELLER, 1901 P. Kristeller, *Andrea Mantegna*, London, 1901.

KRISTELLER, 1902 P. Kristeller, *Andrea Mantegna*, Berlin and Leipzig, 1902.

KRISTELLER, 1909 P. Kristeller, 'Francesco Squarcione e le sue relazioni con Andrea Mantegna', *Rassegna d'Arte*, IX, 10, 1909, pp. iv-v; 11, 1909, pp. iv-v.

KRISTELLER, 1911-12 P. Kristeller, 'Zwei dekorative Gemälde Mantegnas in der Wiener Kaiserlichen Galerie', *Jahrbuch der kunsthistorischen Sammlungen des allerhöchsten Kaiserhauses*, XXX, 1911-12, pp. 29-48.

KRISTELLER 1921 P. Kristeller, 'Giovanni Antonio da Brescia', *Thieme–Becker*, XIV, Leipzig, 1921.

KURZ, 1948 O. Kurz, *Fakes: A Handbook for Collectors and Students*, London, 1948.

KURZ, 1959 O. Kurz, 'Sannazaro and Mantegna', *Studi in onore di Riccardo Filangieri*, II, Naples, 1959, pp. 277-83.

LACLOTTE, 1956 M. Laclotte, 'Peintures italiennes des XIVᵉ siècles à l'Orangerie', *Arte Veneta*, X, 1956, pp. 225-37.

LACLOTTE, 1962 M. Laclotte, 'Mantegna et Crivelli', *L'Oeil*, 85, January 1962, pp. 28-36, 92-3.

LA FARGE and JACCACI, 1907 J. La Farge and A. Jaccaci, *Noteworthy Paintings in American Collections*, New York, 1907.

LAFENESTRE, 1914 G. Lafenestre in *Le Musée Jacquemart-André*, Milan, 1914.

LAMOUREUX, 1979 R.E. Lamoureux, *Alberti's Church of San Sebastiano in Mantua*, New York, 1979.

LANDAU, 1979 D. Landau, 'Primitive italiani – note da Oxford/Early Italians – notes from Oxford', *Print Collector/Il Conoscitore di stampe*, III, 42, 1979, pp. 2-9.

LANDSBERGER, 1952-3 F. Landsberger, 'A New Interpretation of an Old Picture (Andrea Mantegna: Esther and Mordecai)', *Cincinnati Art Museum Bulletin*, n.s., I, 1952-3, pp. 2-4.

LANGEDIJK, 1981 K. Langedijk, *The Portraits of the Medici: 15th-18th Centuries*, Florence, 1981.

LAW, 1921 E. Law, *Mantegna's Triumph of Julius Caesar*, London, 1921.

LAZZARINI and MOSCHETTI, 1908 V. Lazzarini and A. Moschetti, *Documenti relativi alla pittura padovana del secolo XV*, Venice, 1908, pp. 123-70.

LEHMANN, 1973 P. and C. Lehmann, *Samothracian Reflections: Aspects of the Revival of the Antique*, Princeton, 1973.

LEITHE-JASPER, 1986 M. Leithe-Jasper, *Renaissance Master Bronzes from the Collection of the Kunsthistorisches Museum Vienna*, Washington, DC, 1986.

LEMOISNE, 1909 P.A. Lemoisne, *Catalogue raisonné de la collection Martin le Roy*, Paris, 1909.

LEONCINI, 1987 L. Leoncini, 'Storia e fortuna del cosidetto Fregio di S. Lorenzo', *Xenia*, XIV, 1987, pp. 59-110.

LEONCINI, 1988 L. Leoncini, 'Il codice Destailleur Oz III: Avvio ad uno studio critico', *Xenia*, XVI, 1988, pp. 73-94.

LEVI D'ANCONA, 1964 M. Levi d'Ancona, 'Postille a Girolamo da Cremona', *Studi di bibliografia e di storia in onore di Tannaro de Marinis*, III, 1964, pp. 45-104.

LIEBENWEIN, 1988 W. Liebenwein, *Studiolo: Storia e topologia di uno spazio culturale*, 1988.

LIGHTBOWN, 1978 R.W. Lightbown, *Sandro Botticelli: His Life and Work*, 2 vols, London, 1978.

LIGHTBOWN, 1986 R.W. Lightbown, *Mantegna*, Oxford, Berkeley and Los Angeles, 1986.

LIPTON, 1974 D. Lipton, *Francesco Squarcione*, Ph.D. diss., Institute of Fine Arts, New York, 1974.

LOMAZZO, 1584 G.P. Lomazzo, *Trattato dell'arte della pittura, scultura ed architettura*, 1584, ed.,1844.

LONDON, 1930-31 *Italian Drawings Exhibited at the Royal Academy, Burlington House*, 1930; commemorative exh. cat. by A. E. Popham, London 1930, Oxford, 1931.

LONDON, 1953 *Drawings by Old Masters*, exh. cat. by K. T. Parker and J. Byam Shaw, Royal Academy of Arts, London, 1953.

LONDON, 1958 *Catalogue of the well-known Collection of Old Master Drawings Principally of the Italian School formed in the 18th century by John Skippe, now the Property of Edward Holland Martin Esq.*, sale cat. by A. E. Popham, Christie's, London, 20 and 21 November 1958.

LONDON, 1972-3 *Drawings by Michelangelo, Raphael and Leonardo and their Contemporaries*, exh. cat., The Queen's Gallery, London, 1972-3.

LONDON, 1976 *Catalogue of Highly Important Old Master Drawings from the Gathorne-Hardy Collection: Part I of the Italian and French Schools*, sale cat., Sotheby's, London, 28 April 1976.

LONDON, 1980 *The Hatvany Collection*, sale cat., Christie's, London, 24 June 1980.

LONDON, 1981 *Splendours of the Gonzaga*, exh. cat., ed. D. Chambers and J. Martineau, Victoria and Albert Museum, London, 1981.

LONDON, 1984¹ *Old Master Drawings from Chatsworth*, sale cat., Christie's, London, 3 July 1984.

LONDON, 1984² *From Borso to Cesare d'Este: The School of Ferrara 1450-1628*, exh. cat., Matthiesen Ltd, London, 1984; Italian ed., 1985.

LONDON, 1985 *Masterpieces from the National Gallery of Ireland*, exh. cat., National Gallery, London, 1985.

LONDON, 1987 *100 Masterpieces from the Courtauld Collections: Bernardo Daddi to Ben Nicholson*, ed. D. Farr, Courtauld Institute, London, 1987.

LONDON, 1990 *Old Master Drawings*, sale cat., Christie's, London, 3 July 1990.

LONDON and NEW YORK, 1967 *Drawings from the National Gallery of Ireland*, exh. cat., Wildenstein, London and New York, 1967.

LONGHI, 1926, 1967 R. Longhi, 'Lettera pittorica a Giuseppe Fiocco', *Vita artistica*, I, 1926, pp. 127-39; repr. in *Opere complete di Roberto Longhi*, II, Florence, 1967, pp. 77-98.

LONGHI, 1927 R. Longhi, 'Un chiaroscuro e un disegno di Giovanni Bellini', *Vita Artistica*, II, 1927, pp. 133-8.

LONGHI, 1934, 1968 R. Longhi, 'Risarcimento di un Mantegna', *Pan*, II, 1934, pp. 504-12; repr. in *Me pinxit e Quesiti caravaggeschi*, Florence, 1968, pp. 67-73.

LONGHI, 1962, 1978 R. Longhi, 'Crivelli e Mantegna: Due mostre interferenti e la cultura artistica nel 1961', *Paragone*, n.s., XIII, 145, 1962, pp. 7-21; repr. in *Ricerche sulla pittura veneta, 1946-1969*, Florence, 1978, pp. 143-55.

LONGHI, 1956, repr. 1968 R. Longhi, 'Nuovi ampliamenti dell'Officina Ferrarese', 1956; repr. in *Opere complete di Roberto Longhi*, V, Florence, 1956; repr. in 1968.

LOS ANGELES, 1976 *Old Master Drawings from American Collections*, exh. cat. by E. Feinblatt, Los Angeles County Museum of Art, Los Angeles and New York, 1976.

LUCCO, 1990 M. Lucco, 'Padova', in *La pittura nel Veneto: Il Quattrocento*, Milan, 1990, pp. 80-101.

LUZIO, 1888 A. Luzio, 'Giulio Campagnola fanciullo prodigio', *Archivio storico dell'arte*, I, 1888, pp. 184-5.

LUZIO, 1908¹ A. Luzio, 'Isabella d'Este e il Sacco di Roma', *Archivio storico lombardo*, X, 1908, pp. 413-24.

LUZIO, 1908² A. Luzio, 'L'Inventario della Grotta d'Isabella d'Este', *Archivio storico lombardo*, ser. 4, X, 1908, pp. 413-25.

LUZIO, 1909 A. Luzio, 'Isabella d'Este and Giulio II', *Rivista d'Italia*, XII, 12, 1909, pp. 837-76.

LUZIO, 1913 A. Luzio, *La Galleria dei Gonzaga venduta all'Inghilterra nel 1627-8*, Milan, 1913, repr. Rome, 1974.

LUZIO and PARIBENI, 1940 A. Luzio and A. Paribeni, *Il Trionfo di Cesare di Andrea Mantegna*, Rome, 1940.

LUZIO and RENIER, 1890 A. Luzio and R. Renier, 'Il Filelfo e l'Umanesimo alla Corte dei Gonzaga', *Giornale storico della letteratura Italiana*, XVI, 1890, pp. 119-217.

LUZIO and RENIER, 1893 A. Luzio and R. Renier, *Mantova e Urbino: Isabella d'Este ed Elisabetta Gonzaga nelle relazioni famigliari e nelle vicende politiche*, Turin, 1893.

M'CORMICK, 1926 W. M'Cormick, 'America has a new Andrea Mantegna', *International Studio*, LXXXIII, 1926, pp. 62-3.

MADRID, 1986-7 *Dibujos de los siglos XIV al XX: Colección Woodner*, exh. cat., Museo del Prado, Madrid, 1986-7.

MADSEN, 1904 K. Madsen, *Fortegnelse over den Kgl. Malerisamlings*, Copenhagen, 1904.

MANCA, 1989 J. Manca, 'The Presentation of a Renaissance Lord: Portraiture of Ercole I d'Este, Duke of Ferrara (1471-1505)', *Zeitschrift für Kunstgeschichte*, LII, 1989, pp. 522-38.

MANCINI, 1911 G. Mancini, *Vita di Leon Battista Alberti*, Rome, 1911.

MANDALARI, 1893 M. Mandalari, *Saggio di un canzoniere anonimo della Biblioteca Alessandrina …* , Rome, 1893.

MANSUELLI, 1958 G.A. Mansuelli, *Le Gallerie degli Uffizi: Le sculture*, I, Rome, 1958.

MANTUA 1961 *Andrea Mantegna*, exh. cat. by G. Paccagnini with A. Mezzetti and M. Figlioli, Palazzo Ducale, Mantua, 1961.

MANTUA, 1989 *Giulio Romano*, exh. cat., ed. S. Polano, Palazzo Te, Mantua, 1989.

MARANI and PERINA, 1961 E. Marani and C. Perina, *Mantova, Le Arti*, II, Mantua, 1961.

MARCHINI, 1975 G. Marchini, *Filippo Lippi*, Milan, 1975.

MARCON, 1987 S. Marcon, 'Umanesimo veneto e calligrafia monumentale: codici nella biblioteca di San Marco', *Lettere Italiane*, 1987, pp. 252-81.

MARCON, 1988 S. Marcon, in *Biblioteca Marciana Venezia*, ed. M. Zorzi et al., Le grandi biblioteche d'Italia, Florence, 1988, p. 152.

MARDERSTEIG, 1939 H. Mardersteig, 'Nuovi documenti su Felice Feliciano da Verona', *La Bibliofila*, XLI, 1939, pp. 102-10.

MARIACHER, 1957 G. Mariacher, *Il Museo Correr di Venezia: Dipinti dal XIV al XVI secolo*, Venice, 1957.

MARIANI CANOVA, 1969 G. Mariani Canova, *La Miniatura veneta del Rinascimento*, Venice, 1969.

MARINELLI, 1990 S. Marinelli, 'Verona', *La pittura nel Veneto: Il Quattrocento*, Milan, 1990, pp. 622-53.

MARKHAM SCHULZ, 1983 A. Markham Schulz, *Antonio Rizzo: Sculptor and Architect*, Princeton, 1983.

MARTELLOTTI, 1965 G. Martellotti, 'Barzizza, Gasparino', *Dizionario biografico degli italiani*, VII, 1965, pp. 34-9.

MARTIN, 1900 H. Martin, 'Sur un portrait de Jacques-Antoine Marcello', *Mémoires et bulletin de la société nationale des antiquaires de France*, 6th ser., IX, 1900, pp. 229-67.

MARTIN and LAUER, 1929, H. Martin and P. Lauer, *Les Principaux Manuscrits à peintures de la Bibliothèque de l'Arsenal*, Paris, 1929.

MARTINDALE, 1979 A. Martindale, *The Triumphs of Caesar by Andrea Mantegna in the Collection of H. M. The Queen at Hampton Court*, London, 1979.

MASSING, 1977, J.M. Massing, 'Jacobus Argentoratensis: Etude preliminaire', *Arte veneta*, XXXI, 1977, pp. 42-52.

MASSING, 1990¹, J.M. Massing, ' "The Triumph of Caesar" by Benedetto Bordon and Jacobus Argentoratensis: Its Iconography and Influence', *Print Quarterly*, VII, pp. 2-21.

MASSING, 1990², J.M. Massing, *Du texte à l'image: La calomnie d'Apelle et son iconographie*, Strasburg, 1990.

MATTEUCCI, 1902 V. Matteucci, *Le chiese artistiche del Mantovano*, I, Mantua, 1902, p. 136.

MAZZOLDI, 1961 L. Mazzoldi, *Mantova: La Storia*, Mantua, 1961.

MEISS, 1951 M. Meiss, *Painting in Florence and Siena after the Black Death*, Princeton, 1951.

MEISS, 1954 M. Meiss, ' "Ovum Struthionis": Symbol and Allusion in Piero della Francesca's Montefeltro Altarpiece', *Studies in Art and Literature for B. da Costa Greene*, Princeton, 1954, pp. 92-101; repr. in *The Painter's Choice: Problems in the Interpretation of Renaissance Art*, New York, 1976, pp. 105-29.

MEISS, 1957 M. Meiss, *Andrea Mantegna as Illuminator: An Episode in Renaissance Art, Humanism and Diplomacy*, New York, 1957.

MEISS, 1960, 1976 M. Meiss, 'Toward a More Comprehensive Renaissance Palaeography', *Art Bulletin*, XLII, 1960, pp. 97-112; repr. in *The Painter's Choice: Problems in the Interpretation of Renaissance Art*, New York, 1976, pp. 151-75.

MEISS, 1966, 1976 M. Meiss, 'Sleep in Venice: Ancient Myths and Renaissance Proclivities', *Proceedings of the American Philosophical Society*, CX, 1966, pp. 348-82; repr. in *The Painter's Choice: Problems in the Interpretation of Renaissance Art*, New York, 1976, pp. 212-39.

MEISS, 1976 M. Meiss, 'Alphabetical Treatises in the Renaissance', *The Painter's Choice: Problems in the Interpretation of Renaissance Art*, New York, 1976.

MELLINI and QUINTAVALLE, 1962 G.L. Mellini and A.C. Quintavalle, 'In margine alla Mostra del Mantegna', *Critica d'arte*, IX, 52, 1962, pp. 1-20.

MENDELSOHN, 1909 H. Mendelsohn, *Fra Filippo Lippi*, Berlin, 1909.

MEYER ZUR CAPELLEN, 1985 J. Meyer zur Capellen, *Gentile Bellini*, Stuttgart, 1985.

MEZZETTI, 1958 A. Mezzetti, 'Un "Ercole e Anteo" del Mantegna', *Bollettino d'arte*, 4th ser., XLIII, 1958, pp. 232-44.

MIDDELDORF, 1978 U. Middeldorf, 'On the Dilettante Sculptor', *Apollo*, CVII, 1978, pp. 310-22.

MILAN, 1987 *Da Raffaello a Goya … da Van Gogh a Picasso: 50 dipinti dal Museu de Arte di San Paolo del Brasile*, exh. cat. by E. Camesasca, Palazzo Reale, Milan, 1987.

MILAN, 1991 Milan, *Le Muse e il Principe: Arte di corte nel Rinascimento padano*, exh. cat., ed. M. Natale, Museo Poldi Pezzoli, Milan, 1991.

MILLAR, 1960 O. Millar, 'Abraham van der Doort's Catalogue of the Collections of Charles I', *Walpole Society*, XXXVII, 1960.

MILLAR, 1972 O. Millar, 'The Inventories and Valuations of the King's Goods, 1649-1651', *Walpole Society*, XLIII, 1972.

MITCHELL, 1961 C. Mitchell, 'Felice Feliciano Antiquarius', *Proceedings of the British Academy*, XLVII, 1961, pp. 197-223.

MÖHLE, 1959 H. Möhle, review of Halm, Degenhart and Wegner, *Hundert Meisterzeichnungen aus der Staatlichen Graphischen Sammlung München*, *Zeitschrift für Kunstgeschichte*, XXII, 1959, pp. 167-70.

MOLTESEN, 1924-5 E. Moltesen, 'Fire Italienske Billeder I Dansk Eje', *Kunstmuseets Årsskrift*, XI-XII, 1924-5, pp. 75-116.

MOMMSEN, 1952, repr. 1969 T.E. Mommsen, 'Petrarch and the Decoration of the Sala Virorum Illustrium in Padua', *Art Bulletin*, XXXIV, 1952, pp. 95-116; repr. in *Medieval and Renaissance Studies*, ed. E. Rice Jnr., Padua 1969.

MONGAN and SACHS, 1940 A. Mongan and P.J. Sachs, *Drawings in the Fogg Museum of Art*, 3 vols, Cambridge, MA, 1940.

MONGAN, OBERHUBER and BOBER, 1988 A. Mongan, K. Oberhuber and J. Bober, *I grandi disegni italiani del Fogg Art Museum di Cambridge*, Milan, 1988.

MONOD, 1923 G. Monod, 'La Galerie Altman au Metropolitan Museum de New-York', *Gazette des Beaux-Arts*, per. VIII, LXV, 1923, pp. 179ff.

MONTREAL, 1979 *The Art of Connoisseurship*, exh. cat., Museum of Fine Arts, Montreal, 1979.

MORELLI, 1880 G. Morelli (I. Lermolieff), *Die Werk Italienischer Meister in den Galerien von München, Dresden und Berlin*, Leipzig, 1880.

MORELLI, 1883 G. Morelli, *Italian Masters in German Galleries: A Critical Essay on the Italian Pictures in the Galleries of Munich, Dresden and Berlin*, London, 1883.

MORELLI, 1890 G. Morelli (I. Lermolieff), *Kunstkritische Studien über Italienische Malerei*, Leipzig, 1890.

MORELLI, 1891 G. Morelli (I. Lermolieff), *Kunstkritische Studien über Italienische Malerei: Die Galerien zu München und Dresden*. Leipzig, 1891.

MORELLI, 1892-3, 1900, 1907 G. Morelli, *Critical Studies of Italian Painters*, 2 vols, London, 1892-3; 2nd imp., vol. I, 1900; vol. II, 1907.

MORETTI, 1958 L. Moretti, 'Di Leonardo Bellini pittore e miniatore', *Paragone*, IX, 99, 1958, pp. 58-66.

MOSCHETTI, 1929-30 A. Moschetti, 'Le iscrizioni lapidarie romane negli affreschi del Mantegna agli Eremitani', *Atti dell'Istituto veneto*, LXXIX, I, 1929-30, pp. 227-39.

MOSCHINI, 1815 G. Moschini, *Guida di Venezia*, Venice, 1815.

MOSCHINI, 1817 G. Moschini, *Guida per la città di Padova*, Venice, 1817.

MOSCHINI-MARCONI 1955 S. Moschini-Marconi, *Gallerie dell'Accademia di Venezia: Opere d'arte dei secoli XIV e XV*, Rome, 1955.

MUNICH, 1983 *Zeichnungen aus der Sammlung des Kurfürsten Carl Theodor*, exh. cat. by R. Harprath *et.al.*, Staatliche Graphische Sammlung München, Neue Pinakothek, Munich, 1983.

MUNICH, 1986 *Meisterzeichnungen aus sechs jahrhunderten: Die Sammlung Ian Woodner*, exh. cat., Haus der Kunst, Munich, 1986.

MÜNTZ 1889 E. Müntz, 'Le arti in Roma', *Archivio storico dell'arte*, II, pp. 478-85.

MURARO, 1959 M. Muraro, 'A Cycle of Frescoes by Squarcione in Padua', *The Burlington Magazine*, CI, 1959, pp. 89-96.

MURARO, 1966 M. Muraro, 'Donatello e Squarcione', *Donatello e il suo tempo*, exh. cat., Galleria degli Uffizi, Florence, 1966, pp. 387-99.

MURARO, 1974 M. Muraro, 'Francesco Squarcione Pittore "Umanista" ', *Da Giotto al Mantegna*, exh. cat., ed. L. Grossato, Palazzo del Ragione, Padua, 1974, pp. 70-2.

NATALE, 1982 M. Natale, *Museo Poldi Pezzoli: Dipinti*, Milan, 1982.

NEWBERY, BISACCA and KANTER, 1990 T. J.Newbery, G. Bisacca and L. Kanter, *Italian Renaissance Frames*, New York, 1990.

NEW YORK, 1965 *Drawings from New York Collections, 1: The Italian Renaissance*, exh. cat. by J. Bean and F. Stampfle, The Metropolitan Museum of Art, New York, 1965.

NEW YORK, 1985 *Drawings from the Collection of Mr and Mrs Eugene Victor Thaw, Part II*, exh. cat. with introductions by E. V. Thaw and C. Ryskamp, Pierpont Morgan Library, New York, 1985.

NEW YORK, 1988 *Painting in Renaissance Siena, 1420-1500*, exh. cat., The Metropolitan Museum of Art, New York, 1988.

NICCOLÒ DA CORREGGIO, ed. 1969 N. da Correggio, *Opere: Cefalo, Psiche, Silva, Rime*, ed. A. Tissoni-Benvenuti, Bari, 1969.

NOGARA, 1927 B. Nogara, *Scritti inediti e rari di Biondo Flavio*, Studi e testi, 48, Rome, 1927.

NORTHAMPTON, 1979 *Antiquity in the Renaissance*, exh. cat. by W. S. Sheard, Smith College Museum of Art, Northampton, MA, 1979.

NOTTINGHAM and LONDON, 1983 *Drawing in the Italian Renaissance Workshop*, exh. cat. by F. Ames-Lewis and J. Wright, University Art Gallery, Nottingham, and Victoria and Albert Museum, London, 1983.

OBERHAMMER, 1960 V. Oberhammer, *Katalog der Gemäldegalerie, 1: Italiener, Spanier, Franzosen, Engländer*, Vienna, 1960.

OBERHUBER, 1966 K. Oberhuber, 'Eine unbekannte Zeichnung Raffaels in den Uffizien', *Mitteilungen des kunsthistorischen Instituts in Florenz*, XII, 1966, pp. 225-44.

OBERHUBER, 1970 K. Oberhuber, 'Neuentdeckungen', *Albertina Informationen*, III, 4, 1970, p. 6.

OLSCHKI, 1912-21 L. Olschki, *I disegni della R. Galleria degli Uffizi in Firenze*, 5 series of 4 parts each, Florence, 1912-21.

OLSEN, 1951 H. Olsen, 'Et Malet Galleri af Pannini: Kardinal Silvio Valenti Gonzagas Samling', *Kunstmuseets Årsskrift*, XXVIII, 1951, pp. 90-104.

OLSEN, 1961 H. Olsen, *Italian Pictures and Sculpture in Denmark*, Copenhagen, 1961.

OTTLEY, 1816 W.Y. Ottley, *An Inquiry into the Origin and Early History of Engraving*, 2 vols, London, 1816.

OXFORD, 1988 *Duke Humfrey's Library and the Divinity School 1488-1988*, exh. cat. by A. C. de la Mare and S. Gillam, Bodleian Library, Oxford, 1988.

PACCAGNINI, 1969 G. Paccagnini, *Il Palazzo Ducale di Mantova*, Turin, 1969.

PACCHIONI, 1915 G. Pacchioni, 'Belbello da Pavia e Gerolamo da Cremona, miniatori', *L'Arte*, XVIII, 1915, pp. 343-72.

PADUA, 1974 *Da Giotto a Mantegna*, exh. cat., ed. L. Grossato, Palazzo della Ragione, Padua, 1974.

PADUA, 1976 *Dopo Mantegna: arte a Padova e nel territorio nei secoli XV e XVI*, exh. cat., Palazzo della Ragione, Padua, 1976.

PALLUCCHINI, 1971 R. Pallucchini, *I Vivarini: Antonio, Bartolomeo, Alvise*, Vicenza, 1971.

PANOFSKY, 1927 E. Panofsky, 'Imago Pietatis', *Festschrift für Max J. Friedlaender*, Leipzig, 1927, pp. 261-308.

PANOFSKY, 1956¹ D. Panofsky and E. Panofsky, *Pandora's Box: The Changing Aspects of a Mythical Symbol*, New York, 1956.

PANOFSKY, 1956² E. Panofsky, 'Jean Hey's "Ecce Homo": Speculations about its Author, its Donor and its Iconography', *Musées Royaux des Beaux-Arts Bulletin*, V, 1956, pp. 95-138.

PANOFSKY, 1960, repr. 1969, 1972 E. Panofsky, *Renaissance and Renascences in Western Art*, Stockholm, 1960; repr. 1969, 1972.

PARIS, 1926 *Guide illustré du Musée des Arts Décoratifs*, Palais du Louvre, Paris, 1926.

PARIS, 1956 *De Giotto à Bellini: Les primitifs italiens dans les musées de France*, ed. M. Laclotte, Orangerie des Tuileries, Paris, 1956.

PARIS, 1957 *Besançon, le plus ancien musée de France*, Musée des Arts Décoratifs, Paris, 1957.

PARIS, 1975 *Le Studiolo d'Isabelle d'Este*, exh. cat., Musée du Louvre, Paris, 1975.

PARIS, 1984 *Acquisitions du Cabinet des Dessins, 1973-83*, exh. cat., Musée du Louvre, Paris, 1984.

PARIS, 1987 *Ornemanistes du XVᵉ au XVIIᵉ siècle: Gravures et dessins*, exh. cat. by P. Jean-Richard, Musée du Louvre, Paris, 1987.

PARIS, 1988 *L'an V. Dessins des grands maîtres*, exh. cat., Cabinet des Dessins, Musée du Louvre, Paris, 1988.

PARIS, 1990 *Les Dessins vénitiens des collections de l' Ecole des Beaux-Arts*, exh. cat. by E. Brugerolles, Ecole Nationale Supérieure des Beaux-Arts, Paris, 1990.

PARIS, ROTTERDAM and HAARLEM, 1962 *Italiaanse tekeningen in Nederlands bezit*, exh. cat., Paris, Boymans–van Beuningen Museum, Rotterdam, Teylers Museum, Haarlem, 1962.

PARKER, 1927 K.T. Parker, *North Italian Drawings of the Quattrocento*, London, 1927.

PARMA, 1935 *Mostra del Correggio*, exh. cat., Palazzo della Pilotta, Parma, 1935.

PASCHINI, 1939 P. Paschini, *Lodovico cardinale camerlengo*, Rome, 1939.

PASSAVANT, 1864 J.D. Passavant, *Le Peintre-graveur*, 6 vols, Leipzig, 1860-64, V, 1864.

PERINA, 1961 C.T. Perina, 'Pittura', *Mantova i le arte*, II, Mantua, 1961, pp. 239-502.

PERINA and CARPEGGIANI, 1987 C.T. Perina and P. Carpeggiani, *Sant'Andrea in Mantova: Un tempio per la città del principe*, Mantua, 1987.

PESARO, 1988 *L'incoronazione della Vergine e la cimasa di Giovanni Bellini: Indagine e restauri*, exh. cat., Pinacoteca Nazionale, Pesaro, 1988.

PETRIOLI TOFANI, 1986 A.M. Petrioli Tofani, *Gabinetto disegni e stampe degli Uffizi, Inventario 1: Disegni esposti*, Florence, 1986.

PIETRANGELI, 1961 C. Pietrangeli, *Villa Paolina (Quaderni di Storia dell'Arte, XI)*, Florence, 1961.

PIGNATTI, 1970 T. Pignatti, *I disegni dei maestri, 1: Scuola veneta*, Milan, 1970.

PIGNATTI, 1985 T. Pignatti, *Five Centuries of Italian Painting, 1300-1800, from the Collection of the Sarah Campbell Blaffer Foundation*, Houston, 1985.

PILLSBURY and JORDAN, 1987 E. Pillsbury and W. Jordan, 'Recent Painting Acquisitions, III: The Kimbell Art Museum', *The Burlington Magazine*, CXXIX, 1987, pp. 767-76.

PILLSBURY et. al., 1987 E. Pillsbury et. al., *In Pursuit of Quality*, New York, 1987.

PINO, 1548, ed. 1946 P. Pino, *Dialogo di pittura*, 1548, ed. R. and A. Pallucchini, Venice, 1946.

PINTOR, 1907 F. Pintor, *Da lettere inedite di due fratelli umanisti (Alessandro e Paolo Cortesi)*, Perugia, 1907.

POLLARD, 1977 G. Pollard, 'The Felix Gem at Oxford and its Provenance', *The Burlington Magazine*, CXIX, 1977, p.574.

POPE, 1927 A. Pope, 'The New Fogg Art Museum: The Collection of Drawings', *Arts*, XII, 1927, pp. 25-8.

POPE-HENNESSY, 1965 J. Pope-Hennessy, *Renaissance Bronzes from the Samuel H. Kress Collection*, London, 1965.

POPE-HENNESSY, 1966, ed. 1972 J. Pope-Hennessy, *The Portrait in the Renaissance*, Princeton, 1966, 2nd ed., 1972.

POPE-HENNESSY, 1976, repr. 1980 J. Pope-Hennessy, 'The Madonna Reliefs of Donatello', *Apollo*, CIII, 169, 1976, pp. 172-91; repr. in *The Study and Criticism of Italian Sculpture*, Princeton, 1980, pp. 71-105.

POPE-HENNESSY, 1986 J. Pope-Hennessy, 'Masterly Transformations', review of R.W. Lightbown, *Mantegna*, in *The Times Literary Supplement*, 21 November 1986, p. 1315.

POPE-HENNESSY, 1991 J. Pope-Hennessy, *Learning to Look*, London, 1991.

POPE-HENNESSY and LIGHTBOWN, 1964 J. Pope Hennessy and R.W. Lightbown, *Catalogue of Italian Sculpture in the Victoria and Albert Museum*, London, 1964.

POPHAM, 1931-2 A.E. Popham, 'Andrea Mantegna', *Old Master Drawings*, VI, 1931-2, p. 62.

POPHAM, 1936 A.E. Popham, 'Sebastiano Resta and his Collections', *Old Master Drawings*, XI, 41, 1936, pp. 1-19.

POPHAM and POUNCEY, 1950 A.E. Popham, and P. Pouncey, *Italian Drawings in the Department of Prints and Drawings in the British Museum: The Fourteenth and Fifteenth Centuries*, 2 vols, London, 1950.

POPHAM and WILDE, 1949 A.E. Popham and J. Wilde, *The Italian Drawings of the XV and XVI Centuries in the Collection of His Majesty the King at Windsor Castle*, London, 1949.

PORTHEIM, 1886 F. Portheim, 'Mantegna als Kupferstecher', *Jahrbuch der königlich-preussischen Kunstsammlungen*, VII, 1886, pp. 214-26.

PRATILLI, 1939-40 L. Pratilli, 'Feliciano alla luce dei suoi codici', *Atti del reale Istituto veneto di scienze, lettere ed arti*, XCIX, 2, 1939-40, pp. 33-105.

PRINZ, 1962 W. Prinz, 'Die Darstellung Christi im Tempel und die Bildnisse des Andrea Mantegna', *Berliner Museen*, XII, 1962, pp. 52-4.

PUNGILEONI, 1821 L. Pungileoni, *Memorie istoriche di Antonio Allegrei detto il Correggio*, III, Parma, 1821.

PUPPI, 1966 L. Puppi, *La Valle Padana fra Gotico e Rinascimento*, I Maestri del Colore, 258, Milan, 1966.

PUPPI, 1972 L. Puppi, *Il Trittico di Andrea Mantegna per la basilica di San Zeno Maggiore in Verona*, Verona, 1972.

QUINTAVALLE, 1959 A.C. Quintavalle, *Ritrovamenti e restauri a Correggio*, Parma, 1959.

QUINTAVALLE, 1970 A.C. Quintavalle, *L'opera completa del Correggio*, Milan, 1970.

RADCLIFFE, 1989 A. Radcliffe, 'Two Early Romano-Mantuan Plaquettes,' *Studies in the History of Art*, 22, 1989, pp. 93-103.

RAPILLY, 1907 G. Rapilly, *Les chefs-d'œuvre du Musée des Arts Décoratifs*, Paris, 1907.

RAVEGNANI MOROSINI, 1984 M. Ravegnani Morosini, *Signorie e principati: Monete italiane con ritratto 1450-1796*, 3 vols, San Marino, 1984.

REAU, 1955-9 L. Réau, *Iconographie de l'art chrétien*, Paris, 3 vols, 1955-9.

RICCI, 1907 C. Ricci, *La Pinacoteca di Brera*, Bergamo, 1907.

RICCI, 1908 C. Ricci, *Jacopo Bellini e i suoi libri di disegni*, Florence, 1908.

RICHTER, 1939 G. Richter, 'A Mantegna Problem', *Apollo*, XXIX, 1939, pp. 63-5.

RIDOLFI, 1648 ed. 1914 C. Ridolfi, *Le Maraviglie dell'arte*, Venice, 1648, ed. F. von Hadeln, Berlin, 1914.

RIESTER, 1984 L. Riester, 'Mantegna', in 'Notes', *Print Quarterly*, I, 1984, p. 56.

RIGONI, 1927-8, ed. 1970 E. Rigoni, *L'Arte rinascimentale in Padova: Studi e documenti*, Padua, 1970.

RINGBOM, 1965 S. Ringbom, *Icon to Narrative: The Rise of the Dramatic Close-up in Fifteenth-century Devotional Painting*, Åbo, 1965.

RIZZI, 1960 F. Rizzi, 'Aleotti, Ulisse', *Dizionario biografico degli italiani*, II, 1960, p. 155.

ROBERTSON, 1953 G. Robertson, 'The National Gallery Catalogue of Early Italian Schools', *The Burlington Magazine*, XCV, 1953, pp. 28 f.

ROBERTSON, 1968 G. Robertson, *Giovanni Bellini*, Oxford, 1968.

ROBINSON, 1979 C. Robinson, *Lucian and his Influence*, London, 1979.

ROBINSON, 1876 J.C. Robinson, *Descriptive Catalogue of Drawings by Old Masters, forming the collection of John Malcolm of Poltalloch, Esq.*, 2nd ed, London, 1876.

RODELLA, 1988 G. Rodella, *Giovanni da Padova: Un ingegniere gonzaghesco nell'età dell'umanesimo*, Milan, 1988.

ROGNINI, 1985 L. Rognini, *Tarsie e intagli di Fra Giovanni a Santa Maria in Organo di Verona*, Verona, 1985.

ROMANINI, 1966 A.M. Romanini, 'L'Itinerario pittorico del Mantegna e il "primo" rinascimento Padano-Veneto', *Arte in Europa: Scritti di storia dell'arte in onore di Eduardo Arslan*, 1966, I, pp. 437-43.

ROMANO, 1981 G. Romano, 'Verso la maniera moderna: Da Mantegna a Raffaello', in *Storia dell'arte italiana*, II, 2, 1981, pp. 5-85.

ROMANO, 1985 S. Romano, *Ritratto di fanciullo di Girolamo Mocetto*, Modena, 1985.

ROME, 1953 *Mostra Storica Nazionale della Miniatura*, exh. cat., Palazzo Venezia, Rome, 1953.

ROME, 1988 *Da Pisanello alla Nascità dei Musei Capitolini: L'Antico a Roma alla vigilia del Rinascimento*, exh. cat., ed. A. Cavallaro, Musei Capitolini, Rome, 1988.

ROSENTHAL, 1962 E.H. Rosenthal, 'The House of Andrea Mantegna in Mantua', *Gazette des Beaux-Arts*, 6th ser., LX, 1962, pp. 327-48.

ROSSI, 1888 U. Rossi, 'I medaglisti del rinascimento alla corte di Mantova, III: Gian Marco Cavalli', *Rivista italiana di numismatica*, I, 1888, pp. 453-4.

ROSSI, 1892 U. Rossi, 'Gian Marco e Gian Battista Cavalli', *Rivista italiana di numismatica*, V, 1902, p. 483.

ROSSI, 1902 U. Rossi, 'I medaglisti del Rinascimento alla Corte di Mantova, II: Pier Jacopo Alari-Bonacolsi detto Antico', *Rivista italiana di numismatica*, I, 1888, pp. 187-8.

ROTHSCHILD, 1885 J. de Rothschild, ed., *Le mistère du viel testament, publié avec introduction, notes et glossaire*, 6 vols, Paris, 1885; repr. New York, 1966.

ROWLANDS, 1989 E. Rowlands, 'Filippo Lippi and his Experience of Painting in the Veneto Region', *Artibus et Historiae*, 1989, pp. 53-83.

RUBINSTEIN, 1976 R.O. Rubinstein, 'A Bacchic Sarcophagus in the Renaissance', *British Museum Yearbook*, I: *The Classical Tradition*, London, 1976, pp. 103-56.

RUHMER, 1958 E. Ruhmer, *Tura*, London, 1958.

RUHMER, 1966 E. Ruhmer, *Marco Zoppo*, Verona, 1966.

RUSKIN, 1903-12 J. Ruskin, *Works*, ed. E.T. Cook and A. Wedderburn, 39 vols, London, 1903-12.

RUSSELL, 1930 A.G.B. Russell, in *The Vasari Society for the Reproduction of Drawings by Old Masters*, 2nd ser., 3, 1930.

RUSSO, 1990 E. Russo, *Incisori ferraresi nelle stampe del Museo Schifanoia del XVII al XIX secolo*, Ferrara, 1990.

SABBADINI, 1914 R. Sabbadini, *Le scoperte dei codici latini e greci nei secoli XIV e XV*, Florence, 1914.

SAFARIK, 1974 E. Safarik, 'Campagnola, Girolamo', *Dizionario biografico degli italiani*, XVII, 1974, pp. 317-8.

SAMBIN, 1959 P. Sambin, 'Ricerche per la storia della cultura nel secolo XV: La biblioteca di Pietro Donato, c. 1380-1447', *Bollettino del Museo Civico di Padova*, XLVIII, 1959, pp. 53-98.

SAMBIN, 1979 P. Sambin, 'Per la biografia di Francesco Squarcione: briciole documentarie', *Medioevo e rinascimento Veneto: Studi in onore di Lino Lazzarini, Medioevo e umanesimo*, XXXIV, 1979, pp. 443-65.

SANTI, ed. 1985 G. Santi, *La vita e le gesta di Federico di Montefeltro, Duca d'Urbino*, ed. L. Michelini Tocci, 2 vols, Vatican City, 1985.

SAVONAROLA, 1902 M. Savonarola, *De Laudibus Patavii …* , ed. A. Segarizzi, Città di Castello, 1902.

SCARDEONE, 1560, repr. 1979, B. Scardeone, *De Antiquitate Urbis Patavii …* , Basle, 1560, photostatic repr., 1979.

SCHAEFFER, 1912 E. Schaeffer, 'Ein Mediceär-Bildnis von Mantegna', *Monatshefte für Kunstwissenschaft*, V, 1912, pp. 17-21.

SCHMIDT-DEGENER, 1910-11 F. Schmidt-Degener, 'Two Drawings by Andrea Mantegna in the Boymans Museum of Rotterdam', *The Burlington Magazine*, XVIII, 1910-11, pp. 255-6.

SCHMITT, 1974 A. Schmitt, 'Francesco Squarcione als Zeichner und Stecher', *Münchner Jahrbuch der bildenden Kunst*, XXV, 1974, pp. 205-13.

SCHMITT, 1961 U. Schmitt, 'Francesco Bonsignori', *Münchner Jahrbuch der bildenden Kunst*, 3rd ser., XII, 1961, pp. 73-152.

SCHWABE, 1918 R. Schwabe, 'Mantegna and his Imitators', *The Burlington Magazine*, XXXIII, 1918, pp. 215-26.

SEGARIZZI, 1906 A. Segarizzi, 'Ulisse Aleotti, rimatore veneziano del secolo XV', *Giornale storico della letteratura italiana*, XLVII, 1906, pp. 41-66.

SEROUX D'AGINCOURT, 1823, 1828 J.B.L.G. Seroux d'Agincourt, *Histoire de l'art par les monuments*, Paris, II, 1823, III, 1828.

SEROUX D'AGINCOURT, 1840 J.B.L.G. Seroux d'Agincourt, *Denkmäler der Malerei von IV bis zum XVI Jahrhunderts*, Berlin, 1840.

SEZNEC, 1940, 1953, ed. 1972 J. Seznec, *The Survival of the Pagan Gods*, London, 1940 (French ed.), New York, 1953, ed. 1972.

SHAPLEY, 1968 F.R. Shapley, *Paintings from the Samuel H. Kress Collection: Italian Schools, XV-XVI Century*, New York, 1968.

SHAPLEY, 1979 F.R. Shapley, *Catalogue of the Italian Paintings: National Gallery of Art, Washington, DC*, 2 vols, Washington, DC, 1979.

SHAW with BOCCIA-SHAW, 1989 K. Shaw with T.M. Boccia-Shaw, 'Mantegna's pre-1448 Years Re-examined: The S. Sofia Inscription', *Art Bulletin*, LXXI, 1989, pp. 47-57.

SHAW with BOCCIA-SHAW, 1991 K. Shaw with T.M. Boccia-Shaw, 'Mantegna's Ovetari "Angel" Fragment Newly Identified', *Bollettino del Museo Civico di Padova*, LXXVIII, 1991, pp. 21-8.

SIENA, 1990 *Domenico Beccafumi e il suo tempo*, exh. cat., Siena, 1990.

SIGHINOLFI, 1921 L. Sighinolfi, 'La biblioteca di Giovanni Marcanova', *Collectanea Variae Doctrinae Leoni S. Olschki*, Munich, 1921, pp. 187-222.

SIGNORINI, 1976 'L'autoritratto del Mantegna nella Camera degli Sposi', *Mitteilungen des kunsthistorischen Instituts in Florenz*, XX, 1976, pp. 205-12.

SIGNORINI, 1980 R. Signorini, 'Due sonetti di Filippo Nuvoloni ad Andrea Mantegna', in *Studi in onore di Raffaele Spongano*, Bologna, 1980, pp. 165-72.

SIGNORINI, 1985 R. Signorini, *Opvs hoc tenve: La Camera Dipinta di Andrea Mantegna*, Mantua, 1985.

SIGNORINI, 1986[1] R. Signorini, 'Mantegna's Unknown Sons: A Rediscovered Epitaph', *Journal of the Warburg and Courtauld Institutes*, XLIX, 1986, pp. 233-5.

SIGNORINI, 1986[2] R. Signorini, 'Il monumento celebrativo di Andrea Mantegna', in *La cappella del Mantegna in Sant'Andrea a Mantova*, ed. G. Pastore, Mantua, 1986, pp. 23-42.

SIMON, 1971-2 E. Simon, 'Dürer und Mantegna 1494', *Anzeiger des germanischen Nationalmuseums*, 1971-2, pp. 21-44.

SIMON, 1929 K. Simon, 'Der Meister von 1515 = Hermann Vischer?', *Italienische Studien, Paul Schubring zum 60 Geburtstag gewidmet*, Leipzig, 1929, pp. 123-37.

SIMONETTI, 1990 M. Simonetti, 'Techniche della pittura veneta', in *La pittura nel Veneto: Il Quattrocento*, Milan, 1990, pp. 247-70.

SMITH, 1979 A. Smith, ' "Germania" and "Italia": Albrecht Dürer and Venetian Art', *Journal of the Royal Society of Arts*, CXXVII, 1979, pp. 273-90.

SPRIGGS, 1965 S.I. Spriggs, 'Oriental Porcelain in Western Paintings: 1450-1700', *Transactions of the Oriental Ceramic Society*, XXXVI, 1965, pp. 73ff.

STIX, 1930 A. Stix, 'Die Zeichnungen der Ausstellung italienischer Kunst in London', *Belvedere*, IX, 1930, pp. 123-5.

STIX and SPITZMÜLLER, 1941 A. Stix and A. Spitzmüller, *Albertina-Katalog, VI: Die Schulen von Ferrara, Bologna, Parma und Modena, der Lombardi, Genuas, Neapels und Siziliens*, Vienna, 1941.

SUIDA 1905 W. Suida, 'Bemerkungen über einige Meisterwerke', *Zeitschrift für bildenen Kunst*, XVI, 1905, p. 190.

SUIDA, 1946 W. Suida, 'Mantegna and Melozzo', *Art in America*, XXXIV, 1946, pp. 57-72.

SUIDA, 1951 W. Suida, *Paintings and Sculpture from the Kress Collection acquired by the Samuel H. Kress Foundation 1945-51*, New York, 1951.

SUMMERS, 1979 J. David Summers, *The Sculpture of Vincenzo Danti: A Study in the Influence of Michelangelo and the Ideals of the Maniera*, New York and London, 1979.

SYDNEY, 1988 *Study in Genius: Master Drawings from the Royal Library*, exh. cat., Art Gallery of New South Wales, Sydney, 1988.

SZABO, 1983 G. Szabo, *Masterpieces of Italian Drawing in the Robert Lehman Collection in the Metropolitan Museum of Art*, New York, 1983.

TAMASSIA, 1956[1] A M. Tamassia, 'Jacopo Bellini e Francesco Squarcione: Due cultori dell'antichita classica', *Il mondo nel rinascimento: Atti del V Congresso internazionale di studi del rinascimento*, Florence, 1956, pp. 159-65.

TAMASSIA, 1956[2] A.M. Tamassia, 'Visioni di antichità nell'opera del Mantegna', *Atti della Pontificia Accademia Romana di Archeologia, Rendiconti*, XXVIII, 1956, pp. 213-49.

TATRAI, 1972 V. Tátrai, 'Osservazioni circa due allegorie del Mantegna', *Acta historiæ artium Academiæ Scientiarum Hungaricæ*, XVIII, 1972, pp. 233-50.

TELLINI, 1987 C. Perina Tellini in *Sant'Andrea in Mantova: Un tempio per la città del principe*, Mantua, 1987.

TESTI, 1910 L. Testi, 'Per Francesco Squarcione', *Rassegna d'Arte*, X, I, 1910, pp. vi-vii; X, 2, 1910, pp. iv-v.

TESTI, 1915 L. Testi, *La Storia della pittura veneziana*, Bergamo, vol. 1, 1909, vol. 2, 1915.

THODE, 1897 H. Thode, *Mantegna*, Bielefeld and Leipzig, 1897.

TIETZE-CONRAT, 1923 E. Tietze-Conrat, 'Zur Datierung des Hl. Sebastian von Mantegna in der Wiener Galerie', *Kunstchronik und Kunstmarkt*, LVIII, 18, 1923, pp. 339-45.

TIETZE-CONRAT, 1943 E. Tietze-Conrat, 'Was Mantegna an Engraver?', *Gazette des Beaux-Arts*, 6th ser., XXIV, 1943, pp. 375-81.

TIETZE-CONRAT, 1949 E. Tietze-Conrat, 'Mantegna's "Parnassus": A Discussion of a Recent Interpretation', *Art Bulletin*, XXI, 1949, pp. 126-30.

TIETZE-CONRAT, 1955 E. Tietze-Conrat, *Mantegna: Paintings, Drawings, Engravings*, London, 1955.

TIETZE and TIETZE-CONRAT, 1944 H. Tietze and E. Tietze-Conrat, *Drawings of the Venetian Painters*, New York, 1944.

TOMMASOLI, 1978 W. Tommasoli, *La vita di Federico da Montefeltro (1422-82)*, Urbino, 1978, pp. 346-7.

TOSCANO, 1587 R. Toscano, *L'Edificatione di Mantova*, Mantua, 1587.

TRECCANI DEGLI ALFIERI, 1963 G. Treccani degli Alfieri, *Storia di Brescia*, II: *La Dominazione veneta*, Brescia, 1963.

ULLMANN, 1973 L. Ullmann, 'The Post-mortem Adventures of Livy', in his *Studies in the Italian Renaissance*, 2nd ed., Rome, 1973, pp. 53-77.

VALTIERI, 1982 S. Valtieri, 'La fabbrica del Palazzo del Cardinale Raffaelle Riario', *Quaderni dell'Istituto di storia dell'architettura*, XXVII, 1982, pp. 3-24.

VALTURIO, 1472, ed. 1534 R. Valturio [Valturius], *De re militari*, Verona, 1472; ed. cit., Paris, 1534.

VASARI, 1550, 1568, ed. 1849 G. Vasari, *Le Vite de' più eccellenti pittori, scultori ed architettori*, 14 vols, commentary by P. Selvatico, Florence, V, pp. 157-241.

VASARI, 1550, 1568, ed. 1878-85 G. Vasari, *Le Vite de' più eccellenti pittori, scultori ed archtettori*, ed. G. Milanesi, 9 vols, Florence, 1878-85.

VASI, 1794 M. Vasi, *Itinerario istruttivo di Roma*, Rome, 1794.

VENICE, 1966 *Disegni del Pisanello e di maestri del suo tempo*, exh. cat., Fondazione Giorgio Cini, Venice, 1966.

VENICE, 1990 *Tiziano*, exh. cat., Palazzo Ducale, Venice, 1990.

VENTURA, 1987 L. Ventura, 'La religione privata: Ludovico II, Andrea Mantegna e la Cappella del Castello di San Giorgio', *Quaderni di Palazzo Te*, VII, 1987, pp. 23-34.

VENTURI, 1885 A. Venturi, 'Jacopo Bellini, Pisanello und Mantegna in der Sonetten des Dichters Ulisse', *Der Kunstfreund*, I, 1885, cols. 259-62.

VENTURI, 1888¹ A. Venturi, 'Quadri in una cappella estense nel 1586', *Archivio storico dell'arte*, I, 1888, pp. 425-6.

VENTURI, 1888² A. Venturi, 'Gian Cristoforo Romano', *Archivio storico dell'arte*, I, 1888, pp. 49-59, 107-18, 148-58.

VENTURI, 1888³ A. Venturi, 'Nuovi documenti su Leonardo da Vinci', *Archivio storico dell'arte*, I, 1888, pp. 45-6.

VENTURI, 1890 A. Venturi, 'La Pittura', *Archivio storico dell'arte*, III, 1890, p. 287.

VENTURI, 1896 A. Venturi, *Gentile da Fabriano e il Pisanello*, Florence, 1896.

VENTURI, 1906 A. Venturi, 'Corriere fiorentino', *L'Arte*, IX, 1906, pp. 62-4.

VENTURI, 1913, 1914 A. Venturi, *Storia dell'arte italiana*, 11 vols, Milan, 1901-40, vol VII, 2, 1913; vol. VIII, 3, 1914.

VENTURI, 1924 A. Venturi, 'Giambellino', *L'Arte*, XXVII, 1924, pp. 137-40.

VENTURI, 1926 A. Venturi, *Correggio*, Rome, 1926.

VERHEYEN, 1971 E. Verheyen, *The Paintings in the Studiolo of Isabella d'Este at Mantua*, New York, 1971.

VERONA, 1978 *La pittura a Verona tra Sei e Settecento*, exh. cat., Museo del Castelvecchio, Verona, 1978.

VERONA, 1986 *Miniatura veronese del rinascimento*, exh. cat. by G. Castiglioni and S. Marinelli, Museo del Castelvecchio, Verona, 1986.

VERTUE, 1757 G. Vertue, *A Catalogue and Description of King Charles the First's Capital Collection of Pictures … first published from an Original Manuscript in the Ashmolean Museum at Oxford*, 1757.

VESPASIANO DA BISTICCI, ed. 1951 Vespasiano da Bisticci, *Vite*, ed. P. D'Ancona, Milan, 1951.

VICKERS, 1976 M. Vickers, 'The Palazzo Santacroce Sketchbook: A New Source for Andrea Mantegna's "Triumphs of Caesar", "Bacchanals" and "Battle of the Sea Gods" ', *The Burlington Magazine*, CXVIII, 1976, pp. 824-34.

VICKERS, 1978 M. Vickers, 'The Intended Setting of Mantegna's "Triumphs of Caesar", "Battle of the Sea Gods" and "Bacchanals" ', *The Burlington Magazine*, CXX, 1978, pp. 365-70.)

VICKERS, 1983 M. Vickers, 'The Felix Gem in Oxford and Mantegna's Triumphal Programme', *Gazette des Beaux-Arts*, 6th ser., CI, 1983, pp. 97-102.

VIRGINIA et al., 1979-80 *Treasures from Chatsworth: The Devonshire Inheritance*, exh. cat., Virginia Museum of Fine Arts, Richmond; Kimbell Art Museum, Fort Worth; The Toledo Museum of Art; San Antonio Museum Association; New Orleans Museum of Art; The Fine Arts Museums of San Francisco; Royal Academy of Arts, London, 1979-80.

VOLLMER, 1909 R. Vollmer, 'Die alte Gemaldegaleri in Kopenhagen', *Monatshefte für Kunstwissenschaft*, II, 1909, pp. 547-60.

WAAGEN, 1854 G. Waagen, *Treasures of Art in Great Britain*, 3 vols, London, 1854.

WAAGEN, 1855 G. Waagen, *Verzeichniss der Gemälde-Sammlung*, Berlin, 1855.

WARD-JACKSON, 1979 P. Ward-Jackson, *Italian Drawings*, I: *14th-16th Century*, Victoria and Albert Museum Catalogues, London, 1979.

WARDROP, 1960, 1963 J. Wardrop *The Script of Humanism: Some Aspects of Humanistic Script*, Oxford, 1960; New York and Oxford, 1963.

WARSAW, 1990 *Opus Sacrum: Catalogue of the Exhibition from the Collection of Barbara Piasecka Johnson*, exh. cat., Royal Castle, Warsaw, 1990.

WASHINGTON, 1973 *Early Italian Engravings from the National Gallery of Art*, exh. cat. by J. A. Levenson, K. Oberhuber and J. L. Sheehan, National Gallery of Art, Washington, DC, 1973.

WASHINGTON, 1979 *Catalogue of the Italian Paintings*, National Gallery of Art, Washington, DC, 1979.

WASHINGTON et al., 1962-3 *Old Master Drawings from Chatsworth*, exh. cat. by A. E. Popham, Washington, DC, National Gallery of Art, and elsewhere, circulated by the Smithsonian Institution, 1962-3.

WASHINGTON, FORT WORTH and ST LOUIS, 1974 *Venetian Drawings from American Collections*, exh. cat. by T. Pignatti, National Gallery of Art, Washington, DC; Kimbell Art Museum, Fort Worth; St Louis Art Museum, 1974.

WASHINGTON, LOS ANGELES and CHICAGO, 1986 *Renaissance Master Bronzes from the Collection of the Kunsthistorisches Museum, Vienna*, exh. cat. by M. Leithe-Jasper, National Gallery of Art, Washington, DC; Los Angeles County Museum of Art; The Art Institute of Chicago, 1986.

WEGNER, 1958 W. Wegner, *Hundert Meisterzeichnungen aus der Stadlichen Graphischen Sammlung München*, Munich, 1958.

WEISS, 1969, ed. 1988 R. Weiss, *The Renaissance Discovery of Classical Antiquity*, Oxford, 1969, 2nd ed., 1988.

WEIZSÄCKER, 1900 H. Weizsäcker, *Catalog der Gemälde-Galerie des Städelschen Kunstinstituts in Frankfurt am Main*, Frankfurt am Main, 1900.

WESCHER, 1947 P. Wescher, *Jean Fouquet et son temps*, Basle, 1947.

WICKHOFF, 1891 F. Wickhoff, 'Die italienisch Handzeichnungen der Albertina, I: Die venezianische, die lombardische und die bolognesische Schule', *Jahrbuch der kunsthistorischen Sammlungen des allerhöchsten Kaiserhauses*, XII, 1891, pp. CCV-CCXIV.

WILDE, 1969 J. Wilde, 'Studies for Christ at the Column', *Italian Paintings and Drawings at 56 Princes Gate London SW7: Addenda*, London, 1969, pp. 37-41.

WILDE, 1971 J. Wilde, in *Corrigenda and Addenda to the Catalogue of Prints and Drawings at 56 Prince's Gate*, London, 1971.

WILK, 1978 S. Wilk, *The Sculpture of Tullio Lombardo: Studies in Sources and Meaning*, New York and London, 1978.

WIND, 1948 E. Wind, *Bellini's 'Feast of the Gods'*, Cambridge, 1948.

WIND, 1949 E. Wind, 'Mantegna's "Parnassus": A Reply to some Recent Reflections', *Art Bulletin*, XXXI, 1949, pp. 224-33.

WIND, 1960 E. Wind, 'Michelangelo's Prophets and Sibyls', *Proceedings of the British Academy*, LI, 1960, pp. 47ff.

WITTKOWER, 1949 R. Wittkower, *Architectural Principles in the Age of Humanism*, London, 1949.

WOERMANN, 1907 K. Woermann, *Verzeichnis der älteren Gemälde der Galerie Weber in Hamburg*, Hamburg, 1907.

WOLFTHAL, 1989 D. Wolfthal, *The Beginnings of Netherlandish Canvas Painting: 1400-1530*, Cambridge, 1989.

WOLLHEIM, 1987 R. Wollheim, *Painting as an Art*, London, 1987.

WOLTERS, 1960 C. Wolters, in *Museum* (ICOM), XIII, 3, 1960, pp. 135-71.

YRIARTE, 1895-6 C. Yriarte, 'Isabelle d'Este et les artistes de son temps', *Gazette des Beaux-Arts*, XIII, 1895, pp. 13-32, 189-206; XIV, 1895, pp. 382-98, 130-8; XV, 1896, 215-28, 330-46.

YRIARTE, 1901 C. Yriarte, *Mantegna*, Paris, 1901.

ZANETTI, 1771 A. Zanetti, *Della pittura veneziana e delle opere pubbliche de'veneziani maestri*, Venice, 1771.

ZANETTI, 1797 A. Zanetti, *Della pittura veneziana*, II, Venice, 1797.

ZANI, 1802 P. Zani, *Materiali per servire alla storia dell'origine e de'progressi dell'incisioni in rame e in legno e sposizione dell'interessante scoperta d'una stampa originale del celebre Maso Finiguerra fatta nel Gabinetto Nazionale di Parigi*, Parma, 1802.

ZANI, 1817-24 P. Zani, *Enciclopedia metodica critico-ragionata delle belle arti dell'Abate D. Pietro Zani*, part I, 19 vols; part II, 9 vols, Parma, 1817-24.

ZAPPERI, 1979 G. Zapperi, 'Cattanei, Giovan Lucido', *Dizionario biografico degli italiani*, XXII, 1979, pp. 406-8.

ZERI, 1976 F. Zeri, *Italian Paintings in the Walters Art Gallery*, Baltimore, 1976.

ZERI, 1983 F. Zeri, 'Rinascimento e Pseudo-Rinascimento', *Storia dell'arte italiana*, Turin, 1983, pp. 543-72.

ZERI and GARDNER, 1986 F. Zeri and E. Gardner, *Italian Paintings: North Italian School*, The Metropolitan Museum of Art, New York, 1986.

ZERI, ed., 1987 *La pittura in Italia: Il Quattrocento*, Milan, ed. F. Zeri, II, Milan, 1987.

ZIMMERMANN, 1965 H. Zimmermann, 'Drei Chiaroscuro-Bilder von Andrea Mantegna', *Pantheon*, XXIII, 1965, pp. 17-21.

ZORZI, 1988 M. Zorzi, *Biblioteca Marciana, Venezia*, Florence, 1988.

ZUCKER, 1980 M.J. Zucker, ed. *The Illustrated Bartsch, 25, Formerly Volume 13 (part 2): Early Italian Masters*, New York, 1980.

ZUCKER, 1984 M.J. Zucker, ed. *The Illustrated Bartsch, 25: (Commentary), Formerly Volume 13 (part 2): Early Italian Masters*, New York, 1984.

ZUCKER, 1989 M.J. Zucker, 'An Allegory of Renaissance Politics in a Contemporary Italian Engraving: The Prognostic of 1510', *Journal of the Warburg and Courtauld Institutes*, LII, 1989, pp. 236-40.

INDEX

FRIENDS OF THE ROYAL ACADEMY

BENEFACTORS
The Lady Brinton
Sir Nigel and Lady Broackes
Keith Bromley Esq
The John S. Cohen Foundation
The Colby Trust
Michael E. Flintoff Esq
The Lady Gibson
Jack Goldhill Esq
Mrs Mary Graves
D. J. Hoare Esq
Irene and Hyman Kreitman
D. E. Laing Esq
The Landmark Trust
Roland Lay Esq
The Trustees of the Leach
 Fourteenth Trust
Sir Hugh Leggatt
J. H. Lewis Esq
Sir Sidney and Lady Lipworth
Jack Lyons Esq., CBE
Mrs T. S. Mallinson
The Manor Charitable Trustees
Mrs W. Marks
Lieut. Col. L. S. Michael OBE
Jan Mitchell Esq
The Lord Moyne
The Lady Moyne
Mrs Sylvia Mulcahy
G. R. Nicholas Esq
Mrs Vincent Paravicini
Richard Park Esq
Phillips Fine Art Auctioneers
Mrs Adrianne Reed
The Late Anne M. Roxburgh
Mrs Basil Samuel
Lord Sharp CBE
The Very Revd E. F. Shotter
Dr Francis Singer
The Spencer Charitable Trust
Miss K. Stalnaker
Lady Daphne Straight
Mrs Pamela Synge
Harry Teacher Esq
The Henry Vyner Charitable Trust
A. Witkin Vacuum Instruments
 & Products Ltd.
Charles Wollaston Esq

INDIVIDUAL SPONSORS
Gerald M. Abrahams Esq CBE
Mrs C. P. L. Adlington
Richard B. Allan Esq
I. F. C. Anstruther Esq
Mrs Ann Appelbe
J. R. Asprey Esq
Edgar Astaire Esq
Lady Attenborough

W. M. Ballantyne Esq
B. A. Bailey Esq
J. M. Bartos Esq
Mrs Robin Behar
Mrs Olive Bell
P. F. J. Bennett Esq
Sir Erik Bennett
Mrs Susan Besser
Mrs John Bibby
P. G. Bird Esq
Mrs L. Blackstone
Mrs C. W. T. Blackwell
Peter Boizot Esq
C. T. Bowring (Charities Fund) Ltd.

Mrs J. M. Bracegirdle
Mrs Susan Bradman
John H. Brandler Esq
Mrs J. Brice
Cornelius Broere Esq
Lady Brown
Jeremy Brown Esq
Mrs Susan Burns
Richard Butler Esq

Mrs A. Cadbury
Mr and Mrs R. Cadbury
Mrs C. A. Cain
Mrs L. Cantor
Carroll Foundation
E. V. Cass Esq
Miss E. M. Cassin
R. A. Cernis Esq
W. J. Chapman Esq
Miss A. Chilcott Fawcett
M. Chowen Esq
Ian Christie Esq
Mrs Joanna V. Clarke
Clarkson Jersey Charitable Trust
B. R. Clifton Esq
Mrs R. Cohen
P Collin Esq
Mrs N. S. Conrad
Mrs Elizabeth Corob
C. Cotton Esq
Mrs O. Cox-Fill

Mrs Saeda H. Dalloul
Philip Daubeny Esq
John Denham Esq
The Marquess of Douro
Ian Dunlop Esq

Mrs A. Edwards
Kenneth Edwards Esq
Miss Beryl Eeman

Gerry Farrell Esq
Mrs K. W. Feesey MSc.
Mrs. B. D. Fenton
Mrs John N. Ferguson
P. Ferguson Esq
Dr Gert-Rudolf Flick
J. G. Fogel Esq
Miss C. Fox
Mrs Jeremy Francis
Mrs Myrtle Franklin

R. P. Gapper Esq
Graham Gauld Esq
M. V. Gauntlett Esq
Robert Gavron Esq
Stephen A. Geiger Esq
Lady Gibberd
Mrs E. J. Gillespie
Anthony Goatman Esq
Michael I. Godbee Esq
Mrs P. Goldsmith
Michael P. Goodman Esq
Lady Gosling
P. G. Goulandris Esq
Mrs W. Govett
Gavin Graham Esq
Mrs J. M. Grant
Mrs J. Green
R. Wallington Green Esq
R. W. Gregson-Brown Esq
Mrs M. Griessmann
Mrs O. Grogan
Mrs W. Grubman

Mr and Mrs M. Haber
J. A. Hadjipateras Esq
Mrs L. Hadjipateras
Jonathan D. Harris Esq
Robert Harris Esq
R. M. Harris Esq
Mogens Hauschildt Esq
Miss Julia Hazandras
R. Headlam Esq
M. Z. Hepker Esq
Malcolm Herring Esq
Mrs Penelope Heseltine
Mrs K. S. Hill
R. J. Hoare Esq
Reginald Hoe Esq
Mrs A. Hoellering
Mrs Joann Honari
Charles Howard Esq
Mrs Annemarie Howitt
Ms J Huber
John Hughes Esq
Christopher R. Hull Esq
Norman J. Hyams Esq
David Hyman Esq

Mrs Manya Igel
C. Ingram Esq
S. Isern-Feliu Esq
Ms Karen B. Isman

Lady Jacobs
J. P. Jacobs Esq
Mrs J C. Jaqua
Alan Jeavons Esq
Mrs Sonya Jenkins
H. Joels Esq
Dr and Mrs George John
Mrs A. Johnson
K. K. Jonietz Esq
I. E. Joye Esq

Mr and Mrs Kahan
Mr and Mrs S. H. Karmel
Mr D. H. Killick
Peter W. Kininmonth Esq
James Kirkman Esq
Mrs L. Kosta

Mrs E. Landau
Andria Thal Lass
Mrs J. Lavender
Thomas Leaver Esq
Ronald Lee Esq
Morris Leigh Esq
Mrs P. Leighton
Mr and Mrs R. Leiman
R. H. Leming Esq
Mr and Mrs N. S. Lersten
Owen Luder Esq
Mrs Graham Lyons

Mrs S. McGill
Mrs G. M. S. McIntosh
Malcolm McIntyre Esq
Peter McMean Esq
Ms Heather Mackay
Vicountess Mackintosh of Halifax
Mrs Susan Maddocks
Dr Abraham Marcus
The Hon. Simon Marks
Mrs Veronika Marlow
Mr and Mrs V. J. Marmion
Mrs J. E. Marsden
J. B. H. Martin Esq
R. C. Martin Esq

C. Mason-Watts Esq
Mrs C. H. Maunsell
A. Mehta Esq
M. H. Meissner Esq
Ms Pia C. Miller
Mrs Alan Morgan
Mrs Angela Morrison
Mrs A.K.S. Morton
The Jocelyn & Katharine Morton
 Charitable Trust
Miss L. Moule
A. H. J. Muir Esq

The Oakmoor Trust
Ocean Group plc (P. H. Holt Trust)
Jeffery P. Onions Esq
Mrs E. M. Oppenheim Sandelson
Brian R. Oury Esq

Mrs Jo Palmer
Ms J. Palmer-Richards
R. A. Parkin Esq
J. H. Pattisson Esq
Dr L. G. Petty
Mrs M. C. S. Philip
Ralph Picken Esq
G. B. Pincus Esq
William Plapinger Esq

Mrs Janice Rich
P. J. Richardson Esq
Dr A. P. Ridges
Mrs J. R. Ritblat
Dr M.P. Roberts
D. Robertson Esq
Robinson Charitable Trust
F. Peter Robinson Esq
D. Rocklin Esq
Mrs A. Rodman
The Rt Hon. Lord Rootes
Baron Elie de Rothschild
Mr and Mrs Oliver Roux
The Rufford Foundation
The Hon. Sir Steven Runciman CH
Mrs Margaret Rymer

The Worshipful Company of Saddlers
Sir Robert Sainsbury
G. Salmanowitz Esq
Lady Samuel
Mrs Bernice Sandelson
Judith Sandeman-Allen
Mrs L. Schwartz
Mrs Bern L. Schwartz
Ms S. Shah
Shell U.K. Ltd.
Mark Shelmerdine Esq
Mrs Pamela Sheridan
Mohamed Shourbaji
Desmond de Silva Esq QC
R. J. Simia Esq
R. J. Simmons Esq
Mrs E. Slotover
Dr and Mrs Leonard Slotover
Mrs Smiley's Charity Trust
James S. Smith Esq
M. J. Souhami Esq
The Spencer Wills Trust
Mr and Mrs Gunter Z. Steffens
Dr M. Stoppard
James Q. Stringer Esq
Mrs B. Stubbs
Mrs A. Susman
Robin Symes Esq

J. A. Tackaberry Esq
Nikolas D. Tarling Esq
G. C. A. Thom Esq
Anthony H. Thornton Esq
Ms Britt Tidelius
Herbert R. Towning Esq
Mrs Andrew Trollope

A. J. Vines Esq

Mrs C. R. Walford
Mr. D. R. Walton Masters
Mrs C. Warburg
Neil Warren Esq
Miss J. Waterons
Mrs R. Watson
J.B Watton Esq
Mrs C. Weldon
Mr Gilman Welply
Frank S. Wenstrom Esq
W. Weston Esq
Miss L. West Russell
R. A. M. Whitaker Esq
J. Wickham Esq
Wilde Sapte
Colin C. Williams Esq
David Wilson Esq
Mrs I. Wolsenholme
W. M. Wood Esq
R. M. Woodhouse Esq
Fred S. Worms Esq

D. Young Esq

F. Zangrilli Esq

SPONSORS OF PAST EXHIBITIONS

The Council of the Royal Academy thanks sponsors of past exhibitions for their support.
Sponsors of major exhibitions during the last ten years have included:

ALITALIA
Italian Art in the 20th Century 1989

AMERICAN EXPRESS FOUNDATION
Masters of 17th-Century Dutch Genre
Painting 1984
'Je suis le cahier': The Sketchbooks of Picasso
1986

ARTS COUNCIL OF GREAT BRITAIN
A New Spirit in Painting 1981
Gertrude Hermes 1981
Carel Weight 1982
Elizabeth Blackadder 1982
Allan Gwynne Jones 1983
The Hague School 1983
Peter Greenham 1985

AUSTRIAN AIRLINES
Egon Schiele and his Contemporaries from
the Leopold Collection, Vienna 1990

BANQUE INDOSUEZ
Gauguin and The School of Pont-Aven:
Prints and Paintings 1989

BAT INDUSTRIES PLC
Murillo 1983
Paintings from the Royal Academy US Tour
1982/4, RA 1984

BBC RADIO ONE
The Pop Art Show 1991

BECK'S BIER
German Art in the 20th Century 1985

BOVIS CONSTRUCTION LTD
New Architecture 1986

BRITISH ALCAN ALUMINIUM
Sir Alfred Gilbert 1986

BRITISH GYPSUM LTD
New Architecture 1986

BRITISH PETROLEUM PLC
British Art in the 20th Century 1987

BT
Hokusai 1991

**CANARY WHARF DEVELOPMENT
CO**
New Architecture 1986

W.I. CARR
Gauguin and The School of Pont-Aven:
Prints and Paintings 1989

THE CHASE MANHATTAN BANK
Cézanne: The Early Years 1988

**THE DAI-ICHI KANGYO BANK,
LIMITED**
222nd Summer Exhibition 1990

DEUTSCHE BANK AG
German Art in the 20th Century 1985

**DIGITAL EQUIPMENT
CORPORATION**
Monet in the '90s: The Series Paintings 1990

THE ECONOMIST
Inigo Jones Architect 1989

EDWARDIAN HOTELS
The Edwardians and After:
Paintings and Sculpture from the Royal
Academy's Collection 1900-1950 1990

ELECTRICITY COUNCIL
New Architecture 1986

ESSO PETROLEUM COMPANY LTD
220th Summer Exhibition 1988

FIAT
Italian Art in the 20th Century 1989

FINANCIAL TIMES
Inigo Jones Architect 1989

**FIRST NATIONAL BANK OF
CHICAGO**
Chagall 1985

FORD MOTOR COMPANY LIMITED
The Fauve Landscape: Matisse, Derain,
Braque and their Circle 1991

FRIENDS OF THE ROYAL ACADEMY
Elizabeth Blackadder 1982
Carel Weight 1982
Allan Gwynne Jones 1983
Peter Greenham 1985
Sir Alfred Gilbert 1986

GAMLESTADEN
Royal Treasures of Sweden 1550-1700 1989

JOSEPH GARTNER
New Architecture 1986

**J. PAUL GETTY JR CHARITABLE
TRUST**
The Age of Chivalry 1987

GLAXO HOLDINGS PLC
From Byzantium to El Greco 1987
Great Impressionist and other Master
Paintings from the Emil G. Bührle
Collection, Zurich 1991

GUINNESS PLC
Twentieth-Century Modern Masters: The
Jacques and Natasha Gelman Collection 1990
223rd Summer Exhibition 1991

**DR ARMAND HAMMER & THE
ARMAND HAMMER FOUNDATION**
Honoré Daumier 1981
Leonardo da Vinci: Nature Studies
Codex Hammer 1981

THE HENRY MOORE FOUNDATION
Henry Moore 1988

HOECHST (UK) LTD
German Art in the 20th Century 1985

IBM UNITED KINGDOM LIMITED
215th Summer Exhibition 1983

THE INDEPENDENT
The Art of Photography 1839-1989 1989
The Pop Art Show 1991

THE INDUSTRIAL BANK OF JAPAN
Hokusai 1991

INTERCRAFT DESIGNS LIMITED
Inigo Jones Architect 1989

THE JAPAN FOUNDATION
The Great Japan Exhibition 1981

**JOANNOU & PARASKEVAIDES
(OVERSEAS) LTD**
From Byzantium to El Greco 1987

THE KLEINWORT BENSON GROUP
Inigo Jones Architect 1989

LLOYDS BANK
The Age of Chivalry 1987

LOGICA
The Art of Photography 1839-1989 1989

LUFTHANSA
German Art in the 20th Century 1985

MARTINI & ROSSI LTD
Painting in Naples from Caravaggio to
Giordano 1982

MELITTA
German Art in the 20th Century 1985

MERCEDES-BENZ
German Art in the 20th Century 1985

MERCURY COMMUNICATIONS
The Pop Art Show 1991

MIDLAND BANK PLC
The Great Japan Exhibition 1981
The Art of Photography 1839-1989 1989

**MITSUBISHI ESTATE COMPANY UK
LIMITED**
Sir Christopher Wren and the Making of St
Paul's 1991

MOBIL
Treasures from Ancient Nigeria 1982
Modern Masters from the Thyssen-
Bornemisza Collection 1984
From Byzantium to El Greco 1987

NATIONAL WESTMINSTER BANK
Reynolds 1986

THE OBSERVER
The Great Japan Exhibition 1981

OLIVETTI
The Cimabue Crucifix 1983

OTIS ELEVATORS
New Architecture 1986

OVERSEAS CONTAINERS LIMITED
The Great Japan Exhibition 1981

**PARK TOWER REALTY
CORPORATION**
Sir Christopher Wren and the Making of St
Paul's 1991

PEARSON PLC
Eduardo Paolozzi Underground 1986

PILKINGTON GLASS
New Architecture 1986

PRINGLE OF SCOTLAND
The Great Japan Exhibition 1981

REED INTERNATIONAL PLC
Toulouse-Lautrec: The Graphic Works 1988
Sir Christopher Wren and the Making of St
Paul's 1991

ROBERT BOSCH LIMITED
German Art in the 20th Century 1985

**ARTHUR M. SACKLER
FOUNDATION**
Jewels of the Ancients 1987

SALOMON BROTHERS
Henry Moore 1988

**SEA CONTAINERS & VENICE
SIMPLON-ORIENT EXPRESS**
The Genius of Venice 1983

THE SHELL COMPANIES OF JAPAN
The Great Japan Exhibition 1981

SIEMENS
German Art in the 20th Century 1985

SILHOUETTE EYEWEAR
Egon Schiele and his Contemporaries from
the Leopold Collection, Vienna 1990

SWAN HELLENIC
Edward Lear 1985

JOHN SWIRE
The Great Japan Exhibition 1981

TEXACO
Selections from the Royal Academy's Private
Collection 1991

THE TIMES
Old Master Paintings from the Thyssen-
Bornemisza Collection 1988

TRAFALGAR HOUSE
Elisabeth Frink 1985

TRUSTHOUSE FORTE
Edward Lear 1985

UNILEVER
The Hague School 1983
Frans Hals 1990

VORWERK CARPETS LIMITED
The Pop Art Show 1991

WALKER BOOKS LIMITED
Edward Lear 1985

OTHER SPONSORS
*Sponsors of events, publications and other items in
the last two years:*

A.T. Kearney Limited
Bulgari Jewellers
Condé Nast Publications
Dan Air Scheduled
Fina PLC
Forte
Hard Rock Café
IBM United Kingdom Limited
Intercraft Designs Limited
The Leading Hotels of the World
Jaguar Cars Limited
Anton Mosimann
Pizza Express Outside Catering Co
Spero Communications Limited
Mr and Mrs Daniel Unger
Kurt Unger
Venice Simplon-Orient Express
Vorwerk Carpets Limited
White Dove Press
Mrs George Zakhem